MARXISM AND ART

Edited
with Historical
and Critical
Commentary by
MAYNARD
SOLOMON

Wayne State University Press
Detroit, 1979

ESSAYS CLASSIC AND CONTEMPORARY

Originally published by Alfred A. Knopf, Inc., 1973. Copyright © 1973 by Maynard Solomon. All rights are reserved. No part of this book may be reproduced without formal permission.

Reprinted 1979 by Wayne State University Press, Detroit, Michigan 48202.

Waynebook 47

Library of Congress Cataloging in Publication Data

Solomon, Maynard, comp.
 Marxism and art.

 Reprint of the 1974 ed. published by Vintage
Books, New York.
 Bibliography: p.
 Includes index.
 1. Communism and art—Addresses, essays,
lectures. I. Title.
[HX521.S63 1979] 335.43'8'7011 79-2063
ISBN 0-8143-1620-4
ISBN 0-8143-1621-2 pbk.

TO MY MOTHER AND FATHER

CONTENTS

SECTION THREE: **THE BOLSHEVIKS**

SECTION SEVEN: **THE TRAJECTORY OF ART**

PREFACE

This anthology contains selections from the works of thirty-six authors, divided into seven sections. Section one—"A Reader in Marxist Aesthetics"—consists of a set of excerpts from the works of Marx and Engels that are pertinent to an understanding of Marxist philosophy, its goals, and its aesthetic assumptions. The arrangement of sections two and three—"The Second Generation" and "The Bolsheviks"—is roughly chronological, bringing the development of Marxist approaches to the arts up to the early 1930's. Section four is concerned with the emergence of "Zhdanovism" as a dominant feature of Soviet Marxist artistic theory and attitudes from the mid-1930's onward: the selections in this and the following section—"The Return to Marxist Humanism"—are largely devoted to a critique of Zhdanovism and to a number of attempts at retaining or re-establishing the humanist core of Marxist aesthetics.

In the final sections of the book—"The Sources and Function of Art" and "The Trajectory of Art"—chronology gives way to conceptual categories, which may serve to illuminate the main lines of development. A qualitative advance in Marxist aesthetic theory took place during the

1930's in the work of Max Raphael, Walter Benjamin, Ernst Bloch, Harry Slochower, Christopher Caudwell, Alick West, André Breton, André Malraux, among others. This was the point at which the aesthetic of Marxism momentarily overtook Marx's 1845 theses on Feuerbach—with their simultaneous discovery of the power of the thinking subject in history and the necessity of grounding revolutionary theory in historical-political practice. Marxist aesthetics hovered on the edge of a major integrative breakthrough. During the following decades, however, these approaches tended to be regarded as departures from a supposed orthodox norm, as heretical, eccentric, or unwarranted intrusions of non-Marxist ideology into a fully formed and self-contained system.

Now, once again, the serious investigation of the meaning, method, and implications of Marx has been resumed. Therefore, this anthology will trace not the creation of a "new" Marxism but the recognition (and hopefully, the liberation) of hitherto latent aspects of Marxism that have been made manifest through the analysis of Marx by some of his strongest disciples. In another context, T. W. Adorno touched on the dialectics of this latency of ideas: "Hegel taught that wherever something new becomes visible, immediate, striking, authentic, a long process of formation has preceded it and it has now merely thrown off its shell. Only that which has been nourished with the life blood of the tradition can possibly have the power to confront it authentically."[1] And he called attention to Freud's parallel insight, that a liberating idea "must have undergone the destiny of repression, the state of being unconscious, before it could produce such mighty effects on its return."[2] The return of the repressed contents of Marxism at this juncture of its historical evolution has created the groundwork for a Marxist aesthetics in our time.

We will attempt to delineate some of the discernible patterns of historical growth or change in the attitudes of Marxists toward art; to discover whether the followers of Marx and Engels have extended or restricted the implications of Marxism for the arts; we will argue that the Marxist approach indeed contains its specific and unique aesthetic categories rather than being merely (as some would have it) a variant form of the sociogenetic approach to art. We will have traveled a long way from the narrow economic determinism usually equated with Marxism. Whether we will also have journeyed beyond the legitimate aesthetic implications of Marxism—whether the more imaginative, dialectical, and Utopian theories

1. Adorno, *Prisms* (London, 1968), p. 155.
2. Sigmund Freud, *Moses and Monotheism* (New York, 1959), p. 130.

of some modern Marxists are to be seen as departures from a congealed system, or whether they are in fact unfoldings, confirmations, and restorations of the original but latent content of Marxism—is a question that the reader will be in a position to determine for himself. It is my own view that the logic of Marxism itself has inexorably produced an ongoing convergence of aesthetic ideas by many of its best minds, and I have attempted to highlight this in the closing sections of the anthology. I believe it could be demonstrated that even among the earlier followers of Marx there were those who were tending toward an understanding of the transcendent and revolutionary components of the aesthetic dialectic. This is explicit in William Morris; Plekhanov's ambivalent involvement with the play drive confirms it, as does Mehring's acceptance of several of the main tenets of Kantian aesthetics; Rosa Luxemburg's concept of the unfulfilled potentialities of Marxism is in this line, as is Lenin's insistence upon the active role of consciousness, and Bukharin's exposition of poetic language as mediating between biology and revolution. Even Georg Lukács —the Shakespeare of Zhdanovism—appeared in his last works to be on the verge of a dialectical reversal: his recognition of the fundamental teleological pattern of the labor process in Marxism was but a short step away from bridging the chasm that separated him from the Utopianism of Ernst Bloch.

The purpose of the anthology is not to present an abstract demonstration of a thesis. This book is an attempt at a historical survey of past work—with indications of further possibilities—in an important field of aesthetic endeavor. It is to be hoped that larger relevances will be illuminated—the connections between the arts and society, between imagination and history, between art and revolution. And if this book can make a small contribution to understanding why it is that radical and revolutionary movements almost inevitably go through a stage of repressive attitudes toward art and artist, it will have served its purpose.

The anthology is necessarily highly selective. Although I have attempted to represent most of the leading lines of exploration in Marxist aesthetics, and to give at least some representation of the major figures as well, a number of well-known Marxists who have written on the arts are not included. Many of these are critics who, though they have brilliantly applied Marxist categories to the arts, have broken no new theoretical ground. This includes (but is not limited to) critics and scholars such as Arnold

Kettle, Geoffrey M. Matthews, A. L. Morton, Frederick Antal, Wilhelm Hausenstein, Edmund Wilson, Harry Alan Potamkin, Dorothy van Ghent, T. K. Whipple, J. Kashkeen, Arnold Hauser, Hans Mayer, Ernst Meyer, and Lucien Goldmann. Also omitted are the frankly Zhdanovist critics, for reasons set forth in the introduction to section four; the general approach of Zhdanovism to the arts is, however, represented paradigmatically by the excerpts from Lukács' "The Ideology of Modernism." There are, nevertheless, other significant omissions, which can only be justified by lack of space, or by the fact that a given point of view is already represented elsewhere in the anthology. Among these are the important writings of Mikhail Lifschitz, Galvano della Volpe, Hector Agostí, Roger Garaudy, Henri Lefèbvre, Maurice Merleau-Ponty, A. Voronsky, and A. A. Bogdanov. The specialist will readily be able to extend this list. The serious student is referred to the bibliographies.

Each author's selections are introduced by the editor; in addition, he has supplied general introductions to sections four and seven. Citations of the sources from which the selections have been drawn begin on page 627 and a full list of the English-language editions used for quotations from Marx and Engels follows. There are two bibliographies: first, a bibliography of the relevant writings by each of the major contributors together with a highly selective listing of secondary sources; second, a selective bibliography of Marxist writings (primarily in English) on each of the various subdivisions of the arts.

The anthology was initially conceived of as a "classic" collection of basic texts with brief informational headnotes and a general historical introduction. It is wholly because of the insistence of my editor, Angus Cameron (and the concurrence of his colleague, John Simon), that the book has taken its present form—a series of critical commentaries and historical notes on the authors and selections. I am grateful to Mssrs. Cameron and Simon for providing this opportunity. Thanks to Paul Piccone, editor of *Telos*, for permission to reprint the general introduction to section seven and the introduction to Ernst Bloch, which appeared in *Telos* (no. 13, Fall 1972) in slightly different form. Thanks also to the helpful staffs of the New York Public Library and the libraries of Columbia University,

and to Alick West, George Thomson, André Malraux, T. Stanhope
Sprigg, and George Moberg, who provided valuable data. I also wish to
thank Harry Slochower, Peter Bergman, Marx W. Wartofsky, and my
wife for helpful comments and suggestions.

<div style="text-align: right">

MAYNARD SOLOMON
New York
August 1972

</div>

PREFACE TO THE THIRD PRINTING

The interval since the first publication of this book has seen a continued
growth in the reputations and influence of many Marxist critics and
aestheticians. At the same time, there has been some reluctance to
acknowledge the Marxist character of those writers who depart from
the notion of Marxism as a fixed system and instead devote themselves
to the creative application of Marxist principles and methodology. But
submissiveness to doctrinal assumptions is contrary to the critical and
rebellious temper of Marx, who, in *The Eighteenth Brumaire,* wrote of
the need to create "something that has never yet existed" and who set
his followers the restless task of "finding once more the spirit of revolu-
tion, not of making its ghost walk again."

This book is an exact reprint of the Vintage Books edition of 1974,
which corrected a number of minor errors and misprints in the Alfred
A. Knopf edition of 1973.

<div style="text-align: right">

Maynard Solomon
New York
January 1979

</div>

MARX AND ENGELS

KARL MARX AND
FRIEDRICH ENGELS

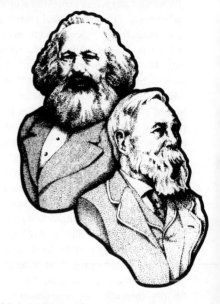

*The world has long dreamed
of something of which it only
has to become conscious in order
to possess it in actuality.*

—Marx, *letter to Arnold Ruge*

As a young man, Karl Marx (1818–1883) aspired to be a poet. A number of poems written for his father and his fiancée survive, along with other poems, a fragment of a drama, and an incomplete fantasy stylistically reminiscent of Lawrence Sterne and E. Th. A. Hoffman. In mid-1837, Marx briefly decided to become a theater critic, to his father's dismay.[1] During his earlier university years (which commenced in 1835) he was as much a student of literature and aesthetics as he was of jurisprudence and philosophy; he studied Greek classics under A. W. Schlegel and ancient mythology under Welcker. He took courses in modern art. He translated Tacitus' *Germania* and Ovid's *Elegies*. In 1837 he read "with delight" Reimarus on the "artistic instincts of the animals."[2] The aesthetic and

1. Heinrich Marx to Marx, September 16, 1837. Marx and Engels, *Werke,* Supplement vol. I (Berlin, 1968), p. 631.

2. Samuel Reimarus, *Allgemeine Betrachtungen über die Triebe der Tiere, hauptsächlich über ihren Kunsttrieb* . . . (Hamburg, 1760). This was a subject which Marx alluded to repeatedly, first in the *Economic and Philosophic Manuscripts of 1844,* and later in *Theories of Surplus Value* and *Capital.*

critical writings of Lessing, Winckelmann, Hegel, and others came under his scrutiny as part of his deep interest in the arts.

Apparently, however, poetic creation represented formlessness, chaos, and danger to Marx. Writing to his father in 1837, Marx refers to the "broad and shapeless expressions of unnatural feeling" which permeate his early poetry. "Everything real grew vague," he wrote, "and all that is vague lacks boundaries."[3] Seeking an anchor, Marx attempted to unite science and art in a quasi-philosophical dialogue, "Cleanthes," but this too bore him "like a false-hearted siren into the clutches of the enemy." He underwent a brief emotional crisis ("I was for several days quite unable to think") and determined thereafter to carry on "positive studies only." "I burned all my poems, my sketches for novellas, etc." Marx had abandoned poetry in favor of philosophy.[4] There, surely, he would be able to discover, as he wrote to his father, "our mental nature to be just as determined, concrete, and firmly established as our physical." Thenceforward, Marx's excursions into aesthetics were to be marked by a clear pattern: many beginnings and no conclusions. From late 1841 through the spring of 1842 he devoted himself entirely to researches and writings on religious art, first for sections of two pamphlets by Bruno Bauer and then for two independent articles, "On Religious Art" and "On the Romantics," which have not survived.[5] In 1857–1858 he took extensive notes in aesthetics and prepared a detailed synopsis of Vischer's *Aesthetik* for an intended encyclopedia entry on the subject, but this project too was never completed. Shortly thereafter, he abandoned his Introduction to his *Contribution to the Critique of Political Economy* (1859), leaving unsolved the problem he had raised of how art transcends its social origins. And Marx never fulfilled his ambition to write an extended study of Balzac's *La Comédie Humaine*.

Friedrich Engels (1820–1895) also began his career as a would-be poet and literary critic. Simultaneous with his pseudonymous writings on religion and social manners for Karl Gutzkow's *Telegraf für Deutschland* in the late 1830's, he dreamed, according to his biographer, Gustav Mayer, of "preaching through poetry the new ideas which were revolutionizing his

3. Marx, letter to his father, November 10, 1837.

4. In the *Doctoral Dissertation* of 1839–1841, Marx insists on instinctual repression as a precondition for maturity: "In order for man to become his only true object, he must have crushed within himself his relative mode of being, the force of passion and of mere nature" (p. 101).

5. Marx's extracts from C. F. Ruhmor's *Italienische Forschungen* (1827) and Johann Jakob Grund's *Die Malerei der Griechen* (1810–1811) survive, together with Marx's marginal comments. See Marx and Engels, *Gesamtausgabe* (Moscow, 1927–1935), part one, vol. I², pp. 116f.

inner world." He wrote poetic cycles to humanity in the style of Shelley, and he began a translation of *Queen Mab;* he composed choral pieces for the musical society in his native Bremen, in which he had served as a chorister. His writings on literary (and occasionally on musical) subjects from 1838 to 1842 fill 150 pages of his collected works.[6] As he progressed rapidly from Gutzkow to Börne, from David Friedrich Strauss to Hegel, from the liberalism of "Young Germany" to left-Hegelianism, to membership in the Chartist movement, to the decisive influence of the Utopian Robert Owen, to his essay on Carlyle and his *Sketch for a Critique of Political Economy* in 1844, to the collaboration with Marx in the same year, he, like Marx, inexorably subordinated his aesthetic and literary interests to politics and economics.

Because of the early subordination of their aesthetic proclivities to the requirements of a revolutionary movement and to the more pressing need to devote themselves to the investigation of history and political economy, Marx and Engels left no formal aesthetic system, no single extended work on the theory of art, nor even a major analysis of an individual artist or art work (excepting, perhaps, the philosophical critique of Eugène Sue's *The Mysteries of Paris* in *The Holy Family*). Marxism, accordingly, does not begin with a theory of art. There is no "original" Marxist aesthetics for later Marxists to apply. The history of Marxist aesthetics has been the history of the unfolding of the possible applications of Marxist ideas and categories to the arts and to the theory of art. This anthology will document some of the stages of that process down to the present.

———

Marx and Engels, however, did leave a large body of brief comments and writings on art and literature. These were first collected in 1933 by Mikhail Lifschitz and F. P. Schiller and were expanded by Lifschitz in editions of 1937, 1948, and 1957; the latest and most comprehensive collection[7] contains just under 1,500 pages of selections drawn from the correspondence, from reviews, encyclopedia articles, marginal notes, manuscript jottings, and excerpts from larger works on political economy, philosophy, and history, in which comments on (or relevant to) art and artists are imbedded usually by way of illustration. An abbreviated but indispensable selection is available in English (Marx and Engels, *Literature and Art,* New York, 1947) based on Lifschitz's earliest collections and on Jean Fréville's edition, *Sur la Littérature et l'Art* (1937). The range of subjects

6. Marx and Engel, *Werke,* Supplement vol. II.
7. *Über Kunst und Literatur,* ed. Manfred Kliem (Berlin, 1967).

touched on by Marx and Engels is immense (the index of names in the 1967 German edition runs to seventy-five pages). Nevertheless, these writings are not a coherent body of texts which clearly define the content of a Marxist approach to art or set the boundaries for such an approach.

In an extraordinary tour de force which has not been surpassed, Mikhail Lifschitz used these texts in the early 1930's to construct a provisional model of Marx's philosophy of art.[8] In it he traced the evolution of Marx's early aesthetic views as they paralleled the phases of his general philosophical outlook, proceeding from Romanticism to Hegelianism, thence through left-Hegelianism and a brief period of bourgeois liberalism, to the agnostic materialism of Feuerbach and ultimately to the grounding of his own philosophy in the labor process, in history and political economy. As Lifschitz somewhat acidly points out, he and his colleagues were publishing and exploring the manuscripts of the early Marx and studying the relationship of Marx to his philosophical predecessors thirty years before those subjects were taken up by Western advocates of a "new Marxism."[9] Utilizing the *Economic and Philosophic Manuscripts of 1844* and the full range of early writings, Lifschitz sketched the outlines of classical aesthetic theory in Marx and simultaneously revealed the reverberations and confirmations of many of its concepts in Marx's later writings.

As for the specific and unique categories of Marxist aesthetics—following the emergence of a distinct Marxist philosophy—Lifschitz focuses especially on art as a form of the labor process, as a mode of education of man's senses, on "the gradual development of man's creative abilities and understanding by means of spiritual production itself and, moreover, by

8. *The Philosophy of Art of Karl Marx,* ed. Angel Flores, trans. Ralph Winn (New York, 1938). A condensed version of this work appeared as "Marx on Esthetics," trans. S. D. Kogan, in *International Literature,* 1933, no. 2, pp. 75–91. A second, enlarged edition appeared in German as *Karl Marx und die Aesthetik* (Dresden, 1967). Lifschitz was born in 1905, studied at the Bauhaus-oriented Moscow Art School in the 1920's. He was associated with the Marx-Engels-Lenin Institute from 1929 until 1941; following his active participation in World War II he has been a member of the Institute for Philosophy at the Academy of Sciences in Moscow. His distinguished career as a professional aesthetician began with important studies of the aesthetics of Hegel and Winckelmann; his range of subjects was later extended to Vico, Belinsky, and others. Apart from his work in collecting and annotating the writings on art and literature of Marx and Engels, he edited a series of volumes on "Classics of Aesthetics," as well as editions of literary works by the German classic authors. His influence on Marxist criticism has been extensive, most decisively on Lukács' work after 1930.

9. Introduction to *Karl Marx und die Aesthetik,* p. 32. Lifschitz neglects, however, to mention that the serious study of the early Marx and of his debt to Hegel and Feuerbach did not continue during the period of Zhdanovist ascendance.

means of the expansion of the 'objective world' of industry" (page 66). Lifschitz stresses Marx's writings on the disparity between social and artistic development, seeing the ultimate purpose of Marx's aesthetic to be the resolution of the contradiction between the growth of productive forces and the increasing alienation of the productive classes, seeing in Marxism a means of abolishing the contradictions between oppressors and the oppressed, between physical and mental labor, thereby making possible the creation of a classless, unalienated, universal culture. For Lifschitz, the historically conditioned "contradiction between art and society is as indispensable an element of the Marxist interpretation of the history of art as is the doctrine of their unity" (page 68). And Lifschitz insists upon the dialectically active role of art: in a brilliant gloss on the *Economic and Philosophic Manuscripts* he writes: "Artistic modification of the world of things is . . . one of the ways of assimilating nature. Creative activity is merely one instance of the realization of an idea or a purpose in the material world; it is a process of objectification" (page 65).

While it is apparent that such factors as these constitute nodal points and fruitful categories of the Marxist approach to the arts, it is equally apparent that no hypothetical reconstruction of a Marxist aesthetic system can be accepted as definitive; at most it may be seen as approximating in theory a work that was never accomplished in actuality. The significance of Lifschitz's monograph is that it revealed the implicit unity of Marxist writings on literature and art by regarding them against the background of the evolution of Marxist theory. As Lifschitz wrote: "In dealing with questions of art and culture, the importance of Marxist theory would be immense even if nothing were known about the aesthetic views of the founders of Marxism" (page 6). Therefore, although their writings on art do not constitute an aesthetic system, neither can they be described as the incoherent "shreds and patches" of which Ernest J. Simmons writes.[10] René Wellek notes that they are "held together by their general philosophy of history and show a comprehensible evolution" if the chronology of their composition is not ignored.[11] A recent study, Peter Demetz's *Marx, Engels, and the Poets*,[12] is helpful in its attempt to follow that chronological development; it traces the origin of the Marxist aesthetic pronouncements in the writings of Young Germany, the left Hegelians and Carlyle (ignoring, however, the Utopian Socialist influence), through the Hegelian and Feuerbachian stages of its development, into a supposed

10. *Continuity and Change in Russian and Soviet Thought,* ed. Ernest J. Simmons (Cambridge, Mass., 1955), p. 452.

11. *History of Modern Criticism* (New Haven and London, 1965), vol. III, p. 233.

12. Stuttgart, 1959. English translation: Chicago, 1967.

period of economic determinism (supported only by a misreading of the Preface to the *Critique of Political Economy*[13]) toward a "more relaxed and tolerant constellation of ideas" exemplified in Engels' later writings. Unfortunately, neither Wellek nor Demetz comes to grips with Lifschitz's brilliant reconstruction.

Perhaps it is the very absence of a definitive work by Marx on criticism or aesthetic theory which has opened the door to interpretation, prevented the reduction of Marxist aesthetics to a rigid set of accepted formulas, and made impossible any impoverishing descent into academicism. Marx's work arose in part as a reaction against the grandiose attempts at the systematization of knowledge by his metaphysical predecessors. His intellectual labors can be regarded as a perpetual tension between the desire to enclose knowledge in form and the equally powerful desire to reveal the explosive, form-destroying power of knowledge. Cohesion and fragmentation warred within him. It cannot be accidental that he brought none of his major system-building works to completion: the *Critique of Hegel's Philosophy of Right*, the *Economic and Philosophic Manuscripts, The German Ideology*, the *Grundrisse*, were all incomplete and, except for an introduction to the first of these, remained unpublished in his lifetime. Even the concluding volumes of *Capital* were abandoned by Marx a half-decade before his death. Resistance to systematization was perhaps inevitable for one who understood the short cuts and ruses by which Hegel had constructed his comprehensive world view and thereby partially closed off the positive development of his philosophy. Feuerbach had already taken the path toward fragmentation in his *Principles for a Philosophy of the Future* and

13. Demetz reprints only a brief passage from the Preface, omitting Marx's careful insistence on the distinction between the material transformation of economic conditions "and the legal, political, religious, aesthetic or philosophical" forms. And he takes extreme liberties in the translation of a crucial line, which he renders: "The manner of production of material life *determines altogether* the social, political, and intellectual life-process" (p. 72, italics added). The original reads: "Die Produktionsweise des materiellen Lebens bedingt den sozialen, politischen und geistigen Lebensprozess überhaupt." This should be translated as: "The mode of production of material life *conditions* the social, political and intellectual life process *in general*." (Marx and Engels, *Selected Works,* vol. I, p. 503). "Determines" could be substituted for "conditions" (although Marx would probably have used a stronger verb than "bedingt" had he intended this reading), but Demetz's substitution of "altogether" for "in general" cannot be justified, nor is this reading given in any responsible translation, whether by Stone, Bottomore, or Wellek.

his *Essence of Religion*. (Later, Kierkegaard and Nietzsche would largely complete the process of converting systematic philosophy into aphorism and revelation.) Marx's world-shattering theses on Feuerbach are in this line of development, as is *The Communist Manifesto*, in which Marx's suppressed poetic strivings find their full expression. The Marxist texts on aesthetics, in this sense, are aphorisms pregnant with an aesthetics— an unsystematized aesthetics open to endless analogical and metaphorical development.

Section one of this anthology consists of a brief "Marxist Reader" in aesthetics containing, in addition to representative comments on art and literature, passages from the works of Marx and Engels which are relevant to the nature of art and its function in social life. No attempt is made here to comment on the aesthetic or critical implications of these passages. The primary purpose of the Reader is to provide a framework through which students may find their own way into the rich proliferation of possibilities, and to provide the background against which the later selections in the anthology may be considered.

The work of post-Engels–Marxist critics and aestheticians should be regarded not only as applications of Marxism to the arts, but as a collective commentary on the writings of Marx and Engels, as attempts to elaborate the legitimate implications of Marxism to the arts. Nevertheless, even the totality of work by Marxists in this field far from exhausts those possibilities, as a careful study of the selections from Marx and Engels will reveal. For example, until the publication of the first two volumes of Lukács' aesthetics—*Die Eigenart der Aesthetik*[14]—there was no systematic (or major) study of the implications for aesthetics of the Marxist theory of the labor-process; no Marxist has yet attempted to formulate a theory of the creative process itself on the basis of Marx's occasional comments on artistic creativity. (Caudwell's lonely effort is written without specific use of Marx's passages on the subject.) The implications of the decisive and wholly original Marxist category of "the fetishism of commodities" have barely been explored, with the notable exception of Walter Benjamin's later writings. The specific proof of Marx's liberating comment that "the forming of the five senses is a labour of the entire history of the world down to the present" (see below, page 60) has not yet been given. Nor has any Marxist critic as yet confronted the explosive

14. (Neuwied, 1963).

potentialities of Marx's and Engels' insistence that the mode of production must be defined biologically as well as in terms of economics (see below, pages 31–32).

A number of Marxist concepts—such as "alienation," "false consciousness," "ideology," "superstructure," "class-consciousness," etc.—have fared better among the philosophers and sociologists.[15] Others, especially those relating to the artist's class affiliation and outlook, have been heavily worked by the practicing critics, often to the exclusion of other significant categories. The analysis of the class origin, position, and ideology of the artist is indeed a fruitful branch of Marxist inquiry, which ·has led to important results both within Marxism and within the various schools of the "sociology of knowledge." But when such analyses have been completed, we are left with a host of other questions: the nature of creativity, the aesthetic experience, the dialectics of form, the psychology of art, the etiology of art forms, the evolving meanings of the work of art, and so on. Restrictive uses of a small portion of the Marxist vocabulary are unfortunate, since the broader application of the totality of categories of Marxist theory is capable of illuminating sectors along the entire range of aesthetic questions.

▬

A secondary function of our selections from Marx and Engels is negative: to define the Marxist approach to art by telling us what it is not, what it cannot be. The selections serve as a counterweight to the ever-present tendencies of later Marxists to equate art with ideology, or to insist on total parallelism between class interest and artistic expression. The writings

15. A few of the more important works in English elucidating these basic philosophical concepts are: H. P. Adams, *Karl Marx in his Earlier Writings* (London, 1940; New York, 1965); Kurt Blaukopf, "Ideology and Reality," *Modern Quarterly,* vol. 2, no. 4 (Autumn 1947), pp. 373–79; Arnold Hauser, *Mannerism* (London, 1965), vol. I, pp. 94–114, and *The Philosophy of Art History* (Cleveland and New York, 1963), pp. 21–40. Henri Lefèbvre, *The Sociology of Marx* (New York, 1968), pp. 3–88; George Lichtheim, *The Concept of Ideology and Other Essays* (New York, 1967), pp. 3–46; Karl Löwith, *From Hegel to Nietzsche* (Garden City, New York, 1967); Georg Lukács, *History and Class Consciousness* (London, 1970); Karl Mannheim, *Ideology and Utopia* (New York, 1936) and *Essays on the Sociology of Culture* (London, 1956); Herbert Marcuse, *Reason and Revolution* (Boston, 1960); István Mészáros, *Marx's Theory of Alienation* (London, 1970); Bertell Ollman, *Alienation: Marx's Conception of Man in Capitalist Society* (Cambridge, 1971); Plekhanov, *Fundamental Problems of Marxism* (New York, 1969); and Alfred Schmidt, *The Concept of Nature in Marx* (London, 1971).

stand as crucial correctives to the tendency to reduce Marxism to economic determinism.

The recognition of ambivalence in class psychology was inherent in Marx's view, as was the knowledge that art transcends its creator's conscious intent and class position. Marx was well aware of the disproportion between artistic achievement and social evolution, fully cognizant of the existence of "universal" factors in art which make possible its impact across class lines and historical boundaries.

Nevertheless, later Marxists have used selected comments of Marx and Engels on literature and art as justification for treating art as a mutant ideological form, for neglecting both the immanent and the transcendent qualities of the work of art, for finding one-to-one relationships between art and politics, or art and class struggle, or art and economic development. Marx and Engels did none of these, but their general emphasis—conditioned as it was by the Enlightenment rather than by the Romantic view of the artist—was on the artist as thinker, as educator, as unfolder of social truths, as one who reveals the inner workings of society, as ideologist who pierces the veil of false consciousness. Engels' highest praise for Balzac is that one could learn more about French society from him "than from all the professional historians, economists and statisticians of the period together." And this is virtually identical with Marx's earlier comment on the great school of British novelists (Dickens, Thackeray, Charlotte Brontë, and Mrs. Gaskell) whose "eloquent and graphic portrayals of the world have revealed more political and social truths than all the professional politicians, publicists, and moralists put together." But even these comments, which stress the utilitarian and educational side of art, express the belief that the sensuous specificity of artistic portrayal (its *materialism*) is of a higher order than more scientific (but also more abstract) analyses of class society and its internal conflicts.

For many decades, "refutations" of Marxism took the form of ritualistically equating it with a mechanistic form of economic determinism. This did not necessarily arise from dishonesty on the part of Marxism's opponents, for it was as a doctrine of economic determinism that Marxism was comprehended and taught by many of its own early adherents, especially during the period of the Second International. Marx and Engels themselves felt that they had paid excessive attention to this aspect of the dialectic during the post-1848 years. Pressing questions of political organization and the task of formulating a critique of capitalist economy (uncovering the source of the proletariat's exploitation) as the basis for a socialist-revolutionary movement had occupied Marx almost exclusively from the mid-

1840's until the early 1870's, leading to neglect of the dissemination of Marxism's underlying philosophical assumptions, which had been left, as Marx wrote, "to the gnawing criticism of the mice" in 1846. It was one of Marx's characteristics that he did not seek to create a nucleus of intellectual disciples trained in these principles, with an understanding of the dialectic and of the materialist conception of history. Engels aside, there was no Marxist of the first rank until the 1880's; many of those who called themselves Marxists (Marx, in despair of his disciples, exclaimed "I am not a Marxist") remained largely under the impression that Marxism was identical with the "economic interpretation of history."

Contributing to this misapprehension is the fact that virtually all the works that constitute the philosophical foundation of Marxism were unknown or unpublished until after the death of Marx. Even more striking is the observation that most of the documents which are crucial for a formulation of the Marxist approach to art remained in manuscript or in obscurity until relatively recent times. Until the publication of *Anti-Dühring* in 1878, the only major statement of Marxist theoretical positions widely known among socialists was *The Communist Manifesto.* Engels' *Ludwig Feuerbach and the Outcome of Classical German Philosophy* appeared in 1888; it included the first publication of Marx's theses on Feuerbach of 1845. Marx's *Poverty of Philosophy,* although published in 1847 in France, achieved its first German publication only in 1885. The correspondence with Lassalle, along with Marx's dissertation on Democritean and Epicurean philosophy, his articles in the *Rheinische Zeitung,* and his 1843 Introduction to *A Contribution to the Critique of Hegel's Philosophy of Right* were made generally available by Mehring in 1902. *The German Ideology* (but for a brief excerpt) remained in obscurity until 1932; the *Economic and Philosophic Manuscripts of 1844, The Dialectics of Nature,* and most of Marx's and Engels' correspondence relevant to aesthetic questions similarly appeared only in the 1930's. Marx's *Fundamental Principles of the Critique of Political Economy* (the *Grundrisse*) was virtually unknown even to specialists until 1953. The assimilation and impact of these works, therefore, is a matter for our own time rather than a nineteenth-century affair, and the chronology of publication goes a long way toward explaining the currents and countercurrents in Marxist philosophy and aesthetics.

Marx himself published no major work (his contributions to Engels' *Anti-Dühring* excepted) during the last decade of his life as he struggled vainly to complete *Capital.* To Engels, in his last years, fell the task of bringing Marxism up to date, of acknowledging and squaring accounts with the various component sources of Marxism, of correcting the distortions

and false emphases which the exigencies of a political-revolutionary movement had woven into the Marxist fabric.[16] Engels' major corrective to the widespread misconceptions about Marxism was in relation to economic determinism, a simplistic sociogenetic theory deriving its main support and wide popularity from its surface lucidity, its apparent ability to explain virtually any idea or historical event in terms of its class origin or its reflection of economic or political interest. This actually was but a variant form of the mechanistic "materialism" of Büchner, Vogt, Moleschott, and other writers of the post-1848 period, whose views were adopted as advanced, common-sense materialism by the socialist working-class movement (especially in Germany) of the later nineteenth century.

The premise of Marxism is this: "It is not men's consciousness that determines their existence, but on the contrary their social existence that determines their consciousness" (see below, page 29). Marxism demonstrates that the conflicts within the material foundation of society (to the extent that the material element can be isolated) give rise to certain forms of consciousness. Engels writes that the "fundamental proposition" of *The Communist Manifesto* is that "in every historical epoch, the prevailing mode of economic production and exchange, and the social organization

16. No biographical study has fully explored the reasons for the sudden and sustained burst of Engels' creativity from the 1870's until his death in 1895. Undoubtedly, the waning productivity of Marx, followed by his death in 1883, spurred Engels to take on the political and intellectual leadership of the Social Democratic movement and simultaneously freed him from the supportive position in which he had labored for a quarter-century. Another important factor was his retirement in 1869—after almost twenty years—from the Manchester cotton-manufacturing firm partly owned by his father, the income from which he had used to support Marx's labors. No separate work (a few minor pamphlets excepted) had appeared from Engels' pen since the brief monograph on *The Peasant War in Germany* (serialized 1850) in which the Marxist conception was extensively applied to a specific segment of history for the first time. Numerous articles on current history and military affairs, reviews of Marx's publications, several now-forgotten polemical pamphlets, and a relatively sparse correspondence constituted the sum of Engels' literary activities during the Manchester period. Nor was he active in the First International during these singularly unproductive decades.

With his removal from Manchester to London in 1870, Engels launched a series of ambitious projects, including *The Dialectics of Nature* (ca. 1873–1886), which evidently was intended to accomplish in the natural sciences what *Capital* was achieving in political economy and economic history. Engels' *Anti-Dühring, The Origin of the Family, Private Property and the State,* and *Ludwig Feuerbach* date from this period and contain the most systematic expression of Marxist philosophical, anthropological, and scientific doctrine, and, for many years, constituted the only accessible statements of the theoretical principles of Marxism other than *The Communist Manifesto.*

necessarily following from it, form the basis upon which is built up, and from which alone can be explained the political and intellectual history of the epoch."[17] Elaborating the implications of this premise, Marxism attempts to show the bondage in which man's consciousness has been held by the relations of material production, to reveal the domination of the producer by the product of his labor. Marxism's goal is the liberation of consciousness, the freeing of praxis from bondage via revolutionary theory. "Theory also becomes a material force as soon as it has gripped the masses" (see below, page 53). As Bloch writes, the economic-dialectical interpretation of history gives "knowledge of the real motivations and substance of a period, and of the actual contents within the shell."[18] Consciousness, shaped by the material base (and by the innate biological structure of man as well), serves to explode the relations of production when these have reached the stage of historical ripeness.

Despite the publication of *Anti-Dühring* and *Ludwig Feuerbach,* Engels' so-called Letters on Historical Materialism of the 1890's indicate that many of Marxism's ablest students (Mehring among them) were still unable to grasp the concept that superstructural consciousness—through its interaction with other levels of the superstructural hierarchy and even by its reaction upon the economic base—could change history. To many, this appeared to negate the "essential" Marxist formulations about the ultimate primacy of matter and of the mode of production, which they understood undialectically as negating the activity of the human subject, converting man into a passive object of material forces.

Marxism, however, has had its greatest successes precisely in the realm of heightening and transforming consciousness as a prelude to the intended transformation of society. At the very time that Engels was composing his last works, Marxism had become the accepted philosophy of a party representing large segments of the German working class, and was making inroads in other countries as well, including Russia, the United States, England and France. Its theories were gripping the masses. To the extent that its exponents emphasized the derivative aspect of the various modes of consciousness they appeared to negate the means of explaining Marxism's influence. Marxism could only account for its revolutionary power (and prevent itself from being transformed into a doctrine of evolutionary-parliamentary passivity) by "correcting" the economic-determinist emphasis, by explaining how men are able to "make their own history" even

17. Preface to the English edition of *The Communist Manifesto,* 1888.
18. Ernst Bloch, *On Karl Marx* (New York, 1971), p. 129.

though they do not do so "out of whole cloth." This posed an apparently insuperable difficulty for those who regarded Marxism as an unalloyed "science of society": if ideas can transform society, how can it be asserted that economic forces are in the last analysis decisive?[19] If superstructural categories are contingent upon the material base, how can it be said that such categories are in turn decisive in the transformation of the material base? If Marxism posits the dependency of superstructure upon material-social-historical development, how can Marxism itself be explained except as a premature expression of a working class which has not yet asserted itself in a decisive economic sense? Further, if the ruling ideas "are the ideas of the ruling class" how can the anticapitalist power of the Marxist theories themselves be explained? Is Marxism exempt from its own laws?

As has been indicated, the issue turns on dialectics. Marx had laid the groundwork for the solution to these difficulties as early as 1843, in the Introduction to *A Contribution to the Critique of Hegel's Philosophy of Right* (see below pages 52–53), where he described the philosophical-artistic "dream-history" in which Germany had avoided the necessity of present political action but in which it had anticipated its revolutionary future.[20] Engels patiently took up this thread in his later writings. In *Ludwig Feuerbach,* he wrote: "Just as in France in the eighteenth century, so in Germany in the nineteenth, a philosophical revolution ushered in the political collapse." Superstructural events—ideas, philosophy, art, etc.— *prefigure* changes in the mode of production. Marxism not only allows for, but demands the heightening of consciousness as a necessary precondition for historical progress.

The stress in Engels' later works upon the active and revolutionary side of superstructural processes reconfirmed the presuppositions from which Marxism originated. The ruling ideas of each age are the ideas of the ruling class (see below, pages 49–50). These include an anticipatory element which comes into being not primarily as the emerging consciousness of a rising class but as the highest level of consciousness of the most advanced members of the ruling class itself, who seek thereby to avoid the painful realities of social existence as well as to transcend their awareness

19. Lenin was to introduce an even greater difficulty. He asserted that the working class could, by itself, only achieve trade-union consciousness, thereby suggesting that the automatic processes of history could not produce socialism.

20. The separation of Marx from Feuerbach hinged on precisely this question of the dynamic subject: "The chief defect of all hitherto existing materialism . . . is that the thing, reality, sensuousness, is conceived only in the form of the *object* or of *contemplation,* but not as *human sensuous activity"* (Theses on Feuerbach).

of impending extinction as a class.[21] These ideas penetrate various strata of society through the mediation of the art forms and theoretical writings in which they are expressed, becoming part of the consciousness of oppressed classes, crystallizing into the Utopian, revolutionary, system-shattering goals of ascending groups—the imaginative models by which the mode of production is ultimately transformed. No revolution can take place without the work of ideological preparation, without the transformation of consciousness. History is an extension of the labor process, in which, writes Marx in *Capital,* "we get a result that already existed in the imagination of the labourer at its commencement" (see below, page 23).[22] And this brings us back into the aesthetic dimension: it is mankind's dream-work—play, poetry, theoretical science, philosophy—its mock world into which the imagination withdraws for sustenance and rejuvenation, which is a necessary motor of the labor process and of history itself.

It is inherently unprofitable to attempt to arrive at discrete categories of a doctrine that aims at philosophical "totality," which seeks not only to dissolve categories but indeed to merge the separate disciplines of knowledge into a single historical discipline. The subdivision of Marxism into an

21. "The bourgeoisie itself . . . supplies the proletariat with its own elements of political and general education; in other words, it furnishes the proletariat with weapons for fighting the bourgeoisie," write Marx and Engels in a different context (*The Communist Manifesto,* chap. one, p. 117). They continue: "Just as, therefore, at an earlier period, a section of the nobility went over to the bourgeoisie, so now a portion of the bourgeoisie goes over to the proletariat, and in particular, a portion of the bourgeois ideologists, who have raised themselves to the level of comprehending theoretically the historical movement as a whole" (*loc. cit.*).

22. Marx's discovery that the labor process consists of the materialization of goal projections (concretizations of the imagination) not only resolves the philosophical problems of causality and teleology (origins and goals, means and ends are inseparably linked) but also constitutes the basis for the formulation of all applications of Marxist theory—whether of politics, philosophy, or aesthetics. For in Marxism the labor process is the model of all social activity, and the teleological element in the labor process demarcates human labor from instinctive animal labor. Engels writes: "The animal merely *uses* external nature, and brings about changes in it simply by his presence; man by his changes makes it serve his ends, *masters* it. This is the final, essential distinction between man and other animals" (*Dialectics of Nature,* p. 291). Lukács explores this subject in a brilliant essay of his final years, "The Dialectics of Labor: Beyond Causality and Teleology," (*Telos,* no. 6 [Fall 1970], pp. 162–74). See also Lucio Colletti, "The Marxism of the Second International," (*Telos,* no. 8 [Summer 1971], pp. 84ff).

ever-increasing number of "categories" tends to obscure the main threads of Marxist thought, including those which are applicable to the formation of a Marxist approach to the arts. Marxism aims to treat each "fact" from the point of view of all the antagonistic relationships within which that fact exists, and the "primary" doctrines or "fundamental" categories of Marxist theory are interpenetrating aspects of such a dialectical totality.

Not only is each separate category of Marxist thought inseparably connected to every other by way of dialectical unity or opposition, but Marxism's concepts cannot be separated either from its assumptions, its methods, or its goal. The student who abstracts one facet of the dialectic and attempts to apply it shortly reaches an impasse which no longer resembles creative or authentic Marxism. Marxism is the symbolism of dialectical conflict, of drama, of the unity of opposites, of revolutionary change, of matter and man in motion, constantly transcending the moment, pointing into the future. The demonstration of this lies in reading Marx rather than his commentators. As Engels wrote to Joseph Bloch: "I would . . . ask you to study this theory from its original sources and not at second hand; it is really much easier." However, we can offer, schematically, a few examples of such dialectical interplay:

—In Marxism, the category of alienation is to be seen as the antithetical state of humanism; alienation is a negative consequence of class-engendered productive relations, which is to be measured against the ideal humanist passion for the liberation of mankind's potentialities, which in turn constitutes the goal of Marxism.

—The Marxist premise—"being determines consciousness"—taken by itself may be read as a deadening statement of human passivity; in Marxism, it must be read as the dialectical twin of the proposition that "men make their own history" and of such formulations as "Theory becomes a material force when it grips the masses." Subject and object interpenetrate and struggle in Marxism: *both* are dynamically active, although the material factor (properly defined) is ultimately decisive.

—Marxism is a philosophy of praxis: "Social life is essentially practical. All mysteries which mislead theory into mysticism find their rational solution in human practice and in the comprehension of this practice."[23] Practice therefore guides theory toward understanding. Simultaneously, theory guides practice toward liberation: "The immediate task of philosophy, which is at the service of history . . . is to unmask self-alienation in its *unholy forms.*" Writing of Luther and the Reformation, Marx notes: "As the revolution then began in the brain of the *monk,* so

23. Theses on Feuerbach.

now it begins in the brain of the *philosopher*." Theory, tested in reality, serves as paradigm of human activity: *"You cannot abolish philosophy without making it a reality."* Thought strives for realization, while "reality must itself strive toward thought."[24]

—Marx writes that "the socialist tendency" takes "the primitive age of each nation" as its pattern (Marx to Engels, March 25, 1868), and the Marxist model of the future is the primitive matriarchal communism of prehistory purged of its terror. Marxism's futuristic thrust is anchored by historical memory, by the restoration of meaning.

—Surplus value is an economic category whose supersession constitutes the foundation for the fulfillment of Marxism's aesthetic and humanist goals: Marx's discovery of the hidden material sources of proletarian exploitation exists as a basis for the conquest of hunger and the satisfaction of mankind's sensuous and spiritual needs and potentialities.

—The labor process is human only to the extent that it is not immediately practical (that is, instinctive); leavened and prepared by the imagination, labor takes on its specifically human form. "Really free labour," writes Marx in the *Grundrisse,* "gives up its purely natural, primitive aspects and becomes *the activity of a subject controlling all the forces of nature in the production process"* (page 124, italics added). It is at this visionary juncture that man determines his destiny and bridges the split between himself and nature: "Man therefore becomes able to understand his own history as a *process,* and to conceive of nature (involving also practical control over it) as his own real body" (page 121).

The aesthetic dialectic in Marxism takes manifold forms, a number of which will be explored in the course of this anthology. The central dialectic may be: art as the product of divisions within the material productive base and art simultaneously as a goal-projecting concretization of human desires capable of a role in the transformation of that material base by means of its consciousness-altering essence. Art simultaneously reflects and transcends; says "Yes" and cries "No"; is created by history and creates history; points toward the future by reference to the past and by liberation of the latent tendencies of the present. Marxism is concerned with the trajectory of art as well as with its sources. Art's ability to transcend the historical moment was of special concern and interest to Marx himself (see below, pages 61–64). It has remained for twentieth-cen-

24. Quotations from Introduction to *A Contribution to a Critique of Hegel's Philosophy of Right.*

tury Marxists to take up the question anew and to indicate the ways in which art serves as a vehicle of the dynamically active subject in history.

Many of Marxism's decisive formulations deal with various aspects of the veils which conceal economic and material reality from consciousness; the fetishism of commodities, reification, alienation, false consciousness, ideology, objectification, estrangement—all of these are aspects of the illusory consciousness which constitute the negative reality of class society. Engels, in the closing pages of *Ludwig Feuerbach,* had presented a model of the driving forces which lie behind this negative reality. As Marcuse perceived, in Marx's work "the negativity of reality becomes a *historical* condition . . . associated with a particular form of society . . . ; the given state of affairs is negative and can be rendered positive only by liberating the possibilities immanent in it."[25] The Marxist critique of capitalism aims to pierce the disguise, to make known this negativity, to liberate consciousness and thereby to move closer to the abolition of the prevailing mode of production and beyond it toward the self-realization of humanity. This gives rise to a basic Marxist methodological approach (by no means the only one)—that of demystification, the rending of the veil of appearance which, as Marx repeatedly insists, does not coincide with the essence of things.[26] Paul Ricoeur places Marxism (perhaps too firmly) in the "school of suspicion" as a philosophy devoted to distinguishing between "the patent and the latent."[27] (Here, we may recall that Marx's favorite motto was the Cartesian "Doubt everything.") The search in Marxism for the real beneath the apparent takes the form of unmasking, of uncovering the positive essence that is hidden by the negative conditions of class existence so that (by the negation of negation) things and men may be restored to their "essential" state of being.[28] Demystification shatters false con-

25. Marcuse, *Reason and Revolution* (Boston, 1960), pp. 313, 315.

26. See, for example, *Capital,* vol. I, p. 547: "That in their appearance things often represent themselves in inverted form is pretty well known in every science except political economy."

27. Paul Ricoeur, *Freud and Philosophy* (New Haven and London, 1970), pp. 32–33.

28. Feuerbach, in his *Essence of Christianity,* had already brought the method of "dis-illusionment" to its highest peak with respect to the anthropological sources of religious belief and practice. Having assimilated this demythicizing approach, one of the major criticisms of Feuerbach by Marx is precisely of his "reduction" of spiritual factors to material ones: "His work consists in resolving the religious world into its secular basis," writes Marx (Theses on Feuerbach), whereas, as Karl Löwith

sciousness, exposes the human relations which underly the commodity relationship, reveals the true motivations of historical movement. The materialistic dialectic, writes Lukács, shows "the path that leads to the conscious control and domination of production and to the liberation from the compulsion of reified social forces."[29]

Here we touch on one of the central difficulties of the Marxist approach to art. Reasoning from the above, many Marxists have analogically utilized the demystification strategy as proper to the analysis of art. Instead of liberating consciousness this tends to deaden both the force and the grace of imagination and to deprive art of its transcending force, converting Marxist aesthetics into sociogenetic reductionism. Certainly it is a function of Marxist criticism to show the derivation of art forms and art works from social-historical processes and in so doing to distinguish between the transitory, class-bound elements of art (the ideological component) and the goal-projecting, revolutionary iconology of art. However, art is not an economic category, nor is it to be confused with the various Marxist categories of false consciousness. Art is itself (like Marxism) a strategy of demystification, a withdrawal from the negative reality of an alienated class society into a different order of reality which common sense deems illusion but which is actually the symbolic precipitate of the materialist-sensuous substructure of human relations and desires. Art is a distinct form of the labor process in which—amid the myriad effusions and narcotic productions of class culture—is kept alive the materialized imagery of man's hope and of that very same human essence which Marxism seeks to reveal. Marxism, having supplied the theoretical means of analyzing the historically shaped contradictions which give rise to art, has the greater task of preserving and liberating the congealed symbols of beauty and freedom which live on within the masterworks of art.

For Marxism, art is many things. Among them, art is man's mode of mediation between the senses and the intellect, between cognition and feeling; it is a means of educating man's senses, his sensibility, and his

points out, "the important thing to Marx is to proceed in the other direction, analyzing historically the contradictions of life on earth and discovering what needs and contradictions within the secular circumstances make possible and demand religion." (Löwith, *From Hegel to Nietzsche* [Garden City, 1967], p. 349). The methodological insistence on antireductionism is reconfirmed by the mature Marx in an important footnote to *Capital* (vol. I, p. 367, n. 1): "It is, in reality, much easier to discover by analysis the earthly core of the misty creations of religion, than, conversely, it is to develop from the actual relations of life the corresponding celestialized forms of those relations."

29. *History and Class Consciousness* (London, 1970), p. 253.

consciousness; it is an activity through which mankind transcends the present, steps beyond the threshold of the given; it is a mode of human expression which provides both the passion and the enthusiasm to permit the transformation of the latent into the actual.

It is within this framework that the Marxist critic takes his place. The possible functions of Marxist criticism are theoretically limitless because the whole of corporeal reality intervenes between the mode of production and the artist. But the critic may not be termed a Marxist merely because he has devoted himself to some portion of the dialectic of art, no matter how dialectically he has analyzed the intricacies of form or the interconnections between symbol and reality, no matter with what sociological precision he has set forth the class make-up of audiences and artist or the material genesis of art forms, the artistic derivatives of ideological patterns. Marxist criticism emerges not accidentally, spontaneously, or dispassionately; the hallmark of the Marxist critic is his passionate involvement in humanity, his "Utopianism," his desire to make the irrational rational, to end exploitation of man by man, to transcend alienation, to eliminate the "unnecessary" tragedies of class society, and to limit the primal conflict between man and natural necessity. Then, as Slochower points out, tragedy will not be eliminated but will be elevated to its purest form, in which man may confront the conditions of existence with dignity.[30] The infinite relations that precede and rise from the art work, radiating and reverberating, are all proper functions of Marxist criticism, but consciousness and purpose ultimately determine the definition of the Marxist. The eleventh thesis on Feuerbach is the starting and the ultimate point of Marxism: "The philosophers have only *interpreted* the world in various ways; the point is to *change* it." To this we may add, with Ernst Bloch, "not just to change the world, but to improve it supremely."[31]

30. *No Voice Is Wholly Lost* (New York, 1945), pp. 275–77.
31. *On Karl Marx* (New York, 1971), p. 151.

A READER IN MARXIST AESTHETICS — SELECTED TEXTS

THE PREREQUISITES OF HISTORY

MARX: THE LABOR PROCESS
from *Capital*

Labour is, in the first place, a process in which both man and Nature participate, and in which man of his own accord starts, regulates, and controls the material re-actions between himself and Nature. He opposes himself to Nature as one of her own forces, setting in motion arms and legs, head and hands, the natural forces of his body, in order to appropriate Nature's productions in a form adapted to his own wants. By thus acting on the external world and changing it, he at the same time changes his own nature. He develops his slumbering powers and compels them to act in obedience to his sway. We are not now dealing with those primitive instinctive forms of labour that remind us of the mere animal. An immeasurable interval of time separates the state of things in which a man brings his labour-power to market for sale as a commodity, from that state in which human labour was still in its first instinctive stage. We presuppose labour in a form that stamps it as exclusively human. A spider conducts operations that resemble those of a weaver, and a bee puts to shame many an architect in the construction of her cells. But what distinguishes the worst architect from the best of bees is this, that the architect raises his structure in

imagination before he erects it in reality. At the end of every labour proc-
ess, we get a result that already existed in the imagination of the labourer
at its commencement. He not only effects a change of form in the material
on which he works, but he also realises a purpose of his own that gives the
law to his modus operandi, and to which he must subordinate his will. And
this subordination is no mere momentary act. Besides the exertion of the
bodily organs, the process demands that, during the whole operation the
workman's will be steadily in consonance with his purpose. This means
close attention. The less he is attracted by the nature of the work, and the
mode in which it is carried on, and the less, therefore, he enjoys it as
something which gives play to his bodily and mental powers, the more
close his attention is forced to be.

The elementary factors of the labour-process are 1, the personal activity
of man, *i.e.,* work itself, 2, the subject of that work, and 3, its instruments.

ENGELS: LABOR POWER AND CREATION
from review of Marx's *Capital*

The capitalist finds on the commodity market under present social condi-
tions *a commodity* which has the peculiar property that *its use is a source
of new value, is a creation of new value,* and this commodity is *labour
power.*

MARX: LABOR POWER
from *Capital*

By labour-power or capacity for labour is to be understood the aggregate
of those mental and physical capabilities existing in a human being, which
he exercises whenever he produces a use-value of any description.

MARX: THE LABOR PROCESS
from *Capital*

The labour process, resolved as above into its simple elementary factors, is
human action with a view to the production of use-values, appropriation of
natural substances to human requirements; it is the necessary condition for
effecting exchange of matter between man and Nature; it is the everlasting

nature-imposed condition of human existence, and therefore is independent of every social phase of that existence, or rather, is common to every such phase.

MARX: THE LABOR THEORY OF VALUE
from *Capital*

Hence, when we bring the products of our labour into relation with each other as values, it is not because we see in these articles the material receptacles of homogeneous human labour. Quite the contrary: whenever, by an exchange, we equate as values our different products, by that very act, we also equate, as human labour, the different kinds of labour expended upon them. We are not aware of this, nevertheless we do it. Value, therefore, does not stalk about with a label describing what it is. It is value, rather, that converts every product into a social hieroglyphic. Later on, we try to decipher the hieroglyphic, to get behind the secret of our own social products; for to stamp an object of utility as a value, is just as much a social product as language. The recent scientific discovery, that the products of labour, so far as they are values, are but material expressions of the human labour spent in their production, marks, indeed, an epoch in the history of the development of the human race, but, by no means, dissipates the mist through which the social character of labour appears to us to be an objective character of the products themselves. The fact, that in the particular form of production with which we are dealing, viz., the production of commodities, the specific social character of private labour carried on independently, consists in the equality of every kind of that labour, by virtue of its being human labour, which character, therefore, assumes in the product the form of value—this fact appears to the producers, notwithstanding the discovery above referred to, to be just as real and final, as the fact, that, after the discovery by science of the component gases of air the atmosphere itself remained unaltered.

MARX: THE PRIMACY OF NATURE AND OF BIOLOGY
from *Pre-Capitalist Economic Formations*

. . . the original conditions of production appear as natural prerequisites, *natural conditions of existence of the producer,* just as his living body, however reproduced and developed by him, is not originally established by himself, but appears as his *prerequisite;* his own (physical) being is a natural

prerequisite, not established by himself. These *natural conditions of existence,* to which he is related as to an inorganic body, have a dual character: they are (1) subjective and (2) objective.

MARX: **PRODUCTION AND CONSUMPTION**
from Introduction to *A Contribution to the Critique of Political Economy*

Production is at the same time also consumption. Twofold consumption, subjective and objective. The individual who develops his faculties in production, is also expending them, consuming them in the act of production, just as procreation is in its way a consumption of vital powers. In the second place, production is consumption of means of production which are used and used up and partly (as e.g. in burning) reduced to their natural elements.

ENGELS: **MAN AND NATURE**
from *Dialectics of Nature*

In short, the animal merely *uses* external nature, and brings about changes in it simply by his presence; man by his changes makes it serve his ends, *masters* it. This is the final, essential distinction between man and other animals, and once again it is labour that brings about this distinction.

MARX: **LABOR, CONSCIOUSNESS, AND BEAUTY**
from *Economic and Philosophic Manuscripts*

Conscious life-activity directly distinguishes man from animal life-activity. It is just because of this that he is a species being. Or it is only because he is a species being that he is a Conscious Being, i.e., that his own life is an object for him. Only because of that is his activity free activity. Estranged labour reverses this relationship, so that it is just because man is a conscious being that he makes his life-activity, his *essential* being, a mere means to his *existence*.

In creating an *objective world* by his practical activity, in *working-up* inorganic nature, man proves himself a conscious species being, i.e., as a being that treats the species as its own essential being, or that treats itself as a species being. Admittedly animals also produce. They build themselves nests, dwellings, like the bees, beavers, ants, etc. But an animal only

produces what it immediately needs for itself or its young. It produces one-sidedly, whilst man produces universally. It produces only under the dominion of immediate physical need, whilst man produces even when he is free from physical need and only truly produces in freedom therefrom. An animal produces only itself, whilst man reproduces the whole of nature. An animal's product belongs immediately to its physical body, whilst man freely confronts his product. An animal forms things in accordance with the standard and the need of the species to which it belongs, whilst man knows how to produce in accordance with the standard of every species, and knows how to apply everywhere the inherent standard to the object. Man therefore also forms things in accordance with the laws of beauty.

HISTORY

MARX:
THE INDIVIDUALIZATION OF MAN THROUGH HISTORY
from *Pre-Capitalist Economic Formations*

But man is only individualised through the process of history. He originally appears as a *generic being, a tribal being, a herd animal*—though by no means as a "political animal" in the political sense. Exchange itself is a major agent of this individualisation. It makes the herd animal superfluous and dissolves it. Once the situation is such, that man as an isolated person has relation only to himself, the means of establishing himself as an isolated individual have become what gives him his general communal character.

ENGELS: DIALECTICS
from *Anti-Dühring*

When we reflect on Nature, or the history of mankind, or our own intellectual activity, the first picture presented to us is of an endless maze of relations and interactions, in which nothing remains what, where and as it was, but everything moves, changes, comes into being and passes out of existence. This primitive, naïve, yet intrinsically correct conception of the world was that of ancient Greek philosophy, and was first clearly formulated by Heraclitus: everything is and also is not, for everything is in *flux,* is constantly changing, constantly coming into being and passing away. But

this conception, correctly as it covers the general character of the picture of phenomena as a whole, is yet inadequate to explain the details of which this total picture is composed; and so long as we do not understand these, we also have no clear idea of the picture as a whole. In order to understand these details, we must detach them from their natural or historical connections, and examine each one separately, as to its nature, its special causes and effects, etc. This is primarily the task of natural science and historical research; branches of science which the Greeks of the classical period, on very good grounds, relegated to a merely subordinate position, because they had first of all to collect materials for these sciences to work upon. The beginnings of the exact investigation of nature were first developed by the Greeks of the Alexandrian period, and later on, in the Middle Ages, were further developed by the Arabs. Real natural science, however, dates only from the second half of the fifteenth century, and from then on it has advanced with constantly increasing rapidity.

The analysis of Nature into its individual parts, the grouping of the different natural processes and natural objects in definite classes, the study of the internal anatomy of organic bodies in their manifold forms—these were the fundamental conditions of the gigantic strides in our knowledge of Nature which have been made during the last four hundred years. But this method of investigation has also left us as a legacy the habit of observing natural objects and natural processes in their isolation, detached from the whole vast interconnection of things; and therefore not in their motion, but in their repose; not as essentially changing, but as fixed constants; not in their life, but in their death. And when, as was the case with Bacon and Locke, this way of looking at things was transferred from natural science to philosophy, it produced the specific narrow-mindedness of the last centuries, the metaphysical mode of thought.

To the metaphysician, things and their mental images, ideas, are isolated, to be considered one after the other apart from each other, rigid, fixed objects of investigation given once for all. He thinks in absolutely discontinuous antitheses. His communication is: "Yea, yea, Nay, nay, for whatsoever is more than these cometh of evil." For him a thing either exists, or it does not exist; it is equally impossible for a thing to be itself and at the same time something else. Positive and negative absolutely exclude one another; cause and effect stand in an equally rigid antithesis one to the other. At first sight this mode of thought seems to us extremely plausible, because it is the mode of thought of so-called sound common sense. But sound common sense, respectable fellow as he is within the homely precincts of his own four walls, has most wonderful adventures as soon as he ventures out into the wild world of scientific research. Here the

metaphysical mode of outlook, justifiable and even necessary as it is in domains whose extent varies according to the nature of the object under investigation, nevertheless sooner or later always reaches a limit beyond which it becomes one-sided, limited, abstract, and loses its way in insoluble contradictions. And this is so because in considering individual things it loses sight of their connections; in contemplating their existence it forgets their coming into being and passing away; in looking at them at rest it leaves their motion out of account; because it cannot see the wood for the trees. For everyday purposes we know, for example, and can say with certainty whether an animal is alive or not; but when we look more closely we find that this is often an extremely complex question, as jurists know very well. They have cudgelled their brains in vain to discover some rational limit beyond which the killing of a child in its mother's womb is murder; and it is equally impossible to determine the moment of death, as physiology has established that death is not a sudden, instantaneous event, but a very protracted process. In the same way every organic being is at each moment the same and not the same; at each moment it is assimilating matter drawn from without, and excreting other matter; at each moment the cells of its body are dying and new ones are being formed; in fact, within a longer or shorter period the matter of its body is completely renewed and is replaced by other atoms of matter, so that every organic being is at all times itself and yet something other than itself. Closer investigation also shows us that the two poles of an antithesis, like positive and negative, are just as inseparable from each other as they are opposed, and that despite all their opposition they mutually penetrate each other. It is just the same with cause and effect; these are conceptions which only have validity in their application to a particular case as such, but when we consider the particular case in its general connection with the world as a whole they merge and dissolve in the conception of universal action and interaction, in which causes and effects are constantly changing places, and what is now or here an effect becomes there or then a cause, and *vice versa.*

None of these processes and methods of thought fit into the frame of metaphysical thinking. But for dialectics, which grasps things and their images, ideas, essentially in their interconnection, in their sequence, their movement, their birth and death, such processes as those mentioned above are so many corroborations of its own method of treatment. Nature is the test of dialectics, and it must be said for modern natural science that it has furnished extremely rich and daily increasing materials for this test, and has thus proved that in the last analysis Nature's process is dialectical and not metaphysical.

MARX: **THE ESSENTIAL FORMULATION OF MARXISM**
from Preface to *A Contribution to the Critique of Political Economy*

The general result at which I arrived and which, once won, served as a guiding thread for my studies, can be briefly formulated as follows: In the social production of their life, men enter into definite relations that are indispensable and independent of their will, relations of production which correspond to a definite stage of development of their material productive forces. The sum total of these relations of production constitutes the economic structure of society, the real foundation, on which rises a legal and political superstructure and to which correspond definite forms of social consciousness. The mode of production of material life conditions the social, political and intellectual life process in general. It is not the consciousness of men that determines their being, but, on the contrary, their social being that determines their consciousness. At a certain stage of their development, the material productive forces of society come in conflict with the existing relations of production, or—what is but a legal expression for the same thing—with the property relations within which they have been at work hitherto. From forms of development of the productive forces these relations turn into their fetters. Then begins an epoch of social revolution. With the change of the economic foundation the entire immense superstructure is more or less rapidly transformed. In considering such transformations a distinction should always be made between the material transformation of the economic conditions of production, which can be determined with the precision of natural science, and the legal, political, religious, aesthetic or philosophic—in short, ideological forms in which men become conscious of this conflict and fight it out. Just as our opinion of an individual is not based on what he thinks of himself, so can we not judge of such a period of transformation by its own consciousness; on the contrary, this consciousness must be explained rather from the contradictions of material life, from the existing conflict between the social productive forces and the relations of production. No social order ever perishes before all the productive forces for which there is room in it have developed; and new, higher relations of production never appear before the material conditions of their existence have matured in the womb of the old society itself. Therefore mankind always sets itself only such tasks as it can solve; since, looking at the matter more closely, it will always be found that the task itself arises only when the material conditions for its solution already exist or are at least in the process of formation. In broad outlines Asiatic, ancient, feudal, and modern bourgeois modes of production can be

designated as progressive epochs in the economic formation of society. The bourgeois relations of production are the last antagonistic form of the social process of production—antagonistic not in the sense of individual antagonism, but of one arising from the social conditions of life of the individuals; at the same time the productive forces developing in the womb of bourgeois society create the material conditions for the solution of that antagonism. This social formation brings, therefore, the prehistory of human society to a close.

ENGELS: THE MATERIALIST CONCEPTION OF HISTORY
from letter to J. Bloch

According to the materialist conception of history, the *ultimately* determining element in history is the production and reproduction of real life. More than this neither Marx nor I have ever asserted. Hence if somebody twists this into saying that the economic element is the *only* determining one, he transforms that proposition into a meaningless, abstract, senseless phrase. The economic situation is the basis, but the various elements of the super-structure—political forms of the class struggle and its results, to wit: constitutions established by the victorious class after a successful battle, etc., juridical forms, and even the reflexes of all these actual struggles in the brains of the participants, political, juristic, philosophical theories, religious views and their further development into systems of dogmas—also exercise their influence upon the course of the historical struggles and in many cases preponderate in determining their *form*. There is an inter-action of all these elements in which, amid all the endless host of accidents (that is, of things and events whose inner interconnection is so remote or so impossible of proof that we can regard it as nonexistent, as negligible), the economic movement finally asserts itself as necessary. Otherwise the application of the theory to any period of history would be easier than the solution of a simple equation of the first degree.

We make our history ourselves, but, in the first place, under very definite assumptions and conditions. Among these the economic ones are ultimately decisive. But the political ones, etc., and indeed even the traditions which haunt human minds also play a part, although not the decisive one.

MARX: **HUMAN ENERGY AND PRODUCTIVE FORCES**
from letter to P. V. Annenkov

It is superfluous to add that men are not free to choose *their productive forces*—which are the basis of all their history—for every productive force is an acquired force, the product of former activity. The productive forces are therefore the result of practical human energy; but this energy is itself conditioned by the circumstances in which men find themselves, by the productive forces already acquired, by the social form which exists before they do, which they do not create, which is the product of the preceding generation. Because of this simple fact that every succeeding generation finds itself in possession of the productive forces acquired by the previous generation, which serve it as the raw material for new production, a coherence arises in human history, a history of humanity takes shape which is all the more a history of humanity as the productive forces of man and therefore his social relations have been more developed. Hence it necessarily follows that the social history of men is never anything but the history of their individual development, whether they are conscious of it or not.

ENGELS:
THE TWOFOLD CHARACTER OF THE MODE OF PRODUCTION
from *The Origin of the Family, Private Property and the State*

According to the materialistic conception, the determining factor in history is, in the last resort, the production and reproduction of immediate life. But this itself is of a twofold character. On the one hand, the production of the means of subsistence, of food, clothing and shelter and the tools requisite therefore; on the other, the production of human beings themselves, the propagation of the species. The social institutions under which men of a definite historical epoch and of a definite country live are conditioned by both kinds of production: by the stage of development of labour, on the one hand, and of the family, on the other. The less the development of labour, and the more limited its volume of production and, therefore, the wealth of society, the more preponderatingly does the social order appear to be dominated by ties of sex. However, within this structure of society based on ties of sex, the productivity of labour develops more and more; with it, private property and exchange, differences in wealth, the possibility of utilizing the labour power of others, and thereby the basis of class antagonisms: new social elements, which strive in the course of generations

to adapt the old structure of society to the new conditions, until, finally, the incompatibility of the two leads to a complete revolution. The old society based on sex groups bursts asunder in the collision of the newly-developed social classes; in its place a new society appears, constituted in a state, the lower units of which are no longer sex groups but territorial groups, a society in which the family system is entirely dominated by the property system, and in which the class antagonisms and class struggles, which make up the content of all hitherto *written* history, now freely develop.

MARX AND ENGELS: SEX AND SOCIETY
from *The German Ideology*

The production of life, both of one's own by labour and of fresh life by procreation, appears at once as a double relationship, on the one hand as a natural, on the other as a social relationship.

MARX AND ENGELS: THE CLASS STRUGGLE
from *The Communist Manifesto*

The history of all hitherto existing society is the history of class struggles.

Freeman and slave, patrician and plebian, lord and serf, guild-master and journeyman, in a word, oppressor and oppressed, stood in constant opposition to one another, carried on an uninterrupted, now hidden, now open fight, a fight that each time ended, either in a revolutionary re-constitution of society at large, or in the common ruin of the contending classes.

In the earlier epochs of history, we find almost everywhere a complicated arrangement of society into various orders, a manifold gradation of social rank. In ancient Rome we have patricians, knights, plebeians, slaves; in the Middle Ages, feudal lords, vassals, guild-masters, journeymen, apprentices, serfs; in almost all of these classes, again, subordinate gradations.

The modern bourgeois society that has sprouted from the ruins of feudal society has not done away with class antagonisms. It has but established new classes, new conditions of oppression, new forms of struggle in place of the old ones.

Our epoch, the epoch of the bourgeoisie, possesses, however, this distinctive feature: it has simplified the class antagonisms. Society as a whole is more and more splitting up into two great hostile camps, into two great classes directly facing each other: Bourgeoisie and Proletariat.

MARX: **IDEOLOGY AND REALITY**
from *The Eighteenth Brumaire of Louis Bonaparte*

Upon the different forms of property, upon the social conditions of existence, rises an entire superstructure of distinct and peculiarly formed sentiments, illusions, modes of thought and views of life. The entire class creates and forms them out of its material foundations and out of the corresponding social relations. The single individual, who derives them through tradition and upbringing, may imagine that they form the real motives and the starting-point of his activity. While Orleanists and Legitimists, while each faction sought to make itself and the other believe that it was loyalty to their two royal houses which separated them, facts later proved that it was rather their divided interests which forbade the uniting of the two royal houses. And as in private life one differentiates between what a man thinks and says of himself and what he really is and does, so in historical struggles one must distinguish still more the phrases and fancies of parties from their real organism and their real interests, their conception of themselves, from their reality.

ENGELS: **BASE AND SUPERSTRUCTURE**
from letter to W. Borgius

Political, juridical, philosophical, religious, literary, artistic, etc., development is based on economic development. But all these react upon one another and also upon the economic basis. It is not that the economic situation is *cause, solely active,* while everything else is only passive effect. There is, rather, interaction on the basis of economic necessity, which *ultimately* always asserts itself. . . . So it is not, as people try here and there conveniently to imagine, that the economic situation produces an automatic effect. No. Men make their history themselves, only they do so in a given environment, which conditions it, and on the basis of actual relations already existing, among which the economic relations, however much they may be influenced by the other—the political and ideological—relations, are still ultimately the decisive ones, forming the keynote which runs through them and alone leads to understanding.

MARX: **MAN AND ECONOMICS**
from *Theories of Surplus Value*

Man himself is the basis of his material production, as of all production which he accomplishes. All circumstances, therefore, which affect man, the subject of production, have a greater or lesser influence upon all his functions and activities, including his functions and activities as the creator of material wealth, of commodities. In this sense, it can truly be asserted that all human relations and functions, however and wherever they manifest themselves, influence material production and have a more or less determining effect upon it.

MARX: **THE UNIVERSAL AND THE PARTICULAR**
from Introduction to *A Contribution to the Critique of Political Economy*

. . . all stages of production have certain landmarks in common, common purposes. *Production in general* is an abstraction, but it is a rational abstraction, in so far as it singles out and fixes the common features, thereby saving us repetition. Yet these general or common features discovered by comparison constitute something very complex, whose constituent elements have different destinations. Some of these elements belong to all epochs, others are common to a few. Some of them are common to the most modern as well as to the most ancient epochs. No production is conceivable without them; but while even the most completely developed languages have laws and conditions in common with the least developed ones, what is characteristic of their development are the points of departure from the general and common. The conditions which generally govern production must be differentiated in order that the essential points of difference be not lost sight of in view of the general uniformity which is due to the fact that the subject, mankind, and the object, nature, remain the same.

FORMS OF CONSCIOUSNESS

MARX AND ENGELS:
BEING, CONSCIOUSNESS, AND THE IDEOLOGICAL REFLEX
from *The German Ideology*

The fact is, therefore, that definite individuals who are productively active in a definite way enter into these definite social and political relations. Empirical observation must in each separate instance bring out empirically, and without any mystification and speculation, the connection of the social and political structure with production. The social structure and the State are continually evolving out of the life-process of definite individuals, but of individuals, not as they may appear in their own or other people's imagination, but as they *really* are; i.e., as they operate, produce materially, and hence as they work under definite material limits, presuppositions and conditions independent of their will.

The production of ideas, of conceptions, of consciousness, is at first directly interwoven with the material activity and the material intercourse of men, the language of real life. Conceiving, thinking, the mental intercourse of men, appear at this stage as the direct efflux of their material behaviour. The same applies to mental production as expressed in the language of politics, laws, morality, religion, metaphysics, etc., of a people. Men are the producers of their conceptions, ideas, etc.—real, active men, as they are conditioned by a definite development of their productive forces and of the intercourse corresponding to these, up to its furthest forms. Consciousness can never be anything else than conscious existence, and the existence of men is their actual life-process. If in all ideology men and their circumstances appear upside-down as in a *camera obscura,* this phenomenon arises just as much from their historical life-process as the inversion of objects on the retina does from their physical life-process.

In direct contrast to German philosophy which descends from heaven to earth, here we ascend from earth to heaven. That is to say, we do not set out from what men say, imagine, conceive, nor from men as narrated, thought of, imagined, conceived, in order to arrive at men in the flesh. We set out from real, active men, and on the basis of their real life-process we demonstrate the development of the ideological reflexes and echoes of this life-process. The phantoms formed in the human brain are also, necessarily, sublimates of their material life-process, which is empirically verifiable and bound to material premises. Morality, religion, metaphysics, all

the rest of ideology and their corresponding forms of consciousness, thus no longer retain the semblance of independence. They have no history, no development; but men, developing their material production and their material intercourse, alter, along with this their real existence, their thinking and the products of their thinking. Life is not determined by consciousness, but consciousness by life. In the first method of approach the starting-point is consciousness taken as the living individual; in the second method, which conforms to real life, it is the real living individuals themselves, and consciousness is considered solely as *their* consciousness.

ENGELS: IDEOLOGY AND FALSE CONSCIOUSNESS
from letter to Franz Mehring

Ideology is a process accomplished by the so-called thinker consciously, it is true, but with a false consciousness. The real motive forces impelling him remain unknown to him; otherwise it simply would not be an ideological process. Hence he imagines false or seeming motive forces. Because it is a process of thought he derives its form as well as its content from pure thought, either his own or that of his predecessors. He works with mere thought material, which he accepts without examination as the product of thought, and does not investigate further for a more remote source independent of thought; indeed this is a matter of course to him, because, as all action is *mediated* by thought, it appears to him to be ultimately *based* upon thought.

The historical ideologist (historical is here simply meant to comprise the political, juridical, philosophical, theological—in short, all the spheres belonging to *society* and not only to nature) thus possesses in every sphere of science material which has formed itself independently out of the thought of previous generations and has gone through its own independent course of development in the brains of these successive generations. True, external facts belonging to one or another sphere may have exercised a codetermining influence on this development, but the tacit presupposition is that these facts themselves are also only the fruits of a process of thought, and so we still remain within that realm of mere thought, which apparently has successfully digested even the hardest facts.

MARX: **ON THE PRODUCTIVITY OF ALL PROFESSIONS**
from *Theories of Surplus Value*

A philosopher produces ideas, a poet poems, a clergyman sermons, a professor compendia and so on. A criminal produces crimes. If we look a little closer at the connection between this latter branch of production and society as a whole, we shall rid ourselves of many prejudices. The criminal produces not only crimes but also criminal law and with this also the professor who gives lectures on criminal law and in addition to this the inevitable compendium in which this same professor throws his lectures onto the general market as "commodities." This brings with it augmentation of national wealth, quite apart from the personal enjoyment which—as a competent witness, Herr Professor Roscher, [tells] us—the manuscript of the compendium brings to its originator himself.

The criminal moreover produces the whole of the police and of criminal justice, constables, judges, hangmen, juries, etc.; and all these different lines of business, which form equally many categories of the social division of labour, develop different capacities of the human spirit, create new needs and new ways of satisfying them. Torture alone has given rise to the most ingenious mechanical inventions, and employed many honourable craftsmen in the production of its instruments.

The criminal produces an impression, partly moral and partly tragic, as the case may be, and in this way renders a "service" by arousing the moral and aesthetic feelings of the public. He produces not only compendia on Criminal Law, not only penal codes and along with them legislators in this field, but also art, belles-lettres, novels, and even tragedies, as not only Müllner's *Schuld* and Schiller's *Räuber* show, but also [Sophocles'] *Oedipus* and [Shakespeare's] *Richard the Third*. The criminal breaks the monotony and everyday security of bourgeois life. In this way he keeps it from stagnation, and gives rise to that uneasy tension and agility without which even the spur of competition would get blunted. Thus he gives a stimulus to the productive forces. While crime takes a part of the superfluous population off the labour market and thus reduces competition among the labourers—up to a certain point preventing wages from falling below the minimum—the struggle against crime absorbs another part of this population. Thus the criminal comes in as one of those natural "counterweights" which bring about a correct balance and open up a whole perspective of "useful" occupations.

The effects of the criminal on the development of productive power can be shown in detail. Would locks ever have reached their present degree of

excellence had there been no thieves? Would the making of bank-notes have reached its present perfection had there been no forgers? Would the microscope have found its way into the sphere of ordinary commerce (see Babbage) but for trading frauds? Doesn't practical chemistry owe just as much to adulteration of commodities and the efforts to show it up as to the honest zeal for production? Crime, through its constantly new methods of attack on property, constantly calls into being new methods of defence, and so is as productive as strikes for the invention of machines. And if one leaves the sphere of private crime: would the world-market ever have come into being but for national crime? Indeed, would even the nations have arisen? And hasn't the Tree of Sin been at the same time the Tree of Knowledge ever since the time of Adam?

In his *Fable of the Bees* (1705) Mandeville had already shown that every possible kind of occupation is productive, and had given expression to the line of this whole argument:

> That what we call Evil in this World, Moral as well as Natural, is the grand Principle that makes us Sociable Creatures, the solid Basis, the *Life and Support of all Trades and Employments* without exception [. . .] there we must look for the true origin of all Arts and Sciences; and [. . .] the moment, Evil ceases, the Society must be spoil'd if not totally dissolve'd. [2d edition, London, 1723, p. 428].

Only Mandeville was of course infinitely bolder and more honest than the philistine apologists of bourgeois society.

MARX: **THE FETISHISM OF COMMODITIES, I**
from *A Contribution to the Critique of Political Economy*

It is only through the habit of everyday life that we come to think it perfectly plain and commonplace, that a social relation of production should take on the form of a thing, so that the relation of persons in their work appears in the form of a mutual relation between things, and between things and persons.

━━━

That a social relation of production takes the form of an object existing outside of individuals, and that the definite relations into which individuals enter in the process of production carried on in society, assume the form of specific properties of a thing, is a perversion and [a] by no means imaginary,

but prosaically real, mystification marking all social forms of labor which create exchange value.

MARX: **THE FETISHISM OF COMMODITIES, II**
from *Capital*

A commodity appears, at first sight, a very trivial thing, and easily understood. Its analysis shows that it is, in reality, a very queer thing, abounding in metaphysical subtleties and theological niceties. So far as it is a value in use, there is nothing mysterious about it, whether we consider it from the point of view that by its properties it is capable of satisfying human wants, or from the point that those properties are the product of human labour. It is as clear as noon-day that man, by his industry, changes the forms of the materials furnished by nature, in such a way as to make them useful to him. The form of wood, for instance, is altered, by making a table out of it. Yet, for all that, the table continues to be that common, everyday thing, wood. But, so soon as it steps forth as a commodity, it is changed into something transcendent. It not only stands with its feet on the ground, but, in relation to all other commodities, it stands on its head, and evolves out of its wooden brain grotesque ideas, far more wonderful than "table-turning" ever was.

The mystical character of commodities does not originate, therefore, in their use-value. Just as little does it proceed from the nature of the determining factors of value. For, in the first place, however varied the useful kinds of labour, or productive activities, may be, it is a physiological fact, that they are functions of the human organism, and that each such function, whatever may be its nature or form, is essentially the expenditure of human brain, nerves, muscles, &c. Secondly, with regard to that which forms the ground-work for the quantitative determination of value, namely, the duration of that expenditure, or the quantity of labour, it is quite clear that there is a palpable difference between its quantity and quality. In all states of society, the labour-time that it costs to produce the means of subsistence, must necessarily be an object of interest to mankind, though not of equal interest in different stages of development. And lastly, from the moment that men in any way work for one another, their labour assumes a social form.

Whence, then, arises the enigmatical character of the product of labour, so soon as it assumes the form of commodities? Clearly from this form itself. The equality of all sorts of human labour is expressed objectively by their products all being equally values; the measure of the expenditure of

labour-power by the duration of that expenditure, takes the form of the quantity of value of the products of labour; and finally, the mutual relations of the producers, within which the social character of their labour affirms itself, take the form of a social relation between the products.

A commodity is therefore a mysterious thing, simply because in it the social character of men's labour appears to them as an objective character stamped upon the product of that labour, because the relation of the producers to the sum total of their own labour is presented to them as a social relation, existing not between themselves, but between the products of their labour. This is the reason why the products of labour become commodities, social things whose qualities are at the same time perceptible and imperceptible by the senses. In the same way the light from an object is perceived by us not as the subjective excitation of our optic nerve but as the objective form of something outside the eye itself. But, in the act of seeing, there is at all events, an actual passage of light from one thing to another, from the external object to the eye. There is a physical relation between physical things. But it is different with commodities. There, the existence of the things *qua* commodities, and the value relation between the products of labour which stamps them as commodities, have absolutely no connection with their physical properties and with the material relations arising therefrom. There it is a definite social relation between men, that assumes, in their eyes, the fantastic form of a relation between things. In order, therefore, to find an analogy, we must have recourse to the mist-enveloped regions of the religious world. In that world the productions of the human brain appear as independent beings endowed with life, and entering into relation both with one another and the human race. So it is in the world of commodities with the products of men's hands. This I call the Fetishism which attaches itself to the products of labour, so soon as they are produced as commodities, and which is therefore inseparable from the production of commodities.

This Fetishism of commodities has its origin, as the foregoing analysis has already shown, in the peculiar social character of the labour that produces them.

MARX: **ALIENATION**
from *Capital*

Within the capitalist system all methods for raising the social productiveness of labour are brought about at the cost of the individual labourer; all means for the development of production transform themselves into means

of domination over, and exploitation of, the producers; they mutilate the labourer into a fragment of a man, degrade him to the level of an appendage of a machine, destroy every remnant of charm in his work, and turn it into a hated toil; they estrange from him the intellectual potentialities of the labour-process in the same proportion as science is incorporated in it as an independent power; they distort the conditions under which he works, subject him during the labour-process to a despotism the more hateful for its meanness; they transform his life-time into working-time, and drag his wife and child beneath the wheels of the Juggernaut of capital. But all methods for the production of surplus-value are at the same time methods of accumulation; and every extension of accumulation becomes again a means for the development of those methods. It follows therefore that in proportion as capital accumulates, the lot of the labourer, be his payment high or low, must grow worse. The law, finally, that always equilibrates the relative surplus-population, or industrial reserve army, to the extent and energy of accumulation, this law rivets the labourer to capital more firmly than the wedges of Vulcan did Prometheus to the rock. It establishes an accumulation of misery, corresponding with accumulation of capital. Accumulation of wealth at one pole is, therefore, at the same time accumulation of misery, agony of toil, slavery, ignorance, brutality, mental degradation, at the opposite pole, *i.e.*, on the side of the class that produces its own product in the form of capital.

MARX: **PROGRESS AND ALIENATION**
from Speech at the Anniversary of the People's Paper

There is one great fact, characteristic of this our nineteeth century, a fact which no party dares deny. On the one hand, there have started into life industrial and scientific forces, which no epoch of the former human history had ever suspected. On the other hand, there exist symptoms of decay, far surpassing the horrors recorded of the latter times of the Roman empire. In our days everything seems pregnant with its contrary. Machinery, gifted with the wonderful power of shortening and fructifying human labour, we behold starving and overworking it. The new-fangled sources of wealth, by some strange weird spell, are turned into sources of want. The victories of art seem bought by the loss of character. At the same pace that mankind masters nature, man seems to become enslaved to other men or to his own infamy. Even the pure light of science seems unable to shine but on the dark background of ignorance. All our invention and progress seem to result in endowing material forces with intellectual

life, and in stultifying human life into a material force. This antagonism between modern industry and science on the one hand, modern misery and dissolution on the other hand; this antagonism between the productive powers, and the social relations of our epoch is a fact, palpable, overwhelming, and not to be controverted. Some parties may wail over it; others may wish to get rid of modern arts, in order to get rid of modern conflicts. Or they may imagine that so signal a progress in industry wants to be completed by as signal a regress in politics. On our part, we do not mistake the shape of the shrewd spirit that continues to mark all these contradictions. We know that to work well the new-fangled forces of society, they only want to be mastered by new-fangled men—and such are the working men.

MARX AND ENGELS: **THE ILLUSION OF THE EPOCH, I**
from *The German Ideology*

This conception of history depends on our ability to expound the real process of production, starting out from the material production of life itself, and to comprehend the form of intercourse connected with this and created by this mode of production (i.e., civil society in its various stages), as the basis of all history; and to show it in its action as State, to explain all the different theoretical products and forms of consciousness, religion, philosophy, ethics, etc., etc., and trace their origins and growth from that basis; by which means, of course, the whole thing can be depicted in its totality (and therefore, too, the reciprocal action of these various sides on one another). It has not, like the idealistic view of history, in every period to look for a category, but remains constantly on the real *ground* of history; it does not explain practice from the idea but explains the formation of ideas from material practice; and accordingly it comes to the conclusion that all forms and products of consciousness cannot be dissolved by mental criticism, by resolution into "self-consciousness" or transformation into "apparitions," "spectres," "fancies," etc., but only by the practical overthrow of the actual social relations which gave rise to this idealistic humbug; that not criticism but revolution is the driving force of history, also of religion, of philosophy and all other types of theory. It shows that history does not end by being resolved into "self-consciousness" as "spirit of the spirit," but that in it at each stage there is found a material result: a sum of productive forces, a historically created relation of individuals to nature and to one another, which is handed down to each generation from its predecessor; a mass of productive forces, capital funds and conditions,

which, on the one hand, is indeed modified by the new generation, but also on the other prescribes for it its conditions of life and gives it a definite development, a special character. It shows that circumstances make men just as much as men make circumstances. This sum of productive forces, capital funds and social forms of intercourse, which every individual and generation finds in existence as something given, is the real basis of what the philosophers have conceived as "substance" and "essence of man," and what they have deified and attacked: a real basis which is not in the least disturbed, in its effect and influence on the development of men, by the fact that these philosophers revolt against it as "self-consciousness" and the "Unique." These conditions of life, which different generations find in existence, decide also whether or not the periodically recurring revolutionary convulsion will be strong enough to overthrow the basis of the entire existing system. And if these material elements of a complete revolution are not present (namely, on the one hand the existing productive forces, on the other the formation of a revolutionary mass, which revolts not only against separate conditions of society up till then, but against the very "production of life" till then, the "total activity" on which it was based), then, as far as practical development is concerned, it is absolutely immaterial whether the *idea* of this revolution has been expressed a hundred times already, as the history of communism proves.

In the whole conception of history up to the present this real basis of history has either been totally neglected or else considered as a minor matter quite irrelevant to the course of history. History must, therefore, always be written according to an extraneous standard; the real production of life seems to be primeval history, while the truly historical appears to be separated from ordinary life, something extrasuperterrestrial. With this the relation of man to nature is excluded from history and hence the antithesis of nature and history is created. The exponents of this conception of history have consequently only been able to see in history the political actions of princes and States, religious and all sorts of theoretical struggles, and in particular in each historical epoch have had to *share the illusion of that epoch*. For instance, if an epoch imagines itself to be actuated by purely "political" or "religious" motives, although "religion" and "politics" are only forms of its true motives, the historian accepts this opinion. The "idea," the "conception" of the people in question about their real practice, is transformed into the sole determining, active force, which controls and determines their practice.

MARX AND ENGELS: **THE ILLUSION OF THE EPOCH, II**
from *The Holy Family*

Every mass *interest* asserting itself in the arena of history for the first time goes far beyond its real limits in the *idea* or *imagination* and is confused with *human* interest in general. This *illusion* constitutes what *Fourier* calls the *tone* of each historical epoch.

MARX: **THE SYMBOLIC POWER OF MONEY**
from *Economic and Philosophic Manuscripts*

By possessing the *property* of buying everything, by possessing the property of appropriating all objects, *money* is thus the *object* of eminent possession. The universality of its *property* is the omnipotence of its being. It therefore functions as the almighty being. Money is the *pimp* between man's need and the object, between his life and his means of life. But *that which* mediates *my* life for me, also *mediates* the existence of other people *for me*. For me it is the *other* person.

> MEPHISTOPHELES
> What, man! confound it, hands and feet
> And head and backside, all are yours!
> And what we take while life is sweet,
> Is that to be declared not ours?
> Six stallions, say, I can afford,
> Is not their strength my property?
> I tear along, a sporting lord,
> As if their legs belonged to me.[1]

Shakespeare in *Timon of Athens:*

> Gold? Yellow, glittering, precious gold? No, Gods,
> I am no idle votarist! . . .
> Thus much of this will make black white, foul fair,
> Wrong right, base noble, old young, coward valiant.
> . . . Why, this
> Will lug your priests and servants from your sides,
> Pluck stout men's pillows from below their heads:

1. Goethe, *Faust,* Part I—Faust's Study, III, cf. Goethe's *Faust,* Part I, translated by Philip Wayne (Penguin, 1949, p. 91).—*Ed.*

This yellow *slave*
Will knit and break religions, bless the accursed;
Make the hoar leprosy adored, place thieves
And give them title, knee and approbation
With senators on the bench: This is it
That makes the wappen'd widow wed again;
She, whom the spital-house and ulcerous sores
Would cast the gorge at, this embalms and spices
To the April day again. . . . Damned earth,
Thou common whore of mankind, that putt'st odds
Among the rout of nations.[2]

And also later:

O thou sweet king-killer, and dear divorce
Twixt natural son and sire! though bright defiler
Of Hymen's purest bed! thou valiant Mars!
Thou ever young, fresh, loved and delicate wooer,
Whose blush doth thaw the consecrated snow
That lies on Dian's lap! Thou *visible God!*
That solder'st *close impossibilities,*
And makest them kiss! That speak'st with every tongue,
To every purpose! O thou touch of hearts!
Think, thy slave man rebels, and by thy virtue
Set them into confounding odds, that beasts
May have the world in empire![3]

Shakespeare excellently depicts the real nature of *money.* To understand him, let us begin, first of all, by expounding the passage from Goethe.

That which is for me through the medium of *money*—that for which I can pay (i.e, which money can buy)—that am *I,* the possessor of the money. The extent of the power of money is the extent of my power. Money's properties are my properties and essential powers—the properties and powers of its possessor. Thus, what I *am* and *am capable* of is by no means determined by my individuality. I am ugly, but I can buy for myself the most *beautiful* of women. Therefore I am not *ugly,* for the effect of *ugliness*—its deterrent power—is nullified by money. I, in my character as an individual, am *lame,* but money furnishes me with twenty-four feet. Therefore I am not lame. I am bad, dishonest, unscrupulous, stupid; but

2. Shakespeare, *Timon of Athens,* Act 4, Sc. 3. (Marx quotes the Schlegel-Tieck translation.)—*Ed.*

3. *Ibid.*

money is honoured, and therefore so is its possessor. Money is the supreme good, therefore its possessor is good. Money, besides, saves me the trouble of being dishonest: I am therefore presumed honest, I am *stupid,* but money is the *real mind* of all things and how then should its possessor be stupid? Besides, he can buy talented people for himself, and is he who has power over the talented not more talented than the talented? Do not I, who thanks to money am capable of *all* that the human heart longs for, possess all human capacities? Does not my money therefore transform all my incapacities into their contrary?

If *money* is the bond binding me to *human* life, binding society to me, binding me and nature and man, is not money the bond of all *bonds?* Can it not dissolve and bind all ties? Is it not, therefore, the universal *agent of divorce?* It is the true *agent of divorce* as well as the true *binding agent*— the [universal][4] *galvano-chemical* power of Society.

Shakespeare stresses especially two properties of money:

(1) It is the visible divinity—the transformation of all human and natural properties into their contraries, the universal confounding and over-turning of things: it makes brothers of impossibilities. (2) It is the common whore, the common pimp of people and nations.

The overturning and confounding of all human and natural qualities, the fraternisation of impossibilities—the *divine* power of money—lies in its *character* as men's estranged, alienating and self-disposing *species-nature.* Money is the alienated *ability of mankind.*

That which I am unable to do as a *man,* and of which therefore all my individual essential powers are incapable, I am able to do by means of *money.* Money thus turns each of these powers into something which in itself it is not—turns it, that is, into its *contrary.*

MARX: **THE PSYCHOLOGY OF CAPITAL ACCUMULATION**
from *Capital*

But original sin is at work everywhere. As capitalist production, accumulation, and wealth, become developed, the capitalist ceases to be the mere incarnation of capital. He has a fellow-feeling for his own Adam, and his education gradually enables him to smile at the rage for asceticism, as a mere prejudice of the old-fashioned miser. While the capitalist of the classical type brands individual consumption as a sin against his function, and as "abstinence" from accumulating, the modernised capitalist is capable of looking upon accumulation as "abstinence" from pleasure.

4. An end of the page is torn out in the manuscript.—*Ed.*

Two souls, alas, do dwell within his breast;
The one is ever parting from the other.[1]

At the historical dawn of capitalist production,—and every capitalist upstart has personally to go through this historical stage—avarice, and desire to get rich, are the ruling passions. But the progress of capitalist production not only creates a world of delights; it lays open, in speculation and the credit system, a thousand sources of sudden enrichment. When a certain stage of development has been reached, a conventional degree of prodigality, which is also an exhibition of wealth, and consequently a source of credit, becomes a business necessity to the "unfortunate" capitalist. Luxury enters into capital's expenses of representation. Moreover, the capitalist gets rich, not like the miser, in proportion to his personal labour and restricted consumption, but at the same rate as he squeezes out the labour-power of others, and enforces on the labourer abstinence from all life's enjoyments. Although, therefore, the prodigality of the capitalist never possesses the bonâ-fide character of the open-handed feudal lord's prodigality, but, on the contrary, has always lurking behind it the most sordid avarice and the most anxious calculation, yet his expenditure grows with his accumulation, without the one necessarily restricting the other. But along with this growth, there is at the same time developed in his breast, a Faustian conflict between the passion for accumulation, and the desire for enjoyment.

ENGELS: **ALL KNOWING IS SENSUOUS MEASUREMENT**
from *Dialectics of Nature*

Matter is nothing but the totality of material things from which this concept is abstracted, and motion as such nothing but the totality of all sensuously perceptible forms of motion; words like matter and motion are nothing but *abbreviations* in which we comprehend many different sensuously perceptible things according to their common properties. Hence matter and motion *cannot* be known in any other ways than by investigation of the separate material things and forms of motion, and by knowing these, we also *pro tanto* know matter and motion *as such*. Consequently, in saying that we do not know what time, space, motion, cause, and effect are, Nägeli merely says that first of all we make abstractions of the real world through our minds, and then cannot know these self-made abstractions

1. Goethe's *Faust*.

because they are creations of thought and not sensuous objects, while all knowing is *sensuous measurement!* This is just like the difficulty mentioned by Hegel, we can eat cherries and plums, but not *fruit,* because no one has so far eaten fruit as such.

MARX: **INVERTED CONSCIOUSNESS AND SELF-ALIENATION**
from Introduction to *A Contribution to the Critique of Hegel's Philosophy of Right*

The basis of irreligious criticism is: *Man makes religion,* religion does not make man. In other words, religion is the self-consciousness and self-feeling of man who has either not yet found himself or has already lost himself again. But *man* is no abstract being squatting outside the world. Man is *the world of man,* the state, society. This state, this society, produce religion, *a reversed world-consciousness,* because they are *a reversed world.* Religion is the general theory of that world, its encyclopaedic compendium, its logic in a popular form, its spiritualistic *point d'honneur,* its enthusiasm, its moral sanction, its solemn completion, its universal ground for consolation and justification. It is *the fantastic realization* of the human essence because the *human essence* has no true reality. The struggle against religion is therefore mediately the fight against *the other world,* of which religion is the spiritual *aroma.*

Religious distress is at the same time the *expression* of real distress and the *protest* against real distress. Religion is the sigh of the oppressed creature, the heart of a heartless world, just as it is the spirit of a spiritless situation. It is the *opium* of the people.

The abolition of religion as the *illusory* happiness of the people is required for their *real* happiness. The demand to give up the illusions about its condition is the *demand to give up a condition which needs illusions.* The criticism of religion is therefore in *embryo the criticism of the vale of woe,* the *halo* of which is religion.

Criticism has plucked the imaginary flowers from the chain not so that man will wear the chain without any fantasy or consolation but so that he will shake off the chain and cull the living flower. The criticism of religion disillusions man to make him think and act and shape his reality like a man who has been disillusioned and has come to reason, so that he will revolve round himself and therefore round his true sun. Religion is only the illusory sun which revolves round man as long as he does not revolve round himself.

The task of history, therefore, once the *world beyond the truth* has disappeared, is to establish the *truth of this world.* The immediate *task of*

philosophy, which is at the service of history, once the *saintly form* of human self-alienation has been unmasked, is to unmask self-alienation in its *unholy forms.* Thus the criticism of heaven turns into the criticism of the earth, the *criticism of religion* into the *criticism of right* and the *criticism of theology* into the *criticism of politics.*

MARX AND ENGELS: CLASS DETERMINATION OF SUPERSTRUCTURE
from *The Communist Manifesto*

Just as, to the bourgeois, the disappearance of class property is the disappearance of production itself, so the disappearance of class culture is to him identical with the disappearance of all culture.

That culture, the loss of which he laments, is, for the enormous majority, a mere training to act as a machine.

But don't wrangle with us so long as you apply, to our intended abolition of bourgeois property, the standard of your bourgeois notions of freedom, culture, law, etc. Your very ideas are but the outgrowth of the conditions of your bourgeois production and bourgeois property, just as your jurisprudence is but the will of your class made into a law for all, a will, whose essential character and direction are determined by the economical conditions of existence of your class.

MARX AND ENGELS: THE RULING IDEAS, I
from *The German Ideology*

The ideas of the ruling class are in every epoch the ruling ideas: i.e., the class, which is the ruling *material* force of society, is at the same time its ruling *intellectual* force. The class which has the means of material production at its disposal, has control at the same time over the means of mental production, so that thereby, generally speaking, the ideas of those who lack the means of mental production are subject to it. The ruling ideas are nothing more than the ideal expression of the dominant material relationships, the dominant material relationships grasped as ideas; hence of the relationships which make the one class the ruling one, therefore, the ideas of its dominance. The individuals composing the ruling class possess among other things consciousness, and therefore think. Insofar, therefore, as they rule as a class and determine the extent and compass of an epoch, it is self-evident that they do this in its whole range, hence among other

things rule also as thinkers, as producers of ideas, and regulate the production and distribution of the ideas of their age: thus their ideas are the ruling ideas of the epoch.

MARX AND ENGELS: **THE RULING IDEAS, II**
from *The Communist Manifesto*

Does it require deep intuition to comprehend that man's ideas, views and conceptions, in one word, man's consciousness, changes with every change in the conditions of his material existence, in his social relations and in his social life?

What else does the history of ideas prove, than that intellectual production changes its character in proportion as material production is changed? The ruling ideas of each age have ever been the ideas of its ruling class.

When people speak of ideas that revolutionise society, they do but express the fact, that within the old society, the elements of a new one have been created, and that the dissolution of the old ideas keeps even pace with the dissolution of the old conditions of existence.

MARX: **THE TRANSITORY ELEMENTS OF IDEOLOGY**
from *The Poverty of Philosophy*

The same men who establish their social relations in conformity with their material productivity, produce also principles, ideas and categories, in conformity with their social relations.

Thus these ideas, these categories, are as little eternal as the relations they express. They are *historical and transitory products*. There is a continual movement of growth in productive forces, of destruction in social relations, of formation in ideas; the only immutable thing is the abstraction of movement—*mors immortalis*.

MARX AND ENGELS:
UNIVERSAL ELEMENTS IN CONSCIOUSNESS
from *The Communist Manifesto*

. . . the social consciousness of past ages, despite all the multiplicity and variety it displays, moves within certain common forms, or general ideas,

which cannot completely vanish except with the total disappearance of class antagonisms.

ENGELS: THE LIMITS OF KNOWLEDGE
from *Anti-Dühring*

. . . the generations which will put *us* right are likely to be far more numerous than those whose knowledge we . . . are in a position to correct . . .

But a man who applies the measure of pure, immutable, final and ultimate truth to knowledge which, by the very nature of its object, must either remain relative for long successions of generations and be completed only step by step, or which, as in cosmogony, geology and the history of man, must always remain defective and incomplete because of the faultiness of the historical material—such a man only proves thereby his own ignorance and perversity.

MARX: ETERNAL RETURN, I
from *The Doctoral Dissertation*

Not once, not twice, but an infinite number of times the same views have come down to us.

. . . every possible art and philosophy was invented and lost again, and these opinions, like relics, have come down to the present world.

. . . we cannot help believing that the same ideas recur to men not once nor twice but over and over again.

ENGELS: ETERNAL RETURN, II
from *Dialectics of Nature*

It is an eternal cycle in which matter moves, a cycle that certainly only completes its orbit in periods of time for which our terrestrial year is no adequate measure, a cycle in which the time of highest development, the time of organic life and still more that of the life of beings conscious of nature and of themselves, is just as narrowly restricted as the space in which life and self-consciousness come into operation; a cycle in which

every finite mode of existence of matter, whether it be sun or nebular vapour, single animal or genus of animals, chemical combination or dissociation, is equally transient, and wherein nothing is eternal but eternally changing, eternally moving matter and the laws according to which it moves and changes. But however often, and however relentlessly, this cycle is completed in time and space, however many millions of suns and earths may arise and pass away, however long it may last before the conditions for organic life develop, however innumerable the organic beings that have to arise and to pass away before animals with a brain capable of thought are developed from their midst, and for a short span of time find conditions suitable for life, only to be exterminated later without mercy, we have the certainty that matter remains eternally the same in all its transformations, that none of its attributes can ever be lost, and therefore, also, that with the same iron necessity that it will exterminate on the earth its highest creation, the thinking mind, it must somewhere else and at another time again produce it.

REVOLUTION AND UTOPIA

MARX: **THEORY AND PRACTICE**
from the eleventh thesis on Feuerbach

The philosophers have only *interpreted* the world, in various ways; the point, however, is to *change* it.

MARX: **SUPERSTRUCTURAL DREAM HISTORY**
from Introduction to *A Contribution to the Critique of Hegel's Philosophy of Right*

As the ancient peoples went through their pre-history in imagination, in *mythology,* so we Germans have gone through our post-history in thought, in *philosophy*. We are *philosophical* contemporaries of the present without being its *historical* contemporaries. German philosophy is the *ideal prolongation* of German history . . . *German philosophy of right and state* is the only *German history* which is on a level with the *official* modern present. The German nation must therefore join this, its dream history, to its present conditions and subject to criticism not only these existing conditions, but at the same time their abstract continuation . . . [T]he real life

embryo of the German nation has grown so far only inside its *cranium*. In a word—*You cannot abolish philosophy without making it a reality.*

MARX: **THE POWER OF THEORY**
from Introduction to *A Contribution to the Critique of Hegel's Philosophy of Right*

The weapon of criticism cannot, of course, replace criticism of the weapon, material force must be overthrown by material force; but theory also becomes a material force as soon as it has gripped the masses. Theory is capable of gripping the masses as soon as it demonstrates *ad hominem,* and it demonstrates *ad hominem* as soon as it becomes radical. To be radical is to grasp the root of the matter. But for man the root is man himself. The evident proof of the radicalism of German theory, and hence of its practical energy, is that it proceeds from a resolute *positive* abolition of religion. The criticism of religion ends with the teaching that *man is the highest essence of man,* hence with the *categoric imperative to overthrow all relations* in which man is a debased, enslaved, abandoned, despicable essence.

ENGELS: **THE DEVELOPMENT OF THE SENSES**
from *Dialectics of Nature*

Just as the gradual development of speech is inevitably accompanied by a corresponding refinement of the organ of hearing, so the development of the brain as a whole is accompanied by a refinement of all the senses. The eagle sees much farther than man, but the human eye sees considerably more in things than does the eye of the eagle. . . . And the sense of touch, which the ape hardly possesses in its crudest initial form, has been developed side by side with the development of the human hand itself, through the medium of labour.

MARX AND ENGELS: **THE LIBERATION FROM THE PAST, I**
from *The Communist Manifesto*

In bourgeois society, living labour is but a means to increase accumulated labour. In Communist society, accumulated labour is but a means to widen, to enrich, to promote the existence of the labourer.

In bourgeois society, therefore, the past dominates the present; in communist society, the present dominates the past.

MARX: **THE LIBERATION FROM THE PAST, II**
from Preface to *Capital*

Alongside of modern evils, a whole series of inherited evils oppress us, arising from the passive survival of antiquated modes of production, with their inevitable train of social and political anachronisms. We suffer not only from the living, but from the dead. *Le mort saisit le vif!*

MARX: **THE USES OF THE PAST**
from *The Eighteenth Brumaire of Louis Bonaparte*

Hegel remarks somewhere that all facts and personages of great importance in world history occur, as it were, twice. He forgot to add: the first time as tragedy, the second as farce. Caussidière for Danton, Louis Blanc for Robespierre, the *Montagne* of 1848 to 1851 for the *Montagne* of 1793 to 1795, the Nephew for the Uncle. And the same caricature occurs in the circumstances attending the second edition of the eighteenth Brumaire!

Men make their own history, but they do not make it just as they please; they do not make it under circumstances chosen by themselves, but under circumstances directly encountered, given and transmitted from the past. The tradition of all the dead generations weighs like a nightmare on the brain of the living. And just when they seem engaged in revolutionising themselves and things, in creating something that has never yet existed, precisely in such periods of revolutionary crisis they anxiously conjure up the spirits of the past to their service and borrow from them names, battle cries and costumes in order to present the new scene of world history in this time-honoured disguise and this borrowed language. Thus Luther donned the mask of the Apostle Paul, the Revolution of 1789 to 1814 draped itself alternately as the Roman republic and the Roman empire, and the Revolution of 1848 knew nothing better to do than to parody, now 1789, now the revolutionary tradition of 1793 to 1795. In like manner a beginner who has learnt a new language always translates it back into his mother tongue, but he has assimilated the spirit of the new language and can freely express himself in it only when he finds his way in it without recalling the old and forgets his native tongue in the use of the new.

Consideration of this conjuring up of the dead of world history reveals at once a salient difference. Camille Desmoulins, Danton, Robespierre, Saint-Just, Napoleon, the heroes as well as the parties and the masses of the old French Revolution, performed the task of their time in Roman costume

and with Roman phrases, the task of unchaining and setting up modern *bourgeois* society. The first ones knocked the feudal basis to pieces and mowed off the feudal heads which had grown on it. The other created inside France the conditions under which alone free competition could be developed, the parcelled landed property exploited, and the unchained industrial productive power of the nation employed; and beyond the French borders he everywhere swept the feudal institutions away, so far as was necessary to furnish bourgeois society in France with a suitable up-to-date environment on the European Continent. The new social formation once established, the antediluvian Colossi disappeared and with them resurrected Romanity—the Brutuses, Gracchi, Publicolas, the tribunes, the senators, and Caesar himself. Bourgeois society in its sober reality had begotten its true interpreters and mouthpieces in the Says, Cousins, Royer-Collards, Benjamin Constants and Guizots; its real military leaders sat behind the office desks, and the hogheaded Louis XVIII was its political chief. Wholly absorbed in the production of wealth and in peaceful competitive struggle, it no longer comprehended that ghosts from the days of Rome had watched over its cradle. But unheroic as bourgeois society is, it nevertheless took heroism, sacrifice, terror, civil war and battles of peoples to bring it into being. And in the classically austere traditions of the Roman republic its gladiators found the ideals and the art forms, the self-deceptions that they needed in order to conceal from themselves the bourgeois limitations of the content of their struggles and to keep their enthusiasm on the high plane of the great historical tragedy. Similarly, at another stage of development, a century earlier, Cromwell and the English people had borrowed speech, passions and illusions from the Old Testament for their bourgeois revolution. When the real aim had been achieved, when the bourgeois transformation of English society had been accomplished, Locke supplanted Habakkuk.

Thus the awakening of the dead in those revolutions served the purpose of glorifying the new struggles, not of parodying the old; of magnifying the given task in imagination, not of fleeing from its solution in reality; of finding once more the spirit of revolution, not of making its ghost walk again.

MARX: **COMMUNISM: THE NEGATION OF ALIENATION**
from *Economic and Philosophic Manuscripts*

Communism as the *positive* transcendence of *private property,* as *human self-estrangement,* and therefore as the real *appropriation of the human*

essence by and for man; communism therefore as the complete return of man to himself as a *social* (i.e., human) being—a return become conscious, and accomplished within the entire wealth of previous development. This communism, as fully-developed naturalism, equals humanism, and as fully-developed humanism equals naturalism; it is the *genuine* resolution of the conflict between man and nature and between man and man—the true resolution of the strife between existence and essence, between objectification and self-confirmation, between freedom and necessity, between the individual and the species. Communism is the riddle of history solved, and it knows itself to be this solution.

The entire movement of history is, therefore, both its *actual* act of genesis (the birth act of its empirical existence) and also for its thinking consciousness the *comprehended* and *known* process of its *coming-to-be*. That other, still immature communism, meanwhile, seeks an *historical* proof for itself—a proof in the realm of the existent—amongst disconnected historical phenomena opposed to private property, tearing single phases from the historical process and focusing attention on them as proofs of its historical pedigree (a horse ridden hard especially by Cabet, Villegardelle, etc.). By so doing it simply makes clear that by far the greater part of this process contradicts its claims, and that, if it has once been, precisely its being in the *past* refutes its pretension to being *essential*.

That the entire revolutionary movement necessarily finds both its empirical and its theoretical basis in the movement of *private property*—in that of the economy, to be precise—is easy to see.

This *material,* immediately *sensuous* private property is the material sensuous expression of *estranged human* life. Its movement—production and consumption—is the *sensuous* revelation of the movement of all production hitherto—i.e., the realisation or the reality of man. Religion, family, state, law, morality, science, art, etc., are only *particular* modes of production, and fall under its general law. The positive transcendence of *private property* as the appropriation of *human* life is, therefore, the positive transcendence of all estrangement—that is to say, the return of man from religion, family, state, etc., to his *human,* i.e., *social* mode of existence.

MARX: **MAN IS THE AIM OF PRODUCTION**
from *Pre-Capitalist Economic Formations*

Among the ancients we discover no single enquiry as to which form of landed property, etc., is the most productive, which creates maximum

wealth. Wealth does not appear as the aim of production, although Cato may well investigate the most profitable cultivation of fields, or Brutus may even lend money at the most favourable rate of interest. The enquiry is always about what kind of property creates the best citizens. Wealth as an end in itself appears only among a few trading peoples—monopolists of the carrying trade—who live in the pores of the ancient world like the Jews in medieval society. Wealth is on the one hand a thing, realised in things, in material products as against man as a subject. On the other hand, in its capacity as value, it is the mere right to command other people's labour, not for the purpose of dominion, but of private enjoyment, etc. In all its forms it appears in the form of objects, whether of things or of relationships by means of things, which lie outside of, and as it were accidentally beside, the individual.

Thus the ancient conception, in which man always appears (in however narrowly national, religious or political a definition) as the aim of production, seems very much more exalted than the modern world, in which production is the aim of man and wealth the aim of production. In fact, however, when the narrow bourgeois form has been peeled away, what is wealth, if not the universality of needs, capacities, enjoyments, productive powers, etc., of individuals, produced in universal exchange? What, if not the full development of human control over the forces of nature—those of his own nature as well as those of so-called "nature"? What, if not the absolute elaboration of his creative dispositions, without any preconditions other than antecedent historical evolution which makes the totality of this evolution—i.e. the evolution of all human powers as such, unmeasured by any *previously established* yardstick—an end in itself? What is this, if not a situation where man does not reproduce himself in any determined form, but produces his totality? Where he does not seek to remain something formed by the past, but is in the absolute movement of becoming? In bourgeois political economy—and in the epoch of production to which it corresponds—this complete elaboration of what lies within man, appears as the total alienation, and the destruction of all fixed, one-sided purposes as the sacrifice of the end in itself to a wholly external compulsion. Hence in one way the childlike world of the ancients appears to be superior; and this is so, in so far as we seek for closed shape, form and established limitation. The ancients provide a narrow satisfaction, whereas the modern world leaves us unsatisfied, or, where it appears to be satisfied with itself, is *vulgar* and *mean*.

MARX: **THE UTOPIAN REFLEX**
from letter to Arnold Ruge

The reform of consciousness exists *merely* in the fact that one makes the world aware of its consciousness, that one awakens the world out of its own dream, that one *explains* to the world its own acts. Our entire purpose consists in nothing else (as is also the case in Feuerbach's criticism of religion) but bringing the religious and political problems into the self-conscious human form.

Our slogan, therefore, must be: Reform of consciousness, not through dogmas, but through analysis of the mystical consciousness that is unclear about itself, whether in religion or politics. It will be evident, then, that the world has long dreamed of something of which it only has to become conscious in order to possess it in actuality. It will be evident that there is not a big blank between the past and the future, but rather that it is a matter of *realizing* the thoughts of the past. It will be evident, finally, that mankind does not begin any *new* work but performs its old work consciously. . . . To have its sins forgiven, mankind has only to declare them for what they are.

MARX:
THE FORMATION AND EMANCIPATION OF THE SENSES
from *Economic and Philosophic Manuscripts*

Man appropriates his total essence in a total manner, that is to say, as a whole man. Each of his *human* relations to the world—seeing, hearing, smelling, tasting, feeling, thinking, being aware, sensing, wanting, acting, loving—in short, all the organs of his individual being, like those organs which are directly social in their form, are in their *objective* orientation or in their *orientation to the object,* the appropriation of that object, the appropriation of the *human* world; their orientation to the object is the *manifestation of the human world;* it is human *efficaciousness* and human *suffering,* for suffering, apprehended humanly, is an enjoyment of self in man.

Private property has made us so stupid and one-sided that an object is only *ours* when we have it—when it exists for us as capital, or when it is directly possessed, eaten, drunk, worn, inhabited, etc.,—in short, when it is *used* by us. Although private property itself again conceives all these direct

realizations of possession as *means of life,* and the life which they serve as means is the *life of private property*—labour and conversion into capital.

In place of *all* these physical and mental senses there has therefore come the sheer estrangement of *all* these senses—the sense of *having.* The human being had to be reduced to this absolute poverty in order that he might yield his inner wealth to the outer world. . . .

The transcendence of private property is therefore the complete *emancipation* of all human senses and attributes; but it is this emancipation precisely because these senses and attributes have become, subjectively and objectively, *human.* The eye has become a *human* eye, just as its *object* has become a social, *human* object—an object emanating from man for man. The *senses* have therefore become directly in their practice *theoreticians.* They relate themselves to the *thing* for the sake of the thing, but the thing itself is an *objective human* relation to itself and to man, and vice versa. Need or enjoyment have consequently lost their *egotistical* nature, and nature has lost its mere *utility* by use becoming *human* use.

In the same way, the senses and enjoyments of other men have become my *own* appropriation. Besides these direct organs, therefore, *social* organs develop in the *form* of society; thus, for instance, activity in direct association with others, etc., has become an organ for *expressing* my own *life,* and a mode of appropriating *human* life.

It is obvious that the *human* eye gratifies itself in a way different from the crude, non-human eye; the human *ear* different from the crude ear, etc.

To recapitulate; man is not lost in his object only when the object becomes for him a *human* object or objective man. This is possible only when the object becomes for him a *social* object, he himself for himself a social being, just as society becomes a being for him in this object.

On the one hand, therefore, it is only when the objective world becomes everywhere for man in society the world of man's essential powers—human reality, and for that reason the reality of his *own* essential powers—that all *objects* become for him the *objectification of himself,* become objects which confirm and realise his individuality, become *his* objects: that is, *man himself* becomes the object. The manner in which they become *his* depends on the *nature of the objects* and on the nature of the *essential power* corresponding *to it;* for it is precisely the *determinateness* of this relationship which shapes the particular, *real* mode of affirmation. To the *eye* an object comes to be other than it is to the *ear,* and the object of the eye is another object than the object of the *ear.* The peculiarity of each essential power is precisely its *peculiar essence,* and therefore also the

peculiar mode of its objectification, of its *objectively actual* living *being*. Thus man is affirmed in the objective world not only in the act of thinking, but with *all* his senses.

On the other hand, looking at this in its subjective aspect: just as music alone awakens in man the sense of music, and just as the most beautiful music has *no* sense for the unmusical ear—is no object for it, because my object can only be the confirmation of one of my essential powers and can therefore only be so for me as my essential power is present for itself as a subjective capacity, because the sense of an object for me goes only so far as *my* senses go (has only sense for a sense corresponding to that object)—for this reason the *senses* of the social man are *other* senses than those of the non-social man. Only through the objectively unfolded rich-ness of man's essential being is the richness of subjective *human* sensibility (a musical ear, an eye for beauty of form—in short, *senses* capable of human gratifications, senses confirming themselves as essential powers of *man*) either cultivated or brought into being. For not only the five senses but also the so-called mental senses—the practical senses (will, love, etc.)—in a word, *human* sense—the humanness of the senses—comes to be by virtue of its object, by virtue of *humanised* nature. The *forming* of the five senses is a labour of the entire history of the world down to the present.

MARX: **SOCIALISM, I**
from *Capital*

. . . a higher form of society, a society in which the full and free develop-ment of every individual forms the ruling principle.

ENGELS: **SOCIALISM, II**
from *Anti-Dühring*

And at this point, in a certain sense, man finally cuts himself off from the animal world, leaves the conditions of animal existence behind him and enters conditions which are really human. . . . It is humanity's leap from the realm of necessity into the realm of freedom.

ART AND SOCIETY

MARX: THE IMMANENCE OF ARTISTIC DEVELOPMENT, I
from Introduction to *A Contribution to the Critique of Political Economy*

. . . The unequal relation between the development of material production and art, for instance. In general, the conception of progress is not to be taken in the sense of the usual abstraction. In the case of art, etc., it is not so important and difficult to understand this disproportion as in that of practical social relations, e.g., the relation between education in the United States and Europe. The really difficult point, however, that is to be discussed here is that of the unequal (?) development of relations of production as legal relations. As, e.g., the connection between Roman civil law (this is less true of criminal and public law) and modern production.

. . . This conception of development appears to imply necessity. On the other hand, justification of accident. Varia. (Freedom and other points.) (The effect of means of communication.) World history does not always appear in history as the result of world history.

. . . The starting point [is to be found] in certain facts of nature embodied subjectively and objectively in clans, races, etc.

It is well known that certain periods of highest development of art stand in no direct connection with the general development of society, nor with the material basis and the skeleton structure of its organization. Witness the example of the Greeks as compared with the modern nations or even Shakespeare. As regards certain forms of art, as e.g., the epos, it is admitted that they can never be produced in the world-epoch—making form as soon as art as such comes into existence; in other words, that in the domain of art certain important forms of it are possible only at a low stage of its development. If that be true of the mutual relations of different forms of art within the domain of art itself, it is far less surprising that the same is true of the relation of art as a whole to the general development of society. The difficulty lies only in the general formulation of these contradictions. No sooner are they specified than they are explained. Let us take for instance the relation of Greek art and of that of Shakespeare's time to our own. It is a well known fact that Greek mythology was not only the arsenal of Greek art, but also the very ground from which it had sprung. Is the view of nature and of social relations which shaped Greek imagination and Greek [art] possible in the age of automatic machinery, and railways, and

locomotives, and electric telegraphs? Where does Vulcan come in as against Roberts & Co.; Jupiter, as against the lightning rod; and Hermes, as against the Crédit Mobilier? All mythology masters and dominates and shapes the forces of nature in and through the imagination; hence it disappears as soon as man gains mastery over the forces of nature. What becomes of the Goddess Fame side by side with Printing House Square?[1] Greek art presupposes the existence of Greek mythology, i.e. that nature and even the form of society are wrought up in popular fancy in an unconsciously artistic fashion. That is its material. Not, however, any mythology taken at random, nor any accidental unconsciously artistic elaboration of nature (including under the latter all objects, hence [also] society). Egyptian mythology could never be the soil or womb which would give birth to Greek art. But in any event [there had to be] *a* mythology. In no event [could Greek art originate] in a society which excludes any mythological explanation of nature, any mythological attitude towards it and which requires from the artist an imagination free from mythology.

Looking at it from another side: is Achilles possible side by side with powder and lead? Or is the Iliad at all compatible with the printing press and steam press? Does not singing and reciting and the muses necessarily go out of existence with the appearance of the printer's bar, and do not, therefore, disappear the prerequisites of epic poetry?

But the difficulty is not in grasping the idea that Greek art and epos are bound up with certain forms of social development. It rather lies in understanding why they still constitute with us a source of aesthetic enjoyment and in certain respects prevail as the standard and model beyond attainment.

A man can not become a child again unless he becomes childish. But does he not enjoy the artless ways of the child and must he not strive to reproduce its truth on a higher plane? Is not the character of every epoch revived perfectly true to nature in child nature? Why should the social childhood of mankind, where it had obtained its most beautiful development, not exert an eternal charm as an age that will never return? There are ill-bred children and precocious children. Many of the ancient nations belong to the latter class. The Greeks were normal children. The charm their art has for us does not conflict with the primitive character of the social order from which it had sprung. It is rather the product of the latter, and is rather due to the fact that the unripe social conditions under which the art arose and under which alone it could appear can never return.

1. The site of the "Times" building in London.

MARX: **THE IMMANENCE OF ARTISTIC DEVELOPMENT, II**
from *Theories of Surplus Value*

With Storch himself the *theory of civilisation* does not get beyond trivial phrases, although some ingenious observations slip in here and there—for example, that the material division of labour is the pre-condition for the division of intellectual labour. How much it *was inevitable* that Storch could not get beyond trivial phrases, how little he had even *formulated* for himself the task, let alone its solution, is apparent from one *single* circumstance. In order to examine the connection between spiritual production and material production it is above all necessary to grasp the latter itself not as a general category but in *definite historical* form. Thus for example different kinds of spiritual production correspond to the capitalist mode of production and to the mode of production of the Middle Ages. If material production itself is not conceived in its *specific historical* form, it is impossible to understand what is specific in the spiritual production corresponding to it and the reciprocal influence of one on the other. Otherwise one cannot get beyond inanities. This because of the talk about "civilisation."

Further: from the specific form of material production arises in the first place a specific structure of society, in the second place a specific relation of men to nature. Their State and their spiritual outlook is determined by both. Therefore also the kind of their spiritual production.

Finally, by spiritual production Storch means also all kinds of professional activities of the ruling class, who carry out social functions as a trade. The existence of these strata, like the function they perform, can only be understood from the specific historical structure of their production relations.

Because Storch does not conceive material production itself *historically*—because he conceives it as production of material goods in general, not as a definite historically developed and specific form of this production—he deprives himself of the basis on which alone can be understood partly the ideological component parts of the ruling class, partly the free spiritual production of this particular social formation. He cannot get beyond meaningless general phrases. Consequently, the relation is not so simple as he presupposes. For instance, capitalist production is hostile to certain branches of spiritual production, for example, art and poetry. If this is left out of account, it opens the way to the illusion of the French in the eighteenth century which has been so beautifully satirised by Lessing. Because we are further ahead than the ancients in mechanics, etc., why

shouldn't we be able to make an epic too? And the *Henriade* in place of the *Iliad*!

ENGELS: **CLASS AND CHARACTERIZATION**
from letter to Ferdinand Lassalle

Your *Sickengen* is entirely on the right road, the principal characters in fact are representatives of definite classes and tendencies and hence definite ideas of their time, and the motives of their actions are to be found not in trivial individual desires but in the historical stream upon which they are being carried. . . . It seems to me . . . that the person is characterized not only by *what* he does but also by *how* he does it, and from this point of view the intellectual content of your drama could only gain by a sharper contrast and juxtaposition of the separate characters.

MARX AND ENGELS: **ART AND DECLINING CLASSES**
from review of Daumer's *The Religion of the New Age*

If the decline of earlier classes, such as the medieval knights, provided the raw material for magnificent and tragic works of art, that of the petty-bourgeoisie characteristically gives rise to nothing but impotent expressions of fanatical ill will and a collection of Sancho Panzaesque saws and maxims.

MARX: **THE TRUTH CONTENT OF ART**
from "The English Middle Class"

The brilliant contemporary school of novelists in England, whose eloquent and graphic portrayals of the world have revealed more political and social truths than all the professional politicians, publicists, and moralists put together . . .

ENGELS: **THE NARCOTIC ELEMENT IN ART**
from "Retrograde Signs of the Times"

It must be a blessed feeling for a legitimist, watching the plays of Racine, to forget the Revolution, Napoleon, and the great week; the glory of the *ancien régime* arises out of the earth, the world covers itself with thick-

piled carpets, in periwig and brocades Louis the absolute promenades along the landscaped avenues of Versailles, and the omnipotent fan of a mistress rules a happy court and an unhappy France.

MARX: **INNATE AESTHETIC QUALITIES**
from *A Contribution to the Critique of Political Economy*

Gold and silver are not only negatively superfluous, i.e., dispensable articles, but their aesthetic properties make them the natural material of luxury, ornamentation, splendor, festive occasions, in short, the positive form of abundance and wealth. They appear, in a way, as spontaneous light brought out from the underground world, since silver reflects all rays of light in their original combination, and gold only the color of highest intensity, viz., red light. The sensation of color is, generally speaking, the most popular form of aesthetic sense.

MARX: **ART AND AUDIENCE**
from Introduction to *A Contribution to the Critique of Political Economy*

Production not only supplies the want with material, but supplies the material with a want. . . . The want of it which consumption experiences is created by its appreciation of the product. The object of art, as well as any other product, creates an artistic and beauty-enjoying public. Production thus produces not only an object for the individual, but also an individual for the object.

MARX: **SYMBOLISM**
from *A Contribution to the Critique of Political Economy*

But no thing can be its own symbol. Painted grapes are no symbol of real grapes, they are imaginary grapes.

MARX: **ART AND FEAR**
from marginal note in Johann Jakob Grund, *Die Malerei der Griechen*

Everything ugly and monstrous despises art. But nevertheless the portrayal of the gods among ancient nations was never altered. Wherever they were

given a perfectly natural portrayal, we find that such treatment received no development. This is because in so far as fear entered into the various conceptions of the gods, and in so far as such gods sanctified the origin of the various social groups, the leaders of such groups found in this fear a means of controlling the populace; in other words, they made this fear of god the citadel of their domination, spreading it among the people and preserving unchanged the ugly, fear-inspiring images of the gods. Since fear paralyzes the mind, people educated and held in fear can never develop and elevate their minds; quite the contrary, the innate ability to imitate and hence acquire artistic feelings, becomes almost completely repressed.

ENGELS: **REALISM AND PARTISANSHIP, I**
from letter to Minna Kautsky

I have read *Old and New*,[1] for which I am heartily grateful to you. The life of the workers of the salt mines is described in just as masterly a way as the life of the peasants in *Stefan*.[2] The scenes of Viennese "society" are also mostly very good. Vienna indeed is the only German city where there is any society. In Berlin there are only "certain circles," and still more uncertain ones, and it therefore offers a field only for a novel on the life of the literary circle, bureaucrats, or actors.

Whether the motivation of the action in this part of your work does not develop a little hastily is easier for you to judge than for me. Much of what produces such an impression on one of us may be perfectly natural in Vienna, with its own sort of international character, full of southern and eastern European elements. The characters in both milieus are drawn with your usual precision of individualization. Each person is a type, but at the same time a completely defined personality—"this one" as old Hegel would say. That is as it should be.

Only for the sake of impartiality I should find something negative, and here I recall Arnold. In truth he is too faultless, and if at last he perishes by falling from a mountain, this can be reconciled with poetic justice only in that he was too good for this world. It is always bad for an author to be infatuated with his hero, and it seems to me that in this case you have given way somewhat to this weakness. Elsa still has traces of personality, although she is also somewhat idealized, but in Arnold personality is entirely dissolved in principle.

1. Minna Kautsky's novel *Old and New* was published in 1884.—*Ed.*
2. Minna Kautsky's novel *Stefan von Grillenhof* was published in 1879.—*Ed.*

The root of this defect is indicated, by the way, in the novel itself. Evidently you felt the need of publicly declaring your convictions, bearing witness to them before the whole world. You have already done this, this is already behind you, and there is no reason to repeat this in such a form.

I am not at all an opponent of tendentious [Tendenz] poetry as such. The father of tragedy, Aeschylus, and the father of comedy, Aristophanes, were both decidedly tendentious poets, just as were Dante and Cervantes; and the main merit of Schiller's *Craft and Loves* is that it is the first German political propaganda drama. The modern Russians and Norwegians, who are writing splendid novels, are all tendentious.

But I think that the bias should flow by itself from the situation and action, without particular indications, and that the writer is not obliged to obtrude on the reader the future historical solutions of the social conflicts pictured. And especially in our conditions the novel appeals mostly to readers of bourgeois circles, that is, not directly related to us, and therefore a socialist-biased novel fully achieves its purpose, in my view, if by conscientiously describing the real mutual relations, breaking down conventional illusions about them, it shatters the optimism of the bourgeois world, instills doubt as to the eternal character of the existing order, although the author does not offer any definite solution or does not even line up openly on any particular side.

ENGELS: **REALISM AND PARTISANSHIP, II**
from letter to Margaret Harkness

If I have any criticism to make, it is only that your story[1] is not quite realistic enough. Realism, to my mind, implies, besides truth of detail, the truthful reproduction of typical characters under typical circumstances. Now your characters are typical enough, to the extent that you portray them. But the same cannot be said of the circumstances surrounding them and out of which their action arises. In *City Girl* the working class appears as a passive mass, incapable of helping itself or even trying to help itself. All attempts to raise it out of its wretched poverty come from the outside, from above. This may have been a valid description around 1800 or 1810 in the days of Saint-Simon and Robert Owen, but it cannot be regarded as such in 1887 by a man who for almost fifty years has had the honor to participate in most of the struggles of the fighting proletariat and has been

1. Margaret Harkness published her novel, *A City Girl,* under the pseudonym "John Law" in 1887.—*Ed.*

guided all the time by the principle that the emancipation of the working class ought to be the cause of the working class itself. The revolutionary response of the members of the working class to the oppression that surrounds them, their convulsive attempts—semiconscious or conscious—to attain their rights as human beings, belong to history and may therefore lay claim to a place in the domain of realism.

I am far from finding fault with your not having written a purely socialist novel, a *Tendenzroman,* as we Germans call it, to glorify the social and political views of the author. That is not at all what I mean. The more the author's views are concealed the better for the work of art. The realism I allude to may creep out even in spite of the author's views. Let me refer to an example.

Balzac, whom I consider a far greater master of realism than all the Zolas, past, present, or future, gives us in his *Comédie Humaine* a most wonderfully realistic history of French "society," describing, chronicle fashion, almost year by year from 1816 to 1848, the ever-increasing pressure of the rising bourgeoisie upon the society of nobles that established itself after 1815 and that set up again, as far as it could (*tant bien que mal*) the standard of the *vielle politesse française* [old French manners]. He describes how the last remnants of this, to him, model society gradually succumbed before the intrusion of the vulgar moneyed upstart or was corrupted by him. How the *grande dame,* whose conjugal infidelities were but a mode of asserting herself, in perfect accord with the way she had been disposed of in marriage, gave way to the bourgeoisie, who acquired her husband for cash or cashmere. And around this central picture he groups a complete history of French society from which, even in economic details (for instance, the redistribution of real and private property after the French Revolution) I have learned more than from all the professional historians, economists and statisticians of the period together.

Well, Balzac was politically a legitimist; his great work is a constant elegy on the irreparable decay of good society; his sympathies are with the class that is doomed to extinction. But for all that, his satire is never keener, his irony never more bitter, than when he sets in motion the very men and women with whom he sympathizes most deeply—the nobles. And the only men of whom he speaks with undisguised admiration are his bitterest political antagonists, the republican heroes of the Cloître Saint Méry, the men who at that time (1830–36) were indeed representatives of the popular masses.

That Balzac was thus compelled to go against his own class sympathies and political prejudices, that he *saw* the necessity of the downfall of his

favorite nobles and described them as people deserving no better fate; that he *saw* the real men of the future where, for the time being, they alone were to be found—that I consider one of the greatest triumphs of realism, and one of the greatest features in old Balzac.

I must own, in your defense, that nowhere in the civilized world are the working people less actively resistant, more passively submitting to fate, more depressed than in the East End of London. And how do I know whether you have not had your reasons for contenting yourself, for once, with a picture of the passive side of working class life, leaving the active side for another work?

ENGELS: **ON BIAS**
from Preface to the German edition of *The Poverty of Philosophy*

The first condition of all criticism—freedom from bias.

MARX: **TENDENTIOUSNESS**
from letter to Ferdinand Lassalle

You would have to Shakespearize more, while at present I consider Schillerism, making individuals the mere mouthpieces of the spirit of the times, your main fault.

ENGELS:
AMBIVALENT REFLECTIONS OF SOCIAL CONDITIONS
from "The State of Germany"

Such was the state of Germany towards the end of the last century. It was all over one living mass of putrefaction and repulsive decay. Nobody felt himself at ease. The trade, commerce, industry, and agriculture of the country were reduced to almost nothing; peasantry, tradesmen, and manufacturers felt the double pressure of a blood-sucking government and bad trade; the nobility and princes found that their incomes, in spite of the squeezing of their inferiors, could not be made to keep pace with their increasing expenditure; everything was wrong, and a general uneasiness prevailed throughout the country. No education, no means of operating upon the minds of the masses, no free press, no public spirit, not even an extended commerce with other countries—nothing but meanness and

selfishness—a mean, sneaking, miserable shop-keeping spirit pervading the whole people. Everything worn out, crumbling down, going fast to ruin, and not even the slightest hope of a beneficial change, not even so much strength in the nation as might have sufficed for carrying away the putrid corpses of dead institutions.

The only hope for the better was seen in the country's literature. This shameful political and social age was at the same time the great age of German literature. About 1750 all the master spirits of Germany were born, the poets Goethe and Schiller, the philosophers Kant and Fichte, and, hardly twenty years later, the last great German metaphysician, Hegel. Every remarkable work of this kind breathed a spirit of defiance and rebellion against the whole of German society as it then existed. Goethe wrote *Goetz von Berlichingen,* a dramatic homage to the memory of a rebel; Schiller, *The Robbers,* celebrating a generous young man who declares open war against all society. But these were their juvenile productions; when they grew older they lost all hope: Goethe restrained himself to satire of the keenest order, and Schiller would have despaired if it had not been for the refuge which science, and particularly the great history of ancient Greece and Rome, afforded to him. These, too, may be taken as examples of the rest. Even the best and strongest minds of the nation gave up all hope as to the future of their country.

ENGELS: THE JOYS OF THE FLESH
from "Georg Weerth"

In one thing Weerth was a master, excelling Heine (because he was healthier and less artificial) and surpassed in the German language by Goethe alone: that was in expressing natural robust sensuousness and the joys of the flesh. Many readers of the *Sozialdemokrat* would be horrified, were I to reprint in it individual *feuilletons* of the *Neue Rheinische Zeitung.* But I haven't the slightest intention of doing so. Yet I cannot refrain from pointing out that there will come a time when German Socialists too will triumphantly get rid of the last traces of German philistine prejudices and hypocritical moral prudery—and anyhow, they only serve as a cover for surreptitious obscenity. Read Freiligrath's "Epistles," for instance— you would really think people had no sexual organs. And yet nobody was more delighted with a quiet bit of smut than Freiligrath, who is so ultra-chaste in his poetry. It is high time that at least the German workers get accustomed to speaking in a free and easy manner about things they themselves do every day or night. They are natural, inevitable, and highly

pleasant things—as witness the people of Rome, Homer and Plato, Horace and Juvenal, the Old Testament, and the *Neue Rheinische Zeitung.*

Moreover, Weerth has also written less obnoxious things, and I am going to take the liberty from time to time of sending some of these pieces to the *feuilleton* of the *Sozialdemokrat.*

MARX: **CENSORSHIP AND TRUTH**
from "Comments on the Latest Prussian Censorship Instruction"

Truth can be as little restrained as light, and in relation to what should it be restrained? In relation to itself? *Verum index sui et falsi* [Truth, the test of itself and of falsehood (Spinoza)]. Hence, *in relation to falsehood?*

If restraint shapes the character of inquiry it is a criterion for shying away from truth rather than from falsity. It is a drag on every step I take. *With inquiry, restraint is the prescribed fear of finding the result,* a means of keeping one from the truth.

Furthermore, truth is universal. It does not belong to me, it belongs to all; it possesses me, I do not possess it. A *style* is my property, my spiritual individuality. *Le style, c'est l'homme.* Indeed! The law permits me to write, only I am supposed to write in a style different from *my own.* I may show the profile of my mind, but first I must show the *prescribed mien.* What man of honor will not blush at this effrontery and rather hide his head under his toga. At least it is conceivable that under the toga there is the head of a Jupiter. The prescribed mien is nothing but *bonne mine à mauvais jeu.*

You admire the charming variety, the inexhaustible wealth of nature. You do not demand that the rose smell like the violet. But the richest of all, the mind, is to exist only in *one* way? I may be humorous, but the law orders that I write seriously. I may be forward, but the law orders that my style be restrained. *Grey on grey* is to be the only permissible color of freedom. Every dewdrop in the sun glitters in an infinite play of colors, but the light of the mind is to produce only one, only the *official color,* no matter in how many individuals and in which objects it may be refracted. The essential form of mind is *brightness* and *light,* and you want to make *shadow* its only appropriate manifestation. It is to be dressed only in black, and yet there are no black flowers. The essence of mind is *always truth itself,* and what do you make its essence? *Restraint.* Only a good-for-nothing holds back, says Goethe, and you want to make the mind a good-for-nothing? Or do you mean the restraint of genius of which Schiller speaks? Then you will first have to transform all citizens and chiefly all

censors into geniuses. But the restraint of genius does not lie in the language of culture permitting no accent and no dialect. Rather it speaks the accent of the substance of things and the dialect of their nature. It is a matter of forgetting restraint and unrestraint, and of crystallizing things. The general restraint of the mind is reason, that universal liberality which is related to *every nature* according to *its essential character*.

Furthermore, if *seriousness* is not to fit into the definition of Tristram Shandy where it is deceitful behavior of the body to cover up the deficiencies of the soul, and if seriousness should mean *substantial* earnestness, then the entire regulation cancels itself. For I treat the ridiculous seriously when I treat it as ridiculous, and the most serious lack of intellectual restraint is to be restrained about a lack of restraint.

Serious and restrained! What wavering and relative concepts! Where does seriousness end, and where does levity begin? Where does restraint leave off, and where does lack of restraint start? We are dependent upon the *temperament* of the censor. Prescribing a temperament for the censor would be just as wrong as prescribing a style for the writer. If you wish to be logical in your aesthetic criticism, prohibit the pursuit of truth in a *too serious* and *too restrained* manner, for the greatest seriousness is the most ridiculous thing, and the greatest restraint is the bitterest irony.

Finally, all this proceeds from a completely wrong and abstract view of *truth*. All purposes of journalistic activity are subsumed under the one general concept of *"truth."* Even if we disregard the *subjective* side, namely that one and the same object appears differently in different individuals and expresses its various aspects in as many various intellects, shouldn't *the character of the object* have some influence, even the slightest, on the inquiry? Not only the result but also the route belongs to truth. The pursuit of truth must itself be true; the true inquiry is the developed truth whose scattered parts are assembled in the result. And the nature of inquiry is not to change according to the object? When the object is humorous, inquiry is supposed to appear serious. When the object is touchy, inquiry is to be restrained. Thus you injure the rights of the object as you injure the rights of the subject. You grasp truth abstractly and make the mind an *inquisitor* who dryly *records the proceedings*.

Or is this metaphysical torment unnecessary? Is *truth* to be understood in such a way that it is constituted by *governmental order,* and is *inquiry* a superfluous and obnoxious third element which cannot be entirely rejected *for reasons of etiquette?* It almost appears that way. For inquiry is understood a priori as being *opposed* to truth and appears therefore with the suspicious official patina of seriousness and restraint a layman is supposed

to display before a priest. Administrative reasoning is the only rationality in politics. Under certain circumstances concessions are to be made to other reasoning and idle talk, but at the same time this reasoning ought to be conscious of the concession and of its real groundlessness: restrained and subservient, serious and boring. When Voltaire says, "Tous les genres sont bons, excepté le genre ennuyeux," the boring type becomes the only type as we can easily observe in the "Proceedings of the Rhenish States." Why not rather the good old German legal style? You are to write freely, but every word is to be a curtsy before liberal censorship, which lets your serious and restrained words pass. By no means should you lose a consciousness of humility!

The *legal emphasis* is not placed on truth, but on restraint and seriousness. Hence, everything causes concern, seriousness, restraint, and above all a kind of truth under whose vague scope a very definite, very doubtful truth appears to be hidden.

ENGELS: **INDIGNATION AND POETRY**
from *Anti-Dühring*

The task of economic science is . . . to show the social abuses which are now developing as necessary consequences of the existing mode of production, but at the same time also as the indications of its imminent dissolution; and to reveal, within the already dissolving economic development, the elements of the future new organisation of production and exchange which will put an end to those abuses. The indignation which creates the poet is absolutely in place in describing these terrible conditions, and also in attacking those apostles of harmony in the service of the ruling class who either deny or palliate these abuses; but how little it can *prove* anything for the particular case is evident from the fact that in *each* epoch of all past history there has been no lack of material for such indignation.

MARX: **ON POETS**
from letter to Joseph Weydemeyer

Write a friendly letter to Freiligrath. Don't be afraid to compliment him, for all poets, even the best of them, are courtesans, more or less, and they have to be cajoled to make them sing. Our F[reiligrath] . . . is a real revolutionary and an honest man through and through—praise that I

would not mete out to many. Nevertheless, a poet—no matter what he may be as a man—requires applause, admiration. I think it lies in the very nature of the species. . . .

MARX: LANGUAGE
from *Pre-Capitalist Economic Formations*

Language itself is just as much the product of a community, as in another respect it is the existence of the community: it is, as it were, the communal being speaking for itself.

MARX: PRODUCTIVE LABOR
from *Theories of Surplus Value*

A writer is a productive labourer not in so far as he produces ideas, but in so far as he enriches the publisher who publishes his works, or if he is a wage-labourer for a capitalist.

An entrepreneur of theatres, concerts, brothels, etc., buys the temporary disposal over the labour-power of the actors, musicians, prostitutes, etc.— in fact in a roundabout way that is only of formal economic interest; in its result the process is the same—he buys this so-called "unproductive labour," whose "services perish in the very instant of their performance" . . . And these services which he has thus bought enable him to buy them again; that is to say, they themselves renew the fund from which they are paid for.

MARX: AESTHETIC NEED AND COMMODITY PRODUCTION
from *Theories of Surplus Value*

Certain *services,* or the *use-values,* resulting from certain forms of activity or labour are embodied in *commodities;* others on the contrary leave no tangible result *existing apart* from the persons themselves who perform them; in other words, their result is not a vendible commodity. For example, the service a singer renders to me satisfies my aesthetic need; but what I enjoy exists only in an activity inseparable from the singer himself, and as soon as his labour, the singing, is at an end, my enjoyment too is at an end. I enjoy the activity itself—its reverberation on my ear. These

services themselves, like the commodities which I buy, may be necessary or may only seem necessary—for example, the service of a soldier or physician or lawyer; or they may be services which give me pleasure. But this makes no difference to their economic character.

MARX: CREATIVITY AND PRODUCTIVE LABOR
from *Theories of Surplus Value*

The capitalist production process, therefore, is not merely the production of commodities. It is a process which absorbs unpaid labour, which makes raw materials and means of labour—the means of production—into means for the absorption of unpaid labour.

It follows from what has been said that the designation of labour as *productive labour* has absolutely nothing to do with the *determinate content* of the labour, its special utility, or the particular use-value in which it manifests itself.

The same kind of labour may be *productive* or *unproductive*.

For example Milton, who wrote *Paradise Lost* for five pounds, was an *unproductive labourer*. On the other hand, the writer who turns out stuff for his publisher in factory style, is a *productive labourer*. Milton produced *Paradise Lost* for the same reason that a silk worm produces silk. It was an activity of *his* nature. Later he sold the product for £5. But the literary proletarian of Leipzig, who fabricates books (for example, Compendia of Economics) under the direction of his publisher, is a *productive labourer;* for his product is from the outset subsumed under capital, and comes into being only for the purpose of increasing that capital. A singer who sells her song for her own account is an *unproductive labourer*. But the same singer commissioned by an entrepreneur to sing in order to make money for him is a *productive labourer;* for she produces capital.

THE SECOND
GENERATION

WILLIAM MORRIS

*Man therefore also forms things
in accordance with the laws of beauty.*
—Marx, *Economic and Philosophic
Manuscripts*

William Morris (1834–1895) was one of those rare men who never found it necessary to repudiate any portion of his past. His life was the process of integrating his aesthetic ideas into the framework of his growing revolutionary awareness. His becoming a Marxist, in the early 1880's, marked a seemingly inevitable stage in his personal evolution and led—rather than to a diminution of his artistic productivity or to withdrawal from aestheticism —to the creation of several of his greatest works, *The Dream of John Ball* and *News From Nowhere,* and to the crystallization of a Marxist aesthetic approach to nature and the labor process. He was perhaps the first major creative artist to become a Marxist on a more than superficial level. His contributions to Marxist aesthetics took so unusual a turn that they have not yet been assessed for what they really are: the first application of the Marxist theory of labor to art, a critique of capitalist society in terms of the alienation of the laborer from the object of his production, a vision of a nonrepressive order founded on the reintroduction of the aesthetic dimension into the labor process.

These ideas are now taken for granted. They have become part of the Marxist heritage during the past few decades because of the publication of

Marx's *Economic and Philosophic Manuscripts of 1844* and of other early writings. It is this recent emphasis on the Feuerbachian and Fourierist side of Marx's development that makes possible a more complete appreciation of the magnitude of Morris' achievement. Marx had written that labor under capitalism is "labor in which man alienates himself" from his essential nature as a human being as well as from the object of his own production, thereby turning labor into "self-sacrifice" and "mortification," and thereby ultimately alienating man from his fellow men. The free, untrammeled exercise of the labor process, for Marx, is creation "in accordance with the laws of beauty." But if the product of labor is wrenched from the laborer by an external system of forced appropriation, then "it confronts him as an alien power," thereby turning the worker's activity into a torment. Labor, which is the affirmation of man's species being, of his essential nature, of his *aesthetic creativity,* is alienated, negated, turned into pain. This pain in turn serves as motor for the negation of alienation, for "the complete return of man to himself as a *social* (i.e., human) being—a return become conscious, and accomplished within the entire wealth of previous development."

Morris could not have known these passages from the *Economic and Philosophic Manuscripts,* nor need he have, for similar ideas had become part of his consciousness through more indigenous influences: through Ruskin, who wrote in 1853 that the crucial question of artistic labor was "whether the workman shall be a living, progressive, and happy human being, or whether he shall be a mere machine, with its valves smoothed by heart's blood instead of oil"; through Ruskin's mentor, Carlyle, in whom were precipitated many of the aesthetic ideas of German classical philosophy and especially those of Goethe and Schiller; and through the Utilitarian philosophers, whose work affected Morris so strongly that he regarded the reading of Mill's antisocialist writings as a major factor in his own conversion to socialism. To Mill and Bentham particularly is Morris indebted for the pain-pleasure dialectic as the driving force of human behavior. (Freud would later enshrine this dialectic at the center of his theory of sexuality.)

That he was predisposed toward discovering these ideas, that he was indeed searching in Marxism for historical and philosophical confirmation of previously conceived notions, is unquestionable. After a brief but intense ecclesiastical period while still at Oxford (he and his friends spoke of founding a new monastic order), Morris was drawn rapidly into an exploration of all the visual arts. He became an architect in 1856, he published his first book of poems (*The Defence of Guenevere*) in 1858; in 1861 he and a number of like-minded artists and craftsmen founded an

architectural and interior design firm—Morris and Co.—where Morris was able to give free rein to his talents in mural painting, stained-glass design, metal work, jewelry and furniture design, embroidery, and ornamental work in every natural medium. Wellek is unkind in writing that "it is the paradox of Victorian aestheticism that Ruskin and Morris wanted to revolutionize society and all the things in it and that finally they and their followers succeeded only in establishing a new decorative style."[1] Rather, one might say that Morris was vainly attempting to re-create with his hands a dream world which industrial capitalism had done away with. All of Morris' early work is an attempted avoidance of confrontation with the alienations of industrial society. None of his pre-Marxist creative writings—the *Guenevere, The Life and Death of Jason,* the translations from the Icelandic sagas (1870 et seq.), *The Earthly Paradise* (1868–1869)— deal with the present. But Morris was not slow to note that the avoidance of the present does not necessarily alter it, and he moved toward the idea that the institutions of society would have to be changed in order to restore the aesthetic dimension in men's lives. After a brief involvement in re-formist organizations (such as the Society for the Protection of Ancient Buildings and the Eastern Question Association) he discovered Marxism (he read *Capital* in its French translation in 1883) and concluded that it was not merely the institutions of society but its very economic foundations which were in need of transformation. Together with Eleanor Marx, Edward Aveling, and others, he founded the Socialist League in 1884, became the editor of its journal, *The Commonweal,* from 1885 to 1890, was arrested several times for socialist agitation, and in general spent the balance of his life in a most remarkable fusion of revolutionary and aes-thetic activity. The beliefs and inclinations of a lifetime—Pre-Raphaelit-ism, the Medieval handicrafts system, the sagas and epics of the Icelandic peoples and of the Greeks, the vision of English national freedom—all were integrated and subsumed under the categories he found in Marxism. "His early attachment to King Arthur had led him irresistibly to Karl Marx," wrote William Gaunt: "The Round Table was a preparation for Communism."[2]

The tracing of the direct influence of Marx and Engels on Morris would be an important achievement. It seems to lie primarily in two works: *Capital* and Engels' *Socialism: Utopian and Scientific,* which appeared in Lafargue's French translation in 1880. In reading these, Morris was extraor-

1. René Wellek. *A History of Modern Criticism* (New Haven and London, 1965), vol. IV, p. 411.

2. William Gaunt, *The Pre-Raphaelite Dream* (New York, 1966), p. 227.

dinarily acute (more so than any Marxist up to the 1920's) in ferreting out and following the outlines and applications of the Marxist theories of alienated labor and revolutionary humanism which had been worked out in the pre-*Manifesto* days. *Capital's* chapters on "The Working Day," on "The Division of Labour and Manufacture," on "Primitive Accumulation of Capital," are drenched in these ideas; it took an artist and a humanist to rediscover them. Marx's description of "the crippling of body and mind" which rises from the division of labor in society and his stress upon the alienation of man from the product of his labor inherent in the transition from handicrafts to manufacture echoed Morris's own beliefs and transformed them in him from an object of faith into an article of knowledge founded on historical and economic analysis. Engels' pamphlet (drawn from *Anti-Dühring*) describes how the development of society's productive forces now makes possible "the completely unrestricted development and exercise" of man's "physical and mental faculties": "man finally cuts himself off from the animal world, leaves the conditions of animal existence behind him and enters conditions which are really human." The domination of the producer by the product comes to an end.

Morris' life was a search for a transcendence of capitalism—with its despoliation of beauty both in labor and in nature, its cash nexus, its destruction of art, its conversion of work into pain, its exclusion of pleasure from the labor process. And this is the ground-bass of the brief set of selections which are excerpted here from Morris' lectures and essays on art and socialism. Writing and speaking not in the dry jargon of the political Marxist but in grand biblical cadences, his was an early vision of a nonrepressive society, socialist in its productive relations, built according to principles of beauty which were to permeate every sphere of life: nature, the labor process, leisure, our homes and surroundings. All were to be in harmony with the nonexploitative social relations which constitute the basis of socialist society. In order to create this ideal of beauty it was necessary for Morris to find a model, to leap into the precapitalist past, into the fourteenth century, before the workshop of Raphael, before merchant capitalism, before the enclosures, before the ravishment of the land and the people which accompanied the process of the primitive accumulation of capital. Every Utopia needs a past upon which to pattern its future. Morris chose the Middle Ages. Marxism confirmed him in his belief that beauty was incompatible with capitalism. "My work is the embodiment of dreams in one form or another," he had written as early as 1856. The task now was to bring about the age of beauty and peace which he had envisioned.

William Morris has not yet found a home. The aesthetic movement has never quite forgiven him his involvement in politics; the British establishment admires him as a national monument, but shudders at his betrayal of his own class; the Marxist parties are proud to claim him for themselves, but are wary of his aestheticism, his certain Medievalism, his Utopianism. Marx too had objected to the romanticist view of feudalism, but in the *Economic and Philosophic Manuscripts* he had noted that "in feudal landed property the lord at least *appears* as the king of the estate," which is itself "like their fatherland." The laborers are bound to the lord by "ties of respect, allegiance and duty. His relation to them is therefore directly political, and has likewise a human, *intimate,* side." So much for the correspondence between Marx and Morris on precapitalist social relations. As for Morris' Utopianism, he will only find his place when the Utopian socialist sources of Marxist thought are granted their full significance. It was in *Socialism: Utopian and Scientific* that Engels tried to reveal Marx's enormous debt to Fourier—to his division of history into stages, his vision of communal organization, his concept of crisis stemming from superabundance, his desire for the liberation of the senses. Most Marxists of the second generation ignored the attempt. Morris was quick to recognize it: he wrote that of all the Utopians "Fourier is the one that calls for the most attention: since his doctrine of the necessity and possibility of making labour attractive is one which Socialism can by no means do without."

MORRIS: **ART, LABOR, AND SOCIALISM**
from *Lectures on Socialism* and *Signs of Change*

I

Some people will perhaps not be prepared to hear that Socialism has any ideal of art, for in the first place it is so obviously founded on the necessity for dealing with the bare economy of life that many, and even some Socialists, can see nothing save that economic basis; and moreover, many who might be disposed to admit the necessity of an economic change in the direction of Socialism believe quite sincerely that art is fostered by the inequalities of condition which it is the first business of Socialism to do away with, and indeed that it cannot exist without them. Nevertheless, in

the teeth of these opinions I assert first that Socialism is an all-embracing theory of life, and that as it has an ethic and a religion of its own, so also it has an aesthetic: so that to every one who wishes to study Socialism duly it is necessary to look on it from the aesthetic point of view. And, secondly, I assert that inequality of condition, whatever may have been the case in former ages of the world, has now become incompatible with the existence of a healthy art.

But before I go further I must explain that I use the word *art* in a wider sense than is commonly used amongst us today; for convenience sake, indeed, I will exclude all appeals to the intellect and emotions that are not addressed to the eyesight, though properly speaking, music and all litera-ture that deals with style should be considered as portions of art; but I can exclude from consideration as a possible vehicle of art no production of man which can be looked at. And here at once becomes obvious the sundering of the ways between the Socialist and the commercial view of art. To the Socialist a house, a knife, a cup, a steam engine, or what not, anything, I repeat, that is made by man and has form, must either be a work of art or destructive to art. The Commercialist, on the other hand, divides "manufactured articles" into those which are prepensely works of art, and are offered for sale in the market as such, and those which have no pretence and could have no pretence to artistic qualities. The one side asserts indifference, the other denies it. The Commercialist sees that in the great mass of civilized human labour there is no pretence to art, and thinks that this is natural, inevitable, and on the whole desirable. The Socialist, on the contrary, sees in this obvious lack of art a *disease* peculiar to modern civilization and hurtful to humanity; and furthermore believes it to be a disease which can be remedied.

This disease and injury to humanity, also, he thinks is no trifling matter, but a grievous deduction from the happiness of man; for he knows that the all-pervading art of which I have been speaking, and to the possibility of which the Commercialist is blind, is *the expression of pleasure in the labour of production;* and that, since all persons who are not mere burdens on the community must produce, in some form or another, it follows that under our present system most *honest* men must lead unhappy lives, since their work, which is the most important part of their lives, is devoid of pleasure.

Or, to put it very bluntly and shortly, under the present state of society happiness is only possible to artists and thieves.

2

ART IS MAN'S EXPRESSION OF HIS JOY IN LABOUR. If those are not Professor Ruskin's words they embody at least his teaching on this subject. Nor has any truth more important ever been stated; for if pleasure in labour be generally possible, what a strange folly it must be for men to consent to labour without pleasure; and what a hideous injustice it must be for society to compel most men to labour without pleasure! For since all men not dishonest must labour, it becomes a question either of forcing them to lead unhappy lives or allowing them to live unhappily. Now the chief accusation I have to bring against the modern state of society is that it is founded on the art-lacking or unhappy labour of the greater part of men; and all that external degradation of the face of the country of which I have spoken is hateful to me not only because it is a cause of unhappiness to some few of us who still love art, but also and chiefly because it is a token of the unhappy life forced on the great mass of the population by the system of competitive commerce.

The pleasure which ought to go with the making of every piece of handicraft has for its basis the keen interest which every healthy man takes in healthy life, and is compounded, it seems to me, chiefly of three elements; variety, hope of creation, and the self-respect which comes of a sense of usefulness; to which must be added that mysterious bodily pleasure which goes with the deft exercise of the bodily powers. I do not think I need spend many words in trying to prove that these things, if they really and fully accompanied labour, would do much to make it pleasant. As to the pleasures of variety, any of you who have ever made anything, I don't care what, will well remember the pleasure that went with the turning out of the first specimen. What would have become of that pleasure if you had been compelled to go on making it exactly the same for ever? As to the hope of creation, the hope of producing some worthy or even excellent work which without you, the craftsman, would not have existed at all, a thing which needs you and can have no substitute for you in the making of it—can we any of us fail to understand the pleasure of this? No less easy, surely, is it to see how much the self-respect born of the consciousness of usefulness must sweeten labour. To feel that you have to do a thing not to satisfy the whim of a fool or a set of fools, but because it is really good in itself, that is useful, would surely be a good help to getting through the day's work. As to the unreasoning, sensuous pleasure in handiwork, I believe in good sooth that it has more power of getting rough and strenuous work out of men, even as things go, than most people imagine. At any rate

it lies at the bottom of the production of all art, which cannot exist without it even in its feeblest and rudest form.

Now this compound pleasure in handiwork I claim as the birthright of all workmen. I say that if they lack any part of it they will be so far degraded, but that if they lack it altogether they are, so far as their work goes, I will not say slaves, the word would not be strong enough, but machines more or less conscious of their own unhappiness.

I have appealed already to history in aid of my hopes for a change in the system of the conditions of labour. I wish to bring forward now the witness of history that this claim of labour for pleasure rests on a foundation stronger than a mere fantastic dream; what is left of the art of all kinds produced in all periods and countries where hope of progress was alive before the development of the commercial system shows plainly enough to those who have eyes and understanding that pleasure did always in some degree accompany its production. This fact, however difficult it may be to demonstrate in a pedantic way, is abundantly admitted by those who have studied the arts widely; the very phrases so common in criticism that such and such a piece of would-be art is done mechanically, or done without feeling, express accurately enough the general sense of artists of a standard deduced from times of healthy art; for this mechanical and feelingless handiwork did not exist till days comparatively near our own, and it is the condition of labour under plutocratic rule which has allowed it any place at all.

The craftsman of the Middle Ages no doubt often suffered grievous material oppression, yet in spite of the rigid line of separation drawn by the hierarchical system under which he lived between him and his feudal superior, the difference between them was arbitrary rather than real; there was no such gulf in language, manners, and ideas as divides a cultivated middle-class person of to-day, a "gentleman," from even a respectable lower-class man; the mental qualities necessary to an artist, intelligence, fancy, imagination, had not then to go through the mill of the competitive market, nor had the rich (or successful competitors) made good their claim to be the sole possessors of mental refinement.

As to the conditions of handiwork in those days, the crafts were drawn together into gilds which indeed divided the occupations of men rigidly enough, and guarded the door to those occupations jealously; but as outside among the gilds there was little competition in the markets, wares being made in the first instance for domestic consumption, and only the overplus of what was wanted at home close to the place of production ever coming into the market or requiring any one to come and go

between the producer and consumer, so inside the gilds there was but little division of labour; a man or youth once accepted as an apprentice to a craft learned it from end to end, and became as a matter of course the master of it; and in the earlier days of the gilds, when the masters were scarcely even small capitalists, there was no grade in the craft save this temporary one. Later on, when the masters became capitalists in a sort, and the apprentices were, like the masters, privileged, the class of journeymen-craftsmen came into existence; but it does not seem that the difference between them and the aristocracy of the gild was anything more than an arbitrary one. In short, during all this period the unit of labour was an intelligent man. Under this system of handiwork no great pressure of speed was put on a man's work, but he was allowed to carry it through leisurely and thoughtfully; it used the whole of a man for the production of a piece of goods, and not small portions of many men; it developed the workman's whole intelligence according to his capacity, instead of concentrating his energy on one-sided dealing with a trifling piece of work; in short, it did not submit the hand and soul of the workman to the necessities of the competitive market, but allowed them freedom for due human development. It was this system, which had not learned the lesson that man was made for commerce, but supposed in its simplicity that commerce was made for man, which produced the art of the Middle Ages, wherein the harmonious co-operation of free intelligence was carried to the furthest point which has yet been attained, and which alone of all art can claim to be called Free. The effect of this freedom, and the widespread or rather universal sense of beauty to which it gave birth, became obvious enough in the outburst of the expression of splendid and copious genius which marks the Italian Renaissance. Nor can it be doubted that this glorious art was the fruit of the five centuries of free popular art which preceded it, and not of the rise of commercialism which was contemporaneous with it; for the glory of the Renaissance faded out with strange rapidity as commercial competition developed . . .

3

In the times when art was abundant and healthy, all men were more or less artists; that is to say, the instinct for beauty which is inborn in every complete man had such force that the whole body of craftsmen habitually and without conscious effort made beautiful things, and the audience for the authors of the intellectual art was nothing short of the whole people. And so they had each an assured hope of gaining that genuine praise and

sympathy which all men who exercise their imagination in expression most certainly and naturally crave, and the lack of which does certainly injure them in some way; makes them shy, over-sensitive, and narrow, or else cynical and mocking, and in that case well-nigh useless. But in these days, I have said and repeat, the whole people is careless and ignorant of art; the inborn instinct for beauty is checked and thwarted at every turn; and the result on the less intellectual or decorative art is that as a spontaneous and popular expression of the instinct for beauty it dost not exist at all. It is a matter of course that everything made by man's hand is now obviously ugly, unless it is made beautiful by conscious effort. . . .

But furthermore, the repression of the instinct for beauty which has destroyed the Decorative and injured the Intellectual arts has not stopped there in the injury it has done us. I can myself sympathize with a feeling which I suppose is still not rare, a craving to escape sometimes to mere Nature, not only from ugliness and squalor, not only from a condition of superabundance of art, but even from a condition of art severe and well ordered, even, say, from such surroundings as the lovely simplicity of Periclean Athens. I can deeply sympathize with a weary man finding his account in interest in mere life and communion with external nature, the face of the country, the wind and weather, and the course of the day, and the lives of animals, wild and domestic; and man's daily dealings with all this for his daily bread, and rest, and innocent beast-like pleasure. But the interest in the mere animal life of man has become impossible to be indulged in in its fulness by most civilized people. Yet civilization, it seems to me, owes us some compensation for the loss of this romance, which now only hangs like a dream about the country life of busy lands. To keep the air pure and the rivers clean, to take some pains to keep the meadows and tillage as pleasant as reasonable use will allow them to be; to allow peaceable citizens freedom to wander where they will, so they do no hurt to garden or cornfield; nay, even to leave here and there some piece of waste or mountain sacredly free from fence or tillage as a memory of man's ruder struggles with nature in his earlier days: is it too much to ask civilization to be so far thoughtful of man's pleasure and rest, and to help so far as this her children to whom she has most often set such heavy tasks of grinding labour? Surely not an unreasonable asking. But not a whit of it shall we get under the present system of society. That loss of popular art is also busy in depriving us of the only compensation possible for that loss, by surely and not slowly destroying the beauty of the very face of the earth.

4

What is it that I need, therefore, which my surrounding circumstances can give me—my dealings with my fellow-men—setting aside inevitable accidents which co-operation and forethought cannot control, if there be such?

Well, first of all I claim good health; and I say that a vast proportion of people in civilization scarcely even know what that means. To feel mere life a pleasure; to enjoy the moving one's limbs and exercising one's bodily powers; to play, as it were, with sun and wind and rain; to rejoice in satisfying the due bodily appetites of a human animal without fear of degradation or sense of wrong-doing: yes, and therewithal to be well-formed, straight-limbed, strongly knit, expressive of countenance—to be, in a word, beautiful—that also I claim. If we cannot have this claim satisfied, we are but poor creatures after all; and I claim it in the teeth of those terrible doctrines of asceticism, which, born of the despair of the oppressed and degraded, have been for so many ages used as instruments for the continuance of that oppression and degradation.

5

To sum up, then, the study of history and the love and practice of art forced me into a hatred of the civilization which, if things were to stop as they are, would turn history into inconsequent nonsense, and make art a collection of the curiosities of the past which would have no serious relation to the life of the present.

But the consciousness of revolution stirring amidst our hateful modern society prevented me, luckier than many others of artistic perceptions, from crystallizing into a mere railer against "progress" on the one hand, and on the other from wasting time and energy in any of the numerous schemes by which the quasi-artistic of the middle classes hope to make art grow when it has no longer any root, and thus I became a practical Socialist.

A last word or two. Perhaps some of our friends will say, what have we to do with these matters of history and art? We want by means of Social-Democracy to win a decent livelihood, we want in some sort to live, and that at once. Surely any one who professes to think that the question of art and cultivation must go before that of the knife and fork (and there are some who do propose that) does not understand what art means, or how that its roots must have a soil of a thriving and unanxious life. Yet it must be remembered that civilization has reduced the workman to such a skinny and pitiful existence, that he scarcely knows how to frame a desire for any life much better than that which he now endures perforce. It is the province

of art to set the true ideal of a full and reasonable life before him, a life to which the perception and creation of beauty, the enjoyment of real pleasure that is, shall be felt to be as necessary to man as his daily bread, and that no man, and no set of men, can be deprived of this except by mere opposition, which should be resisted to the utmost.

ANTONIO LABRIOLA

*By dialectics we mean that
rhythmic movement of understanding
which tries to reproduce
the general outline
of reality in the making.*

—Labriola

INTRODUCTION

The influence of Marxism upon the major disciplines of knowledge began to make itself felt soon after the death of Engels. In the main, its impact was felt in the areas of sociological inquiry, of history, anthropology, political economy, and, of course, in "socialist thought" itself, which was in process of precipitation into a distinct branch of knowledge, in which Marxism became the dominant tendency and the Marxist writings themselves the subject of schismatic development. Among the major figures around the turn of the century whose work was shaped by the encounter with Marxism were Kovalevsky, Tönnies, Lavrov, Ferri, Sorel, Croce, Durkheim, Weber, Simmel, Gentile, Masaryk, Hobson, Berdyaev, Mikhailovsky, Sée, Hilferding, Mead, Veblen, and many others.[1] With some, the encounter triggered an exciting intellectual conflict, resulting in a fruitful expansion of ideas

1. For a summary discussion of this influence, see the introduction to Bottomore and Rubel, *Karl Marx—Selected Writings in Sociology and Social Philosophy* (London, 1963), pp. 29–48; Lichtheim, *Marxism* (New York, 1961), *passim.*

within the various disciplines. Others—such as Croce, Simmel, Berdyaev, Sorel, G. B. Shaw—went through a "Marxist period" and then passed into one or another form of opposition. Simultaneously, the first wave of "revisionism" swept through the Marxist parties, centering on questions of revolutionary goals and tactics but profoundly affecting all aspects of Marxist historical and economic theory as well. From within and without the socialist parties, Marxist doctrine was subjected to critical scrutiny and vigorous debate. An extraordinary mélange of serious and pseudo-scientific works on Marxism appeared in all countries, in which it was often difficult to find any resemblance between the writings of Marx and Engels and the views which were attributed to them by friend and foe alike.

In this atmosphere, the writings of the Italian philosopher Antonio Labriola were important in establishing and popularizing the authentic premises on which Marxism rests. Labriola's *Essays on the Materialistic Conception of History* (1895–96) and *Socialism and Philosophy* (*Letters to Sorel*) (1898) were the first post-Engels expositions of historical materialism. As such, their influence was enormous: *Essays on the Materialistic Conception of History* was translated into French with an introduction by Georges Sorel (who remained a Marxist from 1892 until 1897); editions in all the major European languages followed. Plekhanov, who wrote that Labriola had "given a fuller and better analysis" of Marxism than "any other materialist writer," introduced him to Russian audiences in September 1897 with an extended (and partly critical) essay, "The Materialist Conception of History"—which in turn exercised a powerful intellectual influence on subsequent generations of Marxists. Lenin read Labriola's *Essays* almost immediately upon publication of the French translation, and was so impressed that he urged both his wife and his sister to prepare a Russian translation. (The book appeared in St. Petersburg in 1898, translated by Berezin and Semyonov.) In 1899, Lenin thanked his mother for sending him another book by Labriola—presumably *Socialism and Philosophy*. Trotsky, too, read Labriola's *Essays* in the 1890's, and was fond of quoting from it in later years. Reprinted here are several selections from the *Essays,* indicative of the flexibility and ease with which Labriola handled the relationship between being and consciousness, the extent to which he was conscious of the need for formulation of a Marxist psychology, the depth of his refutation of economic determinism.

━━━

Labriola, who was born in Cassino in 1843, began his academic career as a follower of Hegel, Spinoza, and Herbart. His first work (1862) was a

defense of Hegel's dialectics against the neo-Kantianism of Zeller; his principal pre-Marxist works were on traditional subjects such as *The Doctrine of Socrates* (1871), *Morality and Religion* (1873), and *On Moral Liberty* (1873). From 1874 until his death in 1904 he was professor of philosophy at the University of Rome. He dates the beginnings of his turn toward socialism from 1879 and his explicit acceptance of socialism from around 1887. His first socialist writing was "On Socialism" (1889; he called it a "confession of faith"), followed in 1890 by a pamphlet, *Proletarians and Radicals*. Preferring oral discourse and instruction to writing, he had misgivings about Engels' urging that he write on Communism. Or perhaps, having been a propounder of systematic philosophy in his youth he was loathe to systematize Marxism, to which he was in part attracted precisely because he regarded it as "one of the ways in which the scientific mind has freed itself from philosophy as such." In 1873 he had written in the preface to *On Moral Liberty*: "I vow never to shut myself up in any system as though in a prison." In 1897, a confirmed Marxist, he wrote: "And I can repeat that now."

An independent and original mind, he observed that Marx was being elevated into "a mythical personage" and he resisted the attempts to convert Marxism into scholasticism. He was aware that the theory itself had made "little headway since its first general formulation" and that "Marx himself carried his theory to its full conclusion only in one case, in *Capital*." He viewed German Marxism (in its Kautskyist form) as overly possessive of Marx and Engels, and he goaded the Germans about their evident reluctance to make available the philosophical works of Marx and Engels. Labriola aimed at establishing Marxism as an international philosophy at a time when it was in some danger of being converted into a parochial German socialism. In this his objectives were clearly harmonious with those of the emerging Russian Marxists, as well as of the Latin socialists who were Labriola's primary audience. The Bolsheviks and early Soviet Marxists tended to cite "old Labriola" as an elder statesman; but after the 1920's his works passed into a gentle oblivion. Antonio Gramsci is usually cited as a disciple, but though he often refers to Labriola, his work is more correctly placed in the Luxemburg tradition. Labriola himself could not have founded a school because his works are so firmly rooted in the fundamental and primary concepts of Marxist thought, his main task being the reinforcement and consolidation of those concepts. He was a beloved and influential teacher who launched numerous students (Croce included) on careers which did not always coincide with his own. He would not have wished otherwise, for he himself joined Marx in warning that "tradition must not weigh upon us like a nightmare."

LABRIOLA: HISTORICAL MATERIALISM
from *Essays on the Materialistic Conception of History*

Ethics, art, religion, science, are they then but products of economic conditions?—expositions of the categories of these very conditions?—effluvia, ornaments, emanations and mirages of material interests?

Affirmations of this sort, announced with this nudity and crudity, have already for some time passed from mouth to mouth, and they are a convenient assistance to the adversaries of materialism, who use them as a bugbear. The slothful, whose number is great even among the intellectuals, willingly fit themselves to this clumsy acceptance of such declarations. What a delight for all careless persons to possess, once for all, summed up in a few propositions, the whole of knowledge, and to be able with one single key to penetrate all the secrets of life! All the problems of ethics, aesthetics, philology, critical history and philosophy reduced to one single problem and freed thus from all difficulties!

In this way the simpletons might reduce the whole of history to commercial arithmetic; and finally a new and authentic interpretation of Dante might give us the Divine Comedy illustrated with the process of manufacturing pieces of cloth which the wily Florentine merchants sold for their greater profit! . . .

———

I said some pages back, in my statement of formulas, that the economic structure determines in the second place the direction, and in great part and indirectly, the objects of imagination and of thought in the production of art, of religion and of science. To express this otherwise, or to go further, would be to put one's self voluntarily on the road toward the absurd.

Before all else, in this formula, we are opposing the fantastic opinion, that art, religion and science are subjective developments and historical developments of a pretended artistic, religious or scientific spirit, which would go on manifesting itself successively through its own rhythm of evolution, favored or retarded on this side or that by material conditions. By this formula, it is desired to assert, moreover, the necessary connection, through which every fact of art and of religion is the exponent, sentimental, fantastic and thus derived, of definite social conditions. If I say *in the second place,* it is to distinguish these products from the facts of legal-political order which are a true and proper projection of economic condi-

tions. And if I say *in great part and indirectly the objects* of these activities, it is to indicate two things: that in artistic or religious production the mediation from the conditions to the products is very complicated, and again that men, while living in society, do not thereby cease to live alone by themselves in nature, and to receive from it occasion and material for curiosity and for imagination.

After all, this is all reduced to a more general formula; man does not make several histories at the same time, but all these alleged different histories (art, religion, etc.) make up one alone. And it is not possible to take account of that clearly except at the characteristic and significant moment of the production of new things, that is to say in the periods which I will call revolutionary. Later, the acceptance of the things that have been produced, and the traditional repetition of a definite type, obliterated the sense of the origins of things.

Try, if you will, to detach the ideology of the *fables,* which are at the foundation of the Homeric poems, from that moment of historic evolution where we find the dawn of Aryan civilization in the basin of the Mediterranean, that is to say, from that phase of the higher barbarism in which arises, in Greece and elsewhere, the epic. Or try to imagine the birth and the development of Christianity elsewhere than in Roman cosmopolitanism, and otherwise than by the work of those proletarians, those slaves, those unfortunates, those desperate ones, who had need of the redemption of the Apocalypse and of the promise of the Kingdom of God. Find, if you will, the ground for supposing that in the beautiful environment of the Renaissance romanticism should begin to appear, which scarcely appeared in the decadent Torquato Tasso; or that one might attribute to Richardson or to Diderot the novels of Balzac, in whom appears, as a contemporary of the first generation of socialism and sociology, the *psychology of classes.* Far back, farther, farther, at the first origins of the mythical conceptions, it is evident that Zeus did not assume the character of father of gods and men until the power of the *patria potestas* was already established, and that series of *processus* began which culminated in the State. Zeus thus ceases to be what was at first the simple *divus* (brilliant) or the Thunderer. And it is to be observed that at an opposite point of historic evolution, a great number of thinkers of the past century reduced to a single abstract God, who is a simple regent of the world, all that variegated image of the unknown and transcendental type, developed in so great a wealth of mythological, Christian or pagan creations. Man felt himself more at home in nature, thanks to experience, but felt himself better able to penetrate the gearing of society, the knowledge of which he

possessed in part. The miraculous dissolved in his mind, to the point where materialism and criticism could afterwards eliminate that poor remnant of transcendentalism, without taking up war against the gods.

There is certainly a history of ideas; but this does not consist in the vicious circle of ideas that explain themselves. It lies in rising from things to the idea. There is a problem; still more, there is a multitude of problems, so varied, multiple, multiform and mingled are the projections which men have made of themselves and of their economic-social conditions, and thus of their hopes and their fears, of their desires and their deceptions, in their artistic and religious concepts. The method is found, but the particular execution is not easy. We must above all guard against the scholastic temptation of arriving by deduction at the products of historic activity which are displayed in art and in religion. . . .

LABRIOLA: **FORMS OF CONSCIOUSNESS**
from *Essays on the Materialistic Conception of History*

From the fact that history must be taken in its entirety and that in it the kernel and the husk are but one, as Goethe said of all things, three consequences follow:—

First, it is evident that in the domain of historico-social determinism, the linking of causes to effects, of conditions to the things conditioned, of antecedents to consequents, is never evident at first sight in the subjective determinism of individual psychology. In this last domain it was a relatively easy thing for abstract and formal philosophy to discover, passing above all the baubles of fatalism and free will, the evidence of the motive in every volition, because, in fine, there is no wish without its determining motive. But beneath the motives and the wish there is the genesis of both, and to reconstruct this genesis we must leave the closed field of consciousness to arrive at the analysis of the simple necessities, which, on the one side, are derived from social conditions, and on the other side are lost in the obscure background of organic dispositions, in ancestry and in atavism. It is not otherwise with historical determinism, where, in the same way, we begin with motives religious, political, aesthetic, passionate, etc., but where we must subsequently discover the causes of these motives in the material conditions underlying them. Now the study of these conditions should be so specified that we may perceive indubitably not only what are the causes, but again by what mediations they arrive at that form which reveals them to the consciousness as motives whose origin is often obliterated.

And thence follows indubitably this second consequence that in our

doctrine we have not to re-translate into economic categories all the complex manifestations of history, but only to explain in the *last analysis* (Engels) all the historic facts *by means of the underlying economic structure* (Marx), which necessitates analysis and reduction and then interlinking and construction.

It results from this, in the third place, that, passing from the underlying economic structure to the picturesque whole of a given history, we need the aid of that complexus of notions and knowledge which may be called, for lack of a better term, social psychology. I do not mean by that to allude to the fantastic existence of a social psyche nor to the concept of an assumed collective spirit which by its own laws, independent of the consciousness of individuals and of their material and definable relations, realizes itself and shows itself in social life. That is pure mysticism. Neither do I wish to allude to those attempts at generalization which fill up treatises on social psychology and the general idea of which is to transport and apply to a subject which is called social consciousness the known categories and forms of individual psychology. Nor again do I wish to allude to that mass of semi-organic and semi-psychological denominations by the aid of which some attribute to the social being, as Schäffle does, a brain, a spinal column, sensibility, sentiment, conscience, will, etc. But I wish to speak of more modest and more prosaic things, that is to say, of those concrete and precise states of mind which make us know as they really were the plebeians of Rome at a certain epoch, the artisans of Florence at the moment when the movement of the Ciompi burst forth, or those peasants of France within whom was engendered, to follow Taine's expression, the "spontaneous anarchy" of 1789, those peasants who finally became free laborers and small proprietors, or, aspiring to property, transformed themselves rapidly from victors over the foreigner into automatic instruments of reaction. This social psychology, which no one can reduce to abstract canons because, in most cases, it is merely descriptive, this is what the chroniclers, the orators, the artists, the romancers and the ideologists of every sort have seen and up to now have conceived as the exclusive object of their studies. In this psychology, which is the specific consciousness of men in given social conditions, the agitators, orators and propagandists trust today, and to it they appeal. We know that it is the fruit, the outcome the effect of certain social conditions actually determined;—this class, in this situation, determined by the functions which it fulfills, by the subjection in which it is held, by the dominion which it exercises;—and finally, these classes, these functions, this subjection and this dominion involve such and such a determined form of production and distribution of the immediate means of life, that is to say, a determined economic structure.

This social psychology, by its nature always circumstantial, is not the expression of the abstract and generic process of the self-styled human intellect. It is always a specified formation from specified conditions. We hold this principle to be indisputable, that it is not the forms of consciousness which determine the human being, but it is the manner of being which determines the consciousness (Marx).

But these forms of consciousness, even as they are determined by the conditions of life, constitute in themselves also a part of history. This does not consist only in the economic anatomy, but in all that combination which clothes and covers that anatomy even up to the multicolored reflections of the imagination. In other words, there is no fact in history which does not recall by its origin the conditions of the underlying economic structure, but there is no fact in history which is not preceded, accompanied and followed by determined forms of consciousness, whether it be superstitious or experimental, ingenuous or reflective, impulsive or self-controlled, fantastic or reasoning.

FRANZ MEHRING

*The truth is that
only those scorn the Muses
who have been scorned by them.*
—Mehring, *Karl Marx*

INTRODUCTION

Franz Mehring (1846–1919) came to Marxism in his mid-forties. He was born in Pomerania, where his father—descended from the nobility—was a Prussian officer who later became a high revenue official. Many of Mehring's forebears were Protestant preachers, and he himself was destined for a similar career: "As a child I was supposed to and wished to study theology." After breaking both with his family and with theology, it was as a student of philosophy that he matriculated at the University of Leipzig in 1866; he transferred to the University of Berlin in 1870, where he remained for several years. In 1881 he returned to the University of Leipzig for a year's study and received his doctorate. His dissertation was *German Social Democracy—Its History and Its Teachings,* but he was not yet a Marxist. During the 1870's he had become a follower of Ferdinand Lassalle, and it was as a Lassallean socialist that he contributed to many liberal and democratic newspapers during the 1870's and 1880's. In 1891, shortly after his dismissal as editor of the democratic *Berliner Volkszeitung*

for his opposition to Bismarck's Anti-Socialist Laws, he joined the Social Democratic Party. He soon was established as one of the intellectual leaders of German Social Democracy, and by the time of his death (hastened by imprisonment for his antiwar position) in 1919, he had become the outstanding Marxist historian and literary critic of the age as well as a major political figure who defended Marxism against the revisionist theories of Eduard Bernstein and the nationalist leanings of numerous Social Democrats during the First World War. In late 1918, he joined Rosa Luxemburg, Clara Zetkin, Karl Liebknecht, and others in founding the Communist Party of Germany. A prolific contributor to *Die Neue Zeit* and other radical journals, he wrote hundreds of articles, essays, and reviews on politics, history, military affairs, philosophy, and literature. He corresponded with Engels (who admired his work keenly), and there is a strong probability that he consciously took it upon himself to carry out a good many of the projects which Engels had left incomplete at his death. It was Mehring who collected the early writings (1841–1850) of the founding Marxists and the Marx-Lassalle correspondence (four volumes, 1902), who wrote the definitive history of German Socialism (two volumes, 1897–98), and the first major (still the standard) biography of Marx— *Karl Marx: The Story of his Life* (1918).

Mehring's belated conversion to Marxism was accompanied by a sudden and sustained interest in aesthetics and literary criticism—subjects which he had not previously dealt with. *The Lessing-Legend* (serialized in 1892, published 1893), is usually regarded as the first example of sustained Marxist literary criticism. Mehring wrote on virtually every major figure in German classical literature. There are essays on Winckelmann, Klopstock, Lessing, Herder, Goethe, Kleist, Büchner, Freiligrath, Weerth, Hebbel, Grillparzer, Hofmannsthal, a life of Schiller, a brief biography of Heine; of the non-German authors, he dealt with Cervantes, Rabelais, Molière, Zola, Sue, Byron, Ibsen, Tolstoy, Gorki, and numerous others. Generally, the intention of most of these essays was to bring the classics of literature within the understanding of the working class. (On his seventieth birthday, Rosa Luxemburg wrote to him: "Thanks to your books and articles the German proletariat has been brought into close touch not only with classic German philosophy, but also with classic German literature.")

Simultaneously, he was concerned with aesthetic questions as such, and here he rigorously brought his philosophical training to bear. His aim was to unite the Marxist concern for the ideological content of a work of art with the aesthetic principles of the German classical philosophers—and especially Kant and his disciple Schiller. The first selection, from one of his *Aesthetischen Streifzugen* (*Aesthetic Rambles*) of 1898–99, deals with a

crucial question for Mehring: "whether a scientific history of aesthetic taste could be written as it has developed and changed in human society." Believing that historical materialism "held the key to the solution of this riddle," Mehring discusses the relativity of taste, and concludes that art is "a peculiar and aboriginal capacity of mankind," in the Kantian sense. The discussion which Mehring opened lay largely dormant until the 1950's, when such men as Lukács and Marcuse—from quite different points of view—once again turned their attention to the aesthetic dimension of Kant and Schiller. Mehring was the first to suggest that Marxism was the proper heir to German classical aesthetics as well as to German classical philosophy in general. (That he neglected Hegel's *Aesthetics* was perhaps inevitable; his intellectual environment was hostile to idealist dialectics.) He was also the first to draw attention to the power of metaphor in the writings of Karl Marx, to the *aesthetic* means by which Marxism achieved its enormous persuasive effect.

In criticism, Mehring was and remained a superb sociologist. The second selection, from *The Lessing Legend,* shows that he possessed a great gift for the analysis of the ideological component of literature, for relating the ideas in a work of art to the historical-political framework, for revealing the contradictions in society which produce specific forms of literature at given periods of history. He was aware of the possibilities of a synthesis between historical determination of ideology and the aesthetic effect of the work of art, but he himself made no major attempt at such an integration, perhaps because he lacked the mediating category—psychology—to make the connection, perhaps because such a synthesis would have been irrelevant to the audience which he addressed.

———

The history of Mehring's posthumous reputation exemplifies the pattern of discontinuity which has marked the history of Marxist aesthetics. Publication of his collected works commenced in 1929, and by 1931 six volumes had appeared, when the project was halted. Until 1931, he was revered as an elder statesman, a founder of the Communist Party of Germany, friend of Rosa Luxemburg, pioneer literary critic and historian, and biographer of Marx. In 1931 Stalin published an article entitled "Some Questions Regarding the History of Bolshevism," in which he asserted that the prewar German left-wing Social Democrats had committed a whole series of "political and theoretical errors" and in which he attacked Rosa Luxemburg and her associates as ideological precursors of Trotskyism. In 1932, Ernst Thälmann, leader of the German Communist Party, ordered a sharp

battle against the ideological remnants of "Luxemburgism." A storm
ensued against the old left. The attack against Mehring's literary views was
made by Karl August Wittfogel, Paul Reimann, F. P. Schiller, Kurt Sauer-
land, and, especially, Georg Lukács, who appeared somewhat overzealous
in his annihilation of the man who had been preeminent in Lukács' own
field of specialization—that of classical German literature. He accused
Mehring of an uncritical acceptance of Kant's and Schiller's aesthetics.
Ignoring Engels' rejection of tendentiousness in the arts (see pages 66–
68), Lukács wrote: "It follows from the bourgeois conception of art
(which Mehring was unable to abandon completely) that the 'ideal' of art
is the absence of propaganda." Accordingly, Mehring was guilty of creating
"the germ of the *literary theory of Trotskyism*" (italics in original). That
this was perhaps an "unconscious" process on Mehring's part did not
lessen the offense. Lukács was to become a specialist in discovering pre-
figurations of reactionary ideologies in the works of thinkers of prior ages
(see, for example, his "Nietzsche—Forerunner of German Fascism"). The
Mehring heritage, for Lukács, is also "the heritage of Lassalle, it is eclec-
ticism, it is reactionary ideology." And in still another article of 1933,
which Lukács republished in 1954, he accused Mehring of "complete
abandonment of the theory of reflection of reality." It was only after the
mid-1950's that the German intellectual left began to make an attempt to
restore its past, of which it had been deprived for a quarter-century, per-
haps in an attempt to strip it of its acknowledged leadership of the Marxist
movement from 1848 to 1919. Unfortunately, the restoration of Mehring's
status is being fought out within the guidelines laid down by Lukács, with
Mehring's defenders pointing to his specific literary criticism as examples
of proper application of historical materialism, eschewing his attempts at
integration of classical German aesthetics into Marxism, and indeed finding
implicit in his practical applications a "Leninist" view of literature and
even "a fundamental demand for socialist realism."[1]

MEHRING: **A NOTE ON TASTE**
from *Aesthetic Rambles*

As Marx once said of Hegel's philosophy, one cannot dispose of the aes-
thetics of Kant and Schiller by turning away and with averted head mutter-
ing a few vexed and trite remarks.

1. Josef Schleifstein, *Franz Mehring, sein marxistisches Schaffen* (Berlin, 1959),
p. 134.

In so far as Steiger[1] attempts to prove that aesthetics is a science concerned not with rational concepts but with intuitions, feelings and moods, he only repeats what Kant said much more clearly and impressively a hundred years ago. The difficulty begins in the first place with the question: How are aesthetic judgments nevertheless possible? How can aesthetic taste be objectively determined, if this taste is merely subjective and personal, if every man has his own taste? This question is the fundamental problem of all aesthetics, and until it is answered a scientific treatise on aesthetics is impossible. If Kant's answer is false, then to give the correct answer would be to progress beyond him; but to assume that this decisive question had never before been posed would be to retrogress from him.

Steiger admits that aesthetic feeling develops historically and undergoes constant change. Still he raises the objection that the thousand and one historical questions needed to explain a work of art would be considered by any aesthetician as merely preliminary studies in the history of culture which could not begin to explain the purely aesthetic reaction to a work of art. For this reaction is in each particular case entirely an event of subjective experience.

In itself this is indeed quite correct, and since Kant it has been accepted, even as a matter of course. However, when Steiger tears the aesthetic reaction as a fact of subjective experience from its historical context, he falls into the same error which he criticizes so severely in Büchner and Moleschott, namely that of confusing the natural and the social sciences.

The question of how man is able to perceive falls within the scope of the natural sciences, specifically the physiology of the sense organs; the question of what men perceive and have perceived falls within the scope of the social sciences, specifically, aesthetics. If an Australian Bushman and a civilized European were at the same time to hear a Beethoven symphony, or to see a Raphael Madonna, the psychophysical process of perceiving would be the same in both cases, however this might be set forth in natural science, since as natural beings they are alike. What they would perceive, however, would be quite different, since as members of society, as creatures of historical circumstances, they are quite unlike. But it is by no means necessary to choose such crude contrasts, for not even on the same level of culture are there as many as two individuals whose aesthetic feelings coincide with the regularity of two clocks. As a social being, each individual is a product of factors of environment which cross one another and blend interminably, and which determine his perceptions in incal-

1. This essay is part of a review of Edgar Steiger, *Das Werden des neuen Dramas* (Berlin, 1898).

culably diverse ways. Precisely for this reason each individual has his own personal taste.

Of course, even this subjective taste can have significance, but never more than historical significance, nor relating to other than the perceiving subject. From the differences in the aesthetic tastes of Marx and of Lassalle we can draw certain conclusions regarding the differences in their historical and intellectual processes—as not long ago in another place I attempted to do; but we cannot therefrom draw any conclusions concerning the relative aesthetic value of the poets who appealed to these men. Baron von Stein, certainly one of the most important of Goethe's contemporaries, upon reading *Faust* experienced only a feeling of intense displeasure at the "improprieties" of the Walpurgisnacht scene, thereby revealing a great deal about his own aesthetic education, but nothing about the literary importance of *Faust*. Schopenhauer on one occasion declares that he is not particularly fond of the *Divine Comedy,* but he wisely introduces this subjective judgment on a subjective basis: "I frankly admit that the high reputation of the *Divine Comedy* appears to me to be an exaggeration"; and if we read further to see what Schopenhauer's criticism is, his reflections reveal a great deal about Schopenhauer, but nothing about Dante. Of course, the historical significance of subjective tastes depends entirely upon the historical importance of those who possess them; the extent of our interest in the historical personages Marx, Lassalle, Stein and Schopenhauer determines the extent of our interest in their aesthetic taste. On the other hand the historical significance of subjective taste is nil in the case of personages of corresponding historical importance.

When Professor Erich Schmidt, some years ago, in the course of a public dispute concerning the aesthetic value of Hamerling's *Poems,* pompously announced: "Well, I just don't like them!" this judgment was worthless both objectively and subjectively—at least from the standpoint of aesthetics, though from an ethical standpoint I suppose it might serve as an index of professorial vanity.

Thus the attempt to convert the aesthetic impression as a fact of subjective experience into an objective basis for the determination of taste still fails to transcend the limits of subjective taste. However, the collapse of this attempt also invalidates Kant's assumption that the objective determination of taste is rooted in our "supersensible substrate," in the "indeterminate concept of the supersensible in us."

A supersensible concept can have no historical development, and yet every historical judgment is conditioned historically. Schopenhauer, who relied on Kant's aesthetics, and who was an acute logician when his whims did not block his way, doubtless encountered this contradiction. He says on

one occasion: "A genuine work of art, in order to be enjoyed, really does not require a preamble in the form of a history of art." That is to say, it really does not if Kant is correct in his assumption regarding the objective determination of taste. But this is not the case, for, according to Schopenhauer, "the spirit of the times in each case is like a sharp east wind, which blows through everything. Consequently its mark is found on all action, thought, writing, music and painting, in the flowering of this or that art: it puts its stamp on every activity." To be sure, Schopenhauer does not advance beyond this point, for here his train of thought is interrupted by his familiar crotchet—namely that there is no historical development, that all history is constant repetition, like a kaleidoscope where with each turn the same things reappear in different configurations, etc. In admitting the historical development of aesthetic feeling and yet attempting to make the appreciation of a work of art independent of this development, Steiger falls into a kind of inverted contradiction.

All of these and similar contradictions are dissolved in the simple consequence that either there can be no objective basis whatsoever for determining taste, or there can be such a basis only from an historical point of view. The problem of a scientific aesthetics is whether a scientific history of aesthetic feeling, as it has developed and changed in human society, can be written, whether, in the incalculable and endless confusion of subjective taste, there does not prevail an objective basis for determining such a feeling. Adherents of historical materialism will answer in the affirmative, and will regard precisely the historical materialist method as the only key to the solution of the riddle.

We have seen that Kant's aesthetics, although it sought its roots in the clouds, had a foundation in reality. Kant abstracted his aesthetic propositions from our classical literature—that is, from as much of it as already existed when his *Critique of Pure Reason* was written. Although it has been shown that the objective conditions of taste are not rooted in the sky, but on earth, Kant's aesthetics is not therefore necessarily untenable in and for itself: its critical method is not to be set aside because its absolute system breaks down. There still remains what a mind of Kant's penetrating acuteness perceived in the great literary works of an epoch in its way aesthetically unique.

In the preface to his chief work, Marx says that just as the physicist observes natural phenomena at the point where they occur in their most meaningful form and least obscured by disturbing influences, so he examined the capitalist mode of production in England as the classic ground of this mode of production. Similarly we can say that the laws of aesthetic judgment could nowhere be better studied than in the realm of aesthetic

appearances created by our classic authors "in their most meaningful form and least obscured by disturbing influences." Kant was the founder of scientific aesthetics, even though he failed to recognize the historical conditioning of his aesthetic laws, even though he considered as absolute that which can only be taken as relative. Similarly his contemporaries Adam Smith and Ricardo were the founders of scientific economics, even though they regarded the economic laws of bourgeois society as absolute, whereas they are only historically valid, and in application are constantly violated.

The first prerequisite of a scientific aesthetics is to establish that art is a peculiar and aboriginal capacity of mankind, as indeed Kant did show. However, since reason must be a unity, the power of aesthetic judgment can be separated from it only in the abstract, for the purpose of setting out its laws with full clarity, but not in actual practice, when the feeling of pleasure or displeasure cannot be separated from the capacity for desire and knowledge. For the manner in which we experience phenomena aesthetically is invariably and indissolubly linked with the manner in which we comprehend logically and desire morally. Therefore when Kant says that aesthetic satisfaction is neither logical nor moral, that any judgment of beauty into which the slightest interest enters is quite biased and by no means a pure aesthetic judgment, he sets forth an abstract-absolute proposition in its clearest form. However, if this proposition were to be used as a fixed criterion applied to historical epochs in the evolution of artistic taste, we should discover that there has never yet been a pure aesthetic judgment; in other words, that Kant's law in application under historical conditions has been constantly violated.

MEHRING: **LESSING AND THE DRAMA**
from *The Lessing Legend*

It is impossible to understand Lessing's *Dramaturgie* unless its social aspects are considered. It is no theory of the drama valid for all time. Applied by the hands of aesthetic dullards, this fine and elastic weapon has done much harm. How often has poor Lessing himself been attacked with it, sometimes out of intentional malice, sometimes—which was still more dangerous—out of well-meaning stupidity. He to whom nothing was more foreign than senseless chauvinism is supposed to have hoisted the banner of German against that of French art, to have critically destroyed the French drama in order to lead German drama "towards a better glory," "in the steps of the Greeks and the British."

Schiller's meaning in the following epigram is quite sensible, although he expressed these ideas much more strongly than Lessing ever did:

> The French must never become a model for us,
> No live spirit speaks from their art.

To be sure, Lessing's *Dramaturgie* was the greatest national manifestation Germany had seen since Hutten's broadsides. But the national point of view is always determined by the social interests of the classes representing it, in Hutten's case the German aristocracy, in Lessing's the German middle class. It never occurred to Lessing to attack Molière and Destouches in the same strain as he attacked Corneille and Racine, or to throw Voltaire the writer of middle-class comedies overboard with Voltaire the author of court tragedies. Like all ideology, aesthetic and literary criticism is in the last analysis determined by the economic structure of society. Under fundamentally changed economic conditions, we have now arrived at aesthetic and literary views different from Lessing's. His *Dramaturgie* is neither an infallible revelation nor a faulty stylistic exercise: it must be judged from the social aspect to which it belongs historically. Regarded from this point of view, it is most delightful to read this work, and everywhere one feels the manly and courageous spirit of Lessing, to whom dramatic art was not an idle game but, like all art, a lever of human culture.

The wretched conditions in Germany forced any "National Theatre" to live mainly on foreign plays. With a few mediocre or bad German plays no attractive program could possibly be created; with Lessing's *Sara* and *Minna* at least not a varied one. Among foreign plays the French stood in the front rank, through Gottsched's endeavors and through the great number of translations as well. In this state of affairs only Lessing's *Dramaturgie* caused a certain change. In the main, it still had to settle account with French dramatic art. Thus Lessing wrote his famous condemnation of the French court tragedy, which would have been like poison to the middle class if transplanted to Germany. Lessing overlooked that Corneille and Racine must somehow have been rooted in the national soil in order to become the classical authors of a great nation; he overlooked that their tragedies were rich in theatrical effects and full of powerful tension for their contemporaries. He made fun of the "monsters" of women that Corneille liked to show, and yet Corneille's contemporaries had seen these "monsters" in reality—the princesses of the Fronde. In an even more biased manner than against Corneille, Lessing proceeded against Voltaire

as a writer of tragedies—often not without some malice, due to his experiences in Berlin. Lessing's prejudice seems the greater for the very reason that in his tragedies Voltaire had begun a certain reaction against Corneille and Racine. Nevertheless essentially Lessing was right in fighting against French tragedy. Whatever roots it might have had in a certain historical soil, for all that as a model it was disastrous to middle-class art in Germany. And Lessing speaks as an advocate of this art, not as a critic, enthroned above the clouds, above all times and all nations—one such has ever existed anyway.

It might seem, though, as if in the *Dramaturgie* itself Lessing had presented Aristotle as such an eternally infallible judge. But here again one must know how to make distinctions. Corneille founded the court tragedy on Aristotle's rules; it was the last echo of the appalling treatment that had made the ancient Greek the canonical philosopher of the middle ages. Lessing swept away all this; he opposed to the wrongly understood Aristotle the correctly understood Aristotle. Indeed, he contrasted the Greek tragedy with the French, and never tired of repeating that rules do not create the genius, but genius makes the rules, and that any rule can at any time be brushed aside by a genius. In the triumphant progress of his victorious polemics, he remarks insolently that the aesthetics of Aristotle are as infallible as mathematical truths, and that he could improve any play of the great Corneille according to Aristotle's rules. But he adds at once that for all that he would be no Corneille, and would not have created a masterpiece.

Already in the *Letters on Literature* Lessing had pointed out that according to Greek standards Shakespeare was a much greater tragic writer than Corneille, that he always achieved the aim of the tragedy, while Corneille never did so, even though he followed the path marked out by the ancient Greeks.

Thus Lessing understood that all aesthetics are historically conditioned, and if he did not grasp this fact theoretically, it is implicit in all his writings.

It is quite true to say that in Germany Lessing was the first to point out Shakespeare's greatness; in the *Dramaturgie* especially he praises Shakespeare in many marvellous comparisons. But he always contrasts Shakespeare's historical tragedies solely with the historical tragedies of the French, and it is quite incorrect to trace the German "Shakespearomania" to Lessing. . . .

Not the historical tragedy but the middle-class drama is the ideal of this aesthetician. Diderot is his man, not Shakespeare. Nobody who has really read the *Dramaturgie* can doubt this, and Lessing prefers the French

omedy to the English as decidedly as he prefers the English tragedy to the French. It is clear then how hopeless it is to regard aesthetics as a purely intellectual matter. Of course Lessing knew that from an aesthetic point of view it was ridiculous to mention Diderot and Shakespeare in one breath. He refuted such an equalization, at least indirectly; he did not think of giving Diderot the honor which he attributed so generously to Shakespeare.

But if aesthetics, too, belongs to the superstructure of the class struggle, the connection is quite clear. Shakespeare was no court author, but still much less a middle-class writer. He occasionally paid homage to the court in *Henry VIII,* but whenever he lets the Lord Mayor of London appear, he invariably portrays him in a manner either ridiculous or contemptible. This is understandable considering that the Puritans hated the theatre bitterly while the court granted it a certain protection. The theatre found its real support in the aristocratic youth, which was vigorous and manly, and—all its limitations granted—still the leading class of a great nation in a period of powerful advance when new horizons were appearing. In Shakespeare's tragedies the surge of the sea is heard, while in Corneille's the fountains of Versailles murmur. But how could Shakespeare be a model to Germany, whose aristocracy was as decadent physically as mentally? Lessing therefore unswervingly pointed to the English and French middle-class plays as models for German tragedy and drama. The French comedy, however, was much superior to the English: the middle-class opposition in England had long had its Parliament and its periodical press, while in France it still had to concentrate its whole intellectual vigor in the comedy. Because of Shakespeare's hostile attitude to the middle class of his time, his comedies moved in a world of fairies and fairy tales, adventures and romanticism, with one exception: the *Merry Wives of Windsor.*

Though second-rate as comedy, historically this is a highly important satire. Shakespeare portrayed the aristocrat who has come down in the world and is ridiculed even by the women of the middle class. But what sort of model could this be to the German middle classes, the great majority of whose women did not as yet know a greater honor than to be ridiculed by decadent despots?

Probably Shakespeare did not intend *Merry Wives of Windsor* to be a historical satire; it would be the only occasion on which he scorned the aristocracy to the greater glory of the middle classes! According to an old account, his only middle-class comedy is supposed to have been written for a very harmless reason: to grant the wish of Queen Elizabeth to see the brave Sir John as a lover for once.

When in 1757 Lessing conceived the first plan for his middle-class *Virginia, Emilia Galotti,* he did not imagine what a scathing satire on German

conditions posterity would see in the catastrophe of his dramatic master-piece.

Emilia implores her own father to kill her, as she cannot rely on her senses and her blood in the struggle against the amorous advances of the despot who had ordered her fiancé to be murdered just before their wedding. . . . Emilia does not love the prince. But the fact that she and her father know no way to escape the despot's power other than the murder of the daughter has a ghastly effect on the spectator. It can cause neither fear nor pity. It cannot have any tragic effect, even if it can be traced to real history. Lessing himself has convincingly demonstrated this in Chapter 79 of the *Dramaturgie*.

From the point of view of tragic art the end of the play is indefensible, the reason being that it can be defended only too well from the point of view of history. . . .

In Livy's famous story, the young Lessing saw first the most revolting and striking accompaniment of social oppression: the attack on virginal honor which was as topical in the eighteenth century as it had been two thousand years before, as it still is to-day and will be as long as social oppression exists.

Lessing revealed his dramatic instinct in recognizing the general historical import of this tragic problem as far more important than the single case which had been the cause of a political revolution. He wished to write a middle-class *Virginia,* since "the fate of a daughter who is killed by her father, to whom her virtue is worth more than her life, is tragic enough and has sufficient power to impress the whole soul, even if no political revolution follows it."

Compared with the original story, Lessing's treatment of the subject is not shallower, as Dühring asserts, but deeper.

In eighteenth century Germany a middle-class author who wished to write a middle-class *Virginia* with a really tragic ending would have faced an impossible task. A short time before *Emilia Galotti* was published, in Lessing's Saxon state, an aristocratic family had solemnly celebrated the "wedding" of their daughter whom the ruling despot had chosen as one of his mistresses. On German soil neither an *Emilia* nor an *Odoardo* could be imagined; here one of the most tragic motives of world history challenged the pen of an Aristophanes rather than a Sophocles.

But Lessing would not have been the champion of the middle classes if he had been scornful of this shame rather than incensed by it. In order that his play might be psychologically true, he had to move the scene of action from the half boring, half libertine world of the philistines of his country to the country of the more passionate nation from which the Roman *Virginia*

sprang. Still, if circumstances are otherwise equal, the social forms of life never depend on frontiers; in disunited Italy petty despotism ruled no less than in disunited Germany, though thanks to the ancient culture of the country, in finer and more polished forms.

But essentially petty despotism remained everywhere what it was and was bound to be. There was no punishment for its grotesque and ghastly crimes, and if it is doubtful whether *Emilia Galotti* is a real tragedy, nevertheless the play is rooted in the economic structure of the society in which Lessing's figures lived. And the author could not go beyond those barriers. . . .

Outstanding contemporaries understood the social meaning of the tragedy at once. Herder called the author "a real man" and proposed to him to give the tragedy the motto: "Discite moniti." Goethe saw in it "the deciding step towards a morally inspired opposition against tyrannical autocracy," and even in later years he praised it as an excellent work, a piece full of intelligence, of wisdom, of deep understanding of the world, the expression of an admirable culture "compared with which we are already barbarous again," and one that would appear new in any epoch.

KARL KAUTSKY

*And thus the ideal ended
continually with a disillusionment;
proving itself to be an illusion
after it had done its historical duty
and had worked as an impulse
in the destruction of the old.*

—Kautsky, *Ethics and the Materialist
Conception of History*

INTRODUCTION

Karl Kautsky (1854–1938) was the theoretical leader of the German Marxist movement from the death of Engels until World War I. Born in Prague of a lineage which he described as "polyglot and plebeian," he grew up in an atmosphere of family difficulties and occasional poverty. As a young student he was an ardent Czech nationalist with a vaguely theistic inclination, but, following attendance at the University of Vienna and contact with Darwinian and socialist ideas, he joined the Social Democratic Party in 1875 as a Lassallean socialist and was an active propagandist for the German and Austrian Party press from 1875 to 1880. Like Engels, he published his earliest writings under a pseudonym to avoid confrontation with his father. He became a Marxist after leaving Vienna in 1880; shortly thereafter he made the acquaintance of Marx and Engels in London.

Marx, writing to his daughter Jenny in 1881, described Kautsky as "a mediocrity with a small-minded outlook, superwise (only 26), very conceited, industrious in a certain sort of way" who "belongs by nature to the tribe of the philistines but is otherwise a decent fellow in his own way."

Marx's judgment was premature. In 1883, Kautsky founded the first Marxist theoretical journal, *Die Neue Zeit,* which, after a faltering start ("That the Neue Zeit is to come to an end is no misfortune for the Party," wrote Engels to Kautsky in 1884), provided a platform until the 1920's for the consolidation and development of the socioeconomic aspects of Marxist thought and for presentation of the official political views of German Social Democracy. Engels published many of his later writings in *Die Neue Zeit.* Under Kautsky's expert editorship, it became a forum that attracted the best minds among the German Marxists, and a number of foreign Marxists as well. Before 1900, its contributors included Edward Aveling, Paul Barth, August Bebel, Max Beer, Nicholas Berdyaev (in his Marxist phase), Eduard Bernstein, H. Cunow, Paul Ernst, Jaurès, Labriola, Paul Lafargue, Gustave Landauer, Wilhelm Liebknecht, Rosa Luxemburg, Mehring, Plekhanov, Sorge, Ferdinand Tönnies, and Clara Zetkin. The young Georg Simmel contributed several pseudonymous articles on the humanities, and the work of the founders of the German "sociology of knowledge" school developed within the ambience of *Die Neue Zeit.* The tone of the publication was predominantly "scientific" and rationalist, tending to foreclose the exploration of the more speculative areas of Marxism. For the most part, the representation of the arts was perfunctory, with numerous reviews of contemporary literature from a restricted and largely *belle-lettristic* viewpoint and without specific application of Marxist categories.[1]

———

Kautsky hit his stride as a Marxist scholar in the late 1880's, in defiance of Marx's opinion. His major works include *Karl Marx's Economic Teachings* (1887), *Thomas More and His Utopia* (1888), *The Erfurt Program* (1892), *Forerunners of Modern Socialism* (1895), *The Agrarian Question* (1899), *Ethics and the Materialist Conception of History* (1906), *The Foundations of Christianity* (1908), *The Way to Power* (1909), and his

1. Typical examples are: Ernst on Ibsen, Strindberg and Maupassant; Minna Kautsky (Karl's mother) on contemporary theater and poetry; Eleanor Marx and Edward Aveling on "Shelley and Socialism"; Julie Zadek-Romm on Zola, du Maurier and Bellamy. Paul Lafargue (1842–1911), who was a minor-league Engels, wrote numerous hasty articles on literary subjects and several fascinating if dated attempts at incorporating researches in anthropology and comparative mythology into the Marxist study of ideology. He will be remembered for his classic *The Right to Be Lazy* (1883; English translation 1907), in which he affirmed that the pursuit of leisure and enjoyment was "more noble and more sacred than the anaemic Rights of Man concocted by the metaphysical lawyers of the bourgeois revolution."

edition of volume 4 of Marx's *Capital: Theories of Surplus Value* (1904–1910). Although he remains most highly regarded among scholars for his economic writings, it is his *Thomas More* and especially his *Foundations of Christianity* which have survived, not so much for the specific details of his researches as for the rigorousness with which he applied sociological categories to the explication of ideology. From the latter book we reprint a section dealing with the connection between trade and the development of abstract thinking, in which he explores the brilliantly speculative idea that handicraft development fosters the abilities required by the pictorial arts, and that these in turn make possible the development of polytheism. Conversely (and crucially) the absence of handicrafts among certain trading peoples of the ancient world was a necessary precondition for the development of monotheism. Kautsky himself thought highly of this hypothesis, for he returned to it in 1914 in his book *Are the Jews a Race?* (pages 137 f).

The bibliography of Kautsky's printed works consists of 1,738 separate items. The literary subjects touched on are negligible: a few reviews of books by or on Shakespeare, Shelley, Freiligrath, Heine, Jack London, and William Morris, and an extended essay on "Rebellions in Schiller's Dramas" (1905). There is a brief and superficial passage in his *Thomas More* on the middle-class's use of "satire and mockery" as weapons against the paradigmatic figures—the knight, the monk and the peasant— of the old feudal mode of production, and he cites representative examples of this from *The Decameron, Don Quixote,* and *The Merry Wives of Windsor*. Kautsky evidenced a deep interest in the visual arts, however, during his earliest Marxist years, stemming, perhaps, from identification with his father, who was an unsuccessful painter and scenic designer; from 1880 to 1885 Kautsky published a dozen serious articles in the Viennese *Zeitschrift für Plastik,* such as "Development in Art," "Reflections on Taste in Relation to Art," "Art and Society," "Artist and Worker," and "The Material Situation of the Artist and Its Influence upon Art." Kautsky did not return to the arts as such in his later years. Here again, perhaps, is another instance of the suppression of artistic inclinations among Marxists. What makes this rather probable is the revelation in Kautsky's posthumous memoirs (published 1960) that he had written three novels and numerous theater pieces during the 1870's— all of a thinly disguised autobiographical nature (and all on obviously oedipal subjects)—and had thereafter decided to give up his creative efforts in favor of more "practical" researches and activities. His "inclination to romanticizing," as he called his fictional work, was effectively at an end.

After around 1914 there was a marked decline in Kautsky's powers. The "Pope of Marxism" had set himself adrift from the movement that he had helped to establish, and his later writings (with the notable exception of the incomplete *Errinerungen*) are largely of a negatively polemical nature, with a strong admixture of attempted self-justification.

KAUTSKY:
ART AND THE CONCEPTION OF GOD IN ANCIENT ISRAEL
from *Foundations of Christianity*

Luxury and export industries and art flourished far less than did trade among the Israelites. The reason is probably that they became sedentary at a period when all around them craftsmanship had reached a high point of perfection. Luxury articles were better and cheaper when obtained through trade than when prepared by home industry, which was limited to the production of the simplest goods. Even among the Phoenicians, who became civilized much earlier, the advance of their industry was held back by the competition of Egyptian and Babylonian goods. "In early times the Phoenicians were hardly superior to the inhabitants of the rest of Syria in the field of industry. It is more likely that Herodotus is right when he says that the first Phoenicians that landed on the coasts of Greece were peddling goods that were not produced in their own country, but in Egypt and Assyria, that is the countries inland from Syria. The great cities of Phoenicia first became industrial cities after they had lost their political independence and a large part of their commercial connections."[1]

It may have been the eternal state of war, too, that interfered with the development of crafts. In any case it is certain that they did not develop very far. The prophet Ezekiel gives a detailed account of the trade of Tyre in his lamentation for that city, including the trade with Israel, whose exports are exclusively agricultural: "Judah, and the land of Israel, they were thy merchants: they traded in thy market wheat of Minnith, and Pannag, and honey, and oil, and balm" (Ezekiel 27:17).

When David made Jerusalem his capital, King Hiram of Tyre sent him "cedar trees, and carpenters, and masons: and they built David an house" (II Samuel 5:11). The same thing happened when Solomon was building the temple, and paid Hiram twenty thousand measures of wheat and twenty of oil every year.

Without highly developed luxury crafts, that is without artistic handi-

1. R. Pietschmann, *Geschichte der Phönizier* (1889), p. 238.

crafts, there is no fine art in which to portray the human person, going beyond the outline of the human type to individualize and idealize it.

Such an art presupposes a high level of trade to bring the artist all sorts of materials of all sorts of qualities, thus enabling him to choose those best fitted for his purposes. It also presupposes intensive specialization and generations of experience in the handling of the various materials, and finally a high esteem for the artist, which sets him above the level of forced labor and gives him leisure, joy and strength.

All these elements combined are to be found only in large commercial cities with vigorous and well-established handicrafts. In Thebes and Memphis, in Athens, and later, after the Middle Ages, in Florence, Antwerp and Amsterdam, the fine arts reached their high points on the basis of a healthy craftsmanship.

This was lacking among the Jews, and had its effect on their religion.

The Conception of God in Ancient Israel

Ideas about divinity are extremely vague and confused among primitive peoples, and by no means as clear-cut as we see them presented in the mythology books of the learned. The individual deities were not clearly conceived nor distinguished from one another; they are unknown, mysterious personalities affecting nature and men, bringing men good luck and bad luck, but as shadowy and indefinite, at least at first, as visions in a dream.

The only firm distinction of the individual gods one from the other consists in their localization. Every spot that particularly arouses the fantasy of primitive man seems to him to be the seat of a particular god. High mountains or isolated crags, groves in special places and also single giant trees, springs, caves—all thus receive a sort of sanctity as the seats of gods. But also peculiarly shaped stones or pieces of wood may be taken to be the seats of a deity, as sacred objects the possession of which assures the aid of the deity that inhabits them. Every tribe, every clan tried to obtain such a sacred object, or fetish. That was true of the Hebrews as well, for their original idea of God was quite on the level we have just described, far from monotheism. The sacred objects of the Israelites seem to have been nothing more than fetishes at first, from the images or idols (teraphim) that Jacob steals from his father-in-law Laban to the ark of covenant in which Jehovah is located and which brings victory and rain and riches to the man who possesses it justly. The sacred stones that the Phoenicians and Israelites worshipped bore the name of Bethel, God's house.

The local gods and the fetishes are not distinctly individual on this stage;

often they have the same names, as for example among the Israelites and Phoenicians many gods were called El (plural, Elohim) and others were called by the Phoenicians, Baal, the lord. "Despite the identity of names all these Baals counted as quite distinct beings. Often nothing more was added to distinguish them than the name of the place in which the god in question was worshipped."[2]

It was possible to keep the separate gods distinct in the minds of the people only when the plastic arts had developed enough to individualize and idealize human forms, to present concrete forms with a character of their own, but also with a charm, a majesty or a size or fearsomeness that raised them above the form of ordinary men. At this point polytheism got a material basis; the invisible became visible and so imaginable by all; now the individual gods were permanently distinguished from each other and confusion among them became impossible. From then on men could choose individual figures out of countless numbers of spiritual beings that danced about in the fantasy of primitive man, and give them particular forms.

We can clearly trace how the number of the particular gods in Egypt increases with the development of the fine arts. In Greece too it is certainly no accident that the highest point of the art industry and human representation in the plastic arts coincided with the greatest diversity and sharpest individualization in the world of the gods.

Because of the backwardness of the industry and art of the Israelites, they never carried to completion the progress of the industrially and artistically developed peoples, the replacement of the fetish, the dwelling place of the spirit or god, by the image of the god. In this respect too they remained on the level of the Bedouin mode of thought. The idea of representing their own gods in pictures or images never came into their heads. All the images of gods they knew were images of foreigners' gods, gods of the enemy, imported from abroad or imitated after their model; and hence the hate of the patriots against these images.

This had an element of backwardness; but it made it easier for the Jews to advance beyond polytheism once they learned of the philosophical and ethical monotheism that had arisen in various great cities on the highest level of development of the ancient world for causes we have already mentioned. Where the images of the gods had struck root in the minds of the people, polytheism received a firm basis that was not so easily overcome. The indefiniteness of the images of the gods and the identity of their names in different localities on the other hand, opened the way for popu-

2. Pietschmann, *Geschichte der Phönizier,* pp. 183f.

larizing the idea of one god, compared to whom all the other invisible spirits are but lower beings.

At any rate it is no mere chance that all the monotheistic popular religions came from nations that were still in the nomadic mode of thought and had not developed any notable industry or art: along with the Jews, these were the Persians and later the Arabians of Islam, who adopted monotheism as soon as they came into contact with a higher urban civilization. Not only Islam but the Zend religion is monotheistic; this recognizes only one lord and creator of the world, Ahuramazda. Angromainju (Ahriman) is a subsidiary spirit, like Satan.

It may seem strange that backward elements will adopt an advance more easily and carry it further than more developed elements will; it is a fact, however, that can be traced even in the evolution of organisms. Highly developed forms are often less capable of adaptation and die out more easily, whereas lower forms with less specialized organs can more easily adapt to new conditions and hence be capable of carrying progress further.

In man the organs do not merely develop in an unconscious way; he also develops other artificial organs whose manufacture he can learn from other men. With respect to these artificial forms, individuals or groups can leap over whole stages of development when the higher stage has already been prepared for them by others from whom they can take it over. It is a well-known fact that many farm villages took to electric lighting more easily than the large cities which already had large capital investments in gas lighting. The farm village could jump directly from the oil lamp to electricity without passing through the phase of gas; but only because the technical knowledge required for electric lighting had already been gained in the big cities. The farming village could never have developed this knowledge on its own account. Similarly, monotheism found easier acceptance among the Jews and Persians than among the mass of Egyptians, Babylonians or Hellenes; but the idea of monotheism had first to be developed by the philosophers of these more advanced civilizations.

However at the time with which we are dealing, before the Exile, things had not yet gone so far; the primitive cult of the gods still prevailed.

GEORGI PLEKHANOV

*An idea which is inherently
revolutionary is a kind of dynamite
which no other explosive
in the world can replace.*
—Plekhanov, *Socialism and
 the Political Struggle*

INTRODUCTION

Georgi Valentinovich Plekhanov (1856–1918) was born into a small
landowning family (a violent father, a mother who encouraged his intellec-
tual development). His education was directed toward a military career,
but in 1876 he joined the Narodnik (Populist) movement and became one
of its chief theoreticians. Following several arrests, he was compelled to
emigrate in 1880, an exile which lasted until 1917. Within several years he
had abandoned Narodnism in favor of Marxism, established contact with
Engels, Kautsky, and other major leaders of the international socialist
movement, become a founder of the first Russian Social Democratic Party
("The Emancipation of Labor Group"), and was launched upon a politi-
cal-intellectual career which established him as the foremost Russian
Marxist prior to Lenin, upon whom his works had a profound influence.

Though a revolutionary by trade and by conviction, he was incapable of
revolutionary acts. His break with the Narodniks was over their terrorist
activities, and especially their proposal to assassinate the Tsar. Similarly,
he broke with Lenin in 1905 on the question of armed insurrection, and

upon his return to Russia in 1917 he opposed the seizure of power by the Soviets. Throughout his life he was unable to sanction the historical consequences of his own theories.

His major philosophical works, many of which touch on or deal extensively with the arts, include *Socialism and the Political Struggle* (1883), *Our Differences* (1885), *On the Development of the Monist View of History* (1895), *Essays on the History of Materialism* (1896), and *Fundamental Problems of Marxism* (1908). Four shorter works of pamphlet length are extremely valuable: *Anarchism and Socialism* (1895), *The Materialist Conception of History* (1897), *The Role of the Individual in History* (1898), and *Utopian Socialism of the Nineteenth Century* (1913).

Plekhanov was the first Marxist after Mehring to turn his attention to the arts. He investigated an impressive range of subjects in his detached, dry, scientific style, from the origins of art to the Romantics and Symbolists, from primitive music to eighteenth-century French tragedy and painting, from Baudelaire and Ibsen to Pushkin, Chernyshevsky, Turgenev, Gorki. An erudite scholar, he kept abreast of the latest developments in anthropology, evolutionary thought (Darwin is a major influence on him), sociology, and philosophy, and he applied numerous concepts from parallel disciplines in an attempt to confirm the applicability of historical materialism to the arts.

Plekhanov's primary significance for Marxist aesthetics lies in the intelligent application of the determinist aspect of Marxism to the genesis of art and art forms. Central to his viewpoint is the concept that art arises as a virtually automatic process from the movement of history, called into being by the needs of "the class or stratum whose tastes it expresses." In the first selection, a chapter from *The Role of the Individual in History,* he argues that "gifted persons appear wherever and whenever social conditions are favorable for their development," that such people can "change only the individual aspect of events, not their general direction," and that without this direction "they could never cross the threshold that divides potentiality from reality." Marx and Engels, in *The German Ideology,* held a similar view: "Whether an individual like Raphael succeeds in developing his talent depends wholly on demand, which in turn depends on the division of labour and the conditions of human culture resulting from it" (pages 430–31); and Engels, in his well known letter to Borgius, writes that the great man "has always been found as soon as he became necessary." But these passages, which emphasize the broad framework within which creativity operates, are to be seen as only one side of the dialectic; otherwise, consciousness is converted into purely passive

reflection. Yet this is precisely what Plekhanov does, in a decisive passage of our selection: "When society at a given stage presents certain problems to its spiritual representatives, these problems hold the attention of outstanding minds until they succeed in solving them. Thereupon their attention turns to some other subject." Plekhanov may have intended here to paraphrase Marx's classic formulation that "mankind always sets itself only such tasks as it can solve" (see above, page 29), but in fact he has reversed it, stressing the derivative and genetic aspects of the Marxist dialectic and ignoring its active role. To Plekhanov, art is the solution of a set of problems which arise from the historical development of the mode of production; for Marx, art is a means by which mankind sets tasks *for itself* to aid it in its progress towards freedom. It is the work of crystallized consciousness—art, theoretical science, and philosophy—to offer up for ultimate solution by historical practice the unsolved problems of humanity.

Plekhanov's formulations nevertheless have important implications for the history of art. There are moments in the evolution of each art form in which unexploited and latent potentialities suddenly emerge into view; greatness falls to those artists who are able to grasp the implications of those potentialities, to those who (as Fredric Jameson writes, in a paraphrase of Adorno) are able to "fill all the empty spaces, to work through to their conclusion all the unfinished trends, all the incompletely explored suggestions, to actualize what the material itself shows to be latent and possible."[1] The resulting art work, in turn, carries forward and multiplies new latent possibilities which the further development of history may make manifest.

Plekhanov's *Art and Social Life* (1912), from which the second selection is drawn, heavily influenced an entire generation of Russian Marxists, for whom it constituted the fundamental Marxist text on art. In it, Plekhanov describes the social conditions which give rise to "art for art's sake" on the one hand, and to the "utilitarian" approach to art on the other.[2] These were aesthetic categories of central concern to Russian revolutionaries from the mid-nineteenth century on, and Plekhanov's dispassionate and scholarly exposition constituted the classic solution of these questions for his time. Plekhanov's method accords fully with Marx's insistence that the

1. Fredric Jameson, "T. W. Adorno: Historical Tropes," *Salmagundi*, vol. II, no. 1 (Spring 1967), p. 30.

2. Plekhanov's often-quoted statement that "art for art's sake" develops when artists and art lovers are in "hopeless disaccord with the social environment in which they live," derives from the Utopian Socialist Pierre Leroux (1797–1871), whose ideas (including an early statement of a symbolist aesthetics) were briefly influential in mid-nineteenth-century France and Russia.

products of the mind are to be explained by cleavages within society, but it tends to underplay the dialectical coordinate of this concept: that consciousness itself becomes a motive force as it strips the ideological veil from the "realities" of existence. For Plekhanov, art arises from life and presents itself as an object for analysis and understanding. The practical consequence of this approach is that Plekhanov would prescribe nothing for art or the artist. History would attend to that. This "objective" attitude toward art was repudiated from the late 1920's onward by Soviet Marxists, who—wholly in keeping with Plekhanov's observation that "any given political power . . . always favours the utilitarian view of art"—attempted to negate Plekhanov's sociological laws by *imposing* the utilitarian view upon its artists, thereby creating that very "disaccord with the social environment" which Plekhanov had shown gave rise to "art for art's sake" movements.

Plekhanov's tendency to downgrade "will" in artistic creativity closely parallels his political timidity, his unwillingness to carry forward a historical action unless all the groundwork had been prepared. The Utopian and transcendent powers of art were a closed book to Plekhanov. He remained primarily a major sociologist of art who—using an amalgam of categories from Hegel, Belinsky, Taine, Marx, and Darwin—solved a number of substantive aesthetic questions for his time and raised a number of others which have not yet been fully resolved. Nevertheless, he himself was not devoid of aesthetic sensitivity. He wrote of Gorki that "he was highly unsuited for the role of propagandist . . . i.e., of the man who speaks chiefly in the language of logic" whereas the artist "speaks chiefly in the language of images." Further, while he never integrated this concept into his aesthetic writings, he wrote extensively on what he called the "hieroglyphic" theory of epistemology, which upon examination turns out to be an anticipation of the theory of symbolic form.[3]

Plekhanov was primarily responsible for the incorporation into Marxism of Karl Bücher's theory that primitive art originated in the labor process.[4] A dialectically related theory—and one which haunted Plekhanov because he saw in it a possible refutation of historical materialism as he understood it—is that of the *Spieltrieb* (the play drive) in its relation to labor and to art. Here again Bücher was the focus of Plekhanov's attention, for he

3. Lenin criticized Plekhanov's "hieroglyphic" theory in *Materialism and Empirio-Criticism*. For a defense of Plekhanov against Lenin by a professional Marxist philosopher, see Lyuba Akselrod (Ortodoks), "Review of Lenin's Materialism and Empiriocriticism," in J. M. Edie, et al., eds., *Russian Philosophy* (Chicago, 1965), vol. III, pp. 457–63.

4. *Arbeit und Rhythmus* (Leipzig, 1896).

had reopened this theory of artistic essence which Schiller (following Kant and anticipated by Home's *Elements of Criticism*) had investigated in his *Letters on the Aesthetic Education of Man* and which Herbert Spencer had popularized in the mid-nineteenth century. In the final selection, from the *Letter Without Address No. 3,* Plekhanov comes to grips with this theory. His urgent concern is with the question of priority; "Which comes first then—play before utilitarian activity, or utilitarian activity before play?" He felt that "if play is indeed older than labour and if art is indeed older than the production of useful objects, then the materialist explanation of history . . . *will not stand up* [and] I shall have to argue about the dependence of economics on art and not about the dependence of art on economics." But Plekhanov fails to make Marx's crucial distinction between "primitive instinctive forms of labour" and labor in its "exclusively human" form. For Marx the difference between the instinctive and the human forms of labor is that the human being "raises his structure in imagination *before* he erects it in reality. At the end of every labour-process, we get a result that *already existed in the imagination of the labourer* at its commencement" (see above, pages 22–23; italics added). Play (and art) enter here. Play is a dialectical coordinate of labor. The *creative* element of labor is the imagination, the free "play" of man's "bodily and mental powers." To participate in creative, human labor, man withdraws from the instinctive, repetitive labor process and turns it into play, into mimetic representation, into illusion, into art, so that when he returns to labor it may be transformed into a conscious, supra-instinctive, freedom-creating activity.[5] Work and play are a unity of opposites peculiar to the human species. In this sense, play is the philosophy, the art of work. To argue priority is ultimately non-dialectical.[6] But under capitalism the play and art elements of the labor process tend to diminish, and alienated labor regresses toward the instinctual, repetitive, time-bound, and mechani-

5. Although Marx himself does not deal with play as a category, I do not think that these comments go beyond the legitimate implications of Marxist thought, as the following passage may confirm: "Free time—which includes leisure time as well as time for higher activities—naturally transforms anyone who enjoys it into a different person, and it is this different person who then enters the direct process of production. The man who is being formed finds discipline in this process, while for the man who is already formed it is practice, experimental science, materially creative and self-objectifying knowledge, and he contains within his own head the accumulated wisdom of society" (Marx, *Grundrisse,* pp. 148–49).

6. And yet, we may note that play always precedes labor in childhood, and usually takes its autonomous modes of action from life processes quite remote from labor. In a Marxist sense labor becomes specifically human only through play, but play exists in dialectical opposition to modalities other than labor.

cal labor of lower forms of life. And so the task which Marx outlined in his *Economic and Philosophic Manuscripts* may be seen as the restoration of the play-labor unity, which is to say the restoration of the specifically human element to the labor process. Marx's vision, then, ultimately is identical with Schiller's famous phrase: "Man only plays when he is a man in the full sense of the word, and he is only completely a man when he plays."[7]

Plekhanov, though unable to break out of the question of priority, was nevertheless the first to focus Marxist concern on the fundamental category of play in its relation to both aesthetics and labor. He returned to the subject again in 1910, in his book *N. G. Chernyshevsky,* where he wrote: "the view of art as play, supplemented by the view of play as a 'child of labour,' sheds a very bright light on the essence and history of art. It makes it possible for the first time to view them from a materialist standpoint." Lenin marked this passage approvingly in his *Philosophical Notebooks* (page 531). Lukács touched briefly (and brilliantly) on the subject in *History and Class Consciousness* (pages 138 ff.), seeing the "aesthetic mode" as a means of salvaging man "from the deadening effects of the mechanism of reification" (page 139). But the following generations of Marxists turned away from the subject, which became the special domain of psychoanalytical heretics such as Jung and Rank.[8] It was not until Herbert Marcuse's *Eros and Civilization* that a Marxist would return to the consideration of the play drive, with a brilliant analysis of the radical implications of Schiller's aesthetics in the light of Marx and Freud. Marcuse, however, sees play primarily as lying beyond the realm of necessity, as a contrast to labor rather than in a dialectical unity with it. Labor (whether alienated or creative) is "unfreedom"; play is defined as "unproductive and useless," a means of canceling "the repressive and exploitative traits of labor and leisure." Play, thus sundered from its Utopian-artistic role as the imaginative anticipation of a desired future reality, spins off into a deadening, autonomous purposelessness, into a new form of alienation.

7. Schiller, *Letters on the Aesthetic Education of Man,* Letter 15.

8. See C. G. Jung, *Psychological Types* (New York, 1926), pp. 82f., 134ff., 154ff.; Otto Rank, *Art and Artist* (New York, 1932), pp. 91–110. For a survey of the Freudian literature, see Phyllis Greenacre, "Play in Relation to Creative Imagination," *The Psychoanalytic Study of the Child,* vol. XIV (New York, 1959), pp. 61–80. An extensive bibliography of the subject is in Susanna Millar, *The Psychology of Play* (Middlesex, 1968), pp. 257–81. See also *Yale French Studies,* Number 41 (Game, Play, Literature Issue).

PLEKHANOV: **THE ROLE OF THE INDIVIDUAL IN HISTORY**
from *The Role of the Individual in History*

We must bear in mind the following: in considering the role of great individuals in history we almost invariably suffer from an optical illusion. In assuming the role of the "good sword" to preserve the public order, Napoleon by the same token pushed aside all other generals some of whom could have played the same role equally or almost as well. Once the social need for a vigorous military administrator was satisfied, the path to this post was blocked to all others. The impetus of the social organization was no longer conducive to the display of this kind of skill by other aspirants. And this accounts for the optical illusion just mentioned. Napoleon's personal power appears to us in an extremely exaggerated form because we ascribe to it all the social power which pushed his personal power to the fore and supported it. It seems to be something totally exceptional, because other *similar powers had not passed from potentiality to actuality*. And when we are asked: "What would have happened had there been no Napoleon?" our *imagination* becomes confused and we begin to think that without him the whole social movement upon which his power and influence rested could never have taken place.

In the history of the intellectual development of mankind the success of one individual has seldom so completely blocked the success of other people. Yet here, too, we are not free from the said optical illusion. When society at a given stage presents certain problems to its spiritual representatives, these problems hold the attention of outstanding minds until they succeed in solving them. Thereupon their attention turns to some other subject. By solving the problem, talent A thereby turns the attention of talent B from the problem solved to some other problem. And when we are asked: What if A had died before he had time to solve the problem? we imagine that the thread of society's intellectual development would have been broken. We forget that in the event of A's death the problem would have been tackled by B, C, or D, in which case the thread of society's intellectual development would have continued unbroken despite A's untimely death.

If a man possessing certain gifts is to gain important influence upon the course of events by virtue of such gifts, two conditions are necessary. First, his gifts must make him more capable than anyone else of answering the needs of the given time. If Napoleon, in place of his military skill, had possessed the musical genius of Beethoven, he certainly would not have

become emperor. Second, the existing social order must not frustrate an individual possessing the characteristics needed and useful at the given time. The same Napoleon would have died an obscure general or colonel had the old regime dragged on in France for another seventy-five years.[1]

In 1789, Davoust, Desaix, Marmont, and Macdonald were second lieutenants; Bernadotte was a sergeant-major; Hoche, Marceau, Lefebvre, Pichegru, Ney, Masséna, Murat, and Soult were non-commissioned officers or corporals; Augereau was a fencing instructor; Lannes, a house-painter; Gouvion Saint-Cyr, an actor; Jourdan, a huckster; Bessières, a barber. Brune was a typesetter, Joubert and Junot were law students; Kléber, an architect; while Mortier did not enter military service until the Revolution had already begun. If the old regime had continued until today, not one of us would ever have thought that at the end of the eighteenth century in France, certain actors, typesetters, barbers, house-painters, hucksters, lawyers, and fencing instructors were potential military talents.

Stendhal remarks that a person born at the same time as Titian, i.e., in 1477, could have lived forty years with Raphael, who died in 1520, and Leonardo da Vinci, who died in 1519; that he could have spent many years with Correggio, who died in 1534, and with Michelangelo who lived until 1563 [1564]; that he could have been only thirty-four at the time of Giorgione's death; that he might have been personally acquainted with Tintoretto, Bassanio, Veronese, Giulio Romano, and Andrea del Sarto; in a word, he could have been a contemporary of all the great painters, with the exception of those of the Bolognese school of art which appeared a century later.[2] The same may be said of a person born in the same year as Wouwerman; he could have known almost all the great Dutch painters; while a coeval of Shakespeare lived contemporaneously with a number of outstanding playwrights.[3]

It has long been noted that gifted persons appear wherever and whenever social conditions are favorable for their development. This means that every talent which is realized, i.e., every talent which becomes a social force, is the fruit of social relations. If this is the case, however, it becomes clear why gifted persons can, as we have said, change only the individual aspect of events, not their general direction. As a matter of fact, they

1. It is likely that he would have gone to Russia, where he intended to go a few years before the Revolution. Here he would have distinguished himself in battles with the Turks or with Caucasian mountaineers, yet no one would have suspected that this poor though gifted officer would under favorable conditions have become ruler of the world.

2. Stendhal, *Histoire de la Peinture en Italie,* (Paris, 1899), pp. 23–25.

3. Taine, *Histoire de la Littérature Anglaise* (Paris, 1863), vol. I, p. 467.

themselves exist only as a result of such direction without which they could never cross the threshold that divides potentiality from reality.

It goes without saying that there are talents and talents. As Taine rightly says: "When a new stride in the development of civilization calls forth a new kind of art, scores of talents appear who express the thought of society only partially; they group themselves around one or two geniuses who express it to perfection."[4]

Had some mechanical or physiological circumstance having no connection with the social, political, and spiritual development of Italy caused the death of Raphael, Leonardo, and Michelangelo in their childhood, Italian art would have been less perfect, but the general trend of its development at the time of the Renaissance would have remained the same. Raphael, Leonardo, and Michelangelo did not create the trend, they were merely its best exponents. True enough, a whole school usually grows up around the genius, and his disciples strive to acquire even his minutest methods. That is why the gap which would have remained in Italian art of the Renaissance as a result of the early death of Raphael, Leonardo, and Michelangelo would have profoundly affected many secondary features in the subsequent history of the art. But essentially the history of Renaissance art would not have changed, assuming that no substantial change in the general course of Italy's spiritual development was brought about by general causes.

It is a known fact, however, that quantitative differences turn in the end into qualitative differences. This is true everywhere, and consequently in history also. A given trend in art may remain entirely without any notable expression if an unfavorable combination of circumstances should carry off, one after another, several gifted individuals who might have become its exponents. However, the premature death of such persons would hinder the artistic expression of this trend only if it was not sufficiently profound to bring forward new talents. And since the depth of any given trend in literature or art is determined by its importance for the class or stratum whose tastes it expresses, and by the social role of this class or stratum, here again in the final analysis everything depends upon the course of social development and the relation of social forces.

4. *Ibid.*, vol. I, p. 5.

PLEKHANOV: ART AND SOCIAL LIFE
from *Art and Social Life*

The question of the relationship of art to social life has always played a very important part in all literature that has reached a certain level of development. More often than not the question has been resolved in two ways which are directly contradictory to each other.

Some have said and still say: Man is not made for the Sabbath, but the Sabbath for man. Society is not made for the artist, but the artist for society. Art must promote the development of human consciousness and the improvement of the social order.

Others decisively reject this viewpoint. In their opinion, art is an end in itself, and to turn it into a means of achieving some other end, however noble, is to lower the dignity of a work of art.

The first of these two views was clearly expressed in our advanced literature of the '60s. Even if we leave out Pisarev, who, in his extreme one-sidedness, carried it almost to the point of caricature, we may cite Chernyshevsky and Dobrolyubov as the most well-grounded defenders of this viewpoint among the critics of that day. In one of his first critical essays, Chernyshevsky wrote,

> Art for art's sake—such an idea is as strange now-a-days as "wealth for wealth's sake," "science for science's sake" and so on. All human activities should serve a useful purpose for man, if they are not to be empty, frivolous occupations. Wealth exists so that man may use it, science so that she may be man's guide, and art also must serve some essential purpose and not be an idle amusement.

In Chernyshevsky's opinion, the importance of the arts and, in particular, of "the most serious among them," poetry, is determined by the mass of knowledge they disseminate in society. He writes:

> Art, or rather, poetry (and only poetry, since the other arts do very little in this respect) disseminates among the mass of readers a vast quantity of knowledge and, what is still more important, familiarity with concepts elaborated by science—herein lies the great importance of poetry for life.[1]

He expresses the same idea in his famous dissertation *The Aesthetic Relationship of Art to Reality*. According to its seventeenth thesis, art not

1. N. G. Chernyshevsky, *Collected Works,* vol. I (1906), pp. 33–34.

only reproduces life but also explains it; and works of art often "have the significance of a judgment on the phenomena of life."

In the eyes of Chernyshevsky, and of his pupil Dobrolyubov, the main importance of art lay precisely in its reproduction of life and its passing of judgment on the phenomena of life.[2]

Not only literary critics and theoreticians of art regarded the matter in this light. It is not surprising that Nekrassov called his muse a muse of "sorrow and revenge." In one of his poems, the citizen, addressing the poet, says:

> And thou, poet, art chosen of the skies,
> Voice of truths eternal.
> Think not the hungry mortal's cries
> Unworthy of prophetic song.
> Think not that men have fallen quite,
> God is not dead in man,
> The cry of a believing heart
> Will ever reach man's spirit.
> Become a citizen! In serving art,
> Live for the good of fellow-men,
> Submitting genius to the sense
> Of all-embracing love.

In these words, "citizen" Nekrassov expressed his own conception of the tasks of art. The same viewpoint was shared at that time by the most outstanding personalities in the plastic arts, for example, in painting. In serving art, Perov and Kramskoy strove, like Nekrassov, to be "citizens." And like him, they passed judgment in their works on the phenomena of life.[3]

2. This view was partly a repetition, and partly a further development, of the views worked out by Belinsky in the last years of his life. In his article "A glance at Russian Literature in 1847" Belinsky wrote: "The highest and most sacred interest of society is its own well-being, equally distributed among all its members. The road to this well-being is consciousness, and art can help consciousness as much as science. Science and art are equally necessary: science cannot take the place of art, nor art of science." But art can only contribute to the development of consciousness when it "passes judgment on the phenomena of life." And thus Chernyshevsky's dissertation is linked with Belinsky's final views on Russian literature.

3. A letter from Kramskoy to V. V. Stasov from Mentone (April 30, 1884) is proof of the influence on him of the views of Belinsky, Gogol, Fedotov, Ivanov, Chernyshevsky, Dobrolyubov and Perov (*Ivan Nikolayevich Kramskoy: His Life, Correspondence and Art Criticism* [St. Petersburg, 1888], p. 487). It is worth while noting, however, that the judgments passed on the phenomena of life in I. N. Kram-

A contrary viewpoint on the task of artistic creation had a mighty defender in the Pushkin of the time of Nicholas I. Everyone knows such poems of his as *The Rabble* and *To the Poet*. To the people, demanding that the poet should by his songs improve social morality, he replies scornfully—one might almost say, brutally:

> Away then! May the peaceful poet own
> a common lot with you? Go, struck to stone,
> on your remorseless course of wickedness!
> No song of mine will ease your souls and bless;
> the spirit shrinks from you like open graves.
> Aye, when your madness or your malice raves,
> you've found upon your backs
> the whip, the dungeon-cell, the axe,
> enough for you, enough, insensate slaves.

Pushkin expressed his idea of the poet's task in the following, so often-quoted lines:

> Not for the world, ambition-torn,
> rage of war and profit's cares,
> for inspiration we were born,
> sweetness of harmony, and prayers.

Here we meet the so-called theory of art for art's sake in its sharpest formulation. It was not without good grounds that the opponents of the literary movement of the '60s so readily and often quoted Pushkin.

Which of these two flatly contradictory opinions on the task of art should we take to be right?

In setting out to solve this question, it is essential to note, in the first place, that it is badly formulated. Neither this nor any similar question can be examined from the standpoint of "duty." If in a particular country and at a particular time the artist finds that worldly "agitation" and "battles" are no concern of his, while at another time, on the contrary, he eagerly seeks for battles and for the agitation which inevitably goes with them, this happens, not because some outside authority imposes on him different obligations ("duties") at different times, but because in different social

skoy's critical essays, are far from being as clear as those passed, for example, by G. I. Uspensky, not to mention those of Chernyshevsky and Dobrolyubov.

conditions he is swayed by different feelings. Therefore, a correct approach to the subject requires that we examine it, not from the standpoint of what ought to have been, but from the standpoint of what was and is.

We will therefore pose the question as follows:

What are the principal social conditions in which, in artists and in people taking a lively interest in art, the tendency to "art for art's sake" arises and is strengthened?

When we approach the answer to this question, it will not be difficult to solve another equally interesting question, which is closely related to it:—

What are the principal social conditions in which, in artists and people taking a lively interest in art, there arises and is strengthened the so-called "utilitarian" conception of art, that is, the tendency to accord to works of art "the significance of judgments on the phenomena of life"?

The first of these two questions leads us back again to Pushkin.

There was a time when he did not support the theory of art for art's sake. There was a time when he did not avoid battles, but sought them out. This was during the reign of Alexander I. At that time he did not think that "the people" should be satisfied with whips, dungeons and axes. On the contrary, he exclaimed with indignation, in his *Ode to Liberty*—

> Alas, where'er I look there loom
> whips and chains in serried doom,
> laws broken with no shames or fears,
> slaves with powerless tears
> and power unjust in its distorting gloom.

But later his mood changed radically. In the epoch of Nicholas I, he adopted the theory of art for art's sake. What brought about this tremendous change in his mood?

The beginning of Nicholas I's rule was marked by the catastrophe of December 14,[4] which had a tremendous influence not only on the further development of our "society" but also on Pushkin's personal fate. The defeat of the "Decembrists" meant the disappearance of the most educated and advanced representatives of the society of the time, and inevitably resulted in a considerable lowering of its moral and intellectual level.

"Although I was so young at the time," writes Herzen, "I can yet remember how visibly high society sank and became foul and servile when Nicholas I

4. The "Decembrist" rising of revolutionary noblemen against Tsar Nicholas I in December 1825, brutally suppressed.—TRANS.

ascended the throne. The aristocratic independence and military daring of Alexander's reign vanished in 1826."

It was hard for an intelligent and sensitive person to live in such a society. "All about one was a wilderness, silence," wrote the same Herzen in another essay. "All was pusillanimous, inhuman, hopeless, and, what is more, utterly flat, stupid and petty. Appeals for sympathy were met by servile threats or fear; men either turned away from them or answered with insults." In Pushkin's letters, written during the period when he was composing *The Rabble* and *To the Poet,* one constantly meets with complaints about the boredom and vulgarity of both our capitals. But Pushkin did not only suffer from the vulgarity of the society that surrounded him; his relations with the "ruling circles" also caused him a good deal of unpleasantness.

There is a touching and widely spread legend that in 1826 Nicholas I magnanimously "pardoned" Pushkin for the political "mistakes of his youth," and even became his generous patron. But the facts were very different. Nicholas and his right-hand man in affairs of this sort, Chief of Police A. K. Benckendorf, "forgave" Pushkin nothing; and their "patronage" was expressed in a long series of unbearable humiliations. In 1827, Benckendorf reported to Nicholas:

After meeting me Pushkin spoke enthusiastically about your Majesty at the English Club and made the people dining with him drink your Majesty's health. He's altogether pretty much of a scapegrace, but *it would be an advantage* to be able to guide his pen and his speeches.

The last words reveal the secret of the "patronage" accorded Pushkin. They wanted to make him sing the praises of the existing order. Nicholas and Benckendorf set themselves the task of directing his previously turbulent muse into the path of official morality. When Field-Marshal Paskevich wrote to Nicholas after Pushkin's death, Nicholas replied: "I am sorry about Pushkin, as a writer. I entirely subscribe to your opinion and it may be justly said that in him we mourn the future, not the past."[5]

This means that the unforgettable Emperor prized the dead poet, not for the great works he had written in his short life, but for what he might have written under appropriate police surveillance and guidance. Nicholas expected of him "Patriotic" works like Kukolnik's play, *The Hand of the Almighty Saved the Fatherland.* Even V. A. Zhukovsky, that "other-

5. Shchegolev, *Pushkin* (St. Petersburg, 1912), p. 357.

worldly" poet, who was a first-rate courtier, tried to bring Pushkin to his senses and to inculcate in him a respect for morality. In a letter of April 12, 1826, he wrote:

Our young people (that is, the whole rising generation), whose bad education leaves them without any support in life, have become familiar with your turbulent thoughts, clothed in exquisite verse. You have already done incalculable harm to many—and that should make you tremble. Talent means nothing. The main thing is moral greatness.[6]

It must be admitted that, in *such* a situation, shackled by *such* a patronage, and having to listen to *such* edifying exhortations, Pushkin was quite justified in hating "moral greatness," in feeling the most profound disgust for all the "benefits" which art might produce, and in exclaiming to his advisors and patrons:—

> Away then! May the peaceful poet
> own a common lot with you?

In other words, in the circumstances in which he found himself it was natural for Pushkin to become an advocate of the theory of art for art's sake, and to say to the poet, in his own person:

> You're king, so dwell alone. Your free path tread
> Wherever your free mind your steps may lead;
> Perfect the fruits your secret thoughts have bred,
> And for your high achievement ask no meed.[7]

D. I. Pisarev would have objected that Pushkin was addressing these sharp words, not to his protectors, but to "the people." But at that time the people, in the real sense of the word, were completely excluded from the literary field of vision. For Pushkin, the word "people" had the same meaning as the word "crowd," which he frequently used. And this latter word, of course, had nothing to do with the working mass. In his *Gypsies,* describing the inhabitants of stuffy towns, Pushkin says:

> Ashamed of love, they chase away
> all thought, and their own souls they sell.
> Bowing to idols and their spell,
> for money and for chains they pray.

6. Shchegolev, *Pushkin,* p. 241.
7. Translated by Walter Morison (*Pushkin's Poems* [Allen and Unwin], 1946).

It can hardly be supposed that he was here thinking of the town artisans.

If all this is correct, then we seem to be arriving at the following conclusion:—

The tendency towards art for art's sake arises where the artist is in disaccord with his social environment.

It may be said that the single example of Pushkin is not by itself enough to support such a conclusion. I do not dispute it. But I will cite other examples from the history of French literature—that is, from the literature of a country whose intellectual trends met with the widest sympathy throughout Europe, at least until the middle of the last century.

The French Romantics, Pushkin's contemporaries, were, with few exceptions, fervent supporters of art for art's sake. Théophile Gautier, probably the most consistent of them, launched the following diatribe against the defenders of the utilitarian view of art.

No, you idiots, no, you cretins, you can't make soup out of a book or a pair of boots out of a novel. . . . I swear by the guts of all past, present and future Popes—no, a thousand times, no! I am one of those who consider the superfluous essential; my love for things and people is in inverse proportion to their utility.[8]

The same Gautier, in a biographical note on Baudelaire, highly praised the author of the *Fleurs du mal* because he had defended the "absolute autonomy of art and would not allow poetry to have any other purpose than itself, or any task than that of arousing in the reader's heart a sense of the beautiful in the absolute meaning of the word."

How little the "sense of the beautiful" was connected in Gautier's mind with any social and political considerations, may be gathered from the following declaration:—

I will most gladly renounce my rights as a Frenchman and a citizen, in order to see an original by Raphael or a beautiful woman in the nude.

It would be impossible to go further than this. Yet all the Parnassians[9] would probably have agreed with Gautier even if some of them might have expressed certain reservations about the excessively paradoxical form in

8. Foreword to the novel, *Mademoiselle de Maupin*.

9. A group of French poets initiated and led by Théophile Gautier, Leconte de Lisle and others after the defeat of the 1848 Revolution. They believed in "art for art's sake," and at the same time advocated clarity of imagery and objectivity of content in poetry.—TRANS.

which, especially in his youth, he expressed his demand for the "absolute autonomy of art."

Whence came this mood among the French Romantics and Parnassians? Were they, too, out of tune with the society about them?

In 1857, in an article on the revival at the Théâtre-Français of de Vigny's play *Chatterton*, Théophile Gautier recalled its first presentation on February 12, 1835, and told the following story:

The pit before which *Chatterton* was being played was filled with pale, long-haired youths, who firmly believed that there was no more worthy profession than the writing of verses or the painting of pictures, and who regarded the "bourgeois" with a scorn surpassing beyond compare that of the Heidelberg or Jena undergraduate for the "philistine." [10]

And who were these despised "bourgeois"?

"The bourgeois," replied Gautier, "comprised nearly everyone—bankers, stockbrokers, lawyers, merchants, shopkeepers and so on—everyone, in a word, who did not belong to the secret *cenacle* [that is, to the romantic circle—G. V. P.], and who got his living in a commonplace way." [11]

And here is another witness. In the commentary to one of his *Odes funambulesques,* Théodore de Banville admits that he, too, lived through this phase of hatred for the "bourgeois." At the same time he explains whom precisely the Romantics called by this name.

In the language of the Romantics, a "bourgeois" is a man whose only religion is that of the five-franc piece, whose only ideal is to save his own skin, who in poetry enjoys sentimental ballads and in the plastic arts—coloured lithographs. [12]

In view of this, de Banville asked his readers not to be surprised if, in his *Odes funambulesques*—which, by the way, were published during the last period of romanticism—people whose only crime was that they led a bourgeois life and did not worship Romantic heroes, were treated as the greatest blackguards.

This evidence shows convincingly enough that the Romantics did in fact find themselves out of tune with the bourgeois society round them. True, their disaccord held no threat to bourgeois social relationships. The

10. *Histoire du romantisme,* pp. 153–54.

11. *Ibid.,* p. 154.

12. *Les Odes funambulesques* (Paris, 1858), pp. 294–95.

Romantic circles were composed of young bourgeois who had no objection to these relationships, but inveighed against the dirt, boredom and vulgarity of bourgeois existence. The new art which so much attracted them was their refuge from this dirt, boredom and vulgarity. In the last years of the Restoration and the first half of the reign of Louis Philippe—that is, in the best period of romanticism—the youth of France found it all the harder to become accustomed to the prosaic dirt and boredom of bourgeois life since not so long before France had passed through the fearful storms of the great Revolution and of the Napoleonic era, both of which had profoundly stirred every human passion.[13] When the bourgeoisie had assumed a leading position in society and was no longer fired by the struggle for emancipation, there was only one thing left for the new art to do—to *idealise the renunciation of the bourgeois mode of life.* Romantic art was such an idealisation. The Romantics sought to express their hostility to bourgeois moderation and punctiliousness not only in their works of art but also in their appearance. We have already heard from Gautier that the young men who filled the theatre at the first performance of *Chatterton* wore their hair long. Who has not heard of the red waistcoat sported by Gautier himself, which horrified "respectable people"? Fantastic dress, like long hair, served the young Romantics as a means of counterposing themselves to the hated bourgeois. A pale face served the same purpose. It was like a protest against the well-fed bourgeois. Gautier wrote:

It was then the fashion for the Romantics to look as pale as possible, with even a green and almost corpse-like pallor. This gave a man a fateful, Byronic aspect, as though he were torn asunder by passions and tortured by pangs of conscience, and it made him interesting to women.[14]

Gautier also tells us that the Romantics found it hard to forgive Victor Hugo his respectable outward appearance:

13. Alfred de Musset described this disaccord as follows: "From this moment one might say that two camps were created. On the one hand were the exalted and suffering spirits, all the expansive souls yearning after the infinite. Bathed in tears, they bowed their heads, wrapped themselves in sickly visions and all that could be seen were frail reeds quivering in a sea of bitterness. On the other hand, the men of flesh and blood stood upright and unbending, thoroughly enjoying themselves, and untroubled by any thought save that of counting their money. There remained nothing but a sob and a guffaw—the one coming from the soul, the other from the body" (*La confession d'un enfant du siècle*, p. 10).

14. De Musset, *La confession*, p. 31.

Behind closed doors, when no strangers were present, they used to deplore this weakness of a great genius, which linked him with mankind and even with the bourgeoisie.[15]

It is worth while noting, by the way, that in the efforts of people to give themselves some particular external appearance or another are always reflected the social relationships of the epoch concerned. An interesting sociological study could be written on this subject.

With such an attitude towards the bourgeoisie, the young Romantics inevitably waxed indignant at the thought of "utilitarian art." To make art useful meant, in their eyes, forcing it to serve the very bourgeois they so deeply despised. This explains Gautier's outbursts against the protagonists of utilitarian art, quoted above, whom he described as idiots, cretins, and so on. It also explains his paradoxical idea that the value of people and things was in inverse proportion to their use. All these outbursts and paradoxes are equivalent in their content to Pushkin's:—

Away then! May the peaceful poet own a common lot with you?

The Parnassians and the first French realists (Goncourt, Flaubert and others) were also filled with limitless scorn for the bourgeois society around them. They, too, unceasingly abused the hateful "bourgeois." If they published their works, it was done, so they said, not at all for the broad public, but for the chosen few, for "unknown friends," as Flaubert expressed it in one of his letters. In their opinion, only second-rate writers could appeal to any broad reading public. Leconte de Lisle, considered that, for a writer, a great success was a sign of intellectual inferiority. It is hardly necessary to add that the Parnassians, like the Romantics, were unquestioning supporters of the theory of art for art's sake.

Many such similar examples could be cited. But there is no need. It is already clear enough that the tendency of the artist to accept the theory of art for art's sake arises when he finds himself in disaccord with the society in which he lives. It will be as well, however, to define the nature of this disaccord more precisely.

At the end of the eighteenth century, in the period immediately preceding the great Revolution, leading French artists also found themselves in disaccord with the ruling "society" of the day. David and his friends were opponents of the "old order." And this disaccord was, of course, quite insoluble, in the sense that any reconciliation between themselves and the

15. *Ibid.,* p. 32.

old order was impossible. More than that, the differences of David and his friends with the old order went incomparably deeper than those of the Romantics with bourgeois society. David and his friends were striving to put an end to the old order, while Théophile Gautier and those who thought like him had nothing against bourgeois social relationships, as I have said more than once, but wished only that the bourgeois system should cease to give rise to vulgar bourgeois habits.[16]

Nevertheless, in protesting against the old order, David and his friends knew very well that behind them in serried ranks marched that third estate which was soon to become everything—as the Abbé Sieyès had expressed it. And so the sense of disaccord with the prevailing order was supplemented in their case by sympathy for the new society which was taking shape within the womb of the old and preparing to supplant it. With the Romantics and the Parnassians it was a very different matter. They neither expected nor desired a change in the social order of France. And for that reason, their disagreement with society was without hope and without issue.[17]

Nor did Pushkin expect any changes in the Russia of his day. One might even say that in the reign of Nicholas he had probably ceased to desire them. That is why his attitude to social life too was coloured with pessimism.

It seems to me that I can now add a word to my first conclusion and say:

The tendency of artists, and of those who have a lively interest in art, towards art for art's sake, arises when they are in hopeless disaccord with the social environment in which they live.

Nor is this all. The example of the Russian "men of the sixties" who

16. Théodore de Banville said frankly that the attacks of the Romantics on the "bourgeois" did not have in view the "bourgeoisie" as a social class (*Les Odes funambulesques* [Paris, 1858], p. 294.) This conservative revolt against the "bourgeois," peculiar to the Romantics, which was far from assailing the basis of bourgeois society, has been understood by some Russian would-be theoreticians at the present time (like Mr. Ivanov-Razumnik, for example), as a struggle against philistinism which far exceeds in its scope the social and political struggle of the proletariat against the bourgeoisie. I leave it to the reader to judge the profundity of this conception. In point of fact it shows that people who discuss the history of Russian social thought have, unfortunately, not always given themselves the trouble of making a preliminary acquaintance with the history of thought in Western Europe.

17. A similar hopeless disaccord with their social environment marked the temper of the German Romantics, as has been well demonstrated by Brandes in his book *Die romantische Schule in Deutschland*, vol. II of his work, *Die Hauptströmungen der Literatur des 19—ten Jahrhunderts.*

firmly believed in the approaching triumph of reason, and the example also of David and his friends, who were no less firmly of the same opinion, shows us *that the so called utilitarian view of art, that is to say, the inclination to attribute to works of art the significance of judgment on the phenomena of life, and its constant accompaniment of glad readiness to participate in social struggles, arises and becomes stronger wherever a mutual sympathy exists between the individuals more or less actively interested in artistic creation and some considerable part of society.*

How true this is, is conclusively proved by the following:

When the refreshing storm of the 1848 Revolution burst, many French artists who had previously subscribed to the theory of art for art's sake, decisively rejected this theory. Even Baudelaire, whom Gautier later cited as an example of an artist unshakably convinced of the need for the unconditional autonomy of art, at once began the publication of a revolutionary journal, *Le Salut Public.* True, the journal soon ceased publication, but as late as 1852, in the foreword to the *Chansons* of Pierre Dupont, Baudelaire called the theory of art for art's sake puerile and proclaimed that art must serve social ends. Only the victory of the counterrevolution finally turned Baudelaire and other artists, whose temper was similar to his own, back to the "puerile" theory of art for art's sake. One of the future lights of Parnassus, Leconte de Lisle, revealed very clearly the psychological significance of this about-turn, in the foreword of his *Poèmes antiques,* a first edition of which appeared in 1852. Here we read that—

poetry can no longer give birth to heroic deeds, it can no longer inspire social virtues, because at the present stage, as in all periods of literary decadence, its sacred tongue can express only petty personal experiences . . . and is no longer capable of teaching mankind.[18]

Addressing himself to the poets, he continues: "Poets, what would you say, what would you teach? Teachers, the time has come when your pupil instinctively knows more than you."[19] In the words of the future Parnassian, the task of poetry is to "give an ideal life to those who no longer have a real one."[20] In these profound words the entire psychological secret of the tendency towards art for art's sake is revealed. Later on, we shall have occasion more than once to refer to this foreword of Leconte de Lisle.

To finish with this side of the question, I will add that any given political power, in so far as it is interested in art at all, always favours the utilitarian

18. *Poèmes antiques* [Paris, 1852], Préface, p. vii.
19. *Ibid.,* p. ix.
20. *Ibid.,* p. xi.

view of art. And this is quite understandable: it is in its interests to make all ideologies serve the cause to which it is itself devoted. And since political power, which is sometimes revolutionary, is more often conservative or even entirely reactionary, it would be a mistake to assume that the utilitarian view of art is peculiar to revolutionaries, or to people with advanced ideas. The history of Russian literature graphically shows that even our imperial "guardians" were far from antagonistic to this view of art.

PLEKHANOV: **LABOR, PLAY, AND ART**
from *Letters Without Address*

How did human economy develop from the individual search for food? In Bücher's opinion, we can at present form practically no conception of this; I think, however, that we shall arrive at one if we accept the fact that *the search for food was originally social, and not individual.* Men originally "sought" food just as the social animals seek it: groups of varying size combined forces in order to acquire the *ready gifts* of nature. Earle, from whom I have already quoted in my previous letter, is right in remarking after De la Gironière, that when the Negritos go hunting in whole clans they remind one of a herd of orang-outangs setting off on a predatory raid. The ravaging of fields carried on by the united forces of the Akka pigmy tribe also call such raids to mind. If, by economy, we have to understand the combined activity of men for the purpose of acquiring goods, then such raids must be recognised as one of the very earliest aspects of economic activity.

The original form of acquiring goods was *collection of the ready gifts of nature.*[1] This collection itself can, of course, be sub-divided into several categories, among which were fishing and hunting. After *collection* follows *production*—as seen, for example, in the history of primitive agriculture— sometimes linked with it by a series of scarcely perceptible transitions. Agriculture, of course—even the most primitive—already shows all the marks of economic activity.[2]

1. "Accordingly it was the collecting people and not the hunting people who must have stood at the foot of the ladder of human economic development," as Pankow correctly remarks in *Zeitschrift der Gesellschaft für Erdkunde zu Berlin,* vol. XXX no. 3, p. 162. This is also the view of the Sarasins, in whose opinion hunting only becomes an important "means of obtaining food at a comparatively higher level of development." (*Die Weddahs,* p. 401.)

2. Certain customs of the Australian aborigines show them as disposed to economic activity and again provide evidence that they, too, think of the future. Among these

And since primitive cultivation is very often carried on by the united forces of the clan, a graphic instance is provided of the way in which the social instincts, inherited by primitive man from his anthropoid forbears could be widely applied in his economic activity. The further fate of these instincts was determined by those (constantly changing) mutual relations into which people entered through this activity, or, as Marx expressed it, "in the social production of their means of existence."[3] All this is as natural as could be and *I do not understand what perplexities there can be about this natural course of development.*

Just a moment, though.

According to Bücher the difficulty is as follows. "It would be fairly natural to suppose," he says, "that this upheaval (the transition to an economy from the individual search for food) begins when, in place of the simple appropriation of the gifts of nature for immediate consumption, production for some more remote purpose arises, and labour, as an application of physical force with a conscious aim, replaces the instinctive activity of the organs. But in establishing a purely theoretical postulation of this kind we shall have gained but little. *Labour,* as known among the primitive peoples, is in itself a somewhat vague phenomenon. The closer we approach the point where its development commences the nearer it approaches, both in form and content, to *play.*"[4]

And so the obstacle to understanding the transition from the simple search for food to economic activity lies in the difficulty of drawing a line between labour and play.

The solution of this problem, the relationship of labour to play—or, if you prefer it, of play to labour—is in the highest degree important for the clarification of the *genesis of art.* Therefore I invite you, Sir, to give your patient attention and *weigh up painstakingly* all that Bücher has to say about this. Let him expound his views himself.

"In leaving the restricted limits of the simple search for food man was probably prompted by instincts similar to those observable among higher animals, especially by the instinct of imitation and by an instinctive inclination towards all kinds of experiment. The taming of domestic animals begins, for example, not with useful animals, but with those which man maintains solely for his own pleasure. The development of manufacture

people it is forbidden to root up the plants whose fruit they use for food, as well as to destroy the nests of birds whose eggs they eat, etc. Ratzel, *Anthropo-Geographie,* vol. I, p. 348.

3. Preface to the *Contribution to the Critique of Political Economy.*—Trans.

4. *Four Essays,* pp. 92, 93.

apparently always begins with the painting of the body, the tattooing, piercing or distortion of various parts of the body, after which, little by little the preparation of ornaments, masks, drawings on bark, hieroglyphs and similar occupations develop. . . . Thus, technical skills are elaborated in play and only gradually acquire useful application. And therefore the previously accepted sequence of stages in development must be replaced by their direct opposite: play is older than labour, and art is older than the production of useful objects."[5]

You hear what he says: *play is older than labour, and art is older than the production of useful objects.*

Now you can understand why I asked you to pay particular attention to Bücher's words: they have the closest relationship to the historical theory which I am defending. If play is indeed older than labour and if art is indeed older than the production of useful objects, then the materialist explanation of history, at any rate as expounded by the author of *Capital, will not stand up to the criticism of the facts* and all my reasoning must be turned upside down: I shall have to argue about the dependence of economics on art and not about the dependence of art on economics. But is Bücher right?

Let us first test what he has said about play. We shall deal with art later on.

According to Spencer the chief distinctive feature of play lies in the fact that it does not directly assist the processes essential for the support of life. The activity of the individual at play is not undertaken for any specific, utilitarian purpose. True, the exercise of the organs brought into action by the game is useful for the individual who is playing and so, in the final count, for the whole of his kind. But exercise is not precluded by activity for utilitarian purposes either. It is not a question of exercise, but of the fact that utilitarian activity, besides the exercise and the pleasure it affords, leads to the achievement as well of some practical aim—for instance, that of obtaining food—whereas in play any purpose of this sort is absent. When a cat catches a mouse, besides the pleasure afforded her by the exercise of her limbs she has a welcome morsel of food, while the same cat, when she runs after a ball of thread rolled across the floor, gets nothing but the pleasure afforded by the game. But if this is so, how can such aimless activity arise?

We know how Spencer answers this. Among lower animals the whole strength of the organism is expended on the fulfilment of functions essential to the support of life. Only utilitarian activity is known to the lower ani-

5. *Four Essays*, pp. 93–94.

mals. But on higher rungs of the animal ladder it is quite a different matter. Not all their powers, here, are absorbed by utilitarian activity. Thanks to better nourishment the organism accumulates a certain surplus of strength which demands an outlet and, when the animal plays, it is this demand that it is obeying. Play is the artificial exercise of strength.[6]

Such is the *origin* of play. And what is its *content*? In other words: if, in playing, the animal exercises its strength, why does one animal exercise it in one way and another differently; why are various kinds of play peculiar to different varieties of animal?

According to Spencer, beasts of prey clearly show us that their play consists of sham hunting and sham fighting. All this is "a dramatising of the pursuit of prey—an ideal satisfaction for the destructive instincts in the absence of real satisfaction for them."[7] What does this mean? It means that in animals the content of play is determined by such activity as assists in the support of their existence. Which comes first then—play before utilitarian activity, or utilitarian activity before play? It is clear that utilitarian activity *precedes play, that the former is "older" than the latter.* And what do we find amongst men? Children's "plays," nursing dolls, giving tea-parties and so on are dramatisings of adult activities.[8] But what aims do adults pursue in their activities? In the overwhelming majority of cases they pursue *utilitarian aims*. In other words *activity among human beings in pursuit of utilitarian ends,* that is, activity essential to support the existence of individuals and the whole of society, *also precedes play and is the factor which determines its content.* Such is the conclusion that follows logically from what Spencer says about play.

This logical conclusion completely coincides with the views of Wilhelm Wundt on the same subject.

"Play is the child of labour," says the famous psychophysiologist. "There is not a single form of play which has not its model in one or another kind of serious occupation which, it goes without saying, precedes it in time. For the needs of life compel man to work, and in labour he learns little by little to look upon the use of his strength in the work he is doing as a pleasure."[9]

Play is born of the urge to experience anew the pleasure afforded by the purposive use of strength. And the greater the reserve of strength, the greater the urge to play—other conditions being equal, of course. Nothing is easier than to convince oneself of this fully.

6. Cf. Herbert Spencer, *Principles of Psychology* (London, 1872), vol. II, p. 630.
7. *Ibid.,* p. 631.
8. *Ibid.,* p. 631.
9. *Ethik* (Stuttgart, 1886), p. 145.

ROSA LUXEMBURG

*It is only through a misunderstanding
that I am in the midst
of this whirlpool of world history,
whereas in reality I was born
to look after the geese in the fields.*
—Rosa Luxemburg to Luise Kautsky

INTRODUCTION

Many of her friends and associates expected that Rosa Luxemburg (1871–1919) would make fundamental contributions to the criticism and appreciation of the arts. In her early childhood she developed strong aesthetic inclinations; she was a trained amateur singer who could negotiate Mozart arias and the German *Lieder* repertoire; at a tender age she sketched plants, flowers, landscapes, and portraits in brush and pencil and later worked extensively in oils with sufficient success to draw the admiration of professional painters. Frölich (her first biographer) reports that she wrote poetry as a child: no serious poetry survives, but the few rhymes scattered through the correspondence indicate that she had talents in this direction as well. Her tastes were sound, sensitive and, though generally conventional, were occasionally somewhat advanced, as in her passion for Hugo Wolf's songs, for the watercolors of Turner, for de Coster's *Tyl Ulenspiegel*. Maupassant and Balzac were not altogether to her taste ("of course one must have read them," she wrote to Marta Rosenbaum); she preferred Stendhal, Flaubert, Goncourt, and the Russians. She knew the entire

German classical literature, preferring Lessing to Schiller, and placing Hebbel beneath Grillparzer and Kleist. Her admiration for Goethe and Tolstoy was unbounded. She resisted pamphleteering in art (though she confessed that Gorki's *Mother* "deeply shook" her); writing to Hans Diefenbach of *Jean Christophe,* she finds "the book very worthy and sympathetic, but more of a pamphlet than a novel, not really a work of art."

Given this background, given a grasp of Marxist theory of the highest order, Rosa Luxemburg might well have expanded the limited boundaries within which European Marxism dealt with problems of art.

But in Rosa Luxemburg the aesthetic impulse took a rather extraordinary turn. In her the split between aesthetic appreciation and Marxism is made deliberate and manifest. She did not suppress her love for art or abandon her artistic leanings in favor of her manifold revolutionary activities. Rather, she maintained her love for the arts by a deliberate refusal to analyze or criticize them. This finds its clearest expression in a letter of May 12, 1917, to Hans Diefenbach:

Your idea that I should write a book on Tolstoy means nothing to me. For whom? Why? Everyone can read Tolstoy's books, and those to whom the books themselves bring no strong breath of life will not receive it from any commentary of mine. Can one "explain" Mozart's music to anyone? Can one "explain" wherein the magic of life resides . . . ?

Rosa Luxemburg defended the wholeness of her artistic ego (and her cultural idols) from critical reductionism. And this extended not only to socialist mythicizing criticism but to bourgeois scholarship as well: "I regard . . . the whole stupendous Goethe-literature (i.e., the literature *concerning* Goethe) as waste-paper, and am of the opinion that too many books have already been written."

Despite her resistance to the analysis of art Rosa Luxemburg did compose several works of literary criticism, and in these we find an attempt (which closely parallels Lenin's approach to Tolstoy) at reconciliation of nonsocialist ideology with "progressive" content. Reprinted here are the opening pages of her introduction to her German translation (published 1919) of Vladimir Korolenko's *History of a Contemporary.* No specific Marxist categories are brought to bear; there is no attempt at creation of a Marxist aesthetic approach; the essay is written from a humanitarian-socialist viewpoint in which literature is seen as rising from a particular psychological outlook in turn engendered by large-scale historical movements. This selection is representative of the general approach to literature by many early twentieth-century socialists. Despite its typicality, it

contains several important formulations, including a defense of the aesthetic integrity of the work of art ("the social formula . . . is a matter of secondary importance") and a sensitive view of decadence, as "the full measure of social sympathy under which the energy and resistance of the individual breaks down."

———

Rosa Luxemburg was born in Zamosc, Poland, one of the centers of Jewish life of Eastern Europe, but was raised in Warsaw from the age of two. Her parents were well-off (with intermittent spells of poverty) and her father was a Jewish intellectual-businessman who took a deep interest in world affairs and Western literature and was sympathetic to the Polish national-revolutionary movement. After attending the Gymnasium, she joined the "Revolutionary Socialist Party of the Proletariat" in 1887 and began to study Marxism. In 1889 she left Poland and enrolled at the University of Zürich as a student first of philosophy and then of law. Botany and zoology were prime interests, which maintained a strong appeal in her later years. She received her doctorate in political science in 1897 (her dissertation was "The Industrial Development of Poland"), and in the following year she left the emigrant–revolutionary *Bohème* of Zürich and moved to Germany where she joined the German Social Democratic Party. From then until her assassination in January 1919, Rosa Luxemburg was one of the foremost intellectual and political leaders of the Marxist world. Her major writings are in the fields of political economy and revolutionary tactics. Her more important works are *Social Reform or Revolution* (1899), "Organizational Questions of Russian Social-Democracy" (1904), *The Mass Strike, The Political Party and the Trade Union* (1906), *Introduction to Political Economy* (begun 1907), and *The Crisis in Social Democracy* (1916). Her masterwork is *The Accumulation of Capital* (1913) which is regarded by many as the most significant contribution to Marxist economics after Marx. A controversial writing was the post-humously published incomplete draft of a 1918 work, *The Russian Revolution,* in which she predicted certain aspects of Stalinism on the basis of already discernible trends in Lenin's and Trotsky's thought, and especially in what she saw as their undialectical formulation of the question of "dictatorship *or* democracy." Wrote Luxemburg: "Dictatorship, yes! But this dictatorship consists in the *manner of applying democracy,* not in its *elimination.*" Whether Lenin would have disagreed with her formulation is another matter; Rosa Luxemburg tended to create disagreements where none need have existed.

She was perpetually in opposition: she broke with or vigorously debated with every major Marxist theoretician of the age—with Plekhanov, with Kautsky, with her dear friend Mehring (whose death was perhaps brought on by the news of her murder), with Bernstein (of course), with Lenin, with Wilhelm Liebknecht. Her relationship to her disciples was no warmer: toward Trotsky (who later claimed her posthumous sponsorship for the Fourth International) she was hostile; she maintained a "ferocious dislike" of Karl Radek. Only August Bebel remained unscathed—probably because he was so totally untheoretical ("If the matter is good," he wrote to Bernstein, "I don't give a straw for the method"). She followed Marx's motto—"Doubt everything"—with unvarying fidelity.

Marx and Engels did not escape her careful scrutiny. She approved of Engels' *Peasant War in Germany,* but suggested to a reader that he would do well to read Zimmermann's study of the same subject, on which Engels based himself: "Engels gives really no history . . . the nourishing meat of the events is in Zimmermann." She urged her friends to read Marx "for the freshness of his style and the daring of his thoughts, the refusal to take anything for granted." Taking nothing for granted, she would have broken with Marx too could she have found an issue, and many (not including herself) regarded *The Accumulation of Capital* as a radical revision of Marx's political economy. The closest she came to direct criticism of Marx was in the aesthetic realm rather than in political economy. She wrote to Diefenbach in 1817:

It is above all now the tendency of my taste, in scientific work as well as in art, to treasure only the simple, the calm and the noble: I now find the much-praised first volume of Marx's Capital, with its superabundance of rococo ornamentation in the Hegelian style, an atrocity (for which from the party standpoint I should be placed in a house of correction for five years and disgraced for ten).

Rosa Luxemburg did not turn her talents to quibbling with Marx but rather to the exploration of why his theories had remained essentially undeveloped after his death. In the second selection, "Stagnation and Progress of Marxism," she explores the reasons for this "latency" of Marxist ideas and suggests the conditions under which those ideas might become operative. (The implications for a theory of aesthetics are great, but she does not draw them.) Of all Marxists up to her time, only she had glimpsed the infinity of Marx's thought, the degree to which it transcended the historical matrix in which it was born and the degree to which it remained unusable, "unnecessary," in the early revolutionary and trade-union struggles. That she was able to grasp this is a measure of her desire

to transcend Marx; only the constant testing of his ideas against her own attempts at their refutation could have made this conclusion possible.

Implicit in her analysis of the stagnation of Marxism is a pessimistic view of cultural and artistic development. Trotsky in his Luxemburgian *Literature and Revolution* appears to have drawn such conclusions; and they will recur in the later writings of Marcuse (who is very much in the Luxemburg tradition though he appears to have "forgotten" her) as well. For it is a short step from her thesis of the historically inevitable stagnation of Marxism to the idea of the superfluity (or impotence) of theory, of culture, of philosophy, and of art. She did not draw these conclusions herself, although in an unguarded moment she confessed to Diefenbach that she felt her own major theoretical work, *The Accumulation of Capital*, to be superfluous:

Naturally, the reader must, in order to scientifically appreciate my "Anti-Critique," be a master of national economy in general and of Marxism in particular, and that to the nth degree. And how many such mortals are there today? Not a half-dozen. My work is from this standpoint truly a luxury product and might just as well be printed on handmade paper.

Her discovery of the latency of the deepest concepts of Marxism is simultaneously the discovery of the limitless possibilities inherent in its method, which she calls part of the "means of production" of mankind. Perhaps it was her discovery of the regenerative principle within Marxism—its capacity to reveal new aspects and levels of its theory in each of its confrontations with history—which influenced Georg Lukács to write in his Luxemburgian *History and Class Consciousness:*

Even if we were to assume (though we do not admit) that recent research had disproven the factual basis of every single utterance of Marx beyond any doubt, these results could be admitted without hesitation by every serious "orthodox" Marxist; he could reject every single thesis of Marx without surrendering, even for a moment, his Marxist orthodoxy.

This can be taken as a leap into faith. On a deeper level it is a recognition of the poetry of Marxism as its revolutionary principle.

LUXEMBURG: **ON RUSSIAN LITERATURE**
from Introduction to Korolenko's *History of a Contemporary*

"My soul, of a threefold nationality, has at last found a home—and this above all in the literature of Russia," Korolenko says in his memoirs. This literature, which to Korolenko was fatherland, home, and nationality, and which he himself adorns, was historically unique.

For centuries, throughout the Middle Ages and down to the last third of the eighteenth century, Russia was enveloped in a cryptlike silence, in darkness and barbarism. She had no cultivated literary language, no scientific literature, no publishing houses, no libraries, no journals, no centers of cultural life. The gulf stream of the Renaissance, which had washed the shores of all other European countries and was responsible for a flowering garden of world literature, the rousing storms of the Reformation, the fiery breath of eighteenth-century philosophy—all this had left Russia untouched. The land of the czars possessed as yet no means for apprehending the light rays of Western culture, no mental soil in which its seeds could take root. The sparse literary monuments of those times, in their outlandish ugliness, appear today like native products of the Solomon Islands or the New Hebrides. Between them and the art of the Western world, there apparently exists no essential relation, no inner connection.

But then something like a miracle took place. After several faltering attempts toward the end of the eighteenth century to create a national consciousness, the Napoleonic wars flashed up like lightning. Russia's profound humiliation, arousing for the first time in czardom a national consciousness, just as the triumph of the Coalition did later, resulted in drawing the Russian intellectuals toward the West, toward Paris, into the heart of European culture, and bringing them into contact with a new world. Overnight a Russian literature blossomed forth, springing up complete in glistening armor like Minerva from the head of Jupiter; and this literature, combining Italian melody, English virility, and German nobility and profundity, soon overflowed with a treasure of talents, radiant beauty, thought and emotion.

The long dark night, the deathlike silence, had been an illusion. The light rays from the West had remained obscure only as a latent power; the seeds of culture had been waiting to sprout at the appropriate moment. Suddenly, Russian literature stood there, an unmistakable member of the literature of Europe, in whose veins circulated the blood of Dante, Rabelais, Shakespeare, Byron, Lessing, and Goethe. With the leap of a lion it atoned for

the neglect of centuries; it stepped into the family circle of world literature as an equal.

The chief characteristic of this sudden emergence of Russian literature is that it was born out of opposition to the Russian regime, out of the spirit of struggle. This feature was obvious throughout the entire nineteenth century. It explains the richness and depth of its spiritual quality, the fullness and originality of its artistic form, above all, its creative and driving social force. Russian literature became, under czarism, a power in public life as in no other country and in no other time. It remained at its post for a century until it was relieved by the material power of the masses, when the word became flesh.

It was this literature which won for that half-Asiatic, despotic state a place in world culture. It broke through the Chinese Wall erected by absolutism and built a bridge to the West. Not only does it appear as a literature that borrows, but also as one that creates; not only is it a pupil, but also a teacher. One has only to mention three names to illustrate this: Tolstoy, Gogol, and Dostoyevsky.

In his memoirs, Korolenko characterizes his father, a government official at the time of serfdom in Russia, as a typical representative of the honest people in that generation. Korolenko's father felt responsible only for his own activities. The gnawing feeling of responsibility for social injustice was strange to him. "God, Czar, and the Law" were beyond all criticism. As a district judge he felt called upon only to apply the law with the utmost scrupulousness. "That the law itself may be inefficient is the responsibility of the czar before God. He, the judge, is as little responsible for the law as for the lightning of the high heavens, which sometimes strikes an innocent child. . . ." To the generation of the eighteen-forties and fifties, social conditions as a whole were fundamental and unshakable. Under the scourge of officialdom, those who served loyally, without opposition, knew they could only bend as under the onslaught of a tornado, hoping and waiting that the evil might pass. "Yes," said Korolenko, "that was a view of the world out of a single mold, a kind of imperturbable equilibrium of conscience. Their inner foundations were not undermined by self-analysis; the honest people of that time did not know that deep inner conflict which comes with the feeling of being personally responsible for the whole social order." It is this kind of view that is supposed to be the true basis of czar and God, and as long as this view remains undisturbed, the power of absolutism is great indeed.

It would be wrong, however, to regard as specifically Russian or as pertaining only to the period of serfdom the state of mind that Korolenko describes. That attitude toward society which enables one to be free of

gnawing self-analysis and inner discord and considers "God-willed conditions" as something elemental, accepting the acts of history as a sort of divine fate, is compatible with the most varied political and social systems. In fact it is found even under modern conditions and was especially characteristic of German society throughout the world war.

In Russia, this "imperturbable equilibrium of conscience" had already begun to crumble in the eighteen-sixties among wide circles of the intelligentsia. Korolenko describes in an intuitive manner this spiritual change in Russian society, and shows just how this generation overcame the slave psychology and was seized by the trend of a new time, the predominant characteristic of which was the "gnawing and painful, but creative spirit of social responsibility."

To have aroused this high sense of citizenship, and to have undermined the deepest psychological roots of absolutism in Russian society, is the great merit of Russian literature. From its first days, at the beginning of the nineteenth century, it never denied its social responsibility—never forgot to be socially critical. Ever since its unfolding with Pushkin and Lermontov, its life principle was a struggle against darkness, ignorance, and oppression. With desperate strength it shook the social and political chains, bruised itself sore against them, and paid for the struggle in blood.

In no other country did there exist such a conspicuously early mortality among prominent representatives of literature as in Russia. They died by the dozens in the bloom of their manhood, at the youthful age of twenty-five or twenty-seven, or at the oldest around forty, either on the gallows or as suicides—directly or disguised as duels—some through insanity, others by premature exhaustion. So died the noble poet of liberty, Ryleyev, who in the year 1826 was executed as the leader of the Decembrist uprising. Thus, too, Pushkin and Lermontov, those brilliant creators of Russian poetry—both victims of duels—and their whole prolific circle. So died Belinsky, the founder of literary criticism and proponent of Hegelian philosophy in Russia, as well as Dobrolyubov; and so the excellent and tender poet Kozlov, whose songs grew into Russian folk poetry like wild garden flowers; and the creator of Russian comedy, Griboyedov, as well as his greater successor, Gogol; and in recent times, these sparkling short-story writers, Garshin and Chekhov. Others pined away for decades in penitentiaries, jails, or in exile, like the founder of Russian journalism, Novikov; like the leader of the Decembrists, Bestuzhev; like Prince Odoyevsky, Alexander von Herzen, Dostoyevsky, Chernyshevsky, Shevchenko, and Korolenko.

Turgenev relates, incidentally, that the first time he fully enjoyed the song of the lark he was somewhere near Berlin. This casual remark seems

very characteristic. Larks warble in Russia no less beautifully than in Germany. The huge Russian empire contains such great and manifold beauties of nature that an impressionable poetic soul finds deep enjoyment at every step. What hindered Turgenev from enjoying the beauty of nature in his own country was just painful disharmony of social relations, that ever present awareness of responsibility for those outrageous social and political conditions from which he could not rid himself, and which, piercing deeply, did not permit for a moment any indulgence in complete self-oblivion. Only away from Russia, when the thousands of depressing pictures of his homeland were left behind, only in a foreign environment, the orderly exterior and material culture of which had always naively impressed his countrymen, could a Russian poet give himself up to the enjoyment of nature, untroubled and wholeheartedly.

Nothing, of course, could be more erroneous than to picture Russian literature as a tendentious art in a crude sense, nor to think of all Russian poets as revolutionists, or at least as progressives. Patterns such as "revolutionary" or "progressive" in themselves mean very little in art.

Dostoyevsky, especially in his later writings, is an outspoken reactionary, a religious mystic and hater of socialists. His depictions of Russian revolutionaries are malicious caricatures. Tolstoy's mystic doctrines reflect reactionary tendencies, if not more. But the writings of both have, nevertheless, an inspiring, arousing, and liberating effect upon us. And this is because their starting points are not reactionary, their thoughts and emotions are not governed by the desire to hold on to the *status quo,* nor are they motivated by social hatred, narrow-mindedness, or caste egotism. On the contrary, theirs is the warmest love for mankind and the deepest response to social injustice. And thus the reactionary Dostoyevsky becomes the artistic agent of the "insulted and injured," as one of his works is called. Only the conclusions drawn by him and Tolstoy, each in his own way, only the way out of the social labyrinth which they believe they have found, leads them into the bypaths of mysticism and asceticism. But with the true artist, the social formula that he recommends is a matter of secondary importance; the source of his art, its animating spirit, is decisive.

Within Russian literature one also finds a tendency which, though on a considerably smaller scale and unlike the deep and world-embracing ideas of a Tolstoy or Dostoyevsky, propagates more modest ideals, that is, material culture, modern progress, and bourgeois proficiency. Of the older generation the most talented representative of this school is Goncharov, and of the younger one, Chekhov. The latter, in opposition to Tolstoy's ascetic and moralizing tendency, made the characteristic remark that "steam and electricity hold more love for humanity than sexual chastity

and vegetarianism." In its youthful, rousing drive for culture, personal dignity, and initiative, this somewhat sober, "culture-carrying" Russian movement differs from the smug philistinism and banality of the French and German delineators of the *juste milieu.* Goncharov particularly, in his book *Oblomov,* reached such heights in picturing human indolence that the figure he drew earned a place of universal validity in the gallery of great human types.

Finally, there are also representatives of decadence in Russia's literature. One of the most brilliant talents of the Gorki generation is to be found among them, Leonid Andreyev, whose art emanates a sepulchral air of decay in which all will to live has wilted away. And yet the root and substance of this Russian decadence is diametrically opposed to that of a Baudelaire or a D'Annunzio, where the basis is merely oversaturation with modern culture, where egotism, highly cunning in expression, quite robust in its essence, no longer finds satisfaction in a normal existence and reaches out for poisonous stimuli. With Andreyev hopelessness pours forth from a temperament which, under the onslaught of oppressive social conditions, is overpowered by pain. Like the best of the Russian writers, he has looked deeply into the sufferings of mankind. He lived through the Russo-Japanese war, through the first revolutionary period and the horrors of the counter-revolution from 1907 to 1911. He describes them in such stirring pictures as *The Red Laugh, The Seven Who Were Hanged,* and many others. And like his Lazarus, having returned from the shores of shadowland, he cannot overcome the dank odor of the grave; he walks among the living like "something half-devoured by death." The origin of this kind of decadence is typically Russian: it is that full measure of social sympathy under which the energy and resistance of the individual break down.

It is just this social sympathy which is responsible for the singularity and artistic splendor of Russian literature. Only one who is himself affected and stirred can affect and stir others. Talent and genius, of course, are in each case a "gift of God." Great talent alone, however, is not sufficient to make a lasting impression. Who would deny a Monti talent or even genius, though he hailed, in Dantean *terza rima,* first the assassination by a Roman mob of the ambassador of the French Revolution and then the victories of this same revolution; at one time the Austrians, and later the Directory; now the extravagant Suvárov, then again Napoleon and the Emperor Franz; each time pouring out to the victor the sweetest tones of a nightingale? Who would doubt the great talent of a Sainte-Beuve, the creator of the

literary essay who, in the course of time, put his brilliant pen to the service of almost every political group of France, demolishing today what he worshiped yesterday and vice versa?

For a lasting effect, for the real education of society, more than talent is needed. What is required is poetic personality, character, individuality, attributes which are anchored deeply in a great and well-rounded view of the world. It is just this view of the world, just this sensitive social consciousness which sharpened so greatly the insight of Russian literature into the social conditions of people and into the psychology of the various characters and types. It is this almost aching sympathy that inspires its descriptions with colors of glowing splendor; it is the restless search, the brooding over the problems of society which enables it to observe artistically the enormity and inner complexity of the social structure and to lay it down in great works of art.

LUXEMBURG: **STAGNATION AND PROGRESS OF MARXISM**
from *Karl Marx: A Symposium*

In his shallow but at times interesting causerie entitled *Die soziale Bewegung in Frankreich und Belgien* (The Social Movement in France and Belgium), Karl Grün remarks, aptly enough, that Fourier's and Saint-Simon's theories had very different effects upon their respective adherents. Saint-Simon was the spiritual ancestor of a whole generation of brilliant investigators and writers in various fields of intellectual activity; but Fourier's followers were, with few exceptions, persons who blindly parroted their master's words, and were incapable of making any advance upon his teaching. Grün's explanation of this difference is that Fourier presented the world with a finished system, elaborated in all its details; whereas Saint-Simon merely tossed his disciples a loose bundle of great thoughts. Although it seems to me that Grün pays too little attention to the inner, the essential, difference between the theories of these two classical authorities in the domain of utopian socialism, I feel that on the whole his observation is sound. Beyond question, a system of ideas which is merely sketched in broad outline proves far more stimulating than a finished and symmetrical structure which leaves nothing to be added and offers no scope for the independent efforts of an active mind.

Does this account for the stagnation in Marxist doctrine which has been noticeable for a good many years? The actual fact is that—apart from one or two independent contributions which mark a certain theoretical advance—since the publication of the last volume of *Capital* and of the last

of Engels' writings there have appeared nothing more than a few excellent popularisations and expositions of Marxist theory. The substance of that theory remains just where the two founders of scientific socialism left it.

Is this because the Marxist system has imposed too rigid a framework upon the independent activities of the mind? It is undeniable that Marx has had a somewhat restrictive influence upon the free development of theory in the case of many of his pupils. Both Marx and Engels found it necessary to disclaim responsibility for the utterances of many who chose to call themselves Marxists! The scrupulous endeavour to keep "within the bounds of Marxism" may at times have been just as disastrous to the integrity of the thought process as has been the other extreme—the complete repudiation of the Marxist outlook, and the determination to manifest "independence of thought" at all hazards.

Still, it is only where economic matters are concerned that we are entitled to speak of a more or less completely elaborated body of doctrines bequeathed us by Marx. The most valuable of all his teachings, the materialist-dialectical conception of history, presents itself to us as nothing more than a method of investigation, as a few inspired leading thoughts, which offer us glimpses into an entirely new world, which open to us endless perspectives of independent activity, which wing our spirits for bold flights into unexplored regions.

Nevertheless, even in this domain, with few exceptions the Marxist heritage lies fallow. The splendid new weapon rusts unused; and the theory of historical materialism remains as unelaborated and sketchy as it was when first formulated by its creator.

It cannot be said, then, that the rigidity and completeness of the Marxist edifice are the explanation of the failure of Marx's successors to go on with the building.

We are often told that our movement lacks the persons of talent who might be capable of further elaborating Marx's theories. Such a lack is, indeed, of long standing; but the lack itself demands an explanation, and cannot be put forward to answer the primary question. We must remember that each epoch forms its own human material; that if in any period there is a genuine need for theoretical exponents, the period will create the forces requisite for the satisfaction of that need.

But is there a genuine need, an effective demand, for a further development of Marxist theory?

In an article upon the controversy between the Marxist and the Jevonsian schools in England, Bernard Shaw, the talented exponent of Fabian semi-socialism, derides Hyndman for having said that the first volume of *Capital* had given him a complete understanding of Marx, and that there

were no gaps in Marxist theory—although Friedrich Engels, in the preface to the second volume of *Capital,* subsequently declared that the first volume with its theory of value, had left unsolved a fundamental economic problem, whose solution would not be furnished until the third volume was published. Shaw certainly succeeded here in making Hyndman's position seem a trifle ridiculous, though Hyndman might well derive consolation from the fact that practically the whole socialist world was in the same boat!

The third volume of *Capital,* with its solution of the problem of the rate of profit (the basic problem of Marxist economics), did not appear till 1894. But in Germany, as in all other lands, agitation had been carried on with the aid of the unfinished material contained in the first volume; the Marxist doctrine had been popularised and had found acceptance upon the basis of this first volume alone; the success of the incomplete Marxist theory had been phenomenal; and no one had been aware that there was any gap in the teaching. Furthermore, when the third volume finally saw the light, whilst to begin with it attracted some attention in the restricted circles of the experts, and aroused here a certain amount of comment—as far as the socialist movement as a whole was concerned, the new volume made practically no impression in the wide regions where the ideas expounded in the original book had become dominant. The theoretical conclusions of volume three have not hitherto evoked any attempt at popularisation, nor have they secured wide diffusion. On the contrary, even among the social democrats we sometimes hear, nowadays, re-echoes of the "disappointment" with the third volume of *Capital* which is so frequently voiced by bourgeois economists—and thus these social democrats merely show how fully they had accepted the "incomplete" exposition of the theory of value presented in the first volume.

How can we account for so remarkable a phenomenon?

Shaw, who (to quote his own expression) is fond of "sniggering" at others, may have good reason here, for making fun of the whole socialist movement, in so far as it is grounded upon Marx! But if he were to do this, he would be "sniggering" at a very serious manifestation of our social life. The strange fate of the second and third volumes of *Capital* is conclusive evidence as to the general destiny of theoretical research in our movement.

From the scientific standpoint, the third volume of *Capital* must, no doubt, be primarily regarded as the completion of Marx's critique of capitalism. Without this third volume, we cannot understand, either the actually dominant law of the rate of profit; or the splitting up of surplus value into profit, interest, and rent; or the working of the law of value within the field of competition. But, and this is the main point, all these problems, however important from the outlook of pure theory, are comparatively

unimportant from the practical outlook of the class war. As far as the class war is concerned, the fundamental theoretical problem is the origin of surplus value, that is, the scientific explanation of exploitation; together with the elucidation of the tendency towards the socialisation of the process of production, that is, the scientific explanation of the objective groundwork of the socialist revolution.

Both these problems are solved in the first volume of *Capital,* which deduces the "expropriation of the expropriators" as the inevitable and ultimate result of the production of surplus value and of the progressive concentration of capital. Therewith, as far as theory is concerned, the essential need of the labour movement is satisfied. The workers, being actively engaged in the class war, have no direct interest in the question how surplus value is distributed among the respective groups of exploiters; or in the question how, in the course of this distribution, competition brings about rearrangements of production.

That is why, for socialists in general, the third volume of *Capital* remains an unread book.

But, in our movement, what applies to Marx's economic doctrines applies to theoretical research in general. It is pure illusion to suppose that the working class, in its upward striving, can of its own accord become immeasurably creative in the theoretical domain. True that, as Engels said, the working class alone has to-day preserved an understanding of and interest in theory. The workers' craving for knowledge is one of the most noteworthy cultural manifestations of our day. Morally, too, the working-class struggle denotes the cultural renovation of society. But active participation of the workers in the march of science is subject to the fulfilment of very definite social conditions.

In every class society, intellectual culture (science and art) is created by the ruling class; and the aim of this culture is, in part, to ensure the direct satisfaction of the needs of the social process, and in part to satisfy the mental needs of the members of the governing class.

In the history of earlier class struggles, aspiring classes (like the Third Estate in recent days) could anticipate political dominion by establishing an intellectual dominance, inasmuch as, while they were still subjugated classes, they could set up a new science and a new art against obsolete culture of the decadent period.

The proletariat is in a very different position. As a non-possessing class, it cannot in the course of its struggle upwards spontaneously create a mental culture of its own while it remains in the framework of bourgeois society. Within that society, and so long as its economic foundations persist, there can be no other culture than a bourgeois culture. Although

certain "socialist" professors may acclaim the wearing of neckties, the use of visiting cards, and the riding of bicycles by proletarians as notable instances of participation in cultural progress, the working class as such remains outside contemporary culture. Notwithstanding the fact that the workers create with their own hands the whole social substratum of this culture, they are only admitted to its enjoyment in so far as such admission is requisite to the satisfactory performance of their functions in the economic and social process of capitalist society.

The working class will not be in a position to create a science and an art of its own until it has been fully emancipated from its present class position.

The utmost it can do to-day is to safeguard bourgeois culture from the vandalism of the bourgeois reaction, and create the social conditions requisite for a free cultural development. Even along these lines, the workers, within the extant form of society, can only advance in so far as they can create for themselves the intellectual weapons needed in their struggle for liberation.

But this reservation imposes upon the working class (that is to say, upon the workers' intellectual leaders) very narrow limits in the field of intellectual activity. The domain of their creative energy is confined to one specific department of science, namely social science. For, inasmuch as "thanks to the peculiar connexion of the idea of the Fourth Estate with our historical epoch," enlightenment concerning the laws of social development has become essential to the workers in the class struggle, this connexion has borne good fruit in social science, and the monument of the proletarian culture of our day is—Marxist doctrine.

But Marx's creation, which as a scientific achievement is a titanic whole, transcends the plain demands of the proletarian class struggle for whose purposes it was created. Both in his detailed and comprehensive analysis of capitalist economy, and in his method of historical research with its immeasurable field of application, Marx has offered much more than was directly essential for the practical conduct of the class war.

Only in proportion as our movement progresses, and demands the solution of new practical problems, do we dip once more into the treasury of Marx's thought, in order to extract therefrom and to utilise new fragments of his doctrine. But since our movement, like all the campaigns of practical life, inclines to go on working in old ruts of thought, and to cling to principles after they have ceased to be valid, the theoretical utilisation of the Marxist system proceeds very slowly.

If, then, to-day we detect a stagnation in our movement as far as these theoretical matters are concerned, this is not because the Marxist theory

upon which we are nourished is incapable of development or has become out-of-date. On the contrary, it is because we have not yet learned how to make an adequate use of the most important mental weapons which we had taken out of the Marxist arsenal on account of our urgent need for them in the earlier stages of our struggle. It is not true that, as far as the practical struggle is concerned, Marx is out-of-date, that we have superseded Marx. On the contrary, Marx, in his scientific creation, has outstripped us as a party of practical fighters. It is not true that Marx no longer suffices for our needs. On the contrary, our needs are not yet adequate for the utilisation of Marx's ideas.

Thus do the social conditions of proletarian existence in contemporary society, conditions first elucidated by Marxist theory, take vengeance by the fate they impose upon Marxist theory itself. Though that theory is an incomparable instrument of intellectual culture, it remains unused because, while it is inapplicable to bourgeois class culture, it greatly transcends the needs of the working class in the matter of weapons for the daily struggle. Not until the working class has been liberated from its present conditions of existence will the Marxist method of research be socialised in conjunction with other means of production, so that it can be fully utilised for the benefit of humanity-at-large, and so that it can be developed to the full measure of its functional capacity.

THE BOLSHEVIKS

VLADIMIR ILYICH LENIN

. . . the revolution is made,
at the moment of its climax
and the exertion
of all human capabilities,
by the class consciousness,
the will, the passion and the fantasy
of tens of millions who are urged on
by the very acutest class struggle.
—Lenin, *"Left-Wing" Communism:*
 An Infantile Disorder

Revolution unleashes all forces
fettered hitherto and drives them
from their deep recesses of life
to the surface.
—Lenin to Clara Zetkin

INTRODUCTION

Lenin (1870–1924) was born in Simbirsk, where his father, Ilya Nikolaevich Ulyanov, was superintendent of the school district. His mother, Maria Alexandrovna, was an amateur pianist (the family grand piano still dominates the living room of Lenin's birthplace) and she taught Vladimir Ilyich to play when he was still a boy. She used to say that he had a fine ear and a great aptitude for music. When he was eight he could play children's tunes on the piano, and later he often played duets with his mother. But when he entered the Gymnasium he gave up music, not, writes his younger brother, because it interfered with his studies but because "in those days piano playing was considered an unsuitable occupation for boys." He studied the violin, too, and in later years told his sister Maria that he regretted "not having continued his studies of the piano or the violin."

Throughout his life, Lenin's love for music (and all that it represented to him) warred with his desire to avoid the painful pleasure which it caused him by virtue of its intrinsic meanings and its associational references. At first, the positive side predominated: he and his wife attended concerts and

musicales in the earlier years, both in Geneva and in Finland, and as late as 1913 in Cracow he would repeatedly ask his friend and comrade Inessa Armand to play Beethoven's *Pathétique* Sonata for him. But, writing to Lenin's mother in late 1913, Krupskaya reports that she and Lenin attended a Beethoven quartet concert, and "for some reason the music made us terribly miserable." This becomes the *leit-motif* of Lenin's attitude in later years. Lunacharsky writes that "Lenin was a great music lover" but that "music distressed him." He often invited Lenin to his home where Chaliapin, Romanovsky, the Stradivarius Quartet, or Serge Koussevitsky would perform, but Lenin always begged off, finally confessing: "Of course it is a pleasure to hear good music, but imagine—it distresses me. It seems to work on me too much." Tsurupa (whose home was a musical center in postrevolutionary days) managed to persuade Lenin to hear Romanovsky perform, but noted that Lenin was "evidently wrought up by it." Lenin's sister Maria similarly wrote: "Music had too powerful an effect on his nerves, and when they were upset, as was often the case in the turmoil of life among the émigrés abroad, it affected him badly."

In a famous post-October passage Gorki touches the core of Lenin's ambivalence toward music:

One evening in Moscow . . . Lenin was listening to a sonata by Beethoven being played by Issai Dobrowen, and said: "I know nothing which is greater than the Appassionata; I would like to listen to it every day. It is marvelous superhuman music. I always think with pride—perhaps it is naive of me—what marvelous things human beings can do!"

Then screwing up his eyes and smiling, he added, rather sadly: "But I can't listen to music too often. It affects your nerves, makes you want to say stupid, nice things, and stroke the heads of people who could create such beauty while living in this vile hell. And now you mustn't stroke any one's head—you might get your hand bitten off. You have to hit them on the head, without any mercy, although our ideal is not to use force against any one. H'm, h'm, our duty is infernally hard!"

Lenin had expelled Kantian epistemology from Bolshevik Marxism in his battles with Bernstein, Bogdanov, and Mikhailovsky, but the Kantian categorical imperative had captured his soul. Discipline, denial, self-abnegation, service, and duty—in a word, repression of all needs and desires for personal gratification subjugated the aesthetic and sensuous impulses in Lenin. Socialism could be accomplished, he wrote, "by working with might and main for the building of discipline and self-discipline and for consolidating everywhere organization, order, efficiency, the harmonious cooperation of all the forces of the people." "The revolution demands

of the masses and the individual concentration, the straining of every nerve," he told Clara Zetkin. "It does not tolerate orgiastic states. . . . The proletariat . . . requires no intoxicant to stunt or excite it. . . . It derives its strongest stimulants to struggle from the position of its class, from the communist ideal." Lenin's self-denial extended into many areas. "When I was a schoolboy I went in for skating, but it made me tired and sleepy, and interfered with my studies, so I gave it up." "At one time I was very keen on Latin . . . but it interfered with my other studies, so I gave it up." Lenin also abandoned chess for a while when he returned to Russia from his three-year exile in Siberia in 1900: "Chess is too absorbing, it interferes with your work." Krupskaya reports that in London art museums Lenin (tireless Lenin) became exhausted after ten minutes "and would usually make a very quick exit." (This despite the fact that he loved the visual arts and would often spend hours poring over museum catalogs and writings on art history.) And in his childless marriage, too, the sensuous element is wholly or almost wholly suppressed in favor of a companionate, comradely relationship. When Paul and Laura Lafargue committed suicide in 1911 Lenin commented: "If you can't do any more work for the Party you must be able to face the truth and die."

It was not that Lenin lacked the capacity for enjoyment: asceticism did not come naturally to him. He loved a good glass of beer. He loved to read fiction (mostly Russian); he read *Anna Karenina* "a hundred times." But he would not yield to his natural desires. There was a period of their exile when Lenin and Krupskaya went "every night" to the cinema or theater and left each performance in the middle: Lenin was simultaneously giving way to the aesthetic emotion and denying it the possibility of fulfillment. A later Leninist—Bertolt Brecht—would work out his own theoretical system for circumventing catharsis and the reconciliation of the individual with society which is one aspect of its function. Lenin—against his "nature"—trained himself to be an ascetic in the service of history. But "history," as he told Gorki, "is a cruel stepmother," and though the recognition of necessity is the path to freedom this does not mitigate the painfulness of the process.

Lenin loved to feed the comrades in exile; he tended anxiously to the sick and to the suicidal. But feeding the "children" took precedence over his own needs: there was not room for both. He subsisted on black bread, tea, and porridge after the Revolution; and when he ate an extra portion of bread and dried herring during his convalescence from attempted assassination he confessed his "crime" to the cleaning lady, who found him in the canteen: "I felt very hungry, you know," he said with a smile. Similarly, "yielding" to music, to the arts, to the oceanic aesthetic emotion, was

perhaps seen by him as self-indulgence, as a regression to those early years when he had been cared for, before he had taken on the task of caring for humanity.

Whatever the sources of his ambivalence to the arts, there is no doubt of its existence. And so there are passages in Lenin which are in that line of religious-political resistance to aesthetics which extends from the murder of Orpheus to Plato, from Saint Augustine to Tolstoy. Kierkegaard wrote that "it is well known that music has always been the object of suspicion from the standpoint of religious enthusiasm." Heine told of the peaceful monks of Basle who walked in their garden and heard the nightingale singing so sweetly that they had to banish it. Surely music and poetry can turn individuals and masses away from necessity—in some cases the necessity of acceptance, in others the necessity of self-sacrifice in the cause of social advancement—toward sensuousness, toward individual gratification, toward play, toward childhood.

Zetkin's *Reminiscences of Lenin* contains the most famous of Lenin's negative statements about art, which have served as authority for Zhdanovist censorship and simplistic equations of "modernism" with "decadence":

Every artist, everyone who considers himself an artist, has a right to create freely according to his ideals, regardless of anything. But then, we communists cannot stand idly by and give chaos free rein to develop.

It is beyond me to consider the products of expressionism, futurism, cubism and other "isms" the highest manifestations of artistic genius. I do not understand them. I experience no joy from them.

Art belongs to the people. It must let its roots go down deep into the very thick of the labouring masses. It should be understood and loved by these masses. It must unite and elevate their feelings, thoughts and will. It must awaken and develop the artistic instinct within them. Must we serve sweet cakes to a small minority while the workers and peasants are in need of black bread?

Lenin berated Lunacharsky for printing Mayakovsky's *150,000,000* in an edition of 5000 copies: "Aren't you ashamed of yourself . . . ? Nonsensical, stupid, sheer stupidity and affectation. I think that only one out of ten such things should be printed and in *no more than 1500 copies* for libraries and cranks." And he thought it unseemly to maintain the expensive subsidy for the Bolshoi Theatre "when we haven't enough money to maintain the most ordinary schools in the villages."

But for every such reference another can be cited in opposition. "We're both old fogies," he told Zetkin: "we won't be able to keep pace with the

new art; we'll just have to come trailing along." His distrust of intellectuals is balanced by his enthusiasm for Gorki's plan of a union of the workers and intelligentsia: "Well, that isn't bad. Tell the intelligentsia. Let them come to us." Though he begrudged funds for opera ("landlord culture" he called it), he nevertheless emphasized that proletarian culture could only be created "as the logical development of the store of knowledge mankind has accumulated under the yoke of capitalist, landowner and bureaucratic society."

Lenin's ambivalence to the arts has a social as well as a personal foundation. Revolutionary discipline calls for self-discipline, for suppression of all forms of gratification in the interest of a common purpose. That art possesses communal powers, and can be bent to revolutionary goals was known to Lenin. In the French Revolution's tradition he urged the creation of monumental public art and of popular cultural spectacles. But he was under no illusion as to their aesthetic quality: "Let it not be forgotten that spectacles are not really great art. I would sooner call them more or less attractive entertainments." Lenin's negative attitude toward art in the postrevolutionary period, then, has two sources: his dismay at the tenacity of the aesthetic emotion within himself and his realistic fear that creative life required an extravagance (in both the monetary and psychic spheres) that a society in revolutionary turmoil could ill afford. In this he can be placed squarely in the line of social-minded Russian nineteenth-century critics who regarded art as a utilitarian vehicle of moral uplift. Chernyshevsky, one of Lenin's models, considered poetry's function to be "a disseminator of knowledge and education," and regarded art as merely a substitute reality of an inferior order: "Let art be content with its lofty, splendid mission of being a substitute for reality in case of its absence, and of being a textbook of life for man." That Lenin did not wholly adopt the antiaesthetic attitudes of Chernyshevsky or of Tolstoy[1] is a measure of the Utopian strain which led an underground existence in him, surfacing in such unlikely polemics as *What Is to Be Done?* and (especially) in *State and Revolution.* In *What Is to Be Done?* Lenin quotes Pisarev on the necessity of dream: "If man were completely deprived of the ability to dream . . . then I cannot at all imagine what stimulus there would be to induce man to undertake and complete extensive and strenuous work in the sphere of art, science and practical endeavour."

1. A typical Tolstoyan attitude: "It is art in our time that serves as the chief cause of the perversion of people. . . . It seems as though existing art had but one definite aim—to disseminate vice as widely as possible" (*What Is Art?,* trans. Aylmer Maude [New York, 1962], pp. 260–61).

Lenin's personal ambivalence toward art appears biographically—especially in his letters and conversations—but is not reflected in his actual literary criticism or in his tactical formulations of a Bolshevik policy toward art and the artist. The first selections, three of his essays on Tolstoy, are models of class analysis in the tradition of Marx's *Eighteenth Brumaire* and Engels' comments on Balzac; they are based on the psychological premise that class position and ideological outlook are by no means identical. Marx and Engels had depicted Balzac and Goethe as unconsciously transcending the ideology of their own class. Lenin, extending the insight, points to the conscious transference of allegiance from one's own to that of an oppressed class—in Tolstoy's case to the patriarchal peasantry of Old Russia. (This transference of class allegiance had been described by Marx and Engels in a nonaesthetic context in *The Communist Manifesto*.) Lenin's approach to Tolstoy is also in the Russian socialist tradition: the anarchist Prince Kropotkin had already described Tolstoy's acceptance of "the simple creed of the masses of the Russian peasants" in his *Ideals and Realities in Russian Literature* (1905), but Lenin's more rigorous formulations have exercised an enormous influence and served as valuable correctives to oversimplified sociological analysis.

Lenin's primary contribution to Marxist theory is in the field of revolutionary practice—the nature of the state and the nature of the revolutionary organization necessary to smash the instrumentalities of the old order. The second selection, the 1905 article "Party Organization and Party Literature," deals with the responsibilities of the Party ideologist within the framework of the monolithically organized revolutionary party. It must be read, therefore, in the context of Lenin's debates with the Menshevik parliamentarians on one side and the anarchists and Narodniks on the other. It is crucial to note that Lenin restricts the concept of Party literature to strictly ideological writing within the revolutionary party. ("We are speaking of Party literature and its subjection to Party control. Everyone is free to write and say anything he pleases without the least limitation. But every free association . . . is also free to drive out such members as make use of the Party label to propagate anti-Party views.") His is by no means a call for censorship. Lenin unambivalently sets forth a policy of freedom for the artist within a framework of revolutionary necessity. We note, however, the difficulties with this concept when the Party becomes the state.

As with Marx and Engels, Lenin's writings on art and literature do not constitute an aesthetics; rather, they are illustrative of a particular historical phase in the development of the Marxist theories of revolution and ideology. Certain of Lenin's writings on philosophy during World War I,

however, point beyond the historical moment toward the aesthetic dimension. From the *Philosophical Notebooks* we reprint his notes "Concerning the Question of Dialectics" which represent one of the first attempts after Engels to restore Hegelian dialectics to Marxism. Unable to solve the question of epistemology (the relation between subject and object) which had preoccupied (and marred) *Materialism and Empirio-Criticism* (1909), Lenin turned to the study of the object itself, its contradictions and laws of motion. The germ of an aesthetics of the art-object lies in his unfinished writings on philosophy—in his restatement of the principles of dialectics. He had progressed so far from the theory of art as substitute reality that he noted approvingly Feuerbach's remark "Art does not require that its works be regarded as reality" and underscored Plekhanov's comments on the play drive as the mediating factor between art and labor. Interrupted by the October Revolution, Lenin was unable to carry through his intended fusion of dialectical theory and revolutionary practice, to complete the study which would perhaps have explained how it was possible that a conjunction of historical events and revolutionary will could accomplish the transformation of society.

LENIN:
LEO TOLSTOY AS THE MIRROR OF THE RUSSIAN REVOLUTION
from *Collected Works*

To identify the great artist with the revolution[1] which he has obviously failed to understand, and from which he obviously stands aloof, may at first sight seem strange and artificial. A mirror which does not reflect things correctly could hardly be called a mirror. Our revolution, however, is an extremely complicated thing. Among the mass of those who are directly making and participating in it there are many social elements which have also obviously not understood what is taking place and which also stand aloof from the real historical tasks with which the course of events has confronted them. And if we have before us a really great artist, he must have reflected in his work at least some of the essential aspects of the revolution.

The legal Russian press, though its pages teem with articles, letters and comments on Tolstoy's eightieth birthday, is least of all interested in analysing his works from the standpoint of the character of the Russian

1. I.e., the Revolution of 1905.—*Ed.*

revolution and its motive forces. The whole of this press is steeped to nausea in hypocrisy, hypocrisy of a double kind: official and liberal. The former is the crude hypocrisy of the venal hack who was ordered yesterday to hound Leo Tolstoy, and today to show that Tolstoy is a patriot, and to try to observe the decencies before the eyes of Europe. That the hacks of this kind have been paid for their screeds is common knowledge and they cannot deceive anybody. Much more refined and, therefore, much more pernicious and dangerous is liberal hypocrisy. To listen to the Cadet Balalaikins of *Rech*,[2] one would think that their sympathy for Tolstoy is of the most complete and ardent kind. Actually, their calculated declamations and pompous phrases about the "great seeker after God" are false from beginning to end, for no Russian liberal believes in Tolstoy's God, or sympathises with Tolstoy's criticism of the existing social order. He associates himself with a popular name in order to increase his political capital, in order to pose as a leader of the nation-wide opposition; he seeks, with the din and thunder of claptrap, to *drown* the demand for a straight and clear answer to the question: what are the glaring contradictions of "Tolstoyism" due to, and what shortcomings and weaknesses of our revolution do they express?

The contradictions in Tolstoy's works, views, doctrines, in his school, are indeed glaring. On the one hand, we have the great artist, the genius who has not only drawn incomparable pictures of Russian life but has made first-class contributions to world literature. On the other hand, we have the landlord obsessed with Christ. On the one hand, the remarkably powerful, forthright and sincere protest against social falsehood and hypocrisy; and on the other, the "Tolstoyan," i.e., the jaded, hysterical sniveller called the Russian intellectual, who publicly beats his breast and wails: "I am a bad wicked man, but I am practising moral self-perfection; I don't eat meat any more, I now eat rice cutlets." On the one hand, merciless criticism of capitalist exploitation, exposure of government outrages, the farcical courts and the state administration, and unmasking of the profound contradictions between the growth of wealth and achievements of civilisation and the growth of poverty, degradation and misery among the working masses. On the other, the crackpot preaching of submission, "resist not evil" with violence. On the one hand, the most sober realism, the tearing away of all and sundry masks; on the other, the preaching of one of the most odious things on earth, namely, religion, the striving to replace officially appointed priests by priests who will serve from moral

2. *Rech,* central organ of the Constitutional Democrats, dubbed Balalaikins after a garrulous character in a novel by Saltykov-Shchedrin.—*Ed.*

conviction, i.e., to cultivate the most refined and, therefore, particularly disgusting clericalism. Verily:

> Thou art a pauper, yet thou art abundant,
> Thou art mighty, yet thou art impotent—
> —Mother Russia![3]

That Tolstoy, owing to these contradictions, could not possibly understand either the working-class movement and its role in the struggle for socialism, or the Russian revolution, goes without saying. But the contradictions in Tolstoy's views and doctrines are not accidental; they express the contradictory conditions of Russian life in the last third of the nineteenth century. The patriarchal countryside, only recently emancipated from serfdom, was literally given over to the capitalist and the tax-collector to be fleeced and plundered. The ancient foundations of peasant economy and peasant life, foundations that had really held for centuries, were broken up for scrap with extraordinary rapidity. And the contradictions in Tolstoy's views must be appraised not from the standpoint of the present-day working-class movement and present-day socialism (such an appraisal is, of course, needed, but it is not enough), but from the standpoint of protest against advancing capitalism, against the ruining of the masses, who are being dispossessed of their land—a protest which had to arise from the patriarchal Russian countryside. Tolstoy is absurd as a prophet who has discovered new nostrums for the salvation of mankind—and therefore the foreign and Russian "Tolstoyans" who have sought to convert the weakest side of his doctrine into a dogma, are not worth speaking of. Tolstoy is great as the spokesman of the ideas and sentiments that emerged among the millions of Russian peasants at the time the bourgeois revolution was approaching in Russia. Tolstoy is original, because the sum total of his views, taken as a whole, happens to express the specific features of our revolution as a *peasant* bourgeois revolution. From this point of view, the contradictions in Tolstoy's views are indeed a mirror of those contradictory conditions in which the peasantry had to play their historical part in our revolution. On the one hand, centuries of feudal oppression and decades of accelerated post-Reform pauperisation piled up mountains of hate, resentment, and desperate determination. The striving to sweep away completely the official church, the landlords and the landlord government, to destroy all the old forms and ways of landownership, to clear the land, to replace the police-class state by a community of free

3. From Nekrasov's poem "Who Can Be Happy in Russia?"

and equal small peasants—this striving is the keynote of every historical step the peasantry has taken in our revolution; and, undoubtedly, the message of Tolstoy's writings conforms to this peasant striving far more than it does to abstract "Christian Anarchism," as his "system" of views is sometimes appraised.

On the other hand, the peasantry, striving towards new ways of life, had a very crude, patriarchal, semi-religious idea of what kind of life this should be, by what struggle could liberty be won, what leaders it could have in this struggle, what was the attitude of the bourgeoisie and the bourgeois intelligentsia towards the interests of peasant revolution, why the forcible overthrow of tsarist rule was needed in order to abolish land-lordism. The whole past life of the peasantry had taught it to hate the landowner and the official, but it did not, and could not, teach it where to seek an answer to all these questions. In our revolution a minor part of the peasantry really did fight, did organise to some extent for this purpose: and a very small part indeed rose up in arms to exterminate its enemies, to destroy the tsar's servants and protectors of the landlords. Most of the peasantry wept and prayed, moralised and dreamed, wrote petitions and sent "pleaders"—quite in the vein of Leo Tolstoy! And, as always happens in such cases, the effect of this Tolstoyan abstention from politics, this Tolstoyan renunciation of politics, this lack of interest in and understanding of politics, was that only a minority followed the lead of the class-conscious revolutionary proletariat, while the majority became the prey of those unprincipled, servile, bourgeois intellectuals who under the name of Cadets hastened from a meeting of Trudoviks to Stolypin's ante-room,[4] and begged, haggled, reconciled and promised to reconcile—until they were kicked out with a military jackboot. Tolstoy's ideas are a mirror of the weakness, the shortcomings of our peasant revolt, a reflection of the flabbiness of the patriarchal countryside and of the hidebound cowardice of the "enterprising muzhik."

Take the soldiers' insurrections in 1905–06. In social composition these men who fought in our revolution were partly peasants and partly proletarians. The proletarians were in the minority; therefore the movement in the armed forces does not even approximately show the same nationwide solidarity, the same party consciousness, as were displayed by the proletariat, which became Social-Democratic as if by the wave of a hand. Yet there is nothing more mistaken than the view that the insurrections in the

4. The Trudoviks were a group of democrats in the post-1905 Dumas, with socialist and Narodnik (populist) leanings. Stolypin was head of Nicholas II's cabinet.

rmed forces failed because no officers had led them. On the contrary, the enormous progress the revolution had made since the time of the Narodnaya Volya[5] was shown precisely by the fact that the "grey herd" rose in arms against their superiors, and it was this self-dependency of theirs that so frightened the liberal landlords and the liberal officers. The common soldier fully sympathised with the peasants' cause; his eyes lit up at the very mention of land. There was more than one case when authority in the armed forces passed to the mass of the rank and file, but determined use of this authority was hardly made at all; the soldiers wavered; after a couple of days, in some cases a few hours, after killing some hated officer, they released the others who had been arrested, parleyed with the authorities and then faced the firing squad, or bared their backs for the birch, or put on the yoke again—quite in the vein of Leo Tolstoy!

Tolstoy reflected the pent-up hatred, the ripened striving for a better lot, the desire to get rid of the past—and also the immature dreaming, the political inexperience, the revolutionary flabbiness. Historical and economic conditions explain both the inevitable beginning of the revolutionary struggle of the masses and their unpreparedness for the struggle, their Tolstoyan non-resistance to evil, which was a most serious cause of the defeat of the first revolutionary campaign.

It is said that beaten armies learn well. Of course, revolutionary classes can be compared with armies only in a very limited sense. The development of capitalism is hourly changing and intensifying the conditions which roused the millions of peasants—united by their hatred for the feudalist landlords and their government—for the revolutionary-democratic struggle. Among the peasantry themselves the growth of exchange, of the rule of the market and the power of money, is steadily ousting old-fashioned patriarchalism and the patriarchal Tolstoyan ideology. But there is one gain from the first years of the revolution and the first reverses in mass revolutionary struggle about which there can be no doubt. It is the mortal blow struck at the former softness and flabbiness of the masses. The lines of demarcation have become more distinct. The cleavage of classes and parties has taken place. Under the hammer blows of the lessons taught by Stolypin, and with undeviating and consistent agitation by the revolutionary Social-Democrats not only the socialist proletariat but also the democratic masses of the peasantry will inevitably advance from their midst more and more steeled fighters who will be less capable of falling into our historical sin of Tolstoyism!

5. "The People's Will"—a terrorist populist organization founded in 1879, crushed following the 1881 assassination of Alexander II.

LENIN: **L. N. TOLSTOY**
from *Collected Works*

Leo Tolstoy is dead. His universal significance as an artist and his universal fame as a thinker and preacher reflect, each in its own way, the universal significance of the Russian revolution.

L. N. Tolstoy emerged as a great artist when serfdom still held sway in the land. In a series of great works, which he produced during the more than half a century of his literary activity, he depicted mainly the old, pre-revolutionary Russia which remained in a state of semi-serfdom even after 1861—rural Russia of the landlord and the peasant. In depicting this period in Russia's history, Tolstoy succeeded in raising so many great problems and succeeded in rising to such heights of artistic power that his works rank among the greatest in world literature. The epoch of preparation for revolution in one of the countries under the heel of the serf owners became, thanks to its brilliant illumination by Tolstoy, a step forward in the artistic development of humanity as a whole.

Tolstoy the artist is known to an infinitesimal minority even in Russia. If his great works are really to be made the possession of *all,* a struggle must be waged against the system of society which condemns millions and scores of millions to ignorance, benightedness, drudgery and poverty—a socialist revolution must be accomplished.

Tolstoy not only produced artistic works which will always be appreciated and read by the masses, once they have created human conditions of life for themselves after overthrowing the yoke of the landlords and capitalists; he succeeded in conveying with remarkable force the moods of the large masses that are oppressed by the present system, in depicting their condition and expressing their spontaneous feelings of protest and anger. Belonging, as he did, primarily to the era of 1861–1904, Tolstoy in his works—both as an artist and as a thinker and preacher—embodied in amazingly bold relief the specific historical features of the entire first Russian revolution, its strength and its weakness.

One of the principal distinguishing features of our revolution is that it was a *peasant* bourgeois revolution in the era of the very advanced development of capitalism throughout the world and of its comparatively advanced development in Russia. It was a bourgeois revolution because its immediate aim was to overthrow the tsarist autocracy, the tsarist monarchy, and to abolish landlordism, but not to overthrow the domination of the bourgeoisie. The peasantry in particular was not aware of the latter aim, it was not aware of the distinction between this aim and the closer and

more immediate aims of the struggle. It was a peasant bourgeois revolution because the objective conditions put in the forefront the problem of changing the basic conditions of life for the peasantry, of breaking up the old, medieval system of landownership, of "clearing the ground" for capitalism; the objective conditions were responsible for the appearance of the peasant masses on the arena of more or less independent historic action.

Tolstoy's works express both the strength and the weakness, the might and the limitations, precisely of the peasant mass movement. His heated, passionate, and often ruthlessly sharp protest against the state and the official church that was in alliance with the police conveys the sentiments of the primitive peasant democratic masses, among whom centuries of serfdom, of official tyranny and robbery, and of church Jesuitism, deception and chicanery had piled up mountains of anger and hatred. His unbending opposition to private property in land conveys the psychology of the peasant masses during that historical period in which the old, medieval landownership, both in the form of landed estates and in the form of state "allotments," definitely became an intolerable obstacle to the further development of the country, and when this old landownership was inevitably bound to be destroyed most summarily and ruthlessly. His unremitting accusations against capitalism—accusations permeated with most profound emotion and most ardent indignation—convey all the horror felt by the patriarchal peasant at the advent of the new, invisible, incomprehensible enemy coming from somewhere in the cities, or from somewhere abroad, destroying all the "pillars" of rural life, bringing in its train unprecedented ruin, poverty, starvation, savagery, prostitution, syphilis— all the calamities attending the "epoch of primitive accumulation," aggravated a hundredfold by the transplantation into Russian soil of the most modern methods of plunder elaborated by the tall powerful Monsieur Coupon.[1]

But the vehement protestant, the passionate accuser, the great critic at the same time manifested in his works a failure to understand the causes of the crisis threatening Russia, and the means of escape from it, that was characteristic only of a patriarchal, naïve peasant, but not of a writer with a European education. His struggle against the feudal police state, against the monarchy, turned into a repudiation of politics, led to the doctrine of "non-resistance to evil," and to complete aloofness from the revolutionary struggle of the masses in 1905–07. The fight against the official church was combined with the preaching of a new, purified religion, that is to say, of a new, refined, subtle poison for the oppressed masses. The opposition to

1. A metaphorical name for capitalists current in late nineteenth-century Russian literature.

private property in land did not lead to concentrating the struggle against the real enemy—landlordism and its political instrument of power, i.e., the monarchy—but led to dreamy, diffuse and impotent lamentations. The exposure of capitalism and of the calamities it inflicts on the masses was combined with a wholly apathetic attitude to the worldwide struggle for emancipation waged by the international socialist proletariat.

The contradictions in Tolstoy's views are not contradictions inherent in his personal views alone, but are a reflection of the extremely complex, contradictory conditions, social influences and historical traditions which determined the psychology of various classes and various sections of Russian society in the *post*-Reform, but *pre*-revolutionary era.

That is why a correct appraisal of Tolstoy can be made only from the viewpoint of the class which has proved, by its political role and its struggle during the first denouement of these contradictions, at a time of revolution, that it is destined to be the leader in the struggle for the people's liberty and for the emancipation of the masses from exploitation—the class which has proved its selfless devotion to the cause of democracy and its ability to fight against the limitations and inconsistency of bourgeois (including peasant) democracy; such an appraisal is possible only from the viewpoint of the Social-Democratic proletariat.

———

Tolstoy is dead, and the pre-revolutionary Russia whose weakness and impotence found their expression in the philosophy and are depicted in the works of the great artist, has become a thing of the past. But the heritage which he has left includes that which has not become a thing of the past, but belongs to the future. This heritage is accepted and is being worked upon by the Russian proletariat. The Russian proletariat will explain to the masses of the toilers and the exploited the meaning of Tolstoy's criticism of the state, the church, private property in land—not in order that the masses should confine themselves to self-perfection and yearning for a godly life, but in order that they should rise to strike a new blow at the tsarist monarchy and landlordism, which were but slightly damaged in 1905, and which must be destroyed. The Russian proletariat will explain to the masses Tolstoy's criticism of capitalism—not in order that the masses should confine themselves to hurling imprecations at capital and the rule of money, but in order that they should learn to utilise at every step in their life and in their struggle the technical and social achievements of capitalism, that they should learn to weld themselves into a united army of millions of socialist fighters who will overthrow capitalism and create a

new society in which the people will not be doomed to poverty, in which there will be no exploitation of man by man.

LENIN: **LEO TOLSTOY AND HIS EPOCH**
from *Collected Works*

Tolstoyism, in its real historical content, is an ideology of an Oriental, an Asiatic order. Hence the asceticism, the non-resistance to evil, the profound notes of pessimism, the conviction that "everything is nothing, everything is a material nothing" ("The Meaning of Life," p. 52), and faith in the "Spirit," in "the beginning of everything," and that man, in his relation to this beginning, is merely a "labourer . . . allotted the task of saving his own soul," etc. Tolstoy is true to this ideology in his *Kreutzer Sonata* too when he says: "the emancipation of woman lies not in colleges and not in parliaments, but in the bedroom," and in the article written in 1862, in which he says that universities train only "irritable, debilitated liberals" for whom "the people have no use at all," who are "uselessly torn from their former environment," "find no place in life," and so forth.

Pessimism, non-resistance, appeals to the "Spirit" constitute an ideology inevitable in an epoch when the whole of the old order "has been turned upside down," and when the masses, who have been brought up under this old order, who imbibed with their mother's milk the principles, the habits, the traditions and beliefs of this order, do not and cannot see *what kind* of a new order is "taking shape," *what* social forces are "shaping" it and how, what social forces are *capable* of bringing release from the incalculable and exceptionally acute distress that is characteristic of epochs of "upheaval."

The period of 1862–1904 was just such a period of upheaval in Russia, a period in which before everyone's eyes the old order collapsed, never to be restored, in which the new system was only just taking shape; the social forces shaping the new system first manifested themselves on a broad, nation-wide scale, in mass public action in the most varied fields only in 1905. And the 1905 events in Russia were followed by analogous events in a number of countries in that very "Orient" to the "quiescence" to which Tolstoy referred in 1862. The year 1905 marked the beginning of the end of "Oriental" quiescence. Precisely for this reason that year marked the historical end of Tolstoyism, the end of an epoch that could give rise to Tolstoy's teachings and in which they were inevitable, not as something individual, not as a caprice or a fad, but as the ideology of the conditions of life under which millions and millions actually found themselves for a certain period of time.

Tolstoy's doctrine is certainly utopian and in content is reactionary in the most precise and most profound sense of the word. But that certainly does not mean that the doctrine was not socialistic or that it did not contain critical elements capable of providing valuable material for the enlightenment of the advanced classes.

There are various kinds of socialism. In all countries where the capitalist mode of production prevails there is the socialism which expresses the ideology of the class that is going to take the place of the bourgeoisie; and there is the socialism that expresses the ideology of the classes that are going to be replaced by the bourgeoisie. Feudal socialism, for example, is socialism of the latter type, and the nature of *this* socialism was appraised long ago, over sixty years ago, by Marx, simultaneously with his appraisal of other types of socialism.[1]

Furthermore, critical elements are inherent in Tolstoy's utopian doctrine, just as they are inherent in many utopian systems. But we must not forget Marx's profound observation to the effect that the value of critical elements in utopian socialism "bears an inverse relation to historical development." The more the activities of the social forces which are "shaping" the new Russia and bringing release from present-day social evils develop and assume a definite character, the more rapidly is critical-utopian socialism "losing all practical value and all theoretical justification."[2]

A quarter of a century ago, the critical elements in Tolstoy's doctrine might at times have been of practical value for some sections of the population *in spite of* its reactionary and utopian features. This could not have been the case during, say, the last decade, because historical development had made considerable progress between the eighties and the end of the last century. In our days, since the series of events mentioned above has put an end to "Oriental" quiescence, in our days, when the consciously reactionary ideas of *Vekhi* (reactionary in the narrow-class, selfishly-class sense) have become so enormously widespread among the liberal bourgeoisie and when these ideas have infected even a section of those who were almost Marxists and have created a liquidationist trend—in our days, the most direct and most profound harm is caused by every attempt to idealise Tolstoy's doctrine, to justify or to mitigate his "non-resistance," his appeals to the "Spirit," his exhortations for "moral self-perfection," his doctrine of "conscience" and universal "love," his preaching of asceticism and quietism, and so forth.

1. A reference to *The Communist Manifesto,* chap. III.
2. A quotation from *The Communist Manifesto,* chap. III.

LENIN: **PARTY ORGANIZATION AND PARTY LITERATURE**
from *Collected Works*

The new conditions for Social-Democratic work in Russia which have arisen since the October revolution[1] have brought the question of party literature to the fore. The distinction between the illegal and the legal press, that melancholy heritage of the epoch of feudal, autocratic Russia, is beginning to disappear. It is not yet dead, by a long way. The hypocritical government of our Prime Minister is still running amuck, so much so that *Izvestia Soveta Rabochikh Deputatov*[2] is printed "illegally"; but apart from bringing disgrace on the government, apart from striking further moral blows at it, nothing comes of the stupid attempts to "prohibit" that which the government is powerless to thwart.

So long as there was a distinction between the illegal and the legal press, the question of the party and non-party press was decided extremely simply and in an extremely false and abnormal way. The entire illegal press was a party press, being published by organisations and run by groups which in one way or another were linked with groups of practical party workers. The entire legal press was non-party—since parties were banned—but it "gravitated" towards one party or another. Unnatural alliances, strange "bed-fellows" and false cover-devices were inevitable. The forced reserve of those who wished to express party views merged with the immature thinking or mental cowardice of those who had not risen to these views and who were not, in effect, party people.

An accursed period of Aesopian language, literary bondage, slavish speech, and ideological serfdom! The proletariat has put an end to this foul atmosphere which stifled everything living and fresh in Russia. But so far the proletariat has won only half freedom for Russia.

The revolution is not yet completed. While tsarism is *no longer* strong enough to defeat the revolution, the revolution is *not yet* strong enough to defeat tsarism. And we are living in times when everywhere and in everything there operates this unnatural combination of open, forthright, direct and consistent party spirit with an underground, covert, "diplomatic" and dodgy "legality." This unnatural combination makes itself felt even in our newspaper: for all Mr. Guchkov's witticisms about Social-Democratic tyranny forbidding the publication of moderate liberal-bourgeois news-

1. The reference is to the general strike of October, 1905.—*Ed.*
2. Official organ of the St. Petersburg Soviet of Worker's Deputies in late 1905.—*Ed.*

papers, the fact remains that *Proletary,* the Central Organ of the Russian Social-Democratic Labour Party, still remains outside the locked doors of *autocratic,* police-ridden Russia.

Be that as it may, the half-way revolution compels all of us to set to work at once organising the whole thing on new lines. Today literature, even that published "legally," can be nine-tenths party literature. It must become party literature. In contradistinction to bourgeois customs, to the profit-making, commercialised bourgeois press, to bourgeois literary career-ism and individualism, "aristocratic anarchism" and drive for profit, the socialist proletariat must put forward the principle of *party literature,* must develop this principle and put it into practice as fully and completely as possible.

What is this principle of party literature? It is not simply that, for the socialist proletariat, literature cannot be a means of enriching individuals or groups; it cannot, in fact, be an individual undertaking, independent of the common cause of the proletariat. Down with non-partisan writers! Down with literary supermen! Literature must become *part* of the common cause of the proletariat, "a cog and a screw" of one single great Social-Democratic mechanism set in motion by the entire politically-conscious vanguard of the entire working class. Literature must become a component of organised, planned and integrated Social-Democratic Party work.

"All comparisons are lame," says a German proverb. So is my compari-son of literature with a cog, of a living movement with a mechanism. And I daresay there will ever be hysterical intellectuals to raise a howl about such a comparison, which degrades, deadens, "bureaucratises" the free battle of ideas, freedom of criticism, freedom of literary creation, etc., etc. Such outcries, in point of fact, would be nothing more than an expression of bourgeois-intellectual individualism. There is no question that literature is least of all subject to mechanical adjustment or levelling, to the rule of the majority over the minority. There is no question, either, that in this field greater scope must undoubtedly be allowed for personal initiative, indi-vidual inclination, thought and fantasy, form and content. All this is un-deniable; but all this simply shows that the literary side of the proletarian party cause cannot be mechanically identified with its other sides. This, however, does not in the least refute the proposition, alien and strange to the bourgeoisie and bourgeois democracy, that literature must by all means and necessarily become an element of Social-Democratic Party work, inseparably bound up with the other elements. Newspapers must become the organs of the various party organisations, and their writers must by all means become members of these organisations. Publishing and distributing centres, bookshops and reading-rooms, libraries and similar establish-

ments—must all be under party control. The organised socialist proletariat must keep an eye on all this work, supervise it in its entirety, and, from beginning to end, without any exception, infuse into it the life-stream of the living proletarian cause, thereby cutting the ground from under the old, semi-Oblomov, semi-shopkeeper Russian principle: the writer does the writing, the reader does the reading.

We are not suggesting, of course, that this transformation of literary work, which has been defiled by the Asiatic censorship and the European bourgeoisie, can be accomplished all at once. Far be it from us to advocate any kind of standardised system, or a solution by means of a few decrees. Cut-and-dried schemes are least of all applicable here. What is needed is that the whole of our Party, and the entire politically-conscious Social-Democratic proletariat throughout Russia, should become aware of this new problem, specify it clearly and everywhere set about solving it. Emerging from the captivity of the feudal censorship, we have no desire to become, and shall not become, prisoners of bourgeois-shopkeeper literary relations. We want to establish, and we shall establish, a free press, free not simply from the police, but also from capital, from careerism, and what is more, free from bourgeois-anarchist individualism.

These last words may sound paradoxical, or an affront to the reader. What! some intellectual, an ardent champion of liberty, may shout. What, you want to impose collective control on such a delicate, individual matter as literary work! You want workmen to decide questions of science, philosophy, or aesthetics by a majority of votes! You deny the absolute freedom of absolutely individual ideological work!

Calm yourselves, gentlemen! First of all, we are discussing party literature and its subordination to party control. Everyone is free to write and say whatever he likes, without any restrictions. But every voluntary association (including the party) is also free to expel members who use the name of the party to advocate anti-party views. Freedom of speech and the press must be complete. But then freedom of association must be complete too. I am bound to accord you, in the name of free speech, the full right to shout, lie and write to your heart's content. But you are bound to grant me, in the name of freedom of association, the right to enter into, or withdraw from, association with people advocating this or that view. The party is a voluntary association, which would inevitably break up, first ideologically and then physically, if it did not cleanse itself of people advocating anti-party views. And to define the border-line between party and anti-party there is the party programme, the party's resolutions on tactics and its rules and, lastly, the entire experience of international Social-Democracy, the voluntary international associations of the proletariat, which has constantly

brought into its parties individual elements and trends not fully consistent, not completely Marxist and not altogether correct and which, on the other hand, has constantly conducted periodical "cleansings" of its ranks. So it will be with us too, supporters of bourgeois "freedom of criticism," *within* the Party. We are now becoming a mass party all at once, changing abruptly to an open organisation, and it is inevitable that we shall be joined by many who are inconsistent (from the Marxist standpoint), perhaps we shall be joined even by some Christian elements, and even by some mystics. We have sound stomachs and we are rock-like Marxists. We shall digest those inconsistent elements. Freedom of thought and freedom of criticism within the Party will never make us forget about the freedom of organising people into those voluntary associations known as parties.

Secondly, we must say to you bourgeois individualists that your talk about absolute freedom is sheer hypocrisy. There can be no real and effective "freedom" in a society based on the power of money, in a society in which the masses of working people live in poverty and the handful of rich live like parasites. Are you free in relation to your bourgeois publisher, Mr. Writer, in relation to your bourgeois public, which demands that you provide it with pornography in frames[3] and paintings, and prostitution as a "supplement" to "sacred" scenic art? This absolute freedom is a bourgeois or an anarchist phrase (since, as a world outlook, anarchism is bourgeois philosophy turned inside out). One cannot live in society and be free from society. The freedom of the bourgeois writer, artist or actress is simply masked (or hypocritically masked) dependence on the money-bag, on corruption, on prostitution.

And we socialists expose this hypocrisy and rip off the false labels, not in order to arrive at a non-class literature and art (that will be possible only in a socialist extra-class society), but to contrast this hypocritically free literature, which is in reality linked to the bourgeoisie, with a really free one that will be *openly* linked to the proletariat.

It will be a free literature, because the idea of socialism and sympathy with the working people, and not greed or careerism, will bring ever new forces to its ranks. It will be a free literature, because it will serve, not some satiated heroine, not the bored "upper ten thousand" suffering from fatty degeneration, but the millions and tens of millions of working people—the flower of the country, its strength and its future. It will be a free literature, enriching the last word in the revolutionary thought of mankind with the experience and living work of the socialist proletariat, bringing about permanent interaction between the experience of the past

3. There must be a misprint in the source, which says *ramkakh* (frames), while the context suggests *romanakh* (novels).—*Ed.*

(scientific socialism, the completion of the development of socialism from its primitive, utopian forms) and the experience of the present (the present struggle of the worker comrades).

To work, then, comrades! We are faced with a new and difficult task. But it is a noble and grateful one—to organise a broad, multiform and varied literature inseparably linked with the Social-Democratic working-class movement. All Social-Democratic literature must become Party literature. Every newspaper, journal, publishing house, etc., must immediately set about reorganising its work, leading up to a situation in which it will, in one form or another, be integrated into one Party organisation or another. Only then will "Social-Democratic" literature really become worthy of that name, only then will it be able to fulfil its duty and, even within the framework of bourgeois society, break out of bourgeois slavery and merge with the movement of the really advanced and thoroughly revolutionary class.

LENIN: **ON THE QUESTION OF DIALECTICS**
from *Philosophical Notebooks*

The splitting of a single whole and the cognition of its contradictory parts (see the quotation from Philo on Heraclitus at the beginning of Section III, "On Cognition," in Lassalle's book on Heraclitus) is the *essence* (one of the "essentials," one of the principal, if not the principal, characteristics or features) of dialectics. That is precisely how Hegel, too, puts the matter (Aristotle in his *Metaphysics* continually *grapples* with it and *combats* Heraclitus and Heraclitean ideas).

The correctness of this aspect of the content of dialectics must be tested by the history of science. This aspect of dialectics (e.g., in Plekhanov) usually receives inadequate attention: the identity of opposites is taken as the sum-total of *examples* ["for example, a seed," "for example, primitive communism." The same is true of Engels. But it is "in the interests of popularisation"] and not as a *law of cognition* (*and* as a law of the objective world).

In mathematics: + and −. Differential and integral.

In mechanics: action and reaction.

In physics: positive and negative electricity.

In chemistry: the combination and dissociation of atoms.

In social science: the class struggle.

The identity of opposites (it would be more correct, perhaps, to say their "unity,"—although the difference between the terms identity and unity is

not particularly important here. In a certain sense both are correct) is the recognition (discovery) of the contradictory, *mutually exclusive,* opposite tendencies in *all* phenomena and processes of nature (*including* mind and society). The condition for the knowledge of all processes of the world in their *"self-movement,"* in their spontaneous development, in their real life, is the knowledge of them as a unity of opposites. Development is the "struggle" of opposites. The two basic (or two possible? or two historically observable?) conceptions of development (evolution) are: development as decrease and increase, as repetition, *and* development as a unity of opposites (the division of a unity into mutually exclusive opposites and their reciprocal relation).

In the first conception of motion, *self*-movement, its *driving* force, its source, its motive, remains in the shade (or this source is made *external*— God, subject, etc.). In the second conception the chief attention is directed precisely to knowledge of the *source* of *"self"*-movement.

The first conception is lifeless, pale and dry. The second is living. The second *alone* furnishes the key to the "self-movement" of everything existing; it alone furnishes the key to the "leaps," to the "break in continuity," to the "transformation into the opposite," to the destruction of the old and the emergence of the new.

The unity (coincidence, identity, equal action) of opposites is conditional, temporary, transitory, relative. The struggle of mutually exclusive opposites is absolute, just as development and motion are absolute.

[N.B. The distinction between subjectivism (scepticism, sophistry, etc.) and dialectics, incidentally, is that in (objective) dialectics the difference between the relative and the absolute is itself relative. For objective dialectics there *is* an absolute *within* the relative. For subjectivism and sophistry the relative is only relative and excludes the absolute.]

In his *Capital,* Marx first analyses the simplest, most ordinary and fundamental, most common and everyday *relation* of bourgeois (commodity) society, a relation encountered billions of times, viz. the exchange of commodities. In this very simple phenomenon (in this "cell" of bourgeois society) analysis reveals *all* the contradictions (or the germs of *all* the contradictions) of modern society. The subsequent exposition shows us the development (*both* growth *and* movement) of these contradictions and of this society in the Σ^1 of its individual parts, from its beginning to its end.

1. Summation—*Ed.*

Such must also be the method of exposition (or study) of dialectics in general (for with Marx the dialectics of bourgeois society is only a particular case of dialectics). To begin with what is the simplest, most ordinary, common, etc., with *any proposition:* the leaves of a tree are green; John is a man; Fido is a dog, etc. Here already we have *dialectics* (as Hegel's genius recognised): the individual is the *universal* (cf. Aristoteles, *Metaphysik,* translation by Schwegler, Bd. II, S. 40, 3. Buch, 4. Kapitel, 8–9: "denn natürlich kann man nicht der Meinung sein, dass es ein Haus (a house in general) gebe ausser den sichtbaren Häusern," "οὐ γὰρ ἂν θείημεν εἶναί τνα οἰχῖαν παρὰ τὰς τινὰς οἰχίας").[2] Consequently, the opposites (the individual is opposed to the universal) are identical: the individual exists only in the connection that leads to the universal. The universal exists only in the individual and through the individual. Every individual is (in one way or another) a universal. Every universal is (a fragment, or an aspect, or the essence of) an individual. Every universal only approximately embraces all the individual objects. Every individual enters incompletely into the universal, etc., etc. Every individual is connected by thousands of transitions with other kinds of individuals (things, phenomena, processes), etc. *Here already* we have the elements, the germs, the concepts of *necessity,* of objective connection in nature, etc. Here already we have the contingent and the necessary, the phenomenon and the essence; for when we say: John is a man, Fido is a dog, *this* is a leaf of a tree, etc., we *disregard* a number of attributes as *contingent;* we separate the essence from the appearance, and counterpose the one to the other.

Thus in *any* proposition we can (and must) disclose as in a "nucleus" ("cell") the germs of *all* the elements of dialectics, and thereby show that dialectics is a property of all human knowledge in general. And natural science shows us (and here again it must be demonstrated in *any* simple instance) objective nature with the same qualities, the transformation of the individual into the universal, of the contingent into the necessary, transitions, modulations, and the reciprocal connection of opposites. Dialectics *is* the theory of knowledge of (Hegel and) Marxism. This is the "aspect" of the matter (it is not "an aspect" but the *essence* of the matter) to which Plekhanov, not to speak of other Marxists, paid no attention.

Knowledge is represented in the form of a series of circles both by Hegel (see *Logic*) and by the modern "epistemologist" of natural science, the

2. "For, of course, one cannot hold the opinion that there can be a house (in general) apart from visible houses."—*Ed.*

eclectic and foe of Hegelianism (which he did not understand!), Paul Volkmann (see his *Erkenntnistheoretische Grundzüge,*[3] S.).

"Circles" in philosophy: [is a chronology of *persons* essential? No!]

Ancient: from Democritus to Plato and the dialectics of Heraclitus.

Renaissance: Descartes versus Gassendi (Spinoza?)

Modern: Holbach-Hegel (via Berkeley, Hume, Kant).
 Hegel—Feuerbach—Marx.

Dialectics as *living,* many-sided knowledge (with the number of sides eternally increasing), with an infinite number of shades of every approach and approximation to reality (with a philosophical system growing into a whole out of each shade)—here we have an immeasurably rich content as compared with "metaphysical" materialism, the fundamental *misfortune* of which is its inability to apply dialectics to the Bildertheorie,[4] to the process and development of knowledge.

Philosophical idealism is *only* nonsense from the standpoint of crude, simple, metaphysical materialism. From the standpoint of *dialectical* materialism, on the other hand, philosophical idealism is a *one-sided,* exaggerated, überschwengliches (Dietzgen) development (inflation, distention) of one of the features, aspects, facets of knowledge into an absolute, *divorced* from matter, from nature, apotheosised. Idealism is clerical obscurantism. True. But philosophical idealism is (*"more correctly"* and *"in addition"*) a *road* to clerical obscurantism *through one of the shades* of the infinitely complex *knowledge* (dialectical) of man. [Note this aphorism.]

Human knowledge is not (or does not follow) a straight line, but a curve, which endlessly approximates a series of circles, a spiral. Any fragment, segment, section of this curve can be transformed (transformed one-sidedly) into an independent, complete, straight line, which then (if one does not see the wood for the trees) leads into the quagmire, into clerical obscurantism (where it is *anchored* by the class interests of the ruling classes). Rectilinearity and one-sidedness, woodenness and petrification, subjectivism and subjective blindness—voilà the epistemological roots of idealism. And clerical obscurantism (=philosophical idealism), of course, has *epistemological* roots, it is not groundless; it is a *sterile flower* undoubtedly, but a sterile flower that grows on the living tree of living, fertile, genuine, powerful, omnipotent, objective, absolute human knowledge.

3. P. Volkmann, *Erkenntnistheoretische Grundzüge der Naturwissenschaften* (Leipzig-Berlin, 1910), p. 35.—*Ed.*

4. Theory of reflection—*Ed.*

LEON TROTSKY

*In Paris Lenin had bought himself
a pair of shoes
that had turned out to be too tight.
As fate would have it, I badly needed
a new pair of shoes just then.
I was given Lenin's and at first
I thought they fitted me perfectly.
The trip to the opera was all right,
but in the theater I began to have pains.
On the way home I suffered agonies,
while Lenin twitted me
all the more mercilessly.*
—Trotsky, *My Life*

*I, for my part,
scarcely ever gave Stalin a thought.*
—Trotsky, *My Life*

INTRODUCTION

Why has art become a subject of such violent controversy among Marxists during the past half-century? The great concern of Marxists with aesthetic questions is of relatively recent origin. The only major debate in Marxist circles on any aesthetic question before the twentieth century was between Marx and Engels and Ferdinand Lassalle in 1859, and this had been restricted to a private correspondence which was not published until 1892 (in *Die Neue Zeit*) and appeared in book form only in 1902. The artistic productions of one's political opponents touched off no fireworks in pre-October Marxism. Engels detested Wagner's "music of the future" and engaged in many drawing-room discussions about it, but did not feel it necessary to engage in polemics on the subject. Lenin could still write (in 1910) of a play which he had seen: "Reactionary but interesting." The development of Marxist approaches to the arts during the period up to the Russian Revolution had been relatively harmonious, with the polemics on revisionism, the nature of the state, on revolutionary processes, tactics and strategy, changing aspects of capitalism, etc., finding few reflections in the

aesthetic field. It is true that there were already strong hints of controversy developing—in the Plekhanov-Lunacharsky debates of 1912 concerning such questions as objective criteria for beauty and the possibilities of a proletarian culture as well as in Lenin's prewar chiding of Gorki for joining forces with the Utopian-theological "God-Seekers" and "God-Builders." From the 1920's onward, however, aesthetics and the creative arts became sensitive barometers of political dispute, measuring and reflecting the faintest deviations in the theory and practice of revolution. Plekhanov observed that "any given political power . . . always favours the utilitarian view of art," to which we may add that in our time political power fears the emotional core of art, its nonideological aspects, its instinctual appeal. Few earlier societies have dreaded the creative artist so completely. The avenues of communication may be totally blocked, but the fear of a single poet, writing in isolation, overwhelms the state.

━━━

Which brings us to Trotsky. The following excerpts from his writings on art arose in the course of the first major debates on art in the new Soviet Republic. These debates centered primarily on such questions as: (1) The possibilities or necessity of creating a proletarian culture in conformity with the new proletarian regime; (2) The extent of Communist Party control over artistic activities; (3) The attitude toward the prerevolutionary cultural heritage. Numerous subsidiary questions arose, which soon involved the leading intellectuals of the Party (as well as its literary critics) in a fruitful debate on the nature of art and its relationship to society. The extreme left-wing artists and writers were represented organizationally at first by the *Proletkult,* dedicated to class struggle in art and rashly demanding total autonomy from Party control. Its best ideologist was A. A. Bogdanov, for whom art was primarily a captive reflection of class consciousness and "a means of uniting and rallying class forces." Lenin moved swiftly against *Proletkult*'s organizational demands for autonomy, but its ideas of art as a weapon in class struggle and its antibourgeois attitudes caught fire in such circles as the Smithy Group and the October Group, whose chief spokesman was the proto-Zhdanovist, G. Lelevich. Their main fire was directed against the so-called Fellow-Travelers, non-Party writers of nonproletarian origin sympathetic to the Revolution, who worked primarily in the nineteenth-century traditions. In addition, there was a proliferation of modernist groupings, which were linked to prerevolutionary experiments in all realms of art—such as the symbolists, imagists,

acmeists, Formalists, and futurists. All of these had their adherents after October, though only the futurists (of whom Mayakovsky is the most famous) proclaimed politically revolutionary goals. These groups and the left-wing organizations had the common desire to break in toto with the past. It was against this tendency that virtually all the major Soviet theorists and critics—Trotsky, Bukharin, Lunacharsky, V. Polonsky, and Alexander Voronsky—took a stand, though each did so from varying aesthetic attitudes and therefore with important consequences for the later development of Soviet art. The first phase of this ongoing debate closed in 1925 with a Party resolution (probably drafted by Bukharin) which gave protection to the Fellow-Travelers and proclaimed the principle of free competition and coexistence in literary styles. The arts entered a period (all too brief—it lasted until 1928) of inner ferment in a framework of political tranquillity.[1]

Like Bukharin and Lunacharsky, Trotsky argued against total Party control of the arts. In our first selection, "Art and the Party," he wrote: "The field of art is not one in which the party is called on to command." Nevertheless, he insisted here and elsewhere in *Literature and Revolution* (from which this selection is drawn) that creative freedom could only exist within the "categorical standard of being for or against the Revolution." He upheld, following Lenin, the necessity of preserving the cultural heritage of prior class societies: "The artistic work of man is continuous. Each new rising class places itself on the shoulders of its preceding one." In the tradition of Plekhanov's "objectivism," he insisted that "a work of art should, in the first place, be judged by its own law, that is, by the law of art." And he was quick to recognize that the modernists were engaged in a process of cleansing language of its accumulated and often sterile associations, that "the struggle against the old poetical vocabulary and syntax was, despite . . . extravagances, a progressive rebellion against the closed vocabulary." From Voronsky (and Labriola, who converted Trotsky to Marxism before he had read any major Marxist work) he adopted his

1. A few representative works on the early development of Soviet attitudes toward art include: Alexander Kaun, *Soviet Poets and Poetry* (Berkeley and Los Angeles, 1943), pp. 89–97; E. J. Simmons, ed., *Continuity and Change in Russian and Soviet Thought* (Cambridge, Mass., 1955), pp. 398–416, 433–50; Edward J. Brown, *Russian Literature Since the Revolution* (London, 1969); Victor Erlich, *Russian Formalism* (The Hague, 1955); Rufus W. Mathewson, *The Positive Hero in Russian Literature* (New York, 1958); Avrahm Yarmolinsky, *Literature under Communism* (Bloomington, Ind., 1960). For further information on the influential work of Voronsky, see Brown, *op. cit.*, pp. 197–202; Simmons, *op. cit.*, pp. 407–8; Alexander Dementyev, "Alexander Voronsky," *Soviet Literature*, 1967, no. 2, pp. 189–93.

insistence on supraclass, "universal" factors in consciousness and especially in art—factors common to all class societies. He was superficially acquainted with psychoanalysis and praised it highly although his knowledge of Freud is not based on Freud's major writings but on popularizations and especially on the works of Freud's Social Democratic disciple, Alfred Adler. (In passing, it might be noted that many of the early Bolsheviks were not altogether hostile to psychoanalysis: Radek, Trotsky, and Voronsky were openly favorable; Lunacharsky and Bukharin were ambivalent toward it; and Lenin, who opposed "exaggerated" attention to sexuality, hurriedly sent for a psychiatrist friend to help him care for a suicidal comrade.) The second selection, "Creativity and Class," shows that, like Voronsky, Trotsky insisted on the unconscious factor in artistic creation, on intuitive cognition in art, and argued from this against the possibility (or desirability) of rationally controlling and channeling either art or the artist.

Despite these important and advanced aesthetic opinions, there is a sense in which Trotsky is the most mechanical and pessimistic of all major Marxists concerning the role of art. "The heart of the matter," he said in our final selection, "Art and Class," "is that artistic creativity, by its very nature, lags behind the other modes of expression of a man's spirit, and still more of the spirit of a class. . . . The political writing of a class hastens ahead on stilts, while its artistic creativity hobbles along behind on crutches." By means of this thesis, Trotsky places the artistic millennium in an unspecified future, after proletarian dictatorship, after the abolition of the remnants of class society, after a long and tortuous process of bringing the proletariat, which is "uneducated aesthetically," out of "prehistoric life." Before the proletariat can appreciate and create art it must "pass through the entire history of artistic culture." Art, to Trotsky, is simply a passive reflection of the social order. He is well aware of the centrality of consciousness in Marxism, but he reserves to *political* literature the possibility of activity, of changing the world. From this, it is a half-step to the superfluity of art, or to the reduction of its role to ornament and entertainment. "Art is far less capable than science of anticipating the future," wrote Trotsky in 1936.[2] Trotsky's theory emasculates the power of art— its Utopian drive, its ability to alter consciousness, to concretize social yearnings into goals for activity, its role in making history.

Trotsky's belief that a proletarian art was theoretically impossible was opposed by Lunacharsky and Bukharin, both pointing out—according to Isaac Deutscher—that Trotsky "treated the proletarian dictatorship as a

2. *Leon Trotsky on Literature and Art* (New York, 1970), p. 100.

cultural vacuum and viewed the present as a sterile hiatus between a creative past and a creative future."[3]

Lev Davidovich Bronstein (later "Antid Oto," "Pero," and finally "Trotsky"—after the head warden of an Odessa prison) was born in Yanovka, in the Ukraine, into a well-off Jewish farm family. "As son of a prosperous landowner, I belonged to the privileged class," he wrote in *My Life*. Although his elder sister and brother took music lessons, he himself "had no ear" and his "love of music always remained helpless and unexpressed." (He did, however, later write several popular revolutionary songs.) Educated in Odessa, where he lived with relatives, he at first held no political views, and was indeed "the stubbornest opponent of 'social utopias,'" but he "swung leftward" with startling speed during his last year of school (at Nikolaev) in 1897. He joined a revolutionary group, was arrested for agitation activities, spent two years in prison, and was exiled to Siberia in 1900, escaping to Europe in 1902. He joined Lenin in London as a disciple, but voted with the Menshevik opposition in 1903. He described himself as a nonaligned Social Democrat from then until his return to Lenin and Bolshevism in 1917, although the main thrust of his polemics during the interim was against Lenin. He participated in the 1905 Revolution as president of the Petersburg Soviet, and was again exiled to Siberia. During his second European exile he was established as one of the major Russian Marxists, both for the brilliance and persuasiveness of his historical and political writing and, especially, for the magnificence of his oratory. There is a sense in which all his best writing is oratory—transcribed rhetoric. His arguments are often persuasive for their lofty and somewhat exaggerated style even when their theoretical foundation is weak. Lenin wrote to Plekhanov in 1903 that Trotsky's writing showed "traces of the feuilleton style, and is excessively florid," but he expected that this defect would be outgrown. Trotsky always remained closer to the literary style of Frederick the Great or Count Mirabeau than to that of Karl Marx. Although a confirmed and "orthodox" Marxist, his use of Marxist categories and of dialectics is minimal, especially in his earlier work. "In the writings of Marx, Engels, Plekhanov and Mehring," he noted in an indication of his intuitive and pragmatic Marxism, "I later found confirmation for what in prison seemed to me only a guess needing verification and theoretical justification."

3. Isaac Deutscher, *The Prophet Unarmed* (London, 1959), p. 198.

His early writings on art are journalistic efforts of little lasting interest. He read widely in European literature, and particularly in the French and German novel. As for the fine arts, he confesses that these gave him some difficulty: "In point of fact, I was resisting art as I had resisted revolution earlier in life, and later, Marxism; as I had resisted, for several years, Lenin and his methods." The equation of Art-Revolution-Lenin is fascinating, but difficult to interpret, except perhaps as indicating an unwillingness to wholly "give" himself to a stronger power: for Trotsky it was always important to be in command, even if this led to isolation. He never fully understood that his period of greatest heroism and accomplishment (1917–1923) was precisely the period when he submitted to Lenin's authority and thereby gained his protection. With the death of Lenin, he underwent an emotional crisis (Sedova, his wife, calls it a "critical-nervous condition") which paralyzed his activities, during which those Old Bolsheviks who had resented him as a latecomer and a usurper joined forces to oust him from leadership. "What now brought about his downfall was hostility not to his policies, but to his person," writes E. H. Carr. From the date of his exile in 1929 until his tragic murder in 1940 he achieved the lonely eminence of the righteous outcast. His hand had not lost its cunning, and his last writings (when they are not tormented by his unending search for the reasons for his downfall) reveal a historical grasp and brilliance of detail which mark them for that History of which he was so consciously a servant. Unfortunately, he permitted his later life and writings to be circumscribed by the orbit of Joseph Stalin; he attributed to Stalin an almost theological power (omnipotent evil) in world affairs. Stalin, of course, returned the compliment, seeing Trotsky as the moving force behind all anti-Soviet and antirevolutionary movements, thereby doing much to convert the lonely revolutionary émigré into a major world figure. Trotsky has been described as a prophet, a Promethean, an aristocrat of revolution. But there is also something of Don Quixote in the lean, bearded Jewish intellectual tilting his lance against the winds of history.

His most penetrating literary study—"Céline and Poincaré" [4]—dates from 1935; in it he is jolted into dialectics by his own emotional response to Céline's journey through the cloaca of society. Recognizing Céline's "aversion for the lie" and his simultaneous "disbelief in the truth"—i.e., in those "great projects and hopes" which can lead "humanity from out the dark night of the circumscribed I"—he warns that there can be no second *Journey to the End of the Night:* "Either the artist will make his

4. Originally published in *The Atlantic Monthly,* October, 1935, pp. 413–20; it is readily available in *The Basic Writings of Trotsky* (New York, 1963) and in *Leon Trotsky on Literature and Art* (New York, 1970).

peace with the darkness or he will perceive the dawn." Trotsky himself accomplished neither of these finalities.

TROTSKY: **ART AND THE PARTY**
from *Literature and Revolution*

Does that mean that the Party, quite in opposition to its nature, occupies a purely eclectic position in the field of art? This argument, which seems so crushing, is, in reality, extremely childish. The Marxian method affords an opportunity to estimate the development of the new art, to trace all its sources, to help the most progressive tendencies by a critical illumination of the road, but it does not do more than that. Art must make its own way and by its own means. The Marxian methods are not the same as the artistic. The Party leads the proletariat but not the historic processes of history. There are domains in which the Party leads, directly and imperatively. There are domains in which it only coöperates. There are, finally, domains in which it only orientates itself. The domain of art is not one in which the Party is called upon to command. It can and must protect and help it, but it can only lead it indirectly. It can and must give the additional credit of its confidence to various art groups, which are striving sincerely to approach the Revolution and so help an artistic formulation of the Revolution. And at any rate, the Party cannot and will not take the position of a literary circle which is struggling and merely competing with other literary circles. The Party stands guard over the historic interests of the working-class in its entirety. Because it prepares consciously and step by step the ground for a new culture and therefore for a new art, it regards the literary fellow-travelers not as the competitors of the writers of the working-class, but as the real or potential helpers of the working-class in the big work of reconstruction. The Party understands the episodic character of the literary groups of a transition period and estimates them, not from the point of view of the class passports of the individual gentlemen literati, but from the point of view of the place which these groups occupy and can occupy in preparing a Socialist culture. If it is not possible to determine the place of any given group today, then the Party as a Party will wait patiently and gracefully. Individual critics or readers may sympathize with one group or another in advance. The Party, as a whole, protects the historic interests of the working-class and must be more objective and wise. Its caution must be double-edged. If the Party does not put its stamp of approval on the "Kuznitsa," just because workers write for it, it does not, in advance, repel any given literary group, even from the intelligentsia, in so far as such a

group tries to approach the Revolution and tries to strengthen one of its links—a link is always a weak point—between the city and the village, or between the Party member and the non-partisan, or between the intelligentsia and the workers.

Does not such a policy mean, however, that the Party is going to have an unprotected flank on the side of art? This is a great exaggeration. The Party will repel the clearly poisonous, disintegrating tendencies of art and will guide itself by its political standards. It is true, however, that it is less protected on the flank of art than on the political front. But is this not true of science also? What are the metaphysicians of a purely proletarian science going to say about the theory of relativity? Can it be reconciled with materialism, or can it not? Has this question been decided? Where and when and by whom? It is clear to anyone, even to the uninitiated, that the work of our physiologist, Pavlov, is entirely along materialist lines. But what is one to say about the psycho-analytic theory of Freud? Can it be reconciled with materialism, as, for instance, Karl Radek thinks (and I also), or is it hostile to it? The same question can be put to all the new theories of atomic structure, etc., etc. It would be fine if a scientist would come along who could grasp all these new generalizations methodologically and introduce them into the dialectic materialist conception of the world. He could thus, at the same time, test the new theories and develop the dialectic method deeper. But I am very much afraid that this work—which is not like a newspaper or journalistic article, but a scientific and philosophic landmark, just as the *Origin of Species* and *Capital*—will not be created either today or tomorrow, or rather, if such an epoch-making book were created today, it would risk remaining uncut until the time when the proletariat will be able to lay aside its arms.

TROTSKY: **CREATIVITY AND CLASS**
from *Class and Art*

One cannot approach art as one can politics, not because artistic creation is a religious rite or something mystical, as somebody here ironically said, but because it has its own laws of development, and above all because in artistic creation an enormous role is played by sub-conscious processes— slower, more idle and less subjected to management and guidance, just because they are sub-conscious. It has been said here that those writings of Pilnyak's which are closer to Communism are feebler than those which are politically farther away from us. What is the explanation? Why, just this, that on the rationalistic plane Pilnyak is ahead of himself as an artist. To

consciously swing himself round on his own axis even only a few degrees is a very difficult task for an artist, often connected with a profound, sometimes fatal crisis. And what we are considering is not an individual or group change in creative endeavour, but such a change on the class, social scale. This is a long and very complicated process. When we speak of proletarian literature not in the sense of particular more or less successful verses or stories, but in the incomparably more weighty sense in which we speak of bourgeois literature, we have no right to forget for one moment the extraordinary cultural backwardness of the overwhelming majority of the proletariat. Art is created on the basis of a continual everyday, cultural, ideological inter-relationship between a class and its artists. Between the aristocracy or the bourgeoisie and their artists there was no split in daily life. The artists lived, and still live, in a bourgeois milieu, breathing the air of bourgeois salons, they received and are receiving hypodermic inspirations from their class. This nourishes the sub-conscious processes of their creativity. Does the proletariat of today offer such a cultural-ideological milieu, in which the new artist may obtain, without leaving it in his day-to-day existence, all the inspiration he needs while at the same time mastering the procedures of his craft? No, the working masses are culturally extremely backward; the illiteracy or low level of literacy of the majority of the workers presents in itself a very great obstacle to this. And above all, the proletariat, in so far as it remains a proletariat, is compelled to expend its best forces in political struggle, in restoring the economy, and in meeting elementary cultural needs, fighting against illiteracy, lousiness, syphilis, etc. Of course, the political methods and revolutionary customs of the proletariat can also be called its culture; but this, in any case, is a sort of culture which is destined to die out as a new, real culture develops. And this new culture will be culture all the more to the extent that the proletariat has ceased to be a proletariat, that is, the more successfully and completely socialist society develops.

Mayakovsky wrote a very powerful piece called *The Thirteen Apostles,* the revolutionariness of which was still rather cloudy and formless. And when this same Mayakovsky decided to swing himself round to the proletarian line, and wrote *150 Million,* he suffered a most frightful rationalistic downfall. This means that in his logic he had outrun his real creative condition. With Pilnyak, as we have said already, a similar disparity is to be observed between his conscious striving and the unconscious processes of creation. To this must be added merely this, that arch-proletarian works also do not in themselves provide the writer in present-day conditions with any guarantees that his creativity will prove to be organically linked with the class. Nor do groupings of proletarian writers provide this guarantee,

precisely because the writer, by devoting himself to artistic work, is compelled, in existing conditions, to separate himself from the milieu of his own class and breathe an atmosphere which, after all, is the same as that breathed by the "fellow-travellers."

TROTSKY: **ART AND CLASS**
from *Class and Art*

The heart of the matter is that artistic creativity, by its very nature, lags behind the other modes of expression of a man's spirit, and still more of the spirit of a class. It is one thing to understand something and express it logically, and quite another thing to assimilate it organically, reconstructing the whole system of one's feelings, and to find a new kind of artistic expression for this new entity. The latter process is more organic, slower, more difficult to subject to conscious influence—and in the end it will always lag behind. The political writing of a class hastens ahead on stilts, while its artistic creativity hobbles along behind on crutches. Marx and Engels were great political writers of the proletariat in the period when the class was still not really awakened. (From the meeting: "Yes, you're right there.") I am very grateful to you. (Laughter.) But take the trouble to draw the necessary conclusions from this, and understand why there is not this monolithicity between political writing and poetry, and this will in turn help you to understand why in the old legal Marxist periodicals we always found ourselves in a bloc, or semi-bloc, with artistic "fellow-travellers," sometimes very dubious and even plainly false ones. You remember, of course, *Novoye' Slovo,* the best of the old legal Marxist periodicals, in which many Marxists of the older generation collaborated, including Vladimir Ilyich. This periodical, as everyone knows, was friendly with the Decadents. What was the reason for that? It was because the Decadents were then a young and persecuted tendency in bourgeois literature. And this persecuted situation of theirs impelled them to take sides with our attitude of opposition, though the latter, of course, was quite different in character, in spite of which the Decadents were temporarily fellow-travellers with us. And later Marxist periodicals (and the semi-Marxist ones, it goes without saying), right down to *Prosveshchenie,* had no sort of "monolithic" fiction section, but set aside considerable space for the "fellow-travellers." Some might be either more severe or more indulgent in this respect, but it was impossible to carry on a "monolithic" policy in the field of art, because the artistic elements needed for such a policy were lacking.

But [Feodor] Raskolnikov at bottom doesn't want this. In works of art he ignores that which makes them works of art. This was most vividly shown in his remarkable judgment on Dante's *Divine Comedy,* which in his opinion is valuable to us just because it enables us to understand the psychology of a certain class at a certain time. To put the matter that way means simply to strike out the *Divine Comedy* from the realm of art. Perhaps the time has come to do that, but if so we must understand the essence of the question and not shrink from the conclusions. If I say that the importance of the *Divine Comedy* lies in the fact that it gives me an understanding of the state of mind of certain classes in a certain epoch, this means that I transform it into a mere historical document, for, as a work of art, the *Divine Comedy* must speak in some way to my feelings and moods. Dante's work may act on me in a depressing way, fostering pessimism and despondency in me, or, on the contrary, it may rouse, inspire, encourage me. . . . This is the fundamental relationship between a reader and a work of art. Nobody, of course, forbids a reader to assume the role of a researcher and approach the *Divine Comedy* as merely an historical document. It is clear, though, that these two approaches are on two different levels, which, though connected, do not overlap. How is it thinkable that there should be not an historical but a directly aesthetic relationship between us and a mediaeval Italian book? This is explained by the fact that in class society, in spite of all its changeability, there are certain common features. Works of art developed in a mediaeval Italian city can, we find, affect us too. What does this require? A small thing: it requires that these feelings and moods shall have received such broad, intense, powerful expression as to have raised them above the limitations of the life of those days. Dante was, of course, the product of a certain social milieu. But Dante was a genius. He raised the experience of his epoch to a tremendous artistic height. And if we, while today approaching other works of mediaeval literature merely as objects of study, approach the *Divine Comedy* as a source of artistic perception, this happens not because Dante was a Florentine petty bourgeois of the 13th century but, to a considerable extent, in spite of that circumstance. Let us take, for instance, such an elementary psychological feeling as fear of death. This feeling is characteristic not only of man but also of animals. In man it first found simple articulate expression, and later also artistic expression. In different ages, in different social milieux, this expression has changed, that is to say, men have feared death in different ways. And nevertheless what was said on this score not only by Shakespeare, Byron, Goethe, but also by the Psalmist can move us. (Exclamation by Comrade [Yuri] Libedinsky.) Yes, yes, I came in at the very moment when you, Comrade Libedinsky, were

explaining to Comrade [Alexander] Voronsky in the terms of elementary political instruction (you yourself put it like that) about the variation in feelings and states of mind in different classes. In that general form it is indisputable. However, for all that, you won't deny that Shakespeare and Byron somehow speak to your soul and mine. (Libedinsky: "They will soon stop speaking.") Whether it will be soon, I don't know, but undoubtedly a time will come when people will approach the works of Shakespeare and Byron in the same way as we approach most poets of the Middle Ages, that is, exclusively from the standpoint of scientific-historical analysis. Even sooner, however, will come the time when people will stop seeking in Marx's *Capital* for precepts for their practical activity, and *Capital* will have become merely an historical document, together with the programme of our Party. But at present we do not yet intend to put Shakespeare, Byron, Pushkin in the archives, and we will continue to recommend them to the workers.

NIKOLAI BUKHARIN

VYSHINSKY: *I ask the Court
to explain to the accused Bukharin
that he is here not in the capacity
of a philosopher, but as a criminal,
and he would do better to refrain
from talking here about
Hegel's philosophy. . . .*
BUKHARIN: *A philosopher may
be a criminal.*

—From the transcript of the
"Trial of Bloc of Rights and Trotskyites"

INTRODUCTION

Nikolai Ivanovich Bukharin (1888–1937) was the son of two Moscow
schoolteachers. A brilliant student, he joined the Social Democratic Party
in 1906, and in that year organized a strike in a boot factory, with the help
of fifteen-year-old Ilya Ehrenburg. He studied at Moscow University, was
arrested several times, and escaped to Europe in 1910. In Vienna, he
attended the University, studying economics under Böhm-Bawerk. He was
an artist as well as a student of political economy; Krupskaya reports that
in 1912 he brought his paintings to Lenin in Cracow when he visited him
for the first time. Expelled from Austria in 1914, he went to Switzerland,
Sweden, Norway, and in October 1916 to the United States, where he
coedited a Russian newspaper with Trotsky for a few months. He returned
to Russia after the February revolution and (with Stalin) played a leading
role at the Sixth Party Congress of August 1917. He became a member of
the Party's Central Committee, editor of *Pravda,* and a leading figure in the
Communist International.

He participated actively in all major governmental debates and decisions

until 1929, when he was stripped of his Party offices for opposing the forced collectivization of the countryside. He functioned in lesser posts— including the editorship of *Izvestia*—toward the mid-1930's and by 1936 was given the major responsibility for drafting the new Soviet Constitution. He was tried in 1937, as leader of the oppositionist "Bloc of Rights." He pleaded guilty—in a drama whose tangled threads and ambiguities have not yet been fully explored. Soviet Russia's leading Marxist theoretician, that "happy nature" whom Lenin had loved (he wrote: one "cannot help loving him") and whom he had described in his "Testament" as "the favorite of the whole party," was condemned to death and shot. He has not yet been "rehabilitated."

Bukharin's pre-October writings are on political economy and the nature of imperialism. After the Revolution, he turned to popularization of the principles of Communism and of Marxism, writing a series of books that were an important part of the intellectual equipment of a generation of Communists: *Programme of the Communists (Bolsheviks)* (1918), *ABC of Communism* (coauthored with Preobrazhensky in 1919), and the famous textbook, *Historical Materialism: A System of Sociology* (1921). The last of these contains an erudite and schematic presentation of a sociology of art, from which we reprint a brief excerpt embodying Bukharin's definition of art. Bukharin's sociology arises within the ambiance of Weber, Simmel, and Sombart and may be regarded as an attempt to utilize their findings in the context of a pseudo-Marxist "technocratic" emphasis. Bukharin was at this time heavily influenced (in his autobiographical sketch he called it a "heretical leaning") by Bogdanov's "Empirio-Monism," a rigidly organized doctrine which emphasizes the "objective character of the physical world" at the expense of subjective elements of consciousness, and organizes this objectivity so completely that reality ultimately appears to be nothing more than a mental construct itself. In terms of Marxist theory, it sees superstructural factors as purely derivative, incapable of activity: in other words, it is a sophisticated form of economic determinism. When Bukharin wrote his *Historical Materialism,* Bogdanov was moving into a new phase, which he labeled "Tectology," a theory which explains natural and social movement in terms of a dynamic equilibrium whose unstable harmony is disrupted and then restored. Bukharin swallowed this theory whole, and was convinced that it represented an accurate description of Hegelian (and therefore Marxist) dialectics. He wrote that "Hegel . . . called the original condition of equilibrium the *thesis,* the disturbance of equilibrium the *antithesis,* the reestablishment of equilibrium on a new basis the *synthesis*" (page 74). But this stereotyped and mechanical triad (originally introduced into German philosophy by Fichte, and taken up by

Schelling) was—as Walter Kaufmann and others have repeatedly insisted —never adopted by Hegel. For Hegel (and Marx and Lenin), the dialectical process involves both the unity of opposites *and* their contrariety: the unity of opposites produces self-movement, whereas for Bukharin and Bogdanov the origin of motion—being the product of conflict between wholly antagonistic opposing forces—lies outside of things, requiring a mechanical causative factor to bring it into operation. In terms of a theory of art, Bukharin's overemphasis on the technological factor makes impossible the exploration of creativity, of the inner dynamics of the art object, or of the active role of artistic creation or audience response.

Bukharin's *Historical Materialism* was widely criticized by Western Marxists (most fruitfully by Lukács and Gramsci); Lenin wrote that Bukharin's "theoretical views can only with the greatest doubt be regarded as fully Marxist. . . . [H]e has never learned, and I think never has fully understood, the dialectic."

The height of Bukharin's reputation as the ideological leader of the Communist movement was reached during the mid- and late 1920's, climaxed by his leading role in the authorship of the *Programme of the Communist International* (1928). Occupied in Party and Comintern affairs and conflicts, immersed in questions of socialist economics and global revolutionary tactics, the 1920's passed without further attention by Bukharin to Marxist philosophy as such. During this period, however, he began to emerge as an independent person, in contrast to his earlier tendency to attach himself to the views of one or another of the Bolshevik leaders. Breaking with Trotsky in late 1923 over his agrarian policy, Bukharin became the champion of the peasantry; in this he was Stalin's ally, but when Stalin later adopted Trotsky's position on forced collectivization of agriculture, Bukharin remained immovable and thereby fell from power.

But, as he was later to tell Vyshinsky, "Every negation contains an affirmation, Citizen Procurator." Bukharin's expulsion was simultaneously his liberation from Party affairs, permitting him to devote the next years to a total revision of his philosophical thought. He (with what appears to have been a conscious effort) corrected the false emphases of *Historical Materialism* in his brilliant contribution to the fiftieth anniversary of Marx's death—"Marx's Teaching and Its Historical Importance." He wrote and spoke widely on culture and its relationship to capitalist crisis and socialist requirements.

The old pattern of personal submission was broken. Bukharin's pliability as an individual (Trotsky wrote: "he must always lean on somebody") and his mechanical rigidity as a theoretician (Lenin wrote: "there is something

scholastic in him") came to an end. His former leaders—Lenin, Bogdanov, Trotsky, Zinoviev—were dead or had fallen from grace. He had broken with Stalin. There was no longer anyone to follow except the memory and the example of Lenin, whom he loved, wrote Trotsky, "with the love of a child for its mother." No longer would his philosophy be dominated by a balance of equal forces. Bukharin's period of equilibrium was transformed into a new dynamic dialectic, tragically interrupted before he was able to fully commit his newly gained knowledge to paper.

The main selection, from Bukharin's "Poetry, Poetics, and the Problems of Poetry in the U.S.S.R." is the opening section of his address to the first All-Union Congress of Soviet Writers, August 1934. It is one of the crowning works of Marxist aesthetic theory in the Soviet Union, a synthesis of the Formalist concern for the intrinsic aspects of poetry with the sociological insistence on genetic factors. (Still lacking, unfortunately, was a viable psychology.) Its keynote is the word: "Within the microcosm of the word is imbedded the macrocosm of history." The word is of a double nature, reflecting and embodying the intellectual and emotional poles of experience, summarizing and exemplifying the cognitive and affective modes of comprehension. Logical thought employs concepts, abstractions: it attempts to scrub the sensory from consideration; emotional expression finds its "points of condensation" in images, in symbols. The sensory experience is itself condensed images. The word is "abridged history." "Examine a word, and you discover the palaeontology of language. Words are the depository of the whole previous life of mankind." Poetry, which fixes sensory images in words, "summarizes the world of emotion in its own peculiar way. But these emotions, these experiences, are in themselves experiences of the social-historical man, and in a class society, of the class man. For even such emotions as have their roots in the fathomless biological depths of man, like emotions of an erotic nature, are modified in the course of the historical process." Bukharin had moved through the word to society: the road back would henceforth be an easier one.

It is "forgotten" by friends of Marxism that one of the greatest and most influential schools of literary criticism—the Formalist—flourished and reached its apogee in the Soviet Union in the 1920's. Originating just before the Revolution, the Formalist school rapidly attracted many brilliant young Soviet philologists and students—Boris Eikhenbaum, Roman Jakobson, Victor Shklovsky, Boris Tomashevsky, Yuryi Tynyanov, Victor Vinogradov, Osip Brik, and numerous others—to the intrinsic study of literature, to the exploration of technique and language, to the study of

rhythm, style, and composition, to the exploration of the "how" of literature. (The "New Criticism" of the post–World War II era derived in large part from the pioneering work of Russian Formalists.) Formalism tended to overstate its case, insisting at first on the superfluity of all extrinsic causative factors, including the sociological and the political—and this made it the center of controversy among the Bolshevik intellectuals. In the mid-1920's, Trotsky and Bukharin attacked its extraneous theses—its "world view"—but recognized its merit as "spadework preliminary to future critical synthesis" (Bukharin). Toward the end of the decade the Formalists began to move toward just such a synthesis, but the sociological leftists abrogated free inquiry in literature, and Formalism was officially repudiated in the late 1920's—not, however, before it had created its major works, almost all of which (except some of Jakobson's) were published in the Soviet Union in the 1920's.

Ironically, with the passage of time, it becomes probable that Formalism was not a briefly tolerated carry-over—a "survival"—from the bourgeois past but a significant branch of revolutionary criticism itself: Lunacharsky had called it "a vegetable out of season," but young Communist intellectuals in the academic world were drawn to Formalism during the Civil War and the period of the New Economic Policy, perhaps seeing it as an extension of the Revolution itself into literature. In his "Social and Aesthetic Criteria in Soviet Russian Criticism," Victor Erlich suggests this: "The hard-boiled preoccupation with literary technology, with the 'laws of literary production,' was well attuned to the temper of the age which with Lenin defined socialism as 'Soviet system plus electrification.' " "Perhaps," writes Erlich, "the Formalist methodology was after all more akin to the *Zeitgeist* than the Soviet-Marxist stalwarts were ready to admit."[1] I would suggest that the Formalist depth exploration of the nuclear elements of the literary work of art parallels Marx's attempt in *Capital* to penetrate the macrocosm of capitalism through an assault upon the smallest unit of its productive process—the commodity.

The historical significance of Bukharin's 1934 speech was its reintroduction of Formalist concepts into the aesthetic field, from which they had been proscribed for some years. Bukharin's poetics are a synthesis of the Formalist and sociological positions:

Every poetical work is an integral unity, in which sound, ideas, imagery, etc., are component parts synthetically united. On the other hand, it is also a unity

1. Victor Erlich, "Social and Aesthetic Criteria in Soviet Russian Criticism," in *Continuity and Change in Russian and Soviet Thought,* ed. E. J. Simmons (Cambridge, Mass., 1955), p. 401. See also Erlich, *Russian Formalism* (The Hague, 1955).

from the sociological viewpoint, since all the component parts and their synthesis, taken together, are "ideological reflexes" of a definite period and a definite class. How, then, under such circumstances, is it possible to learn [from the past]? . . . The general answer [is that] "negation" is not sheer destruction, but a new phase in which "the old" exists in *aufgehobener* Form. . . . In such a type of "movement" we have the possibility of a succession which will dialectically combine both a rupture with the old and a peculiar continuation of it.

———

The opening address to the All-Union Writers' Congress was given by one A. A. Zhdanov: it reveals a quite pathological identification of culture and "pornography," an obsession with "orgies," "decay," "decadence," literary "prostitutes," etc., which places it outside the realm of aesthetic discourse. Within two years, the attack upon the Formalist school was renewed (in the critiques of Shostakovich and Meyerhold), and the word "Formalism" itself became equated with cultural counterrevolution. Formalist criticism was again proscribed and its practitioners (including those like Bakhtin, who had moved into a "Structuralist," near-Marxist phase) were unable to publish. Bukharin's synthesis was not to bear fruit in his own country. (In the few years between his speech to the Writers' Congress and his execution, Bukharin's "Poetics" had their impact on Western Marxists—especially on Christopher Caudwell.)

Nicolaevsky relates that when Bukharin was shown the original manuscript of *Capital* he immediately turned to the final, fragmentary pages where Marx had taken up but not developed the Marxist theory of classes. Bukharin was hoping that there was something more in the manuscript than in Engels' edition; but he found nothing. The manuscript corresponded exactly with Engels' published version. Then Bukharin mourned aloud: "Ah, Karlyusha, Karlyusha, why didn't you finish? It was difficult for you, but how you would have helped us!"[2] It was Marx's free choice that he leave his life's work incomplete. With Bukharin, it was another matter.

2. Boris I. Nicolaevsky, *Power and the Soviet Elite* (New York, Washington, London, 1965), p. 20. Peter Bergman advises me that Nicolaevsky related precisely the same anecdote to him, but in reference to D. Riazanoff rather than Bukharin.

BUKHARIN: **WHAT IS ART?**
from *Historical Materialism*

Art is as much a product of the social life as is science or any other outgrowth of material production; the expression "objects of art" will make this apparent. But art is an outgrowth of the social life in the further sense that it is a form of mental activity. Like science, it can develop only at a certain level of productive labor, in default of which it will wither and perish. But the subject of art is sufficiently complicated to justify an investigation of the manner in which it is determined by the course of social life; the first question requiring an answer is: what is art; what is its fundamental social function?

Science classifies, arranges, clarifies, eliminates the contradictions in, the thoughts of men; it constructs a complete raiment of scientific ideas and theories out of fragmentary knowledge. But social man not only thinks, he also feels; he suffers, enjoys, regrets, rejoices, mourns, despairs, etc.; his thoughts may be of infinite complexity and delicacy; his psychic experiences may be tuned according to this note or that. Art systematizes these feelings and expresses them in artistic form, in words, or in tones, in gestures (for example, the dance), or by other means, which sometimes are quite material, as in architecture. We may formulate this condition in other words: we may say, for example, that art is a means of "socializing the feelings"; or, as Leo Tolstoi correctly says in his book, art is a means of emotionally "infecting" men. The hearers of a musical work expressive of a certain mood will be "infected," permeated, with this mood; the feeling of the individual composer becomes the feeling of many persons, has been transferred to them, has "influenced" them; a psychic state has here been "socialized." The same holds good in any other art; painting, architecture, poetry, sculpture, etc.

The nature of art is now clear: it is a systematization of feelings in forms; the direct function of art in socializing, transferring, disseminating these feelings, in society, is now also clear.

BUKHARIN: **POETRY**
from *Poetry, Poetics, and the Problems of Poetry in the U.S.S.R.*

The final subject of this report is that of the problems of poetic creation in the U.S.S.R. But before proceeding to an analysis of these problems, it will be worth our while critically to examine a number of general questions

connected with poetic creation—the more so since there is still a great deal that is not clear here, and this lack of clarity is reflected above all in our literary criticism, which has a great task to perform and does not always perform it well.

Here I must ask my hearers to excuse me. For a certain period of time they may find it rather boring, but boredom, like evil, will the better set off the good that will follow in the latter part of my report, where it will not be so boring, and where I shall, perhaps, encounter violent objections. Here I may invoke the authority of the blessed Augustine, who said that evil exists only in order to set off the good. Having cited such a powerful authority as this, let me ask you to have patience for a little.

Let us first consider poetry as such. The *Encyclopaedia Britannica* says: "Absolute poetry is the concrete and artistic expression of the human mind in emotional and rhythmical language."

It is easy to see that this definition suffers from the fundamental defect that it defines poetry, that is, a concrete form of art, by means of artistic activity, which itself must be defined from the point of view of the specific character of art. The definition is therefore tautological. Moreover, it is obviously necessary somehow to differentiate the special properties of poetic speech, of poetic language and of the corresponding poetic thought, because thought is firmly and indissolubly linked up with language. Ancient Hindu poetics had already developed the Anandavardhana doctrine (tenth century B.C.) of the twofold, "hidden" meaning of poetic speech. According to this doctrine, language in which words are used solely and exclusively in their direct, "customary" sense cannot be called poetic speech. Whatever such speech may convey, it will be prose. Only when the words, by various associations, evoke other "pictures, images, feelings," when "poetic thoughts glimmer, radiate, as it were, through the words of the poet, but are not expressed directly by him," do we have authentic poetry. Such is the doctrine of the *"dhvana,"* of the poetic innuendo, of the hidden meaning of poetic speech. Similar theories have often been associated with a mystic interpretation of poetry and poetic experience, as of something touching the fringe of "other worlds." In ancient China we find, for example, a whole brilliant poetic treatise, the poem *Categories of Verse* by Ssŭ-K'ung T'u (837–908 A.D.), on the theme of divine poetic inspiration where the "True Lord," the "Prime Ancestor," the "Creator of Transformations," the "Spirit-like Transmogrifier," the "Heavenly Loom," the "Wondrous Mechanism," the "Highest Harmony" and, finally, the "Black Nothing"—the Great Tao—lives in a state of inexpressible poetic "inspiration." Having their roots deep in the idea of the magic of the word, such ideas often led to the direct deification of the word, which became a mystic

essence. Thus, we find in one Arab philosopher the interpretation of the "Word" with a capital W, the Greek Logos, not as reason raised to the degree of the world's Demiurge, but as the embodiment of volition creating the world. Yet strange as it may seem, it is a highly characteristic fact that this magical or semi-magical interpretation of the art of words and the art of poetry, after a long cycle of ages, has once more gained currency in our own era; it was comparatively recently that we had a similar interpretation of poetry in bourgeois literary theory and bourgeois poetics.

In our own times Gumilev[1] has expressed this idea in poetic form:

> In days of yore, when o'er a world still new
> God leaned his head, it was a word
> Which made the sun stop in his course,
> And towns were ruined by a word.
>
> But we forgot the word alone is blessed
> 'Mid terrors that are sent us for a rod,
> And in the Gospel that was writ by John
> 'Tis said the word—is God.

In his day Balmont,[2] an unquestioned master of language, attempted to provide a "theoretical" basis for this fetishization of speech-reflexes in his book, *Poetry as Magic,* the very title of which clearly indicates the author's trend of ideas. "The world needs the creation of images," he declared. "The world has its magicians, who broaden and enrich the circle of existence by the magic of their will and the music of their words." This poet, who was organically incapable of logical thinking, produces nothing to "prove" his argument but a long succession of carefully chosen and impressive images, which are intended to take the place of thought. Andrey Biely,[3] on the other hand, once made an attempt to give philosophic depth to the same subject, and word fetishism with him reached truly Himalayan heights. "If there were no words, there would be no world," he wrote. "My Ego, apart from its surroundings, does not exist at all. The world, apart from me, does not exist either. 'I' and 'the world' spring to life only in the process of their union in sound."

1. Gumilev, Nikolai Stepanovich (1886–1921). Russian poet, prose writer and critic. Shot in 1921 for participation in a whiteguard plot. The verses here quoted are from his last book, *The Pillar of Fire.—Ed.*

2. Balmont, Constantine Dmitrievich (b. 1867). Well-known Russian poet. One of the four chief representatives of Russian symbolism—Bryussov, Blok, Balmont and Biely. Emigrated after the October Revolution of 1917.—*Ed.*

3. Russian poet, prose writer and critic (1880–1934). The passage quoted is from an article entitled "The Magic of Words" in his book *Symbolism.—Ed.*

Thus, authors of various theories have lapsed into pure mysticism in their attempts to approach the problems of poetic speech. This, of course, had its causes—causes of a social and historical nature which are not far to seek. But at present this does not concern us. We only want to point out the *existence* of such a way of putting the question, and that at different periods and in different countries.

Such points of view, inasmuch as they are idealistic and mystical, are of course unacceptable to us. They are a sort of refined barbarism, crudely contradictory to all scientific experience. But their very existence emphasizes the problem of the specific character of poetic thought and poetic speech, of that "mystery," "sorcery," and "magic," in which the mystics seek to envelop their readers' minds as in a veil, locking all the doors of rational perception.

But there is nothing mystic in phenomena themselves. The process of life, taken as "experience," has its intellectual, emotional and volitional sides. We make a conventional distinction between logical thought, thought in terms of concepts, and "thought in terms of images," the so-called "realm of emotion." True, in actual life the stream of experience is integral and undivided; nevertheless, in this very unity, we have the intellectual pole and the emotional pole, even though they may not exist in their "pure form," even though they may merge into one another. But it would be entirely and essentially wrong to make an absolute mechanical subdivision of the so-called "spiritual life" into water-tight compartments of feeling and intellect, or of the conscious and the unconscious, or of the directly sensory and the logical. These are not separate domains of abstract categories. They are dialectical magnitudes composing a unity. At one and the same time we are confronted with differences and even with opposites, though these opposites also merge into one another. This likewise gives rise to a certain difference in types of thinking.

Logical thinking employs concepts, which range themselves into a whole ladder of thought, with various rungs, or degrees, of abstraction. Even when we are dealing with the highest type of logical thought—dialectical logic—where the abstract concept includes its concrete attributes, the very concept, as such, causes sensory colours, sounds and tones to lose their vividness. Moreover, perceptive action oversteps the bounds of the senses, although it has its source in them; in summarizing human experience, it perceives, for instance, the subjectivity of colour, and coming closer to a real perception of the world, of its objective nature, independent of the subject, it "replaces" colour by a light wave of definite length. In science, the entire qualitative diversity and multiformity of the world take on other

forms, quite distinct from immediate sensation, but giving a much more adequate reflection of reality—that is, more true.

On the other hand, the entire world of emotions—love, joy, terror, grief, rage, and so on to infinity—the entire world of desire and passion, not as the object of research, but as experience, as well as the whole world of immediate sensations, also have their points of condensation—thought in terms of images. Here there is no abstraction from what is directly experienced. Here the process of generalization does not take us beyond its limits (as is the case in logical thought and in its highest product, scientific thought). Here this very sensory experience—doubly concrete and doubly "alive"—is itself condensed. Here we have, not a scientific reflection of real existence, but a sensorily generalized picture of a phenomenological series, not of the "essence," but of the "phenomenon." This does not by any means signify that we are dealing with an illusion or a dream. Nothing of the sort! This essence appears in the phenomenon. The essence merges into the phenomenon. The senses do not fence us off from the world.

But objective reality is here "reflected" differently. In science, it is reflected as a world of qualitatively diverse forms of matter; in art, as a world of sensory images; in science, as electrons, atoms, species, value, etc.; in art, as colours, odours, hues, sounds, images. The type of thinking here is not the same as in logical thought. Here generalization is achieved not by extinguishing the sensory, but by substituting one complex of sense symbols for a great multitude of other complexes. This "substitute" becomes a "symbol," an "image," a type, an emotionally coloured unity, behind which and in the folds of whose garments thousands of other sensory elements are concealed. Every such unity is sensorily concrete. To the extent that such unities are selected and fixated, *i.e.,* that these experiences are constructively, creatively reproduced, to this extent we have art.

The word itself is a highly complex magnitude. Being the product of many thousands of years of development, it embraces, like some cell of a "spiritual organism," all the problems of thought with both its principles—image and concept. In scientific terminology, it grows as a symbol of the "pure concept"; in poetical speech, it is imagery first and foremost. Consequently, the laws governing both the selection of words and their combination will differ, or, to express it otherwise, poetical speech will inevitably have its specific peculiarities. That remarkable investigator of these problems, Potebnia,[4] who while essentially developing the theory of Hum-

4. Potebnia, Alexander Aphanasyevich (1835–1891). Russian linguist, philologist and writer on the theory of poetry. The passage here quoted is from a work by him entitled *Thought and Language.—Ed.*

boldt,[5] arrived at a number of most original solutions, formulates the polarity of art and science as follows:

Alike in the broad and in the strict sense, all that pertains to thought is subjective; that is to say that, even though conditioned by the external world, it is yet the product of personal creation. But within this all-embracing subjectivity, we can distinguish the objective and the subjective, and refer science to the first and art to the second. The basis for this is as follows: in art, only the image is the common property of all; it is understood differently by everyone, and the understanding of it can consist only of unanalysed (real and wholly personal) feeling, such as is evoked by the image; in science, however, there is no image, and feeling cannot enter save as a subject of research; the sole building material of science is the concept, composed of symbols of the image already objectivized in the word. If art is a process of objectivized primary data of spiritual life, then science is a process of objectivizing art. The difference in degree of objectivity of thought is identical with the degree of its abstractness: the most abstract of sciences, mathematics, is at the same time the most unquestionable one in its principles, the one that least of all admits the possibility of personal views.

It is easy to see that these formulations contain a number of errors. The author does not present any clearly defined ideas on the truthfulness, the objectivity of perception, and a loophole is left open for idealism; he obviously underestimates the social character of language, of the entire creative process, etc.; he draws too sharp a line of demarcation, metaphysically separating different aspects of thought. In consequence there is little that is dialectic here. At the same time there is much that is true and unquestionably deserving of attention. To continue the broken thread of our argument, we may say that the system of concepts proceeds outward through science: taking the sensations as our starting point, we advance further and further beyond their borders, where we perceive the objective character of the world, continually studying new facts and perfecting science, moving along the endless path of converting relative truth into absolute truth, destroying antiquated systems of science as we proceed on our way. In the field of art we do not go beyond the limits of the phenomenological series; here, as we said before, the objective world is reflected differently; here emotions are not made the object of scientific research; here even nature is "humanized." Here, therefore, the "warm," emotional, vivid and metaphorical principle is placed in relative contrast to the "cold," intellectual, logical principle:

5. Humboldt, Karl Wilhelm von (1767–1835). German philologist. Author of *The Heterogeneity of Language and Its Influence on the Intellectual Development of Mankind.—Ed.*

Water and stone,
Verse and prose,
Ice and fire. (*Pushkin.*)

Poetry is understood both in the broad and in the narrow sense of the word. All speech in terms of images is poetical speech; from this point of view Gogol's *Dead Souls* or Pushkin's *The Captain's Daughter* are poetical works. By poetry in the narrow sense is understood not simply the fixation of sensory images in words, but, in addition, rhythmical speech and even rhymed speech. It must not be thought, however, that there are any hard and fast lines of demarcation. The rhymed, rhythmical rules of arithmetic in India have only the sound image; they thus possess one element of poetry, but that does not make them poetry. The philosophical treatise of Lucretius, *De Rerum Natura (On the Nature of Things)*, presents not only sound images but many others besides, and is therefore poetry. Here too, then, one element merges into the other.

Poetic creation and its product—poetry—represent a definite form of social activity, and are governed in their development, regardless of the specific nature of poetic creation, by the laws of social development. As we shall see later, when we go into this question in detail, the "verbal" character of poetic creation is no argument whatever against the sociological treatment of poetry. On the contrary: only by a Marxian analysis of poetry can we understand it in its full scale, in all the totality of its attributes. True, the Marxists have paid but little attention to the specific problems of language. But a deeper analysis of its phenomena inevitably leads to a sociological treatment of the word itself. And indeed it could not be otherwise. Examine a word, and you discover the paleontology of language. Words are the depository of the whole previous life of mankind, which has passed through various social-economic structures, with diverse classes and groupings, different spheres of experience, labour, social struggle, culture. That which Potebnia calls "the heredity of words," and which can be developed into the evolution of language (or languages), is the reflection of actual social-historical life. Within the microcosm of the word is embedded the macrocosm of history. The word, like the concept, is abridged history, an "abbreviature," or epitome, of social-historical life. It is a product of this life, not a Demiurge of history, not a Logos creating a world out of nothing.

We have seen how poetry, as the fixation of sensory images in words, summarizes the world of emotion in its own peculiar way. But these emotions, these experiences are in themselves experiences of the social-historical man, and in a class society, of the class man. For even such emotions as

have their roots in the fathomless biological depths of man, like emotions of an erotic nature, are modified in the course of the historical process. Fixated, selected images therefore cannot but come within the spheres of sociological analysis; they are social phenomena, phenomena of social life. Finally, thinking in terms of imagery is none the less thinking. The emotional element here merges with its opposite. On the other hand, a tremendous wealth of ideas, concepts, standards, ideologies, systems of philosophy enters bodily into poetic unity as an inseparable part of it. Here the intellectual merges with the emotional, that is, with its opposite. The poetic image, as an integral unity, is therefore not "purely" emotional; much less is the unified system of images purely emotional. Hence it follows that poetry, when considered from this angle, is a social product; it is one of the functions of a concrete historical society, reflecting and expressing in a specific form the specific features of its time and—in so far as we are dealing with a class society—of its class.

It is highly ridiculous how certain bourgeois theoreticians, giving a rehash of idealist, philosophical aesthetics or aesthetic philosophy, which has been represented by very great names, by such giants of bourgeois thought as Kant, Schopenhauer and Hegel, keep reiterating surprisingly vapid and tedious arguments to the effect that art in general and poetry in particular have no relation at all to practice, to "interest," to will. Kant, for example, in his *Kritik der Urteilskraft,* asserted this principle with all his force. Schopenhauer contrasts "disinterested" artistic contemplation to the ancillary character of science.[6] According to Hegel, "the object of art should be contemplated in itself, in its independent objectivity, which, though existing for the subject, does so only in a theoretical, intellectual way, not practically, and without any reference whatever to desire or will."[7] All this is utter nonsense. Take the art of ancient Greece. The comedies of Aristophanes are political journalism, but at the same time admirable works of art. There you will find the struggle of parties, definite political tendencies, ridicule of political opponents, etc. And the tragedians—Sophocles, Æschylus, Euripides?

Everyone will understand the significance of the poetic contests that were held there, when the poets were awarded crowns by the crowd. If we went a step further, and if the crowd in the Park of Culture and Rest were to crown with laurels, let us say, Sasha Bezymensky, as the best popular bard, that would be something taken right out of the ancient Greek world.

The objective, and also active, significance of the social function of

6. Schopenhauer, *The World as Will and Idea,* Section 36.
7. Hegel, *Werke: Æsthetik, Dritter Teil* (Berlin, 1843), vol. X (2), pp. 253–54.

poetry—if we are to give it a more general formulation—is to assimilate and transmit experience and to educate character, to reproduce definite group psychologies. This peculiarly perceptive, peculiarly educative and peculiarly effectual function of poetry is truly tremendous, and at times it turns into that of an extraordinarily active militant force.

Here we must emphasize once again that the subjective experience even of a "purely scientific" worker may be just as completely disinterested, in the sense of its remoteness from all practice, as that of the creative artist; that "contemplation" of the astronomical map may, subjectively, be void of any element of self-interest or practicality. But objectively, in the total social relation, *i.e.*, when regarded as a social function, both science and art in general and poetry in particular play, as has been pointed out, a tremendously vital and at the same time a practical role.

The cosmogonies of ancient India, the *Gilgamesh Epic* of Babylon, the Greek *Iliad* and *Odyssey,* the Chinese fables, Virgil's *Æneid,* the works of the great Greek tragedians, the *Song of Roland,* the Russian folk-tales, etc.—were they not all mighty levers of a peculiar social pedagogy, forming people in accordance with their own commandments and canons? The ancient cosmogonies were veritable poetical encyclopaedias. Homer was a fundamental subject of so-called "school" tuition. In Rome the verses of Virgil were crammed and scanned by no means as an empty pastime. The society of those times and its social leaders were thereby reproducing themselves in the realm of ideas, in an idealized form, inculcating their ideas, thoughts, conceptions, feelings, characters, ambitions, ideals, virtues. Even the Aristotelian *catharsis* (purging of the emotions) is a method of peculiar moral and intellectual hygiene (*cf.* Lessing's arguments in his *Hamburgische Dramaturgie* regarding the ultimate moral aim of tragedy). Horace knew what he was doing when he wrote that the aim of poetry was to mingle the useful with the pleasant—*"miscere utile dulci."* The well-known Arab philosopher, Averroës, spoke of tragedy as the "art of praising" and comedy as the "art of censure."[8] Contrary to idealist philosophy, Chernyshevsky, in his famous *Dissertation,* upheld the principle: "What is of general interest in life forms the content of art," and this somewhat crude formula is nevertheless infinitely closer to reality than are the pale shades of "disinterested" idealistic definitions, whose metaphysics carry us away into the almost airless void of an a-social "stratosphere."

The fact that words play a tremendous part in poetic creation, that the specific character of poetry is thought in terms of images, does not in any

8. *Cf.* Ign. Kratschkovsky, *"Die Arabische Poetik im IX Jahrhundert,"* in *Le Monde Oriental,* no. XXIII, 1929. Upsala.

way run counter to a sociological treatment of poetry, because even the word itself is the product of social development and represents a definite condensing point in which a whole series of social factors find their expression. And for this reason we Marxists are faced with the task of subjecting this side of the matter, too, to a Marxist study, *viz.,* the question of language, the question of words, the question of word creation, of the evolution of language, etc.; and it seems to me that quite a considerable theoretical foundation for such a study has been laid in our Marxist and near-Marxist literature.

ANATOLY LUNACHARSKY

*"Death is a serious business,
it forms part of life.
One must know how to die
with dignity. . . ."*
After a silence he added:
"Art, now—it can teach even that."
—Lunacharsky to Ilya Ehrenburg, 1933

INTRODUCTION

The tracing of the artist's class background, affiliations, and ideology dominated Marxist criticism from the death of Engels until the 1930's, and for many this line of exploration has been considered the proper sphere for Marxist exploration of the history of the arts. The selections in the "Marxist Reader" section of this book, however, surely indicate that the tracing of correspondences between art and class is only one of the legitimate implications of the Marxist approach to art. Nevertheless, for historical reasons related to the requirements of revolutionary movements and intellectual reasons related to the rise of sociology as a discipline of knowledge, virtually all Marxist literary practitioners have worked this vein.

The authority in Marxism for this almost exclusive concentration on class as a determinant of art is presumably *The Communist Manifesto,* with its famous slogan—"The history of all hitherto existing society is the history of class struggles." However, the theory of class struggle as the motor of historical movement was never intended by Marx and Engels to replace their more fundamental premise that the mode of production is the

ultimately determining factor in history. Indeed, Engels hints in *Dialectics of Nature* (page 10) that he and Marx stressed class-struggle determinants not because they were the *only* means of entering the historical dialectic but because they were more *fruitful* than other approaches.

But class struggle (a political-historical category) is also a super-structural factor; hence, the tracing of correspondences between art and class involves the interaction of superstructural elements upon one another. The action of the mode of production is implicitly acknowledged but is ig-nored in practice. Is class analysis of a work of art really more fruitful than its analysis in terms of the mode of production (with its economic and bio-logical coordinates as defined by Marx and Engels)? To pose the question in this way raises immense difficulties to those who follow Engels' later expositions of historical materialism unimaginatively, for Engels seems to imply that the connection between art and the mode of production is so complicated by intermediate factors that no necessary connection can be established. Marxist after Marxist has cited Engels' words on the "ulti-mate" influence of the mode of production, his emphasis on its decisiveness "in the last instance" (*in letzter Instanz*) as an article of faith rather than as a tool for analysis. Few Marxist aestheticians have taken up the question of the *direct* influence of the mode of production or the relations of produc-tion or of economic or biological life upon creation of the art work except in the most general sociological terms—i.e., in reference to the broad outlines of the genesis of art forms, questions of audience composition, materials of the artist, development of the instruments of artistic labor, and the like. (Important exceptions in this anthology are Karl Kautsky, Walter Benjamin, and especially Max Raphael, while the anthropological empha-ses of Plekhanov and George Thomson also involve a more direct contact with the economic factor.) Almost invariably, a mediating factor has been substituted to generate a causative relationship. And in most cases this mediating factor has been class and its derivatives—class psychology and class ideology.

The interposition of mediating factors objectively resolves itself on the one hand to increasing the *distance* between the mode of production and the ultimate art object and to widening the gulf between the art object and its observer on the other. In a sense this may be regarded as a defense against the specifically aesthetic qualities of the art work—a means of preventing direct confrontation between the artist and the perceiver, each of whom is converted into a common statistic. The art work also is given an abstract relevance which has little bearing on its specific life history, its aura, its affective meaning. The sociological approach to literature—with its inter-position of multiple mediating factors between social-biological origin and

the art work—converts the work of art into an abstraction from which is drawn a statistical ideological meaning, a meaning which can be stated as a proposition bearing no necessary relationship to either the mode of production or to the discrete art work.

Given, however, the Marxist preoccupation (obsession, perhaps) with art and class, few Marxists have worked fruitfully in this area, partly because proof of a causal connection or dialectical relationship between them is often tenuous. Parallels between class ideology and "the ideas" of a given work of art can often be readily established, but these are no sure sign of a crucial or necessary tie, and the tendency to reduce art to a mutant ideological formation blunts its special (and even more, its revolutionary) essence. Class affiliation is a sociological category subject to more or less precise determination. But class consciousness is almost wholly a psychological category, in which the dialectical complexities are immense, including problems which arise from identification with the oppressor, adoption of the ruling ideas by the oppressed classes, representation of ideas by the opposite, false consciousness, and so on.

One of the most skilled and sensitive analysts of the interpenetration of art and class was Anatoly Vasil'evich Lunacharsky (1875–1933). The first selection, the opening chapter of Lunacharsky's study of Alexander Blok, is a model of Marxist class analysis, wherein careful attention is given to such matters as the evolving "biography" of the class—the nobility—from which the poet emerged; the way in which the artist reflects the disintegration of the class to which he belongs while simultaneously serving as "a bearer of anti-bodies"; the appropriation by other classes of elements of Blok's outlook despite (or perhaps because of) its noble class origin; the conjunction of class and individual psychology in the creation of the poet's *oeuvre*—the simultaneous reflection in Blok of class ideology and "psycho-biological" preconditioning. Lunacharsky possessed the rare ability to show the connections between class consciousness, individual psychology as manifested in a creator's biography, and the ideological meaning of a given work of art. In his *Theses on the Problems of Marxist Criticism* (1928), he wholeheartedly accepted what he called "Plekhanov's principle"—that art depends upon "the forms of production in a given society only to an extremely insignificant extent. They depend on them only through such intermediate links as the class structure of society and the class psychology which has formed as a result of class interest." In applying this principle, Lunacharsky paid particular attention to the ambivalent, contradictory, and even schizophrenic psychology of social classes, and he searched out unconscious tendencies in psychology and in the work of art to an extent previously unknown to Marxists. He let the

work of art lead him to often startling and original conclusions, and rarely drew back when those conclusions hovered on the edge of unorthodoxy. He was not afraid to describe Pushkin's pathos as "almost pathological" and to wonder whether it was perhaps this very quality which made later Russian literature so rich and remarkable. In the essay on Bakhtin's book on Dostoyevsky here reprinted, he—perhaps unwittingly—applied Freud's theory of the splitting of the ego in dream to Dostoyevsky's novels and discovered in Dostoyevsky the repressed revolutionary nihilism which the author of *The Possessed* had tried so hard to purge from his soul. Lunacharsky knew that art was not only the stylized "perpetuation of the object found in reality" but "an act of creation" as well. And most of all he was aware of unsolved problems in art. In his essay on Heine, he noted: "the problems which are linked with the abolition of the contradiction between man as a fully-fledged representative of his class and man as a separate individual, do not, even now, lend themselves easily to solution."

Lunacharsky was born in Poltava in 1875, where his father was a liberal-minded government official. He studied Marxist literature at an early age, and by 1892 was lecturing on Marxism to workers in Kiev. His early life follows the usual pattern of imprisonment, deportation, and exile. He became a Bolshevik in 1903, but after the 1905 Revolution he broke with the Bolsheviks as he came under the influence first of Ernst Mach and then of Bogdanov. In 1917 he rejoined the Bolshevik Party and was appointed by Lenin (who, according to Krupskaya, "always had a weak spot for Lunacharsky") as the first Soviet Commissar of Education (or "Enlighten-ment"), a post which he held until 1929. He died in 1933, in Paris, on his way to Madrid to take up a new post as Ambassador to Spain. His work was suppressed during the Stalin era, and only now has an edition of his collected works begun to appear.

Lunacharsky's intellectual evolution proceeds from the sociological posi-tivism of Spencer (whose influence on turn-of-the-century socialism in all countries—and especially in the United States and England—has not yet been fully assessed), to the empiricism of Ernst Mach and Richard Avenarius, to the "Empirio-Monism" and "God-Building"[1] philosophies

1. The God-Builders—led by Bogdanov, Lunacharsky, Bazarov, Yushkevich—arose after 1905 as a Utopian strain of thought which attempted to reconcile revolu-tionary Marxism with eschatalogical fundamentals. Gorki, who was deeply involved in this movement, summed up its philosophy in the phrase: "God does not exist; he has not yet been invented" (which he later disavowed to Lenin). The God-Builders were the revolutionary negation of the God-Seekers (Berdyaev, Bulgakov, Merezh-kowsky) whose ideology derived from an amalgam of Russian mysticism, Narod-nism, anarchism, and Tolstoyanism. The hostility of Lenin and Plekhanov to the

of Bogdanov, and finally to Leninism. Enormously prolific, he wrote over fifteen hundred articles on virtually every area of art—literature, painting, music, sculpture, aesthetics—and a large number of papers on art, including *Fundamentals of Positivist Aesthetics* (1904; republished in Soviet Russia in 1923), *Dialogue on Art* (1905), *Tasks of Social Democracy in the Arts* (1907), *Letters on Proletarian Literature* (1914), *Culture in the West and in our Country* (1928), *The Class Struggle in Art* (1929) and *Lenin and Literary Studies* (1932). His more properly philosophical works include *Critical and Polemical Studies* (1905), *Echoes of Life* (1906), *Critique of Pure Experience* (1906—a popularization of Avenarius), and the "God-Building" *Religion and Socialism* (1908), in which Lunacharsky invents a new trinity: the forces of production as Father, the proletariat as Son and Marxism as the Holy Ghost. He also wrote a number of dramas, such as *Faust and the City, Vasilisa the Wise,* and *The Magi,* as well as the acutely observed pen portraits of the Soviet leaders—Revolutionary Silhouettes (English translation, 1967).

After October, Lunacharsky was the "good shepherd" (the phrase is Ehrenburg's) of Soviet art, preserving cultural monuments from vandalism, supervising the publication of great literature, keeping the peace between the warring factions of the myriad splinter groups, protecting each stylistic manifestation and artistic school from the onslaughts of the others, protecting all from the pre-emptive moves of the politicians, creating a United Front of the intelligentsia in the service of the Revolution, in addition to laying the educational foundations for the elimination of illiteracy in the Soviet Union and supervising every aspect of educational and cultural life. Despite a strong tendency toward the Tolstoyan moral-uplift function of art, he insisted that his Commissariat's function was to be "impartial in its attitude to different trends of artistic life. As far as questions of form are concerned, the taste of the People's Commissar and all other representatives of authority must be set aside. All persons and groups in art must be given freedom of development. No one movement . . . must be allowed to suppress another." He sympathized most with the Fellow-Travelers working in the "great tradition," but he sanctioned

God-Building movement arises partly out of its attempted compromise with theology, but perhaps even more because it made conscious the unconscious tendencies toward deification of revolution, its leaders and its instrumentalities in Russian Marxism. The movement formally petered out at the start of the World War, but the Messianic strain in Marxism-Leninism continued a subterranean existence which culminated in the deification of Joseph Stalin. With the resurgence of the Feuerbachian aspect of Marxism, the God-Builders will no doubt finally have their day, perhaps through the "not-yet" of Ernst Bloch's "philosophy of hope."

futurism, symbolism, constructivism, Nichevoism, and all the rest. But there was something of Chernyshevsky in him, too, and toward the late 1920's he moved toward the position that the critic must be "a teacher" of the childlike, "sensitive" artist, who possesses "neither special gifts nor special interest in abstract and scientific thinking." By the end of his career he had become a strict constructionist of the "Leninist" approach to art, applying Lenin's *Party Organization and Party Literature* dictums to imaginative literature, insisting on "the right to intervene in the course of culture," capable of writing such a line as: "The proletarian class cannot allow literature to grow like mushrooms in the wood." I do not think that this was a capitulation to the hard-line theorists. Lunacharsky had taken upon himself the mantle of Belinsky. Few were capable of wearing it as well as the first People's Commissar of Education.

LUNACHARSKY: ALEXANDER BLOK
from *Alexander Blok*

Every writer speaks for one class or another.

This does not mean that every writer is the spokesman for his own particular class, the adequate and unadulterated expression of the whole plentitude of its content—its traditions, culture and interests. The classes themselves have each, as one might say, their own social biography. They go through various stages and may be at any given moment at their conception, nearing their prime or on the decline. The biography of a class may even comprise several such peaks and declines. Class background is not always the same for corresponding classes from one country to another. In one country a class may be more markedly in evidence than in another. However, if a class be taken at some specific epoch, it is possible to find among those who may be accounted its spokesmen (usually, of course, more than one, even many different people) some whose work is indeed more or less adequate to express its essence—who seem to have grown out of the very heart of the class in question, whereas others appear rather on its periphery, where they are more subject to the influence of other classes.

It is essential to take into account all those shifts and modifications in that subsoil of class which—in social time and social space—is the breeding-ground of ideology, and at all costs to avoid the pitfalls of oversimplified Marxism or, more exactly, anti-Marxism, which considers class as an indivisible and unchangeable formation and which, for this reason, has difficulty in defining the true social essence of this or that ideology (in relation, for instance, to the works of any particular artist). In this way, a

whole series of such artists can be assigned to the same generalised class category and the differences between them are no longer seen as having their origin in social causes. This approach leads either to such differences being ignored or to their being explained by transient and socially fortuitous elements.

Blok is a spokesman of the nobility (the *dvoryanstvo*). He should be regarded as a scion of the line of the nobility's ideologists and his place is—to extend the metaphor—at the end of that line. With certain reservations he may be considered the last great artist of the Russian nobility.

In so far as his place is at the end of the line of the nobility's historical development, Blok reflects the nadir of its disintegration. Profoundly infected by the traditions of the nobility, he is, at the same time, a bearer of anti-bodies. He is charged with hatred for his milieu and for his class. In so far as he finds these in a state of enfeeblement, of disintegration, and is himself a product of such disintegration, Blok is debarred from seeking salvation in that aristocratic nucleus which still, to all appearances, formed the acknowledged "establishment" of his society: i.e., in the hard core of reactionary bureaucrats and firmly entrenched landed gentry.

One of the characteristic features of the decline of the nobility was, incidentally, that its more or less progressive representatives tended to break away from this central core.

In Russian literature we find a whole series of authors belonging to the nobility who are consciously or half-consciously defending their culture against the most terrible immediate foe of their class—against the bourgeoisie, against capitalism. Nonetheless it is no longer possible for these defenders of aristocratic culture openly to champion the Blimpish platform of the nobility as a class. On the contrary, they are well aware that this kind of aristocratic traditionalism is the most vulnerable joint in the armor of their class. Morally, they shun this hard core of their own class as though it were a black, dirty smear on its face. To this moral revulsion is added a frequently vague but nevertheless anxious premonition that such mechanical, violent, "Black-Hundred"[1] methods of self-defence are doomed to defeat, and that the more ruthless the defence, the more ruthlessly will it be defeated.

In essence, all the nobility's Narodism was rooted in the desire to defend their hereditary culture from the advances of capitalism and from those inevitable results of the development of capitalism, which the more intelligent representatives of the nobility at least partially foresaw. To this end,

1. The Black Hundreds were monarchist gangs organized by the tsarist police to fight the revolutionary movement. They assassinated revolutionaries, attacked progressive intellectuals and perpetrated Jewish pogroms.—*Ed.*

they sought to bring into play not so much the attitudes of the landowners as those of the peasantry, which were complementary to them.

Truth and justice, as the peasant understood them, were in many ways akin to the ideals of his master and came to be adopted by the latter as if they had been his own. The landlord hid behind the peasant, tucking his estate away behind the village, and, from this point of departure, proceeded to work out his own "peasant" ideology according to the promptings of his own class-consciousness. Bakunin, for instance, interpreted the peasant in a spirit of elemental romanticism; Herzen stressed his inborn affinity with certain home-grown germs of socialism; Tolstoy approached him from a lofty moral angle in an exceptionally disinterested religious spirit, and so forth.

Blok came upon the scene to find his own class in a state of extreme disintegration (its central core dominated by Pobedonostsev or post-Pobedonostsev[2] attitudes). The bourgeoisie, on the other hand, were at the height of their power and vigour, although, at the same time, uneasily aware of mortality in face of the unexpectedly rapid, tidal advance of their antipode—the proletariat.

For all his hatred of the bourgeois world, Blok feared the end of the bourgeoisie and the onset of a new era without historical precedent. Nevertheless, even he managed to construct something resembling a personal philosophy out of the tatters of aristocratic tradition, a romanticised conception of the peasantry (the element of "the people"), and a confused, harsh, anxious, burning sympathy for the forces of revolution—a philosophy in which he tried to find the solution to the growing storminess of the social scene.

Class (at a distinct stage of its development and in a distinct subsection of the class as a whole) was the determining factor of Blok's general platform as a citizen, as a political thinker (in so far as he can be considered from this aspect), and as a philosopher (again within his own limits). This particular subsection consisted of the most educated members of the ruined, *semi-déclassé* landed gentry who were at that time having to seek a living from other sources than the land and rapidly becoming indistinguishable from the professional petty bourgeoisie (as, for instance, in the case of Blok himself, who was for all practical purposes reduced to earning a living by his pen).

The fact that Blok happened to be a poet, however, and that, as a poet, he achieved wide recognition and became the mouthpiece of fairly

2. Pobedonostsev—reactionary tsarist statesman, Procurator-General of the Synod, actually head of the government and chief inspirer of the savage feudal reaction under Alexander III. He continued to play a prominent part under Nicholas II.—*Ed.*

considerable circles of the Russian intelligentsia was, to a considerable extent, the result of his own, strictly individual qualities.

Blok's way of thinking, I repeat, is entirely conditioned by matters of class and time. Personal to him—at least to a considerable extent—is the fact that, although his thought found a more or less adequate medium, in his publicistic articles, his diaries, letters, etc., it was first and foremost in poetry that he achieved a supremely individual form of self-expression. Only personal to him to a certain extent, of course. Let us explain:

Blok became a poet because he was extraordinarily sensitive. A heightened sensitivity is a prerequisite of the artist's calling, as of his success. It is possible, however, to imagine an artist in whom the process of thought is highly developed. The images such an artist creates are distinguished by clarity of outline. Almost as clearly as does the language of ideas only, of course, more immediately, vividly and emotionally, they offer an *interpretation* of that reality in contact with which the artist's imagination brings them into being. However, the nobility had no need of such a poet in Blok's time and, even had such a poet intact appeared at the same time as Blok, he would not have been greatly admired even given considerable talent. On the contrary, the extreme nervousness, the uncertainty, the shaky hold on reality and the failure to perceive a clearly defined way through this reality—all ensured a peculiarly enthusiastic reception for a poet such as Blok for whom poetic images are not so much an interpretation, not so much the expression of the artist's profoundly poetical *understanding* of reality as, on the contrary, a manifestation of his inability to understand it, and, as a direct result of this inability, of his hostility towards it.

Hostility towards reality (covering, to a considerable extent, one's own subjective awareness of things and one's own psyche) leads, inevitably, to despair. Blok often came very close to despair. However, he was not a poet of unadulterated hopelessness. On the contrary, at almost all periods of his work he was trying to find—for himself as for his "flock"—some message of consolation.

Yes. Reality is incomprehensible and abhorrent, but there is always the hope that it is nothing but a filthy covering behind which is a high mystery. Perhaps the occasional glimpses of beauty in Nature, man and art are simply mysterious pointers towards something which exists eternally in some other sphere and beckons man to itself, filling him with hope? Perhaps it is possible to touch on these other worlds not only in a flight of white wings towards a dream of holiness, perceiving their blurred contours in the imagination "as in a glass, darkly," as the Apostle Paul has it, but also amidst the dregs of vice, of all that is satanic in life, in the oblivion

which comes of drink and debauch. Perhaps, in a word, it is possible, at the very bottom of the "abyss," to enter into a similar communion with this same eternal power which, itself beyond good and evil, yet promises to whirl man away beyond all hard decisions, troublesome rules, hesitations and anxieties, and to plunge him into the flaming ocean of the supratemporal and supraspatial music of true being?

It may even be, finally (Blok's third period) that the squall of revolution, whose approach can already be sensed, will, on closer inspection, turn out to be the onset of that very divine dance of the violent, wild and primitive element which is destined to burst like lava through the prosaic, boring crust of everyday life.

With regard to existence in its everyday manifestations, Blok is always a revolutionary. He tries to see this existence either as an obstacle to be overcome, or as a symbol, a hint at some other, radically different state of being. He cannot, however, find comfort in any definite religious system. For that matter, he could scarcely have "consoled" his sceptical and sophisticated contemporaries with the aid of any definite religious doctrine or of any pedantically constructed metaphysical system (whether Vladimir Solovyov's or any one else's). This hint of the inexpressible, however— now seen as a glimpse of whitish-blue heights, now of yellowish-black, now of burning red, devoid of all definite form but rich by virtue of its breadth and vast scope and beautiful with the beauty of the ill-defined—this alone might mount to the head like the wine of truth, even though that truth be revealed only to the prophetic mind.[3]

On the other hand, because Blok chose to play the part of a prophet who cannot, or will not, speak out clearly, but who uses the word as though it were a note of music, because he elected to become a *musician,* who operated words and images to suggest a yearning for that which is beyond speech and varied the approaches and the glimmering, half-caught visions in many keys, he became more than the spokesman and the seducer of those of his own class who felt as he did. He appealed not only to the degenerate, *déclassé* nobility with their intensely refined culture, but also to wide circles of the bourgeois intelligentsia, for, at that time, the triumphant bourgeoisie—the detested enemy of the nobility—had itself begun to sing sad songs foreshadowing its own approaching end. It had itself begun to fear reality and, in its own, far clumsier manner, had begun to peer anxiously into the beyond in order to distract its own attention from uneasy contemplation of the historical prospects which were opening up before it.

Certain individual features of Blok's personality were, of course, a *sine*

3. Lunacharsky is referring here to one of Blok's best-known poems, *The Stranger,* in which the poet plays on the tag: *in vino veritas.—Trans.*

qua non of such popularity. However, even these purely personal traits were not without a class foundation. Also, they were subject to class control. I shall explain:

Blok was the scion of several noble families. There is no need to trace his pedigree back too far. His father was not altogether normal. He was a professor of some talent and an original thinker whose unbalanced, nervous temperament made itself felt even in his writings. That demonic unease which is invariably mentioned in reminiscences of Alexander Lvovich Blok was undoubtedly inherited by his son. Together with a certain, perhaps typically German, physical toughness, kindheartedness and sentimentality, truly Blokish traits in the full sense of the word (Blok's ancestors were Germans who had been granted titles of hereditary nobility in Russia), Blok's father, possibly through the Cherkasovs, his maternal ancestors, bequeathed to his son a slightly sadistic kink, an exaggerated sensuality, a tendency towards extremes, a tenseness always near to breaking-point. This demonism was the basic factor of Blok's paternal heredity. But neither can the Beketov line be considered altogether healthy. The Beketov style of living was profoundly ingrained in Blok, for, in his childhood and adolescence, he had grown up under the dominant influence of his mother's family.

"Beketovism" might be described as a well-balanced, harmonious version of the way of life of the cultured nobility. The Beketovs—once rich but, by the time of Blok's birth, considerably impoverished aristocrats—had found an outlet into the world of scholarship, where they were held in considerable esteem. Without breaking either with the traditions of religion or with their attachment to the homeliness and pleasant customs of the country-house idyll, the Beketovs seem to have experienced no difficulty in reconciling all this with a liberal outlook and a rosy belief in enlightenment in a spirit of respect for Art and Science with capital letters.

The Beketovs were thoroughly decent, gentle people with a social conscience. In spite of a certain measure of essentially harmless progressiveness, they were profoundly traditional. All this had the effect of strengthening in Blok those very aristocratic features which attached him to his class. At the same time, however, we know that Blok's mother was inclined to mysticism, that she was an epileptoid, subject to more and more frequent attacks towards the end of her life. So, on the side of the Beketovs also, we find a heightened nervosity and pathological tendencies.

All this taken together and ploughed back into the stormy and bewildering life of the period went to form the subsoil from which grew Blok's profoundly morbid dreams, the flowering of which was the reflection of that life in his own psyche.

On the one hand, Blok's psycho-biological predispositions were in many ways just what might have been expected in a class such as the nobility of that time had come to be. On the other, the social milieu which forms the poet is always on the lookout for a spokesman, for an instrument as perfectly adapted as possible to produce that music the creation of which is the peculiar task of its artists.

When a poet begins his service to society, when he publishes his first songs, and while he mounts the next few steps of the ladder, his fate is in the balance: he may either be rejected or acknowledged.

Whether or not the poet is acknowledged by certain sections of society, which sections are the first to recognise him and the extent of this recognition, are all contributory factors of enormous importance to his further career and even to his development as a writer.

Blok had every qualification to become the prophet, dreamer and latter-day romantic of the nobility, a kind of Novalis singing the sunset of the landowning intelligentsia—and this is just what he did become. Had he not been burdened by his own specific psycho-biological preconditioning, had he been—healthier, let us say, more definite, more balanced—then his work would have passed more or less unheeded by his contemporaries, at any rate by those circles of the intelligentsia who were at that time to some extent the mentors of public taste and who, in fact, took up his poetry as their emblem.

If Blok's way of thinking was the product of his class and his epoch, then his way of expressing his thoughts, or not even so much his thoughts as his emotional complexes, was preconditioned by his psycho-biological nature which, in its turn, was predetermined by a heredity that was itself a reflection of the psycho-biological instability of his class (the product of the growing uncertainty of its position in society). Added to this, his class (together as we have already said, with the kindred masses of the bourgeois intelligentsia) accepted him as their spokesman in his own time, gave him fame, inspired him to become the poet of his epoch, that is, to express certain great and necessary truths. It was the very abnormality—or, to put it mildly, the extreme originality—of Blok's psychological make-up which fitted him so excellently for the writing of that symbolist poetry, which—wavering between the poetic arrogance of high despair and a dream which took many forms groping in the darkness after some kind of salvation from the horrors of life—was most suited to meet the requirements of his public.

LUNACHARSKY: **DOSTOYEVSKY**
from *Dostoyevsky's "Plurality of Voices"*

The social position of Dostoyevsky which reduced him to the status of the lowest of the low, acquainting him with the bitter lot of the injured and insulted, taken in conjunction with his exceptional sensibility, his gift for suffering and compassion, could not fail to put him on the road to a sufficiently vivid form of protest, on the road to dreams of a radical reformation of the whole social system. Attempts are often made to represent Dostoyevsky's affiliation with the Petrashevsky circle as a superficial and passing aberration, and the fact that he was condemned to death for his connection with this circle as just another, completely unprovoked, absurd juridical atrocity on the part of the autocracy. However, such an explanation will simply not do. One would have to be completely devoid of all psychological sensibility and, moreover, be missing a whole series of politically responsive strings in the instrument of consciousness, in order to doubt (even in the absence of direct proofs) that the young Dostoyevsky was among those who "sought for a city." He was indubitably full of anger against social injustice and so profoundly so that, at some half-hidden subterranean level, this anger continued its volcanic work throughout his existence. Its grumblings and rumblings can only be ignored by the politically deaf, and the glow it throws up—only by the politically blind.

Dostoyevsky's clash with autocracy took place in the most violent fashion imaginable. To be condemned to be hung—what could be more violent than that! Forced labour came as an "easing" of the situation.

The question of the physiological causes of Dostoyevsky's illness and of its first origin has still to be solved. While we are on the subject we note in passing that, in this field, Marxist criticism will have to cross swords with modern psychiatry which always interprets what we choose to call morbid phenomena in literature as the result of hereditary sicknesses or, in any case, of causes which bear no relationship to what might be described as the *social biography* of the writer in question. Of course, we do not mean by this that Marxists should deny the existence of disease or the influence of mental illness on the works of this or that writer, if he happened at the same time to be a psychiatrist's patient. It is merely that all these purely psychological factors do seem to follow very logically from certain sociological premises.

In our own good time we shall return to this rich and interesting theme, but now we thought it necessary to mention it in connection with this brief analysis of Dostoyevsky's split personality, which is in itself as impor-

tant a cause of his "plurality of voices" as were social conditions during the epoch of the tempestuous growth of capitalism. After all, other writers, Dostoyevsky's contemporaries, lived under the same social conditions, whereas here we have M. M. Bakhtin proving that Dostoyevsky was the originator of the polyphonic novel—at least on Russian soil.

According to Dostoyevsky himself, his first attack of epilepsy took place while he was still doing forced labour and took the form of a kind of revelation from above after an argument about religion and Dostoyevsky's agonised and passionate opposition to the atheist: "No, no, I believe in God!" This fact is in itself most revealing. Here, too, the social and the biological subsoil seem to bring forth the same fruit, or, rather, combine to bring it forth, not entering into opposition with one another. Driven off to forced labour, Dostoyevsky, who was, like Gogol, extremely conscious of his own genius and of the special role he was called upon to play in life, felt with all his being that autocracy was eating him alive. He did not wish to be eaten. He had to adopt a position which would preserve his prophetic calling and yet not lead to further trouble with the authorities, which could only have ended in immediate catastrophe.

I do not mean that Dostoyevsky tried consciously to become a monarchist, adapting himself to the power that be. Such an assumption would be but poor psychology.

Of course, Dostoyevsky passed through terrible storms of doubt, but "expediency" helped to eliminate, to blur and to soften the "voices" which called him to protest, struggle and sacrifice. The voices which presented the case for the opposition were not those which were over-frank, nor yet those which retained the taint of self-preservation, nor even those which cried "in our present conditions this sacrifice will be in vain," but those which justified an almost opposite position and, on the contrary, found a way to "sublimate" this apparently modest and retiring "expediency."

With the hand of a skilled conjuror, "expediency" illuminated even Dostoyevsky's instinct for self-preservation and the conservative romanticism born of this instinct in a heroic light. Indeed, did not Dostoyevsky have ahead of him a fearless struggle against the radicals and all progressive society? After all, this, too, requires courage.

So the basic foundation of Dostoyevsky's future conciliatory position in relation to the autocracy and the social order was laid in tempests and inner conflict. Dostoyevsky went through hell. To the day of his death he could not convince himself—not only his conscious mind, but his subconscious, his mighty social conscience—of the rightness of this position.

The most superficial analysis of epilepsy, particularly in the form suffered by Dostoyevsky, shows us that aspect which involves a heightening

of the sensibility, a kind of exposure of the nerves, and hence, particularly in the difficult conditions of the society in which he lived, constant suffering often petty in origin, but magnified by the nervous condition. On the other hand, the epileptic attack itself is felt, according to Dostoyevsky's inside evidence, as the onset of the macrocosm, of a feeling of harmony, of oneness with the whole creation. In other words, it represents the triumph of a kind of emotional *optimum*.

But how else is it possible to imagine Dostoyevsky's psychology at that time? What *poles* of thought and feeling must have manifested themselves in this constant battle? On the one side—disgust and indignation in the face of reality; on the other—a passionate hope in the reconciliation of all contradictions, even if only in the next world, even if only in the sphere of mysticism.

Dostoyevsky's gifted and passionate nature delved down and intensified the first aspect of his condition to that terrible torturing of himself and of others which is one of the dominant features of his writing. The second aspect it raised to the point of ecstasy.

In this way, social causes led Dostoyevsky to the "sacred illness" and, having found, in prerequisites of a purely physiological nature (bound up, undoubtedly, with his very giftedness) a suitable subsoil, proceeded to cultivate in him a particular view of life, a particular style of writing—and his illness. By this, I do not in the least mean that in other circumstances Dostoyevsky would never have suffered from epilepsy. I am referring to that extraordinary coincidence which makes us think of Dostoyevsky as being so exactly suited to the role which he in fact came to play. At the same time, Dostoyevsky, the first great petty-bourgeois writer in the history of our culture, reflected in these moods of his the confusion of a wide section of the petty-bourgeois intelligentsia and of the more educated members of this class. To them, he was a very powerful and much-needed organiser, the source of that *Dostoyevshchina* which continued, for certain wide sections of that petty bourgeoisie, to provide one of the main ways of self-preservation right until the time of Leonid Andreyev and even on into our revolutionary days. . . .

———

However, Dostoyevsky's "ecclesiastical revolution" takes place in an atmosphere of even greater humility than Tolstoy's sectarian revolution. It is a task which will take many hundred years, a matter for the distant future, perhaps even for the next world. It is possible that Dostoyevsky, like Tolstoy, is led by the very logic of his thought to perceive this harmonious

coinheritence as a purely nominative ideal, as something which will be realised only in eternity, in infinity, in the sphere of metaphysics.

In this way, God, Orthodoxy, Christ as a democratic, individual, purely ethical principle of the Church—all this was quite essential to Dostoyevsky, for it gave him the opportunity to avoid a final spiritual break with socialist truth while, at the same time, justifying him in anathematising materialist socialism.

These positions also gave him the chance to assume a profoundly loyalist attitude in relation to the tsar and to the whole tsarist regime. At the same time, from the altar end of the Church, the end facing the congregation, it was possible to embellish these ecclesiastical modes with all kinds of effective graces. In this way, Dostoyevsky's Orthodoxy is at once a profoundly conservative principle and, at the same time, a kind of maximalism. Maximalists in the sphere of religion have always been in a position to say to materialists: "You will never dare to include the right to immortality in your programmes. You will never be able to demand absolute bliss and the merging of all men into one 'all-spirit'. We, on the other hand, can manipulate these beautiful, delicious things as much as we like, representing them as the true reality."

A less tragic nature than Dostoyevsky's might, perhaps, have been quite satisfied with this kind of cunningly worked-out self-comforter. But Dostoyevsky, a genius of fathomless profundity, was tormented by his immense conscience, by his acute sensibility. Dostoyevsky challenges his foes again and again under various guises, and these foes are not only philistinism, not only vice in all forms but, first of all and above all, this damnable, self-assured materialism. In his own soul he has killed it, buried it, rolled great stones across the entrance to the tomb. But it is no corpse which is immured behind these stones. Someone is always moving about, someone's heart is beating loudly, giving Dostoyevsky no peace. Dostoyevsky continues to feel that it is not only the socialism outside of himself which will not let him rest, not only the developing revolutionary movement in Russia, Chernyshevsky and his theory, the proletariat in the West, etc.; above all he is tormented by materialist socialism in his own self, which must on no account be allowed to emerge from the underground, which must be spat on, trodden into the mire, humiliated, made to look insignificant and ridiculous. This is what Dostoyevsky does do to it. Not once and not twice. In *The Possessed* he loses all self-control in this respect. And so what? A little time goes by, the smoke of argument dissipates and the mud of insinuation wears off, and the uncompromising disk of real truth begins once again to shine and to beckon.

Of course, after his experience of forced labour, Dostoyevsky did not for

one moment have a genuine faith in his materialistic phantom. Yet it was enough for him to feel the stirrings of doubt to lose all peace of mind. On the other hand, he devoted all his genius for thought, feeling and character-drawing to the erection of altars to heaven. There is something of every-thing: the subtlest sophism and the faith of a charcoal-burner; the frenzy of the "fool in Christ" and refined analysis; the poet's facile gift of winning over the reader by the acute insight attributed to the religious characters, etc. Yet Dostoyevsky returns in doubt again and again to survey his many-storied edifices, understanding that they are not built to last and that, at the first underground tremor caused by the movement of the fettered Titan whom he has buried in his own heart, the whole pile of spillikins is going to collapse.

It seems to me that only if we adopt this approach to Dostoyevsky will we understand the true substructure of that polyphony which Bakhtin has noted in Dostoyevsky's novels and novellas. Only Dostoyevsky's split personality, together with the fragmentation of the young capitalist society in Russia, awoke in him the obsessional need to hear again and again the trial of the principles of socialism and of reality, and to hear this trial under conditions as unfavourable as possible to socialism.

However, if this trial is not given at least an appearance of unbiased fairness, the hearing of it loses all its comforting, soothing properties and cannot be expected to calm the tempest of the soul. So a long line of characters—from revolutionaries to the most superstitious reactionaries—as soon as they emerge from Dostoyevsky's inner world and are allowed to run free, immediately get out of hand and begin to argue each in his own voice, and to prove each his own thesis.

For Dostoyevsky this is a pleasure, an agonising pleasure, all the more so because he realises that, as the author, he retains the conductor's baton, remains the host in whose home all this ill-assorted company have fore-gathered, and can, in the end, always restore "order."

ZHDANOVISM

ZHDANOVISM

Petrograd, 1919: *From the villages in the north of Russia came several thousands of peasants, some hundreds of whom were housed in the Winter Palace of the Romanovs. When the congress was over, and these people had gone away, it appeared that not only all the baths of the palace, but also a great number of priceless Sèvres, Saxon, and oriental vases had been befouled by them for lavatory use. It was not necessary to do this since the lavatories of the palace were in good order and the water system working. No, this vandalism was an expression of the desire to sully and debase things of beauty. Two revolutions and a war have supplied me with hundreds of cases of this lurking, vindictive tendency in people, to smash, deform, ridicule, and defame the beautiful.*
—Gorki, *Days with Lenin*

The dominance of Zhdanovism in Soviet Marxism lasted from the mid-1930's until the 20th Congress of the Communist Party of the Soviet Union in 1956, ending with Khrushchev's admission of the extent and nature of the distortions and crimes in socialist life under the late rule of Joseph Stalin. Zhdanovism can be regarded as a temporary aberration of Marxist criticism peculiar to a particular stage of development of the Soviet Union and the world Communist parties. However, its roots extend into the pre-Stalin era, and its reverberations are still with us. It is perhaps more helpful, therefore, to examine the possibility that elements of Zhdanovism represent general tendencies in the attitudes toward art during postrevolutionary periods. Several lines may be stressed: first, the insistence by revolutionary movements on the creation of a body of exemplary myths in art; second, the rejection of complex and advanced styles in art; third, the censorship of the arts and their subjection to repressive modes of patronage. The first of these is a universal factor in such periods; the function of

art is seen as that of creating a viable body of models for the purpose of emulation and inspiration. Art and the exemplary mythmaking function are merged; art tends to become a form of pedagogy, based on glorification both of the tradition out of which the revolution emerged and of the "new man" who brought about the revolution. The music of the French Revolution consists largely of Hymns, Odes, and large choral works celebrating the principles and the leaders of the Revolution; the mural painting of the Mexican Revolution establishes a pre-Colombian golden age as a model for the future and searches for a principle of heroism in the resistance of the Indian peoples to the Spanish conquests; the Lutheran chorales clothe the Reformation in popular religious symbolism based on resistance to the hierarchical deformations of Christianity within the Catholic Church; the Handel oratorios place the victorious English bourgeois in a tradition of biblical heroism and moral grandeur. Seen from this standpoint, the call for "socialist realism" is a call for heroic self-portraiture, for grandiose representations of the "new men" in the Roman manner—with the genitals well hidden in the flowing folds of their togas. (The painting of the French Revolution, too, had adopted the neo-Stoic Roman style for its heroic portraiture.)

The rejection of complexity in art is also common to revolutionary movements, resulting from the popular role which art undertakes. The French revolutionary composers cast aside the entire superstructure of Baroque style—its advanced harmonic language, its rich polyphony, its highly organized and complex forms—in favor of a square homophonic simplicity utilizing a limited range of harmonies, based almost entirely on march rhythms, insisting on formal patterns so obvious and restricted as to represent one of the great regressions in the history of music. (That this was also an advance—cleansing the heavily laden languages, overly ornamented styles, and polycentric forms of the baroque—is shown by the fact that French revolutionary music, merging with North German, Italian, and Viennese elements, was able to create the Beethovenian synthesis.) Similarly, the concentration on easily mass-produced graphic art in the Mexican and Chinese revolutions represents this trend toward simple and direct art forms for popular education and inspiration. Lenin called for encouragement of monumental and popular arts in the service of the Soviet Revolution—although he clearly recognized that this was not the only (or even primary) role of postrevolutionary art. Mao Tse-tung, in his Yenan talks on literature and art, stressed the importance of the popular and the realistic. Related to this process is the demand for the use of national and folk elements in art as a means of opening avenues of communication to mass

audiences, through utilization of their native modes of expression and their own popular imagery.

Censorship and control, too, are common denominators of the art of postrevolutionary periods, though here the patterns are somewhat more varied, reflecting specific historical circumstances. In many postrevolutionary situations—especially those where most intellectuals fully support the goals of the revolution—censorship is largely unnecessary. Such was largely the case in the Soviet Union during the 1920's, in Cuba to 1970, in China up to the period of the "Cultural Revolution," in certain phases of the French Revolution. In such instances the sole precondition is that the artist not work against the revolution. Censorship that goes beyond this almost universal precondition arises, precisely in accordance with Plekhanov's principle, when there is a basic disharmony between the artist and the state.

Marxism can explain the rise of Zhdanovism, but Zhdanovism has no roots in Marxism itself. Nowhere in Marx or Engels is there a demand that art create artificial exemplary models or serve purely utilitarian ends. On the contrary, Engels specifically opposed tendentiousness in art and Marx believed that bias interferes with the pursuit of truth. As for censorship, no stronger statement of the necessity for creative freedom exists than Marx's humanist "Comments on the Latest Prussian Censorship" of 1842. The Zhdanovist appeal to Lenin speciously applies Lenin's "Party Organization and Party Literature" to a postrevolutionary situation; even in difficult prerevolutionary circumstances, Lenin had insisted on freedom from censorship. At the root of the Zhdanovist aesthetic is the economic determinist theory of direct superstructural reflection of society: the art of the bourgeois world reflects bourgeois economic decadence; the art of socialist society must mirror socialist reality. The general crisis of capitalism is "reflected in a general crisis of capitalist culture—in confusion, decay and despair in all ideas and cultural activity," as one writer put it. Zhdanov, in 1934, spoke of "the decadence and disintegration of bourgeois literature, resulting from the collapse and decay of the capitalist system. . . . Now everything is degenerating—themes, talents, authors, heroes." That this mechanistic determinism could be passed off as Marxism (and accepted as such by both the friends and enemies of Marxism) is itself remarkable, for it overlooks such fundamental Marxist precepts as the active role of theory, the reflection of class struggle in superstructural activity, the transcendence of class position by art and artist, the revolutionary power of theory, the continuity of thought and science in society—in short, the dialectics of history itself. The "dying culture" concept is not inherent in Marxist dialec-

tics (see Marx and Engels on Balzac, Lenin on Tolstoy). "Decadence" has its roots in Victorian antisexuality and achieved some general notoriety in the writings of the Social Darwinists.[1] It was imported into Marxism from Lombroso, Spengler, Max Nordau (whose *Degeneration,* published in 1892, exerted a great influence on socialist and Christian-socialist intellectuals at the turn of the century), and other petty-bourgeois cultural pessimists. Its logic is fascist and racist rather than Communist and Marxist. With Zhdanovism, the idea of degeneration in the arts merges with the Comintern world view of "two camps" and with the economic determinist theory of art as direct reflection to create a pseudo-scientific means of attacking all efflorescences of culture and all attempts to broaden the meanings and languages of the arts. At the root of this approach is a deeply rooted fear of art which can only be fully understood as a psychological rather than as an economic category. It is here that we encounter another general tendency of postrevolutionary movements—the repression of the sexual element of art.

The desexualization of life under repressive class orders (sexuality being a bar to productivity) and in forced-march revolutionary situations (love relationships being in conflict with the need for communal action, interfering with the required subordination of personal gratification to the common good) tends to drive sexuality into the arts, where it carries on a more-or-less disguised, subterranean existence. In postrevolutionary times, this safety valve tends to be blocked by the mobilization of the artist and the high seriousness with which society views the arts. In such societies, the arts tend to be censored, not so much for their ideological content as for their sexual connotations. That this is a perhaps inevitable tendency is undeniable, for sexual repression may be a necessary precondition for self-abnegation and personal submission in the collectivist cause. That this tendency turned pathological with Zhdanovism should be equally clear. Zhdanov's central concern was to bulwark art against the impingement of "irrationality," which he defined as any subject matter beyond the confines

1. The term made its first significant appearance in Marxist aesthetics in Plekhanov's *Art and Social Life* (1912), where Plekhanov insisted on the economic determinist and Darwinian formulation that "Art in periods of decadence, *'must'* itself be decadent." Lunacharsky countered this undialectical view by pointing to the new realms of experience which were being revealed by the modernist movements in art. Plekhanov modified his position somewhat to make allowances for identification with the revolution by bourgeois artists. (Cf. *Art and Social Life,* pp. 209–28.) Marx and Engels, in a book review of 1850, specifically affirmed that the decline of certain classes "provided the raw material for magnificent and tragic works of art" (*Literature and Art,* p. 105). See also Marx's letter to Lassalle of April 19, 1859.

of "normal human emotions." Two touchstones governed his brutal aesthetic views: insanity and sexuality. The intrusion of such characters as "pimps," "chorus girls," "gangsters," "adulterers," "adventurers," "rogues," "depraved criminals," "schizophrenics," and "paranoiacs" into art automatically made him reach for his "gun." His was a bitter outcry for some undefined normality which he evidently could not himself achieve. His disciples pursued similar preoccupations. V. Kemenov, a typical Zhdanovist, writes of modern art that it seeks "to destroy that which is human in man and to rouse in him the beast, with all its base, primitive, animal instincts." Two American Zhdanovists—Martel and Reiss—define decadence as art which tends to "demean human beings, to convert people into mere sexual instruments, to advocate pessimism or mysticism." Lukács, who largely (though ambivalently) accepted Zhdanovism, not from opportunism or automatic obedience but because of a deep agreement with its antisexual aesthetic, wrote that the true poet is one whose "knowledge of man and . . . faith in their fundamental goodness causes him never to doubt their final victory over their animal instincts."[2] Stalin himself wrote no literary criticism, but the watchword of Soviet Zhdanovist criticism was Stalin's "writers are engineers of human souls"; here, the body and its innate drives disappear from Soviet Marxist aesthetics altogether, sublimated into a spirituality worthy of the Counter-Reformation itself.

And so it was inevitable that Zhdanov's and Radek's 1934 call for Socialist Realism coincided precisely with cancellation of the liberal abortion and divorce laws, with passage of strict laws against homosexuality and with the arrest of a large number of homosexuals among the intelligentsia, accused of conspiracy with the Roehm Nazis.[3]

On January 28, 1936, *Pravda* published a violent critique of Shostakovich's highly successful opera *Lady Macbeth of the District of Mzensk,* in which the antisexual core of Zhdanovism was made explicit, and which opened a long series of repressive (and often fatal) actions against Soviet artists. The article, unsigned, was by Zhdanov himself. The music was described as "nervous, convulsive, and spasmodic," involving "the coarsest kind of naturalism."

2. *Studies in European Realism* (London, 1950), p. 274.

3. Shortly thereafter, an antigenetic pseudo-science of agriculture was adopted as official ideology, thereby wreaking havoc with Soviet food production for twenty years. The irrationality of Lysenkoism is closely linked to the irrationality of Zhdanovism. Both are denials of the sexual factor—one in art, the other in life. Lysenkoism involves the narcissistic denial of heredity, indeed of the very idea of parentage itself.

All this is coarse, primitive, and vulgar. The music quacks, grunts, and growls, and suffocates itself, in order to express the amatory scenes as naturalistically as possible. And "love" is smeared all over the opera in the most vulgar manner. The merchant's double bed occupies the central position on the stage. On it all "problems" are solved.

The article closed with "the demand of Soviet culture that all coarseness and wildness be abolished from every corner of Soviet life."

The repressions of the arts during the Stalin period rose from a number of causes—actual or supposed political heresy of individual artists, panic over the rise of fascism in Europe, the placing of the nation on a footing of war economy in preparation for an expected invasion—but it is hard to avoid the conclusion that many specific works of the artists who were persecuted and/or banned contained a common element of sexual rather than political heterodoxy. So far as I am aware, none of the purged artists were political counterrevolutionaries, nor did a single banned work oppose the Soviet Revolution as such. Gladkov was compelled to revise *Cement* for its sexual—not its political—content. Ehrenburg's proscribed early novels were fully Communist in outlook, but centered around sexual conflicts. Babel's vignettes of Jewish life in Odessa and his *contes cruels* of Red Army life during the intervention contained no political heresies; it was their easy hedonism and sexuality (and their realistic refusal to create exemplary myths) which brought Babel down. It is the presence of "forbidden" aspects of sexuality in works by Soviet and Western modernists which is the common denominator of their banishment from Soviet life during the Stalin era, no matter how the criticism of these works was clothed in the rhetoric of pseudo-Marxism. The terms of opprobrium themselves —"decadence," "grossness," "naturalism," "coarseness," "dung-heap," "vulgarity," "depravity," "baseness," "primitive," "corruption"—testify to the preoccupations of the Zhdanovist critic.

The exemplary model of the Stalin era is young Pavel Korchagin, in Ostrovsky's *Born of the Storm*, whose ascetic heroism extends so far that he refuses to make love to a pleading virgin who has been imprisoned with him by the White Guards. Preserving his moral purity and his dedication to the Revolution, he watches as the Whites drag her from the cell to be raped, feeling no twinge of conscience at his denial of her request.

And so the emancipation of the flesh of which Saint-Simon, Fourier, Marx, and Engels had dreamed was proscribed and a tortured theory of antipornography was promulgated as Marxism. Zhdanovism is an Old Testament view of art, wherein the political leader becomes Moses, while artist and audience are the tribes of Israel who have dedicated themselves

to false idols and fornication. Its models are the books which changed humanity—*Uncle Tom's Cabin, The Jungle, Mother;* its vision is of a new Harriet Beecher Stowe who will eradicate evil from a generation which has tolerated decay in its midst for too long. It grows out of the Enlightenment view of art as an exemplary model for humanity. And late-feudal modes of patronage and control were instituted—quite in the manner of enlightened despotism—with all of the devices of princely self-glorification and self-portraiture, including the *deus ex machina,* the saviour *bon prince,* the happy ending, the avoidance of tragedy, the revival of classic models.

Revived, therefore, in a dialectical reversal, is a Utopian conception of art; for Socialist Realism is a picture of man as he should be (socialist man in the process of "becoming") rather than as he is; it is a wish rather than a reality which Stalinist patronage calls upon the artist to depict; art (in Nietzsche's phrase) is a "consecration of the lie," and the Zhdanovists, while outwardly upholding the representational-reflection theory of art as their model, secretly practice the enforcement of ideological deception, of Utopian construct. The dialectic of this process should in time lead to the overthrow of Zhdanovism, to the withering away of bureaucratic patronage, to the insistence that political leadership conform to the images of art, and ultimately to the freedom of the artist, including the forbidden freedom to be realistic.

The following selections—by Gorki, Yuri Davydov, Mao Tse-tung, Jean-Paul Sartre, and W. E. B. Du Bois—are presented as commentaries on Zhdanovism, its sources and categories. None of them is itself Zhdanovist in outlook.

MAXIM GORKI

INTRODUCTION

The first selection, excerpts from Maxim Gorki's address to the 1934 Soviet Writers' Congress, interprets myth as a poetic condensation of man's struggle with nature and society. "Though it idealized men's abilities and was a harbinger, as it were, of their powerful development, the creation of myths was fundamentally realistic. The stimulus can easily be discerned in every flight of ancient fantasy, this always being men's striving to lighten their labour." This magical (Utopian) function merges with the exemplary function so that the mythic heroes serve as models for emulation; the heroes and the tricksters, the wise men and the fools—all of these show the way to freedom, to victory over hostile forces. Realism is defined as the embodiment of an imagining in an image; if to this is added the logic (or passion) of the possible wish, mythic realism turns revolutionary, and "we have the kind of romanticism which underlies the myth, and is most beneficial in its promoting a revolutionary attitude toward reality, an attitude that in practice refashions the world." This is Gorki's own definition of Socialist Realism. That it has nothing in common

with Zhdanovism is apparent. That it should not be swept away in the revulsion against Zhdanovism is equally apparent.

GORKI: **ART AND MYTH**
from *Soviet Literature*

Historians of primitive culture have been completely silent regarding the unmistakable signs of a materialist mode of thought inevitably precipitated by labour processes and by the sum of the facts of ancient man's social life. These signs have come down to us in the form of fairy-tales and myths, which carry memories of the work of taming wild animals, discovering herbs and inventing tools. Even in antiquity men dreamed of aerial flight, which can be seen in legends about Phaëthon, Daedalus and his son Icarus, and the tale of the "flying carpet." Men also dreamed of high-speed travel, hence the fairy-tale about "seven-league boots." The horse was domesticated, the desire to travel along rivers at speeds faster than their currents led to the invention of the oar and the sail, while the striving to smite foes and beasts from a distance brought about the invention of slings, and bows and arrows. Men dreamed of spinning and weaving a tremendous quantity of cloth in a single night, of building "palaces" overnight, i.e., a house fortified against any enemy. The distaff, one of the most ancient of tools, and the primitive hand-loom came into being, as did the Russian fairy-tale about Vasilisa the Wise. One could cite dozens of more proofs of the way ancient fairy-tales and myths stem from the facts of life, dozens of proofs of the far-sightedness of primitive man's thinking in terms of images and hypotheses, this already along technological lines, but a kind of thinking which has led to such present-day hypotheses as, for example, the utilization of the energy of the earth's rotation on its axis or the destruction of polar ice. All the myths and tales of antiquity are crowned, as it were, by the myth about Tantalus, who, up to his neck in water, is tormented by unquenchable thirst—an image of ancient man surrounded by phenomena of the external world which he has not yet learned to understand.

I have no doubt that you know these ancient tales, myths and legends, but I should like their fundamental meaning to be more profoundly understood. I have in view the striving of working men of ancient times to ease their labour, raise productivity, arm themselves against enemies, both quadruped and biped, and also to exert an influence on the hostile natural elements by means of the spoken word, by "spells" and "invocations." The latter fact is of particular importance, since it shows how profoundly men believed in the power of the spoken word, this faith stemming from the

obvious and tangible advantages provided by human speech, which organizes men's social life and labour processes. They even tried to influence the gods through "invocations." This was quite natural, since all the gods of antiquity lived on earth, bore the image of human beings and behaved as such; they favoured the obedient and frowned upon the disobedient, and were just as envious, vengeful and ambitious as human beings are. The fact that man created gods in his own image goes to show that religious thinking did not spring from a contemplation of the phenomena of nature, but sprang from the social struggle. It is quite feasible that "notable" people of antiquity provided raw material for the invention of gods: Hercules, the "hero of labour," and "master of all skills," was eventually elevated to Olympus to sit among the gods. In the imagination of primitive men, a god was not an abstract conception or a fantastic being, but a perfectly real figure equipped with some implement of labour, skilled in one trade or another, and man's instructor and fellow-worker. A god was an artistic embodiment of successes in labour, so that "religious" thinking among the toiling masses is something that must be placed within quotation marks, since this was a purely artistic creation. Though it idealized man's abilities and was a harbinger, as it were, of their powerful development, the creation of myths was fundamentally realistic. . . .

Any myth is a piece of imagining. Imagining means abstracting the fundamental idea underlying the sum of a given reality, and embodying it in an image; that gives us realism. But if the meaning of what has been abstracted from reality is amplified through the addition of the desired and the possible—if we supplement it through the logic of hypothesis—all this rounding off the image—then we have the kind of romanticism which underlies the myth, and is most beneficial in promoting a revolutionary attitude toward reality, an attitude that in practice refashions the world.

YURI DAVYDOV

INTRODUCTION

The ability of future revolutionary governments to avoid Zhdanovism in the arts and sciences will depend on their ability to understand its sources. We have already tried to indicate several of the main tendencies toward Zhdanovism in postrevolutionary societies. If the guillotining of André Chénier and Eulogius Schneider had been understood, we might not have had the murders of Babel, Feffer, and Meyerhold. But there are also national tendencies at work in each revolution which shape its attitudes toward art. Zhdanovism arises in the Soviet Union not primarily in the name of Marx and Engels but in the name of Chernyshevsky, Pisarev, Dobrolyubov, and Tolstoy—all of whom were strongly imbued with anti-aesthetic attitudes, sought to subordinate artistic to pedagogic categories, and reflected in their criticism the patriarchal peasant's fear and hatred of beauty and of art. Our second selection, by the brilliant modern Soviet critic Yuri Nikolayevich Davydov (born 1929), finds in Tolstoy's views of art the expression of what Marx had called "crude communism" (*Economic and Philosophic Manuscripts*), a communism which preached "uni-

versal asceticism and social levelling in its crudest form" (*Communist Manifesto*). It is unnecessary for Davydov to mention Zhdanov. In his description of Tolstoy's Robespierrean dismissal of any art not completely and directly accessible to the peasant mentality, in his exploration of the Tolstoyan insistence on utilitarianism in art, of Tolstoy's proscription of virtually all the major works in the history of the arts as decadent and immoral, we have the image (and one of the component sources) of Zhdanovism. Davydov shows that Tolstoy's "communism" treats art as a consumer product of a purely material nature, that it leads to a leveling that considers man in general and the artist in particular as a thing, in Marx's words as "a piece of communal and common property" which society can manipulate in accordance with its desires. The struggle for a free art becomes a struggle to transcend crude communism, to move forward to a humanist, Marxist communism.

DAVYDOV: **THE TOLSTOYAN VIEW OF ART**
from *The October Revolution and the Arts*

In stressing the universality of the criterion that a work of art should be completely, directly accessible "to all men, without exception," and in his insistence on the absolute applicability of his criterion as a standard for evaluating art, as the only way of distinguishing between true and false artistic values, Tolstoi does not stop even at the necessity of including in the category of false—harmful!—work *The Divine Comedy, Jerusalem Delivered,* "most of" Shakespeare and Goethe, Raphael's *Transfiguration,* etc.

In this alarmingly vague and casual "etcetera" there rings out loud and clear "the music of the raging elements of peasant revolt" to use a favourite expression of Blok. Not the logic but indeed the music of those elements, which in their (historically just) demands for complete equality were bound to demand an immediate levelling distribution not only of material goods, but also of spiritual values, with the risk that the latter would be destroyed if they did not lend themselves to such levelling distribution. For as Marx said: "If you want to enjoy art, you must be an artistically-cultivated person."[1]

It is almost as if Tolstoi is approving of and—at the price of denying himself as an artist—giving his blessing to the cost in destroyed works of

1. K. Marx, *Economic and Philosophic Manuscripts of 1844* (Moscow), p. 141.

art which the approaching revolution was to entail, such destruction as Blok was to tell Mayakovsky about in October 1917, twenty years later.

> I've heard . . .
> from the country . . .
> they've burned . . .
> the library . . .
> on my estate. . . .
> (*From Mayakovsky's poem* Fine!)

Indeed the "clear, reasonable criterion" for which Tolstoi was prepared to cast the "etcetera" to the four winds, all that was not immediately intelligible to the "literate country labourer," had less to do with artistic values than with the legal concept of equality. It was the principle of equality in the legal sense (in this case the equality of all men before art), which Tolstoi, with his serious moral approach to art, applied as an aesthetic principle, appealing to justice.

"Is it just that so much human labour and goodness, so many human lives should be sacrificed to what we call art, which is the property of a small section of society? The natural answer is no, it is not just, and such things ought not to be allowed," Tolstoi replied emphatically.

He is right: it is indeed unjust and "ought not to be allowed." His moral awareness enables him to pinpoint the social contradiction inherent in the distinction between "the art of the upper classes" and "the masses." He begins to go astray when he tries to apply the principle of justice (which rightly belongs to the realm of morality or formal law) to the realm of art, which has its own terms of reference for the discussion and solution of the contradiction in question. Applied to the sphere of art, the principle of justice was not equipped to solve the problem of the accessibility of art to the "working crowd." It ceased to be an essentially positive force, and became a negative, even destructive element. For indeed, in the realm of art the problem of the relationship between people and art could be solved in one way only, and that was by bringing art to a level where it would be accessible "to all without exception."

Where conditions of actual inequality obtain, this can be done—in principle—only by lowering art to the lowest level possible. Any higher level would inevitably make it inaccessible, incomprehensible and alien to some, especially if we insist on the condition that it be not eventually but immediately comprehensible.

Such was the flaw implicit in the attempt to apply the formal principle of

justice to the realm of art, where it did not belong. It was the inevitable result of converting a moral "sense of justice" into a criterion for evaluating works of art, and of adopting as an aesthetic plumb-line "the common sense . . . of the country labourer," as the great writer had done with such remarkable, and tragic, selflessness.

———

It was to a large extent inevitable that Tolstoi should have raised his sense of justice, demanding equality—now consciously, now unconsciously—to the level of a universal criterion to be applied indiscriminately to all spheres of human activity.

By consciously identifying his own position with that of the Russian peasant after the Reform, the "country labourer," Tolstoi was adopting the viewpoint of a man for whom agricultural labour was the source of all wealth, and all cultural values. The sociological basis of this outlook was agricultural labour, manual labour, representing the only "real" labour worthy of the name, and of benefit to the individual and society. The basic juridical principle inherent in this outlook was the principle of equality, understood as equal remuneration for equal (manual) labour. The basic moral deduction to be made from this principle was the concept of justice, according to which a man who makes a greater physical effort and works harder, should be rewarded with greater material wealth. The aesthetic ideal inherent in this outlook was that there be some proportion, some harmony between the amount of physical effort expended by a man (and mankind) and material wealth, in other words between the "physical" man (society) and nature (God), to the point of their being identical, their total fusion.

When a man with this outlook meets wealth—in any form, be it material or cultural—which is not proportionate to the labour of the individual who possesses it, his first instinctive reaction is to divide this wealth fairly and share it out among those who expend a certain amount of physical energy, those who work. If such wealth takes the form of a strip of land which is too large for its owner to work, then it should be divided up; for it is God's gift to man, and man can only justify his possession of it by his capacity to work it daily with his own hands, in the sweat of his brow; in no other way can he justify his owning it. If wealth takes the form of something which cannot be completely, directly divided by "general redistribution" (*chorny peredel*) it is liable to immediate destruction, total eradication. Otherwise the principle of equality would suffer, without which there is no Justice.

For what justice is there if a person can own something which is not (and will not be) justified by the work of his hands and the sweat of his brow?

Directed against landlord property, the principle of equal remuneration for equal labour, above all manual labour, was eventually to evolve into the whole system of bourgeois-protestant attitudes, under the banner of which social relations were to develop in the sixteenth and seventeenth centuries in the most advanced European countries, and which eventually became a universal principle comprehending the principles of labour, labour law, labour morality, labour aesthetics and so on. Directed against bourgeois-capitalist property, as one of the main manifestations of the glaring disproportion between manual labour and material reward which was a feature of nineteenth-century capitalism, this principle became the point of departure of the communist outlook, although it was "as yet completely crude and thoughtless communism."[2]

What is peculiar to Tolstoi's interpretation of the principle of equality, which reflected the peculiar social and legal position of the Russian peasantry after the Reform, is that it was directed both forwards and backwards, both against unearned landlord property and predatory bourgeois capital. Tolstoi's dual, syncretic approach is apparent in the tract in the way capitalists, landowners, bureaucrats and intelligentsia are all lumped together indiscriminately, as "the upper classes," "the idle classes," the parasitic classes, etc. This duality did have a positive value in that it saved Tolstoi from many of the mistaken ideas of the "as yet completely crude and thoughtless communism," in fact from all those ideas which did not answer the needs, attitudes and ideals of the "country labourer." Tolstoi took a wide view of the matter and managed to avoid the sectarian tendencies of egalitarian communism, which preached "universal asceticism and social levelling in its crudest form," to use the words of the *Communist Manifesto*.[3]

There was one particular field, however, where the outlook of the proletarian supporters of egalitarian communism came very close to the peasant aspirations at the time of "general redistribution" (*chorny peredel*), sometimes even to the point of becoming identified with them. This was their attitude to "the art of the upper classes." It was here that Tolstoi, the art theoretician, having identified his standpoint vis-à-vis ethics and society with that of the peasants, paid his greatest tribute to "crude communism," despite the fact that he was basically at variance with the views it put forward.

2. K. Marx, *Economic and Philosophic Manuscripts of 1844* (Moscow), p. 99.
3. K. Marx and F. Engels, *Selected Works*, vol. 1 (Moscow, 1969), p. 134.

MAO TSE-TUNG

INTRODUCTION

Mao Tse-tung's *Problems of Art and Literature* contains his decisive contributions to a conference of writers and artists held in Yenan in May 1942. Our selection from his speech of May 23 is a classic statement of the position that revolutionary art must create exemplary models in order to inspire the masses and advance historical processes: "Such literature and art can stir the people into action, awaken them, and impel them to unite to carry on an organized struggle through which the masses will take destiny into their own hands." Mao elsewhere describes this educational-radicalization function of art as "revolutionary utilitarianism," and it seems likely that this position represents an inevitable and necessary stage in the uses of art during a national-liberation revolutionary struggle. The statement of the position, however, does not resolve the difficult problems that radiate from it, leading on one side to a desired harmony between the artist and the working masses, and on the other to the possibility of deformations of the creative process and impoverishment of the cultural heritage.

MAO TSE-TUNG: **LITERATURE AND REVOLUTION**
from *Talks at the Yenan Forum on Literature and Art*

Literary and art criticism is one of the principal methods of struggle in the world of literature and art. It should be developed and, as comrades have rightly pointed out, our past work in this respect has been quite inadequate. Literary and art criticism is a complex question which requires a great deal of special study. Here I shall concentrate only on the basic problem of criteria in criticism. I shall also comment briefly on a few specific problems raised by some comrades and on certain incorrect views.

In literary and art criticism there are two criteria, the political and the artistic. According to the political criterion, everything is good that is helpful to unity and resistance to Japan, that encourages the masses to be of one heart and one mind, that opposes retrogression and promotes progress; on the other hand, everything is bad that is detrimental to unity and resistance to Japan, foments dissension and discord among the masses and opposes progress and drags people back. How can we tell the good from the bad—by the motive (the subjective intention) or by the effect (social practice)? Idealists stress motive and ignore effect, while mechanical materialists stress effect and ignore motive. In contradistinction to both, we dialectical materialists insist on the unity of motive and effect. The motive of serving the masses is inseparably linked with the effect of winning their approval; the two must be united. The motive of serving the individual or a small clique is not good, nor is it good to have the motive of serving the masses without the effect of winning their approval and benefiting them. In examining the subjective intention of a writer or artist, that is, whether his motive is correct and good, we do not judge by his declarations but by the effect of his actions (mainly his works) on the masses in society. The criterion for judging subjective intention or motive is social practice and its effect. We want no sectarianism in our literary and art criticism and, subject to the general principle of unity for resistance to Japan, we should tolerate literary and art works with a variety of political attitudes. But at the same time, in our criticism we must adhere firmly to principle and severely criticize and repudiate all works of literature and art expressing views in opposition to the nation, to science, to the masses and to the Communist Party, because these so-called works of literature and art proceed from the motive and produce the effect of undermining unity for resistance to Japan. According to the artistic criterion, all works of a higher artistic quality are good or comparatively good, while those of a

lower artistic quality are bad or comparatively bad. Here, too, of course, social effect must be taken into account. There is hardly a writer or artist who does not consider his own work beautiful, and our criticism ought to permit the free competition of all varieties of works of art; but it is also entirely necessary to subject these works to correct criticism according to the criteria of the science of aesthetics, so that art of a lower level can be gradually raised to a higher and art which does not meet the demands of the struggle of the broad masses can be transformed into art that does.

There is the political criterion and there is the artistic criterion; what is the relationship between the two? Politics cannot be equated with art, nor can a general world outlook be equated with a method of artistic creation and criticism. We deny not only that there is an abstract and absolutely unchangeable political criterion, but also that there is an abstract and absolutely unchangeable artistic criterion; each class in every class society has its own political and artistic criteria. But all classes in all class societies invariably put the political criterion first and the artistic criterion second. The bourgeoisie always shuts out proletarian literature and art, however great their artistic merit. The proletariat must similarly distinguish among the literary and art works of past ages and determine its attitude towards them only after examining their attitude to the people and whether or not they had any progressive significance historically. Some works which politically are downright reactionary may have a certain artistic quality. The more reactionary their content and the higher their artistic quality, the more poisonous they are to the people, and the more necessary it is to reject them. A common characteristic of the literature and art of all exploiting classes in their period of decline is the contradiction between their reactionary political content and their artistic form. What we demand is the unity of politics and art, the unity of content and form, the unity of revolutionary political content and the highest possible perfection of artistic form. Works of art which lack artistic quality have no force, however progressive they are politically. Therefore, we oppose both the tendency to produce works of art with a wrong political viewpoint and the tendency towards the "poster and slogan style" which is correct in political viewpoint but lacking in artistic power. On questions of literature and art we must carry on a struggle on two fronts.

JEAN-PAUL SARTRE

INTRODUCTION

Each stage in the political development of the Marxist movement gives rise to certain issues which become fixed as the "proper" questions to be explored by its critics and philosophers. For example, the possibility of a distinct "proletarian" culture shaped many of the concerns of Soviet critics in the 1920's and of Western critics in the 1930's. The central issues of Soviet Marxist criticism—"realism," "typicality," "partisanship," "propaganda," "tendentiousness," "form and content," "decadence," "socialist realism," "responsibility," and so on—continue to be debated among Marxists in our own time. But these are not the only (or even primary) substantive issues of Marxist aesthetics and criticism. This anthology has tried to avoid becoming fixated around the "traditional" but inevitably transitory nodal points of current post-Zhdanov controversy, because this would bar the path to the exploration of new categories, and close off the possibility of applying Marxism to the infinity of legitimate questions which radiate from the arts and from the creative process. There-

fore, we have given only minor representation to the ongoing debates that take place within the categories which preoccupied Marxism during the Zhdanov period. The interested reader can pursue these matters at length in the various writings of Lukács, Roger Garaudy, Ernst Fischer, Henri Lefèbvre, Hans Koch, Hector Agostí, and of many contemporary Soviet, German, and East European aestheticians.

An intelligent treatment of several of these traditional subjects at their present stage of development is to be found in Jean-Paul Sartre's Speech at a Conference of European Writers, held at Leningrad in the Summer of 1963. Sartre speaks here as a Marxist.[1] He points to the core problem of realism, that literature is creation of "a reality which is not initially given," and his comments on decadence similarly focus on the central issue—that there is a dialectical opposition as well as a causal (or parallel) sequence between social developments and literature. He is less telling on the troublesome question of the artist's "commitment" and "responsibility," and appears to abandon it by attributing responsibility to the social forces and relations which shape the artist. In short, he assumes the artist's responsibility as a "given," but is not willing to ask "why," perhaps because this is an emotionally freighted question. Why should the artist be his brother's keeper? Is he to live his own life, or is he to submerge his personal desires in favor of the needs of others? Must he bear the perpetual weight of a categorical imperative? Has he rid himself of theology's ethical injunctions—of Job and Isaac, of Hercules and Aeneas—only to take on the equally burdensome injunctions of the angel of history with his red flag and his insistence on brotherhood and progress? For responsibility is repression, and repression (alienation, estrangement, rationalization—call it what you will) is precisely what the artist joins Communism to escape from, only to find that he has exchanged one mode of repression for another. Surely Marxist ethics and dialectics offers some satisfactory

1. Sartre's existentialist philosophy arose in part as a rival to "official" Marxism in the post–World War II period, and was instrumental in causing a retreat from many outmoded and inflexible positions, and in hastening the revival of the ethical and humanist content of Marxism. Following the devastating critiques of Sartre's philosophy (and especially of his concept of freedom) by such Marxists as Lukács, Marcuse, and Adam Schaff (see George Novack, ed., *Existentialism versus Marxism* (New York, 1966), pp. 134–53, 165–72, 297–314), Sartre moved toward an ambivalent accommodation with Marxism. In the 1960's he wrote that Marxism is "the one philosophy of our time which we cannot go beyond," and affirmed that his own existential philosophy is "an enclave" within Marxism. (*Search for a Method*, New York, 1963.) Such affirmations need not be taken as a ruse, but many observers have noted that Sartre's Marxism omits or revises some of Marxism's central formulations.

answer to these questions (Bloch has come closest to one in his *Das Prinzip Hoffnung*), but Sartre—no more than the Zhdanovists—does not seek it.

SARTRE: **THE NOVEL AND REALITY**
from *Speech at a Conference of European Writers*

The second problem which has also been rightly stressed is that of the relation between novel and reality. But first of all, if we wish to study it, we need a definition of reality. There is not a single writer in this hall who would not like to say something about reality. Nathalie Sarraute told us that this reality had to be discovered. I felt that I agreed with her entirely, but at a point she seemed in danger of being understood in an idealist way, when she spoke of "creating" it. This is the core of the whole problem: creation? expression? or discovery? There is no contradiction between these terms: one can certainly discover through creation, but one should make this clear. On the other hand certain speakers gave the impression that socialist realism simply expresses reality. But we must not forget that socialist novels are still novels, that is to say creation. In other words, the same problem emerges, but in reverse. You may call us idealists, because we are looking for a truth or a reality which is not initially given; but we have a right to answer that you too are creating works of fiction, that you are, when it comes down to it, liars like us. Every writer lies in order to tell the truth.

A further problem is that of values. I think it was Robbe-Grillet who said, and I think he was right here, that many of those who are against the *nouveau roman* base themselves on established values, which they require the writer to reflect, as if the world were already made and all there was for us to do was to describe it. But for me this is not the problem of a true socialist realism. I am going to quote somebody who is not very well thought of by writers: Zhdanov. God knows how many objections can be made to what Zhdanov said! But when he writes: "For socialist realism the task is to interpret the present in the light of the future," he says something which is pregnant with consequence.

If one is to suppose that the future is as rigorously determined as the present, the statement is terrible; it binds the writer hand and foot, and I am afraid that this is how Zhdanov meant it. But if, as I think, the future, though it can no doubt be thought of with optimism, is nonetheless a development which is by definition unknown, uncertain, then to treat the existing world from the point of view of what it will become, of what others

are going to make it, is precisely to contest the present in the name of the future. This is why literature must always retain a critical function, even if one's perspective is optimistic as a matter of principle; perhaps there has precisely been too much insistence here on the positive rôle of literature and not enough on its function of discovery and as a critical mirror. In any case, this problem of the novelist's discovery of his values should be discussed further.

In the same way, I think that there is one question which has been dealt with very superficially: the question of "decadentism," to use a term dear to our friends. When they speak to us of Proust, Joyce and Kafka as decadent authors, very often they have not read them, or, like Ehrenburg, they read them in tiny doses. That is not enough. However, this is not the problem. The real problem is an ideological one, and it must be stressed. Either we accept an utterly naive and simple Marxism, and say: "such and such a society is decadent, therefore the writers who express it are decadent." Example: the great decadent of Tzarist feudalism is clearly Gorky. Or we say: "a decadent society poses new problems for a writer, tortures him in his own consciousness and in his creative activity." Otherwise, would there be any progressive people in a decadent society? Thus we must certainly consider that this society, which contains and produces the artist, also conditions him; but we are not by any means compelled to think of this author strictly as a decadent. On the contrary, he can be recuperated by a new society; and there is no certainty that, in this struggle against his own contradictions, he may not have invented the forms of the ideas which will be used by the liberated society. We have so far only expressed preferences: "I like Proust" or "I don't like Proust." But this has no significance. The real problem is to know what is meant by the "decadence" of the novel? Does it simply reflect social decadence, or is there a dialectical relation between social developments and the novel? If there is not such a relation, I do not know where the dialectic could be found. Perhaps nowhere!

And here finally is the essential problem: the relation of man to man (the words I use are deliberately vague), that is to say responsibility. About this too some very important things were said towards the end of the meeting. In the earlier part everybody had agreed that the writer had a responsibility. Some definitions were given. "I believe in the responsibility of the writer towards his work." All right! That does not mean very much: since the work is, in spite of everything, communication, it implies a responsibility towards the reader. "I believe in the responsibility of a man, an author, towards the best in man." First of all, I do not know what the best in man is, since each of you would describe it differently. And in the second place, I do not see why, if I were concerned with men who were

exploited, crushed, wretched, and not perhaps quite in any condition to be "the best," being full of hate and suffering, I do not see why I should take up a standpoint different from theirs, from that of the exploited against their exploiters. I think we should throw out these vague notions. There does really exist a relation with man, but this too is vague, since "a man" is an abstraction. There are men in specific situations and societies. Hence the true problem here is that the writer's responsibility is in the society which has made him, and in his relation with the others whom that same society has made. And after all we all know this responsibility. Only, in the West we have a kind of individual and diffused responsibility, while in the East, where socialism means man's recovery of control over all that is human, it is held that the responsibility of the writer must also be taken into collective control. To argue whether the writer is, or is not, responsible is fruitless. We must say that the responsibility exists, but takes different forms in the East and in the West. In the capitalist system investments are made through intermediaries; for a western writer, even a progressive one, responsibility follows the same path. Here it is different. Both systems have advantages and disadvantages, but it is at this level that we must pose the problem if we wish to discuss it further.

Finally, I think that we might agree on the idea that a novel is the work of a total man, and that it cannot be good if it is not total. A novel can be total in very many ways. Kafka wrote slim books which are only concerned with specific, petit bourgeois problems. But if one reads them in depth one discovers that totality which a modern, new novel must always aspire to attain. The totality is what the writer and his readers have in common. Society produces both of us, so we must be able to recognize and understand each other through this common context, which makes it possible for us at every instant to speak to each other. So it does not matter very much if literature is called committed or not; it is, necessarily; for a man's totality today is the fact that we risk dying in an atomic war if we do not concert our efforts to prevent it. This is no doubt a less optimistic perspective than that which [Leonid] Leonov so brilliantly outlined, but it is perhaps more serious. This does not mean that the writer is obliged to write about atomic war; it means that a man who is afraid of dying like a rat cannot be quite sincere if he is satisfied writing poems about birds. Something of his epoch must be reflected in his work, in one way or another.

These then are the points of view about which I have the impression that we might not agree unanimously—that is not to be desired, conflict is necessary—but profitably pursue our dialogue. What I have found good in this symposium is that it constitutes a first step; it is a prelude to real discussions in the future.

W. E. B. DU BOIS

INTRODUCTION

As a final commentary on the categories of Zhdanovism, we reprint Dr. W. E. B. Du Bois' 1949 address to the Cultural and Scientific Conference for World Peace, which may be read as an application to intellectual creativity of Engels' writings on freedom as the recognition of necessity. Never losing sight of the inexorable ways in which natural law and social necessity shape and constrict human possibility, Du Bois concentrates here on the transcendent powers of the human spirit: "Compared with the realm of physical law and even of biological and psychological compulsions, the regions where the spirit of man may range, free of all distortion and restraint, are infinitely larger, deeper and broader than the narrow margins of compulsion." The dreams and fantasies of the imagination permit us to "contemplate for a moment what the human soul may do" after it has been liberated from the determinism of class history. The critique of Zhdanovism is unspecific but unmistakable. Du Bois inveighs against those who hold power in the "borderland" (i.e., proletarian dictatorship), where

leaders "choose ignorance, for fear too many will know; give the masses too little, so that a few may have too much, prefer hate to love, lest power change hands." For Du Bois, the suppression of the dream is the surest bar to the passage of mankind from the kingdom of necessity to the realm of freedom.

DU BOIS: **THE NATURE OF INTELLECTUAL FREEDOM**
from *Address to the Cultural and Scientific Conference for World Peace*

Writing and publishing—knowing, expressing and thinking; dreaming and contriving, through the world-old ways of poetry and story, drama and essay; history and the interpretation of human emotion; experience and action—these things occupy the broadest realm of freedom which the mind can grasp. No sane person ever pictured freedom everywhere and at all times. Parts of human action always have been, and always will be, subject to inexorable law. We cannot abolish gravitation because we do not like it; and the law of atomic weights will ever defy Congress. Even where natural law and human effort unite to wrest life from nature, the freedom of human action must yield in greater or lesser degree not simply to probabilities or tendencies which refuse to conform entirely to desire, but to enacted law, which insists that if we would conquer ignorance, men must be made to learn; if we would conquer poverty, thieves cannot be let to steal.

Many who scream for freedom, and despair because struggling humanity is so often coerced by Thou Shalt Not, appear to forget that, compared with the realm of physical law and even of biological and psychological compulsions, the regions where the spirit of man may range, free of all distortion and restraint, are infinitely larger, deeper and broader than the narrow margins of compulsion. Beyond that, while in our ignorance and fear, and with our utter lack of faith in the capacities of the human soul, we stand compelled here and today to remain prisoners of our bellies to an extent which disgraces our science and history. We nevertheless know that we also stand this instant tiptoe on the threshold of infinite freedoms, freedoms which outstretch this day of slavery as the universe of suns outmeasures our little earthly system.

We have but to think of the upsurging emotions of men: of the dreams and phantasies of mind, of imagination and contrivance, playing with the infinite possibilities of ever-revealing truth. We have but to let our minds contemplate for a moment what the human soul may do, once it is free to think and write and say but a morsel of what our thought is capable. Even

the chained and barred fields of work and food and disease today will yield to vaster freedoms when men are let to think and talk and explore more widely in regions already really free.

There is of course a grey borderland, where human effort and natural law combine to raise food, build shelter and train the young. Here inflexible law merges with wish and will, and freedom is an indeterminate variable. Here men may restrain action in order to protect and guide ignorance and inexperience toward using freedom aright. It is in this borderland that more often too many men seek artificially to restrain such freedom as emerges for selfish and short-sighted aims. They choose ignorance, for fear too many will know; give the masses too little, so that a few may have too much; prefer hate to love, lest power change hands and prestige wane. They forget that it is the wide reaches of more complete freedoms that can ultimately best teach and guide our twilight ignorance amid the inescapable iron of law. The borderland where freedom chokes today may easily, as freedom grows, fade into its more complete realm.

Two barriers and two alone hem us in and hurl us back today: One, the persistent relic of ancient barbarism—war: organized murder, maiming, destruction and insanity. The other, the world-old habit of refusing to think ourselves, or to listen to those who do think. Against this ignorance and intolerance we protest forever. But we do not merely protest, we make renewed demand for freedom in that vast kingdom of the human spirit where freedom has ever had the right to dwell: the expressing of thought to unstuffed ears: the dreaming of dreams by untwisted souls.

ANTONIO GRAMSCI

INTRODUCTION

The historical and intellectual developments which produced the explosive
re-emergence and realignment of Marxist thought in our time, and which
have laid the foundation for an integration of a Marxist aesthetics, can only
be sketched here. A few of the more decisive historical factors were the
cluster of events leading to the Khrushchev revelations at the 20th Party
Congress in 1956, and the consequent disintegration of the monolithic
ideological construct which had clothed the Stalin period in a mythicizing
false consciousness; the rise of polycentrism among the world socialist
states and Communist Parties; the emergence into view of "irrational"
factors behind the political events and ideological repressions within the
socialist movement; and the "rehabilitation" of previously anathematized
Marxist thinkers and creative artists, thus opening up a vast realm of
"suppressed" Marxist ideas for exploration. In the capitalist world, in-
creased repression and dehumanizing currents triggered a number of
revolutionary and pseudo-revolutionary movements, virtually all of which
—having rejected the traditional "Marxist categories" as they had come to

be understood during the Zhdanov period—were in search of a "new" revolutionary theory. After a period of theoretical peregrination which led (and is leading) to an exploration of neglected strains of socialist thought —anarchist, Utopian-socialist, populist, nihilist—the picaresque revolutionaries rediscovered Marx. The "new" Marxism which is in process of formation is leavened by the experiences and learning which accompanied the journey, and is characterized by a re-examination of the entire literature of Marxism. Of especial importance has been the rediscovery of the early Marx—Marx the "poet," Marx the converted Jew, Marx the son, the messianic Marx, the humanist and psychological Marx, the "hip" Marx— which flowed from the conjunction of these historical factors and the publication and wide dissemination of his early works, which in turn led to a new reading of the "mature" works. Economic determinism is dead, and the petrified husk of its doctrine has been stripped away to reveal the humanism and Utopianism at the core of Marx's thought. Dialectical thought—a mode of comprehending reality in the process of its becoming, both in its unity and its oppositions, in its totality and in its fragmentation—is emerging from the long sleep imposed on it by the bourgeois scientific revolution, and this permits a reappraisal of the concepts of work and freedom, a re-emergence of revolutionary, eschatological, system-breaking thinking, including the Marxist critique of Marxism itself. This last was perhaps the most important step: rival systems of thought and new disciplines of knowledge were placing intolerable strains upon a rigidified Marxist structure; the questions being asked by Freudians, linguistic philosophy, structuralism, and existentialism were forcing Marxism to reappraise its intellectual viability, to become creative and "Marxist" once more, or to decline. In the field of aesthetics and art criticism, Marxist official positions were outmoded and ineffectual, largely discredited, essentially incapable of grappling with the complex categories of rival theories; official Marxist aesthetics could not account for or match the dialectical insights to be found in the work of the empathy theorists (Worringer, Lipps), the symbolic-linguistic analysts (Ernst Cassirer, Susanne Langer), the Formalists and their Mandarin followers in the New Criticism, the ego-psychologists of the Freudian school (Ernst Kris, K. R. Eissler), or even with the pseudo-dialectical eclectics (Burke, Hyman, Wilson). The super-rationality of Marxist political and class criticism—with its one-to-one equations and its neglect of aesthetic factors—was unsuited to dealing positively with the major developments of modern art, leading to estrangement from Marxism of creative artists, the avant-garde, and the young. The widely advertised hostility of Zhdanovist criticism to twentieth-century art (and its puritanism about both art and erotic life) brought into question the ability

of Marxism to work as a progressive force in the arts or as a guide for revolutionary and humanist artists.

———

The selection from "Marxism and Modern Culture" by the Italian Marxist Antonio Gramsci (1891–1937)[1] was written before the full impact of Zhdanovism had been felt, but it sets the philosophical stage within which that phenomenon took place. There are important implications here for an analysis of the relationship between the intelligentsia and revolutionary philosophy; the selection is presented here, however, to indicate the contradictory stresses to which Marxism is subjected in the course of its development—drawn on one hand into various idealist currents and on the other toward the kind of crude materialism which culminated in Zhdanovism.

Gramsci's essay uncovers a historically conditioned internal dialectic of Marxist thought itself. He views the evolution of Marxism as a series of spiraling oscillations between the metaphysical and the practical, between exploration of theoretical limits and specific applications of theory to social praxis, seeing Marxism as proceeding on one hand toward contact with metaphysical modes of thought, and on the other being pulled back toward common sense and banal materialism of the positivist type. Gramsci tends to hypostatize Marxism into a "pure" doctrine which undergoes a historical process of "blending" with other ideologies or "alien tendencies." Though he cites Rosa Luxemburg's "Stagnation and Progress of Marxism," he overlooks her magnificent insight that Marxism contains certain ideas which lack utility at a given historical moment and which remain latent until historical need calls them forth (see above, pages 158–59). Extending this a bit further, one might say that the latent ideas in Marx can be made manifest only by contact with catalytic agents of subsequent development (both economic and superstructural), and that the

1. Gramsci was born and raised in Sardinia. He studied at the University of Turin, specializing in linguistics and philology, but abandoned his studies in favor of politics. By the end of the World War he was a leader of the left-wing Socialist movement, and participated in the formation in 1921 of the Italian Communist Party. In 1924 he was elected secretary of the Party, founded its newspaper, *Unità*, and was elected to the Italian parliament. He was arrested by the Fascists on November 8, 1926, and sentenced to twenty years' imprisonment. He was released from prison one week before his death on April 27, 1937. His prison writings, published after the defeat of Mussolini, have established him as one of the foremost Marxist theoreticians and philosophers of our time. His writings on literature may be found in *Letteratura e Vita Nazionale* (Turin, 1950), which contains the important essay, "Il teatro di Pirandello."

process described by Gramsci is not merely a fragmentation of a pure doctrine but the process by which that doctrine develops its own legitimate implications.

GRAMSCI: **MARXISM AND MODERN CULTURE**
from *The Modern Prince*

Marxism has been a potent force in modern culture and, to a certain extent, has determined and fertilised a number of currents of thought within it. The study of this most significant fact has been either neglected or ignored outright by the so-called orthodox (Marxists), and for the following reasons: the most significant philosophical combination that occurred was that in which Marxism was blended with various idealist tendencies, and was regarded by the orthodox, who were necessarily bound to the cultural currents of the last century (positivism, scientism), as an absurdity if not sheer charlatanism. (In his essay on fundamental problems, Plekhanov hints at this but it is only touched upon and no attempt is made at a critical explanation.) Therefore, it seems necessary to evaluate the posing of the problem just as Antonio Labriola attempted to do.

This is what happened: Marxism in fact suffered a double revision, was submitted to a double philosophical combination. On the one hand, some of its elements were absorbed and incorporated, explicitly and implicitly, into various idealist currents (it is enough to cite as examples Croce, Gentile, Sorel, Bergson and the pragmatists); on the other hand, the so-called orthodox, preoccupied with finding a philosophy which, from their very narrow point of view, was more comprehensive than a "simple" interpretation of history, believed they were being orthodox in identifying Marxism with traditional materialism. Still another current turned back to Kant (for example, the Viennese Professor Adler, and the two Italian professors, Alfredo Poggi and Adelchi Baratono). In general one can say that the attempts to combine Marxism with idealist trends stemmed mainly from the "pure" intellectuals, while the orthodox trends were created by intellectual personalities more obviously devoted to practical activity who were, therefore, bound (by more or less close ties) to the masses (something which did not prevent the majority from turning somersaults of some historico-political significance).

The distinction is very important. The "pure" intellectuals, as elaborators of the most developed ruling-class ideology, were forced to take over at least some Marxist elements to revitalise their own ideas and to check

the tendency towards excessively speculative philosophising with the historical realism of the new theory, in order to provide new weapons for the social group to which they were allied.

The orthodox, on the other hand, found themselves battling against religious transcendentalism, the philosophy most widely spread among the masses, and believed they could defeat it with the crudest, most banal materialism, itself a not unimportant layer of common sense, kept alive more than was or is thought by that same religion which finds, among the people, its trivial, base, superstitious, sorcery-ridden expression, in which materialism plays no small part.

Why did Marxism suffer the fate of having its principal elements absorbed by both idealism and philosophical materialism? Investigation into this question is sure to be complex and delicate, requiring much subtlety of analysis and intellectual caution. It is very easy to be taken in by outward appearances and to miss the hidden similarities and the necessary but disguised links. The identification of the concepts which Marxism "ceded" to traditional philosophies, and for which they temporarily provided a new lease of life, must be made with careful criticism and means nothing more nor less than rewriting the history of modern thought from the time when Marxism was founded.

Obviously, it is not difficult to trace the clearly defined absorption of ideas, although this, too, must be submitted to a critical analysis. A classic example is Croce's reduction of Marxism to empirical rules for the study of history, a concept which has penetrated even among Catholics . . . and has contributed to the creation of the Italian school of economic-juridical historiography whose influence has spread beyond the confines of Italy. But most needed is the difficult and painstaking search into the "implicit," unconfessed, elements that have been absorbed and which occurred precisely because Marxism existed as a force in modern thought, as a widely diffused atmosphere which modified old ways of thinking through hidden and delayed actions and reactions. In this connection the study of Sorel is especially interesting, because through Sorel and his fate many relevant hints are to be found; the same applies to Croce. But the most important investigation would appear to be of Bergsonian philosophy and of pragmatism, in order to see in full how certain of their positions would have been inconceivable without the historical link of Marxism.

Another aspect of the question is the practical teachings on political science inherited from Marxism by those same adversaries who bitterly combated it on principle in much the same way that the Jesuits, while opposing Machiavelli theoretically, were in practice his best disciples. In an

"opinion" published by Mario Missiroli in *La Stampa* when he was its Rome correspondent (about 1925), the writer says something like this: that it remains to be seen whether the more intelligent industrialists are not persuaded in their own minds that *Capital* saw deeply into their affairs and whether they do not make use of the lessons so learned. This would not be surprising in the least, since if Marx made a precise analysis of reality he did no more than systematise rationally and coherently what the historical agents of this reality felt and feel, confusedly and instinctively, and of which they had the greater awareness after his critical analysis.

The other aspect of the question is even more interesting. Why did even the so-called orthodox also "combine" Marxism with other philosophies, and why with one rather than another of those prevalent? Actually the only combination which counts is that made with traditional materialism; the blend with Kantian currents had only a limited success among a few intellectual groups. In this connection, a piece by Rosa Luxemburg on *Advances and Delays in the Development of Marxism* should be looked into; she notes how the constituent parts of this philosophy were developed at different levels but always in accordance with the needs of practical activity. In other words, the founders of the new philosophy, according to her, should have anticipated not only the needs of their own times but also of the times to come, and should have created an arsenal of weapons which could not be used because they were ahead of their times, and which could only be polished up against some time in the future. The explanation is somewhat captious since, in the main, she takes the fact to be explained, restates it in an abstract way, and uses that as an explanation. Nevertheless it contains something of the truth and should be looked into more deeply. One of the historical explanations ought to be looked for in the fact that it was necessary for Marxism to ally itself to alien tendencies in order to combat capitalist hangovers, especially in the field of religion, among the masses of the people.

Marxism was confronted with two tasks: to combat modern ideologies in their most refined form in order to create its own core of independent intellectuals; and to educate the masses of the people whose level of culture was medieval. Given the nature of the new philosophy the second and basic task absorbed all its strength, both quantitatively and qualitatively. For "didactic" reasons the new philosophy developed in a cultural form only slightly higher than the popular average (which was very low), and as such was absolutely inadequate for overcoming the ideology of the educated classes, despite the fact that the new philosophy had been expressly created to supersede the highest cultural manifestation of the period, classical

German philosophy, and in order to recruit into the new social class whose world view it was a group of intellectuals of its own. On the other hand modern culture, particularly the idealist, has been unable to elaborate a popular culture and has failed to provide a moral and scientific content to its own educational programmes, which still remain abstract and theoretical schemes.

ERNST FISCHER

*Art is necessary in order that man
should be able to recognize
and change the world.
But art is also necessary
by virtue of the magic inherent in it.*
—Ernst Fischer, *The Necessity of Art*

INTRODUCTION

The withdrawal from, and subsequent return to, humanism in the Marxist approach to art is exemplified in the career of the Austrian Ernst Fischer (1899–1972). He studied philosophy at Graz and joined the Social Democratic Party as a journalist, working as an editor of the *Arbeiter-Zeitung*. In 1934, following the brutal suppression of the Austrian workers, he broke with the Social Democrats and joined the Communist Party, in which he served as a leading cultural Stalinist in the campaigns against "fascist ideology," "Trotskyism," "Bukharinism," "decadence," "Formalism," "vulgar sociology," "sectarianism," and so on in the standard Zhdanovist manner. "The ideology of fascism," he wrote in 1937, "concocted out of garbage and filth, was prepared for by the penetration of a stifling mysticism into the natural and social sciences."[1] And in a self-criticism of his early admiration for Trotsky, he wrote: "Ten years ago I had a very

1. "Capitalist Barbarism and Socialist Culture," *Communist International*, December, 1937, p. 962.

nebulous, unfounded idea of Stalin; step by step I became persuaded of the correct policy, the historical greatness of Stalin, the grandeur of his work. . . . A new world has opened up before my eyes."[2]

Fischer worked during the Second World War as a radio commentator in Moscow; after the war he returned to Austria where, after serving in the provisional government and in parliament for a time, he returned to journalism. Since his life had already revealed a pattern of disillusionments linked to new and passionate conversions it was not surprising that he should repudiate his own Stalinism. What was surprising was that Fischer, whose cultural work had been on a machine-made level, would not only remain a Marxist but would commence a serious and sensitive study of the Marxist approach to art. Fischer's *The Necessity of Art*[3] was the first important popular introduction to Marxist aesthetics after Finkelstein's *Art and Society* and played a role in indicating the possibilities of a non-Zhdanovist Communist aesthetics. Essentially Caudwellian in its approach to the function of art (though Caudwell is not mentioned), Fischer's main purpose is to liberalize the concepts (especially those of realism) which had fettered the Marxist response to art. Inevitably, perhaps, Fischer remains largely bound within the traditional categories of pre-thaw Communist criticism. Impelled by the opposition which his flexible "new" approach aroused in East Germany and the U.S.S.R., his later work became both more impassioned and more strident in its affirmations of an undogmatic approach to art and artist. *Art Against Ideology*[4] is largely devoted to an attack on the remnants of the Zhdanovist approach, whose strength and viability Fischer vastly overrates. (At the same time, Fischer appeared to be drifting into an eclectic compound of Marxist humanism, mythic theory and "progressive" theology.) From this book we reprint the passage on "productive memory," an exploration of the dialectics of the imagination, of the way in which the labor process gives rise to the desire to restore man's lost unity with nature, a unity which persists as the memory of a lost paradise and as a model for images of the future— images which are the stuff of art.

2. "The Road of a Left Social-Democrat," *Communist International,* February, 1938, p. 142.

3. Dresden, 1959; English translation, 1963.

4. Hamburg, 1966; English translation, 1969.

FISCHER: **PRODUCTIVE MEMORY**
from *Art Against Ideology*

The imagination is dialectical in so far as anticipating the future is a form of *productive remembering*.

In the work process there is at first an imitation of useful objects found in nature, say a wedge to become an axe. But gradually the object placed before the eye as a model becomes a remembered, an inwardly imagined one; the worker improves, refines the crude model, adapts it more and more closely to his purpose, discovers more advantageous combinations, unrealized possibilities. What was once a material model now appears to the worker as an ideal original image, an *idea* of the thing to be made. The possible as still unformed reality, the stuff that dreams and gods and tools, phantoms and inventions, myths and mechanisms are made of, is the never-ending material of the imagination. The trinity of the creative imagination is there from the beginning. To imagine what has not yet been objectified, what is not yet present; to combine things which are not yet mutually related, to join them together and to establish an interaction between them; to draw what is to be from that which is remembered, to overstep the inadequate here-and-now, to make what has never yet been seen, conceived of or noticed *creatively* visible, conceivable and conscious—that is the imagination's three-fold manner of working. Originating in the working process, it is itself an inward-working process, the simplest and the richest way of working. The imagined, the not-yet present, the *new* is waylaid and captured; not merely the past but the future becomes a cause—an *Ur-Sache*—an original object. But this future is born out of the past, and all that is still to be accomplished is mirrored in memory.

By his work, man destroys his unity with nature. He does violence to nature and fears its revenge. With the increasing division of labour, with the beginning of authority, the division into ruled and rulers, into those who serve and those who enjoy, into haves and have-nots, the memory of a lost paradise, of a golden age, of a time when work was not a curse but a humanizing personal activity, becomes an inexhaustible source for the imagination. Original sin was the fact of becoming man; the imagination works to anticipate a *renewed* condition of the past. Drawing from ancient wells, it transforms a fluid element into something malleable and moulds from it images of the future. The force of the instincts, the power of dreams, the material of memory is enriched by new experience and modi-

fied by reason—yet anticipation is always the result of looking back upon a past which appears golden.

Later we will consider how the imagination produces myths and examine the myth as a model of reality. Now, however, we must try to see how the imagination tends to shrink in the highly developed industrial society.

SIDNEY FINKELSTEIN

The people, yes, the people.
—Carl Sandburg

INTRODUCTION

Sidney Finkelstein (1909–1974) was born in the Williamsburg section of Brooklyn and educated in the New York City school system and at the City College of New York. He received one master's degree in English literature at Columbia University for a thesis called "The Writer in the Victorian Novel," and another at N.Y.U.'s Institute of Fine Arts, published in German as *Der junge Picasso* (1969). While he was working at the Brooklyn Post Office during the Depression he wrote his first book, *Art and Society,* which was revised after service from 1942–1946 in the United States Army and published in 1947 by International Publishers, achieving an instantaneous popularity for its author's infectious delight in the arts, its appreciation of the classic works of twentieth-century modernism, and the deceptive ease with which Finkelstein was able to introduce nonspecialist readers to some of the complexities of artistic creation and its major styles. It should be remembered that until then no American Marxist had attempted a broad survey of the arts in their relation to society. Such books as Granville Hicks' *Great Tradition* (1933) and V. F. Calverton's *Libera-*

tion of American Literature (1932) had left a somewhat bitter taste by their destructive use of class analysis and their total neglect of the aesthetic dimension of art. Nevertheless, during the Popular Front period, first-rate critical studies were produced by Marxists in the universities (representative figures are Newton Arvin, Milton W. Brown, Margaret Schlauch, Oliver Larkin, Edwin Berry Burgum, and William Charvat), and excellent work began to appear in such journals as *Science and Society,* Calverton's *Modern Monthly* (sometimes *Modern Quarterly*), *Marxist Quarterly,* the early *Partisan Review,* and in the "little magazines," especially those linked to the John Reed Clubs. The better-known left-wing literary essayists— Joseph Freeman, Michael Gold, Joshua Kunitz, Isidor Schneider, Malcolm Cowley—were deeply occupied with cultural-political issues of the day; their influential work appeared primarily in *New Masses* and other weeklies. Intensive research into fundamental texts of Marxist aesthetics was inaugurated in 1937 by Angel Flores' "Critics Group" in a series of monographs, and in the periodical *Dialectics.* This auspicious beginning was interrupted by the disintegration of the Popular Front spirit and the onset of World War II. A number of interesting figures of the 1930's were relatively unfamiliar to the left audience: the brilliant work of Harry Alan Potamkin on film was so dense and idiosyncratic that it generated little influence; T. K. Whipple died before his later work on American literature could find an audience; Edmund Wilson—ever passing through stages—had already settled his accounts with Marxism and was moving on in his unending search for a viable past; Kenneth Burke had introjected Marxism so completely that it disappeared within his synthetic philosophy of symbolic form and action; Meyer Schapiro continued to insist on his Marxism but rarely exercized it in his stylistic analyses; "Obed Brooks" had reverted to his professorial identity and abandoned the questions of Marxism and literature of which he had written so knowingly; F. O. Matthiessen had composed a great monograph on American literature (*American Renaissance*) with a profound grasp of humanist dialectics, but was not ready, nor did he ever become ready, to fully accept Marxism.[1]

Finkelstein's book was a fresh breeze; it permitted those on the left who

1. Generally speaking, the special contribution to Marxism of the Americans lay not in criticism, philosophy, or aesthetics, but in journalism, reportage, and chronicle. The outstanding representatives are Randolph Bourne, John Reed, Michael Gold, Malcolm Cowley, and Joseph Freeman, with occasionally brilliant work by Erskine Caldwell, John dos Passos, Ernest Hemingway, Albert Maltz, and Joseph North. For representative examples, see Granville Hicks et al., eds., *Proletarian Literature in the United States: An Anthology* (New York, 1935), and Joseph North, ed., *New Masses: An Anthology of the Rebel Thirties* (New York, 1969).

loved music, literature, and the fine arts to set aside their guilt at enjoyment of the arts; it confirmed the significant social functions of art, its essential nature being seen as one of establishing kinship among people, its aesthetic emotion rising from the leap in understanding which flows from a conquest of another particle of the human experience. Artists of widely varying ideological persuasion are "saved" for Marxism by Finkelstein's alternating use of several theoretical devices: first, by stressing "popular" and "progressive" content in the artwork or biography of the artist; second, through the concept that "decadent" or negative art arises as protest against bourgeois domination of art and intellectual life; lastly, by Finkelstein's main thesis, which is a restatement of the eighteenth-century notion (first developed by Herder and adopted by many representatives of the Romantic and nationalist schools) that all significant art finds its nourishment and regenerative power in folk art. Using these yardsticks, it became possible for Finkelstein to emphasize folk (and by extension, national) elements in art as indicative of a "progressive" outlook. This theory is applied imaginatively and at length in Finkelstein's succeeding books: *Jazz: A People's Music* (1948), *How Music Expresses Ideas* (1952), *Realism in Art* (1954), and *Composer and Nation* (1960).

Finkelstein's strongest field is music. He has a firsthand knowledge and deep appreciation of the entire range of Western music, and he possesses the rare capacity of describing a musical composition in word-imagery that brings its content to life. His only attempt to create a musical aesthetic is in *How Music Expresses Ideas* (Galvano della Volpe in *Critica del Gusto* speaks of the "impudence" of the title), written during the period of Zhdanov's greatest influence, and not altogether free of that influence itself.

The selection reprinted here is in Finkelstein's best manner, illustrating and deepening the Marxist thesis that art educates the senses through its illumination of a portion of reality, converting the unknown into the known, heightening awareness by stripping away a fragment of the alienating veils which cloak our social and productive relations. Art is seen as a "specialized form of creative labor" and the languages of art as a social inheritance for the organization and enhancement of communal ties. Following Marx closely, Finkelstein emphasizes the role of art in recording social life at a particular stage of its historical development, in both its subjective and objective aspects. The educative side of art is stressed, as is its fundamental function in humanizing reality and developing the senses themselves. "The history of the arts is a record of the successive stages in the humanization of reality," writes Finkelstein in an extension of Marx's phrase "The forming of the five senses is a labour of the entire history of the world down to the present" (see above, page 60).

FINKELSTEIN: **ART AS HUMANIZATION**
from *The Artistic Expression of Alienation*

Art is one of the many ways through which people explore and think about the world outside, appraise the changes they have brought about in it, and through this, discover their own growing qualities and potentialities as human beings.

Art accomplishes this as a specialized form of creative labor. It is creative in that it produces works which can continue to exist, as a social possession, after the artist has finished with them. Its specialization lies in its skills with its materials. There are the language of words, the building or carving of objects with various shapes, the organization of sounds in musical patterns of pitch and rhythm, the creation of images through drawing, coloring, modelling, and the organized movements of the human body.

These are the means that society has evolved for the purpose of reflecting life, thinking about it, exchanging experiences, and organizing or enhancing communal activity.

All these materials are a social inheritance taken up by the artist, and they already have more than a mechanical quality, or in other words evoke a living or a human presence, as a social possession. Thus the most ordinary spoken and written language is more than a series of dictionary-definable units but has rhythm, intonation, vivid or colorful imagery. Shapes or images created for the most practical, utilitarian purpose, like tools, dwellings, drawings simply to record information, attain in their very creation, symmetry, curve, texture, rhythm. Music, in the form of song and dance, is as widespread a possession as language, and without this wide provenance in most people's minds and ears of at least a rudimentary but already emotionally evocative music, it is hard to see how individual works of creative music could come into being. People also express their inner states through their bodies. The most commonplace action or gesture has qualities which a painter's line or dancer's movement need only select, fix, isolate and incorporate into another context to become a living part of an art work.

Not only are the materials with which works of art are created given to the artist as a social heritage. Art serves social needs, and it comes into being under conditions or through channels evolved by society. Thus from the earliest civilizations public buildings called forth sculpture and painting. In more recent times, the rise of theaters goes hand in hand with the writing of plays, and the novel develops along with the institution of print-

ing, book selling and libraries. The creations of art in turn become a part of social reality. The world is different because it possesses them.

Basic to the understanding of art is the unending labor process of changing the world to fit human needs. As things of the outer world are turned to human use, manipulated and reshaped, all their manifold qualities are disclosed and the senses grow in response to them. If things in nature appear to have entrancing form, it is because the development of human senses and skills through manifold shaping and form-creating activities have enabled human beings to perceive this. The beauty of art differs from that of nature in that a work of art is a man-made object, and whatever its practical function, or however close its image may be to the outer world, it embodies in its shape and make-up the growth and presence of the human being in the process of discovery.

Art has subject matter and style, content, and form. The subject matter of an art work is some phenomenon in the outer world, or some function to perform, which also becomes a "subject"; that is, a challenge to the artist, a stimulus to thought, a problem to solve, a question to answer. The style of an art work is the unique pattern the artist gives to the socially-inherited materials for reflecting reality, so that they embody and can impart to others the heightened skills, senses and perceptions aroused in him during the process of creation. A work of art may embrace any kind of ideology or doctrine. Its real content, or artistic content, however, is its discovered truth, or in other words the illumination it brings to reality; its disclosure of something new born out of the old; its crystallization of a stage of growth of the human being in response to the surrounding world. This truth is affirmed by the heightened possibilities of life it brings to those who make it their own. The form of a work of art is the reflection, in its all-over structure, of the life-process of the artist in creating it. This life-process includes not only the organized work of the hands, eyes, ears and body, but also the work of the mind, the thinking about life and the resources of past experience brought to the problem at hand. It is this thinking which determines each step in the construction of the finished work.

As with all extensions of knowledge, the discoveries of the individual artist fix and bring into social consciousness a changed view of reality that has already been prepared for by the collective operations of society. The term reality, in reference to art, embraces both the outer, objective world of nature and human activity, and the inner, subjective, psychological world of thought about life and response to it. There are many ways of recording the outer, objective world which are not art: natural science, the writing of history, journalism, sociology, statistics, economics, photography used simply for documentary purposes. The unique quality of art, a quality

which sometimes touches the above activities and makes them enter—accidentally, so to speak—the realm of art, is that it discloses the inner world, corresponding to the outer. In other words, it shows what it means to live at a certain moment, or stage of development, of social life and the conquest of nature. It replaces fact with typicality. It discloses not an actual event but a pattern of outer movement, as a force operating on human hopes and feelings. If the history of the arts shows the utmost diversity in this relationship of inner and outer worlds, from a super-objective art which seems almost mechanistically documentary to an overwhelmingly subjective art which seems to be only a private world of the emotions, this only means that to look at art appreciatively it must also be looked at critically. To see it critically is to place its disclosures into the context of the real world that all people share. This is another way of saying that really to appreciate a work of art, we must ask, what is it that we learn from it that is applicable to all of us; what has been clarified for us that was obscure; what blindness has been turned into knowledge; how have our perceptions and ways of thinking about the world changed?

Art also possesses, and must possess, beauty. Beauty is the awareness of the development of the human senses, as they have grown in response to the continually advancing discovery of the richness of the external world. We can call this development of the senses a product of the humanization of the real world. There is first the humanization of nature, engendered by the adaptation of nature to fit human needs. Through this the secrets of nature are progressively discovered, its laws are revealed so that they come to be consciously used as instruments of human progress, and the mind is enriched by the disclosure of nature's manifold sensuous qualities. There is secondly the humanization of human relations. With the changes, conflicts in and reorganizations of society that make up history, there is a progressive discovery, understanding, mastery and reshaping of the laws governing the organization of society. Human relations become more human in the sense that destructive antagonisms are replaced by cooperation, ignorance and fear are replaced by kinship and understanding, and through cooperation the individual is enabled to develop more freely.

Each stage in the humanization of the external world, including both nature and society, is a stage in the growth of the human being, an enlargement of the scope of individual life, an awareness of a step towards freedom, and a growth of the senses. What happens is not a change in the physical basis of sense perception, but rather that with the new, more fruitful relationships of the individual to the outer world, the eyes "open up" so to speak. Each outer discovery is also an awareness of internal powers and richness. The individual grows by continually rediscovering

himself in the outer world. The esthetic emotion, the recognition of beauty, is the joyous consciousness of this leap in human powers. When we find that a work has the joy and excitement of beauty, this is another way of saying that we have learned from it, in the special way that makes us feel our senses have grown, our powers have become heightened, the world is a little more understandable, and we can thereby live a little differently. The history of the arts is a record of the successive stages in the humanization of reality. The arts reveal, as no other human product can, this process of humanization, of showing it not only in what is depicted from life, but also and more important, in the way it is depicted, the human involvement with outer reality.

BÉLA BALÁZS

Old the castle, old the tale,
Old is my riddle,
Give it your ear.
—Balázs, *Bluebeard's Castle*

INTRODUCTION

Béla Balázs was born in Szeged, Hungary, August 14, 1884. After taking his degree in philosophy, he became a leading literary figure in Hungarian cultural life during the last years of the monarchy, writing numerous volumes of poetry, stories, romances, and dramas, as well as the Maeterlinckian libretto for Bartók's opera *Bluebeard's Castle* (1911), and scenarios for other stage works of Bartók and Kodály. After the fall of the short-lived proletarian regime of 1919 he fled to Vienna, where he became film critic for the newspaper *Der Tag*. In 1923, he wrote *Der sichtbare Mensch* (*The Visible Man*), which was one of the first books in any language on the aesthetics and philosophy of art of the film, and which set out many fundamental questions that were later to be explored by Pudovkin, Eisenstein, John Grierson, Rudolf Arnheim, Siegfried Kracauer, Luigi Chiarini, and many others. Among the subjects dealt with are: film and literature, the nature of visual continuity, the significance of the visible, stylization, tempo, simultaneity, the grotesque, the uses of silence, mass

scenes, the relation of film to dream, and a host of similarly evocative categories. From this pioneering work, we reprint a section incorporating what was to become one of Balázs' main themes: the role of film in restoring the human image to collective consciousness. The invention of printing had tended to render "illegible the faces of men," thus reducing the expressive language of the human body and leading to the atrophy of gesture and expression. The film restores this lost "visual culture" to humanity, along with "the rich and colorful language of gesture, movement and facial expression." Balázs foresees, at the end of a long process of re-education of the senses by the example of film, the prospect of a new, wordless, universal language, with all the possibilities of bringing humanity together which this implies. "The silent film is free of the isolating walls of language differences. If we look at and understand each other's faces and gestures, we not only understand, we also learn to feel each other's emotions. The gesture is not only the outward projection of emotion, it is also its initiator." The film, then, represents a new stage in the arts, one which recaptures the human image and human expressive powers for a mankind that had been stripped of its own reflection by the technological progress (and dehumanizing influences) of an earlier capitalism. "Man has again become visible."[1]

Balázs moved to Berlin in 1926, where he joined the German Proletarian Writers' Association and became a leader of the Communist directed Arbeiter-Theater-Bund. He wrote or collaborated on a number of important screen scenarios, including *Die Abenteuer eines Zehnmarkscheins* (*The Adventures of a Ten-Mark Note*) (1926), *1 + 1 = 3* (1927), *Narkose* (*Narcosis*) (1929), Pabst's *Die Dreigroschenoper* (*The Threepenny Opera*) (1931), and *Das blaue Licht* (*The Blue Light*) (1932). In 1930, he published *Der Geist des Films* (*The Spirit of the Film*), which extended the theoretical explorations of his previous book to such technical subjects as montage, camera technique, cutting, sound, dialogue, optics, and the like; the closing chapter, "Ideological Observations," contains illuminating ideas on the sociology and aesthetics of cinema, on the proletarian

1. I have not attempted to trace the sources of Balázs' aesthetic categories, but it is possible that the ubiquitous influence of Georg Simmel, to whom he dedicated his early *Halálesztetika* (*Aesthetics of Death*) is at work in him, as it is in the writings of the early Lukács, Ernst Bloch, Max Raphael, and Walter Benjamin. This influence usually manifests itself by way of a sociological inversion of categories which Simmel explored from his own point of view and which he described as "epistemological idealism." For some interesting parallels to Balázs, see Simmel's paper, "The Aesthetic Significance of the Face" (1901), in *Essays on Sociology, Philosophy and Aesthetics,* ed. Kurt H. Wolff (New York, 1965), pp. 276–81.

film, and the relation of Marxism to the film art. In the early 1930's[2] Balázs emigrated to the U.S.S.R. and became professor of "cinematographic aesthetics" at the Moscow Art Institute. Jay Leyda reports that Balázs directed his first and only film, *Tissa Burns,* in the U.S.S.R., in 1933.[3] It was never released, probably for "ideological" reasons. Perhaps this is one of the reasons that Balázs did not wish to recall or to write about his years in the Soviet Union. In 1945 he returned to Hungary and became professor of drama and cinematography at the Academy of Art in Budapest, teaching also at the film academies in Poland and Czechoslovakia until his death in 1949.[4] He wrote one more screenplay, *Valahol Europában* (*Somewhere in Europe*) (1947), and in 1948 he completed his major work, *The Theory of the Film*—begun in Vienna, continued in Berlin, largely written in Moscow—the summation of his work on the subject, which has appeared in German, Hungarian, Italian, Russian, and English. We have selected several pages from the section entitled "The Face of Man." The expressivity of "things" rises from their relationship to man: "What makes objects expressive are the human expressions projected onto them." This is a return to a theme which Balázs had developed in his first book: "The milieu becomes the visible 'aura' of Men. . . . Things have meaning only insofar as they have a relationship with Man."[5]

More important than the "physiognomy of things," however, "was the discovery of the human face." Balázs reaffirms his belief in the universal language of the body's expressivity and then launches into a dense and speculative attempt to situate the film closeup of the human face in a supraspatial dimension—that of "microphysiognomy." Drawing an analogy to Bergson's comments on the temporal nature of music (which in turn may be traced back to Saint Augustine), Balázs holds that facial expression "is not a phenomenon pertaining to space." Balázs probably intends this line of exploration to lead into those metasociological categories of universal human essences where he is most at home. Other Marxists have stressed the dialectical process whereby art is simultaneously an expression of socioeconomic-historical genetic factors and of universal or transcendent

2. A diary entry in Balázs' posthumously published *Almodó ifjúság* (Budapest, 1967, p. 445) places his emigration in 1931. The authoritative *Filmlexicon degli Autori e delle Opera* (Rome, 1958), vol. I, p. 354, dates his arrival in the U.S.S.R. from 1933.

3. See Jay Leyda, *Kino* (London, 1960), p. 303.

4. There is some confusion about the date of Balázs' death, complicated by the existence of another Béla Balázs—a Communist political historian who died in 1959.

5. *Der sichtbare Mensch,* 2d ed., p. 92.

human qualities. Balázs is perhaps the first to suggest another dialectic: the simultaneous existence of art within a spatial matrix and a supraspatial (negative-spatial) dimension.

BALÁZS: THE VISIBLE MAN
from *The Sightless Man*

The discovery of printing gradually rendered illegible the faces of men. So much could be read from paper that the method of conveying meaning by facial expression fell into desuetude.

Victor Hugo wrote once that the printed book took over the part played by the cathedral in the Middle Ages and became the carrier of the spirit of the people. But the thousands of books tore the *one* spirit, embodied in the cathedral, into thousands of opinions. The word broke the stone into a thousand fragments, tore the church into a thousand books.

The visual spirit was thus turned into a legible spirit and visual culture into a culture of concepts. This of course had its social and economic causes, which changed the general face of life. But we paid little attention to the fact that, in conformity with this, the face of individual men, their foreheads, their eyes, their mouths, had also of necessity and quite concretely to suffer a change.

At present a new discovery, a new machine, is at work to turn the attention of men back to a visual culture and give them new faces. This machine is the cinematographic camera. Like the printing press, it is a technical device for the multiplication and distribution of products of the human spirit; its effect on human culture will not be less than that of printing press.

For not to speak does not mean that one has nothing to say. Those who do not speak may be brimming over with emotions which can be expressed only in forms and pictures, in gesture and play of feature. The man of visual culture uses these not as substitutes for words, as a deaf-mute uses his fingers. He does not think in words, the syllables of which he sketches in the air like the dots and dashes of the Morse code. The gestures of visual man are not intended to convey concepts which can be expressed in words, but such inner experiences, such non-rational emotions which would still remain unexpressed when everything that can be told has been told. Such emotions lie in the deepest levels of the soul and cannot be approached by words that are mere reflexions of concepts; just as our musical experiences cannot be expressed in rationalized concepts. What appears on the face and

in facial expression is a spiritual experience which is rendered immediately visible without the intermediary of words.

In the golden age of the old visual arts, the painter and sculptor did not merely fill empty space with abstract shapes and forms, and man was not merely a formal problem for the artist. Painters could paint the spirit and the soul without becoming "literary," for the soul and the spirit had not yet been confined in concepts capable of expression only by means of words; they could be incarnated without residue. That was the happy time when paintings could still have a "theme" and an "idea," for the idea had not yet been tied to the concept and to the word that named the concept. The artist could present in its primary form of manifestation the soul's bodily incarnation in gesture or feature. But since then the printing press has grown to be the main bridge over which the more remote interhuman spiritual exchanges take place and the soul has been concentrated and crystallized chiefly in the word. There was no longer any need for the subtler means of expression provided by the body. For this reason our bodies grew soulless and empty—what is not in use, deteriorates.

The expressive surface of our body was thus reduced to the face alone and this not merely because the rest of the body was hidden by clothes. For the poor remnants of bodily expression that remained to us the little surface of the face sufficed, sticking up like a clumsy semaphore of the soul and signalling as best it could. Sometimes a gesture of the hand was added, recalling the melancholy of a mutilated torso. In the epoch of word culture the soul learnt to speak but had grown almost invisible. Such was the effect of the printing press.

Now the film is about to inaugurate a new direction in our culture. Many million people sit in the picture houses every evening and purely through vision, experience happenings, characters, emotions, moods, even thoughts, without the need for many words. For words do not touch the spiritual content of the pictures and are merely passing instruments of as yet undeveloped forms of art. Humanity is already learning the rich and colourful language of gesture, movement and facial expression. This is not a language of signs as a substitute for words, like the sign-language of the deaf-and-dumb—it is the visual means of communication, without intermediary of souls clothed in flesh. Man has again become visible.

Linguistic research has found that the origins of language lie in expressive movement, that is, that man when he began to speak moved his tongue and lips to no greater extent than the other muscles of his face and body—just as an infant does to-day. Originally the purpose was not the making of sounds. The movement of tongue and lips was at first the same spon-

taneous gesturing as every other expressive movement of the body. That the former produced sounds was a secondary, adventitious phenomenon, which was only later used for practical purposes. The immediately visible message was thus turned into an immediately audible message. In the course of this process, as in every translation, a great deal was lost. It is the expressive movement, the gesture, that is the aboriginal mother-tongue of the human race.

Now we are beginning to remember and re-learn this tongue. It is still clumsy and primitive and very far removed as yet from the refinements of word art. But already it is beginning to be able sometimes to express things which escape the artists of the word. How much of human thought would remain unexpressed if we had no music! The now developing art of facial expression and gesture will bring just as many submerged contents to the surface. Although these human experiences are not rational, conceptual contents, they are nevertheless neither vague nor blurred, but as clear and unequivocal as is music. Thus the inner man, too, will become visible.

But the old visible man no longer exists to-day and the new visible man is not yet in existence. As I have said before, it is the law of nature that unused organs degenerate and disappear, leaving only rudiments behind. The animals that do not chew lose their teeth. In the epoch of word culture we made little use of the expressive powers of our body and have therefore partly lost that power. The gesturing of primitive peoples is frequently more varied and expressive than that of the educated European whose vocabulary is infinitely richer. A few more years of film art and our scholars will discover that cinematography enables them to compile encyclopædias of facial expression, movement and gesture, such as have long existed for words in the shape of dictionaries. The public, however, need not wait for the gesture encyclopædia and grammars of future academies: it can go to the pictures and learn it there.

We had, however, when we neglected the body as a means of expression, lost more than mere corporal power of expression. That which was to have been expressed was also narrowed down by this neglect. For it is not the same spirit, not the same soul that is expressed once in words and once in gestures. Music does not express the same thing as poetry in a different way—it expresses something quite different. When we dip the bucket of words in the depths, we bring up other things than when we do the same with gestures. But let no one think that I want to bring back the culture of movement and gesture in place of the culture of words, for neither can be a substitute for the other. Without a rational, conceptual culture and the scientific development that goes with it there can be no social and hence no human progress. The connecting tissue of modern society is the word

spoken and written, without which all organization and planning would be impossible. On the other hand fascism has shown us where the tendency to reduce human culture to subconscious emotions in place of clear concepts would lead humanity.

What I am talking about is only art and even here there is no question of displacing the more rational art of the word. There is no reason why we should renounce one sort of human achievement in favour of another. Even the most highly developed musical culture need not crowd out some more rational aspect of culture.

But to return to the simile of the bucket: we know that the wells that dry up are the wells from which no water is dipped. Psychology and philology have shown that our thoughts and feelings are determined *a priori* by the possibility of expressing them. Philology is also aware that it is not only concepts and feelings that create words, but that it is also the other way round: words give rise to concepts and feelings. This is a form of economy practised by our mental constitution which desires to produce unusable things just as little as does our physical organism. Psychological and logical analysis has shown that words are not merely images expressing our thoughts and feelings but in most cases their *a priori* limiting forms. This is at the root of the danger of stereotyped banality which so often threatens the educated. Here again the evolution of the human spirit is a dialectical process. Its development increases its means of expression and the increase of means of expression in its turn facilitates and accelerates its development. Thus if then the film increases the possibilities of expression, it will also widen the spirit it can express.

Will this newly developing language of facial expression and expressive gesture bring human beings closer to each other or the contrary? Despite the tower of Babel there were concepts common to all behind the different words and one could also learn the languages of others. Concepts on the other hand, have, in civilized communities, a content determined by convention. A universally valid grammar was an even more potent unifying principle holding together the individuals who in bourgeois society were prone to become estranged and isolated from each other. Even the literature of extreme subjectivism used the common vocabulary and was thus preserved from the loneliness of final misunderstanding.

But the language of the gestures is far more individual and personal than the language of words, although facial expression, too, has its habitual forms and conventionally accepted interpretations, to such an extent that one might—and should—write a comparative "gesturology" on the model of comparative linguistics. Nevertheless this language of facial expression and gesture, although it has a certain generally accepted tradition, lacks the

severe rules that govern grammar and by the grace of our academies are compulsory for us all. No school prescribes that you must express your cheerfulness by this sort of smile and your bad humour with that sort of wrinkled brow. There are no punishable errors in this or that facial expression, although children doubtless do observe and imitate such conventional grimaces and gestures. On the other hand, these are more immediately induced by inner impulses than are words. Yet it will probably be the art of the film after all which may bring together the peoples and nations, make them accustomed to each other, and lead them to mutual understanding. The silent film is free of the isolating walls of language differences. If we look at and understand each other's faces and gestures, we not only understand, we also learn to feel each other's emotions. The gesture is not only the outward projection of emotion, it is also its initiator.

The universality of the film is primarily due to economic causes—which are always the most compelling causes. The making of a film is so expensive that only very few nations have a home market sufficient to make film production pay. But one of the preconditions of the international popularity of any film is the universal comprehensibility of facial expression and gesture. Specific national characteristics will in time be permissible only as exotic curiosities and a certain levelling of "gesturology" will be inevitable. The laws of the film market permit only universally comprehensible facial expressions and gestures, every nuance of which is understood by princess and working girl alike from San Francisco to Smyrna. We now already have a situation in which the film speaks the only universal, common world language understood by all. Ethnic peculiarities, national specialities sometimes can lend style and colour to a film, but can never become factors in causing the story to move on, because the gestures which convey the meaning and decide the course of the action must be uniformly comprehensible to every audience everywhere, otherwise the producer will lose money on the film.

The silent film helped people to become physically accustomed to each other and was about to create an international human type. When once a common cause will have united men within the limits of their own race and nation, then the film which makes visible man equally visible to everyone, will greatly aid in levelling physical differences between the various races and nations and will thus be one of the most useful pioneers in the development towards an international universal humanity.

BALÁZS: **THE FACE OF MAN**
from *Theory of the Film*

The basis and possibility of an art of the film
is that everyone and everything looks what it is.

Every art always deals with human beings, it is a human manifestation and presents human beings. To paraphrase Marx: "The root of all art is man." When the film close-up strips the veil of our imperceptiveness and insensitivity from the hidden little things and shows us the face of objects, it still shows us man, for what makes objects expressive are the human expressions projected on to them. The objects only reflect our own selves, and this is what distinguished art from scientific knowledge (although even the latter is to a great extent subjectively determined). When we see the face of things, we do what the ancients did in creating *gods* in man's image and breathing a human soul into them. The close-ups of the film are the creative instruments of this mighty visual anthropomorphism.

What was more important, however, than the discovery of the physiognomy of things, was the discovery of the human face. Facial expression is the most subjective manifestation of man, more subjective even than speech, for vocabulary and grammar are subject to more or less universally valid rules and conventions, while the play of features, as has already been said, is a manifestation not governed by objective canons, even though it is largely a matter of imitation. This most subjective and individual of human manifestations is rendered objective in the close-up.

A New Dimension

If the close-up lifts some object or some part of an object out of its surroundings, we nevertheless perceive it as existing in space; we do not for an instant forget that the hand, say, which is shown by the close-up, belongs to some human being. It is precisely this connection which lends meaning to its every movement. But when Griffith's genius and daring first projected gigantic "severed heads" on to the cinema screen, he not only brought the human face closer to us in space, he also transposed it from space into another dimension. We do not mean, of course, the cinema screen and the patches of light and shadow moving across it, which being visible things, can be conceived only in space; we mean the expression on the face as revealed by the close-up. We have said that the isolated hand would lose its meaning, its expression, if we did not know and imagine its

connection with some human being. The facial expression on a face is complete and comprehensible in itself and therefore we need not think of it as existing in space and time. Even if we had just seen the same face in the middle of a crowd and the close-up merely separated it from the others, we would still feel that we have suddenly been left alone with this one face to the exclusion of the rest of the world. Even if we have just seen the owner of the face in a long shot, when we look into the eyes in a close-up, we no longer think of that wide space, because the expression and significance of the face has no relation to space and no connection with it. Facing an isolated face takes us out of space, our consciousness of space is cut out and we find ourselves in another dimension: that of physiognomy. The fact that the features of the face can be seen side by side, i.e., in space—that the eyes are at the top, the ears at the sides and the mouth lower down—loses all reference to space when we see, not a figure of flesh and bone, but an expression, or in other words when we see emotions, moods, intentions and thoughts, things which although our eyes can see them, are not in space. For feelings, emotions, moods, intentions, thoughts are not themselves things pertaining to space, even if they are rendered visible by means which are.

Melody and Physiognomy

We will be helped in understanding this peculiar dimension by Henri Bergson's analysis of time and duration. A melody, said Bergson, is composed of single notes which follow each other in sequence, i.e., in time. Nevertheless a melody has no dimension in time, because the first note is made an element of the melody only because it refers to the next note and because it stands in a definite relation to all other notes down to the last. Hence the last note, which may not be played for some time, is yet already present in the first note as a melody-creating element. And the last note completes the melody only because we hear the first note along with it. The notes sound one after the other in a time-sequence, hence they have a real duration, but the coherent line of melody has no dimension in time; the relation of the notes to each other is not a phenomenon occurring in time. The melody is not born gradually in the course of time but is already in existence as a complete entity as soon as the first note is played. How else would we know that a melody is begun? The single notes have duration in time, but their relation to each other, which gives meaning to the individual sounds, is outside time. A logical deduction also has its sequence, but premise and conclusion do not follow one another in time. The process of thinking as a psychological process may have duration; but the logical forms, like melodies, do not belong to the dimension of time.

Now facial expression, physiognomy, has a relation to space similar to the relation of melody to time. The single features, of course, appear in space; but the significance of their relation to one another is not a phenomenon pertaining to space, no more than are the emotions, thoughts and ideas which are manifested in the facial expressions we see. They are picture-like and yet they seem outside space; such is the psychological effect of facial expression.

MIKHAIL BAKHTIN

The body of the people and of mankind,
fertilized by the dead,
is eternally renewed and moves forever
forward along
the historic path of progress.
—Bakhtin, *Rabelais and His World*

INTRODUCTION

Zhdanovism in the arts and in criticism consisted of a deliberate and terror-
istic suppression of the traditions of humanist-revolutionary Marxism and
of the early Soviet Communist intellectual heritage itself. At the risk of
oversimplification, Zhdanovism may be described as a self-mutilating proc-
ess whereby a postrevolutionary society cut away the ideas and the ideol-
ogy which had created that very society; a process whereby Marxism and
early Soviet Communism (Bolshevism) were converted into a conformist
dogma based largely on the pre-Marxist and pre-Leninist Russian populist-
democratic intellectual heritage. The writings of many Bolshevik and early
Soviet theoreticians were almost wholly eliminated from public discourse
just as 70 per cent of the Bolshevik delegates to the 1934 Party Congress
were physically annihilated during the purges of the late 1930's.

One of the main preconditions for the defeat of the remnants of
Zhdanovism in Soviet creative life is the resurrection of the suppressed
heritage. The "rehabilitation" of the victims of the purges is an important
part of this process; and in Soviet criticism, philosophy, and aesthetics,

important headway has been made, although the restoration of the past heritage is often accomplished timidly and in a negative fashion, with occasional revivals of the Zhdanov spirit, and with significant omissions.

Among the important early Soviet critics whose works are again now becoming part of Soviet consciousness are Lunacharsky, Voronsky, Shklovsky, and various of the Formalist and Structuralist writers of the 1920's. One of the most significant resurrections is that of Mikhail Bakhtin. Bakhtin was born in 1895 and educated at the University of Petersburg, where he majored in philology. His *Problems of Dostoevsky's Creative Genius*[1] established him as a major Soviet critic. He was the leader of a group of adherents (now called "Bakhtin's School"), which included such figures as V. N. Volosinov and P. Medvedev. He then "disappeared" (I do not know the details) from Soviet literary life for a quarter of a century. In 1957, he was appointed to a post at the University in Saransk. In 1963, his Dostoyevsky book was republished in Moscow, and in 1965 he was finally permitted to publish *Rabelais and His World,* which he had essentially completed in 1940. It is a major work. Bakhtin emerges as a scholar and critic of global magnitude, whose categories of analysis open up large segments of world literature for re-examination.

In this context, we stress only one aspect of Bakhtin's rich contribution: the restoration of the human being to the center of literary criticism. In Marxism, "radicalism" retains its etymological meaning, "to go to the root of things"; for Marx "the root is man himself." But in economic determinism, Kautskyism, Zhdanovism, and such "rational" Marxists as Lukács, "man" is defined without reference to his biological existence: he is split into "lower" (animal, bestial) and "higher" (spiritual, class-conscious) aspects. This catastrophic division of the human being into distinct "material" and "ideal" spheres belongs to Christian theology and bourgeois hypocrisy rather than to Marxism. Marx's teaching is that "man is the highest essence for man," and his goal is the "categoric imperative to overthrow all relations in which man is a debased, enslaved, abandoned, despicable essence" (see above, page 53). In 1883, Engels, warning against the revival of philistinism among the German socialists, praised poets who could express "natural robust sensuousness and the joys of the flesh" (see above, page 70).[2]

1. Leningrad, 1929. See above, pp. 227–31.

2. Marx was somewhat equivocal on this subject in the *Economic and Philosophic Manuscripts of 1844,* where he speaks of "eating, drinking, procreating" as "animal functions." But he hastens to correct himself: "Certainly eating, drinking, procreating, etc., are also genuinely human functions. But in the abstraction which separates

Bakhtin's radicalism cuts so deep that it seeks to restore man's body and its biological functions to the humanist sphere. Taking Rabelais as his text, he reveals how the Utopia of the common people—kept alive in their oral language traditions, festivals, and carnivals—opposes the official ruling-class, hierarchical, spiritual, disembodied view of man with a glorification of the body image, a topsy-turvy negation in which the "lower" processes of man's supposedly "animal" functioning are revealed as the realm of freedom, the path to Paradise, the road to social regeneration and revolution. Bakhtin's is a class-struggle view of literature, in which the Utopian and freedom images of the common people explode into literary conscious-ness and shape its concerns and its content. For those who reject class-inspired Paradises in the hereafter, the body itself becomes the locus of Paradise.[3]

Our selection from *Rabelais and His World* shows how in the medieval folk culture laughter was a means of overcoming the central ideas, images and symbols of official culture. It served this purpose by focusing upon bodily life: "copulation, birth, growth, eating, drinking, defecation." The liberation of the body is accompanied by laughter in the medieval feast, serving as a temporary suspension of hierarchy and prohibition, as a brief entry into "the sphere of utopian freedom." Laughter and freedom are indissolubly linked; laughter serves as the repository of the people's "unofficial truth," thereby conquering fear: "Laughter . . . overcomes fear, for it knows no inhibitions, no limitations. Its idiom is never used by violence and authority." Laughter "is the social consciousness of all the people," and signifies "the defeat of power, of earthly kings, of the earthly upper classes, of all that oppresses and restricts."

Bakhtin shows how Rabelais used the imagery of traditional folklore to construct a new model of the world as a contrast to the medieval hierarchi-cal model. In Rabelais, the top and the bottom change places, the spiritual is displaced to the material, the mind to the body; he "intentionally mixed

them from the sphere of all other human activity and turns them into sole and ulti-mate ends, they are animal" (p. 73). The definitive statements by Engels on this sub-ject are in *The Origin of the Family, Private Property and the State.* Cf. also the extremely important comments in his "On the History of Early Christianity," in Marx and Engels, *On Religion* (Moscow, 1957), pp. 329f.

3. Bakhtin's concepts are a startling dialectical reversal of the typical Zhdanovist and Lukácsian equation of class decadence and bodily functions. For example, in "Healthy or Sick Art," Lukács writes that in a "decaying class society . . . the intellectual powers, understanding and reason, lose significance and yield to instinct; more and more the bowels dominate the head." (*Writer and Critic* [London, 1970], p. 105.)

the hierarchical levels in order to discover the core of the object's concrete reality, to free it from its shell and to show its material bodily aspect—the real being outside all hierarchical norms and values" (page 403). Opposites merge in Rabelais' appropriation of folk imagery: death loses its terror, and becomes "the necessary link in the process of the people's growth and renewal" (page 407). The dying world gives birth to the new one, and this process "is represented in the images of the material bodily lower stratum; everything descends into the earth and the bodily grave in order to die and to be reborn" (page 435). The topsy-turvy, inside-out, back-to-front imagery of the common people and the "positive negation" of man's bodily Utopia serve as instruments of liberation, as vehicles for the transformation of death into resurrection.

The revolutionary aspects of Bakhtin's new categories of criticism will become evident when others take up the task of applying them to the history of literature and the fine arts. Bakhtin himself has already noted the applicability of his theories to Shakespeare and Dante, but it is evident that a whole range of literature—including Swift, Smollett, Sterne, Melville (who perhaps is more Rabelaisian than has been suspected), and Joyce— unfolds new meanings when examined in the light of Bakhtin. As for the fine arts, the ramifications are equally explosive, and may yet lead to an "iconography of the body image."

BAKHTIN: **LAUGHTER AND FREEDOM**
from *Rabelais and His World*

Medieval laughter is directed at the same object as medieval seriousness. Not only does laughter make no exception for the upper stratum, but indeed it is usually directed toward it. Furthermore, it is directed not at one part only, but at the whole. One might say that it builds its own world versus the official world, its own church versus the official church, its own state versus the official state. Laughter celebrates its masses, professes its faith, celebrates marriages and funerals, writes its epitaphs, elects kings and bishops. Even the smallest medieval parody is always built as part of a whole comic world.

This universal character of laughter was most clearly and consistently brought out in the carnival rituals and spectacles and in the parodies they presented. But universality appears as well in all the other forms of medieval culture of humor: in the comic elements of church dramas, in the comic *dits* (fairy tales) and *débats* (debates), in animal epics, *fabliaux* and

Schwänke.[1] The main traits of laughter and of the lower stratum remain identical in all these genres.

It can be said that medieval culture of humor which accompanied the feasts was a "satyric" drama, a fourth drama, after the "tragic trilogy" of official Christian cult and theology to which it corresponded but was at the same time in opposition. Like the antique "satyric" drama, so also the medieval culture of laughter was the drama of bodily life (copulation, birth, growth, eating, drinking, defecation). But of course it was not the drama of an individual body or of a private material way of life; it was the drama of the great generic body of the people, and for this generic body birth and death are not an absolute beginning and end but merely elements of continuous growth and renewal. The great body of satyric drama cannot be separated from the world; it is perfused with cosmic elements and with the earth which swallows up and gives birth.

Next to the universality of medieval laughter we must stress another striking peculiarity: its indissoluble and essential relation to freedom. We have seen that this laughter was absolutely unofficial but nevertheless legalized. The rights of the fool's cap were as inviolable as those of the *pileus* (the clown's headgear of the Roman Saturnalias).

This freedom of laughter was, of course, relative; its sphere was at times wider and at times narrower, but it was never entirely suspended. As we have seen, free laughter was related to feasts and was to a certain extent limited by the time allotted to feast days. It coincided with the permission for meat, fat, and sexual intercourse. This festive liberation of laughter and body was in sharp contrast with the stringencies of Lent which had preceded or were to follow.

The feast was a temporary suspension of the entire official system with all its prohibitions and hierarchic barriers. For a short time life came out of its usual, legalized and consecrated furrows and entered the sphere of utopian freedom. The very brevity of this freedom increased its fantastic nature and utopian radicalism, born in the festive atmosphere of images.

The atmosphere of ephemeral freedom reigned in the public square as well as at the intimate feast in the home. The antique tradition of free, often improper, but at the same time philosophical table talk had been revived at the time of the Renaissance; it converged with the local tradition of festive meals which had common roots in folklore.[2] This tradition of

1. True, such manifestations already express at times the specific limitations of early bourgeois culture; in those cases the material bodily principle becomes petty and degenerate to a certain extent.

2. Up to the second part of the sixteenth century, the literature of free talk (with prevailing material bodily themes) was characteristic. The following were table,

table talk was continued during the following centuries. We find similar traditions of bacchic prandial songs which combine universalism (problems of life and death) with the material bodily element (wine, food, carnal love), with awareness of the time element (youth, old age, the ephemeral nature of life, the changes of fortune); they express a peculiar utopian strain, the brotherhood of fellow-drinkers and of all men, the triumph of affluence, and the victory of reason.

The comic rituals of the feast of fools, the feast of the ass, and the various comic processions and ceremonies of other feasts enjoyed a certain legality. The diableries were legalized and the devils were allowed to run about freely in the streets and in the suburbs a few days before the show and to create a demonic and unbridled atmosphere. Entertainments in the marketplace were also legalized as well as carnival. Of course, this legalization was forced, incomplete, led to struggles and new prohibitions. During the entire medieval period the Church and state were obliged to make concessions, large or small, to satisfy the marketplace. Throughout the year there were small scattered islands of time, strictly limited by the dates of feasts, when the world was permitted to emerge from the official routine but exclusively under the camouflage of laughter. Barriers were raised, provided there was nothing but laughter.

Besides universalism and freedom, the third important trait of laughter was its relation to the people's unofficial truth.

The serious aspects of class culture are official and authoritarian; they are combined with violence, prohibitions, limitations and always contain an element of fear and of intimidation. These elements prevailed in the Middle Ages. Laughter, on the contrary, overcomes fear, for it knows no inhibitions, no limitations. Its idiom is never used by violence and authority.

It was the victory of laughter over fear that most impressed medieval man. It was not only a victory over mystic terror of God, but also a victory over the awe inspired by the forces of nature, and most of all over the oppression and guilt related to all that was consecrated and forbidden ("mana" and "taboo"). It was the defeat of divine and human power, of

recreational, or promenading talks: Noël du Fail, "Rustic and Facetious Talks" (*Propos rustiques et facétieux*), 1547, and Entrapel's "Tales and New Discourses" (*Contes et nouveaux discours d'Entrapel*), 1585; Jacques Tahureau, *Dialogues, 1562;* Nicolas de Chaulières, "Morning Talks" (Matinées), 1585, and "Postprandial Talks" (Les Après-diners); Guillaume Boucher, "After Supper Talks" (Soirées), 1584–1597. "How to Succeed in Life," by Béroalde de Verville, already mentioned, also belongs to this category. All these works represent the special type of carnivalized dialogue and reflect to a greater or lesser extent Rabelais' influence.

authoritarian commandments and prohibitions, of death and punishment after death, hell and all that is more terrifying than the earth itself. Through this victory laughter clarified man's consciousness and gave him a new outlook on life. This truth was ephemeral; it was followed by the fears and oppressions of everyday life, but from these brief moments another unofficial truth emerged, truth about the world and man which prepared the new Renaissance consciousness.

The acute awareness of victory over fear is an essential element of medieval laughter. This feeling is expressed in a number of characteristic medieval comic images. We always find in them the defeat of fear presented in a droll and monstrous form, the symbols of power and violence turned inside out, the comic images of death and bodies gaily rent asunder. All that was terrifying becomes grotesque. We have already mentioned that one of the indispensable accessories of carnival was the set called "hell." This "hell" was solemnly burned at the peak of the festivities. This grotesque image cannot be understood without appreciating the defeat of fear. The people play with terror and laugh at it; the awesome becomes a "comic monster."

Neither can this grotesque image be understood if oversimplified and interpreted in the spirit of abstract rationalism. It is impossible to determine where the defeat of fear will end and where joyous recreation will begin. Carnival's hell represents the earth which swallows up and gives birth, it is often transformed into a cornucopia; the monster, death, becomes pregnant. Various deformities, such as protruding bellies, enormous noses, or humps, are symptoms of pregnancy or of procreative power. Victory over fear is not its abstract elimination; it is a simultaneous uncrowning and renewal, a gay transformation. Hell has burst and has poured forth abundance.

We have said that medieval laughter defeated something which was more terrifying than the earth itself. All unearthly objects were transformed into earth, the mother which swallows up in order to give birth to something larger that has been improved. There can be nothing terrifying on earth, just as there can be nothing frightening in a mother's body, with the nipples that are made to suckle, with the genital organ and the warm blood. The earthly element of terror is the womb, the bodily grave, but it flowers with delight and a new life.

However, medieval laughter is not a subjective, individual and biological consciousness of the uninterrupted flow of time. It is the social consciousness of all the people. Man experiences this flow of time in the festive marketplace, in the carnival crowd, as he comes into contact with other

bodies of varying age and social caste. He is aware of being a member of a continually growing and renewed people. This is why festive folk laughter presents an element of victory not only over supernatural awe, over the sacred, over death; it also means the defeat of power, of earthly kings, of the earthly upper classes, of all that oppresses and restricts.[3]

Medieval laughter, when it triumphed over the fear inspired by the mystery of the world and by power, boldly unveiled the truth about both. It resisted praise, flattery, hypocrisy. This laughing truth, expressed in curses and abusive words, degraded power. The medieval clown was also the herald of this truth.

In his article devoted to Rabelais, Veselovsky characterized as follows the clown's social meaning:

In the Middle Ages, the clown is the lawless herald of the objectively abstract truth. At a time when all life was built within the conventional frameworks of caste, prerogative, scholastic science and hierarchy, truth was localized according to these frameworks; it was relatively feudal, scholastic, etc., drawing its strength from its given milieu; thus truth was a mere result of the rights it could practically exercise. Feudal truth was the right to oppress the slave, to despise his work, to go to war, to hunt in the peasants' fields. . . . Scholastic truth was the right to possess exclusive knowledge outside of which nothing made sense; therefore knowledge had to be defended against everything that could obscure it. . . . All general human truth, not adapted to the caste, to an established profession, i.e., to determined rights, was excluded. It was not taken into consideration, it was despised, dragged to the stake on the slightest suspicion. It was only

3. Profound thoughts concerning the functions of laughter in the history of culture were expressed by Herzen (though he was not acquainted with the laughing Middle Ages): "laughter contains something revolutionary . . . Voltaire's laughter was more destructive than Rousseau's weeping." (Works in nine volumes, Goslitizdat, [Moscow, 1956], vol. 3, p. 92.) And elsewhere: "Laughter is no matter for joking, and we shall not give up our right to it. In the antique world, the public roared with laughter on Olympus and upon earth while listening to Aristophanes and his comedies, and roared with laughter up to Lucian. Humanity ceased to laugh from the fourth century on; it did nothing but weep, and heavy chains fell on the mind amidst moans and pangs of remorse. As soon as the fever of fanaticism subsided, men began to laugh once more. It would be extremely interesting to write the history of laughter. In church, in the palace, on parade, facing the department head, the police officer, the German administrator, nobody laughs. The serfs are deprived of the right to smile in the presence of the landowners. *Only equals may laugh.* If inferiors are permitted to laugh in front of their superiors, and if they cannot suppress their hilarity, this would mean farewell to respect. To make men smile at the god Apis is to deprive him of his sacred rank and to transform him into a common bull." (A. I. Herzen, *On Art* [Moscow, 1954], p. 223.)

tolerated in a harmless form, arousing laughter, without any pretense at any serious role. Thus was the clown's social meaning determined.[4]

Veselovsky gives a correct definition of feudal truth. He is also right to assert that the clown was the herald of another, nonfeudal, nonofficial truth. But this nonofficial truth can hardly be determined as "objectively abstract." Furthermore, Veselovsky sees the clown as isolated from all the mighty culture of medieval humor. He, therefore, considers laughter an external defensive form of this "objective abstract truth," a defense of human value in general, which the clown proclaimed using this external form. If there had been no repressions, no stake, truth would have cast off the clown's attire; it could have spoken in serious tones. Such an interpretation of medieval laughter appears incorrect in our mind.

No doubt laughter was in part an external defensive form of truth. It was legalized, it enjoyed privileges, it was liberated, to a certain extent, from censorship, oppression, and from the stake. This element should not be underestimated. But it would be inadmissible to reduce the entire meaning of laughter to this aspect alone. Laughter is essentially not an external but an interior form of truth; it cannot be transformed into seriousness without destroying and distorting the very contents of the truth which it unveils. Laughter liberates not only from external censorship but first of all from the great interior censor; it liberates from the fear that developed in man during thousands of years: fear of the sacred, of prohibitions, of the past, of power. It unveils the material bodily principle in its true meaning. Laughter opened men's eyes on that which is new, on the future. This is why it not only permitted the expression of an antifeudal, popular truth; it helped to uncover this truth and to give it an internal form. And this form was achieved and defended during thousands of years in its very depths and in its popular-festive images. Laughter showed the world anew in its gayest and most sober aspects. Its external privileges are intimately linked with interior forces; they are a recognition of the rights of those forces. This is why laughter could never become an instrument to oppress and blind the people. It always remained a free weapon in their hands.

4. See A. N. Veselovsky. *Collected Articles* (Leningrad, 1939), pp. 441–42.

CHRISTOPHER CAUDWELL

Well, I had quite a lot more still to say
But it seems pointless to an empty house.
—Atherfe in Caudwell's *Orestes*

INTRODUCTION

Marxist criticism virtually disappeared from British letters after William
Morris' lectures of the 1880's. The Fabian Society was so preoccupied with
breaking the spell of Marx by raising the spirit of J. S. Mill that it had little
inclination to pay serious attention to the arts.[1] George Bernard Shaw—in
his *Quintessence of Ibsenism* (1891), *The Perfect Wagnerite* (1895), and
occasionally in the *Prefaces* to his plays—utilized economic determinist
insights, but these might equally well have been drawn from Nietzsche's
Genealogy of Morals as from *The Communist Manifesto* or *Capital*. Oscar
Wilde's socialism is uninformed by Marx, but his earlier lectures carry
forward the tradition of Ruskin and Morris (see, for example, "The

1. Shaw wrote that, for the most part, "the Fabians were inveterate Philistines.
My efforts to induce them to publish Richard Wagner's *Art and Revolution*, and,
later on, Oscar Wilde's *The Soul of Man Under Socialism,* or even to do justice
to Morris' *News From Nowhere,* fell so flat that I doubt whether my colleagues were
even conscious of them." (Cited in Edward R. Pease, *The History of the Fabian
Society* [New York, 1926], pp. 278–79.)

English Renaissance of Art" of 1882), and in his later writings, especially in *Intentions* (1894), he reaches out for a dialectical view of art in which we may "realize Hegel's system of contraries." His "The Soul of Man Under Socialism" (1891) is largely in the tradition of Morris, but it passionately denies the link between art and society in order to protect the former from the encroachments of the latter. As Wellek writes: "What sounds like the most imperialist claim for art, in practice, often shrinks to a defence of its inviolate corner in life."[2] The echoes of Morris and Ruskin (and Tolstoy as well) are heard in the lectures of Roger Fry, the nonsocialist art historian who defended the sanctity of the fine arts during the period in which they had fled to the margins of society.

The socialist movement produced no significant critic of art or literature, and writings by British Communists on art up to the mid-1930's consisted of only a handful of reviews and ephemeral pamphlets. It was with the rise of the Popular Front against impending war and the threat of fascism that the aesthetic implications of Marxism began to arouse interest. Work in Marxist criticism began to emerge from several art historians—including Anthony Blunt, Frances Klingender, and the Marxist-anarchist aesthetician Herbert Read; the economist John Strachey, in his *Literature and Dialectical Materialism* (1934) and especially in the chapters on literature in *The Coming Struggle for Power* (1933), exercised great influence through his application of the Comintern "dying culture" theory to the contemporary novel—an influence that is readily apparent in the later work of Christopher Caudwell. A Marxist critical "school" began to emerge, centering around *The Left Review* (October 1934 to May 1938) and including Edgell Rickword, Rex Warner, Douglas Garman, R. D. Charques, T. A. Jackson, and Philip Henderson. A major impetus to the project came from creative artists who, seeking a means by which the arts might advance the antifascist and revolutionary cause and attempting to find a Marxist foundation for their work, focused attention on the Marxist theory of art. Among these were the poets W. H. Auden, Stephen Spender, John Lehmann, and C. Day-Lewis. Apart from Spender's Henry James essays in *The Destructive Element* (1935; heavily influenced by Edmund Wilson) none of their criticism was rigorous enough to survive; moreover, its purpose was largely rhetorical, seeking to persuade and to convert. The work of the novelists fared better: the sections on literature of Ralph Fox's *Aspects of Dialectical Materialism* (1934) and his posthumous *The Novel and the People* (1937) were serious efforts, making early use of the recently published letters by Engels on art, and of Marx's and Engels'

2. René Wellek, *A History of Modern Criticism*, vol. IV, p. 412.

scattered writings on art insofar as these had been published in the English edition of the Soviet periodical *International Literature;* Jack Lindsay's *Anatomy of Spirit* (1937) proposed a Freud-Marx synthesis which he applied in his *John Bunyan* (1937), one of the first detailed studies of an author by a British Marxist up to that time.[3] A number of British scholars and scientists—among them the anthropologist V. Gordon Childe, the classical historian Benjamin Farrington, the scientists J. D. Bernal and J. B. S. Haldane—were actively applying Marxism to their special fields with important results. It was in this atmosphere of Popular Front enthusiasm and excitement over Marxism that Christopher Caudwell began his study of the sources of poetry.

━━

To call Caudwell's works a "quarry of ideas" (J. B. S. Haldane) is to pay tribute to the rich tapestry of his thought, to the invigorating and stunning effect of his individual insights and passing comments on the arts in their interrelationship with society, anthropology, psychology, physics, mathematics, and linguistics. But it is also to neglect what is perhaps more important: Caudwell's theory of poetic creation. His *Illusion and Reality* was the first attempt at creating a whole theory of poetry in the light of Marx. The extracts from this work were selected in an attempt to present in a connected manner the essential argument of Caudwell's poetics.

Illusion and Reality opens with the arts and ritual as an original unity, mediated by magic. The primitive group festival is "the matrix of poetry" (page 27), generating and directing the instinctive energy of the tribe into collective actions, organizing collective emotions into a ritual in which is produced "an alienation from reality," an anticipation of a yet-to-be-realized reality. The poet, in withdrawing into the world of art, enters "more closely into communion with humanity" (page 28). The poem projects man "into a world of phantasy which is superior to his present reality . . . a world of more important reality not yet realized, whose realisation demands the very poetry which phantastically anticipates it" (page 30).

With the ossification of mythology, "true religion" emerges, marking the emergence of economic classes in society. Religion becomes primarily an

3. In more recent years, the British have developed a school of literary Marxists who have produced a noteworthy body of intelligent and often brilliant applications of Marxist theory to specific areas of English literature. Among the outstanding moderns are G. M. Matthews, C. H. Hobday, Christopher Hill, Arnold Kettle, and A. L. Morton, whose works are listed in the bibliography.

expression of class coercion, while art "sucks into itself all the fluid, changeful and adaptive characteristics of primitive religion," and becomes now "the emotional expression of the ruling class" (page 43). In the advance of civilization (which Caudwell sees as a progressive movement toward freedom from natural necessity) the instincts are adapted by social relations, and these adaptations are "the means whereby the instinctive energy of man is diverted to drive the machine of society" (page 71). In this process, poetry's main function is seen as "the conditioning of instinctive responses by the relations of society" (pages 71–2). Poetry is the means of focusing "the emotional life of society in one giant 'I' which is common to all" (page 72).[4]

Art, then, is a means by which man returns to the wellsprings of communality (in Caudwell's word, to the "genotype"). Art is an economic activity, rising from the labor process, an activity of men in association, a "mingling of reference and emotion," expressing the relationship between "instinct and environment." Poetry is "clotted social history, the emotional sweat of man's struggle with Nature" (page 130). It performs its social function through the use of language, the major instrument "man has evolved in his associated struggle with Nature" (page 139). Caudwell explores how truth emerges in language; explores as well the gesture, the cry, and (following Bukharin closely) the word, all of which contain and express "instinctive feeling tone and . . . acquired perceptual value" (page 139). The word enables man to enter a common perceptual world through the use of shared symbols, thereby bringing him into contact "with the likeness of the egos of other men" (page 140). The word symbolizes the "shadow world which it has helped to create, and is therefore the symbol of a symbol" (page 145).

4. Following this exposition, the argument of *Illusion and Reality* is interrupted (and contradicted) by a long excursus (chaps. 4–6) on the history and development of British poetry. Here, Caudwell's theme is "the illusion of the epoch" (which derives from Marx's and Engels' *German Ideology;* see above, pages 42–44), described as the single unifying idea of every society; in bourgeois society, Caudwell sees this as the illusion of freedom, and he illustrates the phases of this illusion (personified in such a way that it takes on a rather animistic and idealist character) through an exploration of British poetry from Shakespeare to the poets of the Popular Front. In this excursus, Caudwell fails to apply his poetics in action; he does not attempt to show how poetry reflects or effects the adaptation or conditioning of the instincts to society, nor how it serves as means of focusing the emotional life of that society. Literature and art, following an initial (primarily Shakespearean) period of primitive accumulation, are largely seen as opiate; the role of art "is now that of adapting the multitude to the dead mechanical existence of capitalist production, in which work sucks them of their vital energies without awakening their instincts" (p. 107).

The poet, then, enters the collective through a withdrawal into the deepest layers of the self; he withdraws into illusion in order to find a desired "reality" which is then externalized, projected, and in the process of becoming a collective experience serves to transform social or economic life. Next, Caudwell seeks to show how poetry achieves this collective response: "the emotions are only found in real life adhering to bits of reality; therefore bits of reality . . . must always be presented to achieve the emotional attitude" (page 153). Language is the collectively under-stood symbol of reality, and through its organization the poet is able to create a mock world in which emotional attitudes are shared—a world in which "the common ego" holds sway.

For Caudwell, art rises as an externalization of dream, "generated by the struggle with Nature, by the need for association in that struggle, and by the development of vocal and visual symbols which that association made necessary" (page 185). Restating his theory, Caudwell shows how the primitive (later the poet) builds and unbuilds the illusory world in accordance with "the laws of the social ego" and how this collective dream prepares the way for action. Caudwell's insight is that fantasy is the motor of changes in consciousness and history, developing "as the inseparable accompaniment of action, which creates it and which it in turn anticipates and calls into being in a richer form" (page 194).

Dream is *determined,* reflecting "a real movement into daylight of material phenomena at present unrecognised." Therefore we can "dream with accuracy of the future"; thought is "a movement which, with the help of dream, can be fully realised in practise." Here, dream passes beyond its own sphere "into that of the social revolution."

In the excerpts from the chapter entitled "Poetry's Dream-Work," Caudwell shows *how* poetry operates to create the mock interior world, doing so through rhythm, controlled irrationality, and penetration of the surface layers of consciousness by means of the attachment of art's lan-guages to segments of external reality, thereby plunging into the "emo-tional underworld adhering to those pieces" (page 199). The poetic process permits the withdrawal from external reality. The world of instinct rises to view; the subject emerges from the object; the social ego emerges from the social world. Caudwell proposes that art changes the world, that the world of art is changed by the creation of the individual art work, that the artist's consciousness is altered by his having forced "new, dumb and unformulated experiences" into the sphere of consciousness, and that the audience's consciousness is reshaped by the incursion of the new art work. The revolutionary element in art coincides dialectically with its ability to express the emotional consciousness that springs directly from the instincts.

And here Caudwell at last touches upon the transcendent power in art: "great art—art which performs a wide and deep feat of integration—has something universal, something timeless and enduring from age to age." And he defines this as "the timelessness of the instincts, the unchanging secret face of the genotype which persists beneath all the rich superstructure of civilisation" (page 203).

Immediately following this insight (which completes his poetics), Caudwell attempts to reconcile it with the precepts of *The German Ideology* and *The Communist Manifesto* that in "class society art is class art," that the artist necessarily expresses and is the voice of that class "whose experience in general resembles his own—his own class," that this class which practices art, "the class at whose pole gathers the freedom and consciousness of society, [is] in all ages the ruling class" (page 203). It is a neat solution, but tautological: the artist must reflect the consciousness of the ruling class because consciousness gathers only at the pole of the ruling class. The unanswered question is to what extent the members of the ruling class belong to the genotype, to what extent they share the general consciousness of humanity and are subject to the drives and desires of all human beings of all eras. Caudwell's achievement is that he was able to present this contradiction in his poetics. He thereby offered a provisional answer to the riddle of Marx's Introduction to the *Critique of Political Economy*.

———

As with all original thinkers, one can find the traces of scores of other writers and philosophers in Caudwell's works. The diversity of his sources should not obscure the fact that there are several main lines of modern thought which intersect in Caudwell to form the foundation of his aesthetic theory. These are Marxism-Leninism, the so-called "Cambridge School" of British anthropology, and Freudianism.[5]

5. Other significant influences include such poetic theorists as I. A. Richards and his disciple William Empson; the field anthropologists; psychological schools of every variety—Gestalt, behaviorist, Freudian-revisionist, and Jungian; the physicist-theorists such as Eddington, Jeans, Heisenberg; the modern philosophers—especially Whitehead, Wittgenstein, Russell, and Bergson. The French materialists and the German idealists are known to him only through the mirror of Marxism; he had no direct contact with Diderot, Kant, Schiller, Hegel, Feuerbach, or Schopenhauer. There is a decisive connection between Caudwell and the Schiller who wrote that art is a means of healing "the wounds of civilization, the split between man and nature and between man's intellect and his senses," but Schiller is incorporated into Caudwell indirectly—by way of Freud and Jung. Similarly, Feuerbach's theory of religion (and poetry) as the

Although Caudwell was familiar with only a few brief passages from Marx's *The German Ideology*,[6] it played an important role in his Marxism. From it he absorbed the basic early formulations of the Marxist view of ideology as inverted reflection of reality; from it he took (and applied extensively and dogmatically) the neo-Hegelian concept of the "illusion of the epoch" and the idea that the essential illusion of the bourgeois epoch is the illusion of freedom.[7] His formulations on the primacy of being, on the nature of primitive consciousness, and on the movement of history through the action of men in association are often phrased in the language of Marx's and Engels' Feuerbachian period. Caudwell's critique of religion and his comments on the nature of the religious reflex is largely derived from Marx's Introduction to the *Critique of Hegel's Philosophy of Right* (see above, pages 48–49). From *The Communist Manifesto,* Caudwell took and developed the idea that in all ages the ruling ideas are the ideas of the ruling class. From *Capital* he developed the concept that art is a special form of the division of labor; from the final section of volume I, he took Marx's description of the history of British capitalism and applied it imaginatively to the history of British literature. Essential to Caudwell's argument is Engels' presentation—in *Anti-Dühring*—of Hegel's concept that freedom is the recognition of necessity. The *Economic and Philosophic Manuscripts* had not yet been published in English; they were known only to a limited number of German and Soviet scholars, and Caudwell was not able to grasp the implications of the discussion of alienation and reification in Marx's chapter on commodity fetishism in *Capital*. He made limited use of these concepts in *Romance and Realism,* and in his essay "Beauty—A Study in Bourgeois Aesthetics," which appears in *Further Studies in a Dying Culture.*[8]

outward projection of man's inner essence is at the heart of Caudwell's system, but it entered it by way of the British and French cultural anthropologists.

6. Printed in Emile Burns, *Handbook of Marxism* (London, 1935).

7. I am unable to trace the source of Caudwell's encounter with these passages, which appeared in English only after his death. It perhaps derives from Plekhanov's "Psychology of the Epoch" chapter in *Fundamental Problems of Marxism;* more likely, the passages had been cited in some secondary source that Caudwell had read.

8. This essay, which is the first extended Marxist examination of the nature of beauty, is not reprinted here, primarily for reasons of length, but also because in it Caudwell, though correctly defining beauty as a social product, fails to come to grips with the major philosophical theories of beauty, and, after briefly disposing of both I. A. Richards' theory of beauty as coenesthesia and the neo-Platonic idea of absolute beauty, replaces them with the inadequate and undialectical proposition that beauty is the social ordering of affective elements in socially known things. This pas-

Lenin's influence is less specific but equally persuasive. Through him, Caudwell's work is informed with a spirit of single-minded revolutionary purpose, faith in the inevitability of proletarian action, the subordination of each and all to collective necessity. Plekhanov's specific writings on art were evidently unknown to Caudwell, but a number of Plekhanov's basic ideas on art and ideology appeared in his *Fundamental Problems of Marxism,* and it is possible that Caudwell's synthesis of anthropology and Marxism had its inspiration in Plekhanov. Bukharin's *Historical Materialism* proposed a bloodless social psychology akin to that of Plekhanov, and his Marxism similarly was leavened by sociology and anthropology. Caudwell absorbed Marxism through the framework that Plekhanov and Bukharin had erected. Bukharin's Address to the 1934 Soviet Writers' Congress had a profound effect on Caudwell, and he incorporated a number of Bukharin's leading ideas on the dialectics of language into *Illusion and Reality,* to the point of virtual paraphrase. He did not know the work of Ernst Bloch, Walter Benjamin, Max Raphael, or Georg Lukács.

Although he would have strongly disagreed with the formulation, a major aspect of Caudwell's poetics is its Utopianism. He wrote that poetry "exhibits a reality beyond the reality it brings to birth and nominally portrays, a reality which though secondary is yet higher and more complex."[9] We cited earlier his statement that poetry projects "man into a world of phantasy which is superior to his present reality precisely because it is a world of superior reality—a world of more important reality not yet realised, whose realisation demands the very poetry which phantastically anticipates it."[10] And yet, because he was a "good Marxist," Caudwell followed Lenin and Plekhanov in using "Utopian" as a term implying the unfeasible, the impractical, the unscientific, the "Nowhere" of impotent socialist theorizing.

If Caudwell had remained wholly within the confines of "orthodox" Marxism, he could not have created an aesthetics. It was his greatness that he brought the Marxist approach to art out of the sociological trough and into contact with the germinating influences of the scientific minds who had been expanding the boundaries of knowledge outside of the Marxist sphere.

sive and conservative view of beauty conflicts with the revolutionary implications of *Illusion and Reality,* altogether missing the revolutionary leap inherent in the aesthetic emotion. Nevertheless, the essay contains an important recapitulation of Caudwell's general aesthetic theories and contains brilliant expositions of the relationship between art and science, and of beauty as a dialectical unity involving subject and object mediated by society.

9. *Illusion and Reality,* p. 30.
10. *Loc. cit.*

It was his understanding of the possibility of synthesis which permitted basic Marxist concepts to be seen in a new light.

The second primary source of Caudwell's thought lies in his amalgamation of ideas drawn from various modern schools of anthropology, and in particular those that derived from earlier folklorists and anthropologists such as Tylor, Frazer, Lang, and Crawley. It is through the work of the Cambridge School (Gilbert Murray, F. M. Cornford, A. B. Cook, and Jane Harrison), the French sociological-anthropological group headed by Emile Durkheim, and Frazer's disciple, Bronislaw Malinowski, that Caudwell absorbed the concept of the ritual basis of artistic creation, its origin in magical forms of economic activity, and the idea of art as the expression of unrealized collective fantasies. (The sources of his literary style are here, too.) A few examples will show the parallels. Harrison's *Ancient Art and Ritual*[11] is devoted to showing "how primitive art grew out of ritual, how art is in fact but a later and more sublimated, more detached form of ritual" (page 225). She denotes the essential difference between religion and art: "There is one infallible criterion between the two. . . . Primitive religion asserts that her imaginations have objective existence; art . . . makes no such claim" (pages 226–27). Caudwell echoes this; the art viewer "accepts the phantasy as expressing objective reality while immersed in the phantasy, but, once the phantasy is over, he does not demand that it still be treated as part of the real world."[12] Harrison shows the way in which ritual arouses collective feeling, that it is "a collective emotion . . . necessarily felt as something more than the experience of the individual, as something dominant and external," and that ritual-religious projections are embodiments of "the social life of the group."[13] Harrison even anticipates Caudwell's view that art is essentially of an economic nature; she writes: "the life of imagination, cut off from practical reaction as it is, becomes in turn a motor-force causing new emotions, and so pervading the general life, and thus ultimately becoming 'practical.' "[14] Cornford writes: "The whole magical process . . . is not to be conceived as a mock ceremonial, mimicking a real process, and designed to cause that real process to happen some time afterwards. . . . [M]agical action consists in actually *doing what you want done*."[15] From Durkheim's *The Elementary Forms of the Religious Life*[16] Caudwell appears to have taken

11. New York, 1913.
12. *Illusion and Reality*, p. 34.
13. *Themis* (Cleveland and New York, 1962), pp. 45, 47.
14. *Ancient Art and Ritual*, p. 211.
15. *From Religion to Philosophy* (New York, 1957), p. 77.
16. London, 1915.

the concept of withdrawal into the mock world of illusion; Durkheim writes that in the collective ritual "everything is just as though he really were transported into a special world, entirely different from the one where he ordinarily lives, and into an environment filled with exceptionally intense forces that take hold of him and metamorphose him" (page 250). In religion, "men believe themselves transported into an entirely different world from the one they have before their eyes. . . . Religious force is only the sentiment inspired by the group in its members, but projected outside of the consciousness that experiences them, and objectified" (pages 258, 261). Caudwell takes all of these (and many more) suggestive anthropological explanations of ritual, magic, and religion and applies them in his own way to the process of artistic creation.

Malinowski is a prime influence on Caudwell, who appropriates his descriptions of the nature of magic, his linkage of magic to economics ("the magical ritual is intimately bound up with the technical activities"[17]), his definition of culture, his differentiations between ritual and science, and, especially, his critique of Freud's instinct and oedipal theories.[18]

This brings us to the third mainstream that fed Caudwell's thought: that of Freud's psychoanalytical theory. This has been difficult for the disciples of Caudwell to fully acknowledge. Thus far, the only exposition of this aspect of Caudwell's poetic theory has been by an opponent of Caudwell—Maurice Cornforth. He pointed out the Freudian basis of Caudwell's theoretical position—on poetry's dream work, on the psyche and fantasy, on art as wish fulfillment and collective daydream, on the split between natural and social man, on the dialectical interplay between instinct and civilization in a critique of 1950. In the course of the heated discussion that followed, none of Caudwell's defenders was willing to admit to what extent the young hero of British Marxist aesthetics might have been "tainted" by the influence of Freud. Part of the reason for this is that Caudwell himself introduced Freudian elements into his work while appearing on the surface to be an explicit opponent of Freud and psychoanalysis.

Caudwell was haunted by the shadow of Freud.[19] He dwells on him at length in *Illusion and Reality,* returns to him in two essays in *Studies in a Dying Culture* ("Freud" and "Love"), and again in the essay "Conscious-

17. *Sex, Culture and Myth* (New York, 1962), p. 274.

18. See Malinowski, *Sex and Repression in Savage Society* (New York, 1960), pp. 164ff., 189, 236.

19. In his last mystery thriller, *The Six Queer Things,* written probably in 1936, he portrays an evil psychoanalyst, a member of a ring of criminals who commits innocent victims to mental institutions in order to obtain their fortunes.

ness" in *Further Studies.* And this was natural, for sociology almost always rises out of a flight from psychology. But (as Engels, Weber, Simmel, Plekhanov, and Bukharin had found) the deeper one plunges into sociology the more necessary psychology becomes. It was Caudwell's flight from Freud which perhaps brought him to Marx in the first place. Rejecting Freudian individual psychotherapy, Caudwell writes: "The single organism is a slave to its environment," and he insists that we "must establish sociology before we can establish psychology."[20] The only proper therapy is the individual acting upon and changing the environment. It does not occur to Caudwell that the neurotic is in most cases incapable of such action. And he criticizes Freud's hypothesis of the oedipus complex with the observation that it "may be due to an obstacle in the environment, round which the shadows have to move, and that the complex will alter if the obstacle is moved."[21]

But the questions of therapy and the operation of the oedipus complex are peripheral to Caudwell's unending dispute with Freud; his main disagreement is that Freud sees human culture as "simply the tragedy of the crippling of the free instincts by the social restraints they have freely created."[22] He pictures Freud as believing that in history "the instincts . . . desperately attempt to gratify themselves, oppressed by the tyrant Reality's laws."[23] And he counterposes to this the notion that "it was precisely to moderate and lessen the frustration and crippling of the instincts by the *environment* that civilization was evolved."[24] He writes: "The instincts, unadapted by society, are blind and therefore unfree. . . . Man's freedom is obtained by association, which makes it possible for him to acquire mastery over Nature."[25]

The essential difference between Caudwell and his description of Freud's theory, however, is that Caudwell sees the evolution of society and its superstructure as the adaptation of the instincts to an ever-changing environment, whereas Freud supposedly sees this as a repression of man's innate instinctual structure. Caudwell criticized this alleged Freudian position from the point of view of Engels' definition of freedom.[26] Writes Caudwell: "It is in the process of living, in experience, that the instincts, those blind patterns, are modified by reality and, becoming conscious of its

20. *Studies,* p. 186.
21. *Studies,* p. 187.
22. "Consciousness," in *Further Studies,* p. 181.
23. *Studies,* p. 178.
24. *Illusion and Reality,* p. 167.
25. *Ibid.,* p. 163.
26. Engels, *Anti-Dühring,* chap. 11.

necessity, change it and themselves, and so become more free."[27] And again, "The progress of consciousness, insofar as it increases [man's] knowledge of causality, increases his freedom."[28] This would be a telling criticism were it not for two things. First, the evidence of the wounds which repressive civilization has inflicted upon mankind in the course of "progress" and of the advance of technology and knowledge; secondly, that it misstates Freud's position. For although Freud wrote that "it is impossible to overlook the extent to which civilization is built up upon a renunciation of instinct," he was himself dissatisfied with this obviously "correct" thesis (which led toward a Rousseauan solution), and he added that "civilization is a process in the service of Eros, whose purpose is to combine single human individuals, and after that families, then races, peoples and nations, into one great unity, the unity of mankind."[29]

Similarly, although Freud saw that "the liberty of the individual is no gift of civilization," he also understood that the desire for freedom proves favorable to "the further development of civilization." He wrote: "The urge for freedom, therefore, is directed against particular forms and demands of civilization or against civilization altogether."[30] Civilization's repression of freedom is the motive force which brings the will to freedom into existence, thereby transforming society and moving it to a new stage of development. The advance of repression leads to revolution, to the explosion of restraints, to the restoration of primal freedom on a historical plane.

Caudwell himself could not overlook the fact that class civilization leads to the gradual and inevitable enfeeblement of biological drives, for it was a passionate need to heal the wounds of mankind which led Caudwell to Communism. And it is Communism, the abolition of "civilization" (class society up to now—the prehistory of mankind), which seeks to transcend this decisive form of alienation. Caudwell would not have disagreed with this. He would have attributed it to the fetters of bourgeois society. Nevertheless, there is a fundamental contradiction in his poetics, resulting from his failure to understand the dialectical process whereby civilization simultaneously maims the instincts and leads toward a higher stage in which the instincts will be liberated. Caudwell did not see such a liberation as the goal of Communism. He writes: "It is nonsense to talk of these adaptations as crippling freedom *qua* adaptations. They only cripple freedom to the

27. "Consciousness," *Further Studies*, p. 182.
28. *Studies*, p. 178.
29. Freud, *Civilization and Its Discontents*, pp. 44, 69.
30. *Ibid.*, pp. 42, 43.

degree in which they grow obsolete and begin to stifle the developing freedom they have already generated. This crippling is not a sign that adaptations must be done away with but that fresh adaptations are needed."[31] Art for Caudwell is such an adaptation, and if it is merely a means of "conditioning of instinctive responses by the relations of society"[32] it is thereby passive—incapable of changing that society.

Caudwell was aware of this contradiction, fully aware that "art is the consciousness of the necessity of the instincts,"[33] and that the socialization of dream in art prepares the way for action. Art, for Caudwell, is therefore not merely adaptation; it is revolution, revolution against that very renunciation of instinctual gratification of which both Freud and Caudwell had written. Caudwell did not live to do more than present the unresolved contradiction. But he had introduced Freud into Marxism (albeit in the guise of a critique of Freud), moved the dialogue with depth psychology to its highest level before Marcuse, and he had found in Marx and Engels a theory of individual freedom through the merging of one's psyche with the collective which served him as an instrument of self-analysis and personal liberation. For Caudwell, the Marxist categories served to expand the Freudian concepts. He was leaping beyond the individual treatment of Freudian therapy, finding a liberation in Marxism not possible for those who were withdrawing from the social-revolutionary matrix into that very "I" from which Caudwell was emerging. His poetics of withdrawal and return, from reality to illusion to a "higher" reality, from the "I" to men-in-association, is the path of his own life's journey. His poetics is, therefore, the autobiography of an artist.

━━━

Christopher Caudwell (Christopher St. John Sprigg) was born October 20, 1907, in Putney, England. His father (who died in 1932, aged sixty-six) was an author and journalist of traditional and essentially conservative views. His mother was a graphic artist and miniaturist; she died in 1916, when her son was eight years old. He attended the Roman Catholic Ealing Priory School until he was just fifteen (November 1922), abandoning his formal education to become a cub reporter and book reviewer on the *Yorkshire Observer,* of which his father was literary editor. In 1925 he moved to London, where he edited a trade journal, *British Malaya,* from

31. *Illusion and Reality,* p. 167.
32. *Ibid.,* p. 72.
33. *Ibid.,* p. 155.

1926 to 1928. In 1927, with the proceeds of legacies from an aunt, he and his brother acquired an aeronautical publishing company, *Airways Publications Ltd.* In addition to issuing one monthly magazine, *Airways,* of which his brother had previously been the editor, the firm published several other aeronautical journals, popular flying magazines, and an annual aviation reference book. He and his brother also founded an advertising and public relations agency specializing in aviation and marine accounts, which was later sold. Lack of capital forced the liquidation of the publishing company in 1934.

Caudwell's career as a writer began prior to the termination of his commercial activities; thereafter he supported himself completely by free-lance writing, which included five popular books on various aspects of aviation, seven mystery-thrillers, numerous articles on aeronautical subjects, some science-fiction short stories, an unpublished science-fiction novel, *Heaviside,* and a number of stories in the style of Kafka. He edited a collection of *Uncanny Stories,* and wrote a good deal of death-haunted, erotic poetry, a selection from which was published after his death. All of his work until May 1935 was published under his real name—Christopher St. John Sprigg. In that month, a naturalist novel of crime and punishment, *This My Hand,* appeared, with the name "Christopher Caudwell" on its title page. The adoption of this pseudonym—which was his mother's maiden name—marked his break with the commercial hack work that had occupied him until then.[34]

34. The Marxist penchant for pseudonyms is an indication of the desire to sever the ties with the biographical past, as well as to break with tradition generally. On the surface, it symbolizes the repudiation of (or flight from) the father. The young Engels basks in his paternal home watching with delight the outrage heaped upon his pseudonymous works by his male relatives. Kautsky could not publish under his own name until he had left Vienna and his father's influence. Trotsky takes three non-Jewish pseudonyms. Lenin could have returned to the paternal Ulyanov name had he wished. Stalin denies the flesh altogether in his metallic pen name. Rosa Luxemburg disavows both her sex and her Jewishness with the Junius pseudonym. Caudwell's is the clearest example of father-repudiation, for his pseudonym is identification with the mother through adoption of her maiden name. Whether this also represents imitation of the paternal love object as a means of obtaining the father's love is less clear; no doubt the twin aspects are dialectically linked. The pseudonymous pattern is not universal among Marxists. Marx used none, even under conditions of persecution; Plekhanov, of course, was obedient to the father principle and used pseudonyms only to evade the censor; Bukharin (who took the name "Orlov" in exile) later readopted his parents' name.

Caudwell was not unaware of the psychological implications of pseudonyms. In *Romance and Realism,* he finds it significant that many women novelists "adopted masculine pen-names," seeing this as their acceptance of masculine "values" (p. 100).

It was in late 1934 that Caudwell became deeply interested in Marxism. By mid-1935, he had drenched himself in Marx, Engels, Lenin, Stalin, Bukharin, Plekhanov, and the British Marxists. Within a few months he had completed and revised *Illusion and Reality,* written at the furious rate of four thousand words a day in Cornwall, where he had retired specifically to study Marxism. In November he moved to the dockside district of London, and within a month or two had joined the Poplar branch of the Communist Party of Great Britain, in which he functioned as an ordinary member—raising funds for the Spanish Loyalists, speaking at open-air rallies, selling *The Daily Worker,* posting placards, attending branch meetings, participating faithfully in all the day-to-day activities—eventually becoming secretary of the branch. He took part in street rallies, and was assaulted and jailed on at least one occasion. He kept the Party ignorant of his theoretical researches and intellectual activities. In 1936 he took a course in Marxism and literature with Alick West and Douglas Garman. Writes West: "We knew him then as Christopher Sprigge [sic] and he said nothing about his own writing."[35] He wrote nothing for the Party press, and in July 1936 he contracted with Macmillan for the publication of *Illusion and Reality* under the pseudonym that was unknown to the Party or his comrades in Poplar.

Late in 1936, he was chosen by his branch to drive an ambulance (purchased with funds raised by its members) to Spain. In December he enlisted in the International Brigade of the Spanish Loyalist Army, was trained as a machine gunner, and became political delegate for his group and joint editor of the Batallion Wall newspaper. He was killed February 12, 1937, in the battle of Jarama River. *Illusion and Reality* was in galleys at the time. Left behind were the manuscripts which were later published as *Studies in a Dying Culture* (1938), *The Crisis in Physics* (1939), *Poems* (1939), *Further Studies in a Dying Culture* (1949), and *Romance and Realism* (1970). Still to be published is an essay entitled "Heredity and Development." A biography is being written, by George Moberg.[36]

———

Christopher Caudwell was reborn through Marxism, and it was only natural that he should give his life back to Communism. In his gratitude

35. Alick West, *One Man in His Time* (London, 1969), pp. 181—82.
36. Dr. Moberg and Caudwell's brother, Mr. T. Stanhope Sprigg, have supplied me with important biographical data. Dr. Moberg has established the chronology of Caudwell's Marxist works on the basis of his correspondence.

for the powerful defenses which Marxism had lent him, it was perhaps inevitable that his later writings constituted a regression to an increasingly "official" and doctrinaire approach. *Illusion and Reality* was followed by the sixteen essays that were later published in the books listed above. All of these were titled "Studies in a Dying Culture" by Caudwell, and all of them are variations of his position that every branch of bourgeois culture—"art, philosophy, physics, psychology, history, sociology and biology"—is undergoing a crisis rising not merely from the imperialist economic crisis but from the "basic bourgeois illusion" that "man is naturally free," that "all the organisations of society are held to limit and cripple his free instincts, and furnish restraints which he must endure and minimise as best he may."[37] The working out of this one-sided (and often idealist) theory gives rise to the most stunning insights, to the "quarry of ideas" that characterizes Caudwell's work.

But Caudwell's poetic theory as developed in *Illusion and Reality* is thrown overboard. The *Studies* represent the process by which Caudwell stripped himself of most of his non-Marxist influences (the main exception is anthropology) so that he might emerge as a "pure" Communist; they clear the surrogates and former ego ideals from the field so that a new one may alone take its place—the Party. Thus, Caudwell's *Studies* never applied his poetic theory to any work of art or literature. His study of D. H. Lawrence, for example, is an almost pure exercise in the dying-culture theme in the manner of John Strachey. The "conscious" side of art suddenly takes over. Art as mimetic representation begins to emerge. Realism, decadence, function, purpose, content—the catchwords and phrases of the 1934 Soviet Writers' Congress, of the Comintern Program, begin to enter Caudwell's 1936 *Studies*.

In a few passages of *Romance and Realism*, Caudwell begins the descent into proto-Zhdanovism—accepting "socialist realism" as the task of the novelist (page 119), reverting to economic determinism (page 137), insisting that revolutionary truth is foreclosed to fellow travelers, and (tragically) accusing C. Day-Lewis and Stephen Spender of "an anxious solicitude about the freedom of the writer" in the Soviet Union: "They do not accept that whatever methods are necessary for a social transformation must be necessary in art, and that, if it is in fact essential for the progress of society, its process must be consciously known and controlled; this applies to art, as well as to hat-making" (page 132). The "quarry of ideas" was beginning to run out.

37. *Studies,* p. xx.

Caudwell's road was toward constriction, not toward expansion. It was Christopher Sprigg, Communist, who wrote the later *Studies,* not Christopher Caudwell. *Illusion and Reality,* then, represents a transitional stage in Caudwell's "becoming"; in it is a delicate and unstable balance of contending and complementary intellectual forces; in it, Caudwell held for a moment a theory of poetic creation compounded of anthropology and psychoanalysis within the philosophical-revolutionary structure of Marxism. But that moment passed. The first of the *Studies*—on beauty—recapitulates the theory, and extends it to the aesthetic emotion. Thereafter, the "conversion" was completed (it had already been hinted at in the closing pages of *Illusion and Reality*), and Caudwell began the scorched-earth process of withdrawal and consolidation. For every conversion signals a departure as well as an arrival, a repudiation as well as a culmination, a death as well as a second birth.[38]

Caudwell's life was a search for order, for form. His mystery stories are in the classic pattern of the English detective novel. Their essential character is that they are law-abiding in structure and in content as well. Similarly, the textbooks on aeronautical subjects are attempts to lay down the rules and to guide others in following them. That there was a subterranean stream in his creative work—in the erotic poetry (even here he did not break the rules of versification), in his Kafkaesque short stories—is undeniable; but it is also true that Caudwell did not seek their publication during his lifetime. In his work within the Communist Party he "submitted" to the dreary, "essential" tasks of the routine comrade, and this although (as he told his friend Paul Beard) he disliked most of these activities. His was a progression from Tom Swift to Lenin, marked by obedience and "lawfulness." But the underground stream surfaced and overflowed. Christopher St. John Sprigg became Christopher Caudwell. He broke with obedience first in *This My Hand,* and then in *Illusion and Reality,* signaled by the adoption of a pseudonym. Using his alter ego he would get to the root of things, find the origins of poetry and of his own self, find some way of justifying (and protecting himself against) his love for his fellow man, a love which he transmuted into a love for "men in association." His rejection and simultaneous incorporation of Freud rises

38. "Every metamorphosis is to some extent a swan song, to some extent the overture to a great new poem." (Marx, letter to his father, 1837.)

from an unconquerable ambivalence: he needed Freudian dream theory to penetrate the congealed layers of consciousness so that he might enter the mobile world of fantasy, but he had to reject Freud so that the road to autobiography could be blocked. Individual psychology had to be converted into class psychology.

Caudwell's greatest weakness as a poetic theorist is precisely in his inability to deal with man as an individual rather than as part of a class, a genus, a genotype, a generalized mankind. But class man does not write poetry: Shakespeare does; Donne does; Wordsworth does. It is he who withdraws into Caudwell's mock ego world in order to obtain rejuvenation, in order to dream, in order to gain energy and create models for the transformation of his own life and the lives of other human beings. And so, Caudwell's psychological search remained unended, incomplete. His theory of art remained unfinished, because just as in his own life he would not admit the individual factor, in his criticism he would not enter the biographical dimension—that crucial zone which mediates between psychology and sociology, between the work of art and the drives which created it, between the audience and the artwork—without which no Marxist psychology of art is possible. Caudwell deprived himself of the means to follow the poet into his dream world. This path, of necessity, is biographical—for though the poet is a member of a class, a representative of the genotype, a paradigm of his fellow human beings, he nevertheless remains unique, separate, discrete, subject to the processes and events of his own biographical-historical development.

CAUDWELL: **ILLUSION AND REALITY**
from *Illusion and Reality, A Study of the Sources of Poetry*

"The Birth of Poetry"

Poetry is characteristically song, and song is characteristically something which, because of its rhythm, is sung in *unison,* is capable of being the expression of a collective emotion. This is one of the secrets of "heightened" language.

But why should the tribe *need* a collective emotion? The approach of a tiger, of a foe, of rain, of an earthquake will instinctively elicit a conditioned and collective response. All will be menaced, all will fear. Any instrument to produce such a collective emotion is therefore unnecessary in such situations. The tribe responds dumbly, like a frightened herd of deer.

But such an instrument is socially necessary when no visible or tangible

cause exists, and yet such a cause is *potential*. This is how poetry grows out of the economic life of a tribe, and how illusion grows out of reality.

Unlike the life of beasts, the life of the simplest tribe requires a series of efforts which are not instinctive, but which are demanded by the necessities of a non-biological economic aim—for example a harvest. Hence the instincts must be harnessed to the needs of the harvest by a social mechanism. An important part of this mechanism is the group festival, the matrix of poetry, which frees the stores of emotion and canalises them in a collective channel. The real object, the tangible aim—a harvest—becomes in the festival a phantastic object. The real object is not here now. The phantastic object is here now—in phantasy. As man by the violence of the dance, the screams of the music and the hypnotic rhythm of the verse is alienated from present reality, which does not contain the unsown harvest, so he is projected into the phantastic world in which these things phantastically exist. That world becomes more real, and even when the music dies away the ungrown harvest has a greater reality for him, spurring him on to the labours necessary for its accomplishment.

Thus poetry, combined with dance, ritual, and music, becomes the great switchboard of the instinctive energy of the tribe, directing it into trains of collective actions whose immediate causes or gratifications are not in the visual field and which are not automatically decided by instinct.

It is necessary to prepare the ground for harvest. It is necessary to set out on an expedition of war. It is necessary to retrench and retract in the long scarcity of winter. These collective obligations demand from man the service of his instinctive energy, yet there is no instinct which tells him to give them. Ants and bees store instinctively; but man does not. Beavers construct instinctively; not man. It is necessary to harness man's instincts to the mill of labour, to collect his emotions and direct them into the useful, the economic channel. Just because it is economic, *i.e.* non-instinctive, this instinct must be *directed*. The instrument which directs them is therefore economic in origin.

How can these emotions be collected? Words, in ordinary social life, have acquired emotional associations for each man. These words are carefully selected, and the rythmical arrangement makes it possible to chant them in unison, and release their emotional associations in all the vividness of collective existence. Music and the dance co-operate to produce an alienation from reality which drives on the whole machine of society. Between the moments when the emotion is generated and raised to a level where it can produce "work," it does not disappear. The tribal individual is changed by having participated in the collective illusion. He is educated—*i.e.* adapted to tribal life. The feasts or corroborees are crises of

adaptation—some general and intended to last throughout life, such as the initiation or marriage ceremonies, others regularly renewed or directed to special ends, such as the harvest and war festivals or mid-winter Saturnalias.

But this collective emotion organised by art at the tribal festival, because it sweetens work and is generated by the needs of labour, goes out again into labour to lighten it. The primitive conducts such collective tasks as hoeing, paddling, ploughing, reaping and hauling to a rhythmic chant which has an artistic content related to the needs of the task, and expressing the collective emotion behind the task.

The increasing division of labour, which includes also its increasing organisation, seems to produce a movement of poetry away from concrete living, so that art appears to be in opposition to work, a creation of leisure. The poet is typically now the solitary individual; his expression, the lyric. The division of labour has led to a class society, in which consciousness has gathered at the pole of the ruling class, whose rule eventually produces the conditions for idleness. Hence art ultimately is completely separated from work, with disastrous results to both, which can only be healed by the ending of classes. But meanwhile the movement has given rise to a rich development of technique.

These emotions, generated collectively, persist in solitude so that one man, alone, singing a song, still feels his emotion stirred by collective images. He is already exhibiting that paradox of art—man withdrawing from his fellows into the world of art, only to enter more closely into communion with humanity. Once made fluid, this collective emotion of poetic art can pervade the most individual and private transactions. Sexual love, spring, a sunset, the song of the nightingale and the ancient freshness of the rose are enriched by all the complex history of emotions and experience shared in common by a thousand generations. None of these reactions is instinctive, therefore none is personal. To the monkey, or the man reared like Mowgli by a wolfish foster-mother, the rose would be something perhaps edible, a bright colour. To the poet it is the rose of Keats, of Anacreon, of Hafiz, of Ovid and of Jules Laforgue. For this world of art is the world of social emotion—of words and images which have gathered, as a result of the life experiences of all, emotional associations common to all, and its increasing complexity reflects the increasing elaboration of social life.

The emotions common to all change with the development of society. The primitive [of a] food-gathering or hunting tribe projects himself into Nature to find there his own desires. He changes himself socially to conform

with Nature. Hence his art is naturalistic and perceptive. It is the vivid drawings of Palaeolithic man or the bird- and animal-mimicking dances and songs of the Australian aborigine. Its sign is the totem—the man really Nature. Its religion is mana.

The crop-raising and herd-rearing tribe is an advance on this. It takes Nature into itself and changes Nature to conform with its own desires by domestication and taming. Its art is conventional and conative. It is the arbitrary decoration of Neolithic man or the elaborate rituals of African or Polynesian tribes. Its sign is the corn-god or the beast-god—Nature really man. Its religion is one of fetishes and spirits.

The introduction of Nature into the tribe leads to a division of labour and so to the formation of chiefs, priests and ruling classes. The choragus detaches himself from the ritual and becomes an actor—an individual. The art depicts noble persons as well as gods. The chorus becomes an epic—a collective tale about individuals—and, finally, the lyric—an individual utterance. Man, already conscious, first of his difference, and then of his unity with Nature, now becomes conscious of his internal differences, because for the first time conditions exist for their realisation.

Thus the developing complex of society, in its struggle with the environment, secretes poetry as it secretes the technique of harvest, as part of its non-biological and specifically human adaptation to existence. The tool adapts the hand to a new function, without changing the inherited shape of the hands of humanity. The poem adapts the heart to a new purpose, without changing the eternal desires of men's hearts. It does so by projecting man into a world of phantasy which is superior to his present reality precisely because it is a world of superior reality—a world of more important reality not yet realised, whose realisation demands the very poetry which phantastically anticipates it. Here is room for every error, for the poem proposes something whose very reason for poetical treatment is that we cannot touch, smell or taste it yet. But only by means of this illusion can be brought into being a reality which would not otherwise exist. Without the ceremony phantastically portraying the granaries bursting with grain, the pleasures and delights of harvest, men would not face the hard labour necessary to bring it into being. Sweetened with a harvest song, the work goes well. Just because poetry is what it is, it exhibits a reality beyond the reality it brings to birth and nominally portrays, a reality which though secondary is yet higher and more complex. For poetry describes and expresses not so much the grain in its concreteness, the harvest in its factual essence—which it helps to realise and which are the conditions for its own existence—but the emotional, social and collective complex which

is that tribe's relation to the harvest. It expresses a whole new world of truth—its emotion, its comradeship, its sweat, its long-drawn-out wait and happy consummation—which has been brought into being by the fact that man's relation to the harvest is not instinctive and blind but economic and conscious. Not poetry's abstract statement—its content of facts—but its dynamic rôle in society—its content of collective emotion—is therefore poetry's *truth*.

"Development of Modern Poetry"

All bourgeois poetry is an expression of the movement of the bourgeois illusion, according as the contradiction rooted in bourgeois economy emerges in the course of the development of capitalism. Men are not blindly moulded by economy; economy is the result of their actions, and its movement reflects the nature of men. Poetry is then an expression of the real essence of associated men and derives its truth from this.

The bourgeois illusion is then seen to be a phantasy and bears the same relation to truth as the phantasy of primitive mythology. In the collective festival, where poetry is born, the phantastic world of poetry anticipates the harvest and, by so doing, makes possible the real harvest. But the illusion of this collective phantasy is not a mere drab copy of the harvest yet to be: it is a reflection of the emotional complex involved in the fact that man must stand in a certain relation to others and to the harvest, that his instincts must be adapted in a certain way to Nature and other men, to make the harvest possible. The collective poetry or [of?] the festival, although it is a confused perception of the real harvest-to-be is an accurate picture of the instinctive adaptations involved in associated man's relation to the harvest process. It is a real picture of man's heart.

In the same way bourgeois poetry reflects, in all its variety and complexity, the instinctive adaptations of men to each other and Nature necessary in those social relations which will produce freedom—for freedom, as we saw, is merely's man's phantastic and poetic expression for the economic product of society which secures his self-realisation. We include of course in this economic product not merely the commercial or saleable product of society, but the cultural and emotional products, including men's consciousnesses themselves. Hence this bourgeois illusion regarding freedom, of which bourgeois poetry is the expression, has a reality in so far as it produces, by its existence, freedom—I do not mean in any formal sense, I mean that just as primitive poetry is justified by the material harvest it produces, which is the means of the primitive's freedom, so bourgeois

poetry is justified by the material product of the society which generates it in its movement. But it is a freedom not of all society, but of the bourgeois class which appropriates the major part of society's products.

For freedom is not a state, it is a specific struggle with Nature. Freedom is always relative, relative to the success of the struggle. The consciousness of the nature of freedom is not the simple contemplation of a metaphysical problem, but the very act of living and behaving like a man in a certain state of society. Each stage of consciousness is definitely won; it is only maintained as a living thing by social movement—the movement we call labour. The working-out of the bourgeois illusion concerning freedom, first as a triumphant truth (the growth and increasing prosperity of capitalism), next as a gradually revealed lie (the decline and final crisis of capitalism) and finally as its passage into its opposite, freedom as the life-won consciousness of social necessity (the proletarian revolution), is a colossal movement of men, materials, emotions and ideas, it is a whole history of toiling, learning, suffering and hoping men. Because of the scale, energy and material complexity of the movement, bourgeois poetry is the glittering, subtle, complex, many-sided thing it is. The bourgeois illusion which is also the condition of freedom for the bourgeoisie is realised in their own poetry, because bourgeois poets, like the rest of the bourgeoisie, realise it in their lives, in all its triumphant emotion, its tragedy, its power of analysis and its spiritual disgust. And the consciousness of social necessity which is the condition of freedom for the people as a whole in classless, communist society, will be realised in communist poetry because it can only be realised in its essence, not as a metaphysical formula, but by living as men in a developing communist society, which includes living as poets and readers of poetry.

The bourgeois sees man's instincts—his "heart," source of his desires and aims—as the source of his freedom. This is false inasmuch as the instincts unadapted are blind and unfree. But when adapted by the relations of society they give rise to emotions, and these adaptations, of which the emotions are the expression and mirror, are the means whereby the instinctive energy of man is diverted to drive the machine of society: the machine of society, revolving, enables man to face Nature and struggle with her, not as individual, instinctive man but as associated, adapted men. Thus the instincts drive on the movement which secures man's freedom. This illusion and this truth about the relation of the instincts to freedom and society

work themselves out in bourgeois poetry and constitute its secret energy and constant life. Thus, knowing the essence of this bourgeois illusion to be a special belief concerning "individualism" or the "natural man," which in turn derives from the conditions of bourgeois economy, we cannot be surprised that the bourgeois poet is the lonely man who, apparently turning away from society into himself, by so doing expresses the more strongly the essential relations of contemporary society. Bourgeois poetry is individualistic because it expresses the collective emotion of its era.

We saw that all literary art—originally generated by the passage of mythology into religion, so that poetry separated itself from mythology—is rooted in freedom, and is the expression of the spontaneity of society, which in turn is based on the material products of society and is a kind of mould of the emotional relations these material products demand of associated man. It is because art is the expression of freedom that, in a developed class-society, art is an expression of the illusion, not of all society but only of the ruling class. In the course of the development of the bourgeois illusion, literary art in turn separates the story from poetry. Poetry, younger, more primitive, more emotionally direct, is therefore in capitalist culture concerned with the emotions struck from the instincts— like sparks from flint—in the conditioning of instinctive responses by the relations of society. It expresses the part of the bourgeois illusion which sees the heart and the feelings of the individual man as the source of freedom, life and reality, because the freedom of society as a whole rests ultimately on the drive of those instincts whose struggle with Nature has created society. Because it must use the collective world of language it focuses all the emotional life of society in one giant "I" which is common to all, and gives to all men one breathless experience.

The story takes the reverse of the tapestry, and expresses the instincts as they emerge in society in one adapted individual. In this case the individualism of bourgeois society is expressed as an interest in men not as abstracted into one common experience, but as *characters,* as social types living in a real world.

"The World and the 'I' "

Language is the most flexible instrument man has evolved in his associated struggle with Nature. Alone, man cannot plough Nature deeply; hence alone he cannot know her deeply. But as associated man, master of economic production, he widens his active influence on her, and therefore enlarges the truth which is the product of that action. Language is the essential tool of human association. It is for this reason that one can hardly

think of truth except as a statement in language, so much is truth the product of association.

How does truth emerge in language? The word is a gesture, a cry. Take, for example, a herd of beasts that give a certain cry in situations of danger. When one cries, the others, as a result of a current of primitive passive sympathy, are terrified too, and all flee together.

The cry therefore has a subjective side, a "feeling-tone," all *feel* terrified at the cry.

But the cry also indicates some *thing* terrifying, a foe or danger. The cry therefore has an objective side, a *reference* to something perceivable in reality.

Evidently for purely animal existence a few brief cries suffice. Some animals are dumb. But for the animal engaged in economic production in association—the animal called man—the cry becomes the *word*. Its "value" is now no longer instinctive—resulting from the relation of genotype to habitual environment—it becomes "arbitrary"—resulting from the relation of modified genotype to artificial environment in economic production. In becoming the word as a result of association for economic production, the cry still retains its two sides, its instinctive feeling-tone and its acquired perceptual value, but both are made more precise and complex.

The feelings of the herd have a general similarity, because of the similarity of their instinctive make-up. Their perceptions also have a similarity, because of the likeness in their way of living. These like feelings are not known to the individual animals as like, any more than each knows the other's perceptual worlds are like. The individual animal feels and sees *alone*. We, the onlookers, deduce the likeness in the emotional and perceptual worlds of the animals from the similarity of their behaviour; but the animals cannot be conscious in this way of a like world.

Man *knows* that there is a likeness in the worlds of men; this likeness is expressed for example in science, the world of perceptual reality. In the same way he knows there is a likeness in feelings. This likeness is expressed in art, the world of affective reality.

Man only came to know this likeness in his perceptual worlds when he entered into association with other men. Why did he so enter? In order to change his perceptual world. This contradiction is simply the basic contradiction of science—that man learns about reality in changing it. That is precisely what an experiment does; and the experiment is crucial for science. This characteristic contradiction reaches its final expression in Heisenberg's Principle of Indeterminacy, which declares that all knowledge of reality involves a change in reality. All laws of science are laws stating

what actions produce what changes in reality. Science is the sum of the changes in perceptual worlds produced by men in their history, preserved, organised, made handy, compendious and penetrating.

In the same way, man learns of the likeness of the egos of other men by attempting to change them. This change is essential for living in association as men. Man's instinct is to do always such and such. Unless therefore these instincts can be modified to make him do something different, man will respond instinctively instead of in a conditioned way, and society will be impossible. Men live in a common feeling-world only in so far as they are able to produce changes in each other's feelings by action. This change in feeling is crucial for art. The sum of such changes, organised and made independent of men, is what art is, not in abstraction, but emerging in concrete living.

Both science and art exist nascently in the animal. The wooing of the female, the frightening of enemies, mean that the active animal must change feeling in the other. The courtship dance and the threatening preliminaries to a fight are art in embryo. But both are done instinctively. They lack freedom and are therefore unconscious. They do not belong to a socially conditioned world. Only those feelings which are changed by means not given explicitly in the nature of man or of the natural environment are the subject of art. In so far as art exposes the real necessity of the instincts by exposing all the various possible changes following from the various possible means of influencing them, art becomes conscious of the necessity of the world of feeling, and therefore free. Art is the expression of man's freedom in the world of feeling, just as science is the expression of man's freedom in the world of sensory perception, because both are conscious of the necessities of their worlds and can change them—art the world of feeling or inner reality, science the world of phenomena or outer reality.

The common flight of a herd from a terrifying object indicated by the cry of one, is science in embryo, but only becomes science when it is the consciousness of a change in the perceptual world produced, not by fleeing from danger instinctively, but by altering it economically—by, for example, making weapons or a snare and killing the dangerous animal, or retreating in an organised way, covering the rear.

Science and art, although expressions of the social commonness in perceptual and feeling worlds, do not reduce men to replicas of each other. On the contrary, because they deal with possible *changes,* and are expanded and enriched in proportion as new changes are discovered, they are the means whereby individual differences are realised. Differences which at

the animal level reveal themselves as a hare-lip or an extra plumpness, now appear as subtle differences of emotional life or *Weltanschauung,* colouring and enriching the whole complex of reality. Language is the special medium whereby these changes are made social coin. Words are the money of the ideological market of mankind. Even as a few exchange transactions express all the bewildering complexity of modern social being, so a few sounds express all the rich universe of emotion and truth which is modern man's ideological world.

———

We saw that man's interaction with Nature was continuously enriched by economic production. Economic production requires association which in turn demands the word. For men to work together, that is, to operate together non-instinctively, they must have a common world of *changeable* perceptual reality, and by changeable I mean changeable by their actions; and by changeable by their actions I include predictable change, such as dawn and eclipse, and locatable change, such as "here" and "there," for man's control over himself makes it possible for him to be at such-and-such a place by night, for example, and so in effect change reality by his actions as a result of simple perceptual discrimination of sequence and location. Hence, by means of the word, men's association in economic production continually generates changes in their perceptual private worlds and the common world, enriching both. A vast moving superstructure rises above man's busy hands which is the reflection of all the change he has effected or discovered in ages of life. Presently this common world becomes as complex and remote from concrete social life as the market, of which its secret life and unknown creative forces are the counterpart.

This is the shadow world of thought, or ideology. It is the reflection in men's heads of the real world. It is always and necessarily only symbolical of the real world. It is always and necessarily a reflection which has an active and significant relation to the object, and it is this activity and significance, and not the projective qualities of the reflection, which guarantee its truth. Every part of the Universe projectively reflects the remainder; only man is conscious of his environment. The idea is not the thing: the reflection is not the object; but one expresses or reflects the other. The words are tied to percepts which are photographic memory-images of bits of reality. These percepts are fused into concepts, are organised and ordered in the broadest and most abstract way. Or, more accurately, out of the broad, humming chaos of "existence"—the simplest percept—other

concepts and percepts arise by differentiation and integration. All this phantasmagoria is accepted by man as only symbolic, just as a remembered percept is accepted as symbolic. When man recalls a certain horse or dwells on the concept "horse," in neither case does he suppose a horse is actually in his head. Even when he dwells on the refined concept "two" he still does not suppose all two things are in his head or that his head is double.

The word refers to this shadow world of thought, and conjures up portions of it in a man's head. The Common Perceptual World, with all the condensations, organizations and displacements it has undergone, refers to and symbolises outer reality. It is all the percepts of reality mobilised for action. It is a compendium of what happens to percepts when the underlying reality is affected. The word symbolises this shadow world which it has helped to create, and is therefore the symbol of a symbol.

━━

Now in precisely the same way when poetry—or literary art generally—wishes to "symbolise" the social ego, wishes to convey affective attitudes in an organised way, it is still compelled to make some statement about reality. The emotions are only found in real life adhering to bits of reality; therefore bits of reality—and moreover *organised* bits—must always be presented to achieve the emotional attitude. But the statement about reality selected for the underlying emotional attitude is not supposed to be about *material* reality, any more than science's Mock Ego is supposed to be a real man. It is a mock world; it is an illusion, accepted as such. So, by a long road, we have arrived back at the illusion, the *mimesis,* which is the essence and puzzle and method of literary art.

This mock ego of science and this mock world of art are both necessary because object and subject are never parted in experience, but engage in the contradiction of an unceasing struggle. Science and art, separated out from mythology by an initial division of labour so that each can be better developed, keeps as a souvenir of separation a kind of scar or blind side like the Norwegian trolls which are hollow behind. This hollowness or blind side is the mock ego of science and the mock world of art. Science and art are like the two halves produced by cutting the original human hermaphrodite in half, according to the story of Aristophanes in Plato's *Symposium,* so that each half evermore seeks its counterpart. But science and art do not when fitted together make a complete concrete world: they make a complete hollow world—an abstract world only made solid and

living by the inclusion of the concrete living of concrete men, from which they are generated.

What then is the *purpose,* the social function, of science and art? Why are reared upon this mock world and this mock man a frigid but true image of reality and a phantastic but warm reflection of man's own countenance?

Both are generated as part of the social process: they are social products, and the social product whether material or ideological can have only one goal, that of freedom. It is freedom that man seeks in his struggle with Nature. This freedom, precisely because it cannot be won except by action, is not a freedom of mere contemplation. To attain it a man does not merely relapse into himself—"let himself go." Just as the spontaneity of art is the result of laborious action, so freedom has as its price, not eternal vigilance but eternal labour. Science and art are guides to action.

(1) *Science* makes available for the individual a deeper, more complex insight into outer reality. It modifies the perceptual content of his consciousness so that he can move about a world he more clearly and widely understands; and this penetration of reality extends beyond his dead environment to human beings considered objectively, that is, as objects of his *action,* as the anvil to his hammer. Because this enlarged and complex world is only opened up by men in association—being beyond the task of one man—it is a *social* reality, a world common to all men. Hence its enlargement permits the development of associated men to a higher plane at the same time as it extends the freedom of the individual. It is the consciousness of the necessity of outer reality.

(2) The other world of *art,* of organised emotion attached to experience, the world of the social ego that endures all and enjoys all and by its experience organises all, makes available for the individual a whole new universe of inner feeling and desire. It exposes the endless potentiality of the instincts and the "heart" by revealing the various ways in which they may adapt themselves to experiences. It plays on the inner world of emotion as on a stringed instrument. It changes the emotional content of his consciousness so that he can react more subtly and deeply to the world. This penetration of inner reality, because it is achieved by men in association and has a complexity beyond the task of one man to achieve, also exposes the hearts of his fellow men and raises the whole communal feeling of society to a new plane of complexity. It makes possible new levels of conscious sympathy, understanding and affection between men, matching the new levels of material organisation achieved by economic production. Just as in the rhythmic introversion of the tribal dance each performer retired into his heart, into the fountain of his instincts, to share in common

with his fellows not a perceptual world but a world of instinct and blood-warm rhythm, so to-day the instinctive ego of art is the common man into which we retire to establish contact with our fellows. Art is the consciousness of the necessity of the instincts.

"The Psyche and Phantasy"

Because of its archaic and instinctive nature, the reality which makes up the conscious material of dream is crude and limited as compared with the reality of waking consciousness. This applies not merely to the external reality which figures in a dream as "dream thoughts," but to internal reality, the "I" which experiences them. It is a mean, petty and selfish "I." We are not conscious of any nobility or heroic quality in this "I"; on the contrary, it never does anything we can really be proud of. Even its achievements are gained too easily. After waking from dream we are only too glad we are not "really like that." And in fact we are not, for it is the process of association which makes men noble and heroic, which gives their character more beauty and worth. Hence the "I" of dream, stripped of so much of its social adaptation, is stripped of its largeness and human value.

Yet we see phantasy even in the form of dream reaching out towards an ameliorative rôle. In dream the ego experiments in action upon reality, but it is now a plastic reality without the stiffness of material things. In the space of a night it is possible to combine and recombine, free from the immediate tension of a direct contact with reality[1] and the limitations of manipulating real stuff.

It is possible to experiment with new forms of reality more appropriate to our instincts and to experience in a provisional way what these forms would feel like and how our instincts would react to their achievement. Thus the illusion of dream has this biological value, that by experimenting ideally with possible realities and attitudes towards them it paves the way for such changes in reality. Dream prepares the way for action; man must first dream the possible before he can do it. It is true that the realisation of our dream is never the same as the dream; it looks different and it feels different. Yet it also has something in common with our desire, and its realisation was only possible because dream went before and lured us on, as the harvest festival made possible the harvest. Of course dream is too

1. This plasticity and recombination of psychical elements possible in the introversion of sleep is perhaps a reflection of a similar physiological process in all the higher cells of the body and therefore the biological "reason" for sleep. In sleep the conditioning of the whole body may undergo a liquidation and digestion such as takes place with consciousness in dream.

archaic and too phantastically isolated from social reality to be of much value in the concrete living of civilised man.

The "remedy" for the illusory character of dream is not to abolish dream but to so enlarge and extend it that it becomes increasingly close to the realisation it is made to anticipate; to fill it more full of life and reality and vivid content. Once again freedom is extended by an extension of the consciousness of necessity. This programme calls for the socialisation of dream.

Obviously the brute-man did not evolve these externalisations of dream, as we have done, by taking thought. They were generated by his struggle with Nature, by the need for association in that struggle, and by the development of vocal and visual symbols which that association made necessary. The real world discovered with the aid of the mock ego, and the real ego explored by means of the mock world are the conscious world and the conscious ego and, therefore, the social world and the social ego.

In the dance and the chant man retires into a half-sleep by dismissing the world of immediate reality. This enables him to play fast and loose with the world of external reality, to build and unbuild it. But not arbitrarily and lawlessly—there would be no point or object in such an occupation. He builds it according to the laws of the social ego, and he does this because in the dance and the chant, while withdrawing from the world of external reality, he maintains touch with the subjective world of his fellows by moving his body in rhythm, by repeating the same words in unison, by weaving between them an emotional network of common feelings evoked by social common objects, such as notes of music, animals mimicked in the dance, words denoting socially recognised entities or experiences. Thus the items of the common perceptual world are selected, organised, blended and reorientated round the social ego, the "god" of early Greek ritual who descended into his worshippers and who was nothing but the symbol of the heightened common ego formed by the dance.

Of course, as society develops, poetry detaches itself from the common festival. Civilised man more easily secures physiological introversion—the rhythm of poetry is sufficient to achieve it—and the collective subjective significance of words keeps him in touch with his fellows without the need for that collective festival which has been out-moded by the division of labour, a division reflected in the wider range and greater content of language itself.

Such art is timeless, for man himself is still timeless, still lives entirely in the Now from age to age, with only a fabulous past and future.

———

Thus phantasy develops as the inseparable accompaniment of action, which creates it and which it in turn anticipates and calls into being in a richer form. And practice, enriched, corrects phantasy's anticipation and makes possible a new level of achievement. Thus phantasy adapts man in two ways—his instincts to the ego of society, and his perception to the perception of society. This adaptation ennobles and heightens and makes free the dumb brute of the genotype, because the ego of society and the perception of society is infinitely more penetrating and rich and complex than that of the unaided individual, just as man in association is more powerful against Nature than solitary man.

All thought, all feeling, reflects in some measure the categories of science or art. Science and art are generated in our daily existence. Scientific systems and art works are merely the highest forms of organisation, the essence of this daily concrete life.

Science and art become *practical,* they enter into concrete real life, directly we knock away the mock world from any artistic construction and substitute a real world, or knock away the mock impersonal ego from any scientific construction and substitute a real human being. In the first case we give an "unattached" human desire a real materialisation; in the second we give a part of reality the shape of an answer to human desire. Thus, in entering into real concrete life, artistic and scientific constructions become, as it were, blended or "impure," special instead of general, concrete instead of abstract, and the language we use to make this possible belongs to the realm of persuasion—the ordinary language of daily life, removed from the pure and "impractical" worlds of science and art. We must not regret this forced descent. Science and art were made for man, not man for science and art. But there is more to it than that. Science and art were made *from* man, not man from science and art.

"The Future of Poetry"

Of the future one can only dream—with greater or less success. Yet to dream is not to associate "freely" but to have certain phantasies, a certain reshuffling of memory-images of past reality blended and reorganised in a new way, because of certain real causes in present reality. Even dream is *determined,* and a movement in dream reflects perhaps a real movement

into daylight of material phenomena at present unrecognised. That is why it is possible to dream with accuracy of the future—in other words, to predict scientifically. This is the prophetic and world-creating power of dream. It derives its world-creating power, not by virtue of being dream—this is denied by the phantasies of madmen—but because it reflects in the sphere of thought a movement which, with the help of dream, can be fully realised in practice. It draws its creative power, like the poetry of the harvest festival, from its value as a guide and spur to action. It is dream already passed out of the sphere of dream into that of social revolution. It is the dream, not of an individual, but of a man reflecting in his individual consciousness the creative rôle of a whole class, whose movement is given in the material conditions of society.

"Poetry's Dream-Work"

In an earlier chapter we stated that modern poetry was composed of words, was non-symbolical, irrational, concrete, characterised by condensed affect, and rhythmical. Investigating dream we found that as compared with other forms of phantasy it also was non-symbolical, and irrational. Poetry is composed of words; dream is composed of memory-images. Dream-images do not follow rational laws drawn from external reality, but, as psycho-analysis shows, the flow of images is explained by affective laws.

Dream is neither directed thinking nor directed feeling, but free—that is non-social—association. Hence the associations of dream are personal and can only be understood by reference to the dreamer's personal life. The secret law of dream's structure is the "dream-work."

Poetic irrationality bears this resemblance to dream, that its flow of images is explained by affective laws; but it is not "free" association as in dream. Poetic feeling is directed feeling—feeling controlled by the social ego. Poetic associations are social.

As the dreamer lives entirely in the images of his dream, without reference to another reality, so the reader of poetry lives in the words of the poetry, without reference to the external world. The poet's world is *his* world. As he reads the poem he feels the emotions of the poet. Just as the pythoness or bacchante speaks for the god in the first person, so the reader under the influence of poetic illusion feels for the poet in the first person.

The images of dream, like the ideas of poetry, are concrete. In each dream, and in each poem, the memory-image and the word play a different part, and therefore have different meanings. Dreams and poems are incon-

sistent among themselves. Each dream and each poem is a world of its own.

Poetry is rhythmical. Rhythm secures the heightening of physiological consciousness so as to shut out sensory perception of the environment. In the rhythm of dance, music or song we become *self*-conscious instead of conscious. The rhythm of heart-beat and breathing and physiological periodicity negates the physical rhythm of the environment. In this sense sleep too is rhythmical. The dreamer retires into the citadel of the body and closes the doors.

Why is "physiological" introversion more necessary in poetry than in story, so that the poet accepts the difficulties of metre and rhyme? The answer is that introversion must be stronger in poetry. By introversion is not meant merely a turning-away from immediate environment—that could be secured by sitting in a quiet study, without disturbance. Such introversion is equally desirable for all kinds of thought, for scientific thinking and novel-reading as well as poetry, and it is not secured by the order of the words but by an effort of concentration. Some people can "concentrate" on a difficult scientific book or a book of poetry in conditions where others cannot. This kind of introversion does not therefore depend upon the order of the words. No one has suggested facilitating scientific writing by making it metrical.

But there is another aspect of introversion. In introversion for scientific phantasy it is true that we turn away from immediate environment, yet none the less we turn towards those parts of external reality of which the words are symbols. Ordinarily we see, hovering behind language, the world of external reality it describes. But in poetry the thoughts are to be directed on to the feeling-tone of the words themselves. Attention must sink below the pieces of external reality symbolised by the poetry, down into the emotional underworld adhering to those pieces. In poetry we must penetrate behind the dome of many-coloured glass into the white radiance of the self. Hence the need for a physiological introversion, which is a turning-away not from the immediate environment of the reader *but from the environment (or external reality) depicted in the poem*. Hence poetry in its use of language continually distorts and denies the structure of reality to exalt the structure of the self. By means of rhyme, assonance or alliteration it couples together words which have no rational connection, that is, no nexus through the world of external reality. It breaks the words up into lines of arbitrary length, cutting across their logical construction. It breaks down their associations, derived from the world of external reality, by means of inversion and every variety of artificial stressing and counterpoint.

Thus the world of external reality recedes, and the world of instinct, the affective emotional linkage behind the words, rises to the view and becomes the world of reality. The subject emerges from the object: the social ego from the social world. Wordsworth said correctly: "The tendency of metre is to divest language, in a certain degree, of its reality, and thus to throw a sort of half-consciousness of unsubstantial existence over the whole composition." In the same way Coleridge reached out after a like conception to ours: "Metre is simply a stimulant of attention"—not of any attention but a special kind of attention—attention to the affective associations of the words themselves.

We have here a distinction between poetry and the novel which it is vital to grasp. In the novel too the subjective elements are valued for themselves and rise to view, but in a different way. The novel blots out external reality by substituting a more or less consistent mock reality which has sufficient "stuff" to stand between reader and reality. This means that in the novel the emotional associations attach not to the words but to the moving current of mock reality symbolised by the words. That is why rhythm, "preciousness," and style are alien to the novel; why the novel translates so well; why novels are not composed of words. They are composed of scenes, actions, *stuff,* people, just as plays are. A "jewelled" style is a disadvantage to the novel because it distracts the eye from the things and people to the words—not as words, as black outlines, but as symbols to which a variety of feeling-tone is directly attached. For example when someone exclaims "Brute!" we do not think of animals and then of brutish qualities, but have a powerful subjective reaction suggesting cruelty and clumsiness. This is a poetic reaction to a word; the other is a story reaction.

Because words are few they are what Freud called "over-determined." One word has many affective associations because it has many "meanings" (*e.g.* the word "brute" can mean a foolish person, a cruel person, the order of animals, etc.). In novel-writing the words are arranged so that all other pieces of reality are excluded except the piece required, and the emotional association is to the resulting structure. Poetic writing is concerned with making the emotional associations either exclude or reinforce each other, without a prior reference to a coherent piece of reality, *e.g.* in novel-writing, in the phrase "the Indian Ocean" the word "ocean" has been restricted to a specific geographical ocean, which *then* has emotional associations for the reader. In poetry "the Indian sea" has a different meaning, for the emotional associations are, not to a particular sea but to the word "Indian" and the word "sea," which affect each other and blend to produce a glowing cloudy "feeling" quite different from the novel-writer's phrase.

Of course there may be stretches of poetic writing in a novel (for example in Proust, Malraux, Lawrence and Melville) or of novel-writing in poetry (the purely explanatory patches in Shakespeare's plays), but this does not affect the general characteristics. The difference is so marked that it explains the strange insensitivity to poetry displayed by so many great novelists, and a similar fondness for bad novels on the part of so many great poets. This difference between the technique of poetry and the novel determines the difference between the spheres of the two arts.

What is the basis of literary art? What is the inner contradiction which produces its onward movement? Evidently it can only be a special form of the contradiction which produces the whole movement of society, the contradiction between the instincts and the environment, the endless struggle between man and Nature which is life.

I, the artist, have a certain consciousness, moulded by my social world. As artist I am concerned with my artistic consciousness, represented by the direct and indirect effect on me of all the art I have felt, and all the emotional organisation which has produced in me a conscious subject. This consciousness is contradicted by my experience—that is, I have a *new* personal experience, something not given in the social world of poetry. Therefore I desire what is called self-expression but is really self-socialisation, the casting of my private experience in such a form that it will be incorporated in the social world of art and appear as an art-work. The art-work represents the negation of the negation—the synthesis between the existing world of art (existing consciousness or theory) and my experience (life or practice).

Therefore at the finish the world of art will be changed by the incursion of my art-work. That is the revolutionary aspect of my rôle as artist. But also my consciousness will be changed because I have, through the medium of the art world, forced my life experience, new, dumb and unformulated, to become conscious, to enter my conscious sphere. That is the adaptative aspect of my rôle as artist. In the same way with the appreciator of art, his consciousness will be revolutionised by the incursion into it of a new art-work; but his appreciation of it will only be possible to the extent that he has had some similar experience in life. The former process will be revolutionary; the latter adaptative.

Rather than use the word revolutionary, however, it would be better to use the word evolutionary, restricting the other to cases where the new content of experience is so opposed to the existing consciousness that it

requires a wholesale change, a complete revision of existing categories (conventions, traditions, artistic standards) for its inclusion, a revision which is only possible because concrete life itself has undergone a similar change in the period. The Elizabethan age was one of such periods. We are at the beginning of another such now.

It is plain that it is the emotional consciousness—that consciousness which springs directly from the instincts—with which the artist is concerned. Yet exactly the same relation holds between the scientist and his hypothesis (equivalent of the art-work) and the rational consciousness, that consciousness which springs directly from the perception.

Since the mediating factor in art processes is the social ego in its relation to the experience of individuals, it is plain that the integration performed by the art-work can only be achieved on condition that the item of private experience which is integrated (*a*) is *important,* concerned with deep emotional drives, with the unchanging instincts which, because they remain the same beneath the changing adaptations of culture, act as the skeleton, the main organising force in the social ego which ages of art have built up; (*b*) is *general,* is not a contradictory item of experience peculiar to the artist or one or two men, but is encountered in a dumb unconscious way in the experiences of most men—otherwise how could the art-work be meaningful to them, how could it integrate and give expression to their hitherto anarchic experience as it gave expression to the artist's?

Condition (*a*) secures that great art—art which performs a wide and deep feat of integration—has something universal, something timeless and enduring from age to age. This timelessness we now see to be the timelessness of the instincts, the unchanging secret face of the genotype which persists beneath all the rich superstructure of civilisation. Condition (*b*) explains why contemporary art has a special and striking meaning for us, why we find in even minor contemporary poets something vital and immediate not to be found in Homer, Dante or Shakespeare. They live in the same world and meet the same bodiless forces whose power they experience.

This also explains why it is correct to have a materialist approach to art, to look in the art-works of any age for a reflection of the social relations of that age. For the experience of men in general is determined in general by the social relations of that age, or to be more accurate, the social relations of that age are simply man's individual experiences averaged out, just as a species is a group of animals' physical peculiarities averaged out. Since art lives in the social world, and can only be of value in integrating experiences general to men, it is plain that the art of any age can only express the general experiences of men in that age. So far from the artist's being a lone

wolf, he is the normal man of that age—in so far as he is an artist. Of course normality in consciousness is as rare as normality in vision, and, unlike the latter, it is not a fixed physical standard but one which varies from year to year. Moreover his normality is, so to speak, the norm of abnormal experiences. It is the norm of the queerness and newness and accident in contemporary men's lives: all the incursions of the unexpected which shake their inherited consciousness. Hence the apparent abnormality of the artist.

This, finally, explains why in a class society art is class art. For a class, in the Marxian sense, is simply a group of men whose life-experiences are substantially similar, that is, with less internal differences on the average than they have external differences from the life-experiences of men in other classes. This difference of course has an economic basis, a material cause arising from the inevitable conditions of economic production. Therefore the artist will necessarily integrate the new experience and voice the consciousness of that group whose experience in general resembles his own—his own class. This will be the class which practises art—the class at whose pole gathers the freedom and consciousness of society, in all ages the ruling class.

This is the most general movement of literary art, reflecting the most general law of society. Because of the different techniques of poetry and the novel—already explained—this movement is expressed in different ways in poetry and in the novel.

Poetry concentrates on the immediate affective associations of the word, instead of going first to the object or entity symbolised by the word and then drawing the affective association from that. Since words are fewer than the objects they symbolise, the affects of poetry are correspondingly condensed, but poetry itself is correspondingly cloudy and ambiguous. This ambiguity, which Empson takes to be the essence of poetry, is in fact a by-product. Now this concentration upon the affective tones of words, instead of going first to the symbolised reality and then to the feeling-tone of that reality, is—because of the nature of language—a concentration on the more dumb and instinctive part of man's consciousness. It is an approach to the more instinctively common part of man's consciousness. It is an approach to the secret unchanging core of the genotype in adapted man. Hence the importance of physiological introversion in poetry.

This genotype is undifferentiated because it is relatively unchanging. Hence the timelessness of poetry as compared to the importance of time sequence in the novel. Poetry speaks timelessly for one common "I" round which all experience is orientated. In poetry all the emotional experiences of men are arranged round the instincts, round the "I." Poetry is a bundle of

instinctive perspectives of reality taken from one spot. Precisely because it is cloudy and ambiguous, its view is far-reaching; its horizon seems to open and expand and stretch out to dim infinity. Because it is instinctive, it is enduring. In it the instincts give one loud cry, a cry which expresses what is common in the general relation of every man to contemporary life as a whole.

But the novel goes out first to reality to draw its subjective associations from it. Hence we do not seem to feel the novel "in us," we do not identify our feelings with the feeling-tones of the novel. We stand inside the mock world of the novel and survey it; at the most we identify ourselves with the hero and look round with him at the "otherness" of his environment. The novel does not express the general tension between the instincts and the surroundings, but the changes of tension which take place as a result of change in the surroundings (life-experience). This incursion of the time element (reality as a process) so necessary in a differentiated society where men's time-experiences differ markedly among themselves, means that the novel must particularise and have characters whose actions and feelings are surveyed from without. Poetry is internal—a bundle of "I" perspectives of the world taken from one point, the poet. The story is external—a bundle of perspectives of one "I" (the character) taken from different parts of the world.

Obviously the novel can only evolve in a society where men's experiences do differ so markedly among themselves as to make this objective approach necessary, and this difference of experience is itself the result of rapid change in society, of an increased differentiation of functions, of an increased realisation of life as process, as dialectic. Poetry is the product of a tribe, where life flows on without much change between youth and age; the novel belongs to a restless age where things are always happening to people and people therefore are always altering.

GEORGE THOMSON

If we are to study the origin of poetry,
we must study the origin of speech.
And this means the origin of man himself,
because speech is one of his
distinctive characteristics.
We must go right back to the beginning.

—George Thomson

INTRODUCTION

An often overlooked aspect of Marxism is that it is devoted in some measure to a search for origins—of society, of institutions, of the manifold motive sources of history and its superstructural epiphenomena. It is in this sense that Marxism is linked to a number of other systems of post-Enlightenment thought. With the anthropological demonstration of the natural and human origins of religion, the way was opened to an exploration of the basic sources of every aspect of reality. The origin of species, of language, of the arts, of religion, of man, of mythology, of moral ideas, of the family—these were subjects that some of the best minds of the time turned to, seeking out the roots of human life, behavior, and institutions. It is the common search for sources which unites Marx with Nietzsche, with the mythologists from Schelling and Strauss to Müller and Bachofen, with Morgan, McClennan, and Maine, with Darwin, Spencer, and Häckel, with Bücher, Wallaschek, Frazer, and Freud.

A reaction against the speculative nature of such studies set in early in

the twentieth century and has dominated historical research until our own time. The search for origins was largely banned from the humanities and found refuge in several of the newer disciplines. Pragmatism and positivism eschewed the subject; the ultimate "insolubility" of all such questions caused a reversion to a more "scientific" approach in which the findings of research might be subject to a higher probability of confirmation. And here lay much of the appeal of economic determinism: it permitted the fixation of a first cause within the realm of historical confirmability and attributed all further development to interaction with or causation by that confirmable locus. It allowed the researcher to confine himself to the known and the knowable; it fixed limits on the chaos of past knowledge; it set aside the search for prelogical, prehistorical, presocial causes. In the process, Marxism was largely converted from a philosophy of origins into a search for ascertainable causes.

Simultaneous with the abandonment of the search for origins was the abandonment of Utopia—for these are inextricably linked in that the essence of the Utopian reflex (as Marcuse has demonstrated) is the projection into the future of an "original" state of harmony or gratification.

Caudwell—inspired by the preoccupation of early Marx and late Engels with origins and by Marx's and Lenin's vision of the withering away of the symbols and institutions of oppression—turned away from ascertainable causes and plunged into the sources of poetry. Unfortunately, most of his admirers hesitated to follow him into the depths. Many critics have been influenced by Caudwell, gripped by his passion and by the persuasive heat of his ideas. His admirers are numerous—Alick West, Louis Harap, Alan Bush, Arnold Kettle, Jack Lindsay, G. M. Matthews, Ernst Fischer, Georg Lukács, and others—but their approval has not extended to the application of his ideas in practice. Jacob Bronowski, in his *William Blake: A Man Without a Mask*,[1] which revolutionized Blake studies, would acknowledge himself neither a Marxist nor a Caudwellian, but he came closer to utilizing Caudwell's poetics than any other critic of British literature, perhaps because he did not hesitate to enter the biographical dimension in his study of the artist.

Caudwell's greatest disciple, the classical scholar George Thomson, continued Caudwell's search for origins in a series of major studies that are regarded as fundamental works in their field: *Aeschylus and Athens: A Study in the Social Origins of Drama* (1941), *Studies in Ancient Greek Society: The Prehistoric Aegean* (1949), and *Studies in Ancient Greek Society: The First Philosophers* (1955). The latter volumes are detailed

1. London, 1944.

expansions and consolidations of the material covered in *Aeschylus and Athens*. These works cover a vast range of subjects—matriarchal organization, kinship, land tenure, Greek and Indo-European prehistory, the origins of the epic, the growth of slavery, the development of science, the beginnings of private property and the institutions of the state, the influence of commodity production and the circulation of money upon the growth of Greek philosophy—all of them interpreted in the light of Marxist theory, and climaxed by Thomson's fundamental concern: the tracing of the evolution of Greek tragedy from its sources in magic and ritual, through the fertility play and the dithyramb, to the works of Aeschylus, Sophocles, and Euripides.

The first selection, from the closing pages of *Aeschylus and Athens,* sees the achievement of catharsis—the stimulation and relief of "emotional stresses due to the contradictions generated in the course of social change" —as the common function of the Dionysiac orgies, of the initiations into the Mysteries, and of tragedy. But Thomson, unlike Plato on one side and Brecht on the other, refuses to see the purgative effect of art as simplistically subversive or conservative of the social order. Restating the essential Caudwellian theory of the nature of poetry, Thomson concludes that "the arts are conservative of the social order, in that they relieve the pressure on its members, but at the same time they are subversive, because they promote a recurrence of the stresses which they stimulate in order to relieve." This superb statement of the dialectics of the social function of art constitutes a fundamental position in the Marxist approach to art.

An important and briefly influential work was Thomson's brochure *Marxism and Poetry* (1946), dealing with the origin and evolution of poetry in terms of a sociological, psychological, and linguistic synthesis; in its brilliantly condensed yet popular style it reviews the relationships between labor and consciousness, speech and magic, work and poetry, individual inspiration and collective expression. Thomson, like Caudwell and Plekhanov, leans too heavily on Bücher's theory of the origin of the arts in the rhythmical movements of collective labor. A Marxist modification of this theory is urgently required because ethnological research (especially in music) threatens to discredit it altogether. (I believe that the necessary revision of this theory will show that it applies to the early *development* of the arts in neolithic class society rather than to the *origins* of those arts in the paleolithic era.) Thomson later revised chapters of this brochure and incorporated them into the first volume of his *Studies in Ancient Greek Society*. The chapter called "Improvisation and Inspiration" is reprinted here. It constitutes perhaps the best introduction to Caudwell's poetic theory, outlining the function of poetry in withdrawal of "conscious-

ness from the perceptual world into the world of fantasy," showing the ways in which poetical speech differs from common speech (thus permitting the weaving of "the special spell of poetry" and opening the gates to the Caudwellian "dream world"), tracing the correspondences between the mimetic dance and poetry as an economic-psychological function, sketching the transition from magic and prophecy to poetry and the common ego, in which is stored the suppressed energy of revolutionary transformation.

George Derwent Thomson was born in 1903, and educated at Dulwich College and King's College, Cambridge. He taught Greek in the Irish language at the University of Galway in the 1930's; since 1937 he has been Professor of Greek at the University of Birmingham. His works include translations from Aeschylus, monographs on *Greek Lyric Metre* (1929) and *The Greek Language* (1960), a *Manual of Modern Greek* (1966), and translations from the Irish. His stated goal is the restoration of the Greek heritage to its former position as "a message of hope for the future"; he wishes to rescue it from the Mandarins, for whom the humanities have become a privileged and desiccated refuge. His belief is that Marxism provides the means by which that goal can be reached.

THOMSON: **PITY AND FEAR**
from *Aeschylus and Athens*

It may be concluded that, in keeping with their common origin, these three rites—the orgy of the Dionysiac *thíasos,* initiation into the Mysteries, and tragedy—fulfilled a common function—*kátharsis* or purification, which renewed the vitality of the participants by relieving emotional stresses due to the contradictions generated in the course of social change. And this purpose was achieved by the expression of what had been suppressed. The different forms which this function assumed are explained by the increasing complexity of the social structure which rendered the mode of expression progressively less violent. In the Dionysiac orgy, all the participants were subjected to an actual hysterical seizure, involving automatism, paroxysms, and analgesia. When the orgy became a passion play, the active part was restricted to the performers, who may have exhibited acute symptoms themselves, like the ecstatic dancers of many modern tribes, but in the spectators they excited nothing more than feelings of terror and floods of tears. In the Mysteries, the initiates still have to participate actively in many of the rites, but the chief of these is a mystical drama performed for them by others; and at the tragic festivals the role of all but a fraction of those present has become entirely passive, being confined to expressing

those emotions of pity and fear which are evoked in them by the climax of the plot. And, lastly, although the stresses have not grown less severe, the intensity of the symptoms has steadily diminished, because the growing individuation of society, resulting from the more manifold divisions of labour, has so deepened and enriched the emotional and intellectual life of the people as to render possible a proportionately higher level of sublimation.

The principle of *kátharsis* is accepted by modern psychologists. It provides relief by giving free outlet to repressed emotions through such channels as the practice of confession or participation in public festivals. The citizen who has purged himself in this way becomes thereby a more contented citizen. The emotional stresses set up by the class struggle are relieved by a spectacle in which they are sublimated as a conflict between man and God, or Fate, or Necessity. Plato banned tragedy because it was subversive of the established order; Aristotle replied that a closer analysis showed it to be conservative of the established order. For, like modern psychologists, he assumed that, where there is maladjustment between the individual and society, it is the individual that must be adapted to society, not society to the individual. Modern psycho-analysts have only been able to maintain this attitude because the majority of their patients have belonged to the wealthy classes. Applied to the community as a whole, their therapy would necessarily involve them in the task of investigating the laws governing the social environment with a view to adapting it to the patients. The psycho-analyst would become a revolutionary.

One of the effects of civilisation is undoubtedly to multiply the possibilities of nervous disorders. As society grows more complex, it develops fresh contradictions. If this were the whole of the matter, we should have reason to curse Prometheus; but it is not. The relation between the two processes is not a mechanical one, but dialectical. These internal maladaptations resulting from social development accumulate to a point at which they precipitate a reorganisation of society itself; and, after they have been thus resolved, there emerges a new set of contradictions operating on the higher level. This reciprocal pressure between the members of the organism and its structure as a whole is the dynamic of evolution, both biological and social. Man learns by suffering. And it is these contradictions that find expression in the arts. The artist may endeavour to reform the world, like Shelley, or to escape from it, like Keats, or to justify it, like Milton, or simply to describe it, like Shakespeare, but it is this discord between the individual and his environment, which, as an artist, he feels with peculiar force, that impels him to create in fantasy the harmony denied to him in a world out of joint. And since these works of art embody

the spiritual labour that has gone to their production, they enable the other members of the community, through the experience of seeing or hearing them, which is a labour less in degree but similar in kind, to achieve the same harmony, of which they too are in need, but without the power of constructing it for themselves. Therefore, the arts are conservative of the social order, in that they relieve the pressure on its members, but at the same time they are subversive, because they promote a recurrence of the stresses which they stimulate in order to relieve. They are a form of the organisation of social energy, and the flood which they set in motion may at any moment, in favourable conditions, reverse its direction. The artist leads his fellow men into a world of fantasy where they find release, thus asserting the refusal of the human consciousness to acquiesce in its environment, and by this means there is collected a store of energy, which flows back into the real world and transforms the fantasy into fact. This, then, is the connection between such masterpieces of human culture as Greek tragedy and the mimetic dance, in which the savage huntsmen express both their weakness in the face of nature and their will to master it.

THOMSON: **IMPROVISATION AND INSPIRATION**
from *Studies in Ancient Greek Society*

With us poetry is seldom, if ever, improvised. It is a matter of pen and paper. There must be many contemporary poets whose melodies are literally unheard. They have been written down by the poet, printed, published, and read in silence by individual purchasers. Our poetry is a written art, more difficult than common speech, demanding a higher degree of conscious deliberation.

It is important to remember that this feature of modern poetry is purely modern. In antiquity and the middle ages, and even to-day among the peasantry, the poet is not divided from his audience by the barrier of literacy. His language is different from common speech, but it is a spoken language, common to him and his audience. He is more fluent in it than they are, but that is only because he is more practised. To some extent they are all poets. Hence the anonymity of most popular poetry. Generated spontaneously out of daily life, it passes, always changing, from mouth to mouth, from parents to children, until the faculty of improvisation decays. Only then does it become fixed, and even then it preserves a distinctive quality, which we describe by saying that, however perfect it may be in point of craftsmanship, it lacks the quality of conscious art. That is just what it does lack—the stamp of an individual personality; and inevitably

so, because it is the product not of an individual but of a community. The primitive poet is not conscious of his medium as something different from common speech; and in fact, as we have seen, the difference is less. Hence he is able to improvise. As he succeeds in objectifying his medium, he loses the gift of improvisation, but at the same time acquires the power of adapting it to his own personality, and so becomes a conscious artist.

On the other hand, the effect of poetry is still, as it has always been, to withdraw the consciousness from the perceptual world into the world of fantasy. In comparing poetical speech with common speech we saw that it was more rhythmical, fantastic, hypnotic, magical. Now, in our conscious life, all the factors that make up our distinctive humanity—economic, social, cultural—are fully active: individual differences are at their maximum. Hence, just as the mental processes of conscious life reveal the greatest diversity between individuals, so common speech, which is their medium, is marked by the greatest freedom of individual expression. But when we fall asleep and dream, withdrawing from the perceptual world, our individuality becomes dormant, giving free play to those basic impulses and aspirations, common to all of us, which in conscious life are socially inhibited. Our dream world is less individualised, more uniform than waking life.

Poetry is a sort of dream world. Let me quote from Yeats:

> The purpose of rhythm is to prolong the moment of contemplation, the moment when we are both asleep and awake, which is the one moment of creation, by hushing us with an alluring monotony, while it holds us waking by variety, to keep us in that state of perhaps real trance, in which the mind liberated from pressure of the will is unfolded in symbols.[1]

One might quarrel with the word "liberated," but that does not matter now. The language of poetry, being rhythmical, is hypnotic. Not so hypnotic as to send us to sleep altogether. If we analyse any metre in any language, we find in it precisely that combination of monotony and variety, that interplay of like and unlike, which, as Yeats perceived, is needed to hold the mind suspended in a sort of trance, the special spell of poetry, caught between sleep and waking in the realm of fantasy.

And so, when we say a poet is inspired, we mean that he is more at home than other men in this subconscious world of fantasy. He is exceptionally prone to psychical dissociation. And through this process his inner conflicts—the contradictions in his relationship to society—are discharged,

1. W. B. Yeats, *Essays* (London, 1924), pp. 195–96.

relieved. The discords of reality are resolved in fantasy. But, since this world into which he retires is common to him and his fellow men, the poetry in which he formulates his experience of it evokes a general response, expressing what his fellows feel but cannot express for themselves, and so draws them all into a closer communion of imaginative sympathy:

> Und wenn der Mensch in seiner Qual verstummt,
> Gab mir ein Gott, zu sagen, wie ich leide.[2]

His fellows are tormented by unsatisfied longings which they cannot explain, cannot express. He too is unable to explain them, but thanks to the gift of inspiration he can at least express them. And when he expresses them they recognise his longings as their own. As they listen to his poetry they go through the same experience as he did in composing it. They are transported into the same world of fantasy, where they find the same release.

In the mimetic dance, directed by their leader, the savage huntsmen preenact the successful prosecution of the hunt, striving by an effort of will to impose illusion on reality. In fact all they do is to express their weakness in the face of nature, but by expressing it they succeed to some extent in overcoming it. When the dance is over, they are actually better huntsmen than they were before. In poetry we see the same process at a higher level. Civilised man has succeeded to a large extent in mastering nature, but only by complicating his social relations. Primitive society was simple, classless, presenting a weak but united front against nature. Civilised society is more complex, richer, more powerful, but, as a necessary condition of all this, it has always hitherto been divided against itself. Hence the conflict between society and nature—the basis of magic—is overlaid by a conflict between the individual and society—the basis of poetry. The poet does for us what the dance-leader does for his fellow savages.

The primitive poet does not work alone. His audience collaborates. Without the stimulus of a listening crowd he cannot work at all. He does not write, he recites. He does not compose, he improvises. As the inspiration comes to him, it produces in his listeners an immediate response. They surrender to the illusion immediately and wholeheartedly. In these circumstances the making of poetry is a collective social act.

When we read a poem, or hear one being read, we may be deeply moved, but we are seldom completely "carried away." The reaction of a

2. "And when man in his agony is dumb, I have God's gift to utter what I suffer." Goethe, *Tasso*, 3432–33.

primitive audience is less sublimated. The whole company throw themselves into the world of make-believe: they forget themselves. I have seen this many times in the west of Ireland. Or listen to this account of a Russian minstrel reciting in a hut on one of the islands on Lake Onega:

> Utka coughed. Everybody became silent. He threw his head back and glanced round with a smile. Seeing their impatient, eager looks, he at once began to sing. Slowly the face of the old singer changed. All its cunning disappeared. It became childlike, naïve. Something inspired appeared in it. The dovelike eyes opened wide and began to shine. Two little tears sparkled in them; a flush overspread the swarthiness of his cheeks; his nervous throat twitched. He grieved with Ilya of Murom as he sat paralysed for thirty years, gloried with him in his triumph over Solovey the robber. All present lived with the hero of the ballad too. At times a cry of wonder escaped from one of them, or another's laughter rang through the room. From another fell tears, which he brushed involuntarily from his lashes. They all sat without winking an eye while the singing lasted. Every note of this monotonous but wonderfully gentle tune they loved.[3]

These people were illiterate; yet poetry meant something for them which it certainly does not mean for English people to-day. We have produced Shakespeare and Keats, it is true, and they were greater than Utka. But Utka was popular, and that is more than can be said of Shakespeare or Keats in our country to-day.

Let us push on from Russia into Central Asia and see how, sixty years ago, the Turkmens listened to their poetry:

> When I was in Etrek, one of these minstrels had a tent close to ours, and as he visited us of an evening, bringing his instrument with him, there flocked around him the young men of the vicinity, whom he was constrained to entertain with his heroic lays. His singing consisted of forced guttural sounds, more like a rattle than a song, and accompanied at first with gentle touches on the strings. But as he became excited the strokes grew wilder. The hotter the battle, the fiercer the ardour of the singer and his youthful listeners; and really the scene assumed the appearance of a romance, as the young nomads, uttering deep groans, hurled their caps into the air and dashed their hands in a passion through their hair, as though they were furious to combat with themselves.[4]

These Turkmens, poet and listeners alike, were literally entranced.

Turning to ancient times, we may recall a Byzantine writer's visit to the court of Attila:

3. Quoted by H. M. Chadwick, *The Growth of Literature* (Cambridge, 1925–1939), vol. 2, p. 241.

4. A Vambéry, *Travels in Central Asia* (London, 1864), p. 322.

When dusk fell, torches were lit, and two Huns came out in front of Attila and chanted songs in honour of his victories and martial prowess. The banqueters fixed their eyes on the singers, some of them enraptured, others greatly excited as they recalled the fighting, while those whom old age had condemned to inactivity were reduced to tears.

This is the context in which we must study the *Iliad* and *Odyssey*. How did the ancient Greeks react to Homer? We are apt to assume that they behaved just like ourselves, but this is a mistake. In one of Plato's dialogues a Homeric minstrel describes the effect of his recitals on himself and his audience:

When I am narrating something pitiful, my eyes fill with tears; when something terrible or strange, my hair stands on end and my heart throbs. . . . And whenever I glance down from the platform at the audience, I see them weeping, with a wild look in their eyes, lost in rapture at the words they hear.[5]

When such poets are questioned about the nature of their art, they all give the same answer. They all claim to be inspired in the literal sense of the word—filled with the breath of God:

A skilled minstrel of the Kirghiz can recite any theme he wants, any story that is desired, extempore, provided only that the course of events is clear to him. When I asked one of their most accomplished minstrels whether he could sing this or that song, he answered: "I can sing any song whatever, for God has implanted this gift of song in my heart. He gives the words on my tongue without my having to seek them. I have learnt none of my songs. All springs from my inner self."[6]

We remember Caedmon, inspired by an angel that visited him in dreams, and Hesiod, who was taught by the Muses while tending his flocks on Helikon, and Phemios and Demodokos, the minstrels of Ithaca and Phæacia: "I am self-taught," says Phemios, "for God has implanted all manner of songs in my heart."[7]

For primitive peoples everywhere the poet is a prophet, who being inspired or possessed by a god speaks with the god's voice. For the ancient Greeks the connection between prophecy (*mantiké*) and madness (*manía*) was apparent in the words themselves. To them the magical origin of

5. Plato, *Io*, 535.

6. V. V. Radlov, *Proben der Volksliteratur der türkischen Stamme* (St. Petersburg, 1866–1904), vol. V, p. xvii.

7. *Odyssey*, xxii, 347–48.

poetry and prophecy was self-evident, because the symptoms of both reminded them of the orgiastic dances that survived in their cults of Dionysus:

All good epic poets are able to compose not by art but because they are divinely inspired or possessed. It is the same with lyric poets. When composing they are no more sane than the Korybantes when they dance. As soon as they engage in rhythm and concord, they become distracted and possessed, like the Bacchants who in their madness draw milk and honey from the streams.[8]

These religious devotees were subject under the influence of music to hysterical seizures, which were explained by saying that they were *éntheoi,* that they had "a god in them." At this level we can no longer speak of art. We have reached its roots in magic.

Inspiration and possession are the same thing. In primitive society mental disorders involving loss of consciousness and convulsions are attributed to possession by a god or animal or ancestral spirit.[9] This idea emanates from the ecstasy of the mimetic dance, in which the performers lose consciousness of their identity as they impersonate the totemic animal—the symbol of the heightened common ego evoked by the dance.

Hysteria is a neurosis—a conflict between the individual and his environment which issues in a revolt of the subconscious. It is common among savages, not because they are more prone to such conflicts than we are, but because their consciousness is shallower, less resilient. It is treated by magic. When the first symptoms appear, a song is chanted over the patient. This facilitates the psychical dissociation, precipitates the fit. Here, then, we have poetry at a purely magical level, or rather not poetry at all but the form of therapeutic magic out of which poetry evolved. For magic too is a revolt of the subconscious, cured in the same way. The difference is that in the mimetic dance this hysterical propensity is organised collectively—it is organised mass hysteria; whereas these individual seizures are sporadic. But the treatment is essentially the same. The patient is exorcised. The possessing spirit is evoked and expelled by the magic of the song. The exorcist who administers the treatment—the shaman, medicine-man or witch-doctor, as he is variously called—is usually himself a hysterical subject who has undergone a special training. The relation of the exorcist to the patient is thus similar to that of the leader to his followers in the mimetic dance.

Prophecy is a development of possession. One of the commonest condi-

8. Plato, *Io,* 533.
9. See Thomson, *Aeschylus and Athens,* pp. 374–78.

tions of exorcising a patient is that the possessing spirit should be forced to reveal its name, and often, after revealing its name, it demands to be propitiated in return for releasing its victim. In this way the procedure becomes a means of proclaiming the will of the gods and so of predicting the future. The hysterical seizure assumes the form of a prophetic trance, in which the patient becomes a medium in the modern spiritualistic sense— a vehicle for the voice of a god or spirit. In this condition he expresses fears, hopes, anticipations of the future, of which in his conscious life he is unaware. We still say that coming events cast their shadows before. They impinge on our subconscious, causing an indefinable unrest, and in the prophet, whose subconscious, being abnormally active, is constantly liable to erupt, they rise to the surface.

And finally the prophet becomes a poet. In primitive thought there is no clear line between prophecy and poetry. The minstrels described in the Homeric poems are credited with second sight, and their persons are sacrosanct. The poet is the prophet at a higher level of sublimation. The physical intensity of the trance has been mitigated, but it is a trance all the same. His psyche is precipitated into fantasy, in which his subconscious struggles and aspirations find an outlet. And just as the prophet's predictions command general acceptance, so the poet's utterance stirs all hearts.

In this way we are able, with Caudwell, to define the essential nature of art:

> Art changes the emotional content of man's consciousness so that he can react more subtly and deeply to the world. This penetration of inner reality, because it is achieved by men in association and has a complexity beyond the power of one man to achieve, also exposes the hearts of his fellow men and raises the whole communal feeling of society to a new plane of complexity. It makes possible new levels of conscious sympathy, understanding and affection between men, matching the new levels of material organisation achieved by economic production. Just as in the rhythmic introversion of the tribal dance each performer retired into his own heart, into the fountain of his instincts, to share with his fellows not a perceptual world but a world of instinct and blood-warm rhythm, so to-day the instinctive ego of art is the common man into which we retire to establish contact with our fellows.[10]

There is one other aspect of inspiration that may be mentioned here. Just as magic was for a long time the special province of women, so we find all over the world that inspiration in prophecy and poetry belongs especially to them. The evidence is all the more striking because their

10. Caudwell, *Illusion and Reality*, p. 155.

part in primitive life is not nearly so well documented as the men's. I am not going to enlarge on this subject now. The reader may study it in the pages of Bücher, Briffault, and Chadwick.[11] It was more than a poet's fancy that prompted Homer and Hesiod to invoke the aid of female deities. The woman's part in the origin of music is commemorated in the word itself.

11. See Bücher, *Arbeit und Rhythmus* (Leipzig, 1919), pp. 343–52; Robert Briffault, *The Mothers* (London, 1927), vol. 2, pp. 514–71; Chadwick, *The Growth of Literature,* vol. 3, pp. 186–88, 413, 663, 895–98.

BERTOLT BRECHT

The point is not to leave the spectator
purged by a cathartic but to leave him
a changed man; or rather, to sow
within him the seeds of changes which
must be completed outside the theater.
—Brecht to Tretyakov

The philosophers have only interpreted
the world in various ways;
the point is to change it.
—Marx, 11th Thesis on Feuerbach

It is not the function of the poet
to relate what has happened, but what
may happen—what is possible according
to the law of probability or necessity.
—Aristotle, *Poetics* IX, 1

INTRODUCTION

Eugen Berthold Friedrich Brecht was born in Augsburg in 1898. He took up the study of medicine and science at Munich University, serving as an orderly at the front in 1918, the year in which he wrote the first of those plays which have marked him as an outstanding playwright of the twentieth century. He became a poet and dramatist in a German milieu that reflected many of the leading postwar international avant-garde trends, including expressionism, Dada, futurism, surrealism, and the indigenous reflections of Soviet experiments in proletarian dramaturgy. A leading nonparty Communist intellectual, he was forced into exile in 1933. He settled successively in Denmark, Sweden, Finland, and, from 1941, in the United States, where he lived and worked until 1947. In 1949 he returned to East Berlin, where he headed the Berliner Ensemble until his death in 1956.

In 1926, Brecht converted from left-wing socialism to Marxism, and thereupon began a unique attempt at forging a dramatic art in the service of revolution, an art (it was hoped) which through a conscious effort could negate the narcotic aspects of the artistic function: its reconciling of its

audience to collective authority, its ability to act as an escape valve deflecting revolutionary action into harmless avenues—in short, its historical role as guardian of the social order.

This view of art as narcotic is based on a partial and undialectical view of the sociopsychological function of art;[1] nevertheless, Brecht had touched a raw nerve in the theory and practice of revolutionary art, and it became his self-imposed task to indicate a theoretical means by which art could short-circuit its palliative effects. His argument centered on the question of catharsis.

The idea of catharsis as the goal of tragic art was introduced into philosophy by Aristotle:

Tragedy, then, is an imitation of an action that is serious, complete, and of a certain magnitude; in language embellished with each kind of artistic ornament, the several kinds being found in separate parts of the plan; in the form of action, not of narrative; through pity and fear effecting the proper purgation of these emotions.[2]

For Aristotle pity and fear are aroused by "Recognition," which is defined as "a change from ignorance to knowledge."[3] A perfect tragedy should "imitate actions which excite pity and fear, this being the distinctive mark of tragic imitation."[4] The object of tragedy, then, is to arouse pity and fear through a disturbance of inner equilibrium brought about by a heightening in consciousness, which is in turn followed by a purgation (negation) of those emotions, thereby resulting in a new, higher, equilibrium. The object of catharsis is not, for Aristotle, the simple restoration of an existing harmony; rather, it is the disruption of harmony in order to create a new state of consciousness, a new awareness of necessity.

The interpretation presented here is not the only possible one, as may be seen in the vast literature on Aristotle's theory of catharsis. And it is true that in the closing pages of the *Politics* (VII, 7) Aristotle restates the theory in such a way as to indicate that catharsis may be regarded as aiming at "a pleasant feeling of relief" which may "afford harmless delight" to the audience, and describes the process as being similar to a form

1. See George Thomson's remarks on the simultaneously subversive and conservative effects of art (above, pages 346–47) and Max Raphael's discussion of the pseudo-Marxist equation of art and religion (below, pages 452–53).

2. *Poetics* VI, 2 (Butcher translation).

3. *Poetics* XI, 4.

4. *Poetics* XIII, 2.

of homeopathic medicine or treatment for a condition already pre-existent in the spectator. Nevertheless, it is clear that Aristotle's catharsis is not the simple, lulling narcotic that Plato saw as a primary purpose of art when he compared the effect of music to the singing and rocking motion of women nursing their infants.[5] If there is not a radical core in Aristotle's ambivalent poetic theory, there is a radical aspect that is wholly ignored by the Brechtian interpretation.

The selections here from Brecht's writings on theater concentrate on his central dispute with Aristotelian catharsis,[6] indicating the points of difference between traditional theater and the new "epic theater" that Brecht proposed as a means of circumventing the narcotic role of art. The sources of Brecht's theory cannot be explored in this brief space, but it may be indicated that Brecht's theater is in part an outgrowth of Erwin Piscator's mixed-media, agitprop, activist theater of the early 1920's, which in turn was heavily influenced by Kerzhentsev's Proletkult theater in young Soviet Russia; the Brechtian "estrangement effects"—those double alienations by which he intends to negate catharsis in practice—were foreshadowed in their essential details by the Soviet Formalist, Victor Shklovsky. The deliberate alienation of traditional artistic form occurs, of course, in many of the modes of modern art of the early twentieth century, and Brecht's "epic theater" must be placed within the milieu of Joyce, Döblin, Pirandello, Claudel, the Japanese Nō play, Frank Wedekind (an important Brechtian prototype), Eisenstein, Pudovkin, Bartók (especially the theater works on which he collaborated with Béla Balázs), Picasso, Stravinsky, and Ernst. Brecht's theories arise at the junction of international modernist currents, the revolutionary didacticism of the post-October period, and the tumultuous German cultural movement of the Weimar years.

Brecht's thesis that catharsis restores the audience to a state of recon-

5. *Laws* VII, 790–91.

6. In a sense, Brecht's quarrel is not really with Aristotle, but with the naturalist illusionist theater, and especially that of Stanislavsky, whom he regarded as creating a substitute for religion within the theater. Brecht's artistic thrust was against illusionism: "Only the man who is free of illusions, who compels the exploiter to reveal himself without justification, can direct his own life" (Brecht, "Notes on Stanislavsky," *Tulane Drama Review*, no. 26, p. 157). He charges Stanislavsky with converting theater into religion: "It rests on the same social basis as religion. The social function of religion is . . . the process of rendering the faithful passive. The same can be said of the theatre" (*ibid.*, p. 159). The tendency toward equating art and religion so common among Marxists surfaces here, wholly ignoring the decisive differences between these superstructural categories.

ciliation with evil is based upon a mechanistic (triadic) dialectics, which we met earlier in Bukharin and Bogdanov (whose theories of art helped to shape the Proletkult movement). In this dialectics, all rises out of equilibrium and is restored to equilibrium. The theatrical experience purges pity and fear (disequilibrium), thereby creating harmony (equilibrium). Terror and pity—those emotions which properly directed lead to revolutionary action—are neutralized in the theatrical experience. But even on its own terms this new equilibrium contains the consciousness of the art work that gave rise to it; it therefore is an equilibrium already disrupted by a new consciousness, tending toward a new negation.

What Brecht strives for is the didactic heightening of the consciousness of oppression within the theater, without a cathartic resolution.[7] Brecht's estrangement effects aim to create the possibility of *catharsis interruptus,* with the purgation taking place outside the theater, in the social arena, in the realm of revolutionary action.

The whole point of Brecht's theory is to turn art into a Marxist-Leninist "weapon" in the class struggle. "I wanted to take the principle that it was not just a matter of interpreting the world but of changing it, and apply that to the theater," he wrote in his Notes on Strittmatter's play *Katzgraben.* "What we must achieve is the creation of militancy in the audience."[8] The eleventh of Marx's theses on Feuerbach is the root of Brecht's "epic theater." Brecht's question is: "How can the unfree, ignorant man of our century, with his thirst for freedom and his hunger for knowledge; how can the tortured and heroic . . . man of this ghastly century obtain his own theatre which will help him to master the world and himself?" Brecht's is an attempt to construct such a theater.

What Brecht fails to recognize is that one of the crucial functions of artistic catharsis (and of the aesthetic experience in general) is to purge the violent and antihuman drives of man, to bring him closer (through that very empathy which Brecht eschews) to his brothers and sisters, to neu-

7. There is a sense in which Brecht's "epic theater" is a defense against the aesthetic emotion itself. The author, the actor, the audience, all must keep their distance to avoid the empathetic involvement which might trigger catharsis. The insistence on typical characters, on estrangement effects, on montage and cinematic intrusions all work to circumvent psychological identification. The dialectic of the process is such that in Brecht's greater works, repression of empathy is so total that it turns into its opposite, and the *apparent* absence of affect is converted into an experience drenched in repressed emotions.

8. Cited in Martin Esslin, *Brecht: The Man and His Work* (Garden City, N.Y., 1969), p. 143.

tralize man's drive to rape, castrate, and mutilate, to permit unity with a collective in the service of mankind. Brecht's theory presupposes that the aggression which can be aroused within the theater will inevitably be channeled toward humanistic goals; but such aggression can also be turned to war and fascism or inward against the individual himself. The avoidance of catharsis in art can serve to frustrate energy rather than to direct it toward positive goals. Noncathartic art may block action by refusing to permit symbolic victory. Symbolic solutions within the theater (the happy ending, reconciliation, "recognition" in the Aristotelian sense) serve as models of a release that the audience will seek in reality (politically) if the social-historical factors are favorable. For no catharsis is ever completed within the theater. (If it were otherwise, the memory of the experience would be totally effaced.) All tragic art continues beyond the theater into life, by virtue of the transformation of consciousness which has taken place, through the impingement of new symbols of freedom and necessity which rise from the aesthetic experience. Slochower writes that Kafka's novels avoid catharsis and because of this "the feeling of dread and anxiety is rarely lifted, and at the close the reader is still in the grip of the modern furies." It is not, he continues, a question of avoiding unhappy endings: "The great classical heritage is mainly that of tragedy. . . . But we are purged of pity and fear partly because the enemy appears in dramatic-sensuous form and can therefore be *met*."[9] Thus, the interruption of catharsis may inhibit rather than encourage revolutionary action.

Catharsis is a necessary precondition for revolutionary rebirth. The old life must be completed before the new life can be launched. The terrors and fears which accompany the move to maturity, into manhood, must be allayed, negated, transcended. Catharsis is initiation—the strengthening of the ego through knowledge of necessity so that the youth may cast his skin, separate himself from the symbols of childhood, and take his place among the elders. In a sense, then, catharsis is repression, but repression in the service of progress. And there can be no progress without purgation of pity and fear.[10]

9. *Mythopoesis,* p. 299.

10. The American Marxist Leon Samson (who anticipated a number of significant developments in Marxist aesthetics, including aspects of Caudwell's poetics), wrote of Aristotle's catharsis that it was a means of purging man of those emotions—pity and fear—which "render a man impotent in battle." He concludes from this that "one of the chief functions of art is to prepare man for war—war which the regime of property makes imperative between nation and nation, class and class, man and man." ("The Proletarian Philosophy of Art," *Modern Quarterly,* vol. V, no. 2 [Spring 1929],

The one-sided and schematic presentation given here of Brecht's equally one-sided views[11] in no way disposes of the very real problems of the function of art in class society which Brecht (and later, Herbert Marcuse) brought to light. Brecht's observation that traditional art may serve as a substitute for social action is not a fantasy, and his argument is in a long philosophical tradition. The solution of the problem lies in history. One must ask (in the manner of Marx and Plekhanov), *Under what historical and psychological conditions is it possible for the revolutionary potential of art to be immobilized?* And, *Under what conditions does the cathartic effect of tragic or critical-realist art nullify rather than activate revolutionary energy?* The unraveling of these questions by an examination of specific art works and art forms in specific class societies at particular moments in time may reveal that the paralytic aspect of catharsis rises in epochs which are in a pre- (or pseudo-) revolutionary turmoil but which are not yet committed to a revolutionary solution. Art, in such periods, serves an audience (torn between its consciousness of the need for change and its emotional desire for stasis) as a substitute for action, very much as philosophy served to create the German "dream history" alluded to by Marx. Some recent examples are the Weimar Republic period between World War I and 1933, the United States in the post-McCarthy period, Mexico in the postrevolutionary years. But such periods are conditional, temporary, in flux, unstable by their very nature, and eventually lead to their own negation, and therefore to the negation of this temporary paralysis of art's revolutionary function.

BRECHT: "EPIC THEATER"
from *Brecht on Theatre*

I

The modern theatre is the epic theatre. The following table shows certain changes of emphasis as between the dramatic and the epic theatre:

p. 237; reprinted with minor changes in *The New Humanism* [New York, 1930], pp. 196–97).

11. It should be mentioned that Brecht did not insist that his "epic theater" was the only form which could create revolutionary art. And he recognized (especially in his later years) that pleasure and entertainment properly defined were a necessary complement to the instructive-didactic aspects of theater.

DRAMATIC THEATRE	EPIC THEATRE
plot	narrative
implicates the spectator in a stage situation	turns the spectator into an observer, but
wears down his capacity for action	arouses his capacity for action
provides him with sensations	forces him to take decisions
experience	picture of the world
the spectator is involved in something	he is made to face something
suggestion	argument
instinctive feelings are preserved	brought to the point of recognition
the spectator is in the thick of it, shares the experience	the spectator stands outside, studies
the human being is taken for granted	the human being is the object of the inquiry
he is unalterable	he is alterable and able to alter
eyes on the finish	eyes on the course
one scene makes another	each scene for itself
growth	montage
linear development	in curves
evolutionary determinism	jumps
man as a fixed point	man as a process
thought determines being	social being determines thought
feeling	reason

2

Many people imagine that the term "epic theatre" is self-contradictory, as the epic and dramatic ways of narrating a story are held, following Aristotle, to be basically distinct. The difference between the two forms was never thought simply to lie in the fact that the one is performed by living beings while the other operates via the written word; epic works such as those of Homer and the medieval singers were at the same time theatrical performances, while dramas like Goethe's *Faust* and Byron's *Manfred* are agreed to have been more effective as books. Thus even by Aristotle's definition the difference between the dramatic and epic forms was attributed to their different methods of construction, whose laws were dealt with by two different branches of aesthetics. The method of construction

depended on the different way of presenting the work to the public, sometimes via the stage, sometimes through a book; and independently of that there was the "dramatic element" in epic works and the "epic element" in dramatic. The bourgeois novel in the last century developed much that was "dramatic," by which was meant the strong centralization of the story, a momentum that drew the separate parts into a common relationship. A particular passion of utterance, a certain emphasis on the clash of forces are hallmarks of the "dramatic." The epic writer Döblin provided an excellent criterion when he said that with an epic work, as opposed to a dramatic one, can as it were take a pair of scissors and cut it into individual pieces, which remain fully capable of life.

This is no place to explain how the opposition of epic and dramatic lost its rigidity after having long been held to be irreconcilable. Let us just point out that the technical advances alone were enough to permit the stage to incorporate an element of narrative in its dramatic productions. The possibility of projections, the greater adaptability of the stage due to mechanization, the film, all completed the theatre's equipment, and did so at a point where the most important transactions between people could no longer be shown simply by personifying the motive forces or subjecting the characters to invisible metaphysical powers.

To make these transactions intelligible the environment in which the people lived had to be brought to bear in a big and "significant" way.

This environment had of course been shown in the existing drama, but only as seen from the central figure's point of view, and not as an independent element. It was defined by the hero's reactions to it. It was seen as a storm can be seen when one sees the ships on a sheet of water unfolding their sails, and the sails filling out. In the epic theatre it was to appear standing on its own.

The stage began to tell a story. The narrator was no longer missing, along with the fourth wall. Not only did the background adopt an attitude to the events on the stage—by big screens recalling other simultaneous events elsewhere, by projecting documents which confirmed or contradicted what the characters said, by concrete and intelligible figures to accompany abstract conversations, by figures and sentences to support mimed transactions whose sense was unclear—but the actors too refrained from going over wholly into their role, remaining detached from the character they were playing and clearly inviting criticism of him.

The spectator was no longer in any way allowed to submit to an experience uncritically (and without practical consequences) by means of simple empathy with the characters in a play. The production took the subject-matter and the incidents shown and put them through a process of aliena-

tion: the alienation that is necessary to all understanding. When something seems "the most obvious thing in the world" it means that any attempt to understand the world has been given up.

What is "natural" must have the force of what is startling. This is the only way to expose the laws of cause and effect. People's activity must simultaneously be so and be capable of being different.

It was all a great change.

The dramatic theatre's spectator says: Yes, I have felt like that too—Just like me—It's only natural—It'll never change—The sufferings of this man appall me, because they are inescapable—That's great art; it all seems the most obvious thing in the world—I weep when they weep, I laugh when they laugh.

The epic theatre's spectator says: I'd never have thought it—That's not the way—That's extraordinary, hardly believable—It's got to stop—The sufferings of this man appal me, because they are unnecessary—That's great art: nothing obvious in it—I laugh when they weep, I weep when they laugh.

3

The epic theatre is chiefly interested in the attitudes which people adopt towards one another, wherever they are socio-historically significant (typical). It works out scenes where people adopt attitudes of such a sort that the social laws under which they are acting spring into sight. For that we need to find workable definitions: that is to say, such definitions of the relevant processes as can be used in order to intervene in the processes themselves. The concern of the epic theatre is thus eminently practical. Human behaviour is shown as alterable; man himself as dependent on certain political and economic factors and at the same time as capable of altering them. To give an example: a scene where three men are hired by a fourth for a specific illegal purpose (*Mann ist Mann*) has to be shown by the epic theatre in such a way that it becomes possible to imagine the attitude of the four men other than as it is expressed there: i.e. so that one imagines either a different set of political and economic conditions under which these men would be speaking differently, or else a different approach on their part to their actual conditions, which would likewise lead them to say different things. In short, the spectator is given the chance to criticize human behaviour from a social point of view, and the scene is played as a piece of history. The idea is that the spectator should be put in a position where he can make comparisons about everything that influences the way in which human beings behave. This means, from the aesthetic point of

view, that the actors' social gest becomes particularly important. The arts have to begin paying attention to the gest. (Naturally this means socially significant gest, not illustrative or expressive gest.) The gestic principle takes over, as it were, from the principle of imitation.

This marks a great revolution in the art of drama. The drama of our time still follows Aristotle's recipe for achieving what he calls catharsis (the spiritual cleansing of the spectator). In Aristotelian drama the plot leads the hero into situations where he reveals his innermost being. All the incidents shown have the object of driving the hero into spiritual conflicts. It is a possibly blasphemous but quite useful comparison if one turns one's mind to the burlesque shows on Broadway, where the public, with yells of "Take it off," forces the girls to expose their bodies more and more. The individual whose innermost being is thus driven into the open then of course comes to stand for Man with a capital M. Everyone (including every spectator) is then carried away by the momentum of the events portrayed, so that in a performance of *Oedipus* one has for all practical purposes an auditorium full of little Oedipuses, an auditorium full of Emperor Joneses for a performance of *The Emperor Jones.* Non-aristotelian drama would at all costs avoid bundling together the events portrayed and presenting them as an inexorable fate, to which the human being is handed over helpless despite the beauty and significance of his reactions; on the contrary, it is precisely this fate that it would study closely, showing it up as of human contriving.

4

What the film really demands is external action and not introspective psychology. Capitalism operates in this way by taking given needs on a massive scale, exorcizing them, organizing them and mechanizing them so as to revolutionize everything. Great areas of ideology are destroyed when capitalism concentrates on external action, dissolves everything into processes, abandons the hero as the vehicle for everything and mankind as the measure, and thereby smashes the introspective psychology of the bourgeois novel. The external viewpoint suits the film and gives it importance. For the film the principles of non-aristotelian drama (a type of drama not depending on empathy, mimesis) are immediately acceptable. Non-aristotelian effects can be seen in the Russian film *The Road to Life,* above all because the theme (re-education of neglected children by specific socialist methods) leads the spectator to establish causal relationships between the teacher's attitude and that of his pupils. Thanks to the key scenes this analysis of origins comes so to grip the spectator's interest that he "instinc-

tively" dismisses any motives for the children's neglect borrowed from the old empathy type of drama (unhappiness at home plus psychic trauma, rather than war or civil war). Even the use of work as a method of education arouses the spectator's scepticism, for the simple reason that it is never made clear that in the Soviet Union, in total contrast to all other countries, morality is in fact determined by work. As soon as the human being appears as an object the causal connections become decisive. Similarly in the great American comedies the human being is presented as an object, so that their audience could as well be entirely made up of Pavlovians. Behaviourism is a school of psychology that is based on the industrial producer's need to acquire means of influencing the customer; an active psychology therefore, progressive and revolutionary. Its limits are those proper to its function under capitalism (the reflexes are biological; only in certain of Chaplin's films are they social). Here again the road leads over capitalism's dead body; but here again this road is a good one.

5

So is this new style of production *the* new style; is it a complete and comprehensible technique, the final result of every experiment? Answer: no. It is *a* way, the one that *we* have followed. The effort must be continued. The problem holds for all art, and it is a vast one. The solution here aimed at is only *one* of the conceivable solutions to the problem, which can be expressed so: How can the theatre be both instructive and entertaining? How can it be divorced from spiritual dope traffic and turned from a home of illusions to a home of experiences? How can the unfree, ignorant man of our century, with his thirst for freedom and his hunger for knowledge; how can the tortured and heroic, abused and ingenious, changeable and world-changing man of this great and ghastly century obtain his own theatre which will help him to master the world and himself?

6

It must never be forgotten that *non-aristotelian theatre* is only *one* form of theatre; it furthers specific social aims and has no claims to monopoly as far as the theatre in general is concerned. I myself can use both aristotelian and non-aristotelian theatre in certain productions.

7

The rejection of empathy is not the result of a rejection of the emotions, nor does it lead to such. The crude aesthetic thesis that emotions can only be stimulated by means of empathy is wrong. None the less a non-aristotelian dramaturgy has to apply a cautious criticism to the emotions which it aims at and incorporates. Certain artistic tendencies like the provocative behavior of Futurists and Dadaists and the icing-up of music point to a crisis of the emotions. Already in the closing years of the Weimar Republic the post-war German drama took a decisively rationalistic turn. Fascism's grotesque emphasizing of the emotions, together perhaps with the no less important threat to the rational element in Marxist aesthetics, led us to lay particular stress on the rational. Nevertheless there are many contemporary works of art where one can speak of a decline in emotional effectiveness due to their isolation from reason, or its revival thanks to a stronger rationalist message. This will surprise no one who has not got a completely conventional idea of the emotions.

The emotions always have a quite definite class basis; the form they take at any time is historical, restricted and limited in specific ways. The emotions are in no sense universally human and timeless.

The linking of particular emotions with particular interests is not unduly difficult so long as one simply looks for the interests corresponding to the emotional effects of works of art. Anyone can see the colonial adventures of the Second Empire looming behind Delacroix's paintings and Rimbaud's "Bateau Ivre."

If one compares the "Bateau Ivre" say, with Kipling's "Ballad of East and West," one can see the difference between French mid-nineteenth century colonialism and British colonialism at the beginning of the twentieth. It is less easy to explain the effect that such poems have on ourselves, as Marx already noticed. Apparently emotions accompanying social progress will long survive in the human mind as emotions linked with interests, and in the case of works of art will do so more strongly than might have been expected, given that in the meantime contrary interests will have made themselves felt. Every step forward means the end of the previous step forward, because that is where it starts and goes on from. At the same time it makes use of this previous step, which in a sense survives in men's consciousness as a step forward, just as it survives in its effects in real life. This involves a most interesting type of generalization, a continual process of abstraction. Whenever the works of art handed down to us allow us to share the emotions of other men, of men of a bygone period, different social classes, etc., we have to conclude that we are partaking in interests

which really were universally human. These men now dead represented the interests of classes that gave a lead to progress. It is a very different matter when Fascism today conjures up on the grandest scale emotions which for most of the people who succumb to them are not determined by interest.

8

Thus what the ancients, following Aristotle, demanded of tragedy is nothing higher or lower than that it should entertain people. Theatre may be said to be derived from ritual, but that is only to say that it becomes theatre once the two have separated; what it brought over from the mysteries was not its former ritual function, but purely and simply the pleasure which accompanied this. And the catharsis of which Aristotle writes—cleansing by fear and pity, or from fear and pity—is a purification which is performed not only in a pleasurable way, but precisely for the purpose of pleasure. To ask or to accept more of the theatre is to set one's own mark too low.

———

The theatre as we know it shows the structure of society (represented on the stage) as incapable of being influenced by society (in the auditorium). Oedipus, who offended against certain principles underlying the society of his time, is executed: the gods see to that; they are beyond criticism. Shakespeare's great solitary figures, bearing on their breast the star of their fate, carry through with irresistible force their futile and deadly outbursts; they prepare their own downfall; life, not death, becomes obscene as they collapse; the catastrophe is beyond criticism. Human sacrifices all round! Barbaric delights! We know that the barbarians have their art. Let us create another.

———

How much longer are our souls, leaving our "mere" bodies under cover of the darkness, to plunge into those dreamlike figures up on the stage, there to take part in the crescendos and climaxes which "normal" life denies us? What kind of release is it at the end of all these plays (which is a happy end only for the conventions of the period—suitable measures, the restoration of order—), when we experience the dreamlike executioner's axe which cuts short such crescendos as so many excesses? We slink into *Oedipus;* for taboos still exist and ignorance is no excuse before the law.

Into *Othello;* for jealously still causes us trouble and everything depends on possession. Into *Wallenstein;* for we need to be free for the competitive struggle and to observe the rules, or it would peter out. This deadweight of old habits is also needed for plays like *Ghosts* and *The Weavers,* although there the social structure, in the shape of a "setting," presents itself as more open to question. The feelings, insights and impulses of the chief characters are forced on us, and so we learn nothing more about society than we can get from the "setting."

We need a type of theatre which not only releases the feelings, insights and impulses possible within the particular historical field of human relations in which the action takes place, but employs and encourages those thoughts and feelings which help transform the field itself.

The old A-effects quite remove the object represented from the spectator's grasp, turning it into something that cannot be altered; the new are not odd in themselves, though the unscientific eye stamps anything strange as odd. The new alienations are only designed to free socially-conditioned phenomena from that stamp of familiarity which protects them against our grasp today.

Our own period, which is transforming nature in so many and different ways, takes pleasure in understanding things so that we can interfere. There is a great deal to man, we say; so a great deal can be made out of him. He does not have to stay the way he is now, nor does he have to be seen only as he is now, but also as he might become. We must not start with him; we must start on him. This means, however, that I must not simply set myself in his place, but must set myself facing him, to represent us all. That is why the theatre must alienate what it shows.

At no moment must he go so far as to be wholly transformed into the character played. The verdict: "he didn't act Lear, he was Lear" would be an annihilating blow to him. He has just to show the character, or rather he

has to do more than just get into it; this does not mean that if he is playing passionate parts he must himself remain cold. It is only that his feelings must not at bottom be those of the character, so that the audience's may not at bottom be those of the character either. The audience must have complete freedom here.

—

And here once again let us recall that their task is to entertain the children of the scientific age, and to do so with sensuousness and humour. This is something that we Germans cannot tell ourselves too often, for with us everything easily slips into the insubstantial and unapproachable, and we begin to talk of *Weltanschauung* when the world in question has already dissolved. Even materialism is little more than an idea with us. Sexual pleasure with us turns into marital obligations, the pleasures of art subserve general culture, and by learning we mean not an enjoyable process of finding out, but the forcible shoving of our nose into something. Our activity has none of the pleasure of exploration, and if we want to make an impression we do not say how much fun we have got out of something but how much effort it has cost us.

—

That is to say, our representations must take second place to what is represented, men's life together in society; and the pleasure felt in their perfection must be converted into the higher pleasure felt when the rules emerging from this life in society are treated as imperfect and provisional. In this way the theatre leaves its spectators productively disposed even after the spectacle is over. Let us hope that their theatre may allow them to enjoy as entertainment that terrible and never-ending labour which should ensure their maintenance, together with the terror of their unceasing transformation. Let them here produce their own lives in the simplest way; for the simplest way of living is in art.

THEODOR W. ADORNO AND HANNS EISLER

*Cultural criticism finds itself faced
with the final stage of the dialectic
of culture and barbarism.
To write poetry after Auschwitz
is barbaric.*
—Adorno, *Prisms*

*And just because he's human
A man would like a little bite to eat.
He won't get full on a lot of talk
That won't give him bread and meat.*
—Brecht/Eisler, "United Front Song"

INTRODUCTION

With the deaths of Mehring, Luxemburg, Liebknecht, and Bebel, and the defection of Kautsky, German Social Democracy was left without a single intellectual leader of world stature. In the meantime, the lead in sociological scholarship passed to the followers of Max Weber, Werner Sombart, and Georg Simmel, and the journal which Weber and Sombart had founded, *Archiv für Sozialwissenschaft,* became the foremost avenue for exploration of various aspects of the "sociology of knowledge." Nevertheless, the post–World War I years were a period of Marxist intellectual germination of the highest order, the results of which (for historical reasons related to the rise of fascism and the dispersion and death of its leading thinkers) have not yet been fully assimilated. These were the years of Georg Lukács' *History and Class Consciousness,* of Ernst Bloch's *Spirit of Utopia,* of Bertolt Brecht's emergence from expressionism into the theory of "epic theater," the years in which Marcuse, Adorno, Benjamin, and Raphael began to come to maturity, the period during which aspects of the implications of a Marxist psychology began to be

grasped by such men as Erich Fromm and Wilhelm Reich, a period in which many of the outstanding artists, writers, and musicians were drawn toward Communism and consciously attempted to create an avant-garde art of revolutionary purpose.

In 1923, assisted by private endowments, a group of brilliant young scholars centered around the University of Frankfurt-am-Main formed the Institute of Social Research (*Institut für Sozialforschung*), in which were merged several streams of advanced sociological and philosophical exploration. It was Marxist and neo-Hegelian in orientation and was also heavily influenced by Weber's sociological principles, and it represents an important stage in the encounter between Marxism and sociology. Though individual members of the group of contributors and organizers of the Institute may have been linked in various ways to political organizations on the left, and all were strongly antifascist, the over-all impression was one of conscious disaffiliation from contemporary politics. It may, in fact, have been the distance from politics and the freedom from involvement in Party affairs and conflicts which permitted the Frankfurt School to achieve a level of scholarship and a daring in the application of Marxism to the various disciplines of knowledge of an extraordinarily high order. The earliest emphasis of the Frankfurt School was on political economy, but when the editorship of its publication passed from Carl Grünberg to Max Horkheimer in 1931, its focus shifted to major questions of philosophy, psychology, literature, music, aesthetics, and mass culture. The volumes of the *Zeitschrift für Sozialforschung* (1932–1941) contain a remarkable series of essays and reviews on these subjects by Herbert Marcuse, Theodor W. Adorno, Horkheimer, Fromm, Robert Briffault, and Walter Benjamin, all clearly Marxist or heavily influenced by dialectical materialism, as well as a large number of more strictly sociological pieces by Leo Lowenthal, Raymond Aron, Franz Borkenau, Wittfogel, Charles Beard, and Ferdinand Tönnies. In addition, several of the pro-Marxist psychoanalysts—Reich, Fromm, Otto Fenichel—were contributors, paving the way for the synthesis which Marcuse, Slochower, Norman O. Brown, and others were to attempt in later years. Other contributors included the philosopher-theologians Karl Löwith and Paul Tillich.

With the advent of hitlerism the Frankfurt School was forced to leave Germany, but, under the guidance of Horkheimer, it flourished for a while in exile. Horkheimer, Adorno, Frederick Pollock, Lowenthal, and Marcuse found refuge in the United States (all arrived in 1934 except Adorno who, after four years at Oxford University, took a post at Princeton University in 1938). The *Zeitschrift* continued to appear until 1941 (after 1939 its name was changed to *Studies in Philosophy and Social Science*), but it was

a hopeless dream that it could long survive transplantation; its roots were in the soil of the Weimar Republic, and though it gave the appearance of being beyond politics its survival was deeply enmeshed with the fortunes of the German antifascist left, whose eradication led inevitably to the demise of its intellectual media.

Adorno, who was born in 1903, studied philosophy, musicology, psychology, and sociology at the University of Frankfurt. A musician and a composer as well as a philosopher, he studied composition with B. Sekles and Alban Berg, piano with E. Jung and Edward Steuermann, and musicology at the University of Vienna. From 1928 to 1931 he was editor of the Viennese music periodical for new music, *Anbruch,* and following his arrival in the United States he was music director of the Princeton Radio Research Project. During his exile, he made a living through his participation in sociological research projects, including the classic *The Authoritarian Personality,* published in 1950. All but one of his major early publications (the exception was his monograph on Kierkegaard's aesthetics, 1933) were on musical subjects and were printed in the Institute's *Zeitschrift:* "Sociological Aspects of Music" (1932), "On Jazz" (1936), "The Fetishistic Character of Music and the Regression of Hearing" (1938), and "Fragments on Wagner" (1939), as well as a coauthored volume on Alban Berg (1937). He was one of the leading critical exponents of the Schoenberg-Berg-Webern school of postexpressionist atonality and the twelve-tone system of composition.[1]

In 1949, Adorno returned to Germany, where he taught philosophy and sociology at the University of Frankfurt, participated in the reorganized Institute of Social Research, and commenced the publication of a series of books on music, literature, and philosophy which places him in the first rank of neo-Hegelian dialectical thinkers of the twentieth century, and the impact of which (except through the mediation of Herbert Marcuse's post-1960 writings) has not yet been felt upon world thought. Among these works are the collections of essays *Prisms* (1955, English translation 1967), *Dissonanzen* (1956), *Moments Musicaux* (1964), three volumes of *Noten zur Literatur* (1958, 1961, 1965); short books on *Mahler* (1960), and *Alban Berg* (1963); an introduction to the sociology of music (1962); and the philosophical works—*Drei Studien zu Hegel* (1957), *The Dialectics of the Enlightenment* (1947, with Max Horkheimer), and *Negative Dialectics* (1966). Adorno, who died in 1969, did not write the

1. Thomas Mann's musicological discussions and philosophical theories of music in *Doctor Faustus* were worked out in collaboration with Adorno, after Mann had read the unpublished manuscript of *Philosophie der neuen Musik* (1949).

major work of synthesis around which his total *oeuvre* might be organized. As Fredric Jameson has pointed out, Adorno's work resolves itself into "various fragments" which are "organized around a center which has been left out."[2] Put another way, Adorno's life has been devoted to critical analysis and opposition, but not to construction or synthesis. He knows what he opposes—the diminution of the individual and of the mind in an increasingly totalitarian industrial world—but he does not accept any theory or politics by which that totalitarian grip might be broken, and (decisively) he has no vision of a workable future or memory of a viable past. "Men must act in order to change the present petrified conditions of existence, but the latter have left their mark so deeply on people, have deprived them of so much of their life and individuation, that they scarcely seem capable of the spontaneity necessary to do so," writes Adorno.[3] He continues: "From this, apologists for the existing order draw new power for their argument that humanity is not yet ripe," and he rejects this glimpse of futility; but he finds the possibility of avoiding suffocation only in negative dialectics, in perpetual criticism, in keeping alive the instruments of consciousness "without any preconceptions as to where it might lead," grasping the despairing hope that someday there will be "an ultimate break in society's omnipotence."[4] But we are not persuaded that Adorno believes in even this glimmer of hopeful transcendence: his work is saturated with a *fin de siècle* spleen (verging toward boredom with the human condition); his brilliant insights tend to frustrate rather than inspire; his dialectics, cut off from the living branch of history, spins toward the void. The Utopian dimension, the vision of the future, is a closed book to Adorno, caught in a perpetual tension between a capitalism which his mind has rejected and a Communism which he does not wish to accept. Where he glimpses the Utopian dimension in his musical researches he does so only in order to condemn it as illusory. Thus, in his "Fragments on Wagner," he sees Wagner's nihilism only as "the form adopted by Utopia in the early period of bourgeois decay."[5] And although in his book on Mahler he points to Mahler's Utopia as residing in "the memory traces of childhood," he insists on the impossibility of Utopian transcendence.[6]

Still, Adorno remains the most interesting dialectician and sociologist of music in our time, the first to trace the dialectical interplay between musi-

2. Jameson, "T. W. Adorno, Or, Historical Tropes," *Salmagundi,* vol. 2, no. 1 (Spring 1967), p. 40.
3. "Society," *Salmagundi,* no. 10–11 (Fall 1969–Winter 1970), p. 153.
4. *Loc. cit.*
5. *Studies in Philosophy and Social Science,* vol. VIII (1939), p. 49.
6. *Mahler* (Frankfurt, 1960), p. 187.

cal form and the social order that it rises from and parallels. It will be an important task to separate his method and his flashes of insight from his pessimism.

It was doubtless on the common ground of their mutual interest in the twelve-tone system (rather than politics) that Adorno collaborated with Hanns Eisler[7] on *Composing for the Films,* a book sponsored by the Film Music Project of the New School for Social Research, financed (as was Adorno's Princeton Project) by the Rockefeller Foundation, and published in 1947.

The three excerpts from *Composing for the Films* included here will briefly illustrate both the brilliance and the maddening eccentricity of Adorno's insights. (It is our assumption that Adorno is almost wholly responsible for the underlying philosophical attitudes of these selections.) The first of these fixes the sociological position of the performer as rising from his sale of his person, seeing this as a historical carry-over from precapitalist forms of patronage. The performer is regarded as a passive object of the controlling patronage, the victim of self-humiliation and conformism. Wholly overlooked is the musical experience itself, in which the performer symbolically "conquers" the audience and establishes his discrete individuality. Also overlooked is the long historical process (beginning with Handel in England and Haydn in the Napoleonic period) whereby performers and composers became emulatory models and culture heroes for large segments of society, including members of the ruling classes. The second selection illustrates one of Adorno's central concerns—the nature of musical perception. Here, as in his extended essay "The Fetishistic Character of Music and the Regression of Hearing,"[8]

7. Eisler was born in 1898 in Leipzig, studied composition in Vienna with Schoenberg and Webern and remained a lifelong exponent of the twelve-tone system of composition. Simultaneously, he was a militant proletarian composer who wrote many of the outstanding songs of the international Communist movement, including the "Comintern Song," "Forward, We've Not Forgotten," "In Praise of Learning," and the classic "United Front Song" (the latter two with words by Brecht). Strongly influenced by Brecht, he composed numerous theater pieces and cantatas to Brecht texts as well as incidental music for plays by Brecht, Odets, and Shaw, and music to texts by Silone and others. He emigrated to the United States in 1933; from 1942 to 1948 he lived in Hollywood, composing film scores. From 1948 until his death in 1962 he lived in Berlin, where he led a master class in composition at the Academy of the Arts and composed many proletarian-nationalist works for large choral groups, including the "National Hymn" of the German Democratic Republic. See Heinz Alfred Brockhaus, *Hanns Eisler* (Leipzig, 1961).

8. *Zeitschrift für Sozialforschung,* vol. VII (1938); reprinted in *Dissonanzen,* 1956.

Adorno stresses the "archaic" character of acoustical perception, its ability to preserve "traits of long bygone, pre-individualistic collectivities" more effectively than optical perception, and the regressive process by which industrial civilization has debased the sense of hearing through commercialized music, mechanical mass-reproducibility, and the use of music in advertising. The communal, Utopian strands of musical perception are reified, fetishized, "put into the service of commercialism." Music—the memory of collectivities—becomes the "medium in which irrationality can be practiced rationally." The value of the selection lies not so much in its pessimistic conclusions but in Adorno-Eisler's reintroduction into modern discourse of German philosophical idealism's speculations about the nature of music. The concept of fetishization of art derives from Marx's writings on commodity-fetishism (see above, pages 38–40), but the idea of an irreversible regressive pattern in our ability to perceive the art object is anti-Marxist and strongly parallels the Zhdanovist insistence on decadence as the primary characteristic of art under imperialism. Marx himself wrote that the education of the five senses "is a labor of the entire history of the world down to the present," perceiving a progressive pattern in aesthetic (sensuous as well as artistic) perception.

The third selection conveys the intriguing theory that film music possesses a cryptomagical function, serving "as a kind of antidote against the picture," that it "corresponds to the whistling or singing child in the dark," that its purpose is the exorcism of "fear" aroused by the very nature of the motion picture itself.[9] Music supplies the stimulus to motion in film, awakens the life petrified within the frozen celluloid replicas of external reality. The relationship between music and film "is antithetic at the very moment when the deepest unity is achieved." For the sake of argument, one may set against this Schopenhauer's comment: "Suitable music played to any scene, action, event or surrounding seems to disclose to us its most secret meaning, and appears as the most accurate and distinct commentary upon it."[10]

Whether Adorno's specific judgements are accepted, whether he is regarded as Marxist or neo-Hegelian, he compels Marxism to investigate the dialectics of the art object, the nature of artistic perception, the complex

9. This idea was anticipated by the brilliant Marxist film theoretician Harry Alan Potamkin: "For the western audience, accustomed to the music of the organ or the orchestra, the absence of music would, I am certain, prove ominous and even terrifying." ("Music and the Movies," *The Musical Quarterly,* vol. XV, no. 2 [April 1929], p. 281.)

10. *The World as Will and Idea,* Third Book.

and baffling problems of base and superstructure, the degree to which a work of art is inextricably linked to the social structure. The questions he raises are the proper province of Marxist criticism.

ADORNO AND EISLER: **THE SOCIOLOGY OF THE MUSICIAN**
from *Composing for the Films*

In order to understand the personnel problem of cinema music, some more general reflections on the sociology of the musician may be appropriate. The whole realm of musical performance has always had the social stigma of a service for those who can pay. The practice of music is historically linked with the idea of selling one's talent, and even one's self, directly, without intermediaries, rather than selling one's labor in its congealed form, as a commodity; and through the ages the musician, like the actor, has been regarded as closely akin to the lackey, the jester, or the prostitute. Although musical performance presupposes the most exacting labor, the fact that the artist appears in person, and the coincidence between his existence and his achievement, together create the illusion that he does it for fun, that he earns his living without honest labor, and this very illusion is readily exploited.

Before the jazz age, most people used to look with contempt at a musician who led a dance orchestra. This deprecating glance is the rudiment of an attitude that has to some extent shaped the social character of musicians. In the early bourgeois era musicians were called in from the servants' quarters where even Haydn had to take his meals, and were subject to the laws of competition. But the taint of social outcasts still clings to them. Even the austere chamber-music player sometimes assumes the posture of an obsequious and resentful headwaiter who hopes for a tip. Even he still takes note of the ladies and gentlemen of the audience, and ingratiates himself by the sweetness of his playing and the smoothness of his manners. His turned-up coat collar, the violin under his arm and the studied carelessness of his appearance remind his audience of his colleagues of the café, from whose ranks he has often come.[1]

Some of the best qualities of musical reproduction, its spontaneity, its sensuousness, its aspect of vagrancy opposed to settled orderliness—in short, everything that is good in the much-abused notion of the itinerant

1. Flaubert described this type as early as the middle of the nineteenth century: "The singer Lagardy had a beautiful voice, more temperament than intelligence, more pathos than feeling. He was both a genius and a charlatan, and in his nature there was as much of a barber as of a toreador" (*Madame Bovary*).

musician—is reflected in the popular picture of the gypsy. If this picture were eradicated, musical performance, too, would probably come to an end, just as, if complete technical rationalization were achieved and if music could really be "drawn" rather than written down in symbols, the function of the interpreter, the intermediary, would merge with that of the composer who "produces" music.

At the same time, the habit of rendering "service"—in Germany, orchestra players speak of *Abenddienst,* evening service—has left ominous marks on musicians. Among these is the mania to please, even at the price of self-humiliation, manifested in a thousand ways that range from over-elegant dress to zealous pandering to what the audience wants. This conformism of professional musicians shackles modern composition even more than the passivity of the concert-goers. There remains also a very special and anachronistic kind of envy and malice, and a fondness for intrigue, the disreputable heritage of a profession only superficially adjusted to competitive conditions. It is such archaic features that fit paradoxically into the trend of musical mass culture, which does away with competition, while still needing the old-fashioned gypsy-like traits as an added attraction. A servility both coquettish and impudent is useful for ensnaring the customer; intrigue and the irresistible urge to deceive one's colleagues, often combined with insincere "comradeship," harmonize with the more pragmatic role of business. The musicians in control have a spontaneous understanding of the aims and practices of the amusement industry. In fact, the latecomer industry of motion pictures has not rid itself of the precapitalist elements of musicianship, the social type of the *Stehgeiger,*[2] despite its apparent contradiction to industrial production and the artistic incompetence of its outspoken representatives. On the contrary, this "irrational" type itself has been given a monopolistic position in the streamlined set-up. The industry, out of deepest kinship, has attracted him, preferred him to all musicians with objective tendencies, and made him a permanent institution. He has been regimented like other sham elements of a former spontaneity. The cinema exploits the barber aspect of his personality as a Don Juan, and his headwaiter functions as a troubadour de luxe, and occasionally even gives him the role of a bouncer to keep undesirable elements out. Its musical idea is *schmaltz* in a chrome metal pot. But since the regimentation of the gypsy musician deprives him of the last vestiges of spontaneity which the inexorable technical and organizational machinery has already undermined, objectively nothing is left of the itinerant musician except a few bad mannerisms of performance.

2. The violinist who stands while he conducts a café orchestra, the other members remaining seated.

ADORNO AND EISLER:
EYE, EAR, AND THE FUNCTION OF MUSIC
from *Composing for the Films*

The function of music in the cinema is one aspect—in an extreme version—of the general function of music under conditions of industrially controlled cultural consumption. Music is supposed to bring out the spontaneous, essentially human element in its listeners and in virtually all human relations. As the abstract art *par excellence,* and as the art farthest removed from the world of practical things, it is predestined to perform this function. The human ear has not adapted itself to the bourgeois rational and, ultimately, highly industrialized order as readily as the eye, which has become accustomed to conceiving reality as made up of separate things, commodities, objects that can be modified by practical activity. Ordinary listening, as compared to seeing, is "archaic"; it has not kept pace with technological progress. One might say that to react with the ear, which is fundamentally a passive organ in contrast to the swift, actively selective eye, is in a sense not in keeping with the present advanced industrial age and its cultural anthropology.[1]

For this reason acoustical perception preserves comparably more traits of long bygone, pre-individualistic collectivities than optical perception. At least two of the most important elements of occidental music, the harmonic-contrapuntal one and that of its rhythmic articulation, point directly to a group modelled upon the ancient church community as its only possible inherent "subject." This direct relationship to a collectivity, intrinsic in the phenomenon itself, is probably connected with the sensations of spatial depth, inclusiveness, and absorption of individuality, which are common to all music.[2] But this very ingredient of collectivity, because of its essentially

1. A remark of Goethe's confirms this. "According to my father everyone should learn to draw, and for that reason he had great regard for Emperor Maximilian, who was said to have given explicit orders to that effect. He also more seriously urged me to practice drawing than music, which, on the other hand, he recommended to my sister, even keeping her at the piano for a good part of the day, in addition to her regular lessons." (*Dichtung und Wahrheit,* Part I, Book iv.) The boy, visualized by the father as a representative of progress and enlightenment, is supposed to train his eye, while the girl, who represents historically outmoded domesticity and has no real share in public life and economic production, is confined to music, as was generally the case with young upper-class women in the nineteenth century, quite apart from the role of music throughout oriental society.

2. Cf. Ernst Kurth: *Musikpsychologie* (Berlin, 1931), pp. 116–36: e.g. "There is not only the perceptual space that is drawn into musical expression from outside;

amorphous nature, leads itself to deliberate misuse for ideological purposes. Since music is antithetical to the definiteness of material things, it is also in opposition to the unambiguous distinctness of the concept. Thus it may easily serve as a means to create retrogression and confusion, all the more so because, despite its nonconceptual character, it is in other respects rationalized, extensively technified, and just as modern as it is archaic. This refers not only to the present methods of mechanical reproduction, but to the whole development of post-medieval music. Max Weber even terms the process of rationalization the historical principle according to which music developed. All middle-class music has an ambivalent character.[3] On the one hand, it is in a certain sense precapitalistic, "direct," a vague evocation of togetherness; on the other hand, because it has shared in the progress of civilization, it has become reified, indirect, and ultimately a "means" among many others. This ambivalence determines its function under advanced capitalism. It is *par excellence* the medium in which irrationality can be practiced rationally.

It has always been said that music releases or gratifies the emotions, but these emotions themselves have always been difficult to define. Their actual content seems to be only abstract opposition to prosaic existence. The greater the drabness of this existence, the sweeter the melody. The underlying need expressed by this inconsistency springs from the frustrations imposed on the masses of the people by social conditions. But this need itself is put into the service of commercialism. Because of its own rationality, so different from the way it is perceived, and its technical malleability, music can be made to serve regression "psychotechnically" and in that role is more welcomed in proportion as it deceives its listeners in regard to the reality of everyday existence.

Such tendencies affect culture as a whole, but they manifest themselves with particular blatancy in music. The eye is always an organ of exertion, labor, and concentration; it grasps a definite object. The ear of the layman, on the other hand, as contrasted to that of the musical expert, is indefinite and passive. One does not have to open it, as one does the eye, compared to which it is indolent and dull. But this indolence is subject to the taboo that society imposes upon every form of laziness. Music as an art has

there is also a space or inner listening, which is an autonomous musico-psychological phenomenon" (p. 134); or: "The spatial impressions of music also claim their independence; it is essential . . . that they should not arise by the detour of any perceptual image. They pertain to energetic processes, and are autogenous" (p. 135).

3. This perhaps helps to explain why modern music meets with so much greater resistance than modern painting. The ear clings to the archaic essence of music, while music itself is involved in the process of rationalization.

always been an attempt to circumvent this taboo, to transform the indolence, dreaminess, and dullness of the ear into a matter of concentration, effort, and serious work. Today indolence is not so much overcome as it is managed and enhanced scientifically. Such a rationally planned irrationality is the very essence of the amusement industry in all its branches. Music perfectly fits the pattern.

ADORNO AND EISLER: **MUSIC AND THE FILM**
from *Composing for the Films*

Since their beginning, motion pictures have been accompanied by music. The pure cinema must have had a ghostly effect like that of the shadow play—shadows and ghosts have always been associated. The magic function of music that has been hinted at above probably consisted in appeasing the evil spirits unconsciously dreaded. Music was introduced as a kind of antidote against the picture. The need was felt to spare the spectator the unpleasantness involved in seeing effigies of living, acting, and even speaking persons, who were at the same time silent. The fact that they are living and nonliving at the same time is what constitutes their ghostly character, and music was introduced not to supply them with the life they lacked— this became its aim only in the era of total ideological planning—but to exorcise fear or help the spectator absorb the shock.[1]

Motion-picture music corresponds to the whistling or singing child in the

1. Kurt London makes the following illuminating remark: "It [motion-picture music] began not as a result of any artistic urge, but from the dire need of something which would drown the noise made by the projector. For in those times there was as yet no sound-absorbent walls between the projection machine and the auditorium. This painful noise disturbed visual enjoyment to no small extent. Instinctively cinema proprietors had recourse to music, and it was the right way, using an agreeable sound to neutralize one less agreeable." (*Film Music* [London, n.d.], p. 28.) This sounds plausible enough. But there remains the question, why should the sound of the projector have been so unpleasant? Hardly because of its noisiness, but rather because it seemed to belong to that uncanny sphere which anyone who remembers the magic-lantern performances can easily evoke. The grating, whirring sound actually had to be "neutralized," "appeased," not merely muted. If one reconstructed a cinema booth of the type used in 1900 and made the projector work in the audience room, more might be learned about the origin and meaning of motion-picture music than from extensive research. The experience in question is probably a collective one akin to panic, and it involves the flashlike awareness of being a helpless inarticulate mass given over to the power of a mechanism. Such an impulse is easily rationalized, for instance, as fear of fire. It is basically the feeling that something may befall a man even if he be "many." This is precisely the consciousness of one's own mechanization.

dark. The real reason for the fear is not even that these people whose silent effigies are moving in front of one seem to be ghosts. The captions do their best to come to the aid of these images. But confronted with gesticulating masks, people experience themselves as creatures of the very same kind, as being threatened by muteness. The origin of motion-picture music is inseparably connected with the decay of spoken language, which has been demonstrated by Karl Kraus. It is hardly accidental that the early motion pictures did not resort to the seemingly most natural device of accompanying the pictures by dialogues of concealed actors, as is done in the Punch and Judy shows, but always resorted to music, although in the old horror or slapstick pictures it had hardly any relation to the plots.

The sound pictures have changed this original function of music less than might be imagined. *For the talking picture, too, is mute.* The characters in it are not speaking people but speaking effigies, endowed with all the features of the pictorial, the photographic two-dimensionality, the lack of spatial depth. Their bodiless mouths utter words in a way that must seem disquieting to anyone uninformed. Although the sound of these words is sufficiently different from the sound of natural words, they are far from providing "images of voices" in the same sense in which photography provides us with images of people.

This technical disparity between picture and word is further accented by something much more deep-lying—the fact that all speech in motion pictures has an artificial, impersonal character. The fundamental principle of the motion picture, its basic invention, is the photographing of motions. This principle is so all-pervading that everything that is not resolved into visual motion has a rigid and heterogeneous effect with regard to the inherent law of the motion-picture form. Every movie director is familiar with the dangers of filmed theater dialogues; and the technical inadequacy of psychological motion pictures partly derives from their inability to free themselves from the dominance of the dialogue. By its material, the cinema is essentially related to the ballet and the pantomime; speech, which presupposes man as a self, rather than the primacy of the gesture, ultimately is only loosely superimposed upon the characters.

Speech in motion pictures is the legitimate heir to the captions; it is a roll retranslated into acoustics, and that is what it sounds like even if the formulation of the words is not bookish but rather feigns the "natural." The fundamental divergencies between words and pictures are unconsciously registered by the spectator, and the obtrusive unity of the sound picture that is presented as a complete reduplication of the external world with all its elements is perceived as fraudulent and fragile. Speech in the motion picture is a stop-gap, not unlike wrongly employed music that aims at being

identical with the events of the screen. A talking picture without music is not very different from a silent picture, and there is even reason to believe that the more closely pictures and words are co-ordinated, the more emphatically their intrinsic contradiction and the actual muteness of those who seem to be speaking are felt by the spectators. This may explain—although the requirements of the market supply a more obvious reason—why the sound pictures still need music, while they seem to have all the opportunities of the stage and much greater mobility at their disposal.

Eisenstein's theory regarding movement can be appraised in the light of the foregoing discussion. The concrete factor of unity of music and pictures consists in the gestural element. This does not refer to the movement or "rhythm" of the motion picture as such, but to the photographed motions and their function in the picture as a whole. The function of music, however, is not to "express" this movement—here Eisenstein commits an error under the influence of Wagnerian ideas about the *Gesamtkunstwerk* and the theory of aesthetic empathy—but to release, or more accurately, to justify movement. The photographed picture as such lacks motivation for movement; only indirectly do we realize that the pictures are in motion, that the frozen replica of external reality has suddenly been endowed with the spontaneity that it was deprived of by its fixation, and that something petrified is manifesting a kind of life of its own. At this point music intervenes, supplying momentum, muscular energy, a sense of corporeity, as it were. Its aesthetic effect is that of a stimulus of motion, not a reduplication of motion. In the same way, good ballet music, for instance Stravinsky's, does not express the feelings of the dancers and does not aim at any identity with them, but only summons them to dance. Thus, the relation between music and pictures is antithetic at the very moment when the deepest unity is achieved.

GEORG LUKÁCS

I asked Lukács . . . whether [his father]
was reconciled to the new order.
He said: "Well, not quite.
He doesn't say anything to me, of course,
but I think he has some secret plans.
I think perhaps he is plotting
to overthrow us.
And the funny thing about it is
that the day he gets back his fortune
is the day I get hanged!"
—Crystal Eastman (1919)

INTRODUCTION

Georg Szegedy von Lukács was born April 13, 1885, in Budapest, into an aristocratic Jewish family (his father headed the wealthiest bank in Hungary). He took his doctorate in sociology under Georg Simmel in Berlin in 1906, and for the next decade was one of the leading figures in a philosophical milieu which included Simmel, Dilthey, Jaspers, Bloch, and Heidegger. The sources of his early thought lay first in neo-Kantianism and then in Hegel; he was heavily influenced at this time by Dilthey and Husserl. He settled in Heidelberg in 1912, and there came within the orbit of Max Weber, who was another major influence. His work during this pre-Communist period was concerned primarily with philosophy and aesthetics. He contributed numerous reviews and articles to Hungarian and German publications (he edited or co-edited several periodicals devoted to theater and the arts). Among his early books, the most significant are *The Development of Modern Drama* (1908), *The Soul and Its Forms* (1911),

and *Theory of the Novel* (1920; written around 1915). In 1918, he joined the Communist Party of Hungary.[1]

Following the pattern so common among Marxist intellectuals-turned-revolutionists, Lukács abandoned aesthetics and the arts as such when he joined the Party, giving his attention to politics and to subjects of revolutionary tactics and strategy. On these he brought to bear his rigorous training in philosophy and sociology. In the years up to 1930 he wrote numerous theoretical papers—"The Question of Parliamentarianism," "Opportunism and Putschism," "Legality and Illegality," "The Crisis of Syndicalism in Italy," "Organizational Questions of Revolutionary Initiative," "The Spontaneity of the Masses," "On the Question of the Party and the Youth," and many others along similar lines. In brief, he grappled with precisely those subjects that preoccupied most revolutionary theoreticians —Lenin, Kautsky, Béla Kun, Bukharin, Trotsky, Adler, Turati—of the period. Lukács returned to Hungary, and emerged as Commissar of Education in the short-lived Communist government of Béla Kun in 1919. Whether he consciously aspired to become a Hungarian Lenin or Trotsky is speculative, but a contemporary report by Crystal Eastman[2] gives this impression. Describing the "slender, fair-haired, studious Jew with blue eyes, and spectacles" who, she said, acted as "political commissar for one of the Red Guard companies at the front," she wrote: "Lukács is interested in his educational reforms. . . . But Lukács is more interested now in the army. He is as proud of the fighting spirit of his company of Red Guards as Napoleon ever was of his chosen troops." When she cried out against the shooting of six deserters, Lukács replied: "We are in the war. . . . In war, fugitives and traitors must be shot. If not, all right, then, let the Czechs in and the revolution will be lost."

The importance of Lukács' collection of essays, *History and Class Consciousness* (1923), lies almost wholly outside the realm of aesthetics, although certain important implications for Marxist aesthetics can be drawn from several of its major positions—including Lukács' insistence (also developed by Karl Korsch) that the genesis and doctrines of Marx-

1. Lukács' biographical and intellectual development can hardly be understood apart from the historical and social developments in Hungary between the wars. He is an outstanding member of a Hungarian Marxist school which produced (among others) Attila József, Frederick Antal, Béla Balázs, J. Szigeti, Arnold Hauser, Zoltán Kodály, Tibor Dery, Gyula Hay, György Boloni, and Eugene Varga, and which heavily influenced Karl Mannheim. (See Paul Ignotus, "Radical Writers in Hungary," *The Journal of Contemporary History,* vol. 2, pp. 149–66, and István Mészáros, "Lukács' Concept of Dialectic," in G. H. R. Parkinson, ed., *Georg Lukács* [London, 1970], pp. 39, 44.)

2. *Liberator,* August 1919.

ism itself must be subjected to Marxist analysis, his intricate analysis of class consciousness and the nature of social classes, his restoration of the concept of "totality" to Marxist dialectics, and his formulations concerning the Hegelian roots of Marxism.[3] Lukács—some years before the publication of Marx's 1844 manuscripts—pointed out the centrality of the concept of alienation in Marx's thought. The development of these philosophical positions was barred for a time because the book was regarded by the Communist movement as a Luxemburgian defense of positions analogous to those rejected by Lenin in *Left-Wing Communism—An Infantile Disorder* (1920). Nor was the Marxist movement prepared for Lukács' criticism of Engels on several fundamental scores (which were to be taken up in the post-Stalin years by Eastern European "Marxist-Humanists" and French Marxist-Existentialists).[4] To a contemporary observer it might well have appeared that Lukács was clearing the Marxist pantheon of several of its eminences in order to make room for a new, Hungarian presence.

Ernst Bloch, in his 1924 review of the book, anticipated the criticism it would arouse; he predicted: "The Russians . . . will even sense in it a breakaway. . . . Some of them will say that Marx had not placed Hegel on his feet in order that Lukács might put Marx back on his head."[5] Primarily, however, *History and Class Consciousness* was seen as part of Lukács' bid for leadership of the Hungarian Communist Party and for a major place in the world Communist movement. And it was his Hungarian antagonist, Béla Kun, who was influential in bringing about its denuncia-

3. Fredric Jameson's important work, *Marxism and Form* (Princeton, N.J., 1971), argues that *History and Class Consciousness* marks a stage in the development of Lukács' "lifelong meditation on narrative [and] its relationship to the reality it expresses . . ." (p. 163; see also p. 190). I find this an overvaluation of the ideological component, coupled with an underestimation of historical and biographical factors in Lukács' development. Slipping into apparent idealism, Jameson writes: "I would be tempted to reverse the causal relationship as it is generally conceived, and to claim that if Lukács became a Communist, it was precisely because the problems of narration raised in the *Theory of the Novel* required a Marxist framework to be thought through to their logical conclusion" (p. 182).

4. Lukács charged Engels with converting Marxism into positivism. He also held, contra Engels, that dialectics did not exist in nature but only in history and social relations. "The decisive characteristic of the dialectic—mutuality between subject and object, unity between theory and practice— . . . is not present in the knowledge of nature" (*History and Class Consciousness*, p. 17).

5. "Actualität und Utopie: Zu Lukács' Philosophie des Marxismus," *Der neue Merkur,* vol. VII, pp. 457–77, cited in Victor Zitta, *Georg Lukács' Marxism* (The Hague, 1964), p. 140.

tion by the Fifth Congress of the Comintern, in which Zinoviev himself led the attack.

Lukács made his peace with the Party in a self-criticism and reconciled himself with the shade of Lenin via a relatively orthodox biography of 1924. His 1925 review of Bukharin's *Historical Materialism* draws back somewhat from the more extreme positions of *History and Class Consciousness* but continues to assert the importance of Rosa Luxemburg as an economic theorist second only to Marx and the need for a more dialectical (Hegelian) Marxism. During the twenties, Lukács was arrested in Vienna, but was released (partly through the intervention of Thomas Mann)[6] before an imminent extradition to Hungary (where he was under sentence of death) could take place. Lukács' political career essentially came to an end with the rejection of the so-called "Blum Theses," which he submitted to the Hungarian Party Congress in 1928. His activity as a Marxist literary historian and aesthetician commenced with his retirement from the inner-party political arena. In 1930–1931 he worked at the Marx-Engels-Lenin Institute in Moscow, where he read Marx's 1844 manuscripts (he felt that they canceled the theoretical basis of *History and Class Consciousness*) and began his enduring friendship with Mikhail Lifschitz, who was then in the process of drawing together the threads of Marx's writings on art and literature into a coherent philosophy of art.

Lukács returned to Berlin for two years but was forced to flee into exile in 1933. He remained in the Soviet Union until 1944, where he worked on the editorial boards of several international Communist literary journals and in the Philosophical Institute of the Academy of Sciences in Moscow. He was jailed (apparently because he was a foreigner) by his Soviet hosts for several months in 1941 but was released upon the intervention of leading Communist intellectuals. It was during this decade that Lukács' distinguished achievements as a Marxist literary historian first made their appearance, in a prolific series of articles which were later collected in *Goethe and His Age* (1947), *Russian Realism in World Literature* (1949), *German Realists of the Nineteenth Century* (1951), *Balzac and French Realism* (1952), *The Historical Novel* (1955), and others. He was also a leading participant in doctrinal disputes on the nature and function of literature.

6. Mann considered Lukács his greatest critic. He regarded his thought as essentially Jesuitical, however, writing that his impression of Lukács was of "an almost hair-raising abstractness." He deliberately modeled the character of Naphta—the Jew and Marxist turned Jesuit—in *The Magic Mountain* on Lukács, describing Naphta as "a keen tortured intellect" who, "like many gifted people of his race . . . was both natural aristocrat and natural revolutionary."

It was a Talmudic period, in which orthodoxy was measured by adherence to principles of "realism," "critical realism," "partisanship," "socialist realism," "Party spirit," "typicality," and so on, whereas deviation was signaled by "naturalism," "modernism," "formalism," "decadence," and so on. (A few concepts—such as "revolutionary romanticism" and "tendentiousness"—occupied a bitterly disputed border zone.) Essentially, despite the furious criticism of his work in the late 1940's by Zhdanovists, Lukács' writings during this period marked his withdrawal from the Utopian and Hegelian components of Marxism which he had stressed in the early 1920's to a centrist, but nonetheless orthodox position. He worked within the generally accepted categories of Soviet Communist aesthetics, faithfully applying these to a vast realm of literary and philosophical subject matter. After the war, he was appointed Professor of Aesthetics and Philosophy at the University of Budapest and also served as a member of Parliament. In 1956, following the Hungarian revolt, Lukács served in the Imre Nagy government. When the Russians occupied Budapest, he took shelter in the Yugoslav Embassy and then was exiled to Rumania. He returned to Budapest in 1957, where he resided until his death in 1971, writing massive volumes on central problems of philosophy, literature and aesthetics. Part one of his massive *Aesthetics—The Specific Nature of the Aesthetic*—appeared in 1963; his essays on Solzhenitsin were published in 1969; still to come are Lukács' *Ontology* and his *Ethics*.[7]

———

A copious and important literature on Lukács has already begun to emerge (see the bibliography for a partial listing). This is devoted largely to devel-

7. The pattern of discontinuity in Lukács' intellectual development has been observed by most critics (Peter Demetz and Fredric Jameson are notable exceptions) and has been stressed by Lukács himself in his self-criticisms and his repeated disaffirmations of aspects of his pre-Communist and early Communist writings. Although this is not the place to demonstrate it, I think it possible that the source of this discontinuity in Lukács' thought rises from his alternations between rebellion against and obedience to a series of authority-figures, both bourgeois and Communist. Much of the appeal of *History and Class Consciousness* may lie in its wholesale rejection (only partially disguised) of the primal Marxist leaders—including Plekhanov, Lenin and Engels—and his insistence upon the necessity for a critique of Marx himself. (Lukács' guide and model in his struggle against the Marxist "fathers" was the woman theoretician, Rosa Luxemburg.) Retribution by the leaders of the Comintern caused Lukács to acknowledge his *hubris* with self-criticism and remorse (although with unspoken reservations) and to commence a long period of unqualified service. The Hungarian rebellion of 1955 perhaps stirred the old embers of desire, but this was quickly dissipated in a reversion to obedience.

oping the epistemological and political implications of his early Communist writings, and especially of *History and Class Consciousness,* and the philosophical implications of his pre-Marxist writings in aesthetics. His *Theory of the Novel* is in the process of being apotheosized on one hand as an Ur-text of existentialist ontology, and on the other (see especially Lucien Goldmann) as an (apparently unconscious) proto-Marxist aesthetic classic. The reverberations of Lukács' early thought are vast, and the major thinkers whose insights and concerns have been shaped by his work include Karl Mannheim, Sartre, Merleau-Ponty, Benjamin, Adorno, Bloch, Slochower, Marcuse, Korsch and Balázs. These influences do not run wholly in one direction: Balázs and Bloch, for example, may be counted among the sources of Lukács' early messianic tendencies; Korsch was attempting to outline the Hegelian threads in the Marxist fabric simultaneous with Lukács.

Our selections are all from Lukács' post-1930 writings, which have aroused less attention, although it is in these writings that his conscious application of Marxist categories to literature and aesthetics may be found. A judicious view of Lukács' achievement in his post-1930 critical and philosophical works is difficult but necessary. Present-day opinion tends to either overpraise or minimize their importance. Many speak of him as the "foremost Marxist critic," paying homage to the breadth of his erudition, the vastness of the canvas upon which he works. Some writers describe his career as "an intellectual disaster" (George Lichtheim) and his work as that of a man "who had lost his philosophy without gaining in politics" (Franz Borkenau). An American Marxist, Edwin Berry Burgum, calls Lukács an anachronistic "pre-Freudian romantic" and Ernst Bloch writes that Lukács' theory of literature provides "sociologistic-schematic blinkers" which obscure "the utopian perspective of every great work of art." George Steiner balances these negative appraisals by observing that Lukács "appears to have mastered nearly the whole of modern European and Russian literature," and pointing out that Lukács was the greatest contemporary student of Balzac, Thomas Mann, the nineteenth century novel, and the historical novel. Though he sees the high seriousness, political immediacy, and revolutionary purpose of Lukács' view of literature as redeeming qualities, Steiner notes that Lukács' works are nevertheless marred by Zhdanovist influences and that his view of numerous major bourgeois philosophers often reduces them to forerunners of fascism: "Lukács is haunted by the ruin of German and western European civilization. He is searching for culprits to hand over to the Last Judgment of history."[8]

8. *Language and Silence,* p. 337.

Lukács—despite his grounding in classical German philosophy—has consistently described virtually all philosophical developments after Marx as tending toward the irrationalities of mysticism and racism, thereby providing the intellectual background for retrograde political movements. "It must be shown," he said in 1948, "that from Nietzsche *via* Simmel, Spengler, Heidegger, etc., a *direct line* leads to Hitler and that the Bergsons and Paretos, the pragmatical and semantic philosophers, the Berdyaevs and Ortegas have likewise created an intellectual atmosphere from which the drive towards a fascist outlook has been able to derive ample impetus."[9]

This passage bares a contradiction in Lukács' theoretical position. A firm adherent of the (supposedly) Leninist reflection theory of ideology and art, Lukács here portrays ideology as anticipating future reality. Throughout his work, Lukács has been beset by this contradiction, which he will not resolve because it opens up the Utopian dimension in art—a dimension which he has deliberately closed off from view. In *The Historical Novel*, he wrote: "What Marx said of legal institutions applies in wide measure to literary forms. They cannot stand higher than the society which brought them forth. Indeed . . . they *should not* stand higher—in the sense, say, of anticipating coming perspectives of development by romantic-Utopian projections of the future into the present" (page 348). But Lukács knows that the reflection theory downgrades the revolutionary potential of both art and ideology, and is forced in practice to combat this inertia by a ruse: "Great artists," he writes, "have ever been pioneers in the advance of the human race. By their creative work they uncover previously unknown interconnections between things—interconnections which science and philosophy are able to put into exact form only much later."[10] No dialectical fusion of opposites is proposed: in theory he will not allow art or ideology to transcend its historical-class genesis; in practice he falls into simple idealism by proposing that art reflects future historical events. Thus, in his essays on Goethe and his contemporaries he writes: "This literature is the work of ideological preparation of the bourgeois-democratic revolution in Germany."[11] And again: "The works of young Goethe represent a revolutionary peak of the European Enlightenment, the ideological preparation for the great French Revolution" (page 39). It would be expected that an orthodox Marxist would dwell on the actual class position and outlook of Goethe and the *Sturm und Drang* movement in precapitalist Germany, and perhaps find the mechanism by which an art

9. Speech to Wroclaw Conference, 1948, cited in *Modern Quarterly,* vol. 4, no. 3 (Summer 1949), p. 253.
10. *Studies in European Realism,* p. 114.
11. *Goethe and His Time,* p. 12.

created within the framework of German benevolent despotism later was able to serve the needs of a bourgeois class for which it was not created.

The problem with Lukács is not that he is too orthodox a Marxist but that he is not orthodox enough. For Marx had solved this very problem (in regard to philosophy) in his *Introduction to a Critique of Hegel's Philosophy of Right*. Lukács ignored Marx's solution and remained fixed within the parameters of the Hegelian epistemology which Marx had superseded.

Throughout Lukács' life Hegel remained the unassailable touchstone of his thought, despite Lukács' acceptance of the Marxist inversion of the Hegelian dialectic, and it may be possible that a number of the contradictions between the phases of Lukács' career will find their resolution in his unvarying fidelity to and development of Hegel's aesthetics. In Lukács, Hegel is essentially regarded as the sole parent of Marxism; the Feuerbachian and Utopian stages of Marx's development are neglected, although it was in them that Marx completed his separation from Hegel. In a passage cited above, we saw that Lukács attributed to Marx the belief that legal institutions (and by implication art) "cannot stand higher than the society which brought them forth." Surely Lukács was aware that one of Marx's best-known comments on art expresses precisely the opposite thought: "It is well known that certain periods of the highest development of art stand in no direct connection with the general development of society, nor with the material basis and the skeleton structure of its organization" (see above, page 61). And it is even more remarkable that the very thought attributed by Lukács to Marx is actually Hegel's, in his *Philosophy of Right* (see below, pages 460–61).

Like the young Hegel, early Lukács had cast off from the shores of certainty, and discovered and then rejected the avenues of possible liberation which his successors were later to "rediscover." Both returned to the shore. Marcuse writes: "Hegel's enlightened optimism and his tragic praise of a lost paradise were replaced by an emphasis on historical necessity."[12] Lukács in his pre-Marxist writings had glimpsed the unity of the rational and the irrational; in 1908, he wrote of the mythic underpinnings of poetry and understood that both myth and poetry are simultaneously "distant and near to life," embodying "the real and irreal, the naive and all-signifying, the spontaneous and symbolic, adornment and simple pathos."[13] As a Marxist, Lukács succeeded in ironing out the rich complexities of this subject: "Myth, like any other ideology, can have no

12. *Reason and Revolution*, p. 33.
13. *The Sociology of Modern Drama*, p. 166.

existence detached from the material process of production."[14] He had found his way out of what must have appeared to him as a dialectical chaos: "Those who have arrived at such knowledge [Marxism] know, in spite of all temporary darkness, both whence they have come and where we are going. And those who know this find the world changed in their eyes: they see purposeful development where formerly only a blind, senseless confusion surrounded them."[15] The dissonances of Lukács' thought dissolved into the tonic chords of realism, optimism, "affirmation of life," "glorification of human greatness"; the vital core of his work became, as Johan Vogt put it, "his engrossment with the unity, or in some cases the lack of unity, between emotion and reason."[16]

The first selection, "The Ideology of Modernism" (1955), illustrates Lukács' powerful attack upon morbidity and pathology in art. He regards modernism not as protest but as rejection of reality, containing no concrete criticism, escaping into existential nothingness. Whether depiction of pathology and abnormality is identical with their glorification is a debate which Lukács does not care to enter. Elsewhere he had written that the object of proletarian humanism "is to reconstruct the complete human personality and free it from the distortion and dismemberment to which it has been subjected in class society,"[17] but he sees depiction in art of that same dismemberment as a self-defeating naturalism. Dialectically, it would appear otherwise,[18] and Lukács' failure to explore this possibility can only

14. *Beiträge zur Geschichte der Aesthetik* (Berlin, 1954), p. 271.
15. *Studies in European Realism*, p. 2.
16. *Festschrift zum achtzigsten Geburtstag von Georg Lukács*, p. 32.
17. *Studies in European Realism*, p. 5.
18. Lukács is of course aware of this difficulty and has countered it in various ways. For example, in "Idea and Form in Literature" he quotes Marx on how the alienation of capitalist productive relations conveys to the proletariat a feeling of powerlessness: the proletariat "feels itself annihilated in this alienation, sees in it its own powerlessness and the reality of an inhuman existence." If this is true it clearly is a proper subject for realistic portrayal. But Lukács insists that such powerlessness inevitably generates "indignation," without which the naturalist protest is merely superficial. However, it appears to me that this is merely a call for tendentious positive characters in literature rather than a call for realism, for the indignation which powers revolutionary consciousness need not reside *in* the work; it may *arise* from it. Zola and his followers understood this, and *Germinal, The Lower Depths, The Jungle,* and even *Mother* have provided the necessary leap beyond the page. Hamlin Garland, the American populist, gave a classic formulation of this process in the 1890's: "The realist . . . sees life in terms of what it might be, as well as in terms of what it is;

be attributed to the ascetic and antisexual moral standards by which he judges literature and character.

In a wholly "unnecessary" and tangential passage of *Studies in European Realism,* Lukács unwittingly gives us some insight into these standards. He recounts an anecdote from Gorki's *Reminiscences of Tolstoy* in which Gorki related how a certain widow had quarreled with him and how he had violently repulsed her, striking her with a shovel. From this, Lukács concludes that Gorki "never allows himself to be dragged down, even for an instant, into her atmosphere of beastliness and filth. . . . For all the coarseness of the whole anecdote, it yet expresses Gorki's manliness, inner purity and delicacy no less distinctly than all his other manifestations and all his writings." Universalizing the anecdote, Lukács writes that the "modern author faces the constantly increasing bestiality of life without being able to do anything about it. He either surrenders to this bestiality and depicts it in its naked, senseless, animal grossness or else he escapes from it into a sphere in which his withdrawal from life and all its brutality can be made superficially credible." Two things are wrong with Lukács' retelling of Gorki's anecdote. First, he flatly describes the widow as "a former prostitute" whereas Gorki had merely said "possibly." More important, Lukács omits the central point: Tolstoy's reaction to the story. "You understood that she wanted you?" asks Tolstoy. "I don't remember," Gorki replies. "I hardly think that I can have understood." "Well now! But it's obvious. Of course she wanted you."[19] The point, then, of Tolstoy's wisdom, was that Gorki had failed to understand the widow's humanity, failed to grasp the fact of her love (at least, her sexual desire) for him. Objectively, it was Gorki who displayed inhumanity here in rejecting an offer of love with a blow of his spade. That Lukács could reverse the ethical and human implications of the episode (and falsify or distort its central point) reveals his own psychological preoccupations, advising a cautious reading of his literary criticism.

———

The second selection, "Shakespeare and Historicism," is meant to give some indication of the ease and profundity with which Lukács can briefly

but he writes of what is, and, at his best, suggests what is to be, by contrast. . . . He aims to hasten the age of beauty and peace by delineating the ugliness and warfare of the present; but ever the converse of his picture rises in the mind of the reader." (*Crumbling Idols* [Cambridge, Mass., 1960], p. 44.)

19. Gorki, *Reminiscences of Tolstoy, Chekhov, and Andreyev* (New York, 1959), pp. 16–19.

scan a major literary area, and the flexibility with which he handles class and historical determinants. Primarily, however, we choose it to illustrate Lukács' handling of the dialectical concept of "totality." Lukács, though he repudiated many of its positions, wrote in 1967 that it was "one of the great achievements" of *History and Class Consciousness* to have "reinstated the category of totality" to the methodologically "central position it had occupied throughout Marx's works.[20] In *History and Class Consciousness* Lukács defined this concept: "In brief . . . the essence of the dialectic method lies in the fact that in every aspect correctly grasped by the dialectic the whole totality is comprehended and that the whole method can be unravelled from every single aspect" (page 170). Marcuse described Hegel's dialectic as one in which "every particular form can be determined only by the totality of the antagonistic relations in which this form exists."[21] Lukács emphasizes that the idea of totality "can never, of course, be more than a guiding principle; . . . it can never be more than an approximation of totality."[22] Totality involves the finding of the whole in its parts, the universal in the particular; Lenin's is perhaps the most widely known definition: "The splitting of a single whole and the cognition of its contradictory parts . . . is the essence of dialectics" (see above, page 183).

In the present selection, Lukács weaves back and forth between the historical crises of the feudal-bourgeois class struggle and the human collisions "which sprang necessarily and typically from the contradictions" generated by this historical process. Historical conflict (totality) is stated "in terms of typical-human opposites" (the particular). "In this way Shakespeare concentrates the decisive human relations round these historical collisions . . . [T]he human features absorb the most essential elements of this great historical crisis." In the Roman plays Shakespeare "concentrates the most general tendencies of crisis in his epoch round some important collision which has typical universality and depth." Does this exhaust the totality of dialectical relations in which Shakespeare's historical plays exist? Clearly not. Lukács' view of totality applied to criticism is highly selective: the details of literature are seen as symbolic transactions from which historical reality emerges, but the art work itself is engulfed by that which it symbolizes, losing its own identity and specificity. Man disappears into type. Art is transformed into ideology. Greatness and genius remain unsolved problems. "History" replaces life. Mind conquers the emotions. Biography and psychology are ruled out of the sphere of dialecti-

20. Preface to *History and Class Consciousness*, p. xx.
21. *Reason and Revolution*, p. 26.
22. *Meaning in Contemporary Realism*, p. 100.

cally active generative principles: Lukács considers the "biographical-psychological, genetic method" as an impracticable means of portraying genius; the man of genius "proves his genius by the originality with which he extends, concentrates and generalizes the most important tendencies in the life of an epoch."[23]

▬▬

Lukács, in the works of his second aesthetic period, established and refined a number of useful analytical concepts—especially that of critical realism. He restored to Marxism its legitimacy as the heir of classical German aesthetics. Primarily, however, his accomplishment was to have brought to perfection the traditional modes of Soviet Marxist criticism and to have applied these to the masterpieces of the novel from Cervantes to Thomas Mann. Yet his work of this period is rendered somewhat defective both by its rigid adherence to those restrictive categories which he played so important a role in defining, as well as by his refusal to grant significance to the dialectics of personality in the creative process.

Lukács entered a final phase of his work in the mid-fifties. Freed from political constraints, and from his own political ambitions as well, it was to be anticipated that his subsequent writings would mark both an end and a new beginning. In them, Lukács begins to come to terms with those critiques of Soviet Marxism which were undermining the philosophical and political assumptions which underlay his middle-period critical practice. It must be remembered that the ideological solidarity of the Communist movement during the 1930's and 1940's was such that no Communist intellectual felt it necessary to deal seriously with Marxist (not to speak of non-Marxist) contributions which emanated outside the mainstream of the movement as such. Lukács was now compelled for the first time to face some of the implications of the work of Benjamin, Max Raphael, Marcuse, Adorno, Caudwell, Sartre, Breton and (especially) Bloch. It was to be a

23. *The Historical Novel*, p. 304. An important critic of Lukács (and author of a forthcoming *Life and Work*), István Meszáros, sees Lukács' essence as the "quest for a deeper understanding of the complexities of mediation" within "the ultimate unity of a dynamically changing dialectical totality." He believes that Lukács' work consists of the systematic exploration of "the intricate problems of mediation" and he finds Lukács' solutions ultimately defective because of the "unwarranted intrusion of 'immediacy' into his general world view." (See Meszáros, "Lukács' Concept of Dialectic," in G. H. R. Parkinson, ed., *Georg Lukács* [London, 1970], pp. 34–85; see also Roy Pascal, "Georg Lukács: The Concept of Totality," in the same book, pp. 147–71.)

struggle in which Lukács—though fighting a rear-guard action—would not prove unequal to the task: for he had been to the farthest boundaries of Marxism some four decades earlier. In a sense, he was now attempting to close off a number of the avenues of development which he himself had revealed as a young Communist. Thus, Lukács acknowledges the teleological nature of the labor-process in his densely-argued "Dialectics of Labor: Beyond Causality and Teleology" (see page 16, note 22), but insists that art in some way escapes this aspect of the materialist dialectic despite the evident fact that art is a form of the labor-process. Thus, in his work on the particularity of the aesthetic category, he deals with the transcendent and timeless component of art (citing the famous passage from Marx's Introduction to *A Contribution to the Critique of Political Economy*) but denies that the assumption of a common humanity (Caudwell's genotype) follows from this; instead, he finds the answer in a pseudo-Hegelian category: "this common substratum is the continuity of development, the real transactional reaction of the parts in it, the fact that the development does not originate in its entirety at the beginning, but always proceeds through the results of earlier stages which correspond to needs, and incorporates them."[24] And he attempts to solve the riddle which Marx had posed: why the masterpieces of Greek art still constitute "a source of aesthetic enjoyment and in certain respects prevail as the standard and model beyond attainment" (see above, page 62). Lukács writes that the evocative power of such works "lies in this: that just here one's own past comes to life, made present—and not just the personal history of any single individual, but his history as a member of humanity whose fate is also experienced in works constituting the present. . . . Men experience in great works of art the present and past of humanity, perspectives on its development."[25] Clearly, Lukács was not ready to admit the future into his ontology of art; however, he (almost parenthetically) touches here on the biographical substratum of the individual ("one's own past comes to life") and almost appears to acknowledge some involvement of universal human elements in the impact of art.

Lukács may have been fighting a rear-guard action in his final theoretical works; nevertheless, future attempts by Marxists to overestimate the Utopian component of art, to project the work of art into eternity as a theological substitute, to stress the trajectory of art while downgrading the relevance of its material sources, cannot ignore either the substance or the authority of Lukács' positions.

24. Cited in *Marxism and Art: Writings in Aesthetics and Criticism,* edited by Berel Lang and Forrest Williams (New York, 1972), p. 231.

25. *Ibid.,* p. 233.

It would be both premature and presumptuous to attempt, in a brief space, to deal with Lukács' monumental *Aesthetics*. It is surely the most ambitious and learned Marxist work in this field, and as such will have to be appraised by analysts whose stature is comparable to Lukács' own. The final selection is the Introduction to that work, which sets forth Lukács' intentions: the delimitation of aesthetics from other modes of reaction to objective reality; the demonstration that art rises from everyday life and ultimately is re-assimilated to the daily practical needs of human beings; the restatement of basic Marxist philosophical principles concerning the relationship between consciousness and being, and their application to the problems of aesthetics; the insistence upon the "universality of the reflection of reality as the basis for all interrelationships between man and his environment"; the dialectical essence of art—that it is both a product of social development and a means by which man creates himself. In addition, it contains a brief autobiographical sketch of Lukács' intellectual development, in which he sees his final task to be the redemption of the unfinished aesthetic business of his pre-October period, the realization of "the dream of my youth with an entirely different world concept and method."

At every moment in Lukács' last works one has the sense of being in contact with a great mind and keen intelligence. There is no subject which he fails to illuminate, none where his work does not give rise to larger relevances or to contrary interpretations which flow from his point of departure. If we cannot always agree with his answers, we are constantly aware that he knows all the questions—and on a level not surpassed by any other Marxist critic of the twentieth century.

LUKÁCS: THE IDEOLOGY OF MODERNISM
from *The Meaning of Contemporary Realism*

It is to the credit of Robert Musil that he was quite conscious of the implications of his method. Of his hero Ulrich he remarked: "One is faced with a simple choice: either one must run with the pack (when in Rome, do as the Romans do); or one becomes a neurotic." Musil here introduces the problem, central to all modernist literature, of the significance of psychopathology.

This problem was first widely discussed in the Naturalist period. More than fifty years ago, that doyen of Berlin dramatic critics, Alfred Kerr, was writing: "Morbidity is the legitimate poetry of Naturalism. For what is poetic in everyday life? Neurotic aberration, escape from life's dreary routine. Only in this way can a character be translated to a rarer clime and

yet retain an air of reality." Interesting, here, is the notion that the poetic necessity of the pathological derives from the prosaic quality of life under capitalism. I would maintain—we shall return to this point—that in modern writing there is a continuity from Naturalism to the Modernism of our day—a continuity restricted, admittedly, to underlying ideological principles. What at first was no more than dim anticipation of approaching catastrophe developed, after 1914, into an all-pervading obsession. And I would suggest that the ever-increasing part played by psychopathology was one of the main features of the continuity. At each period—depending on the prevailing social and historical conditions—psychopathology was given a new emphasis, a different significance and artistic function. Kerr's description suggests that in naturalism the interest in psychopathology sprang from an aesthetic need; it was an attempt to escape from the dreariness of life under capitalism. The quotation from Musil shows that some years later the opposition acquired a moral slant. The obsession with morbidity had ceased to have a merely decorative function, bringing colour into the greyness of reality, and become a moral protest against capitalism.

With Musil—and with many other modernist writers—psychopathology became the goal, the *terminus ad quem,* of their artistic intention. But there is a double difficulty inherent in their intention, which follows from its underlying ideology. There is, first, a lack of definition. The protest expressed by this flight into psychopathology is an abstract gesture; its rejection of reality is wholesale and summary, containing no concrete criticism. It is a gesture, moreover, that is destined to lead nowhere; it is an escape into nothingness. Thus the propagators of this ideology are mistaken in thinking that such a protest could ever be fruitful in literature. In any protest against particular social conditions, these conditions themselves must have the central place. The bourgeois protest against feudal society, the proletarian against bourgeois society, made their point of departure a criticism of the old order. In both cases the protest—reaching out beyond the point of departure—was based on a concrete *terminus ad quem:* the establishment of a new order. However indefinite the structure and content of this new order, the will towards its more exact definition was not lacking.

How different the protest of writers like Musil! The *terminus a quo* (the corrupt society of our time) is inevitably the main source of energy, since the *terminus ad quem* (the escape into psychopathology) is a mere abstraction. The rejection of modern reality is purely subjective. Considered in terms of man's relation with his environment, it lacks both content and direction. And this lack is exaggerated still further by the character of the *terminus ad quem.* For the protest is an empty gesture, expressing nausea,

or discomfort, or longing. Its content—or rather lack of content—derives from the fact that such a view of life cannot impart a sense of direction. These writers are not wholly wrong in believing that psychopathology is their surest refuge; it is the ideological complement of their historical position.

This obsession with the pathological is not only to be found in literature. Freudian psychoanalysis is its most obvious expression. The treatment of the subject is only superficially different from that in modern literature. As everybody knows, Freud's starting point was "everyday life." In order to explain "slips" and day-dreams, however, he had to have recourse to psychopathology. In his lectures, speaking of resistance and repression, he says: "Our interest in the general psychology of symptom-formation increases as we understand to what extent the study of pathological conditions can shed light on the workings of the normal mind." Freud believed he had found the key to the understanding of the normal personality in the psychology of the abnormal. This belief is still more evident in the typology of Kretschmer, which also assumes that psychological abnormalities can explain normal psychology. It is only when we compare Freud's psychology with that of Pavlov, who takes the Hippocratic view that mental abnormality is a deviation from a norm, that we see it in its true light.

Clearly, this is not strictly a scientific or literary-critical problem. It is an ideological problem, deriving from the ontological dogma of the solitariness of man. The literature of realism, based on the Aristotelean concept of man as *zoon politikon,* is entitled to develop a new typology for each new phase in the evolution of a society. It displays the contradictions within society and within the individual in the context of a dialectical unity. Here, individuals embodying violent and extraordinary passions are still within the range of a socially normal typology (Shakespeare, Balzac, Stendhal). For, in this literature, the average man is simply a dimmer reflection of the contradictions always existing in man and society; eccentricity is a socially-conditioned distortion. Obviously, the passions of the great heroes must not be confused with "eccentricity" in the colloquial sense: Christian Buddenbrook is an "eccentric"; Adrian Leverkühn is not.

The ontology of *Geworfenheit* makes a true typology impossible; it is replaced by an abstract polarity of the eccentric and the socially-average. We have seen why this polarity—which in traditional realism serves to increase our understanding of social normality—leads in modernism to a fascination with morbid eccentricity. Eccentricity becomes the necessary complement of the average; and this polarity is held to exhaust human potentiality. The implications of this ideology are shown in another remark of Musil's: "If humanity dreamt collectively, it would dream Moosbrugger."

Moosbrugger, you will remember, was a mentally-retarded sexual pervert with homicidal tendencies.

What served, with Musil, as the ideological basis of a new typology—escape into neurosis as a protest against the evils of society—becomes with other modernist writers an immutable *condition humaine.* Musil's statement loses its conditional "if" and becomes a simple description of reality. Lack of objectivity in the description of the outer world finds its complement in the reduction of reality to a nightmare. Beckett's *Molloy* is perhaps the *ne plus ultra* of this development, although Joyce's vision of reality as an incoherent stream of consciousness had already assumed in Faulkner a nightmare quality. In Beckett's novel we have the same vision twice over. He presents us with an image of the utmost human degradation—an idiot's vegetative existence. Then, as help is imminent from a mysterious unspecified source, the rescuer himself sinks into idiocy. The story is told through the parallel streams of consciousness of the idiot and of his rescuer.

Along with the adoption of perversity and idiocy as types of the *condition humaine,* we find what amounts to frank glorification. Take Montherlant's *Pasiphae,* where sexual perversity—the heroine's infatuation with a bull—is presented as a triumphant return to nature, as the liberation of impulse from the slavery of convention. The chorus—i.e. the author—puts the following question (which, though rhetorical, clearly expects an affirmative reply): "Si l'absence de pensée et l'absence de morale ne contribuent pas beaucoup à la dignité des bêtes, des plantes et des eaux . . . ?" Montherlant expresses as plainly as Musil, though with different moral and emotional emphasis, the hidden—one might say repressed—social character of the protest underlying this obsession with psychopathology, its perverted Rousseauism, its anarchism. There are many illustrations of this in modernist writing. A poem of Benn's will serve to make the point:

> O that we were our primal ancestors,
> Small lumps of plasma in hot, sultry swamps;
> Life, death, conception, parturition
> Emerging from those juices soundlessly.
>
> A frond of seaweed or a dune of sand,
> Formed by the wind and heavy at the base;
> A dragonfly or gull's wing—already, these
> Would signify excessive suffering.

This is not overtly perverse in the manner of Beckett or Montherlant. Yet, in his primitivism, Benn is at one with them. The opposition of man as

animal to man as social being (for instance, Heidegger's devaluation of the social as *"das Man,"* Klages' assertion of the incompatibility of *Geist* and *Seele,* or Rosenberg's racial mythology) leads straight to a glorification of the abnormal and to an undisguised anti-humanism.

A typology limited in this way to the *homme moyen sensuel* and the idiot also opens the door to "experimental" stylistic distortion. Distortion becomes as inseparable a part of the portrayal of reality as the recourse to the pathological. But literature must have a concept of the normal if it is to "place" distortion correctly; that is to say, to see it *as* distortion. With such a typology this placing is impossible, since the normal is no longer a proper object of literary interest. Life under capitalism is, often rightly, presented as a distortion (a petrification or paralysis) of the human substance. But to present psychopathology as a way of escape from this distortion is itself a distortion. We are invited to measure one type of distortion against another and arrive, necessarily, at universal distortion. There is no principle to set against the general pattern, no standard by which the petty-bourgeois and the pathological can be seen in their social context. And these tendencies, far from being relativized with time, become ever more absolute. Distortion becomes the normal condition of human existence; the proper study, the formative principle, of art and literature.

LUKÁCS: **SHAKESPEARE AND HISTORICISM**
from *The Historical Novel*

Now we are able to see clearly and provide an answer to the historical question posed at the beginning of this chapter: How was it that when historical consciousness had barely developed or hardly existed at all, that when the historical novel was no more than caricature both of the novel and of history, it was yet possible to have great historical dramas? We are referring here primarily, of course, to Shakespeare and a number of his contemporaries. But not only to them, for some of the tragedies of Corneille or Racine, of Calderon or Lope de Vega are undoubtedly historical tragedies which have a tremendous import and effect. Today it is a well-known fact already that this wave of great drama, and *historical* drama along with it, arose out of the crises and break-up of the feudal system. It is also well-known—and immediately verifiable for anyone who reads Shakespeare's chronicle plays attentively—that the most notable writers of the period had deep insights into the important collisions of this great transitional age. In Shakespeare, especially, a whole set of the inner contradic-

tions of feudalism, pointing inevitably to its dissolution, emerge with the greatest clarity.

However, what interested these writers—and Shakespeare above all— was not so much the complex, actual historical causality responsible for the decline of feudalism, as the human collisions which sprang necessarily and typically from the contradictions of this decline, as the forceful, interesting historical types among the older, declining human stock of feudalism and the new type of hero, the humanist noble or ruler. Shakespeare's cycle of historical plays, in particular, is full of collisions of this kind. With brilliant clarity and discernment he views the welter of contradiction which had filled the uneven but fatal path of feudal crisis over centuries. Shakespeare never simplifies this process down to a mechanical contrast between the "old" and the "new." He sees the triumphant humanist character of the rising new world, but also sees it causing the breakdown of a patriarchal society humanly and morally better in many respects and more closely bound to the interests of the people. Shakespeare sees the triumph of humanism, but also foresees the rule of money in this advancing new world, the oppression and exploitation of masses, a world of rampant egoism and ruthless greed. In particular, the types representing the social-moral, human-moral decay of feudalism are portrayed in his historical plays with incomparable power and realism and sharply opposed to the old, inwardly still unproblematic and uncorrupted, nobility. (Shakespeare feels a keen, personal sympathy for this latter type, at times idealizes him, but as a great, clear-sighted poet regards his doom as inevitable.) His clear eye for the social-moral features which emerge from this violent historical crisis allows Shakespeare to create historical dramas of great historical authenticity and fidelity, even though he has not yet experienced history as history in the sense of the nineteenth century, in the sense of the conception which we have analysed in the work of Scott.

This, of course, has nothing to do with the innumerable, small factual anachronisms in Shakespeare. Historical authenticity, in the sense of costume, objects etc., is always treated by Shakespeare with the sovereign licence of a great dramatist, who knows instinctively how immaterial such small features are as long as the big collision is right. Therefore, Shakespeare states every conflict, even those of English history with which he is most familiar, in terms of typical-human opposites; and these are historical only insofar as Shakespeare fully and directly assimilates into each individual type the most characteristic and central features of a social crisis. Characterizations as of Richard the Second or Richard the Third, contrasts in character as between Henry the Fifth and Percy Hotspur always have

this marvellously observed, social-historical basis. But their dramatic effect is essentially social-moral, human-moral "anthropological"; in all these cases Shakespeare is portraying the most general, regulative features of such social collisions and contradictions.

In this way Shakespeare concentrates the decisive human relations round these historical collisions with a force unparalleled before and after him. With the great tragedian's disregard for so-called probability (which Pushkin always fought passionately in his theoretical writings) Shakespeare always allows the human point to emerge from the historical struggles of his time, but he both concentrates and generalizes it to such a degree that the opposites often acquire an antique clarity and sharpness. There is the sense of a classical chorus when, in the third part of Henry the Sixth, Shakespeare brings onto the battlefield a son who has killed his father and a father who has killed his son, and the son says:

> From London by the king was I press'd forth;
> My father, being the Earl of Warwick's man,
> Came on the part of York, press'd by his master;
> And I, who at his hands receiv'd my life,
> Have by my hands of life bereaved him.

Then, later in the scene:

> SON
> Was ever son so rued a father's death?
> FATHER
> Was ever father so bemoan'd his son?
> KING HENRY
> Much is your sorrow; mine ten times so much.
> Was ever king so griev'd for subjects' woe?

Similar features can be pointed out at all the great moments of these plays. Shakespeare always looks for these magnificent human confrontations in history and finds them in the real historical struggle of the War of the Roses. He is historically faithful and authentic because the human features absorb the most essential elements of this great historical crisis. Let us point to just one example, Richard the Third's wooing of Anne. The immediate content of this scene is a human-moral one, no more than the measuring of two human wills. But this very character of the scene bears tremendous historical witness to the magnificent energy and thoroughly amoral cynicism of the most significant figure produced by this period of dissolution, namely the last tragic protagonist of the civil war of the nobles.

It was not by chance that Shakespeare, at the height of his powers, should have abandoned historical subjects in the narrow sense. Yet he remained true to history in the sense in which he experienced it, and produced even more magnificent canvases of this historical transition than in his chronicle plays. For in the great tragedies of his maturity (*Hamlet, Macbeth, Lear* etc.) he used the legendary anecdotal material of the old chronicles in order to concentrate certain social-moral problems of this transition crisis even more powerfully than was possible when tied to the events of English history. These great tragedies breathe the same historical spirit as the historical plays in the narrower sense, except that they retain no more of external events, of the (from a dramatic point of view) accidental ups and downs of the social struggles of real history, than is indispensable to the crystallization of the central human-moral problem. For this reason the great tragic figures of Shakespeare's maturity are the most colossal historical types of this transition crisis. Precisely because Shakespeare was able to proceed here with greater dramatic concentration and a more "anthropological" kind of characterization than in the "histories," these great tragedies are historically more profound and true in Shakespeare's sense than the latter.

It would be quite wrong to view Shakespeare's adaptation of legendary material as a form of "modernization" in the modern sense. There are important critics who consider that the Roman plays, written concurrently with the great tragedies, really portray English events and English characters and simply use the ancient world as costume. (At times we find similar statements even in Goethe.) But in judging these plays what matters is precisely the generalizing nature of Shakespeare's characterization, the extraordinary breadth and depth of his insight into the various currents forming the crisis of his period. And the classical world is a living social-moral force in this period; it is not felt as a distant past to which one has to reach back. Thus when Shakespeare portrays Brutus, say, he can see the stoic features of aristocratic republicanism in living evidence about him in his own time. (Think, for example, of the friend of Montaigne's youth, Etienne de la Boëtie.) Since Shakespeare was familiar with this type and his deepest social-human characteristics, he was able to adapt from Plutarch's history those features which the two periods had in common, historically and "anthropologically." Thus, he does not simply inject the spirit of his period into the ancient world, but rather brings to life those tragic events of antiquity which were based on historical-moral experiences inwardly similar to those of his own time; so that the generalized form of the drama reveals the features which the two ages hold objectively in common.

For this reason, the Roman plays belong stylistically alongside the great tragedies of Shakespeare's maturity. In them he concentrates the most general tendencies of crisis in his epoch round some important collision which has typical universality and depth. In them, the first real historical drama reached its climax—and this historical drama owed its existence to the first transition crisis of the rising new society.

LUKÁCS:
INTRODUCTION TO A MONOGRAPH ON AESTHETICS
from *The Specific Nature of the Aesthetic*

The book herewith presented to the public forms the first part of an Aesthetics, centering in the philosophic foundations of the aesthetic *Setzung* (setting), the derivation of the specific category of aesthetics, its delimitation from other areas. By concentrating on this complex of problems and touching concrete questions of aesthetics only where it is required in order to clear up the problems, this volume forms a closed entity in itself and is also completely comprehensible without those that are to follow.

It is indispensable to delineate the place of the aesthetic attitude in the totality of human activities, in human reactions to the outside world, the relationship of the aesthetic form created by the latter and its categoric construction (its structure, etc.) with other types of reaction to objective reality. Impartial observation of this relationship provides, in rough outlines, the following picture. The behaviour of man in everyday life is the most important, though it is still largely unexplored in spite of its central importance for the understanding of higher and more complicated types of reaction. Without wishing to anticipate the detailed explanations given in the work itself, it is necessary to mention here briefly the basic ideas of the construction. The everyday behaviour of man is both the starting and end point of all human activity. This means that if we imagine everyday life as a huge stream, science and art branch from it in higher forms of reception and reproduction of reality, become differentiated and take shape according to their specific aims, achieve their pure form in this characteristic stemming from the needs of life in society, to return at last—as a result of its effect, its influence on the life of people—into the stream of everyday life. Thus, this stream is constantly enriched by the highest achievements of the human mind, assimilates these to its daily, practical needs, from which new branches of higher forms of objectivization arise as questions and demands. Such a process calls for thorough investigation of the complicated mutual relationship between the immanent consummation of works

of science and art and the social needs giving rise to them. The special categories and structures of man's scientific and artistic reactions to reality can only be derived from this dynamics of genesis, of development, of self-regulation, of being rooted in the life of mankind. The reflections in the present work are of course directed towards recognition of the particularity of the aesthetic. However, since people live in a single reality, with which they stand in mutual relationship, the essence of the aesthetic can only be understood even approximately in constant comparison with other types of reaction. The relationship to science is the most important, but it is also indispensable to discover the connections with ethics and religion. Even the psychological problems appearing here occur as necessary consequences of questions aimed at what is specific in aesthetic *Setzung*.

Of course, no aesthetics can stop at this stage. Kant could still be satisfied with answering the general methodological question of the claim to validity of aesthetic judgments. Irrespective of our opinion that this question is not a primary one but, as far as the construction of aesthetics is concerned, highly derivative, no philosopher who seriously undertakes to clarify the essence of the aesthetic, can—since the Hegelian aesthetics—be satisfied with such a narrowly confined frame and with a placing of the problem so onesidedly oriented towards the theory of cognition. The present text, both in its basic outlook and in its detailed considerations, will frequently deal with questionable aspects of Hegelian aesthetics; nevertheless, the philosophic universality of its concept, its historico-systematic synthesis remain a permanent model for the outline of any aesthetics. Only the three parts of this aesthetics together may achieve a partial approach to this high example. For, quite apart from the knowledge and talent of anyone undertaking such an experiment today, the standards of universality set up in Hegelian aesthetics are objectively much more difficult to transform into practice at present than in Hegel's time. The historico-systematic theory of the arts, discussed in detail by Hegel, thus remains outside the area circumscribed by the plan of this whole work. Part Two—bearing the provisional title: "Works of Art and Aesthetic Attitude"—will, in the main, deal concretely with the specific structure of the work of art, which in Part One is derived and outlined only in general form; the general categories arrived at in Part One can only then obtain their real and defined physiognomy. The problems of content and form, *Weltanschauung* and selection of form, technique and form, etc., can emerge in Part One only in general, as questions on the horizon; their concrete nature can be illuminated philosophically only during the detailed analysis of the structure of art works. The same applies to the problems of creative and receptive attitudes. Part One can advance only to their general outline, rendering the

methodological "place" according to the possibility of determination. Also, the real relationship between everyday life on the one hand and scientific, ethical, etc., attitudes and aesthetic production and reproduction on the other, the categoric essence of their proportions, interrelations, effects, etc., demand most concrete analyses, which could not be included in Part One in principle, directed as it is towards the philosophic foundations.

The situation is similar as regards Part Three. (Its provisional title is: "Art as a Socio-historical Phenomenon.") Yet Part One unavoidably already contains not only some historical excursions but constantly refers to the original historic nature of each aesthetic phenomenon. The historico-systematic character of art was first formulated, as mentioned before, in Hegel's aesthetics. The rigidity of the Hegelian systematization deriving from its objective idealism has been corrected by Marxism. The complicated mutual relationship between dialectical and historical materialism is in itself a significant indication that Marxism does not seek to deduce historical stages of development from the internal development of the idea, but on the contrary strives at grasping the real process in its complicated historico-systematic determination. The unity of theoretic (in this case: aesthetic) and historical determination is realized in its final consequence in an extremely contradictory manner and can therefore be penetrated, both in principle and in single concrete cases, only through an uninterrupted cooperation between dialectical and historical materialism.[1] Aspects of dialectical materialism dominate in Parts One and Two of this work, as it aims at giving conceptual expression to the essence of the aesthetic. There is, however, hardly any problem that can be solved without at least an indicative clarification of the historical aspects inseparably united with aesthetic theory. Part Three is dominated by the method of historical materialism, because the historical determinants and characteristics of the genesis of the arts, their development, their crises, their leading or subordinate role, etc., are in the foreground of its interest. Its task is to investigate first of all the problem of uneven evolution in the genesis, in the *Sein und Werden* (being and becoming) and in the effect of the arts. At the same time this means a breach with all "sociological" vulgarization of the origin and effect of the arts. Such a permissibly simplifying socio-historical analysis is, however, impossible without making constant use of the results of dialectical-materialist research into the categoric construction, structure and disposition of each art in order to perceive its historical character. The

1. Tendencies towards the vulgarization of Marxism during the Stalin era are also revealed by the fact that dialectical materialism and historical materialism were temporarily treated as separate sciences and "specialists" were even trained for each of these branches.

permanent and living mutual influence of dialectical and historical mate-
rialism is shown here from another side, but no less intensively than in the
two first parts.

As the reader may see, the construction of these aesthetic investigations
differs rather strongly from the usual. This does not, however, imply an
originality of method. On the contrary, the investigations involve no more
than as correct as possible an application of Marxism to the problems of
aesthetics. If such a definition of the task is not to be misinterpreted from
the outset, it is necessary to explain, if only in a few words, the position
and relationship of this aesthetics to that of Marxism. When I wrote my
first contribution to the aesthetics of Marxism about thirty years ago,[2] I
advocated the thesis that Marxism had its own aesthetics, and my view met
with considerable resistance. The reason was that, prior to Lenin, Marx-
ism, even in its best theoretical representatives such as Plekhanov or
Mehring, limited itself almost entirely to the problems of historical mate-
rialism.[3] Only since Lenin has dialectical materialism returned to the
centre of interest. This is why Mehring, who incidentally based his aes-
thetics on Kant's "Critique of Judgment," could see in the divergencies
between Marx–Engels and Lassalle no more than the clash of subjective
judgments of taste. This controversy has, of course, long been solved. Since
the brilliant study by M. Lifschitz on the evolution of the aesthetic views of
Marx, since his careful collection and systematization of the scattered
utterances of Marx, Engels and Lenin on aesthetic questions, there can be
no more doubt about the connection and cohesion of their train of thought.[4]

However, the demonstration and proof of such a systematic connection
is still far from solving with finality the demand for an aesthetics of Marx-
ism. If aesthetics or at least its perfect skeleton were explicitly included in

2. "The Sickingen debate between Marx-Engels and Lassalle," in Georg Lukács:
Karl Marx und Friedrich Engels als Literaturhistoriker (Berlin, 1948, 1952).

3. F. Mehring, *Gesammelte Schriften und Aufsätze* (Berlin, 1929); now: *Gesam-
melte Schriften* (Berlin, 1960 ff.); by the same author: *Die Lessing Legende* (Stuttgart,
1898, last edition Berlin, 1953); G. W. Plekhanov, *Kunst und Literatur,* translated
from Russian into German by J. Harhammer (Berlin, 1955).

4. M. Lifschitz, *Lenin o kulture i isskustwe, Marksistsko-Leninskoje isskustwos-
nanije* ("Lenin on Culture and Aesthetics, Marxist–Leninist Aesthetics") (Moscow,
1932); by the same author: "Karl Marx und die Aesthetik," *Internationale Literatur,*
III/2/1933/127 ff.; M. Lifschitz and F. Schiller, *Marx i Engels o isskustwe i literature*
("Marx and Engels on Art and Literature") (Moscow, 1933); *Karl Marx-Friedrich
Engels, Über Kunst und Literatur* (publ. by M. Lifschitz [1937] German edition by
Kurt Thoricht—Roderich Fechner, Berlin, 1949); M. Lifschitz, *The Philosophy of
Art of Karl Marx,* translated by R. Winn (New York, 1938); by the same author:
Karl Marx und die Aesthetik (Dresden, 1960).

the collected and systematically arranged utterances of the classics of Marxism, then nothing but a good running commentary would be needed in order to present us with a complete Marxist aesthetics. But there can be no question of this! Ample experience shows that not even a direct monographic application of this material to each particular question can provide what is scientifically essential for the construction of the whole. One has to face the paradoxical situation that a Marxist aesthetics does exist and does not exist at one and the same time, that it still has to be conquered, even created through independent research, and that the result still only presents and fixes something already existing conceptually. This paradox, nevertheless, resolves itself upon considering the whole problem in the light of the method of materialistic dialectics. The age-old literal sense of Method, indissolubly connected with the path to cognition, contains the demand upon thinking that it should follow definite paths to definitive results. The direction of these paths is with indubitable evidence included in the totality of the world concept provided by the classics of Marxism, especially as the end-stations of such paths are set clearly before us by the results at our disposal. The paths to be followed and the methods to be met are—though not directly and not visibly at first glance—clearly indicated by the method of dialectical materialism, if one wishes to establish the essence (*auf den Begriff bringen*) of objective reality and to examine the reality of a particular area in accordance with its truth. Only if this method, this direction has been practiced and followed through one's own independent research, does the possibility arise of finding what one is looking for, of correctly constructing Marxist Aesthetics, or at least of approaching its true nature. Whoever entertains the illusion of mentally reproducing reality and at the same time Marx's conception of reality through mere interpretations of Marx, is bound to miss both. Only an unbiased observation of reality and its elaboration through the method discovered by Marx can achieve fidelity to both reality and to Marxism. In this sense, though each part and the whole of this work is the result of independent research, it cannot claim originality, as its means of approaching truth and its entire method is based on the study of the oeuvre handed down by the classics of Marxism.

Fidelity to Marxism, however, means at the same time attachment to the great traditions of the mental mastering of reality to date. In the Stalin era, especially on the part of Zhdanov, those features were exclusively emphasized that separate Marxism from the great traditions of human thought. If this had resulted only in stressing what was qualitatively new in Marxism, viz., the leap that separated its dialectics from its most developed predecessors, say from Aristotle or Hegel, it could have been relatively justified. Such a viewpoint could even have been considered necessary and useful,

ad it not—in a deeply undialectical way—onesidedly isolated and therefore metaphysically emphasized the radically new in Marxism, and had it not neglected the aspect of continuity in the evolution of human thought. But reality—and therefore its mental reflection and reproduction as well—is a dialectical unity of continuity and discontinuity, of tradition and evolution, of gradual transition and leaps. Scientific socialism itself is something completely new in history, yet at the same time it fulfils a human longing that has existed for thousands of years, something the best minds of humanity deeply strove for. The situation is the same with the conceptual recognition of the world through the classics of Marxism. The deep influence of Marxism, which cannot be shaken by any attacks or by silence, rests not least on the fact that with its aid the basic facts of reality, of human life are revealed and become the content of human consciousness. This gives a double meaning to the new phenomenon: not only does human life receive a new content, a new significance through the previously non-existent reality of socialism, but at the same time the present and past that were considered as known, all of human existence, are newly illuminated through the de-fetishization achieved by the Marxist method and research and its results. All past efforts to seize it in its truth thus become comprehensible in an entirely new sense. Perspectives of the future, recognition of the present, insight into the tendencies that have brought it forth in thought and practice, thus form an indissoluble mutual relationship. One-sided emphasis on what separates and is new, conjures up the danger of confining everything concrete and rich in determinations in the genuinely new in an abstract otherness, and thereby impoverishing them. Confrontation of the characterization of dialectics in Lenin and in Stalin shows the consequences of such a methodological difference quite clearly; and the frequent unreasonable attitudes towards the inheritance of Hegelian philosophy led to an often frightening poverty of content in the logical investigations of the Stalin era.

In the classics themselves there is no trace of such metaphysical confrontation of old and new. Their relationship is manifested rather in the proportions produced by socio-historical evolution itself through letting the truth make its appearance. Insistence on this only correct method is, if possible, even more important in aesthetics than in other areas. For here an exact analysis of the facts will show with special clarity that conceptual consciousness of the practical achievements in the domain of aesthetics always lags behind such achievements. This is why those few thinkers who relatively early attained clarity regarding the real problems of aesthetics have become extraordinarily significant. On the other hand—as our analysis will show—often apparently distant trains of thought, e.g., philosophi-

cal or ethical, are very important for the understanding of aesthetic phenomena. Without anticipating too much of what has its appropriate place in the detailed considerations, let us only mention here that the entire construction and all explanatory details of this work—just because it is indebted to the Marxian method for its existence—are deeply determined by the results achieved by Aristotle, Goethe and Hegel in their various writings, not only those dealing directly with aesthetics. If, in addition, I express my gratitude to Epicurus, Bacon, Hobbes, Spinoza, Diderot, Lessing and the Russian revolutionary-democratic thinkers, I have, of course, only enumerated the names most important to me; this does not exhaust by far the list of authors to whom I feel obliged for this work, in its entirety as well as in its details. The manner of quoting corresponds to this conviction. There is no intention of discussing problems concerning the history of the arts or of aesthetics. What we are interested in is the clarification of facts or lines of evolution that are important for the general theory. Therefore, in harmony with the particular theoretical constellation, those authors or works will be quoted who either expressed something— correct or significantly false—for the first time, or whose opinion appears especially characteristic of a certain stage of development. It would not correspond to the intentions of this work to strive for completeness in citing literary evidence.

It follows from what has been said so far that the polemic edge of the entire work is directed against philosophical idealism. The fight against its theory of cognition would naturally exceed the framework of this work; we are concerned with the specific questions in which philosophic idealism has proved to be an obstacle to the adequate comprehension of specifically aesthetic facts. We shall speak of the confusions that arise when aesthetic interest centres on beauty (and perhaps on its salient features) mainly in the Second Part; here this group of questions will only be touched on casually. It is the more important, in our opinion, to refer to the necessarily hierarchical character of any idealistic aesthetics. For, if the various forms of consciousness figure as ultimate determinants of the objectivity (*Gegenständlichkeit*—quality of being objects) of all things investigated, of their place in the system, etc., and are not—like in materialism—considered as types of reaction to something objectively existing and already concretely formed, independently from consciousness, then they necessarily become the supreme judges of mental order and construct their system hierarchically. Historically the degrees such a hierarchy contains differ widely. But this will not be discussed here, as we are solely concerned with the very essence of any such hierarchy, which falsifies all objects and relationships. It is a widely spread misunderstanding to believe that the materialistic

conception of the world—priority of being over consciousness, of social being over social consciousness—is also of a hierarchical character. For materialism, the priority of being is above all the establishment of a fact: being exists without consciousness, but no consciousness exists without being. But no hierarchical subordination of consciousness to being follows from this. On the contrary, only this priority and its concrete theoretical and practical recognition by consciousness create the possibility of a real conquest of being through consciousness. The simple fact of work is a striking illustration of this. And if historical materialism states the priority of social being over social consciousness, this again is a mere recognition of an existing fact. Social practice too is directed towards dominating social being; nor does the fact that it has been able to achieve its aim in a very relative degree up to the present set up a hierarchical relationship between the two, but merely determines those concrete conditions in which successful practice becomes objectively possible, while at the same time, of course, determining its concrete limits, the scope offered by the respective social being for the unfolding of consciousness. Thus, historical dialectics—and by no means a hierarchical structure—becomes visible in this relationship. If a little sailing boat proves to be helpless against a storm easily overcome by a mighty steamer, it is only the real superiority or limitation of the particular consciousness in the face of being that becomes apparent, not a hierarchical relationship between man and the forces of nature; the more so as historical evolution—and with it the growing comprehension by consciousness of the true quality of being—constantly increases the possibilities of rule by the former over the latter.

Philosophical idealism has to design its world concept in a radically different way. It is not the real and changing relationship of forces that create a temporary superiority or inferiority in life; but from the outset there is a hierarchy of those potentialities of consciousness that not only produce and arrange the forms of objectivity and the relations between the objects, but are also mutually linked by hierarchical degrees. To elucidate the situation in the light of our problem: when Hegel classifies art under apprehension (*Anschauung*), religion under perception (*Vorstellung*), philosophy under concept (*Begriff*), and considers them as ruled by these forms of consciousness, then an exact, "eternal," irrefutable hierarchy has been created, which—as everybody familiar with Hegel knows—determines also the historical fate of art. (That the young Schelling fits art into his hierarchical order in a contrary manner does not alter the principles.) It is obvious that an entire knot of pseudo-problems is thereby created, which has caused methodological confusion in every aesthetics since Plato. Regardless of whether idealistic philosophy, from a particular aspect,

establishes a superiority or inferiority of art with respect to other forms of consciousness, thought is diverted from the investigation of the specific characteristics of objects, and the latter will—often quite inadmissibly—be brought to a common denominator to make possible their comparison within a hierarchical order and their insertion at the desired hierarchical level. Whether we are concerned with problems of the relationship of art to nature, to religion or to science, etc., the pseudo-problems must everywhere cause distortions in the forms of objectivity, in the categories.

The significance of the break thus brought about with every kind of philosophical idealism becomes even more obvious in its consequences if we further concretize our materialistic point of departure, viz., if we comprehend art as a peculiar manifestation of the reflection of reality, a manifestation which itself is but one among various forms of the universal relationship of man to reality, of man's reflection of reality. One of the most decisive basic ideas of this work is that all types of reflection—we analyse primarily those of everyday life, of science and of art—always picture the same objective reality. This starting point, however obvious and even trivial it may appear, has far-reaching consequences. Since materialistic philosophy does not consider all forms of *Gegenständlichkeit,* all categories belonging to objects and their relations, as products of a creative consciousness, as idealism does, but rather sees in them an objective reality existing independently of consciousness, all divergencies and even contradictions can arise within this materially and formally united reality. To be able to understand the complicated dialectics of this unity of unity and diversity, one has to break first with the widely held idea of a mechanical, photographic reflection. If this were the basis from which the differences grow, then all specific forms would have to be subjective disfigurements of this only "authentic" reproduction of reality, or the differentiation would have to possess a purely ulterior, completely unspontaneous, only consciously-mental character. However, the extensive and intensive infiniteness of the objective world compels all living creatures, above all man, to adaptation, to unconscious selection in reflection. The latter—despite its fundamentally objective character—thus also possesses inescapable subjective components, which at the animal level are purely physiologically conditioned, while with man they are, in addition, socially conditioned. (Effect of work on enrichment; expansion, intensification, etc., of human capacity to reflect reality.) Differentiation—especially in the areas of science and art—is a product of social being, of the needs growing from its soil, of man's adaptation to his environment, of the increase in his capabilities correlated to the necessity of becoming equal to entirely novel tasks. True, physiologically and psychologically these reciprocal effects, these

adaptations to the new must be achieved directly within the individual, but they acquire from the outset a social universality, because the new tasks, the new circumstances that have a modifying influence, are endowed with a universal (social) quality and permit of individual-subjective variants only within this social scope.

The elaboration of the specific traits of the aesthetic reflection of reality takes up a qualitatively and quantitatively decisive part of the present work. These investigations are, in accordance with its basic aim, of a philosophic character, i.e., they are centered on the question of what are the specific forms, relations, proportions, etc., acquired by the world of categories in the aesthetic *Setzung* common to every reflection. Of course, psychological problems are unavoidably broached as well, and a special chapter (the eleventh) is devoted to them. It has to be emphasised, furthermore, that the basic philosophic aim necessarily dictates primarily the elaboration, in all the arts, of the common aesthetic traits of reflection, though—in harmony with the pluralistic structure of the aesthetic sphere— the peculiarities of the individual arts will as far as possible be considered in the treatment of the category problems. The very particular phenomenal form of the reflection of reality in such arts as music or architecture make it inevitable to devote a separate chapter (the fourteenth) to these special cases, with a view to clarifying these specific differences in such a way as to preserve in them at the same time the validity of general aesthetic principles.

This universality of the reflection of reality as the basis for all interrelationships between man and his environment has, in the final analysis, very far-reaching ideological consequences with regard to the concept of the aesthetic. For every consistent idealism, any form of consciousness of significance in human existence—in our case the aesthetic—must be of a "timeless," "eternal" nature, as its genesis is explained hierarchically in connection with a world of ideas; insofar as it can be treated historically, this is done within a metahistorical framework of "timeless" being or validity. However, this apparently formal methodological position must necessarily become converted into content, into *Weltanschauung*. For it necessarily follows that the aesthetic belongs to the "essence" of man both productively and receptively, whether it be determined from the standpoint of the world of ideas or the world spirit, anthropologically or ontologically. Our materialistic outlook must produce an entirely opposite picture. Objective reality, which appears in the various types of reflection, is not only subject to permanent change, but the latter bears evidence of well-determined directions, lines of evolution. Reality itself, in accordance with its objective nature, is historical; the historical determinants of content and

form appearing in the various reflections are correspondingly only more or less correct approximations to this aspect of objective reality. A definite historicity can, however, never consist in a mere change of content of unchanging forms, with unalterable categories. This change of content must have a modifying influence on the forms, must lead first to certain functional shifts within the categorical system, and at a certain stage even to explicit transformations: the creation of new and the disappearance of old categories. A certain historicity of the doctrine of categories follows from that of objective reality.

Of course, one has to be most careful as to the degree and extent to which such changes are of an objective or of a subjective quality. Although we hold the view that in the last analysis nature too has to be considered historically, the single steps of this evolution with its objective changes have hardly any importance for science. All the more important is the subjective history of the discovery of objectivities, relationships, categorical connections. Only in biology might it be possible to ascertain a turning-point and hence an objective genesis in the formation of the objective category of life—at least in the part of the Universe known to us. The situation is different qualitatively where man and human society are concerned. Here we are undoubtedly faced with the genesis of single categories and of categorical connections that cannot be "derived" from the mere continuity of evolution so far; this genesis sets special claims to cognition. It would, however, lead to a distortion of the true facts if we wanted to separate methodologically the historical exploration of the genesis from the philosophical analysis of the phenomenon brought forth by it. The true categorical structure of each such phenomenon is most intimately connected with its genesis; the demonstration of a categorical structure is possible—completely and in its right proportions—only when the objective dissection is organically connected with clarification of the genesis; the derivation of value at the beginning of Marx's *Capital* is the best example of this historico-systematic method. Such an amalgamation will be attempted in the concrete explanations of the present work concerning the basic phenomenon of the aesthetic and its sundry branches. This methodology becomes a matter of *Weltanschauung* insofar as it involves a radical break with all those views that perceive in art, in the artistic attitude, some extrahistorical, idea-like phenomenon or at least something belonging ontologically or anthropologically to the "idea" of man. Like work, science and all social activities of man, art too is a product of social development, of man becoming man through his work.

Even beyond this, however, the objective historicity of being and its peculiarly emphatic appearance in human society have important conse-

quences for grasping in principle the specific quality of the aesthetic. It will be the task of our detailed explanations to demonstrate that the scientific reflection of reality seeks to free itself from all anthropological, sensual and mental determinations, and that it endeavours to portray all objects and their relations as they are in themselves, independent of consciousness. Aesthetic reflection, on the other hand, sets out from the world of man and is directed towards it. As will be explained in due course, this does not mean a simple subjectivism. On the contrary, the objectivity of the objects is preserved, but in such a way that every typical form of relatedness to human life is included in it, so that its appearance corresponds to the particular stage of man's interior and exterior development, which is a social development. This means that every aesthetic formation includes— and takes its due place in—the *hic et nunc* of its genesis as an essential aspect of its decisive objectivity. Every reflection is, of course, determined objectively by the fixed place of its realization. Even in the discovery of truths in mathematics or in pure natural sciences, the point in time is never accidental; however, this is of objective importance more for the history of science than for knowledge itself, from the point of view of which it may be considered completely indifferent when and under what—necessary—historical conditions, say, the Pythagorean proposition was first formulated. Without entering here into a discussion of the complicated situation in social sciences, it must be stated that the effect of the temporal position may, in its varying forms, obstruct the elaboration of real objectivity in the reproduction of socio-historical facts. The opposite is true as regards the aesthetic reflection of reality: never yet has a significant work of art taken shape without creatively bringing to life the respective historical *hic et nunc* at the portrayed moment. Regardless of whether the artists concerned are conscious of this or create in the belief that they produce something time- less, continue an earlier style, materialise an "eternal" ideal taken from the past, their works, if artistically genuine, grow out of the deepest en- deavours of the era of their production; content and form of truly artistic works cannot be separated from this soil of their genesis just from the standpoint of aesthetics. It is precisely in works of art that the historicity of objective reality receives its subjective as well as its objective shape.

This historical nature of reality leads to another important set of prob- lems, which is primarily also of a methodological nature but, like every problem of a correctly—and not just formally—understood methodology, turns necessarily into a matter of *Weltanschauung*. We have in mind the problem of *Diesseitigkeit* (immanence). Considered purely methodologi- cally, immanence is an essential demand of scientific cognition as well as of artistic creation. Only when a set of phenomena appears as being fully

comprehended purely through its immanent qualities, through the equally immanent laws affecting it, can it be considered as scientifically known. In practice, of course, such perfection is always only approximate; the extensive and intensive infiniteness of objects, their static and dynamic relations, etc., do not allow any perception in its respective given form to be regarded as absolutely final and as forever excluding corrections, limitations, extensions, etc. This "not yet" in the scientific conquest of reality has in the most varied ways, from magic to modern positivism, been interpreted as transcendency, irrespective of the fact that much that was once classed as *ignorabimus* has long since become part of exact science as a soluble, if perhaps practically still unsolved, problem. The rise of capitalism, the relationship between science and production, combined with the great crises of religious ideologies, have replaced naive transcendency by a complicated and more refined one. Already at the time when the defenders of Christendom attempted to rebuff the Copernican theory ideologically the new dualism was formed: a methodological conception that connects the immanence of the given world of phenomena with the denial of its ultimate reality, so as to dispute the competence of science to declare something valid about this world. On the surface, the impression may arise that the devaluation of the world's reality does not matter, since, in practice, people can fulfil their immediate tasks in production, whether they consider the object, means, etc., of their activity as things that exist in themselves or as mere apparitions. However, such a view is sophistic for two reasons. First, every active man is always convinced in real practice that he is dealing with reality itself; even the positivist physicist is convinced of this when, e.g., carrying out an experiment. Second, such a view, if it is—for social reasons—deeply rooted and widely held, disintegrates the more mediate spiritual-moral relations of man to reality. Existentialist philosophy, in which man, "thrown" into the world, faces the Nothing, is—from a socio-historical viewpoint—the necessary complementary antipole of the philosophic development leading from Berkeley to Mach or Carnap. The real battlefield between *Diesseitigkeit* and *Jenseitigkeit* (transcendence) is, beyond question, ethics. For this reason, the decisive determinations of this controversy can only be touched on but not fully explained in the present work; the author hopes before long to be able to present his views in systematic form on these questions too. Let us only note here briefly that the old materialism—from Democritos to Feuerbach—was able to explain the immanence of the structure of the world only in a mechanical way; and therefore, on the one hand, the world could still be conceived as a clockwork needing transcendental influence to set it in motion; in such a world concept, on the other hand, man could only appear as the necessary prod-

uct and object of immanent worldly laws, leaving his subjectivity, his practice unexplained. Only the Hegel-Marxian doctrine of man's self-creation through his work, which Gordon Childe in a fortunate turn of phrase has formulated as "man makes himself," has completed this immanence of the world concept and created the ideological basis for an immanent-worldly ethic, the spirit of which has been alive for long in the ingenious ideas of Aristotle and Epicure, Spinoza and Goethe. (In this connection, the theory of evolution in the living world, the constantly closer approach towards the origin of life from the reciprocal effects of physical and chemical laws, of course, plays an important role.)

For aesthetics, this question is of the greatest importance and will consequently be fully set forth in the detailed elaboration of the present work. It would serve no purpose to anticipate here briefly the results of these investigations, which can only possess convincing force through development of all factors concerned. Nevertheless, to avoid hiding the author's standpoint in the Foreword, it will suffice to say that the immanent *Geschlossenheit* (enclosedness), *Aufsichselbstgestelltsein* (self-centredness) of every genuine work of art—form of reflection that has no analogy in other domains of human reaction to the outside world—always willy-nilly expresses in its contents an avowal of *Diesseitigkeit*. Therefore, the contrast between allegory and symbol is, as Goethe so ingeniously recognized, a question of "to be or not to be" for art. Therefore, as will be shown in a separate chapter (the sixteenth), art's struggle to liberate itself from the tutelage of religion is a fundamental fact in its formation and development. The genesis has to demonstrate how art has fought its way from the natural conscious confinement of primitive man to transcendency, without which initial stages would be unimaginable in any area, to a certain independence in the reflection of reality, to its peculiar elaboration. What is of moment here, is the evolution of objective aesthetic facts and not what their executors thought of their own actions. Especially in artistic practice, the divergence between action and consciousness of it is especially considerable. Here the motto of our whole work, taken from Marx: "They know it not, but they do it," takes on special significance. It is thus the objective categorical structure of the work of art that again changes into *Diesseitigkeit* every trend of consciousness towards the transcendent, a tendency that is naturally very frequent in the history of mankind; it achieves this by appearing as what it is, as part of human life, immanent as a symptom of its momentary *Geradesoseins* (being just so). The frequent rejection of art, of the principle of aesthetics, from Tertullian to Kierkegaard, is nothing accidental, but rather the recognition of its true nature by the camp of its born enemies. Nor does the present work simply register these inevitable

struggles, but takes a resolute stand in them: for art, against religion, in the sense of a great tradition that extends from Epicure through Goethe to Marx and Lenin.

The dialectical development, dissection and reunion of such manifold, contrasting, converging and diverging determinations of *Gegenständlichkeiten* and their relationships require a proper method for their presentation. In briefly explaining here its fundamental principles the author in no way wishes to use the Foreword as a means of justifying the method of presentation. Nobody can see its limits and faults clearer than the author himself. He only wishes to stand up here for his intentions; he is not entitled to pass judgment as to where he has duly realized them and where he has failed. Thus, in what follows only the principles will be dealt with. These are rooted in materialistic dialectics, the consistent carrying out of which, in such an extensive area comprising so many remote subjects, calls above all for a break with the formalistic means of presentation that rest on definitions and mechanical delimitations and on "neat" compartmentation in subdivisions. If, in order, at a single stroke, to reach the centre, we set out from the method of determinations (*Bestimmungen*), as opposed to that of definitions, then we return to the dialectical foundations of reality, the extensive and intensive infiniteness of objects and their interrelations. Every attempt to grasp this infiniteness mentally is bound to have imperfections. Definition, however, fixes its own partiality as something final and must therefore violate the fundamental character of the phenomena. Determination is considered from the outset as something provisional, needing completion, something whose very nature requires it to be carried on, developed, specified. This means that whenever, in the present work, an object, a relationship of *Gegenständlichkeiten,* a category is moved into the light of conceptuality and concreteness through its determinations, it always involves a dual meaning and intention: to denote the respective object in such manner that it is recognized as something unmistakable, without however claiming that recognition at this stage should comprise totality and that one should therefore stop there. The object can be approached only gradually, step by step, by examining one and the same object in various contexts, in various relationships to various other objects, whereby the initial determination is not cancelled in the process—otherwise it would have been false—but on the contrary is constantly enriched and, as it were, steals ever closer upon the infiniteness of the object towards which it is directed. This process takes place in the most varied dimensions of the mental reproduction of reality and can in principle be treated as completed only relatively. If, however, this dialectic is applied correctly, there is a constantly increasing advance in clarity and richness of

the determination concerned and of its systematic coherence; it is therefore necessary to distinguish the reappearance of the same determination—in various constellations and dimensions—from simple repetition. Progress so achieved is not only a step forward, a deepening penetration into the nature of the object to be grasped, but it will at the same time—if performed really correctly, really dialectically—throw new light on the road already traversed in the past; indeed, only now will it become passable in a deeper sense. In the days when my first, very inadequate attempts in this direction appeared, Max Weber wrote me that they had a similar effect to Ibsen's dramas, the beginning of which only became comprehensible from their ending. I saw in this a clear understanding of my intentions, even though the work in question did not merit such praise. Perhaps, so I hope, the present effort may lay more claim to being the realization of such a method of thought.

Finally, the reader should permit me to refer quite briefly to the origin of my Aesthetics. I set out as a literary historian and essayist, who sought theoretical support in the aesthetics of Kant and, later, of Hegel. In the winter of 1911/12, in Florence, the first plan for an independent, systematic Aesthetics arose, on which I worked in Heidelberg between 1912 and 1914. I am still grateful for the sympathetically critical interest that Ernst Bloch, Emil Lask and above all Max Weber displayed towards my attempt. It failed completely. And if I here passionately oppose philosophical idealism, this criticism is directed against the tendencies of my youth as well. Seen superficially, the war interrupted that undertaking. The *Theory of the Novel*,[5] written in the first year of the war, was directed more towards problems of the philosophy of history, for which aesthetic problems served only as symptoms. My interest centered on ethics, history and economics. I became a Marxist, and the decade of my political activity coincided with my coming-to-grips with Marxism, of making my own way. When I returned to an intensive occupation with artistic problems, about 1930, systematic aesthetics was merely a distant perspective. Only two decades later could I think of realizing the dream of my youth with an entirely different world concept and method, and of carrying it out with an entirely different content and radically contrary method.

5. Georg Lukács, *Die Theorie des Romans. Ein geschichtsphilosophischer Versuch über die Formen der grossen Epik* (Berlin, 1920). English translation, London, 1971.

MAX RAPHAEL

*Paradoxically, the work of art closest
to perfection is both
most profoundly determined by its time
and goes furthest
beyond it into timelessness.*
—Max Raphael

INTRODUCTION

Herbert Read wrote of Max Raphael that "he was a pioneer whose seminal
significance will only be realised in the future,"[1] but Raphael's work is
already beginning to reshape the concerns of art history and Marxist aes-
thetics. He was a profound scholar and a dialectical thinker of the first rank,
whose fields of specialized knowledge ranged from prehistoric and neolithic
art to Cézanne and Picasso, from Greek dialectics to modern sociology,
from medieval architecture to Le Corbusier. He wrote a classic study
of the Doric Temple, and an equally classic monograph on the Marxist
theory of knowledge. With a sensibility and intelligence informed by such
diverse influences as Aristotle, Aquinas, Meister Eckhart, and the German
Idealist philosophers, and within a methodological framework wholly
Marxist, he explored the ways in which art mediates between imagination
and matter, the ways in which art crystallizes and stores in itself that

1. Read, Introduction to *The Demands of Art* (Princeton, N.J., 1968), p. xx.

revolutionary force which, when released by the action of consciousness and activated by the processes of politics and history, can transform the world in accordance with the model which art has provided.

The long selection from *Prehistoric Cave Paintings* illustrates the full range of Raphael's method and may serve as an ideal model of Marxist criticism. In it, Raphael interweaves a concrete analysis of the specific art works with the economic foundation and superstructural ideology of paleo-lithic society. He shuttles back and forth between theory and practice, illuminating larger questions of philosophy and aesthetics in passing, now plunging into formal analysis and now returning from the art work to the polar coördinates of mind and society which are its matrix, carrying with him a sense of larger relevances, always guided by the principle that the art of the past serves to "remind us that our present subjection to forces other than nature is purely transitory," convinced that paleolithic art, properly understood, is "a symbol of our future freedom."

For Raphael, superstructural categories arise from the primal conflict between man and nature: "The lesser man's physical domination of the world, the greater his need for imaginary spiritual domination of it, and the interaction between these two kinds of domination creates the differentia-tions and integrations, that is to say, the increasing complexities of every civilization." Magic and action were united in paleolithic man: "theory and practice were one . . ."; "through magic paleolithic man compensated for his actual helplessness." Art is determined by societal substructure and superstructural ideology; and these are mediated by the artist's sensibility. The individual creates art: "The work of art . . . attests the unity of the ego in its own creation." The artist creates art, but not out of whole cloth: art rises under the "compulsion of the economic and social conditions . . . and second, of the ideologies that allege to dominate the undomi-nated sector of the world by fantastic means, thus incidentally helping to create new instruments for extending human power over nature, society and consciousness." Art simultaneously serves and subverts the ruling class; the artist not only uncovers "the unconscious ideas underlying the ruling interests . . . he can go beyond this and see the universally human values in the historically determined conditions of his time and express the former in the latter in such a manner that his work—although a product of his time—transcends all temporal limits and acquires 'eternal charm,' that is to say, validity for all times and imperishable value. But if the artist, by his creative effort, rises above his time, his will nevertheless remains the social slave of the compulsions of his time, of the ideas of its ruling class."

The ruling ideas include Utopian strivings: paleolithic art shows us "a

maximum of spiritually creative power placed in the service of the ruling ideas and classes, and they represent these ideas and classes not as they were, but as they were reflected in social wishful thinking."

The second selection, "Notes on the Nature of Art," consisting of a group of brief extracts from the same monograph, is included to highlight the theoretical insights which flash aphoristically through Raphael's work.

The selection from Raphael's essay on Rembrandt's drawing "Joseph Interprets Pharaoh's Dreams" illustrates the power of his iconographic and formal analyses. Here (and Raphael considered this a necessary stage in criticism) the work of art is withdrawn from its genetic contexts and viewed in terms of its specificity. "In this book," Raphael wrote, "we deal with one part of the task only—that of grasping the work of art *as* a work of art."[2] We follow Raphael's eye as it moves into the drawing, seeking internal antimonies and formal patterns, retreating for a moment to contemplate the metaphysical implications of Rembrandt's treatment of the legend (the negative relationship to medieval Catholicism, the positive link to Protestant mysticism), returning to summarize the pictorial space in all its dimensions and balanced movements, closing in on the chief protagonists to elucidate their psychic reality by means of the analysis of line, shading and gesture, withdrawing once more into philosophical speculation on definition by negation, on the ways in which Rembrandt's characters "partake of nonbeing," on how they are "aware of the reality of their existence." Turning for a moment to the biblical literary model of the drawing (*Genesis* 41:40), Raphael comments on how Rembrandt's drawing is a preservation of "a transitory moment in an act of continuous procreation" in which the viewer is aware of the events that led up to the preserved moment and simultaneously aware that the meaning of Pharaoh's dreams will be unraveled and of the consequences of that interpretation. Then, in a suggestive and speculative passage, Raphael groups the major and subsidiary characters in terms of gradations of consciousness— from passivity to self-awareness—and he comments on the means by which they are simultaneously given "particularity and totality" by Rembrandt. "The relation between unmistakable particularity and human universality varies according to each figure's significance." He then moves "within" the characters to explore their psychic state, showing how the sense of touch and of hearing can be distinguished in each figure. Finally, the critic re-forms the individual figures into the organic social unit and group context that Rembrandt had conceived and, having achieved this moment of reconstruction, steps back, looks at it from the *outside,* analyz-

2. *Demands of Art*, p. 4.

ing the line of vision which Rembrandt has forced upon the observer so that "some part of us—some immaterial part" may be "drawn into the work and merged with it," subjecting our consciousness to a new view of possible reality. But even this instant of comprehension—this moment which brings "all opposites into unity within the work of art"—is insufficient for Max Raphael. "Every work of art is a storehouse of creative energies." The task for the viewer is "how to transform his life or that of his community in the light of this new source of energy."[3]

The final selection illustrates the manner in which Max Raphael deals with formal problems of Marxist aesthetics. He cites the famous passage in the Introduction to *A Contribution to the Critique of Political Economy* (see above, page 62), in which Marx describes the transcendent element in art—that element which though bound up in its origin with "certain forms of social development" nevertheless continues to "exert an eternal charm" on later ages and, contrary to the idea of progress, prevails "as the standard and model beyond attainment." Raphael's disagreement with Marx's feeble solution to his own riddle is standard: others have pointed out that the view of classical Greece as the childhood of humanity is a commonplace of German Idealism, occurring in Winckelmann, Herder, Goethe, and Hegel before Marx appropriated it.[4]

Marx was grappling with his own roots in German philosophy; his formulation on Greek art is little more than an admission that Hegel was correct in writing: "The phases through which the spirit seems to have passed, it still possesses in the depths of the present."[5] It has not previously been pointed out, however, that there was one other occasion on which Marx returned to the problem, and offered an alternative solution to it along materialist lines. This is in the recently published *Grundrisse der Kritik der Politischen Ökonomie* manuscripts of 1857–1859 (see above, pages 56–57). There he proposes that the "childlike world of the ancients appears to be superior" because in the ancient world man appears as the aim of production, whereas under capitalism "production is the aim of man and wealth the aim of production." The ancient conception is the more "exalted." In Marxism, progress includes regression, the diminution of the human being under class society as a concomitant of the development of the productive forces.

3. *Demands of Art*, p. 5.
4. Compare Marx's comment with the following by Herder: "Seek now, or attempt, an Iliad, try to write as Aeschylus, Sophocles and Plato did; it is impossible. The simple mind of the child (Kindersinn), the untroubled outlook upon the world, in short, *die griechische Jugendzeit*, is past" (*Ideen*, book IV, chap. IV).
5. Hegel, *Philosophy of History*, p. iii.

One of Raphael's chief aims in this selection is to combat the pseudo-Marxist equation of art and opiate. His citation of the passage on Greek art is an attempt to show that Marx did not regard art as purely contingent on social development, as simply an ideological means by which oppressed classes are held in a trancelike subjection. He insists that art is a weapon of revolutionary transformation, that its narcotic uses are a reversal of its essential nature, that its purpose is not that of religion—the reconciliation of class antagonisms through illusory salvation.[6]

Raphael writes that the problem raised by Marx is unsolved, but he himself attempts a solution—one which is the core of his aesthetic theory: "Art is an ever-renewed creative act, the active dialogue between spirit and matter; the work of art holds man's creative powers in a crystalline suspension from which it can again be transformed into living energies." The art of the ancient Greeks, in this reading, might be seen as an as-yet-unresolved stage in the liberation of humanity, stemming from a specific organization of social relations, awaiting release by renewed contact with a revolutionary audience. I believe that this theory—which Raphael shares directly with Benjamin, Breton, and Malraux, and which is consistent with the aesthetic-philosophic outlook of Bukharin, Caudwell, West, Gorki, Bloch, Slochower, and Rosa Luxemburg—constitutes an irreducibly central position within Marxist aesthetics.

━━

Max Raphael was born in Schönlanke, Germany in 1889. He studied art history with Heinrich Wölfflin, philosophy with Georg Simmel, and political economy with Gustav von Schmoller at the University of Berlin; at Munich University he continued his study of political economy with Lujo Brentano; in Paris, he attended lectures by Henri Bergson and met Rodin

6. Marcuse and Brecht tend toward the opposite position, to a pessimistic valuation of culture and an almost complete equation of traditional art with opiate. Whether these views are reconcilable is an open question, involving necessary differentiations between the origins of art, the uses of art in class societies, the ultimate "essence" of art. If Raphael is correct, he is correct about the origins and purpose of art and about the great works of the human imagination. Nevertheless, the coöption of mass art (and even revolutionary art) in class society, the use of art for repressive purposes, shows that there is some factual foundation for pessimism. The dialectical question may be whether art leads in some sense beyond the pleasure principle, whether the creative and dissolving forces of life and history are not perhaps locked in an eternal struggle and find their points of condensation in decisive art works of each period.

and Picasso. His first book, *Von Monet zu Picasso* (*From Monet to Picasso: A History and Aesthetic of Modern Painting,* 1913) opens with what he called the "Riddle of the Sphinx" ("der Sphinxfrage"), to which his life was to be devoted: Is it possible to arrive at an objective determination of the nature of creativity? It proceeds—in opposition to the Kantian denial of an objective principle of taste—to a pioneering examination of Impressionism, Post-Impressionism, Expressionism, and the leading exponents of these trends—Monet, van Gogh, Cézanne, Gauguin, Matisse, Picasso—with the aid of the theoretical principles of James, Wundt, Bergson, Simmel, and Kandinsky. The search was launched, but far from ended. Raphael plunged into the study of older art (Poussin and French medieval art), of Schiller's aesthetics, of various aspects of creativity, and for a while he devoted himself as well to such nonaesthetic subjects as geology, biology, botany, sociology, and medieval history. He turned also to literature, writing a study of Shakespeare and composing a series of dramas, which he subsequently destroyed. After serving briefly in the German army during World War I, Raphael returned to the philosophy of creativity in his *Idee und Gestalt* (*Idea and Form: A Guide to the Nature of Art,* 1921). The twenties passed without another major work. From 1920 to 1932 Raphael lived in Berlin, where he taught at the *Volkshochschule,* giving seminars in such diverse subjects as Aristotle, Meister Eckhart, Aquinas, the dialectics of Hegel, Marx and Lenin, the philosophy of Husserl and Scheler, and the history of ancient Greek dialectical thought. He wrote of this period that for him, "reality was registered as on a blank tablet—everything was accepted before a personal point of view had been taken up."[7] It was to be the confrontation of art with Marxism which ended Raphael's period of germination, providing him with the answer to the Sphinx riddle. The study of *Die Dorische Tempel* (*The Doric Temple,* 1930) paved the way for Max Raphael's Marxist period, which was to be marked by such works as *Proudhon-Marx-Picasso: Three Essays in the Sociology of Art* (1933), *Towards a Concrete Dialectic Theory of Knowledge* (1934), and the art history works of his last years. From 1932 to 1940, Max Raphael lived in France; after a brief detention in concentration camps, he managed to emigrate to the United States, where he lived until his sudden death in 1952.

His work was known and admired by students of art history and philosophy during his lifetime, as well as by a handful of Marxists in various countries, few of whom had any conception of the importance of his work

7. Cited by Herbert Read, Introduction to *The Demands of Art,* p. xvi.

as a whole. Nor could they have had. Like so many victims of the modern diaspora, Max Raphael spent his most creative years as a refugee,[8] his manuscripts in his suitcase, isolated from the public battleground of ideas, unable to gather around him a group of disciples and students to disseminate his ideas, barely able to make a living or to achieve publication of the works that poured from his pen during the last years, wholly out of touch with the Communist movement which was his natural forum, perhaps fearful that the Communist aesthetics which he was creating in the postwar United States might bring a renewal of that persecution from which he had fled. He published nothing during the McCarthy period, although *The Demands of Art* had been completed and translated before his death. In his last years he had written three books on the art of the Stone Age, as well as a book on *Classical Man in Greek Art,* a study entitled *Worker, Art and Artist: Contributions to a Marxist Science of Art,* and a revision of his earlier book on dialectics to be re-entitled *The Marxist Foundation of a Theory of Spiritual Creation.* These, with the exception of *The Demands of Art,* remain unpublished, together with major unfinished manuscripts on Flaubert, Racine, Homer, Shakespeare, and Spinoza. The appreciation of his achievement—spurred by such aestheticians as Susanne Langer and Herbert Read, as well as by the efforts of Robert S. Cohen (who is editing some of the manuscripts for publication)—is now commencing.

RAPHAEL: **THE ELEMENTS OF THE PALEOLITHIC WORLD**
from *Prehistoric Cave Paintings*

The present study deals with the oldest known paintings; it does not deal with primitive art, even less with the beginnings of art. Disregarding paleontological or geological standards, archaeology, on the basis of

8. It is a startling fact that virtually every classic contribution to Marxism—from Marx and Engels to Kautsky, Plekhanov, Lenin, Luxemburg, Lukács, Trotsky, Bloch, Brecht, Balázs, Raphael, Marcuse and Benjamin—was written in a state of exile from the author's homeland. Marxism begins with Marx's banishment from Germany to Paris and Engels' removal to England in 1843, and the pattern has remained relatively unbroken down to the present. The significant exceptions—Bakhtin, Gramsci, Bukharin—may be ascribed to situations of "internal exile." Curiously, even Stalin proves no exception, for his lone major work (*The Problems of Nationalities and Social Democracy*) was written in Vienna. Without wishing to enter here upon the speculative reasons for this interesting pattern, one can reasonably assert that creative Marxism flourishes in a set of specific conditions of personal alienation, and may rise from the attempt to restore or achieve a state of individual harmony.

known paleoliths, teaches us that the paleolithic era comprised at least two great phases. The first and earlier phase was common to Europe, North Africa and Asia Minor because several land bridges across the Mediterranean enabled the inhabitants of these continents to be in constant communication. In Europe, southwest and northwest of the Pyrenees, the interruption of this contact produced a development different from that which took place in regions that probably saw the beginnings of human civilization. And the examples of paleolithic art we possess come exclusively from this second phase of the Old Stone Age. But there is no reason to assume that art developed only then. The weapons represented in the cave paintings in Dordogne and Cantabria, as well as the logical and elaborate system of magic signs on the neolithic Egyptian pottery, indicate that wood painting and carving must have existed during the early paleolithic era; but because of the perishable nature of the material used, this art was lost forever. Only because the nature of history and the forms of art were theoretically misunderstood could these facts have been overlooked heretofore. Thus the dogma that paleolithic paintings belong to so-called primitive art gained favor. It has been said that paleolithic artists were incapable of dominating surfaces or reproducing space: that they could produce only individual animals, not groups, and certainly not compositions. The exact opposite of all this is true: we find not only groups, but compositions that occupy the length of an entire cave wall or the surface of

a ceiling; we find representation of space, historical paintings, and even the golden section! But we find no primitive art.

Although the cave paintings appear modern to all who come in contact with them, in reality, there is no art more distant and alien to us who center our spiritual creation either on man or on man's relation to the gods he has created. Paleolithic art is centered around the animal; there is no place in it for the middle axis, for symmetry and balance inspired by the structure of the human body. Rather, everything is asymmetric and shifted. The objects are not represented as they appear when seen from a distance, as we are accustomed to seeing them in paintings from the times of classical antiquity, but as near at hand—for the paleolithic hunter struggled with the animal at close quarters, body against body; only the invention of the bow, which in the paleolithic age meant a revolution comparable to the invention of the boat and the plow in the neolithic age and of the steam engine in the Christian era, made the distant view possible. Finally, the object of paleolithic art is not to picture the individual existence of animals and men, but to depict their group existence, the herd and the horde. If, despite all that, the cave paintings strike us as being modern in conception, and therefore familiar, the reason is that they were produced in a unique historical situation and are a great spiritual symbol: for they date from a period when man had just emerged from a purely zoological existence, when instead of being dominated by animals, he began to dominate them. This emancipation from the animal state found an artistic expression as great and universally human as was later found by the Greeks to express their emancipation from agriculture, when they broke with an existence bound exclusively to the soil and took up navigation and maritime trade and began to live the social-political life of the polis. The paleolithic paintings remind us that our present subjection to forces other than nature is purely transitory; these works are a symbol of our future freedom. Today, mankind, amidst enormous sacrifices and suffering is, with imperfect awareness, striving for a future in the eyes of which all our history will sink to the level of "prehistory." Paleolithic man was carrying on a comparable struggle. Thus the art most distant from us becomes the nearest; the art most alien to us becomes the closest.

But to study cave painting exclusively from the point of view of its distance from us, or its proximity, can only result in adding theoretical errors to recognized objective difficulties. One such theoretical error is to conceive history as progress along a straight line, to imagine that what exists today has been created gradually out of nothing, as though the process of history followed the pattern laid down in the Biblical story of creation. Actually, no one has ever been able to discover an absolute

'origin" for the very reason that the idea of an absolute origin is only a metaphysical hypothesis. A number of categories are present in all real existence and thinking and in the relations between existence and thinking; these categories remain fundamentally constant, only their concrete realizations vary historically, change and evolve. The conception of history as progress along a straight line paradoxically results in making it impossible to explain what we desire to explain. This does not mean that there is no historical evolution, but rather, that the social forces which create history are antagonistic and, like the forces of the physical universe, express the interaction of sluggish and living energies; the former radiate from a fixed point, the latter push forward from epoch to epoch. This antagonism transforms dynamic forces into static conditions, and disintegrates static conditions into negatively operating forces. The transverse section of historical existence is thus distinguished from the longitudinal section of historical development, although the transverse section only unfolds the qualities contained in the longitudinal section, while the longitudinal section is a necessary product of the static conditions that are born and pass away in the transverse section. All the actions and events of human societies rest upon limited material prerequisites: nature on the one hand, and working tools and weapons by which man makes nature accessible, on the other. The lesser man's physical domination of the world, the greater his need for imaginary spiritual domination of it, and the interaction between these two kinds of domination creates the differentiations and integrations, that is to say, the increasing complexities of every civilization. By this development within a limited arena, man gradually secures the relative domination of the world he knows; but at the same time he destroys its limits when they become materially too small and spiritually too narrow. The unfolding of the transverse section which rests upon the economic reproductive process and the struggle of economy, society, and politics against religion, morality, art and science, drives toward the development of a longitudinal section, the creation of a new and wider basis of existence *out of* the old one, then alongside it and following it. Seen from this new longitudinal phase the preceding phase always seems to be less complex: the world of Egyptian agriculture is simpler than the world of Phoenician maritime trade: the world of the nomad hunter simpler than the world of the Mesopotamian peasant. But this "simplicity" is entirely relative: the late hunting age is more complex than the early age of the farmer working with hoe or stick, and for that reason the frescoes on the ceiling of Altamira are more complex than the ornamentation of neolithic earthenware. Man again and again starts from the beginning, each time on a higher level, that is to say, he finds new forms of expression for developments that have already

run their course elsewhere, and rushes on toward new stages that have not been passed by mankind before. But all the fundamental categories are present even at the lowest stage, and both at the lowest and the highest spirals of development they unfold their activity in antagonistic dimensions and diverse domains that form a totality from which the forward-moving stream issues. In this sense, paleolithic painting is a very complex developmental stage within an early epoch of mankind.

The paleolithic peoples, as shown by the transformation of their stone implements and of their artistic styles, were history-making peoples *par excellence;* they were in the throes of a continuous process of transformation because they squarely confronted the obstacles and dangers of their environment and tried to master them. For that reason, they are in fundamental opposition to the so-called primitive peoples of today. The existence of these modern primitives is stagnant because they avoid all those changing difficulties of material life that cannot be mastered by the means of production they have adopted once and for all. In compensation, they develop the methods of fantastic-ideological domination of the world more extensively, superstitiously and rigidly. But the paleolithic peoples did not know of this great discrepancy between an absolutely restricted material basis and an unrestrained and elaborate ideology, or if they did know of it they did not tolerate it for very long. Because of this fundamental difference between the "primitive" peoples of today and the paleolithic peoples, prehistory cannot be reconstructed with the aid of ethnography. Ethnography might explain isolated prehistorical facts if the explanations fit in the general context of prehistoric times, but it is not correct to evaluate the life of the paleolithic peoples on the basis of the conditions prevalent among the primitive peoples of today, because whatever these primitive peoples have in common results from their having remained at one stage of material development. If totemism existed in the paleolithic age, it need not necessarily have the qualities and functions it displays today even among the most primitive hunting tribes. Thus, paleolithic art cannot be understood by drawing an analogy with the sculpture of the "primitive peoples," with which it has absolutely nothing in common, because these primitive peoples either use the bow and arrow, or live in surroundings chosen in accordance with their primitive means of production and weapons, while the paleolithics constantly struggled against a dangerous environment. For that reason we must attempt to understand the cave paintings as a spiritual expression *sui generis.*

Here we are confronted with another paradox which is the stumbling block of modern historians of art. On the basis of their theories, they cannot interpret art and translate the language of artistic forms into uni-

versal philosophical concepts. In particular, paleolithic archaeology, disdaining, so to speak, its own magnificent discoveries, has regarded its own material as a collection of unrelated fragments and thus completely missed the forms and even the subject matter expressed by the forms. The first condition for the understanding of paleolithic art is to recognize the existing material for what it is—and very often we have to deal not with single animals, but with groups; the second condition is to interpret the parts in relation to the whole, and not to isolate them on the basis of unproved hypothetical constructions; the third condition is to obtain the meanings and contents from the ascertainable forms of the groups and individual animals on the assumption that, in art, content and form tend to become identical. As soon as one recognizes the facts and discards the prejudice that the paleolithic artist could draw and paint only individual animals, the meanings of these groups are discernible. These meanings, because they recur, very often enable us to make inferences regarding the compositional devices by which the groups and the individual animals are constructed and organized. These devices in turn throw more light on the contents of the works of art and, in the end, thanks to the mutual clarification of form and content, even the individual animals acquire a new significance.

In the caves that we know the same animals appear almost everywhere: aside from a few carnivorous animals such as lions and bears, there are horses, bison, oxen, mammoths, ibexes, and so forth. The frequency with which each animal appears varies with the caves. At La Pasiega, for example, stags and does predominate; at Les Combarelles, horses; at the nearby Font-de-Gaume, bison. In each case, the other animals are represented as subordinate to the predominant species, and for a long time, their relations remain the same. Thus at Les Combarelles, the horses are repeatedly represented as hostile to the bison and bulls: the reindeer as friendly to the mammoths, and it can be shown that three different breeds of horses live peacefully together and form cross breeds while a fourth breed appears only occasionally. At Font-de-Gaume, the bison fight against the horses they have found there before, only in the end to be overwhelmed by the much-older mammoths. The conflict between the hind and the bison, which is depicted on the ceiling of Altamira, can also be found at Castillo and at Les Combarelles. The character of each animal seems to be as limited as the subject matter; everywhere the reindeer live a bright cheerful idyll, just as the bison live a stormy drama; the horses display playful sensitivity and the mammoths unshakable dignity and gravity. What did the artist represent by this constancy in change? Animals as he observed them in nature? Animals as objects of his desires and actions? Or animals as representative of himself, that is to say, his social group? The Abbé Breuil

emphasizes repeatedly that the animals depicted are not the same as those whose bones were found in the debris of hearths, and that, for instance, the mammoth was often represented even after it had ceased to exist on French soil. What does this discrepancy between art and life signify? What was the motive force of this art: naturalism, magic, or totemism? Or all three combined?

Let us go one step further: the animals are arranged in various groups; in the simplest group, the pair, the animals are represented as standing one beside the other or one inside the other or one "crossing" the other. The animals of the first group (one beside the other) are shown in three positions: head to head, rump to rump, or head to rump. In this last case we have, in rudimentary form, a procession such as is developed in Teyjat, of a male, a female and a young ox. The meeting of heads is the initial form of a unity that in other instances goes as far as the complete merging of two animals into *one* body that has two heads pointing in opposite directions. Where two animals are depicted one inside the other, the heads point either in the same or in opposite directions, and these animals may be of the same or of different species. In such groups the artist may have intended to represent them one behind the other, with the body conceived as transparent, and if so, the visualized or remembered form of the entire animal was preferred to a partial view of the figure standing behind. The groups that we defined as "crossed" are formed of two animals, one superimposed on the other, coming from opposite directions; here we have the most rudimentary form of crowds, many animals grouped together with no space among them. The difficulty in understanding such groups of superimposed animals led to the theory of the palimpsest, as though, for lack of space the same spot had been covered by several layers of paintings without the background being either recognized or removed. Diverse as these groups may be, they rarely follow a geometric pattern imposed *a priori,* as is, for instance, the case with the group of three mammoths at Les Combarelles; if a geometric pattern is present, it usually has the form of the letter "V" or of a slanting line with angles at each end. What is important is that in the larger groups there appear not only actors but also spectators, a kind of chorus that endows the depicted event with great solemnity and validity in the social consciousness.

What was meant by these groups of animals paired, in procession, "crossing," crowded together, or in a geometric design? The meaning is unmistakable with regard to those animal paintings which contain darts and other weapons. However, even within the magic of hunting, the desire to slay is only one element. On many animals there are vertical lines separating fleshy parts from the ribs or bones—the more vulnerable parts

from the less vulnerable parts; later the modelling of the animal goes slanting horizontally across the body, and three parts can be distinguished: the head, the middle and the rump. Strikingly enough the middle section is the largest; later it decreases in size, and the front and rear sections are shown larger. The head and the sexual organ had a special significance for the magic of fertility and for the masks, so that one can follow the growing power of the ruling medicine-men in the changing sizes of the various body parts. The magic of dissection is supplemented by the magic of propitiation: the dead animal is seated on its hind legs, votive offerings are served, as can be seen in an isolated example at Niaux. Besides the magic of hunting there was the magic of fertility; the frequently recurring diagonals leading from the animal's rump to its belly could be interpreted in the latter sense. Then there is the magic of transfer: envied qualities of other animals are transferred, as in the group "horse and lion" of Font-de-Gaume, in which the lion's strength is obviously transferred to the pair of horses directly under the lion's neck while larger and older animals play the part of spectators. But even here the question arises: to whom is the lion's strength transferred? For whose sake is magic practised? This brings us to a second group of paintings whose subject matter is totemistic rather than magical. To this group belongs, no doubt, a large part of the pictures showing animals in combat, the animals in these cases representing clans. The pictures usually show the animals in the "crossed" position. Animals pictured one inside the other may represent pregnancy; this device may also be interpreted to mean alliance in the struggle, while the superimposition of animals may stand for domination, mediation or a promise of support. The latter is probably the case in the many pictures showing a mammoth superimposed on other groups of animals. At Les Combarelles, one can clearly distinguish between the left walls of the cave corridors on which scenes of combat predominate, and the right walls on which idyllic, peaceful scenes predominate. At Font-de-Gaume a male and a female bison are first shown in combat and then as a united group, which can be interpreted either as a wedding or a ceremony of reconciliation between two clans; and inversely, on the last wall at Les Combarelles, the dissolution of such a united group is depicted in a painting showing two representatives of the Lybian breed of horses taking away a male in a group of horses belonging to the Tarpan breed, attended and aided by friends (mammoths) and enemies of the combined horse clans. Or does this removal of the horse represent the funeral of a clan chief? At the end of the picture where the two formerly interlocked animals stand back to back with the tails lightly touching one another, a small horse is shown leaping out of the larger one: this can often be observed wherever an animal is

represented as having been mortally struck by a weapon. Is this meant to show the soul of the animal leaving the body? Do we have here a connecting link for our knowledge of the interment of the dead and the feasts that were offered them?

However indefinite the interpretations of the groups remain, because there is no clear line of demarcation between the hunting of animals and the hunting of people, between the rites of fertility and the rites of marriage, or between the doubling of the body and the addition of a soul, the fact that totemism and magic coexisted in the world-view of the paleolithics in a specific manner is indisputable, although the two are different in nature and originate from different sources. At that time magic signified two ideas simultaneously: (1) the mental concentration of the sorcerer on his own intended action in all its details and the attraction and participation of the animals in this imagined action, and (2) the externalization of this intellectual and emotional concentration, the real action *against* the animal. Paleolithic man knew no magic without action, nor could he imagine action without magic; to him, theory and practice were one. This unity dissolved only when the social development from hunting to agriculture compelled the sorcerer to actions that no longer could be carried out by a human group. Then magic became a superstition and was replaced by religion. Previously, it had been neither superstition nor faith, but a science: it contained the totality of all the existing social knowledge and took into account all the tools, weapons and actions by which society was to be transformed. Without question, the basis of magic as of all other sciences was a material need: to feed, clothe, shelter and defend against all attacks a society of a given size with given means of production in given natural surroundings, This magic was founded on the belief that if an image of an object was hit, the original object was hit, too, and for that reason the image had to be made as similar to the original as possible; and on the belief that an animal once it had fallen under the spell could no longer resist the power of man. In other words, through magic paleolithic man compensated for his actual helplessness with regard to certain superior physical qualities of the animals by the power contained in his knowledge of the animal, by his ability to trap it, to surprise it at certain moments particularly favorable for slaying. The slaying was done with the aid of his hands, or more accurately, of many hands: those of the entire hunting group. The hand was *the* instrument of magic, and the earliest awareness of this fact is directly attested by the hands that are represented singly or in groups in many places, for example at Gargas and Castillo. The hands were pictured naturalistically or as geometric patterns. Thus we see that magic is the root of the so-called naturalism of paleolithic art and that the

ormal means for artistically transcending the "natural" form is the hand
as will be shown later). But could a mere material need, which at the very
moment of its satisfaction renewed itself and made man the slave of his
hunger be the source of the monumental character of paleolithic painting?
This is unlikely. Finger paintings in sand have been made for many cen-
turies and are still being made by certain hunting tribes. They also exist in
the clayey soil of certain caves. The fact that such drawings are found in
the most inaccessible places points to an entirely different explanation.

Then as today man was both part of nature and opposed to nature (that
is, animals), he also lived with and fought against his fellow man. Only in
groups was he a match for powerful animals, only in well-organized hordes
was he a match for roaming herds. Man could fight against animals in both
a real and a magical sense only when he was organized in society. It was
only with the help of his fellow men that he could assert himself in the
struggle of all against all. We know nothing about this organization except
what a correct understanding of the works of art that we still possess can
reveal to us. And these tell us first of all that man represented his social
unity as a group by animals. Furthermore, they tell us that there were few
such groups, because there are relatively few animals that we can with
certainty identify as clan animals; the recurrence of the same animals at
various places can be explained by the migration of a population grown too
large, which formed new settlements similar to the colonies formed by
Greek cities. These groups had their shrines in caves; thus they were only
partly nomadic, but we are unable to ascertain who wandered with the
animals and who remained at home. Some enlightenment on this point can
be found in the evolution of the forms at Altamira. The earlier paintings
were asexual, later sex is represented with such intensity that sexual desire
becomes the expression of the disintegrating force, while its counterpart in
the same pictures, the female magician, becomes the embodiment of
harmonious wisdom. The works of art reveal that the forms of social
consciousness and organization must have been diverse indeed, because
only the representations of the mammoths follow a prearranged geometri-
cal pattern, only the reindeer appear exclusively in pairs, only the horses
admit different breeds into their groups, that is to say, combinations of
various clans; further, only with regard to the bison does the mammoth play
a special role, and it seems that in the clan of bison there was a far-
reaching differentiation among the spheres of power of the warrior, the
judge and the medicine man, and that this clan was familiar with all the
conflicting claims to power of these three groups. The family was not
unknown as we may judge from groups showing three animals: a male, a
female, and a young one. In these groups sometimes the male and some-

times the female is shown in the center. But whatever the social organization may have been in each case, however tenaciously each group clung to its own as the best, all these groups express and embody the consciousness of their unity in the shape of an animal, not a human being. This is the fundamental character of totemism. Just as the Jews were forbidden to make an image of God, so it seems that the artistically gifted paleolithics were forbidden to represent humans in their monumental mural art—a prohibition obviously social in origin, for their carvings did represent humans (although in small numbers). This explains why not only men were put in masks, but the animal character of the masks was made unrecognizable—not because of inadequate ability, but because of social will and compulsion. But by depriving man of his right to represent the unity of his own society the paleolithics were led to assume a conflicting attitude toward animals. As representing the group unity animals had to be conceived as superior to man, and this superiority had to increase as the relationships within the groups grew more and more complex, as differences in power and struggles for power increased. On the other hand, the animal as object of the hunt had to appear to the magic consciousness as fundamentally conquerable, and with every advance in the art of fashioning stone and wood, in the art of setting traps, this conquest grew easier; in other words, the animal had to lose in physical superiority. Ideologically, this conflict could be solved by the separation of the totemic animals from the other animals, by declaring them taboo; the artistic solution of this conflict was that art driven by totemism (and only by totemism) to monumentalism used the proper and predominant means of magic: the hand, in order to endow the naturalistic likeness required by magic with significant form. In practical social life, this conflict between the sorcerers and the representatives of worldly power may not always have been solved peacefully.

It would be futile to undertake to write a history of the magic and totemistic currents in paleolithic ideology on the basis of the works of art known today, in which magical contents are expressed with great monumentality and epoch-making events of clan history with unsurpassed "naturalism." The history of paleolithic painting is not a development towards naturalism and monumentalism, but an evolution *within* a realistic monumentalism. However, the temporal sequence of the works of art shows us that because the two currents coexisted and because the artists were compelled to express them both in a synthesis, each of them grew richer in meaning: magic became socialized, society itself became a specific magic force. Because magic became socialized, the paleolithic's conception of it rose above the mere idea of casting spells to kill an animal; they began

to develop an understanding of cause and effect. Sex was placed more and more in the foreground as the dominant need, and the close association of love and death was one of the fundamental experiences of paleolithic man: it was easier to slaughter the animals when they were in heat or to surprise them in the act of copulation; moreover, strength spent on women was wasted for not enough strength remained for the hunting of animals (this was true only if women did not participate in the hunting). The slaying of the animal was followed by rites intended to propitiate it, and by its dissection, which was also of a ritual character. Here, in the paleolithic age, we have not only the first conception of the *Liebestod,* but the first idea of catharsis, and the germ of the chorus. At Les Combarelles especially, the scenes that have social significance are so solemn and include so many participants that they impress one as state occasions. At the same time, both morally and politically, paleolithic ideology reaches universal human dimensions, and some of the scenes have the grandeur of Aeschylean tragedies.

Magic endowed this monumentalism which was rooted in totemism with life and fulness thanks to its increasingly subtle observation of nature and the invention of various forms without destroying the unity of the traditional imagery. The degree of the paleolithic capacity for differentiation becomes clear to us when we copy on the same sheet several contours of mammoths or bison; only then do we see how dissimilar are these figures even if they belong to the same type of composition. Wherever all four legs of an animal are preserved, we find to our amazement that each leg has a different form in accordance with its different natural or compositional function, and that the contours of these legs, despite their differences, are combined to form a logically conceived group comparable to the Greek reliefs in variety of nuances and richness of contrasts. Because of magic, paleolithic monumentalism did not degenerate into empty abstraction, but preserved its vitality and massive power to the very last. On the other hand, totemism saw to it that "naturalism" never degenerated into a petty imitation of nature which overlooked the whole for the sake of accuracy of detail, but developed into that realism which transcends nature in nature itself, which is capable of conceiving the accidental mode and fact of being as being pure and simple, as substance that differentiates itself in phenomena, so that things and bodies never become a schematization of the genus, never an "idea" of force, but force itself in all its concreteness.

It has often been maintained that "primitive" man could not adequately distinguish his "ego" from other members of his group (including both humans and animals), nor assert it against them. This does not apply to paleolithic man, at least not to the paleolithic artist. If the sorcerer had not

the consciousness, and even the complete conviction, of the superiority of his spiritual powers over those of the animal, he would never have been able to "believe" in the success of his magic. It would be incorrect to argue that the sorcerer would not have practised magic if he had not believed that there was a close relation between himself and the animal. The most modern scientist, even the most sensualistic Machian idealist, must assume that his "sensations" have some kind of correspondence with the object; otherwise science would be a mythical invention on which technology would never be built, unless it were by a permanent miracle. Nor is the totemic animal any proof against the existence of the ego-consciousness, for the totem is neither the animal nor the social unity; the former only represents the latter in the totem. But representation implies difference, in this case the difference between the individual and his community. Thus one might say that consciousness of his own ego and being aware of its difference from other human egos prevented man from representing society as a whole. But if magic and totemism attest that the ego was distinguished from nature and society, the work of art goes further, for it attests the unity of the ego in its own creation.

Even going back to the earliest Aurignacian epoch, we find either *one* line element that is varied or two different, but related elements that are playfully contrasted in all possible ways. We find a few proportions or geometrical relations that combine these elements to form one structure; we can discern their beginning, middle and end—in short, we have a qualitatively and quantitatively unified whole despite spatio-temporal diversity. And because the creation has unity, we are forced to assume the existence of an underlying, unified conception. Even the senseless assumption that this unity was produced by an unconscious process would only prove that the unity had become so natural that it could sink into the subconscious. It is a completely different question whether this ego-consciousness is internally unified or divided. And it seems that at this point a change did occur in the course of the development of the paleolithic age. The bison at Altamira are obviously in contradiction with themselves and can only represent human beings who have become conscious of their internal antagonisms. But the composition of the ceiling at Altamira also proves that these men had the strength to master such antagonisms, at least in the synthesis of the artistic process. When the paleolithics began to paint the cave walls, their spiritual life was no longer comparable to that of a child, and every attempt to explain their art with the help of children's drawings starts from a fundamentally false assumption, as will be clear when the content of this ego-consciousness is examined.

The economic foundations which are the substructure of a society, and

the ideology which is its superstructure, determine its art; but these two factors must first pass through the artist's sensibility, and achieve a personal, spiritual life as aesthetic feeling. The mural paintings of the paleolithic caves reveal several typical groups of such aesthetic feelings that sometimes appear separated and sometimes combined. The strongest is the feeling of the greatness, the power and the dignity of Being. "He did not love, he loved to be," a Persian poet said. This is not an infatuation with any concrete forms of existence but a kind of adoration, a sacred devotion to Being, pure and simple; not for a being that has transcended the phenomenal world, but for the Being that has divested itself of all mere relationships and yet includes the individual—not as an accident but as an essence; for Being that does not transcend the world but *is* in its constancy. The paleolithics constantly felt that their lives were in danger, and this feeling contributed to raising their sense of empirical existence to the level of Being. This can best be illustrated by the generation of 1430, the generation of Van Eyck, Masaccio, Konrad Witz and Fouquet—the generation which after the breakdown of the feudal conception of heaven felt the solid ground of earth under its feet, from which the world could be securely and calmly examined with the new conviction that "being is, and non-being cannot be" (Parmenides). This has absolutely nothing in common with the adoration or imitation of nature—it is rather an affirmation of the world as imperishable, objective and dynamic, not an affirmation by man, but a self-assertion, self-creation and self-revelation of its substance. Whether the object that represented that being was motionless or mobile, whether Being was conceived as inert or as subject to an impersonal, non-vitalist force, these artists achieve the same objectivity, the same freedom from purely subjective elements and even from human consciousness. Paleolithic art displays the first great wonderment before the miracle of pure Being that mankind was not able to translate into concepts before Parmenides.

There is another group of aesthetic emotions in which the subjective element appears sometimes as sensitivity, so that the conflicts are expressed less vigorously, sometimes as the personal revolt against the authority of objective being, and which later assumes the form of tragic heroism, such as was rediscovered by Aeschylus with all his self-destructive and simultaneously reconciling dualism. Ibsen said that in every human face one can see an animal which discloses the deepest essence of its possessor's soul; likewise, in every animal of the paleolithic paintings (and even more so in every animal species) there is the face of a human or a human group which reveals its fundamental needs and motive forces through the animal. Such attempts to discover the psychic factors may lead to arbitrary interpretations; but this much is certain: the paleolithic artists of the late Magda-

lenian period were quite familiar with all the innermost recesses of the human soul, with the comedy that is daily acted out between consciousness and being. But these psychic differentiations are no more than a concretizing feature; what is important is the will that creates the conflicts, the self-destructive tragedy or the comedy that exposes itself to ridicule, its authentic or false (that is, hypocritical) heroism. And such a dualism only confirms the fact that sense of being had nothing in common with imitation of nature, but that it was a metaphysical axiom whose man-made character had been erased and destroyed. On the other hand, the presence of tragic dualism shows that this hypostatized Being, this self-effacement of homo faber in his product did not suffice him, that he was confronted with the task of harmonizing the oppositions, with the problem of beauty as their synthesis. We only know of one solution: the hind on the ceiling at Altamira. This "Hagia Sophia" of magic is the prototype of all those who until Baudelaire followed the ideal of *Beauté* and strove to the end that formal beauty have beauty itself as its content—in other words, the strength and greatness of the emotion was matched by an equally strong intelligence.

Does this mean that paleolithic man did not differ essentially from the Greek and from modern man, and that all the theories of the pre-logical and mystical mentality of the emotionally dominated primitive do not apply to him or are nonsensical, and intended to glorify modern superstition? Let us try to understand what is expressed in art. In works of art we are confronted with the artist's ability—ability not in the sense of acquired technique or capacity for imitating nature, but in the sense of reproducing the existing social world in materials that speak to our senses. Such an ability is based upon will, and this in turn upon compulsion. The compulsion acting upon the artist is first the compulsion of the economic and social conditions, that is to say, the means of production, organizations and other devices by which society dominates the world and satisfies its needs; and, second, of the ideologies that allege to dominate the undominated sector of the world by fantastic means, thus incidentally helping to create new instruments for extending human power over nature, society and consciousness. In the artist, this compulsion becomes will: he takes a position toward it, he accepts or rejects it; yet the freedom of this will is limited. Even the thinker can conceive a non-existing world only as a Utopia; the most the artist can do is to take an attitude of opposition toward the world that he reproduces artistically. Flaubert's hatred for the bourgeois was both a negation of socialism and a potrayal of the bourgeoisie. Within his will the artist has only two alternatives: either to take the side of the ruling class of his time or to propagandize the cause of the

·uled class. A social-critical attitude is the utmost limit beyond which art cannot go. But the artist's ability is less subjected to society than his will. With his talent he can not only uncover the unconscious ideas underlying the ruling interests, not only disclose the concealed developmental tendencies of the ruling class before this class has the will and strength to assert them, he can go beyond this and see the universally human values in the historically determined conditions of his time and express the former in the latter in such a manner that his work—although a product of his time—transcends all temporal limits and acquires "eternal charm," that is to say, validity for all times and imperishable value. But if the artist, by his creative effort, rises above his time, his will nevertheless remains the social slave of the compulsion of his time, of the ideas of its ruling class. This is true to an even greater extent of every monumental art which by definition renounces all purely anecdotal elements, everything that is purely descriptive, literary, in brief, all the *petite histoire* of inner and outer life, and transcends all programs to reach those elements which can be seen or heard by men of all times and all nations.

Franco-Cantabrian art does not tell us anything about the daily life of the "masses." It does not teach us anything about their external existence. We have no clear picture of their methods of hunting, and only from the nature of the stone implements and the few reproduced weapons can we infer that trapping the animals played an important part in paleolithic life. We know nothing about their habitations, for the caves were not dwellings, but sites of festivities, and perhaps temporary abodes for young people about to be initiated. We know nothing about their food. If the men wandered with the herds or even if they hunted relatively near their dwellings, little meat was probably brought home for the women and children, who in that case must have chiefly fed on plants and fruits—a difference in the mode of feeding that must have resulted in considerable differences in temperaments and attitudes toward life. We know just as little about the relationships between the sexes and family life, even though its existence can scarcely be disputed. And we have no idea which of these half-nomads followed the herds and which remained behind, and what were the relations between the former and the latter. The cause of the sudden collapse and disappearance of paleolithic art at its climax, in so far as it cannot be explained by the invention of the bow and the social developments following, may be sought in the nature of the sexual relationships that developed in connection with the partially nomadic life of the men. We know nothing of paleolithic social organization, even though from certain signs we can infer with some plausibility that society was stratified and that the power of certain classes: the sorcerers and warriors, constantly increased. We know

nothing about the relations between the various totemic clans, even though the paintings point to the existence of peaceful agreements and unions between clans as well as to constantly recurring struggles against the same enemies. And we know absolutely nothing about the spiritual life of the "masses" of that time, for what the works of art that have survived show us is a maximum of spiritually creative power placed in the service of the ruling ideas and classes, and they represent these ideas and classes not as they were, but as they were reflected in social wishful thinking. In every known society art has had the function of creating a synthesis of real actions and theoretical-ideological ideas. This synthesis of compulsions and wishes in the paleolithic age displays a striking power of emotion and thought. But it does not tell us anything about the distance between these artists and their "communities," their "public"—unless one may infer from the authenticity and perfection of the monumental character of this art during its entire life-span, from the Aurignacian to the Magdalenian epochs, that genius and *profanum vulgus* were not separated by an unbridgeable gulf and that the people were not merged into *"one"* community, in which the "priest," that is, the sorcerer, offered his faithful a kingdom of heaven, but that there was a social interaction rich in contrasts which built a general culture on the basis of great artistic values. In this respect, paleolithic France may have been little different from the Gothic or the classical age. But here we are in the domain of conjecture, and we are handicapped by the fact that prehistory has no literary documents, although it is true that it has no misleading, ambiguous or falsified documents either. This fact makes it impossible for us to trace the process through which the materially and socially limited domination of the world was transformed into social feelings and social knowledge and finally into magical and totemistic ideologies and in which manner art became the synthesis of all of them. It also limits the concreteness of our statements when we try to go from art to reality. Our knowledge of paleolithic civilization will always remain fragmentary.

RAPHAEL: **NOTES ON THE NATURE OF ART**
from *Prehistoric Cave Paintings*

Art is the creative act which gives the material and ideological life-contents of a concrete society adequate visible forms. These forms are not completely determined by their antecedents nor do they arise mechanically under the pressure of external influence nor are they the product of both; the truth is that they have no history of their own. More precisely: art has

historical roots that lie outside it, and it has historical consequences that again lie outside it. Art as such is not a historical act but an act of creating values. Art belongs to two spheres: its roots are in the sphere of history, and its life is in the sphere of objective categories and values. Only the degree of its approximation to perfection can be studied from a historical point of view. Paradoxically, the work of art closest to perfection is both most profoundly determined by its time and goes furthest beyond it into timelessness, while the imperfect work of art remains caught in the spatial and temporal conditions precisely because it has been touched by them most superficially. Only the great artist can grasp and master the whole historical reality, lesser artists cling to the fragments of this reality that float on the surface. The main task of a history of art is to show that these determined forms—forms and not contents!—must necessarily arise from definite economic, social, political, moral, religious, etc., roots, that these forms express them, represent them, manifest them; vice versa, that they react on these roots and play a part in their transformation. Every attempt to go beyond this task and to constitute an immanent history of the development of forms necessarily leads to reducing the creative process to a mechanical act. The result is a catalogue or a sequence of "styles," but not a history of art or even of styles. Art as such has no history, there is only a theory of art which is the theory of artistic creation; but this theory of art itself has a concrete content only if it can explain artistic creation as the transformation, the translation of historical situations into the language of visible forms, and this as a necessary process. This task has never been formulated, let alone solved.

The thesis of a homogeneous compositional principle for a whole epoch has a significance that goes beyond the paleolithic age: it raises the problem whether such formal unity cannot be found in other epochs too. I have already mentioned the fact that all Greek plastic art is based on the Euclidean frame of reference. The history of Greek plastic art could be written as the history of a theme with variations according to whether this frame of reference was used to express a higher power or human will, and whether this human will referred to a movement within the human figure or to the relation of man to space. During the Renaissance all the dominant artistic forms were derived from man's anatomic structure, his system of muscles, his circulation of blood. The artists used chiefly either one aspect of this conception or the whole conception as a unity of mutually determined partial phenomena; and this defines the difference between Leo-

nardo and Raphael (or Michelangelo). Without dwelling upon those periods of art which see the measure of all things not in man, but in man's relation to God (like the Egyptian and medieval periods), I should like to stress the importance of this thesis for a general history of the human spirit. It illustrates the progress man had made in the understanding of himself, and thereby of asserting himself as *homo mensura,* the measure against nature. Also, it enables us for the first time to investigate the derivation of the form system, conceived as homogeneous, from its material and ideological bases. It enables us to understand all art centered on man as a contrast to his real motion through space in his role of nomadic hunter or sea navigator, and all art centered on the relation between man and God as a contrast to man's sedentary life: the spiritual movement into the infinite corresponds to physical immobility; and the fixation of spirit in the finite, to constantly renewed physical motion. Finally, it enables us to show why a definite world of forms must necessarily correspond to definite material and religious bases. Thus the history of art can leave the Linnean stage of cataloguing unessential characteristics and become a serious science.

———

The term "art" is employed in three seemingly related, but essentially different meanings: (1) the imitation of a ready-made world (whether it be the product of nature or religion, emotion or reason); (2) the portrayal of a contradiction between fixed and ready-made forms on the one hand, and contents in process of development on the other (or between fixed contents and forms in process of development); and (3) the constitution of a world of more or less autonomous forms, which draws its life from itself, and which is adequate to the contents. The first idea of art negates the basic importance of the contradictory tension existing between the process of experience, which achieves unity of conception starting from the manifold external and internal reality, and the process of artistic creation, which methodically translates the original conception into a sensual theme and later into an artistic whole for the purpose of achieving the identity of nature and art, spirit and sensibility. The second idea of art recognizes the heterogeneity of the two orders but superimposes them one on the other, just as an arbitrarily ornamented veneer is superimposed on the natural grain of the wood, and considers the dualism of form and content, the paradox of non-identity of life and artistic representation, an unchangeable principle. Only the third idea of art rests upon the fundamental assumption that the outer and inner worlds, the object and the soul, natural and social

compulsions achieve unity in an autonomous element of form that unfolds spontaneously and methodically from a theme both concrete and universal into self-sufficient artistic creation.

———

Duality of causes and effects is only a simplified expression of a complex reality. Even if this reality is grasped, the profound artistic content is not exhausted; the act of artistic creation has produced a content that comprises more than was supplied by reality and by social consciousness. The reason for this is not that the artist created new contents by the intensity of his feeling (his genius)—such contents would remain finite and historically determined just like the existing contents—but that he penetrated the existing contents with all the coordinates of human spirit and thus secured ever more universal meanings. This chain of meanings which begins with the relatable content of the subject or the describable form and attitude of the object and ends in profound universal human contents, constitutes the unfolding of the concrete conception (individual idea). The formal unfolding of the theme into artistic representation rests upon it or is identical with it.

———

We have seen that the paleolithic artist was greatly dependent on natural and social reality, and that this reality often assumed an increasingly dual character: hunting economy and gathering economy, two modes of feeding that increased the differences between the sexes, nomadic and sedentary portions of the individual life and of society, totemism and magic. These tensions and antagonisms of real life produced an increasing compulsion to overcome them in works of art. The creation of works of art was possible only under a system of laws which set a new and maximum resistance to man's spiritual creativeness. But these laws—then as today—could be established only on the basis of a leap into freedom, a leap made possible by the developmental stage of the existing society and by the artist's talent, which is nothing more than the specific artistic form of the history- and civilization-making powers of society as a whole.

———

In the eyes of paleolithic man, taking possession by the hand and slaughtering were identical, and he did not conceal this. Today taking possession of

things is done with money, and slaughtering is veiled behind various ideologies. In the Old Stone Age, the artist was a sorcerer, a privileged member of his clan; today, the artist is a pariah, an outcast forced to live on the margin of society. In paleolithic art horses and bison represented man and society. Géricault, too, painted horses not merely out of love for sport. Comparing the horses at Font-de-Gaume with those of Géricault (Derby d'Epsom), we can see not only the progress that has been made since the Old Stone Age in the representation of space and in composition, but also the Faustian relation of the finite individual to the infinite universe and the division of modern man into being and thinking, consciousness and unconsciousness, etc.—in brief, we can see social isolation and madness as the acquired fate of the artist.

The study of paleolithic art should serve as a reminder to us that it is high time to put an end to the prehistory of man and to begin a new era, in which the human race will consciously make its history. "What's past is prologue."

RAPHAEL:
REMBRANDT: "JOSEPH INTERPRETS PHARAOH'S DREAMS"
from *The Demands of Art*

Each thing takes its form by negation, through the fact that it not only passes through its death as something external to it but also lives in it. In a sense, all Rembrandt's human figures partake of nonbeing—not because they are incomplete and have not yet come into being: but precisely because they are separated from that which they no longer are, from that which has died. They are all aware of the relativity of their existence; Joseph is well aware that even his link with God is relative. But Spinoza's theorem that every determination is a negation is only partially valid: it is necessary to add the constitution of the remaining being as the core to which all determinations apply, the essential determinateness of the being that has not been abandoned. We need not digress into philosophical speculation here, but we may say this much: all individual men are expositions of the same fundamental mood in its immanent diversity, and each individual man therefore reveals some portion of the other's inwardness. We have justified this proposition with respect to Joseph and Pharaoh. The moment we add that Pharaoh, after all his earlier failures, was incapable of unconditional faith in Joseph's abilities, we have explained the poses and gestures of the councilors. But the man standing at the right, too,

is no more than an aspect of Pharaoh: he represents the royal dignity which the man on the throne so plainly lacks. A single individual idea projects its existence in all its multiplicity, and when all multiplicities have been added up, the total again comes to a self-contained whole.

We have already shown how each figure is wrested from the surface as though from the primal ground, how it comes into being and is constructed before our eyes. This process leads to a particular being. But the lives of the men in this drawing are not fixed forever in the conventions of habit; they carry their pasts with them, as pure intensity, into a future far from this present yet very close to their primordial past, their common origin. Existence is only a transitory moment in an act of continuous procreation that extends beyond all present particularities to the totality of personality and its conditions. And still further beyond, to the primordial oneness of Substance. The latter manifests itself in the viewer's certainty that the dream will be interpreted and that the interpretation will have consequences. We can imagine that Pharaoh's dependence on Joseph or Joseph's need of Pharaoh is momentarily interrupted or changed in intensity, but we cannot imagine that this relationship will ever come to an end (save by death). Despite the relativity of being between becoming and ceasing to be, it has a fullness that far surpasses one-sidedness and uniformity.

The relation between being and consciousness lights up existence; it

expresses the process by which being attains self-awareness. In the three councilors, being, instead of including consciousness, is split off from it. It is consciousness that watches being, and this is why each individual's consciousness varies and resembles no other. Rather, we see here various degrees of consciousness, ranging from subconsciousness in the lower parts of the bodies to consciousness proper in the heads and, in between, the struggle against passivity for full, active consciousness. Accordingly, some bodies are heavier at the bottom than at the top, and vice versa. Often the figures are least heavy somewhere in the middle and heavier at the bottom and the top.

Connected with man's consciousness is his freedom of will, his autonomy and responsibility. We have already emphasized, in our discussion of how Rembrandt represented and particularized his figures, to what extent they are determined. Such lack of freedom as they show has thus been imposed from "above," not from "below" (i.e., by influences, circumstances, etc.). They are not the product of the workings of any fate, but momentary manifestations of an eternal substance. They justify the moment in its passing because it reveals more than their individualities and more than their specific function within a social reality—the innermost, inviolable axis around which everything takes shape—the axis which we may with equal propriety name resemblance to God, freedom of will, or hope of immortality. These three terms are merely aspects of one and the same ultimately ineffable reality, from which we emerge for a fleeting moment and to which we return.

The men Rembrandt created in this drawing are in essence persons— i.e., both particularity and totality. The form of their empirical existence is neither portrait nor type, but a unique yet universally human determination of the whole man. Here, in terms of psychology—or, more accurately, with respect to what Rembrandt regarded as essentially real in man—he most resembles Shakespeare even though he did not, like Shakespeare, carry particularity to the point of *hubris,* i.e., he did not create comic or tragic figures. The relation between unmistakable particularity and human universality varies according to each figure's significance. The greater this is, the greater the contrasts and the tension between the particular and the universal; the result is a correspondingly greater unity of the mental state which may tend toward the active or passive side. In all this Rembrandt is fond both of contrasts (Joseph–Pharaoh) and of transitions (the councilors become progressively more relaxed, more passive, starting from the left).

When we examine the psychic functions more closely, we are struck by

the predominance of inwardness and wisdom. These men live from the inside out. They are absorbed in themselves. The dark spots in place of their eyes suggest that their inner vision is stronger, more assured, than their divided outward vision. What goes on inside them matters more than what is going on around them. The external senses are the means of revealing inner experiences; this is true even of the sense of touch, customarily our means of closest contact with the world. In this drawing the sense of touch is emphasized in various ways. I have already discussed the figure of Joseph; now let us look at Pharaoh, at how he sits, sagging, how he holds the scepter. Or the way the councilors touch themselves. Sounds, too, are distinctly to be heard in this silent drawing. Every viewer will hear the rhythm in which Joseph speaks: searching but sure; with pauses, because he must listen, because the words do not flow from him mechanically but carry the weight of divine revelation. We can also distinguish types of listening among the other figures. These men are, on the one hand, endowed with the keenest sensibilities and, on the other, with an unmovable core of existential wisdom. They are not thinkers or questioners; they sense their own needs and abilities. They understand, indeed they solve, their difficulties by assisting or by restraining themselves.

In this social relationship these men do not rely wholly upon their own wills or purposes. They are individuals within a group context which is conceived of as a category more basic than and superior to themselves, the first stage in the development of substantial being. The more individualized they are, the more closely they are bound up with the group, for one and the same principle governs both—the emphasis throughout is on meaning and on composition. This principle creates the group and endows it with an organic hierarchy of social values—i.e., the group does not smother individuality nor is it a mere sum of individuals. These men are complete beings (in the sense just defined) within the group; they form a social unit for all their individual diversity because this, too, is merely a single aspect of a spiritual substantial unity.

Not only the figures *in* the drawing but also the viewer *in front of it* has acquired greater concreteness. The picture imposes upon the viewer a specific attitude and mode of being. To mention the obvious first: Rembrandt has put us at a certain distance from which alone we can contemplate the drawing alertly and objectively. The line of vision he has provided is also the guiding line. This line is the horizontal at the top of the pedestals of the columns; beginning at Joseph's head, it continues as a curve above the other heads. Furthermore, he gives us a meeting line which divides Joseph's body at the point of the golden section (smaller part from the

left). Where the line of vision intersects it, the two main linear motifs meet: the ellipse around the figures and the diagonal that separates light from dark areas. When we have followed them both to the end we realize that a change has occurred. There is no longer *only* a point of view *from* which to look at the drawing. Some part of us—some immaterial part—has been drawn into the work and merged with it. Detached from us, it now soars beyond all determinations of space. Now we are freed from the subject matter, now we are confronted with the specific content, and all that remains to us is consciousness of a creative power which has made the invisible visible—and not only this, but mystery and miracle as well—and subjected them all to a new order. When we now look away from the picture at the world around us, it does not much resemble the drawing, but we know that it *is*, nevertheless, like it. We are convinced that its essential order, its purity, its holiness, and the inner beauty of its soul are merely veiled by chaotic accidents. When we see how spiritual breadth in a barely outlined body may be transformed into spiritual narrowness within a fully realized body; how currents of energy are metamorphosed into heavy masses; how relative finitude may be made to approach the infinite and the absolute—when we have seen all this, we realize at last how Rembrandt, starting from an intuitive idea (conception, motif), following a method of continuously concrete deduction, has brought all opposites into unity within the work of art. For a moment the source and substance—eternally one—shines forth.

RAPHAEL: **ART, OPIATE, TRANSCENDENCE**
from *The Demands of Art*

The main question Marx set out to answer was: How does it come about that man is the slave of the commodities he himself produces, and how can man free himself—become human again? His answer is: Human society is the basic fact, and its basic activity, continuously repeated, is the production of its means of subsistence and the propagation of the race. There is only one science (for understanding human society), and that is history, and the first object of this science is to formulate the laws governing the process of production and its development over the generations. The ideologies of law, government, art, morality, and religion are superstructures which grow upon this real objective activity. Marx was far from denying the importance of these superstructures in the historical process. Once they have come into existence, the state and law, morality, etc., react on the

productive process; they are instruments of power in the hands of the exploiting class, and to the exploited they serve as opiates. On the basis of this insight Marx made the notorious statement: "religion is the *opium* of the people"[1]—a statement which vulgar Marxists are trying to extend to art.

This is not the place to analyze Karl Marx's theory of art.[2] I should like, however, to refer to a passage at the end of *A Contribution to the Critique of Political Economy* in which he brilliantly formulated the main, but still unsolved, problem of his own—and every—theory of art. He says:

> But the difficulty is not in grasping the idea that Greek art and epos are bound up with certain forms of social development. It rather lies in understanding why they still constitute with us a source of aesthetic enjoyment and in certain respects prevail as the standard and model beyond attainment. A man can not become a child again. . . . But does he not enjoy the artless ways of the child and must he not strive to reproduce its truth on a higher plane? Is not the character of every epoch revived perfectly true to nature in child nature? Why should the social childhood of mankind, where it had obtained its most beautiful development, not exert an eternal charm as an age that will never return? There are ill-bred children and precocious children. Many of the ancient nations belong to the latter class. The Greeks were normal children. The charm their art has for us does not conflict with the primitive character of the social order from which it had sprung. It is rather the product of the latter, and is rather due to the fact that the unripe social conditions under which the art arose and under which alone it could appear can never return.[3]

It is perhaps no accident that Marx's manuscript breaks off at this point, for he had come to a problem which he could not solve. How can art, that is, an ideological superstructure in a specific type of economy, continue to be effective after this type of economy has ceased to exist? How can the ideological superstructure be timeless if the foundation has a finite history? Marx's answer has nothing whatever to do either with historical materialism or with Communism as a guide for changing the world. It sounds petty bourgeois, almost indistinguishable from Burckhardt's answer in his history of Greek culture, save that the latter used the term "adolescence" rather than "childhood." If such a thing as eternal charm exists despite determi-

1. *Contribution to the Critique of Hegel's Philosophy of Right,* Introduction.

2. [See the author's *Proudhon, Marx, Picasso: Trois études sur la sociologie de l'art.*]

3. Translated by N. I. Stone (Chicago, 1904), pp. 311f.

nation by historical, economic, and social conditions, then there must also be eternal sources that correspond. And if so, history cannot be the only science and the economy its primary object. The only alternative would be to provide an accurate analysis of the spiritual process that links up historical conditions with these "eternal charms"—more accurately, with the values created by men, transcending the limits of a given epoch but not the limits of historical time in general. The phrase "eternal charm"—which is doubly untenable, both as "eternal" and as "charm"—shows how far Marx was from having solved the problem he raised so astutely. We repeat, the problem remains unsolved.

And there are good reasons for this. If we apply to the thesis that art is an ideological superstructure, its own presupposition, i.e., that of historical materialism, we find that historical materialism itself is only an ideological superstructure of a specific economic order—the capitalistic order in which all productive forces are concentrated in the economic sector. A transitional epoch always implies uncertainty: Marx's struggle to understand his own epoch testifies to this. In such a period two attitudes are possible. One is to take advantage of the emergent forces of the new order with a view to undermining it, to affirm it in order to drive it beyond itself: this is the active, militant, revolutionary attitude. The other clings to the past, is retrospective and romantic, bewails or acknowledges the decline, asserts that the will to live is gone—in short, it is the passive attitude. Where economic, social, and political questions were at stake Marx took the first attitude; in questions of art he took neither. He reflected the actual changes of his time, which is to say that he made economics the foundation of thought which it had become in fact. He did not lose sight of the further problem, but as he could not see the solution, he left it unsolved. Had he been able to show that an active attitude toward art also exists, he would have brought the understanding of art up to the level of his revolutionary position.

Whatever the deficiencies of Marx's theoretical attitude toward art may have been, he was perfectly aware that after the economic, social, and political revolution the most difficult revolution would still remain to be made—the cultural one. Nowhere did he ever exclude art, as he excluded religion, on the ground that there would be no place for it in a classless society. The pseudo-Marxists who put art on the same footing with religion do not see that religion sets limits to man's creative capacities, diverts him from the things of this world, and reconciles class antagonisms by obviously imaginary and frequently hypocritical theories of love, whereas art is an ever-renewed creative act, the active dialogue between spirit and matter;

the work of art holds man's creative powers in a crystalline suspension from which it can again be transformed into living energies. Consequently, art by its very nature is no opiate; it is a weapon. Art may have narcotic effects, but only if used for specific reactionary purposes; and from this we may infer only that attempts are made to blunt it for the very reason that it is feared as a weapon.

THE TRAJECTORY
OF ART

MARXISM AND UTOPIA

*Smile not at the fantasy of one who foresees in the
region of reality the same outburst of revolution that
has taken place in the region of intellect. The thought
precedes the deed as the lightning the thunder.*
—Heine, *Religion and Philosophy in Germany*

*But far more mightily than by the past, is the mind
influenced by the future; the former leaves behind
only the quiet perception of remembrance, while
the latter stands before us with the terrors of hell or
the happiness of heaven. . . . [T]he future is the
empire of poetry.*
—Feuerbach, *The Essence of Religion*

*The social revolution of the nineteenth century cannot
draw its poetry from the past, but only from the future.*
—Marx, *The Eighteenth Brumaire*

Lenin described the three sources and chief component parts of Marxism
as German idealist philosophy, British political economy, and French
Utopian socialist thought. In this he was only reiterating and systematizing
the many acknowledgments by Marx and (especially) Engels of the debts
to their predecessors. But curiously, and no doubt inevitably, this piety
took the form of negation, and not in the Hegelian sense of cancellation-
transcendence-preservation. During the Kautskyist and Stalinist periods the
component sources of Marxism were rigorously excluded from the proper
study of Marxism, and the representatives and symbols of those sources—
including Utopianism—were anathematized. Marxism was said to have
progressed from Utopia to science, to have rationalized the irrational ele-
ments in all prior systems. In the process, Utopian thought was rejected as
unscientific, fantastic, and reactionary.

Accordingly, there is some controversy as to the legitimacy of the
Utopian strain in Marxism, which can only be dealt with by a clarification
of Marx's and Engels' attitude toward Utopia. Simply put, the founding

Marxists paid homage to the brilliant insights and critical formulations of their Utopian predecessors—especially Fourier, Saint-Simon, Robert Owen, and Weitling—while branding as reactionary the schematic programs and representations of the form of future society both by the great Utopians and (mainly) by their sectarian disciples. Engels' critique in *Socialism: Utopian and Scientific* was aimed at the Utopians' unhistorical blueprints for the future: "These new social systems were from the outset doomed to be utopias; the more their details were elaborated, the more they necessarily receded into pure phantasy."[1] The anti-Utopian passages of *The Communist Manifesto* similarly are thrusts against the programs of Owenite and Fourierist sects: "Such phantastic pictures of future society, painted at a time when the proletariat is still in a very undeveloped state and has but a phantastic conception of its own position, correspond with the first instinctive yearnings of that class for a general reconstruction of society."[2] Marx, in a letter to Sorge of October 19, 1877, spoke of Utopian socialism's "fancy pictures of the future structure of society" as "silly, stale and basically reactionary."[3] The critique of Utopia is political and historical: "These sects act as levers of the movement in the beginning, but become an obstruction as soon as the movement outgrows them. . . . [W]e have here the infancy of the proletarian movement, just as astrology and alchemy are the infancy of science."[4] Engels' most exact statement concerning this aspect of Utopia is in his articles on *The Housing Question* (1873): "To be utopian does not mean to maintain that the emancipation of humanity from the chains which its historic past has forged will be complete only when the antithesis between town and country has been abolished; the utopia begins only when one ventures, 'from existing conditions,' to prescribe the *form* in which this or any other antithesis of present-day society is to be resolved."[5] Korsch believes that Marx's quarrel with the Utopian socialists is not "inspired by their idea of a future commonwealth totally different from the present state of contemporary bourgeois society." On the contrary: "the weakness of the Utopian socialists lies in the fact that, in attempting to portray a socialist future, they at bottom only idealized the existing conditions of society, leaving out the shadows."[6]

1. *Selected Works*, vol. III, p. 119.
2. *Ibid.*, vol. I, p. 135.
3. Marx and Engels, *Selected Correspondence, 1846–1895* (New York, 1942), p. 350.
4. *Selected Works*, vol. II, p. 271.
5. *Ibid.*, vol. II, pp. 368–69.
6. Karl Korsch, *Karl Marx* (New York, 1963), p. 53. Northrop Frye makes the important point that Engels dismissed "the possibility of setting up *a* utopia within

Marx paid tribute to Utopianism in his letter to Kugelmann of October 9, 1866: "In the utopias of a Fourier, an Owen, etc., there is the anticipation and imaginative expression of a new world."[7] Engels wrote of "the inspired ideas and germs of ideas which everywhere emerge through their covering of phantasy."[8] And in the *Manifesto* the "critical element" of Utopian thought is stressed: "They attack every principle of existing society. Hence they are full of the most valuable materials for the enlightenment of the working class."[9] The founding Marxists opposed the schematic programs and universal panaceas of the Utopians but not the revolutionary core of Utopian thought.[10] Their critiques referred to ideas or schemata that were in principle unrealizable. Lenin used the word exclusively in this sense: "Utopia is a Greek word, composed of *ou*, not, and *topos*, a place. It means a place which does not exist, a fantasy, invention or fairy-tale. In politics, utopia is a wish that can never come true—neither now nor afterwards, a wish that is not based on social forces and is not supported by the growth and development of political, class forces."[11] But while Marxism specifically rejected this aspect of Utopia, it simultaneously incorporated both the critical and the anticipatory tendencies of Utopianism. As Bloch writes: "All Utopias, or nearly all, despite their feudal or bourgeois commission, predict communal ownership, in brief, have socialism in mind." In the Utopias, he continues, there "came to expression the expectant tendency that permeates all human history. Only in Marxism, however, did it find concrete expression, precisely because Marxism disclosed the real possibilities. And Marxism also reveals totality . . . which is the method and the subject matter of all authentic philosophy. But for the first time this totality appears not as a *static*, as a *finished principle* of

a pre-socialist world," as a "place of refuge" within capitalist society. (*The Stubborn Structure: Essays on Criticism and Society* [Ithaca, N.Y., 1970], p. 113.)

7. *Selected Works,* vol. II, p. 417.

8. *Ibid.,* vol. III, p. 120.

9. *Ibid.,* vol. I, p. 135.

10. Marx and Engels were opposed in principle to speculations on the specific details of the organization of future society; they did not wish to go beyond predictions of the downfall of capitalism. However, they were not always consistent in this: Engels ventures guardedly into predictive Utopianism in *The Origin of the Family,* and Marx's *Critique of the Gotha Programme*—with its famous passages on the "withering away of the state" under socialism—is wholly within the predictive Utopian tradition, as is Lenin's *State and Revolution.*

11. Lenin, "Two Utopias," in *On Utopian and Scientific Socialism* (Moscow, 1965), p. 66.

the whole, but rather as a *utopian,* or more precisely, as a *concrete utopian* totality, as the process latency of a still unfinished world."[12]

Karl Mannheim had earlier redefined "Utopia," thereby seeking to free it from the connotations of futility which both Marxism and bourgeois complacency had attached to it: "A state of mind is utopian when it is incongruous with the state of reality within which it occurs. . . . Only those orientations transcending reality will be referred to by us as utopian which . . . tend to shatter the order of things prevailing at the time." The Utopian consists of "those ideas and values in which are contained in condensed form the unrealized and the unfulfilled tendencies which represent the needs of each age. . . . The existing order gives birth to utopias which in turn break the bonds of the existing order, leaving it free to develop in the direction of the next order of existence."[13]

It is within this definition of Utopia that Marxism itself takes its place. Of greater significance, however, Marxism is the first philosophy to perceive and insist upon the active and anticipatory (which is to say, Utopian) nature of philosophy itself, the first to transcend the contemplative role which had held sway from Plato through Hegel, keeping philosophy, as Bloch points out, "fixed *in a relationship to what was past*—a relationship built into all contemplation."[14]

━━━

The formulation of the process by which theory (rising from the specific conditions of a historical period) guides praxis toward a desired future was given by Marx himself in the course of his breakaway from Hegel. His solution of this problem occurs in the Introduction to *A Contribution to a Critique of Hegel's Philosophy of Right* (1843). Hegel's *Philosophy of Right* had insisted on the derivative, mirroring role of philosophy: "It is just as absurd to fancy that a philosophy can transcend its contemporary world as it is to fancy that an individual can overleap his own age, jump over Rhodes."[15] And Hegel had fought the Utopian side of philosophy with equal vigor: "One word more about giving instructions as to what the world ought to be. Philosophy in any case always comes on the scene too late to give it. As the thought of the world, it appears only when actuality is

12. Ernst Bloch, *On Karl Marx* (New York, 1971), p. 136.
13. Karl Mannheim, *Ideology and Utopia* (New York, 1936), pp. 192, 199.
14. Bloch, *On Karl Marx*, p. 101.
15. Hegel, *Philosophy of Right,* translated by T. M. Knox (London, Oxford and New York, 1967), p. 11.

already there cut and dried after its process of formation has been completed. . . . The owl of Minerva spreads its wings only with the falling of the dusk."[16]

For Hegel, activity was denied to the philosopher, and reserved to Absolute Spirit. Against the assignment of this passive role to philosophy Marx launched a major critique which insists upon the central and active role of the philosopher. Referring to Luther and the Reformation, he wrote: "as the revolution then began in the brain of the *monk,* so now it begins in the brain of the *philosopher.*" And in his classic formulation: "Theory also becomes a material force when it grips the masses." Marx would (and did) liberate philosophy from contemplation and set it "at the service of history . . . to unmask self-alienation in its *unholy forms.*" The proletariat *and* philosophy are the twin motors of revolution: "As philosophy finds its *material* weapon in the proletariat, so the proletariat finds its *spiritual* weapon in philosophy. . . . Philosophy cannot be made a reality without the abolition of the proletariat, the proletariat cannot be abolished without philosophy being made a reality." Marx had discovered and maintained a delicate dialectical balance: philosophy, by itself, is incapable of revolution: "It is not enough for thought to strive for realization, reality must itself strive toward thought."[17] The separation of Marx from Hegel turns on the same issue as his separation from Feuerbach—the activity of the human subject.[18]

Marx returned to (and summarized) the critique of Hegel on this point in *The Holy Family:*

With Hegel, the philosopher is only the organ through which the creator of history, the Absolute Spirit, arrives at self-consciousness *by retrospection* after the movement has ended. The participation of the philosopher in history is reduced to this retrospective consciousness, for real movement is accomplished by the Absolute Spirit *unconsciously,* so that the philosopher appears *post festum.*

Hegel is doubly inconsistent: first because, while declaring that philosophy constitutes the Absolute Spirit's existence he refuses to recognize the *real*

16. *Ibid.,* pp. 12–13.

17. This and the preceding quotations are from "Introduction to a Contribution to the Critique of Hegel's Philosophy of Right," in Marx and Engels, *On Religion* (Moscow, 1957), pp. 41–58.

18. See the theses on Feuerbach: "The chief defect of all hitherto existing materialism . . . is that the object, reality, sensuousness, is conceived only in the form of the *object* or *contemplation* but not as *human sensuous activity, practice,* not *subjectively.*" *Selected Works,* vol. I, p. 13.

philosophical individual as the *Absolute Spirit;* secondly, because according to him the Absolute Spirit makes history only in appearance.[19]

Following Heine and other left-Hegelians, Marx's Hegel-Critique examined the historical process by which Germany after Luther failed to join the bourgeois-revolutionary upsurge and instead fought out its battles in the realm of the superstructure (in its "cranium"), creating thereby a Utopian "dream-history" (Marx's phrase) which Germany—headed by its proletariat—must now seek to convert into reality.[20] Hegel's *Philosophy of Right* denied that philosophy could transcend its own genesis;[21] Marx affirmed the transcendent power of thought (indeed in that very philosophy which culminated in Hegel), analyzed the disproportion between philosophical "dream-history" and political reality, and discovered the process by which philosophy (and art as well, later Marxists would propose) propels the images of possibility into existence as models of social transformation.

Marx touched the essence of the matter in a letter to Ruge of September, 1843: "The world has long dreamed of something of which it only has to

19. *The Holy Family* (Moscow, 1956), p. 115. For elaborations on this point, see Lukács, *History and Class Consciousness* (London, 1970), p. 16f., and Bloch, *On Karl Marx*, p. 110f.

Marx's biographical receptivity to the idea of a revolutionary role for philosophy is worth exploring, for it is evident that as early as his letter to his father in 1837 and the *Doctoral Dissertation* of 1839–1841 the need to assert the discrete individuality of Karl Marx ("the real philosophical individual"?) was already beginning to emerge.

20. Hegel had anticipated his rebellious disciples on this point, in his *Lectures on the Philosophy of History:* "France has a sense of reality, of accomplishment, because ideas there are translated more directly into action; consequently men there have applied themselves practically to reality. . . . In Germany the same principle aroused the interest of consciousness but was only developed in a theoretical manner. We have all kinds of commotions within us and about us; but through them all the German head prefers to let its sleeping cap sit quietly where it is and silently carries on its operations beneath it." (Cited in Korsch, *Marxism and Philosophy* [London, 1970], p. 40). See also Karl Löwith, *From Hegel to Nietzsche* (Garden City, 1967), pp. 96–99.

21. Hegel's philosophy also includes (often centrally) ideas that express precisely the opposite of this formulation, stressing the dialectic between thought and action. Without pretending to enter into a discussion here of Hegel's philosophy as a whole, the crucial point in the present connection is that Marx took Hegel's categorical emphasis in the *Philosophy of Right* on the passive role of philosophy and *reversed* it, revealing the historical circumstances which lead to philosophical "dream-history" which in turn serves as the Utopian model of revolutionary transformation.

become conscious in order to possess it in actuality. It will be evident that there is not a big blank between the past and the future, but rather that it is a matter of *realizing* the thoughts of the past. It will be evident, finally, that mankind does not begin any *new* work but performs its old work consciously."[22] It may be time to use the term "Utopian" (or, perhaps, "Utopian Communist," in Engels' phrase) for this dialectical and materialist theory, in which Marxism subverted the "rationality" of Hegel's systematic philosophy.[23]

The Marx of the Hegel-Critique exploded what we may term the "historical determinism" of Hegel's *Philosophy of Right* in 1843. Was this, however, merely a transitional position, later repudiated or abandoned by Marx? Did Marx himself return to a historical determinism reminiscent of Hegel's own after he had become a "mature" Marxist? This, of course, would be the view of Louis Althusser, who believes that the "epistemological break" with Hegel and Feuerbach took place in 1845 and that "true" Marxism can be dated only from 1857.[24] That there is such an "epistemological break" is undeniable. Galvano della Volpe and Lucio Coletti properly place it in 1843, simultaneous with the Hegel-Critique, prior to

22. Marx, *The Writings of the Young Marx on Philosophy and Society,* ed., Lloyd Easton and Kurt Guddat (New York, 1967), pp. 214–15.

23. The purpose of such a restoration is not to return Marxism to a stage which it had already surpassed, but to re-emphasize the transcendent and revolutionary fundamentals of Marxist theory. A more thorough treatment of the dialectics of Utopia would have to take into account the negative aspects of certain forms of transcendent thought. See Mannheim, *Ideology and Utopia,* for distinctions between Utopia and "counter-Utopia"; Harry Slochower, *Mythopoesis* (Detroit, 1970), for a contrast between myth and "mythopoesis"; Georges Duveau, *Sociologie de l'Utopie* (Paris, 1961), for a useful characterization of "left utopianism" and "right utopianism," and of the opposition between mythic thought and utopia. Bloch himself contrasts Utopia with "concrete utopia," as well as utopian with "utopistic."

24. Louis Althusser, *For Marx* (London, 1969). Althusser's is an attempt to split off from Marxism many of the humanist, aesthetic, and Utopian formulations of Marx's early works and to prevent the ongoing reconciliation of Marx with his predecessors. His is a difficult task, which he accomplishes only by blinding himself to the reverberations and confirmations of early Marx in the later works, by a Jesuitical avoidance of contradictory evidence (through the ruse of focusing on the extraneous detail), and by ruling obsolete the dialectical laws themselves. He writes that Stalin's "expulsion of the 'negation of the negation' from the domain of the Marxist dialectic" should be regarded as evidence of his "theoretical perspicacity" (p. 200, n). This is not a minor point, for if the negation of the negation stands, then Hegel, Feuerbach, the Utopians, and pre-Marxist culture are all preserved in Marxism at the same time that they are superseded.

the *Economic and Philosophic Manuscripts of 1844.* Adam Schaff cites Engels as placing the emergence of Marxism in Marx during 1841; this is surely too early, preceding by two years both Marx's adherence to Feuerbach and his conversion to Communism.[25] Engels wrote, in his *History of the Communist League* (1885), that he himself had arrived at Communism during his first Manchester period (1843–1844) and that Marx had arrived at the theory of historical materialism and the class struggle in 1843–1844, specifically in the Hegel-Critique and his other contributions to the *Deutsch-Französische Jahrbücher* of February, 1844.[26] The Hegel-Critique is committed to the concepts of class struggle and the ideal of Communism; Marx's critique of theology had already incorporated and transcended Feuerbach (although the language remains that of Feuerbach at his most eloquent and poetic).

Decisively, Marx himself wrote that "the first work which I undertook for a solution of the doubts which assailed me was a critical review of the Hegelian philosophy of law, a work the introduction to which appeared in 1844 in the *Deutsch-Französische Jahrbücher,* published in Paris."[27] He

25. That Marx's Hegel-Critique of 1843 marks a decisive reversal in his own thought may be seen by the following from "The Leading Article in No. 179 of the Kölnische Zeitung," of July, 1842: "But philosophers do not grow out of the earth like mushrooms; they are the fruit of their time. . . . The same spirit that builds philosophical systems in the brain of the philosophers builds railroads by the hands of the workers. Philosophy does not stand outside the world any more than man's brain is outside him because it is not in his stomach; but philosophy, to be sure, is in the world with its brain before it stands on the earth with its feet. . . . Every genuine philosophy is the spiritual quintessence of its time." (Easton and Guddat, *Writings of the Young Marx,* p. 122.)

There is no essential difference between this view and Hegel's in his *Philosophy of Right.* The break with Hegel was still to come.

26. *Selected Works,* vol. III, p. 178. Engels is, however, not always consistent on this point. In the Preface to *Ludwig Feuerbach* (1888) he dates the working-out of the materialist conception of history to 1845, and writes that the theses on Feuerbach are "the first document in which is deposited the brilliant germ of the new world outlook" (*Selected Works,* vol. III, p. 335).

For a useful distinction between "ideological communism" and "scientific communism" in early Marx, see Auguste Cornu, "Hegel, Marx and Engels," in *Philosophy for the Future,* ed. Sellars, McGill, and Farber (New York, 1949), p. 55. Cornu marks the emergence of the former in Marx's essays for the *Deutsch-Französische Jahrbücher,* noting that the transition to a scientific Communism instilled with the content of political economy and French socialist thought occurs in the *Economic and Philosophic Manuscripts of 1844, The Holy Family* (1845), and the theses on Feuerbach (1845).

27. *Selected Works* vol. I, p. 503.

wrote this in the Preface to his *Contribution to the Critique of Political Economy* of 1859, in which the classic formulation of Marxism appears. And in the Introduction to that work he reaffirmed and reformulated the very same Utopian reflex by which imagination crystallizes the images of the desired mastery of necessity: "All mythology masters and dominates and shapes the forces of nature in and through the imagination; hence it disappears as soon as man gains mastery over the forces of nature."[28]

There are other confirmations in the "mature" Marx of his early insistence on the transcendent power of the imagination. In the *Eighteenth Brumaire* he described how bourgeois-revolutionary movements clothe themselves in the heroic traditions of the past, and commented: "Thus the awakening of the dead in those revolutions served the purpose of glorifying the new struggles, not of parodying the old; of magnifying the given task in imagination, not of fleeing from its solution in reality; of finding once more the spirit of revolution, not of making its ghost walk again."[29] Here, Marx sees the past not merely as the dead nightmarish weight of inherited evils (as in the preface to *Capital* and elsewhere) but also as providing the imagination with the means of advancing the revolutionary struggle—the return to a heroic past in order to achieve a breakthrough to the future.

But Marx could not abide the possibility that self-deception might be a necessary motor of proletarian revolution. He therefore went on to criticize those earlier revolutions which "required recollections of past world history in order to drug themselves concerning their own content," and he insisted on the necessity for stripping away "all superstition in regard to the past." The proletarian revolution must proceed without masks, without the narcoticism of deceptive disguise: "The social revolution of the nineteenth century cannot draw its poetry from the past, but only from the future. . . . In order to arrive at its own content, the revolution of the nineteenth century must let the dead bury their dead."[30] (Here, Marx appears to abandon the reference backward without which no vision of the future is comprehensible.) Marx simultaneously recognizes the Utopian anticipation of future stages of human progress as well as the weight of accumulated traditions and reified forms which prevent humanity from moving toward that very future.

It is in his observations upon the labor process, however, that Marx

28. *A Contribution to the Critique of Political Economy* (Chicago, 1904), pp. 310–11.

29. *Selected Works,* vol. I, p. 309.

30. *Ibid.,* p. 310.

fixed the power of the imagination as the irreducible factor which separates man from the lower orders of living things. His interest in this had been aroused as early as 1837, when he read Samuel Reimarus on "the artistic impulses of the animals."[31] His first Marxist references to this subject occur in *The Economic and Philosophic Manuscripts of 1844:* "Man makes his life-activity itself the object of his will and of his consciousness. . . . Conscious life-activity directly distinguishes man from animal life-activity. It is just because of this that he is a species being. . . . [A]n animal . . . produces only under the dominion of immediate physical need, whilst man produces even when he is free from physical need and only truly produces in freedom therefrom. . . . Man therefore also forms things in accordance with the laws of beauty."[32] The classic statement is in *Capital:* "What distinguishes the worst architect from the best of bees is this, that the architect *raises his structure in imagination before he erects it in reality.* At the end of every labour process, we get *a result that already existed in the imagination of the labourer at its commencement.*"[33]

In one of his very last manuscripts, the *Abstract of Morgan's Ancient Society* (1880–1881), Marx paid his final tribute to the overleaping potentialities of "the imagination, that great faculty so largely contributing to the elevation of mankind."[34] In the 1843 Hegel-Critique he had uncovered the goal-projecting power of philosophy's dream world, which, however, he then saw as arising from historically derived conditions of political backwardness; in his mature work Marx revealed imaginative anticipation to be inherent in the labor process itself. He touched on the applications of this pattern to mythology and revolutionary ideology but he never undertook the extension of the theory to art and literature.[35] In the

31. Reimarus, *Allgemeine Betrachtungen über die Triebe der Tiere, hauptsächlich über ihren Kunsttrieb . . .* (Hamburg, 1760). See Marx, letter to his father, November 10, 1837, in Easton and Guddat, *Writings of the Young Marx,* p. 47.

32. Marx, *Economic and Philosophic Manuscripts of 1844,* trans. Martin Milligan, pp. 75–76.

33. Marx, *Capital,* vol. I, p. 157. Italics added.

34. Marx and Engels, *Ueber Kunst und Literatur* (Berlin, 1967), vol. I, pp. 238, 624.

35. Marx never applied this thesis to art, although he was keenly aware of the disproportion between artistic development and material progress. Since the parallelisms between art and mythology or art and philosophy are on the surface, one wonders why Marx did not make the connection himself. Perhaps this is the by-product of Marx's own early biographical development, in which his artistic proclivities were almost wholly suppressed, and his numerous attempts at aesthetic exploration were aborted (see above, page 4). The young Marx attempted to channel his creativity into a supposedly less chaotic, more ordered and rational field of study

following pages we will encounter some of the aesthetic reverberations of this crucial aspect of Marx's dialectic.

—that of philosophy. Recognition of the Utopian kinship between art, philosophy, and mythology might have forced the realization that he had escaped one biographical "dream-world" only to find himself in another of essentially identical psychological nature. Indeed, Marx's general avoidance of philosophy-as-such in his last decades may indicate that he came to just such a realization and moved on to political economy (surely *there* was rationality!) as a haven from philosophy as well as art.

FRIEDRICH ENGELS

*The memory of gratification
is at the origin of all thinking,
and the impulse to recapture past
gratification is the hidden driving power
behind the process of thought.*
—Marcuse, *Eros and Civilization*

*The relationship which
stands at the origin
of all culture, of every virtue,
of every nobler aspect of existence,
is that between mother and child;
it operates in a world of violence
as the divine principle
of love, of union, of peace.*
—Bachofen, *Das Mutterrecht*

INTRODUCTION

Before Marx died he bequeathed to Engels the task of incorporating into Marxism the anthropological researches of Lewis Henry Morgan (1818–1881), which Marx regarded as having confirmed in primitive society the theory of historical materialism. In 1880–1881, Marx took extensive notes and abstracts from Morgan's *Ancient Society* (1877), and Engels utilized these as the basis for his *The Origin of the Family, Private Property and the State,* the first edition of which appeared in 1884, a year after the death of Marx, and in which is made explicit for the first time the Marxist myth of primitive matriarchal communism as the model for a classless society.

The Origin of the Family stands on a theory of prehistory first elaborated by Johann Jakob Bachofen (1815–1887) in *Das Mutterrecht* (1861) and incorporated into his own system by Morgan.[1] Primitive

1. Lewis H. Morgan, *Ancient Society, or, Researches in the Lines of Human Progress from Savagery through Barbarism to Civilization* (Chicago, various dates), pp. 359 ff.; J. J. Bachofen, *Myth, Religion, and Mother Right: Selected Writings,* translated by Ralph Manheim (Princeton, N. J., 1967).

society is seen as an evolution from mother-right to patriarchal forms of organization: the "break" with primitive communism and the concomitant beginnings of private property and the state may be dated from the "overthrow of mother-right," which Engels described as "the world-historic defeat of the female sex."[2]

Included here from Engels' book are his summary of Bachofen's views and his paraphrase of Bachofen's interpretation of Aeschylus' *Oresteia* as reflecting in ritual-literature this revolutionary-regressive transition to patriarchal class domination.

The centrality of this theory of transition to the Marxist view of history cannot be overestimated. Engels wrote: "The rediscovery of the original mother-right gens as the stage preliminary to the father-right gens of the civilized peoples has the same significance for the history of primitive society as Darwin's theory of evolution has for biology, and Marx's theory of surplus value for political economy." "The mother-right gens has become the pivot around which this entire science turns."[3]

The origin of class society and the overthrow of mother-right occur simultaneously.[4] And, in the Marxist Utopian model, they will end simul-

2. *The Origin of the Family*, in *Selected Works*, vol. III, p. 233. The researches of Morgan and Bachofen have been the subject of great debate. The interested reader may find some commentary on the present state of this dispute in: Bronislaw Malinowski, *Sex, Culture and Myth* (New York, 1962); Gordon Rattray Taylor, *Sex in History* (New York, 1954); Taylor's introduction to Robert Briffault, *The Mothers* (abridged edition, New York, 1963); the various works of the outstanding Marxist anthropologist, V. Gordon Childe; Bernhard J. Stern, *Lewis Henry Morgan, Social Evolutionist* (Chicago, 1931), and the same author's *Historical Sociology* (New York, 1959), pp. 163–90, 277–303; the major works of George Thomson (see above, pp. 343–44); the special literature on the subject by followers of Freud, Jung (whose school has utilized the myth of the Great Mother as the core of a mystical theosophy), and the various anthropological schools (of particular importance are papers by J. R. Swanton, R. H. Lowie, Alfred Kroeber, George Peter Murdock, and Ralph Linton). See also Norman O. Brown, *Life Against Death* (New York, 1961) for an attempt—informed by Marxism—to focus Freudian concern on the biological pre-oedipal mother and the anthropological Great Mother of Bachofen (pp. 126, 280, and *passim*). The most successful such attempt known to me is a paper by Martin Grotjahn, "The Primal Crime and the Unconscious," in *Searchlights on Delinquency,* ed. K. R. Eissler (New York, 1949), pp. 306–14.

3. *The Origin of the Family*, p. 201.

4. "The first class antagonism which appears in history coincides with the development of the antagonism between man and woman in monogamous marriage, and the first class oppression with that of the female sex by the male. Monogamy was a great historical advance, but at the same time it inaugurated, along with slavery and private wealth, that epoch, lasting until today, in which every advance is likewise a relative regression, in which the well-being and development of the one group are

taneously in a Communist society which abolishes "the absolute domination of the male over the female sex" which is the "fundamental law" of class societies.[5] The first alienation in biology is the separation of the child from the mother; class society begins with matricide. Prehistory will end with the restoration of subject and object, with the smashing of the instrumentalities of the state (which are the historical-symbolic projections of father-right), and by the ultimate "withering away" of the state itself. It is the revolutionary restoration (on a new level—cleansed of terror, cannibalism, and brutality—and accelerated by science and technology) of primitive communism and of the primal mother-child harmony which is the Marxist Utopia.[6]

Applying psychoanalytical categories here, one might suggest that art begins with the alienation from the mother and embodies the desire to transcend that alienation, which, therefore, may be seen as the necessary precondition of creativity.[7] The dream of the earliest harmony—philogenetically primitive matriarchal communism, ontogenetically the infancy-

attained by the misery and repression of the other. It is the cellular form of civilized society" (*ibid.*, p. 240); "In the monogamous family . . . we have a picture in miniature of the very antagonisms and contradictions in which society, split up into classes since the commencement of civilization, moves" (*ibid.*, p. 242).

Engels does not venture to predict the precise form in which equality of the sexes will be achieved under Communism, but he closes his book with a quotation from Morgan indicating that Communism is the negation of the negation of primitive matriarchal communism: *"It will be a revival, in a higher form, of the liberty, equality and fraternity of the ancient gentes"* (*ibid.*, p. 334).

5. *Ibid.*, p. 241.

6. For a contrary view, see Karl Korsch, *Karl Marx* (New York, 1963), pp. 67–68. Korsch sees Marxism as a straight-line progressive, evolutionary view of history in which each prior stage is wholly superseded: "Marx presents human society as an historical development progressing from a lower to a higher organization of the material productive forces" (p. 68). Korsch overlooks Engels' quote from Morgan cited in footnote 4 as well as the importance to Marx of the discovery that "civilization" represented a clear regression from primitive communism as regards the position of women. Compare, for example, Marx's earlier acceptance of Fourier's belief that "the humiliation of the female sex is an essential feature of civilization as well as of barbarism" (in *The Holy Family*, p. 259) with the central thesis of *The Origin of the Family*. Engels writes: "The power of these primordial communities . . . was broken by influences which from the outset appear to us as a degradation, a fall from the simple moral grandeur of the ancient gentile society. The lowest interests . . . usher in the new civilised society, class society" (*Origin of the Family*, p. 267).

7. Cf. Warner Muensterberger, "The Creative Process: Its Relation to Object Loss and Fetishism," in W. Muensterberger and S. Axelrad, eds., *The Psychoanalytic Study of Society*, vol. II, pp. 161–85 (New York, 1962).

Eden—is the displaced goal of Utopia, which bases its future goal on a remembered Paradise, a Paradise Lost but never abandoned in wish. Artistic cognition is repression, but is also the desire to master necessity in order to restore the pre-oedipal situation, to restore the matriarchal brotherhood. For, as Bachofen proposes, it is only under matriarchy that fraternity can flourish: "The paternal principle implies limitation to definite groups, but the maternal principle, like the life of nature, knows no barriers. The idea of motherhood produces a sense of universal fraternity among all men, which dies with the development of paternity."[8] It is to be hoped that the processes of history will provide salvation for the fathers as well.

ENGELS: **THE OVERTHROW OF THE MATRIARCHY**
from *The Origin of the Family, Private Property and the State*

The study of the history of the family dates from 1861, from the publication of Bachofen's *Mother Right*. In this work the author advances the following propositions: 1) that in the beginning humanity lived in a state of sexual promiscuity, which the author unhappily designates as "hetaerism"; 2) that such promiscuity excludes all certainty as regards paternity, that lineage, therefore, could be reckoned only through the female line—according to mother right—and that originally this was the case among all the peoples of antiquity; 3) that consequently women, who, as mothers, were the only definitely ascertainable parents of the younger generation, were treated with a high degree of consideration and respect, which, according to Bachofen's conception, was enhanced to the complete rule of women (gynaecocracy); 4) that the transition to monogamy, where the woman belongs exclusively to one man, implied the violation of a primeval religious injunction (that is, in actual fact, the violation of the ancient traditional right of the other men to the same women), a violation which had to be atoned for, or the toleration of which had to be purchased, by surrendering the woman for a limited period of time.

Bachofen finds evidence in support of these propositions in countless passages of ancient classical literature, which he had assembled with extraordinary diligence. According to him, the evolution from "hetaerism" to monogamy, and from mother right to father right, takes place, particularly among the Greeks, as a consequence of the evolution of religious ideas, the

8. *Myth, Religion and Mother Right,* p. 80.

intrusion of new deities, representatives of the new outlook, into the old traditional pantheon representing the old outlook, so that the latter is more and more driven into the background by the former. Thus, according to Bachofen, it is not the development of the actual conditions under which men live, but the religious reflection of these conditions of life in the minds of men that brought about the historical changes in the mutual social position of man and woman. Bachofen accordingly points to the *Oresteia* of Aeschylus as a dramatic depiction of the struggle between declining mother right and rising and victorious father right in the Heroic Age. Clytemnestra has slain her husband Agamemnon, just returned from the Trojan War, for the sake of her lover Aegisthus; but Orestes, her son by Agamemnon, avenges his father's murder by slaying his mother. For this he is pursued by the Erinyes, the demonic defenders of mother right, according to which matricide is the most heinous and inexpiable of crimes. But Apollo, who through his oracle has incited Orestes to commit this deed, and Athena, who is called in as arbiter—the two deities which here represent the new order, based on father right—protect him. Athena hears both sides. The whole controversy is briefly summarised in the debate which now ensues between Orestes and the Erinyes. Orestes declares that Clytemnestra is guilty of a double outrage; for in killing *her* husband she also killed *his* father. Why then have the Erinyes persecuted him and not Clytemnestra, who is much the greater culprit? The reply is striking:

> *Unrelated by blood* was she to the man that she slew.[1]

The murder of a man not related by blood, even though he be the husband of the murderess, is expiable and does not concern the Erinyes. Their function is to avenge only murders among blood-relatives, and the most heinous of all these, according to mother right, is matricide. Apollo now intervenes in defence of Orestes. Athena calls upon the Areopagites—the Athenian jurors—to vote on the question. The votes for acquittal and for the conviction are equal. Then Athena, as President of the Court, casts her vote in favour of Orestes and acquits him. Father right has gained the day over mother right. The "gods of junior lineage," as they are described by the Erinyes themselves, are victorious over the Erinyes, and the latter allow themselves finally to be persuaded to assume a new office in the service of the new order.

This new but absolutely correct interpretation of the *Oresteia* is one of the best and most beautiful passages in the whole book, but it shows at the

1. Aeschylus, *Oresteia. Eumenides.—Ed.*

same time that Bachofen himself believes in the Erinyes, Apollo and Athena at least as much as Aeschylus did in his day; he, in fact, believes that in the Heroic Age of Greece they performed the miracle of overthrowing mother right and replacing it by father right. Clearly, such a conception —which regards religion as the decisive lever in world history—must finally end in sheer mysticism. . . .

HARRY SLOCHOWER

*All that is transitory
is but a symbol.*
—Goethe, *Faust*

*Those who cannot remember the past
are condemned to repeat it.*
—Santayana

*Give me your hand, only a finger,
And I will see this whole round earth
as if it were my own.*
—Richard Dehmel

INTRODUCTION

Harry Slochower was born in Bukowina (old Austria) in 1900 and attended the Staatsgymnasium at Czernowitz from 1911 until 1913, when his family emigrated to the United States. He received his B.S.S. from City College of New York in 1923, where he was a student of the philosopher Morris Raphael Cohen. He studied at the Universities of Munich, Berlin, and Heidelberg and got his doctorate at Columbia University in 1928 with a thesis entitled *Richard Dehmel: Der Mensch und der Denker* (Dresden, 1928). After another year of European travel and researches on Schopenhauer, he returned to the United States and taught comparative literature and German at Brooklyn College from 1930 until 1952, and at the New School of Social Research from 1946 to date. His courses in the drama and the novel were heavily attended and introduced several generations of enthusiastic students to the study of literature in terms which united radical humanism with depth exploration of the symbolic meanings of art. In 1952 he was "separated" from his post at Brooklyn College for invoking the Fifth Amendment in a Congressional investigation. He carried a legal fight to the

Supreme Court, which led, in 1956, to a landmark decision reinforcing the Bill of Rights' protections against the persecution of ideas. Though reinstated, he did not return to Brooklyn College but instead chose to pursue the practice of psychoanalysis, which he had commenced in 1948. He now practices in New York, where he is also editor of *American Imago,* a psychoanalytical quarterly (founded by Freud) devoted to the arts and humanities. He remains on the faculty of The New School, as well as the graduate divisions of Drew University and Sir George Williams University (Montreal).

Slochower's major works include *Three Ways of Modern Man* (1937), *Thomas Mann's Joseph Story* (1938), *No Voice Is Wholly Lost* (1945), and *Mythopoesis* (1970). In addition, he has published several hundred papers and reviews in many of the leading philosophical, literary, Marxist, and psychoanalytical journals. He became a contributor to *The New Masses* and *Science and Society* in the later 1930's. He was closely associated at that time with the German antifascist émigré circle—including Ernst Bloch, Thomas Mann, Oskar Maria Graf, Ernst Toller, Bertolt Brecht, and Hanns Eisler—and some of his early articles and reviews dwell on the literature produced by this group. His first book in English, *Three Ways of Modern Man,* traces varying patterns of ideological response to industrial capitalism in the twentieth-century novel. The "three ways" are exemplified by Sigrid Undset (feudal socialism, "salvation through surrender," the agrarian-Catholic-medieval solution), Thomas Mann (the bourgeois-liberal, Faustian solution), and Martin Anderson Nexö (the socialist-humanist, futurist path). Slochower's main emphasis is on the need for synthesis: "For all their differences, Undset, Mann and Nexö (and the writers grouped about them) are yet combinable, for . . . they have each drawn from the positive sources of our age" (page 223). Art is seen as pointing "beyond the immediate," as a means of bridging "historical differentiations" (page 221), as a unity of the unique and the recurrent, as a revolutionary "transcendence of naturalistic materials" (page 194). *Three Ways of Modern Man* is thus a paradigm of Popular Front Marxist criticism, for it seeks the broadest possible unification of artistic-ideological currents as a means of confronting the "fourth way"—fascism.

Slochower's primary concern, which unifies all of his work, is the search for the common denominator. For a Marxist, of course, the root of things is man, and Slochower scans world literature and myth with the utmost sensitivity for those threads which, drawn together, might form a United Front of the arts in the service of a universal humanism. His desire is for synthesis, for transcendence of alienation, and above all, for reconciliation. This leads him to stress those universals in Marxism which, though lying

within history and subject to its forces, constitute the suprahistorical dimension of what Marx called "man's universal human essence." It was therefore inevitable that Slochower became the first American philosopher-critic to make extended use of Marx's *Economic and Philosophic Manuscripts of 1844,* his *Introduction to a Critique of Hegel's Philosophy of Right* (both of which express Marx's Feuerbachian concern with human universals), and the "Fetishism of Commodities" chapter of *Capital.*

The search for universals led Slochower to Freud. In *No Voice Is Wholly Lost* he seeks to reconcile aspects of Marx and Freud in a dynamic synthesis based on their clash and their congruence. "The need," he writes, "is for a psychology of politics, as well as for a sociology of psychic life" (page 310). In the postwar period, Slochower's Marx-Freud synthesis met resistance on all sides—from Marxists who were fearful that Freudianism led to a diminution of revolutionary energy; from Freudians who, in the years following Freud's death, were so concerned with maintaining the purity of their system against the numerous strains of revisionism that they tended to ignore the sociological emphasis of Freud's *Civilization and Its Discontents,* "Why War?," and *Group Psychology and the Analysis of the Ego;* from bourgeois critics who were then engaged in a massive retreat from the genetic analysis of art, whether sociological or psychological. Slochower's pioneering work in this area begins to re-emerge after the impact of Marcuse and Norman O. Brown, after Sartre's popularization of the needed synthesis of Marx and Freud, after the establishment of Erik Erikson's school of "psychohistory."

His recent work has utilized psychoanalysis more explicitly in an attempt to explore the nature of the creative process. Of particular importance is the essay "Symbolism and the Creative Process of Art,"[1] in which he investigates the "necessary" psychological and social conditions under which man's symbol-making capacities may be transformed into works of art, under which "pathology can be integrated with creativity." Art is seen as a redemptive activity, as a "disturber of the world's false peace," as an affirmation which proceeds *through* alienation to transcendence. In another paper, "Genius, Psychopathology and Creativity,"[2] Marx's basic formulation is rephrased but retained: "The genetic-historical and the topographic are the 'material' base out of which the structure and form derive and grow, and with which they maintain a dynamic contact, even as they transcend the base," and he calls for a dialectical approach which would see "both the dynamic *continuum* and the dynamic *discontinuity* as operat-

1. *American Imago,* vol. 22, nos. 1–2 (Spring–Summer 1965), pp. 112–27.
2. *American Imago,* vol. 24, nos. 1–2 (Spring–Summer 1967), pp. 3–5.

ing in the process of creativity." Genius and creativity rise from crises, from disturbances in both the ego and the social order: "unease and dis-ease are essential conditions for creativity."

——

The following selections are intended to illustrate several of the leading motifs of Slochower's work. First is the groundbreaking article, "Literature and Society," which appeared in *The New Masses* in 1939, and warned against reductionist tendencies in Marxist Popular Front criticism, stressing a fundamental dialectic of art, which is the way in which "particular and universal categories operate *within* the compass of the social, which shape their *form* and *direction*." Slochower begins to deal with the pivot from which Marxist Utopianism rises—"the element of *transcendence* in art, its vision, in short the symbolic pointing which gives art its more than immediate import." He recognizes the explosive meaning of Marx's phrase, that the function of art is to "humanize man's sensibilities," and the possibilities of hope which this implies. And, restoring the central concerns of German classical aesthetics, he insists that art mediates between extreme alternatives—history and law, time and eternity, thought and action, man and nature, permanence and change—and that it does this through the sensuous nature of its form; next, that the ideological-intellectual meaning of a work can be unraveled only through examining the *process* (the style) by which the author arrives at his conscious conclusions (rather than the "conclusions" themselves) and by assessing "the relative artistic reality of the characters." This expands Engels' thesis that bias in literature flows from plot and character, making it into a principle of literary criticism. Slochower writes that "criticism must seek the idea in literature as it has become *body* through the complex web of the artistic process. The meaning of art is implicit. Its ideology is embedded in the evolution of the plot, in the execution of the action and the actors. . . . It follows that the ideal of literary criticism is *the dramatization* of the artistic process, a task that requires something like a restatement of the artist's own operation."

This last is Slochower's forte, both as lecturer and critic—the re-creation of the ambience and "feeling" of a work of art through an impressionistic retelling of its plot and dramatic description of its characters. Applied to broad sections of Western literature in Slochower's major works, it has produced some of the most telling critical writing in Marxism. The interpretation of Malraux's *Man's Fate* reprinted below illustrates this method, which is utilized within a framework which constantly tests the relative reality of the characters and their conscious and unconscious motivations

against the ethical standards of the Revolution for which they are supposedly striving. This selection also illustrates the subtlety of Slochower's Marx-Freud synthesis, in which his own ideological coordinates are deeply imbedded within the critical process, where they work most effectively at illuminating the convergence and divergence of libidinal drives and revolutionary action.

Slochower's search for the shifting, historical manifestations of the human essence has led him to a unique reshaping of the mythic interpretation of literature, to the exploration and analysis of common patterns in the masterworks of world literature, which derive from the myths but differ from them in being *re*-creation, the casting of archetypal situations in symbolic structures. This concern first surfaced in his important study *Thomas Mann's Joseph Story* (1938), where he writes of myth as providing not merely exemplary models but "co-ordinates that give man's past meaning and reason" (page 9). It was not until the mid-1940's, however, that he began a systematic attempt to rescue the myth from its usual association with obscurantism and mysticism; *Mythopoesis* (1970) marks the culmination of this effort.[3] Mythopoesis (literary myth-making) is seen as a means by which the central values of each historical epoch are organized. Unlike the myth itself, it does not attempt to "restore the dead past" but to *"redeem* its living heritage" (page 15). It recreates the ancient stories during periods of crisis and transition: "It is at this juncture that our great prophets and artists would redeem the values of the past and present in their *symbolic* form, transposing their historic transitoriness into permanent promises" (page 15). Its main tradition is "of a rebellious quest . . . pitted against a paralyzing tradition" (page 16).

The basic form of Slochower's literary mythic pattern is a dialectical triad, followed by an epilogue: it begins in Eden, is followed by the "crime," expulsion and quest of the hero, and then by reconciliation, homecoming, and rebirth. The "homecoming" is followed by an "epilogue," in which the revolutionary quest begins all over again. The hero simultaneously recognizes the "symbolic values which are present in the very tradition he has violated" and becomes the remolder of that same tradition through society's assimilation of the content of his quest. The function of mythopoeic art is not adaptive (Slochower recognizes the exceptions) but revolutionary: the quest of the tragic hero constitutes the critique of "the existing social norms and points to a futuristic order which is envisaged as inte-

3. An important stage in this process was Slochower's critical discussion of Ernst Cassirer's philosophy of symbolic forms. See Slochower, "Ernst Cassirer's Functional Approach to Art and Literature," in *The Philosophy of Ernst Cassirer* (Evanston, Ill., 1949), pp. 633–59.

grating the valuable residues" (page 34) of the superseded order. The hero has challenged the rottenness of the state. He is redeemed *only* because he has rebelled. In Slochower's reading of world literature, the reconciliation of the hero with the social order—his homecoming—is prologue to a new expedition toward freedom. "Mythic transcendence does not allow for a paradisiac ending" (page 26); "the harmony attained carries within itself the earlier moments of dissidence and contains the seeds of a renewed conflict" (page 23).

In *Mythopoesis,* Slochower applies this Utopian theory to selected works from a wide range of world literature—from the Book of Job and the Greek tragedies to Dante, Cervantes, *Hamlet, Faust, Moby Dick, The Brothers Karamazov, Pelle the Conqueror,* Gide, Kafka, Sartre, and Thomas Mann—stressing always that the specific symbolic representation of the mythic pattern "receives its vitality from history, from the mark of time, place and atmosphere" (page 40). He seeks to "show the extent to which the historic scene and social hierarchical divisions define each of the poetic myths and give expression to their partisan 'ideology.'" The link with traditional Marxist criticism is maintained within a transcendent framework: for Slochower, the essential dialectic is the interweaving of the universal and the temporal.

In the final selection, from the opening pages of "The Function of Myth in Existentialism," Slochower demonstrates Existentialism's fixation upon the second stage of the mythic pattern—the "revolt of the individual against the mythic collective"—and its inability to come to terms either with the birth of the hero (the sources of rebellion) or his redemption (the hero's homecoming and the dialectical transformation of society). Existentialism therefore accepts "homelessness, estrangement, fear, and anguish" as finalities rather than as necessary stages in the creation of a humanized future. In its denial of sources and reconciliations, Existentialism robs the myth (and revolutionary activity) of its precarious power to heal mankind's wounds, to point beyond the present toward a communal future which has incorporated and redeemed the past at the moment of its supersession.

Slochower's work has been a continuous series of reconciliations. An early review, published in 1928 (*Archiv für Sozialwissenschaft und Sozialpolitik,* vol. 60), attempts to reconcile Hegel and Marx, not in the expectation that this will move Marx toward Idealism: "rather it will bring the Idealist Hegel closer to Naturalism." His *Richard Dehmel* (1928) focuses on a

poet in whom elements of Nietzsche and Marx converge. As we have seen, *No Voice Is Wholly Lost* attempts a fusion of Marx and Freud, and in a polyphonic survey of Western literature between the wars stresses the common human core within the variety of literary responses to an alienated civilization. As he progresses, Slochower incorporates one after another of the major thinkers into his thought, in which Marx remains the constant touchstone.[4] His primary imagery is of continuity, the "living chain which connects the recurrent scenes of the human drama," the indivisibility of knowledge, the singleness of truth, the carryforward of "values created in the past by our living mythic tradition," the vision of a future which has mastered its past, in which human tragedy will arise from the natural conditions of life (and death) rather than from the mediation of repressive class orders.

SLOCHOWER: **LITERATURE AND SOCIETY**
from *The New Masses*

Some years have passed since Michael Gold leveled his celebrated attack on Thornton Wilder. The attack roused the esthetes from their pure dreams in a magical stratosphere. It resulted in their questioning of the Platonic-Kantian argument, popularized by Schopenhauer, that the artist was to shun life's fugitive and adventitious facets, and concern himself solely with the permanent forms of reality.

Is it necessary today, after the brutal gesture of book burnings and artistic ostracism by the Hitlers, to labor the point that literature and politics are parts of the human pattern and coexist in the framework of reality? Indeed, to the extent that it is sensitive to the total human situation, art cannot but encompass the social. Such inclusion, as Thomas Mann puts it today, constitutes the *democratic* nature of art.

It is simply mechanical to hold as Joseph Wood Krutch did, as late as 1933, that "man *qua* artist and man *qua* reformer are antithetical things." The writer may not want to concern himself with society, but society concerns himself with him. Whether they desire it or not, the writer and politician are locked within the same frame and exert reciprocal effects on each other. To be sure, art gives expression to individual and permanent

4. In an important chapter, "The Marxist Homage to Creative Labor" (*Mythopoesis*, pp. 284–89), Slochower proposes labor as Marx's "universal constant," as "the mythic category" which "is independent of all forms of society," and which provides "the lever for the changes and developments in man's biological nature" as well as the necessary condition under which men make their own history.

forms in human existence, as well. And these forms, as we shall see later, are decisive for the evaluation of artistic execution. Yet, it should be noted at the outset that these particular and universal categories operate *within* the compass of the social, which shapes their *form* and *direction*. In short, art is an effect. And, in turn, it affects. From this angle, *there is no escapist literature*. All art, whether it be the type of *The Bridge of San Luis Rey* or of the naturalistic strike novel, is both a resultant of forces operative outside of it, as well as a power, affecting the social graph.

However, the real problem of the relation between literature and society arises only at this point. The difficult question which the critic faces is not that the two realms are concatenated, but the *nature* of this connection and the *manner* in which it is revealed by the form and the process of art.

The reaction to the tradition of esthetic essences was an extreme naturalism. As against the mystic vision that a rose "was a rose, was a rose," most phenomena were class-angled in terms of *Redder than the Rose*. The pendulum swung with storm and stress vehemence toward a position that, at times, overstated and over-simplified the social context of literature. A one-to-one correspondence replaced the former all-to-none correspondence. Critics demanded "reality," a demand met by the documentary novel and drama, presenting a literal translation of the immediate historic present. Despite its vigor, spontaneity, and daring, it must be set down that, in its initial impatience, this movement tended to throw out the baby with the bath. It omitted what the opposition had overstressed, namely the element of *transcendence* in art, its vision, in short the symbolic pointing which gives art its more than immediate import. Even Dos Passos, perhaps the subtlest representative of this direction, often produced either flat, indistinguishable types that suggested the obvious or unique individualities that were incomprehensible. The depiction of atomic entities was baffling, since the reader was unacquainted with their antecedent biography. Such resultants appeared like homeless waifs, windowless monads in a pre-established disharmony. James Joyce and his imitators represented a similar phenomenon from *within*. Their subjective detailing was at one with the atomism of the naturalists in that both presented reality as broken, chopped multiplicity. What this literature omitted was the unifying dialectic, the *relations* that give meaning to things and which alone produce the element of overlap in art. It is this overlap which explains the phenomenon Karl Marx recognized when he wrote that "certain periods of highest development of art stand in no direct connection with the general development of society, nor with the material basis and the skeleton structure of its organization."

Still, as noted, this art was historically a wholesome antidote to that pale literature which, fearing to contaminate its eternal haven by treatment of specific human beings, produced an emasculated, anaemic universal man. That such an approach will limit even exceptionally gifted artists is seen in a work like *The Magic Mountain,* with its overbalance of cerebral talk and well behaved types, and of course by most of the expressionistic writers.

The error common to both the naturalistic and the idealistic writer and critic is in the choice of extreme alternatives: of time or eternity, of history or law, of change or permanence, of the particular or the general. In both, the universe is deterministically closed, monistically encircled. In this way they do violence to the intrinsic nature of the artistic object. For the quality unique to art is that of *mediating* between these extremes. Art presents coordinates applicable to man and his world generally. In this respect, however, it performs the service also rendered by science and philosophy. Wherein art differs from the latter is that its form is of a *sensuous* nature. That is, its universals appear through the medium of *particular, concrete situations and characters.*

In short, art strives toward uniting the idealistic universality of the esthetic emphasis with the naturalistic concreteness of the so-called materialistic esthetics. Hence, as Georg Lukács has pointed out, the critic's question becomes: to what extent has the artist solved "the riddle of elevating individuality to the typical without destroying the individual relief"? The greatest problem of a writer consists in such interweaving of the multifarious lines that criss-cross and make up the nature of the individual, lines that issue from his group, class, epoch, and constitute, at the same time, the recurrent patterns of human existence as a whole. This consideration helps the writer to steer between giving the literal and accidental (the fallacy of simple documentation) and offering mere philosophic abstraction (the fallacy of "pure" art). Where an art does not transmute the idea by sensuous means, where its tendency does not arise from the situation, there the critic will discover that the "idea" is weak. In this sense, poor art spells poor propaganda. The greatness of art depends on the fusion between the sensuous and the abstract.

From these considerations follow a number of pertinent implications for the literary critic in his attempt to do justice to the "meaning" of art.

The writer tells a *story*. In its course, he may introduce abstract ideologies, formulated by his characters, or else stated independently of them. How determine the intellectual import of the work? Some critics select "the philosophy" of a character whom they choose as the "voice" of the author. Others take some comment made in the course of the plot. Still others regard the concluding portion as the "idea" of the work as a whole, as the

writer's preferred "solution" of his problem. Such methods must be regarded as highly misleading. To begin with, a writer creates *all* his characters. Every one of them must have something of the author in them, and hence, in some sense, he affirms everything expressed in his work. Nor may the conclusion be taken as the writer's complete "point." For this ignores two vital factors: the *process* by which the end is reached and *the relative artistic reality of the characters.*

The process contains the hurdles, the temptations, "the enemy." And the enemy in art must be considered as *part* of the writer's meaning, conviction, and ideology, which sometimes profoundly modifies the conclusion voiced at the end. Likewise with characters. When a writer ostensibly names character "A" as his ideal, but succeeds in infusing character "B" with greater life, that fact has something to do with determining the ideology of a writer. Indeed, in times of violent transitions, when a writer is torn by various currents, the critic may expect to find such ironic reservations revealed in the discrepancy between what an author states his forensic meaning to be, and his actual artistic creation. The phenomena of Sigrid Undset, Thomas Mann, and Martin Andersen Nexö illustrate the point. We might briefly note two other examples. In terms of its avowed directive, Knut Hamsun's work holds up the agrarian order as a contemporary ideal. But this attitude receives an impressive qualification by the process of his more recent novels in which the "natural" characters lose their glamour, become uprooted vagabonds, flirting with the more stable "ambitions" of security and technical efficiency. Similarly Proust. His novel ends with an elaborate, abstract justification for the patient depiction of his society. Yet, the story itself mercilessly exposes its frozen patterns.

These reflections suggest that criticism must seek the idea in literature as it has become *body* through the complex web of the artistic process. In other words, the meaning of art is implicit. Its ideology is embedded in the evolution of the plot, in the execution of the action and the actors. The "how" conditions the "what." It follows that the ideal of literary criticism is *the dramatization* of the artistic process, a task that requires something like a restatement of the artist's own operation. That is, literary criticism must do justice to the psychology of art.

As applied to contemporary literature, the problem of criticism is greatly complicated by our chaotic scene. Literature has ever mirrored man's estrangement from compulsive actualities, sometimes through realism, sometimes through the magical transcendence of symbolism. This estrangement, accentuated by the introduction of quantitative norms, such as money, machinery, and production for profit, resulting in the depersonalization of man, has today reached chaotic proportions. War and fascism

have wrought transvaluations of values in all directions at once. It is therefore not surprising that literature has become uncertain of its material, that its symbolism is involved, becoming tortured and masochistic, nostalgic and hypertrophied. So contradictory have our mores become that literature is often an inorganic aggregate of social, psychological, anthropological and various other motifs. Consider the confusion and jumble of the art produced as a result of the fascist steamroller. There are the works of the exiles, torn from their homes, which they both love and despise, hailing their new homes in which they must needs feel somewhat homeless. Or consider the many inner questionings of writers who remained in Hitlerland, who have outwardly accepted Nazi regimentation but whose enthusiasm cannot very well be regimented. An art growing on a base of this kind will naturally evolve anomalies in form and process. Such art cannot be free. Since man, through his spirit, is ever fated to question his world, he can never be completely free. But the obstructions of fortuitous calamities *are* removable. And social freedom is the condition for human and artistic freedom. The function of art, Marx once noted, is to "humanize man's sensibilities," to make possible the development of man to a "complete" human being. This universal art requires a free, universal society.

SLOCHOWER: **MALRAUX—MAN'S FATE**
from *André Malraux*

A man of action is always ruthless;
no one has a conscience but an observer.
—Goethe

The individual stands in opposition to society,
but he is nourished by it.
And it is far less important to know what differentiates him
than what nourishes him. . . .
A soul is just as valuable as a differentiation.
Every psychological life is an exchange,
and the fundamental problem of the living individual
is knowing upon what he intends to feed.
—Preface to *Days of Wrath*

Malraux's work is concerned with the secret of individuality within the compass of its public relations. The problem arises from the fact that Malraux's characters are revolutionary socialists who have reached the *post-*

intellectual stage where they have to make a *decision*. As socialists, they recognize the necessity of communal solidarity and action. But, as revolutionaries, they cannot completely identify themselves with the collective interest. This is so, because in Malraux the revolutionary is an individual of heroic stature and vision. As such, he can never be completely at one with "The Law," and can never altogether accept a "party line." In this conception, Malraux comes close to the problem as seen by Gide and Silone. But, where they treat individual apartness as a final necessity, Malraux sees the problem as only beginning at this point. Because his people are exceptional, they are lonely. But, because they are lonely, they feel the need for communication all the more. Their exceptionalism at once separates them from and brings them closer to the group. Malraux's basic problem is *the differential* between organized control and unique expression. Malraux begins with individualistic characters (Ch'en, the Spanish anarchists), and ends with integrated personalities (Katov, Manuel). But his central problem is focused on those in whom both forces operate simultaneously (Kyo and Magnin).

Malraux's three major novels *Man's Fate, Days of Wrath,* and *Man's Hope* treat historic events. In all of them social forces condition the action and passion of the characters and give point to the dramatic situation. Yet, in each novel, Malraux introduces characters who tower over their situation. They present a three-cornered war. One is waged by revolutionaries against the Fascist international. Another is carried on by the revolutionaries against coordination in any kind of collectivity.

———

Man's Fate is weighted on the individual formula, with the opening scene setting the tone of Malraux's preoccupation. Ch'en has been sent out by his party to seize papers from a man who must first be rendered defenseless. From the angle of the *political* task, the papers, the man, and the act to be performed are general elements. But Ch'en has experienced terrorism in his own family. His great need is for *personal* revenge. He must feel the act to be *his* act, and he must come to sensuous grip with the living body. But the man he is to kill is sleeping. As Ch'en stands in front of him, he hesitates, hoping that the man will wake up and fight. He considers lifting the mosquito netting which covers the identity of the sleeping body. So involved is Ch'en in his emotional conflict that he forgets the political objective altogether, that of procuring the document. But his personal anguish is irrelevant to the organizational objective. And when he appears before his comrades, he simply reports: "It's done."

This opening scene sounds Malraux's larger theme, the tragedy of crime and guilt. In Ch'en, the guilt sense is a compound of his Christian upbringing and his social alignment. Ch'en is the extreme limit of the revolutionary, the revolutionary as terrorist. His anarchistic self-obsession is the psycho-social facet of his homosexualism. Ch'en is unable to shift responsibility to the social body by accepting its authority. Because he must take the full weight of responsibility upon himself, he suffers the most intense guilt agony and the deepest solitude. For this very reason his craving for communication is bottomless. It must be as complete as the gaping loneliness which calls it forth, and it leads him to seek it in the absolute communication of death. His plan to kill Chiang Kai-shek is made as much with a view towards the general's death as to his own. It is the "completion" of his masochistic Eros straining towards Thanatos.

Ferral, the head of the Franco-Asiatic Consortium, approximates the Ch'en dilemma on the side of "the enemy." Despite his position, Ferral, too, lacks status. He is too proud to be a conformist or a hypocrite, refuses to join the Legion of Honor, and is only half-heartedly accepted by the French Tories. In his case, terrorism takes on the form of lust. And, as Ch'en must have physical contact, so Ferral must have visible "proof" that he is achieving communication, as when he insists on the light being turned on while he is embracing his mistress, Valerie. And when, outraged by this act of humiliation, Valerie writes him: "You will die, dear, without having suspected that a woman is a human being," Ferral recalls stories of revenge on faithless lovers which remind of Ch'en's terroristic method. Ferral realized that he never went to bed with anyone "but himself." There is only a formal difference between Ch'en's homosexualism and Ferral's auto-eroticism. He understands that "his will to power never achieved its object, lived only by renewing it," that the only thing he was eager to possess was "himself."

At the opposite pole stands the Russian Katov, one of the organizers of the revolt. Katov has also experienced suffering in his personal and political life. But Katov has "absolutely" (his favorite term) succeeded in submerging his self in the social task. Where Ch'en and Ferral are preoccupied with the problems of their self, Katov appears as the most self-effacing revolutionary in the story, a self-effacement which, at the same time, provides him with greatest self-assurance. The high point of his self-assurance is reached in the scene where Katov gives up the cyanide he had reserved for himself. This act is one of supreme self-sacrifice (similar to that of the comrade, in *Days of Wrath*), for Katov knows that now he will be burned alive.

The full complexity of Malraux's problem is embodied in the character

of Kyo. His split origin (he is half French and half Japanese) makes at once for his alienation and the need for integration. When his wife May tells him that she has gone to bed with another man, Kyo shrugs his shoulders. As an enlightened communist, Kyo theoretically grants such rights to his wife. But actually, he suffers the searing torment of the wound dealt to his person. And as he walks out to carry through a crucial revolutionary task, he is lashed by the "solitude, the inescapable aloneness behind the living multitude like the great primitive night behind the dense, low night under which this city of deserted streets was expectantly waiting."

"The great primitive night" in Kyo's socialism is the "secret" of his individuality. Kyo is not an organizer who simply carres out orders, like Vologin. The revolution to him is not a matter of names and items on index cards. It is a living thing for him, sunk into his skin "with its weak points like wounds." In Kyo's revolutionary doctrine, Will and Individuality operate as free factors within his frame of social determinism. Going beyond the Spinozistic-Hegelian notion of freedom as the cognizance of necessity, Malraux urges that, through consciousness and knowledge, man can also *choose* and, hence, also determine. This constitutes man's dignity. The driving force behind Kyo's revolutionary fervor is "to give to each of these men whom famine, at this very moment, was killing like a slow plague, the sense of his own dignity." He fights Fascism because it does not allow man to choose either his life or his death. When Kyo is asked by Koenig, the Chief of Chiang's police: "You want to live?" Kyo replies: "It depends how." And when Koenig prods him on the meaning of dignity, Kyo defines it as the opposite of humiliation. But a moment before he thought of it in positive terms, as "my life." Kyo retains his dignity in death because he can choose death. Precisely because it is his alternative to serving as a stool-pigeon, it becomes the highest expression of his life. "What would have been the value of a life for which he would not have been willing to die?" Kyo's notion of individual freedom appears on the political plane. He is shown as not in full accord with the tactics of his organization, and is opposed to his party's decision to hand over the arms. When Vologin urges that "the only logical attitude of a militant communist" is obedience, Kyo inwardly agrees with Ch'en's reply that "it's not through obedience that men go out of their way to get killed—nor through obedience that they kill . . . Except cowards."

That Kyo nonetheless remains within "the ranks," can be traced to his view that his movement has a *futuristic* dynamics. Marxism encourages "the exaltation of a will." It allows for revolutionary innovations by the individual and is, as such, the opposite of a fixed order which dehumanizes man by imposing its will on him. That is, to Kyo, the Marxist movement

calls for both individual spontaneity and societal attachment. In it, he can combine his ethics with his politics.

Kyo's political reservations thus appear as part of the novel's psychological burden. Seen from this angle, *Man's Fate* is profoundly non-political. Although the story involves the clash between personalities who belong to opposing international factions, it deals, in the main, with the personalities themselves. "Society" hovers in the background only. The focus is on psychological individuation shown precisely at the point where it overlaps the general social and political interest. There is the feeling that any kind of political strategy entails human and ethical injustice, that politics cannot deal adequately with the emotions, least of all with those of a Ch'en, but only a little better with those of a Kyo. Private suffering cannot be eliminated by the social body, for it issues from the fact of individual existence. This is "La Condition Humaine." Those who recognize its inevitability and adjust their acts accordingly can be saved. For those who drug themselves with power into the illusion of self-sufficiency, the novel offers no grace.

Man's Fate deals with the inescapable Unknown, the Sphinx in human existence which renders tragedy inevitable. It is the tragedy of man's solitude issuing from the "exposure" of that which cannot be protected by the collective netting. Yet there are different levels of solitude, and different qualities in the efforts to establish communication. Clappique seeks refuge in his mythomania and in sex. But he fails to banish fear and remains lonely, for he knows there is no identification to be found "in the women who open their thighs and their hearts while thinking of something else." Ferral likewise is alone. He, too, knows that there can be no self-transcendence in his autistic relationship with men and women. Ch'en's autoeroticism is somewhat checked by his attempt at social identification. He, at least, seeks to "die on the highest possible plane." His Absolute of Death in action meets with the Absolute of passivity achieved by Gisors through his opium. In all, there is denial of life and a forgetting, a dissolving of the self, rather than its organization. Lacking all social faith they are left helpless when faced by individual frustration. Thus, when Ferral is confronted by Valerie's rejection, he is completely emptied. The only urge left in him is towards violence and humiliation. On the other hand, even as Kyo is tormented by May's act, he can be consoled by the fact that she is not simply a woman to him, but also a comrade.

The embrace by which love holds beings together against solitude did not bring its relief to man; it brought relief only to the madman, to the incomparable monster, dear above all things, that every being is to himself and that he

cherishes in his heart . . . My kind are those who love me and do not look at me, who love me in spite of everything, degradation, baseness, treason—*me* and not what I have done or shall do—who would love me as long as I would love myself—even to suicide.

SLOCHOWER: **EXISTENTIALISM AND MYTH**
from *The Function of Myth in Existentialism*

Some approaches to Existentialism have viewed it as an expression of the dilemmas presented by our war years, particularly those confronting man in the aftermath of the Second World War. Existentialism would counter the historical perspective by grounding itself in absolute categories. Yet the specific historical situation of France and Germany, it has been argued, provides the catalyst for its vogue.

But only the catalyst. And only the mood and accent of the movement. For Existentialism is geared to principles which have a renowned philosophical ancestry and relationship: the doubt and critique of Descartes, Pascal, and Montaigne, the either-or choice of Kierkegaard, Nietzsche's voluntarism, Husserl's phenomenology, Heidegger's "anxiety" and "anguish," and Jaspers's neo-Cartesian radical doubt and irresolvable antinomies.

The supra-historical concern of Existentialism appears more directly in its reference to the myth. Sartre has treated the Orestes myth in *The Flies,* and Camus (who may be considered as at least related to the movement) has been preoccupied with the myth of Sisyphus. The Existentialist approach to the myth might well suggest their basic burden as well as their own historic involvement.

To state our thesis forthwith:

Existentialism has seized on one aspect of mythopoesis and raised it to an absolute. It centers on the second stage of the myth, that which is concerned with the revolt of the individual against the mythic collective. It is the stage in which Job challenges the Lord to justify the afflictions heaped upon him, Prometheus defies Zeus, Oedipus demands to know how in nature he was evil, Orestes trespasses the law of the Erinyes. It is Dante identifying himself with Paolo and Francesca, Don Quixote countering the traditional chivalric myth and the secular authorities of his historic present. It is Hamlet in his mother's room, Faust abandoning his Gothic chamber, Siegfried defying Wotan, Ahab leaving wife and home, Joseph wandering to Egypt. In these literary myths, the individual challenges his authoritative communality and exercises freedom in making his personal choice. In this

process of loosening, the mythic hero experiences alienation, fear, and guilt. Yet, he continues on his journey away from "home," accepting the responsibility of his free action or his crime.

However, this is but the midway stage of mythopoesis. It is preceded by the initial stage *out of which* the ego is *born,* and it is followed by the third stage where the ego finds *reconciliation* with and rehabilitation in his collective. Job is reconciled with the Lord of the Whirlwind, Prometheus with Zeus, Oedipus with Theseus, his father-substitute, Orestes with his replaced authorities, Apollo and Athena, and so on. This reconciliation becomes possible because the individual grows to awareness of the hybris in his revolt, of the dangers in an unqualified repudiation of the old. This leads to his limiting and restraining his own demon. His choice can thereby become *critical* and *self-critical,* and his responsibility *ethical.* Moreover, the last stage is possible only because there has been recognition of the first stage. The hero can be redeemed only because he can return "home." To be sure, reconciliation retains, as a dialectical moment, the element of revolt *through* which the mythical hero has passed. The hero does not submit or surrender. He is not redeemed by returning as a child to a collective nursery. In the third stage, the authoritative code itself has been modified by virtue of the individual challenge. That is, the hero is saved *because* of his revolt.

Thus, basic to the graph of the traditional literary myth is the notion that there is a *common* ground to human experience, that man lives in the same universe of matter and motion, and that he functions in typical and recurrent emotional and psychologic patterns. Even as the myth deals with the heroic variation, this variation is seen as existing within "the deeper sources of common life" (J. Lindsay) which follow the graph of a timeless schema. The literary myth objectifies man's communal existence. It voices our collective beginnings and our collective goals. It rests on belief in "the people." The hero forever revolts against his commune; but he revolts only against its static forms, its "systematized" stage, against what Eliot calls "mass-culture." But in his very revolt he gets to know the excesses of his own demon, and by recognizing learns to control and tame it. Thereby he becomes ready for re-alignment. He is no longer in fear of the demonic powers—although still subject to them—for these powers are now *known* to him. But, to repeat, the hero can be redeemed in a new home because he once came from an old home. The myth is the celebration of the high recognition-moment of man's collective status.

The myth of Existentialism lives exclusively in the second stage: i.e., negation of the old collective ("essences," "metaphysics," "the system," etc.), and accepts the resulting homelessness, estrangement, fear, and

anguish as a final "resting" point. It does not subject its negation to critical self-analysis. It does not explore the question of the sources and bases out of which it has arisen. The individual is not born—he is "thrown" into existence. And as he has no parents, he produces no offspring. For this reason, Existentialism cannot and does not ask the question of rehabilitation. Its hero does not attempt to mitigate, humanize, or socialize his guilt. Existentialism does refer to "temporality" and the future. It even speaks of the past and of tradition. But this past is "freely" created, not discovered as an objective existence. Its impious re-creation of our heritage produces a futurism without a future—to use Mann's characterization of Nazism as "Futurismus ohne Zukunft." Where the classic myth relates the ego's rebellion to the common ground of things, Existentialism would relate it to the groundlessness of things, to "Nothing." It begins with "Nothing" and its goal, at least with some, is the nothingness of death.

ALICK WEST

*To arrive at a solution
even in the political problem,
the road of aesthetics must be pursued,
because it is through beauty
that we arrive at freedom.*
—Schiller

INTRODUCTION

Alick West was born in 1895, into a middle-class English family. His mother died when he was five, and he was brought up by a father who upheld the traditional virtues of duty, patriotism, and success while he himself failed in various professions. West attended Highgate School until 1913, and after a four-year internment in Germany, he went to Trinity College, Dublin, graduating in 1922. Abandoning the pursuit of a doctorate at the University of Berlin, he became a Lecturer at Basle University from 1926 to 1934, where he lectured on Pater, Oscar Wilde, Defoe, and Fielding (his 1958 *Mountain in the Sunlight* returns to these writers), among other subjects drawn from English life and letters. Among his early intellectual influences were Nietzsche and Freud. In this connection, a paper of 1922 is entitled "Need for a New Myth." In Dublin he acted as a medium for a spiritualist and experimented with automatic writing, and a decade later we still find him asking dead Virgil whether he should marry. He is impressed by the pseudo-scientific ideas of Frederick Soddy about such "life forces" as chlorophyll and the sun's energy, and for the first time

begins to speak of what will become his central idea, "the frustration of social energy by the very existence of property in the form of money."[1] In 1929 he read Marx, Engels, and Owen. His first impulse was to apply historical materialism to Marxism itself and, with the aid of Freud and Jung, to seek out the "possible unconscious motives of socialism."[2] In 1935, following several personal tragedies, he returned to England and joined the Communist Party, of which he remained a critical and probing member until his death in 1972. In his autobiography, *One Man in His Time,* he continues his search for the unconscious sources of revolution. With excruciating honesty he sets forth his own father-fixation, his several attempts at suicide, his fears and indecisions, his more-than-occasional despair, his attraction to mysticism, and his troubled thoughts about fascism. West proposes that radical movements must come to terms with the complex psychological motivations of their members. He holds out the hope and the possibility that the recognition of such motivations by revolutionary parties, the making conscious of what had been repressed and censored, would prevent the eruption of those irrationalities and dis-illusionments which periodically decimate the revolution from within its own ranks.

Alick West's main theme is energy. The purpose of language and art is regarded as a means of coordinating social activity, as a means of crystal-lizing man's creative power as it struggles against the innate forces of biological, natural, and social disintegration. In the selection printed below, West writes that "the value of literature always consists in its organizing social energy in a particular activity," and his startling interpretation of a Shakespeare sonnet reveals how Shakespeare stimulates this energy by depicting the fall toward annihilation which inheres in the season of the yellow leaves and the twilight of the fading sunset. Art, for West, is a means of renewal, a stimulation of energy toward life as life struggles against death.

The consistency with which West applies this theory throughout his career is in itself remarkable. From *Crisis and Criticism* (1937) to *The Mountain in the Sunlight* (1958), he explores the interrelationship between art and energy. In the latter book, which includes stimulating essays on Bunyan, Defoe, Pater, and Wilde, he writes of "the energy that carries out

1. *One Man in His Time,* p. 119.
2. *One Man,* p. 127.

revolutions that express the needs, not only of a class, but of humanity" (page 10). He shows that in Defoe the expenditure of human energy is channeled into the pursuit of profit, money, and trade, thereby being deflected from its true course, which is seen as the release of energy to shatter the existing repressive structure of society; in his comprehensive study of Joyce's *Ulysses* in *Crisis and Criticism* he concludes (after a masterly analysis of the "mysterious unity" of Bloom and Dedalus) that Joyce "does not organize social energy" but rather "irritates it" because the social activity embodied in the novel is directed toward "a lower level of activity" than that which created it. In his autobiography, he puts it most succinctly: ". . . energy is truth. . . ."

That this concept has a Marxist basis is not altogether certain. West quotes Marx on "the energy of the species" and he asserts as an article of faith that the creative energy by which man makes his history "must" have a material source, perhaps rising from the movement of matter; but when he himself poses the question of the source and character of this energy he must confess: "I have no answer." Still, it is worth searching for the sources of a theory that has produced some of the most original and sensitive literary criticism of the twentieth century. I would suggest that such a thesis was implicit in Marx's "Men make their own history" and in his famous passage on the labor process, where he wrote that "labour is, in the first place, a process in which both man and nature participate, and in which man *of his own accord* starts, regulates and controls the material reactions between himself and nature." The italicized words permit no other interpretation. That Marx did not make this explicit was only natural, since it would have been difficult to readmit into his system what might have appeared as a reincarnation of that Hegelian "Spirit" which persists in haunting Marxism no matter how frequently it is exorcised. Lenin, as we saw earlier, turned to Hegel's analyses of dialectical *self-movement* in his search for the sources of revolutionary will, and perhaps it is this very will which is identical with West's "energy" and provides its Marxist justification.

Parallels to non-Marxist thinkers immediately suggest themselves. Energy in West's sense is akin to Shaw's Vital Force, to Bergson's *élan vital,* even to Wilhelm Reich's orgone. Caudwell uses "energy" in precisely the same way as West. Some may say that it is nothing more than Freud's libido under a different name, i.e., the vital instinctual energy of the species stemming from the innate structure of its biological drives. Or, more properly, it might be said to be Freud's Eros in perpetual struggle with Thanatos, for, as West writes in the essay which follows: "Continual energy is required in the endless war against the forces of disintegration.

Every form of life that our social organisation has created falls into nothing unless it is continually renewed. . . . It is [the] ceasing to exist of nature and man that indirectly, by contrast, arouses the energy which shall maintain the world." West's "ceasing to exist," then, can be read as a force which counters energy, a force which is in itself negative energy, the death urge, Thanatos, tending toward nothingness. The crucial difference between West and Freud is that West sees energy as partaking of, deriving from kinship, from collective experience, whereas Freud does not consistently recognize the cooperative and communistic roots of Eros, nor the class nature of Thanatos.

That there is a theological kernel in West's approach is possible: his family were devout Baptists and he remained a believer until early manhood; his imagery is informed with the symbolism of the Christian myth; he has a special passion for Bunyan and the Baptist sects from which he sprang. But this should cause no great concern. There is more of communism in the medieval Christian freedom-symbolism of Bunyan than in the hierarchical dogmatism of Zhdanov. The theological concerns for renewal, rebirth, and resurrection carry forward the continuing archetypes of freedom, from which art draws so much of both its language and its sustenance. West put this better: "Religion thus becomes an image of the splendour to which human life can attain if men are true to the power within them which is the grace of Christ, and if they fight against all that would enslave them in the name of the law and morality of tradition—the landlords, the rich, and the domination of money and the market over men."[3]

In stressing West's main theme, we are perhaps underplaying the variety of his critical contributions. With Bukharin and Caudwell (whom he knew in 1936; he was writing of him shortly before his own death) he recognized the necessity of going to the sources of language as a precondition for the study of literature. Well before the domination of Zhdanovism (during which his creativity was of a lower quality), he resisted and analyzed the Party "attempt to suppress aesthetic experience," seeing this as "due to the fact that those feelings of social solidarity which are awakened in aesthetic experience are still attached to bourgeois society, and a vague realisation of their incompatibility with consciously accepted Marxism leads to the demand for the suppression of aesthetics."[4] During a period when Marxists increasingly tended to view art primarily as ideological reflection he pointed out that "the activity of art is rooted in the activity of the people

3. *Mountain in the Sunlight,* p. 41.
4. *Crisis and Criticism,* p. 96.

who are society and never wholly in society's political form."[5] He knew that "all relations in society derive from the common humanity of men living upon the earth" and that all segments of society are related in an interaction, "whether of life or death."[6] Above all, his vision is imbued with the concept of art as revolution: "Nothing less than the full joy of art, the beauty for which there is no language but its own, is adequate to express the meaning of revolution; and nothing less than revolution is capable of releasing in reality the creative power which in art makes all things human, but which the inhumanity of capitalism frustrates."[7]

When Alick West seriously proposed in the 1950's that the Cultural Committee of the British Communist Party "should have equal standing with the Political Committee in the leadership of the Party" there was no comment, and the convention at which he spoke passed on to other business. The aesthetic dimension would have to await better days. Meanwhile, Alick West continued to write of that imaginary mountain of which Bunyan had dreamed, where the poor refresh themselves in "the pleasant beams of the sun" and the poet looks on from afar, hoping that one day he too might find comfort on the mountain in the sunlight.

WEST: **FORM**
from *Crisis and Criticism*

Whatever the degree of idiomatic expression, the value of literature always consists in its organising social energy in a particular activity. . . .

Literature conveys this feeling of social energy by expressing the conflicting phases in its organisation, and giving a symbolical form of achieved organisation.

In the first place, literature relates its content to the conflicts inherent in the organisation of any group. As the high proportion of abuse and exhortation in idiom indicates, one of the main tasks is to hold an organisation together and to continue its action. This does not happen without the expenditure of energy; and there is a tendency in every individual, developed in him by his early experiences as consumer, to withhold that energy and let other people do the work. As idiomatic expression alternates between abuse and encouragement, so literature works with a similar alternation in the allied moods. The content is shown in relation to suc-

5. *Mountain in the Sunlight*, p. 115.
6. *Ibid.*, p. 9.
7. *Ibid.*, p. 131.

ceeding or mingled feelings of activity or inertia, hope or fear, courage or despondency.

Literature also uses the alternating feelings of the individual towards society which accompany these moods. Just as it is the function of idiom to convey to the individual either that he is outside the pale and sunk to the level of the animals, or—though far less rarely—that he is an honoured part of it, so literature expresses its content through alternating moods of feeling oneself a part of society, or being in rebellion against it or outcast from it. This latter distinction corresponds to two different causes why the general opinion of a society may expel an individual member—either because he only consumes and is below the general standard of social activity, or because he is above it and produces in a new way. (The conflicts of class relations will be touched on later; the statements here correspond to the general conditions of production, not to the particular movement.)

One of the ways, then, in which literature makes its content living, is that it relates it to these fundamental experiences in social organisation. But, as already said, the variations in method are numberless.

Literature also relates its content to the character of human work, which has to see the world as it is in itself, in order to be able to change it into a world for us. Just as idiom expresses a situation in terms of the body or of bodily movement, so literature, and especially poetry, through comparisons and images describes human and non-human in terms of one another, and thereby makes the non-human into an expression of the human. But at the same time, through accurately describing what is used for an image as it is in itself, it shows the non-human in its true character. Literature shows both the natural and social world in terms of the actual and desired relation to them and of their objective reality. In the case of the social world, the process is especially complex; in a novel for example, the characters are made to behave in such a way that the general action shall symbolise the actual and desired relation to the social world, but they must also act according to objective standards of psychological truth.

In either case, the presentation of the world as our world and as itself awakens the feeling of social energy because it is a repetition of our own activity in making the world human through work.

Literature does not only show its content in terms of the conflicts inherent in organising a group and its particular activity. It also conveys the sense of power to achieve organisation and to use its energy. The very fact that a new content is integrated into the forms of language and literary expression created in the past, has an effect, because it suggests that the instruments of language and expression through which we have got thus

far, will also enable us to meet this situation. But that is common in some degree both to literature and other printed matter. The effect of form in literature is partly due to the fact that it is contradictions and conflicts that it unites; the form is felt as form by contrast with what would break it. It is also partly due to the fact that words in literature have echoes of their other senses than the plain one of the obvious context. They have more of their social body, as it were; and this, together with the rich suggestion arising out of their greater significance, conveys a bodily feeling of the social weft of our lives. Finally, the coherence of the mutually modifying parts into one whole appeals to our experience of social existence, and gives the sensation of a more harmonised organism than the social organism actually is.

The earlier statement, that literature lives language, thus means that as language organises a group and its particular activity, so literature expresses its content in terms of the conflicts inherent in this organisation and of their reconciliation in the completed work.

This interpretation of literature in terms of our actual social experience only takes account of the general conditions of that experience. It neglects the movement described by Marx in the passage quoted earlier from one form of social organisation to the next, and this movement is the essential character of the changing social organism. Nevertheless, it may be well to illustrate by an example what has been said up to the present. I take a well-known sonnet by Shakespeare.

> That time of year thou mayst in me behold
> When yellow leaves, or none, or few do hang
> Upon those boughs which shake against the cold,
> Bare ruin'd choirs, where late the sweet birds sang.
> In me thou seest the twilight of such day
> As after sunset fadeth in the west;
> Which by and by black night doth take away,
> Death's second self, that seals up all in rest.
> In me thou seest the glowing of such fire,
> That on the ashes of his youth doth lie
> As the death-bed whereon it must expire,
> Consum'd with that which it was nourish'd by.
> This thou perceiv'st, which makes thy love more strong,
> To love that well which thou must leave ere long.

Since we have not yet considered the movement of society, the significance of the content of the sonnet cannot be discussed. What will be attempted is—not an interpretation of the sonnet—but to show how the

above analysis helps us to appreciate how this particular form makes the realisation of the content a moving experience.

Applying the general idea that literature makes its particular content living for us by conveying a bodily feeling of the social energy without which that content could either not exist at all, or could not be spoken about, we note in the first place, that the sense of transience throughout the sonnet is indirectly a stimulation of the energy that strives against the universal wasting by time. It awakens the fundamental experience that continual energy is required in the endless war against the forces of disintegration. Every form of life that our social organisation has created, falls into nothing unless it is continually renewed. That sense is strong here, because the poem shows not only nature in itself—autumn, twilight and the fire—moving towards its annihilation; nature's decay is also that of man. It is this ceasing to exist of nature and man that indirectly, by contrast, arouses the energy which shall maintain the world.

This general feeling is conveyed in a manner similar to that noted by Mr. Pearsall Smith in his remarks on the kinæsthetic perception through phrasal verbs. In the first four lines, the few yellow leaves, so clearly seen and so near falling after the preceding "none," evoke a physical sensation of the stillness of an autumn day, when the yellow leaves, that a breath would remove, are hanging on the boughs; and there is a muscular feeling of how a single touch would make them fall. Then there is an alternation in the manner of conveying transience through bodily perception similar to the fundamental contrast between organisation and disintegration, activity and passivity. In the first four lines, we wait, as it were, on transience; it is in the surrounding air, while the leaves hang motionless. In the next four lines, the mere passive expectancy has become active motion, the fading away of the light in the west; and the indefinable mental sensation as the attention goes from the leaves quite near to the distant horizon makes us take part in the movement to nothingness; and the impending act of "black night," with its contrast to the yellow leaves, intensifies the effect of this change from waiting to movement. Then, with a similar effect in our sensation, the transience which had been far away in the sky, is concentrated in the glowing of the fire, which, in that it lies waiting on its death-bed but still glowing, unites the contrary impressions of passivity and activity in the preceding lines. Because of this form of expression, transience is not a mere idea, but a material, bodily feeling of those experiences that make it a significant reality for us.

Another tone in this is the alternation of feeling in the individual towards society according as he participates or not in its activity—the alternation between feeling himself a part of society and being isolated

from it, which the precariousness of our individual and social existence makes a continual fear. The effect of this sonnet is not only due to its evoking the energy that fights against disintegration of organised life, but also the energy of the desire to remain a part of that life, not to follow the light into nothingness, not to be removed from living society.

At the same time, this alternation between energy and decay, between being a part of society and thrown into outer darkness, also expresses the alternation between the world as it is and the world as we make it, the world as the object of that organised energy which the first alternation awakens. The autumn, the twilight, the fire are made human in meaning; and yet the more human they are made, the more vivid is the sense of their own reality. The "bare ruin'd choirs" are human; yet just for that very reason the phrase only intensifies the physical apprehension of the actual boughs "which shake against the cold." In the last image, the personification ("his youth") is most direct; yet the objective realisation of the glowing among the ashes is most actual. The world is human, and itself, with equal reality. That is the double character of the world as the object of human work. The manner in which the sonnet expresses its content, epitomises our social existence.

The last two lines resume the conflicts between energy and disintegration, activity and passivity, membership of and isolation from society; and between the world in itself and the human world.

> This thou perceiv'st, which makes thy love more strong,
> To love that well which thou must leave ere long.

The realisation of transience is a stimulus to love actively, instead of merely accepting; to be one with all the energy of life, before leaving it. And, taking up and reversing the line, "Consum'd with that which it was nourish'd by," these last two lines transform the transience, which has been shown as a power that man cannot resist, into the source of human energy, which is now nourished by what consumes it.

Further, the ability to impose significant order on these conflicts stimulates still further the social energy which the expression of them has aroused, by making it feel its creative power.

We feel the content of the poem with sadness and delight, because its form awakens the life of our most fundamental experience, our existence as members of a society organising itself to make a human world. For the moment we perceive as active social beings, not accepting life as given, but knowing that its continuance depends on us. For the poem does not merely take and use the existing words. "This thou perceiv'st" is itself perception.

By its expression through the fundamental conflicts inherent in it, the poem continues that social organisation which has made us able to perceive autumn and twilight, and able to love. The form conveys the content in such a way that we have a bodily feeling of the social life which alone has made the content real for us.

ANDRÉ BRETON

*The imaginary is that which tends
to become real.*
—Breton, Preface to *Le Revolver
à Cheveux blancs*

*Perseus wore a magic cap
that the monsters he hunted down
might not see him.
We draw the magic cap down over eyes
and ears as a make-believe
that there are no monsters.*
—Marx, *Capital*

*The marvelous is everywhere,
hidden from the eyes of the vulgar,
but ready to explode like a time bomb.*
—Péret, *Anthologie des Mythes*

INTRODUCTION

French Marxism paid little attention to the arts until the October Revolution brought a number of humanitarian and antiwar writers—Romain Rolland, Anatole France, Henri Barbusse, Raymond Lefèbvre, Marcel Martinet, and Paul Vaillant-Couturier—within the orbit of the newly formed Communist Party of France. Thereafter—throughout the 1920's, the Popular Front period, the Resistance, the Cold War years, the post-Stalin era—thousands of French creative figures and intellectuals became Communists or "sympathizers" for periods of varying duration. These included Gide, Malraux, Picasso, Léger, Aragon, Eluard, and Sartre, plus scholars, scientists, and intellectuals in every field of endeavor.[1] The French intelligentsia has been more deeply "involved" with Marxism (although in an ambivalent way) than the intelligentsia of any major nation apart from the U.S.S.R.

1. For details, see David Caute, *Communism and the French Intellectuals, 1914-1960* (New York, 1964), and George Lichtheim, *Marxism in Modern France* (New York, 1966).

The French have tended to be somewhat apologetic about their contributions to Marxism, perhaps because France was the source of so many non-Marxist (and pre-Marxist) socialist traditions. Marx and Engels were Germans, and Engels in his later years looked on the German working class as the apple of his eye; he and the Kautskyists were prone to place the needs of German Social Democracy above the interests of the French movement. French Social Democracy began as a stepchild of a German movement, and in later years the French Communist Party tended to accept a similarly subordinate ideological role vis-à-vis the Soviet Union. Nevertheless, the only way in which one can write (as Althusser does) of a theoretical impoverishment in French socialist culture[2] is to ignore the many streams of Utopian, egalitarian, and anarchist socialism which arose in France from the Revolution onward, beginning with such major figures as François-Noël Babeuf (1760–1797), Henri de Saint-Simon (1760–1825), Etienne Cabet (1788–1856), and François-Marie-Charles Fourier (1772–1837). Later in the nineteenth century, the Babouvist tradition of revolutionary dictatorship found its continuers in Philippe Buonarroti (1761–1837) and Louis-Auguste Blanqui (1805–1881), while anarchism found its father in Pierre-Joseph Proudhon (1809–1865) and Louis Blanc proclaimed himself a defender of a democratic socialism. The expounders and followers of Saint-Simonian and Fourierist socialism included such important theorists as Pierre Leroux, Victor Considérant, Barthelemy-Prosper Enfantin, Théophile Thoré, Constantin Pecqueur, Philippe-Joseph-Benjamin Buchez, and Saint-Amand Bazard.[3]

The first French Marxists—Paul Lafargue, Jules Guesde, Charles Longuet—were themselves partly Blanquist, Lassallean, or Bakuninist in outlook.[4] In the 1880's and 1890's, the writings of the German Marxists began to be issued in translation, along with Sorel's popularizations of Antonio Labriola, but their impact was softened by the pervasiveness of Juan Jaurès' Fabian-like brand of Marxism. Unfortunately, Emile Durk-

2. See Louis Althusser, *For Marx* (New York, 1969), p. 23ff.

3. For the aesthetic theories of French Utopian socialism, see H. J. Hunt, *Le Socialisme et le romantisme en France* (Oxford, 1935); Félix P. Thomas, *Pierre Leroux, sa vie, son oeuvre, sa doctrine* (Paris, 1904); Plekhanov, *Utopian Socialism of the Nineteenth Century* (Moscow, n.d.), pp. 57f. Proudhon's sociology of art is explored by Max Raphael, *Proudhon, Marx, Picasso: Trois Études sur la Sociologie de l'Art* (Paris, 1933). See also Donald Drew Egbert, *Social Radicalism and the Arts: Western Europe* (New York, 1970), pp. 117–205.

4. Paul Lafargue (see above, page 113, note 1, and bibliography) wrote occasionally and superficially on literature. For attitudes of Jules Guesde and others toward art and socialism, see Eugenia W. Herbert, *The Artist and Social Reform: France and Belgium* (New Haven, 1961), pp. 26–28.

heim's attempt at a critical synthesis of the Comteian, Saint-Simonian, and Marxist sociological traditions was never carried to completion.[5]

The start of serious work in Marxist philosophy in France dates from the mid-1920's, with the "Philosophers" group, which included Henri Le-fèbvre, Georges Politzer, Norbert Guterman, Georges Friedmann, Pierre Morhange, and Pierre Nodier. In the mid-1930's the "Circle of the New Russia" (later renamed the "Association for the Study of Soviet Culture") included several outstanding Marxist philosophers, critics and linguists, including René Maublanc, Marcel Cohen, Auguste Cornu, Paul Nizan, and Jean Cassou.

Despite this widespread interest in Marxism, France produced little in the way of the systematic application of Marxist aesthetics before World War II. Jean Fréville prepared French editions of the writings of Marx, Engels, Lenin, and Stalin on literature and art; a handful of minor critics utilized Marxist ideas in criticism of literature and the fine arts; a few local Zhdanovists began to emerge as guardians of the cultural front.[6]

Nevertheless, the French prewar contribution is considerable, and I believe that we may even speak of a "Parisian School" of Marxist aesthetics which (despite or because of its lack of systematization) has served as a counterbalance to the tendency toward petrifaction of Marxist categories. The major components of this school (if such it was) are revolutionary

5. See Emile Durkheim, *Socialism* (New York and London, 1962).

6. The post-1945 period was marked by a virulent French Zhdanovism, ending with the 20th Party Congress. In the 1960's, French Marxism split into a number of currents, including a neo-Stalinist positivism, a speculative Hegelianism similar to that of the Frankfurt School, and various types of left existentialism. Lichtheim points to the "increasingly metaphysical character" of the French debates over humanism and alienation as evidence of a growing split between theory and practice (*Marxism in Modern France,* p. 182). The German "dream-history" of which Marx wrote in 1843 has at last moved across the Rhine. The smashing of French national power by Nazism, the subsequent failure of the French proletarian revolution to materialize, and the fragmentation of French imperial power by the national liberation movements of Asia and Africa, created fertile ground for a displacement of political struggles to the speculative superstructure.

Some interesting postwar work in Marxist aesthetics has been done by Roger Garaudy (after his "liberation" from Zhdanovism), by Henri Lefèbvre, and by Lucien Goldmann, author of the highly regarded *The Hidden God: A Study of Tragic Vision in the Pensées of Pascal and the Tragedies of Racine* (New York, 1964). I am unable to locate a Marxist basis for Goldmann's central categories—"world vision" and "tragic vision"—which are derived from Dilthey and pre-Marxist Lukács. For a contrary assessment, see Raymond Williams, "Literature and Sociology: In Memory of Lucien Goldmann," *New Left Review,* no. 67 (May–June 1971), pp. 3–18.

surrealism and contemporary German Marxist aesthetics, and it consisted of an informal but fertile interchange between such men as Breton, Aragon, Péret, and Malraux on one side and such German émigrés as Max Raphael and Walter Benjamin—both of whom spent the major portion of the thirties in Paris.[7]

For the most part, the contributions of the French in this alliance utilized the manner of pronouncement, revelation, and exhortation rather than rigorous development and application. In brief, they were manifestoes of the highest order. The manifesto has roots both in the histories of revolutionary parties and in radical or avant-garde cultural movements. In France, such creative artists as Barbusse, Aragon, Gide, Malraux, Breton, Eluard, Léger, and Picasso effected a merger of these twin streams in their spoken and written manifestoes, which simultaneously were proclamations of their faith in revolution and programmatic pronouncements on the art and aesthetics of the revolutionary movement. Later in this anthology appears Malraux's brilliant manifesto-speech to an international writers' conference (pages 563–66). Here we reprint several typical selections from the writings and speeches of the surrealist poet and spokesman André Breton.

———

Breton was born in 1896. As a medical student, he served during World War I treating the wounded in psychiatric wards. He joined the Dada movement in 1919, withdrawing in 1922 together with others who "realized that the futility of Dada was even greater than the futility of the reality against which it protested."[8] From then until his death in 1966 Breton was surrealism's outstanding theoretician, mirroring in his life and work the contradictions and fluctuations of the movement as a whole. His career may be visualized as a series of syntheses of an original theory of creative inspiration with successive philosophical doctrines. Surrealism begins with a pragmatic and determinist theory of artistic creativity through spontaneous, "automatic" release of the "inner" (i.e., unconscious) contents of the psyche, and gradually accumulates additional layers of theoretical justification and modification. In view of this, one cannot

———

7. Benjamin's debt to surrealism is widely evidenced; Malraux, in turn, was influenced by Breton and even more by Benjamin, whom he knew in Paris. See Benjamin, letter to Max Horkheimer, Aug. 10, 1936, in Benjamin, *Briefe* (Frankfurt-am-Main, 1966), vol. 2, p. 717.

8. Anna Balakian, *Surrealism: The Road to the Absolute,* p. 124.

define surrealism at any given stage of its development: it has a history, it remains in a state of "becoming" for a generation, and its doctrine can be fully understood only by taking up the totality of its various integrations in the course of its history.

Schematically, one may point to a number of nodal junctures that mark the more significant intellectual stages of surrealism's unfolding: the movement begins as a fusion of French symbolism and Dada with Freudian id and dream theory; exalting individualist revolt (including criminality) and the total subversion of bourgeois values, it moves outward around 1925 toward more effective revolutionary action, discovering Lenin, Trotsky, and the October Revolution, entering into an ambivalent alliance with French Communism, participating in political protest and working-class activity during the following decade. It acquires in Hegel's objective-idealist dialectics (learned partly from Lenin's *Philosophical Notebooks*) a philosophy that explains the opposition and interaction (as Herbert Read puts it) "between the world of objective fact . . . and the world of subjective fantasy"; it merges Freud's instinct theory with Engels' revolutionary call for sexual equality and a transcendent monogamy; it unites Rimbaud's plea "Change life" with Marx's "Transform the world"; and finally it comes to rest (during Breton's U.S. exile) in Fourier. The surrealist journey is not a linear progression—from Baudelaire-Rimbaud to Tristan Tzara and Apollinaire, Freud and Janet, Marx and Engels, Hegel, Lenin, and Trotsky. Every stage is incorporated into each preceding one. The result is one of the more ambitious aesthetic-philosophical integrations of twentieth-century Marxism.

The pieces chosen are intended to illustrate a few aspects of surrealist thought. A passage from the *Second Surrealist Manifesto* (1930) announces Breton's adherence to historical materialism and his identification of Marxism with surrealism as fraternal derivatives of the Hegelian system, both dedicated to revolutionary solutions of human problems—love, madness, art, religion, and, in the first place, the conquest of hunger. The next selection, from *Les Vases Communicants* (dedicated to Freud in 1932), sees the function of poetry as the surmounting of "the irreparable divorce of action and dream." This Utopian-revolutionary concept harks back to Baudelaire ("Imagination is the queen of truth, and the *possible* is one of the provinces of truth") and anticipates both Malraux and Caudwell. Third, we reprint the closing moments of Breton's speech to the International Writers' Congress held at Paris in June 1935, in which he defends the integrity of the individual work of art and of the collective cultural heritage against the attacks from both the right and the left (Zhdanovism

was born the previous year). Tragically, surrealism's main preoccupation in the later 1930's was to be, as Robert S. Short noted, "the defence of art's independence against the only political movement they had believed in."[9] Reaffirming the poet's ability to change the world, Breton rejects the concept of "propagandistic poetry" and calls for that union of Rimbaud and Marx which he must have known was premature, irrelevant, and certainly "Utopian" in 1935. Our final selection is a Fourierist paragraph from *L'Amour fou* (1937) illustrating the Freud-Engels union referred to above, in which Breton speculates on the possible form of family and sexual relations under Communism.[10]

The inevitable question in the surrealist synthesis is "What predominates?" Which of the elements constitutes the structural framework within which the other elements become operative? Is Marxism the underlying philosophy of the surrealist movement? These are difficult questions, because of the splits among the surrealists themselves and because surrealism's synthesis has different basic coordinates depending on how (and when) one approaches it. Surrealism is an unstable doctrine, subject to sudden dialectical reversals. Caudwell recognized this when he wrote that surrealism, like political anarchism, "negates itself in practice."[11] No doubt the tragic flaw in surrealism is in the theory of unconscious creativity with which it began, which Breton in the first *Surrealist Manifesto* (1924) defined as "pure psychic automatism by which we propose to express, either verbally, or in writing, or in any other manner the real function of thought." The revolutionary-philosophical-Utopian-psychological superstructure erected above this theory (which denies both form and consciousness) can only serve to ward off the inevitable collapse of the entire synthesis. Sartre, in *What Is Literature?*, saw this when he noted that the poetic theory of surrealism, in which the artist is regarded as a "modest recording device" for the transmission of unconscious or collective experiences, tends inevitably toward quietism rather than toward revolution (pages 181–182). Freud had been unwilling to ratify the surrealists' use of his dream theories because, as Leon Edel points out, he considered the distortions and condensations of dream imagery "as forms by which man concealed from himself the unpalatable truths of his instincts" whereas "the surrealists

9. R. S. Short, "The Politics of Surrealism." In *The Left Wing Intellectual between the Wars* (New York, 1966), p. 20.

10. Breton, in his *Ode à Charles Fourier* (1947; written 1945), dates his immersion in the works of Fourier from the 1940's, but the ideas of the Utopian had begun to shape Breton's thought at a much earlier time.

11. Christopher Caudwell, *Illusion and Reality* (London, 1937), p. 112.

regarded them as a liberation from the conventional and from the clichés of art."[12] It is possible that it was this fundamental "error" at the foundation of surrealist theory which compelled the surrealists to seek rationality in realms outside of poetry and art—in Hegel, Marx, and Lenin. The flaw in the theory[13] may therefore be seen as its motive force, which creates a perpetual and irreconcilable disequilibrium.

Today, after a period of decline and neglect, the surrealists' insistence on a socialism based on the psychological-aesthetic-biological needs of humanity has made surrealism highly relevant to contemporary radical movements in the industrialized countries. Some of its current influence may be due to the later writings of Herbert Marcuse. Retracing Breton's steps, Marcuse has arrived at the identical synthesis of Marx, Hegel, Freud, Lenin, Fourier, and the French symbolist poets. And in specifically rejecting the "automatism" of surrealistic creative theory he has cleared the way for the utilization of the surrealist philosophical-aesthetic synthesis within a Marxist framework.

BRETON: SURREALISM AND HISTORICAL MATERIALISM
from *The Second Manifesto of Surrealism*

Surrealism, although a special part of its function is to examine with a critical eye the notions of reality and unreality, reason and irrationality, reflection and impulse, knowledge and "fatal" ignorance, usefulness and uselessness, is analogous at least in one respect with historical materialism in that it too tends to take as its point of departure the "colossal abortion" of the Hegelian system. It seems impossible to me to assign any limitations—economic limitations, for instance—to the exercise of a thought finally made tractable to negation, and to the negation of negation. How can one accept the fact that the dialectical method can only be validly applied to the solution of social problems? The entire aim of Surrealism is to supply it with practical possibilities in no way competitive in the most immediate realm of consciousness. I really fail to see—some narrow-minded revolutionaries notwithstanding—why we should refrain from supporting the Revolution, provided we view the problems of love, dreams,

12. Leon Edel, "Psychoanalysis and the 'Creative' Arts," *Modern Psychoanalysis,* ed. Judd Marmor (New York and London, 1968), p. 630.

13. The creative practice of the surrealists contradicts their creative theory at every turn, despite the widely publicized "dream-creations" and "automatic writing" of some.

madness, art, and religion from the same angle they do. Now, I have no hesitation in saying that, prior to Surrealism, nothing systematic has been done in this direction, and at the point where we found it *the dialectical method, in its Hegelian form, was inapplicable for us too.* There was, for us too, the necessity to put an end to idealism properly speaking, the creation of the word "Surrealism" would testify to this, and, to quote Engels' classic example once again, the necessity not to limit ourselves to the childish: "The rose is a rose. The rose is not a rose. And yet the rose is a rose," but, if one will forgive me the parenthesis, to lure "the rose" into a movement pregnant with less benign contradictions, where it is, successively, the rose that comes from the garden, the one that has an unusual place in a dream, the one impossible to remove from the "optical bouquet," the one that can completely change its properties by passing into automatic writing, the one that retains only those qualities that the painter has deigned to keep in a Surrealist painting, and, finally, the one, completely different from itself, which returns to the garden. That is a far cry from an idealistic view of any kind, and we would not even bother to refute the allegation if we could cease to be the object of attacks of simplistic materialism, attacks which stem both from those who by base conservatism have no desire to clarify the relations between thought and matter and from those who, because of a revolutionary sectarianism only partly understood, confuse, in defiance of what is required, this materialism with the materialism that Engels basically distinguishes from it and which he defines above all as an "intuition of the world" called upon to prove itself and assume concrete form:

In the course of the evolution of philosophy, idealism became untenable and was repudiated by modern materialism. The latter, which is the negation of negation, is not the simple restoration of the former materialism: to the durable substructure of the latter it adds all the thought that philosophy and science has amassed in the course of two thousand years, and the product of that long history itself.

We also intend to place ourselves at a point of departure such that for us philosophy is "outclassed." It is, I think, the fate of all those for whom reality is not only important theoretically but for whom it is also a matter of life or death to make an impassioned appeal, as Feuerbach desired, to that reality: our fate to give as we do, *completely,* without any reservations, our allegiance to the principle of historical materialism, his to thrust into the face of the shocked and astounded intellectual world the idea that "man is what he eats" and that a future revolution would have a better

chance of success if the people were better nourished, in this specific case with peas instead of potatoes.

━━━

Our allegiance to the principle of historical materialism . . . there is no way to play on these words. So long as that depends solely on us—I mean provided that communism does not look upon us merely as so many strange animals intended to be exhibited strolling about and gaping suspiciously in its ranks—we shall prove ourselves fully capable of doing our duty as revolutionaries.

BRETON: **ACTION AND DREAM**
from *Les Vases Communicants*

The poet of the future will surmount the depressing notion of the irreparable divorce of action and dream. He will hold the magnificent fruit of the tree whose roots are intertwined and will be able to persuade those who taste it that there is nothing bitter about it. Borne by the current of his time, he will assume for the first time without distress the responsibility for the reception and transmission of signals which press upon him from the depth of souls. He will maintain at any price in each other's presence the two terms of the human relation, by whose destruction the most precious conquests would instantaneously become null and void: the objective awareness of realities, and their internal development in what, by virtue of a sentiment individual on one hand, universal on the other, is magical about it until proved otherwise. This relation can pass for magical in that it consists of an unconscious, immediate action of the internal on the external, so that there readily slips into the summary analysis of such a notion the idea of a transcendent mediation which would be, moreover, that of a demon more than of a god. The poet will oppose this simplistic interpretation of the phenomenon in question: in the immemorial prosecution of intuitive knowledge by rational knowledge, it will be the poet's responsibility to produce the capital evidence that will put an end to the dispute. The poetic operation, henceforth, will be conducted in broad daylight. We shall renounce picking quarrels with certain men who will tend to become all men, renounce manipulations long suspect to others, long equivocal in themselves, in which we have indulged in order to keep eternity in the moment, to dissolve the general in the particular. We shall no longer cry miracle! each time that, by the more or less involuntarily compounded

mixture of these two colorless substances which are existence subject to the objective connection of beings and existence concretely escaping this connection, we manage to achieve a precipitate of a lovely, lasting color. We shall already be outside, mingling with the others in the light of day, and will not have to look with an expression of greater complicity and intimacy than theirs on the truth when it shakes its hair streaming with light at the dark window.

BRETON: **THE CULTURAL HERITAGE**
from a *Speech to the International Association of Writers for the Defense of Culture*

On this occasion we have no intention whatsoever of modifying the line which has been ours for ten years. We have already said that our ambition was to show the use that could legitimately be made of our cultural heritage in our era and in the West. In the realm of poetry and in the realm of the plastic arts which are our special province, we still think (1) that this cultural heritage must be constantly inventoried; (2) that it must be decided what is deadwood in it so as to rapidly eliminate it; (3) that the only acceptable part furnished by the remainder must be used not only as a factor in human progress, but also *as an arm which inevitably turns against bourgeois society as that society degenerates*. To light our path through the labyrinth of existing human works the judgment of posterity is, in all truth, a fairly sure guide since the spirit of man ever feels its way along, but also ever goes forward. It is not a question here of substituting desires for realities: independently of whatever constitutes its "manifest content," the work of art lives to the degree that it ceaselessly re-creates emotion, and to the degree that an ever more general sensibility from day to day draws from it a more and more necessary sustenance. This is the case, for example, of a body of work such as that of Baudelaire; I cannot imagine his prestige ceasing to grow in the eyes of new generations of poets, even Soviet poets. This property, possessed here and there by certain artistic works, can appear to us only as a function of their very particular situation in time, of that air of being *figureheads* at the prow of a ship that they assume in relation to the historical circumstances that unleashed them. They bring about a perfect balance between the inner and the outer: it is this balance that objectively confers authenticity upon them; it is this balance that causes them to be called to pursue their dazzling career without being affected by social upheavals. A cultural heritage in its acceptable form is above all the sum of such works with an exceptionally rich "latent content." These works, which today in poetry are those of Nerval, Baudelaire,

Lautréamont, and Jarry and not the many so-called "classic" works (the classics that bourgeois society has chosen for itself are not ours), remain above all else messengers and their influence ceaselessly increases in such a way that it would be useless for a poet of our time to oppose their being so chosen. Not only can literature not be studied outside the history of society and the history of literature itself; it also cannot be written, in each era, unless the writer reconciles two very different concrete facts: the history of society up to his time, and the history of literature up to his time. In poetry a body of work such as that of Rimbaud is a perfect example of this, and from the point of view of historical materialism revolutionaries must make it their own, not partially, but totally. I am assured that at the last commemoration of the dead of the Commune, the Paris Association of Revolutionary Writers paraded past the wall under the banner "To the Militants of the Commune: Rimbaud, Courbet, Flourens." The use here made of Rimbaud's name is improper. Revolutionaries must not answer the disloyalty of their adversaries by disloyalty on their part. To represent Rimbaud—the artist and the man at grips with all his problems—as having arrived in May 1871, at a conception of his role that could be contrasted with that of today's poetic researchers is to falsify the facts. To do that, or brazenly to claim that Rimbaud fell silent "for lack of an audience"—in the same way that by playing on a simple coincidence of names people once tried to make us confuse the author of the *Chants de Maldoror,* Isidore Ducasse, with the Blanquist agitator Félix Ducasse—is knowingly to bear false witness. The first act of courage for a revolutionary must be to prefer life to legend. The real Rimbaud of that period, who was, certainly, won over socially to the revolutionary cause, is not only the author of "Les Mains de Jeanne-Marie," but also the author of "Le Coeur volé." Nor is he exclusively, as some would lead us to believe, the very young "sharpshooter of the Revolution" of the barracks of Babylon; he is also the man fully occupied with problems apparently external to the Revolution, the man who is wholly revealed in the so-called "Lettre du voyant," quite characteristically dated May 15, 1871.

In the present period, one of our first cultural duties, one of our first duties on the literary plane, is to shelter such works full of sap against all falsification from the right or from the left which would result in their being impoverished. If we cite the work of Rimbaud as an example, let it be plainly understood that we could also cite that of Sade, or with certain reservations, that of Freud. Nothing can force us to deny these names, just as nothing will force us to deny the names of Marx and Lenin.

From where we stand, we maintain that the activity of interpreting the world must continue to be linked with the activity of changing the world.

We maintain that it is the poet's, the artist's role to study the human problem in depth in all its forms, that it is precisely the unlimited advance of his mind in this direction that has a potential value for changing the world, that this advance—insofar as it is an evolved product of the super-structure—cannot help but reinforce the necessity to change this world economically. In art we rise up against any regressive conception that tends to oppose content to form, in order to sacrifice the latter to the former. If today's authentic poets were to go in for propagandistic poetry, which as presently defined is completely exterior, this would mean that they were denying the *historical* conditions of poetry itself. To defend culture is above all to take over the interests of that which intellectually resists serious materialist analysis, of that which is viable, of that which will continue to bear fruit. It is not by stereotyped declarations against fascism and war that we will manage to liberate either the mind or man from the ancient chains that bind him and the new chains that threaten him. It is by the affirmation of our unshakeable fidelity to the powers of emancipation of the mind and of man that we have recognized one by one and that we will fight to cause to be recognized as such.

"Transform the world," Marx said; "change life," Rimbaud said. These two watchwords are one for us.

BRETON: **L'AMOUR FOU**
from *L'amour fou*

The perfect adequacy which tends to be that of love between two beings no longer meets with any obstacle at this moment. The sociologist should perhaps beware, who, under European skies, confines himself to casting a misty glance from the smoky and roaring mouth of the factories to the dreadful restive peace of the fields. It has not stopped occurring there; perhaps it is more timely than ever to recall that this adequacy is one of the goals of human activity; that economic and psychological speculation, however hostile to each other they appear in our times, coincide in focusing upon it. Engels, in *The Origin of the Family,* does not hesitate to make *individual sexual love,* born of this *higher form of sexual relations which is monogamy, the greatest moral progress* accomplished by man in modern times. Whatever inflections one attempts today to give to Marxist thought on this point, as on so many others, it is undeniable that the authors of the *Communist Manifesto* unceasingly opposed the hopes of a return to "dis-orderly" sexual relations which marked the dawn of human history. Once private property is abolished, "it can be affirmed with reason," Engels

declares, "that *far from disappearing, monogamy will be rather for the first time achieved.*" In the same work, he insists several times over on the *exclusive* character of this love which, at the cost of what deviations—I know both miserable and grandiose ones—has finally *found* itself. This view of what is doubtless most enthralling in the consideration of the human condition and future can only be corroborated more clearly by that of Freud, for whom sexual love, even as it is already given, *breaks the collective links created by the race, transcends national differences and social hierarchies, and thereby contributes to a great measure to the progress of culture.* These two conceptions, which assign the less and less frivolous conception of love as the principal fundamental to moral as well as cultural progress, seem to me in themselves of a nature to constitute the finest part of poetic activity as a tested means of focusing the perceptible and moving world on a single being as well as a permanent force of anticipation.

HERBERT MARCUSE

In his last years, he tried to find the answer to the terrible question why human freedom and happiness declined at the stage of mature civilization when the objective conditions for their realization were greater than ever before.

—Marcuse, Introduction to Franz Neumann's
The Democratic and the Authoritarian State

INTRODUCTION

Herbert Marcuse's emergence to a central and controversial place in current thought and politics is one of the more explosive events in modern intellectual history. Born in 1898 in Berlin, he studied at the Universities of Berlin and Freiburg, taking his Ph.D. at the latter university after service in the World War. In 1917 he joined the Social Democratic Party of Germany, resigning the following year, over what he regarded as the Party's complicity in the murders of Rosa Luxemburg and Karl Liebknecht. Whether he had any other formal political affiliations during his Weimar years is unclear. From 1924 to 1929 he was a publisher in Berlin, abandoning this in favor of his philosophical studies, which he pursued under Husserl and Heidegger from 1929 to 1933. In 1934 he emigrated to the United States and until 1942 lectured at Columbia University. His interest in Marx emerged early: his first published essay was a Heideggerian "Contribution to the Phenomenology of Historical Materialism" (1928), and the central concern of his first period (1928–1941) was the relationship between German philosophical and sociological thought and Marxism,

concentrating particularly on the Hegelian sources of Marx's thought. From 1933 onward he became associated with the "Frankfurt School" headed by T. W. Adorno and Max Horkheimer, whose work exercised a major influence on his own thought; he wrote more than one hundred reviews and articles for their journal, the *Zeitschrift für Sozialforschung,* between 1933 and 1941 and was himself a leading member of the Institute of Social Research. He published a number of important studies on the relationship between liberal tendencies in philosophy and their liquidation in fascist totalitarianism. Like many German intellectuals of his period, he was preoccupied with the suspicion (paradigmatically represented by Thomas Mann in *Doctor Faustus*) that *Kultur* and consciousness somehow bore a major responsibility for the rise of repression, and ultimately of Nazism itself. His *Reason and Revolution: Hegel and the Rise of Social Theory* (1941) seeks to absolve Hegel of such responsibility and comes to grips with the question of Germany's "dream history" along lines laid down by Hegel (in his *Lectures on the Philosophy of History*), by Heine (in *Religion and Philosophy in Germany*), and by the early Marx (see above, pages 460–64), wherein German intellectual life is detached from the sphere of political action and anchors itself "in the 'soul' of the individual."[1] Germany finds itself capable of revolutionary action only in thought, thereby creating an unbridgeable gulf between theory and practice.[2] Brandes had described the German glorification of wish as "impotence itself conceived as a power";[3] Marcuse, too, saw German philosophical idealism as resulting from the impotence of the German intellectuals "who fulfilled them-

1. *Reason and Revolution*, p. 15.

2. That Marxism itself may be subsumed under Marx's concept of "dream history" is worth examination. If Rosa Luxemburg's thesis on the "irrelevance" of Marx's completion of *Capital* to the working-class movement is correct (see above, pages 154–59), this emerges as a distinct possibility. Certainly Marxism in its Kautskyist period—wherein German Social Democracy adhered to precepts of revolutionary theory while it practiced a rather quiescent reformism—fully qualifies for Marx's phrase: "In politics, the Germans have *thought* what the other nations have *done.*" And even after Lenin had exploded this "dream history" by his insistence on a revolutionary party of a new type and by focusing Marxist theory on the question of the state, German superstructural evasion re-emerged in full force with the Frankfurt School. Marcuse's *One-Dimensional Man* (Boston, 1964) may be regarded as having abandoned the attempt to heal the split between theory and practice in favor of a rationale for that very split: the impotence of the intellectual is found to be *la condition humaine,* and is projected on to the industrial working class; in the absence of any "instrument of liberation," dream history finds its modern justification.

3. *Main Currents in Nineteenth Century Literature* (New York, 1902), vol. II, p. 27.

selves in a realm of science, art, philosophy, and religion"—a realm which became for them the "true reality" and a refuge from revolutionary politics. Though he acknowledges that German culture and philosophy served "as the repository for truths which had not been realized in the history of mankind," Marcuse's suspicion of superstructural activity persisted, and formed the foundation of his later cultural pessimism.

In an important essay, "The Affirmative Character of Culture" (1937), Marcuse foreshadows the direction of his later writings on art. Affirmative culture and beauty in art are seen as the illusory Utopian dimension which bourgeois society tolerates to relieve the anguish of reality, to provide an escape from pain, to pierce the veil of commodity-fetishism for the individual in such a way as to bring him the illusion of happiness. Marcuse writes: "The rebellious idea becomes an accessory in justification. . . . In affirmative culture even unhappiness becomes a means of subordination and acquiescence. By exhibiting the beautiful as present, art pacifies rebellious desires."[4] Following Schiller, Marcuse does see the dialectical obverse of this process, wherein "art became the presage of possible truth," serving as an archetype of freedom. Recognizing this, however, is far from believing it, and Marcuse's emphasis is on the narcotic aspect of beauty, on the need to negate affirmative culture in order to achieve socialism; he believes that the "assertion that today culture has become unnecessary contains a dynamic, progressive element."

Looking back upon his writings of the 1930's, Marcuse raises the question "whether the mind did not itself bear part of the responsibility" for totalitarian coordination and terror.[5] The suspicion of "mind" and "culture" leads to Nichevoism, and then to withdrawal. Thus, Marcuse's first period apparently ended in a deadlock, inaugurating years of virtual silence. From 1942 to 1950 he served first in the Office of Strategic Services and then in the U.S. Department of State, becoming chief of the division of research of the central European branch. Whether official service for a government committed after 1945 to counterrevolution and nuclear armament constituted identification with the aggressor in a psychological sense is a question of speculation; it is more probable that Marcuse sought to use his post to bring about the democratization and denazification of Germany. That such service was not conducive to objective (let alone partisan) explorations of the possibilities of human liberation is rather more clear. Marcuse published nothing from 1942 until 1948, and from then until his departure from Cold War employment wrote only a handful of reviews and an important paper on Sartre's *Being and Nothingness*.

4. *Negations*, p. 121.
5. *Negations*, p. xiv.

Marcuse found his way back with the help of Freud. It is difficult to date the beginnings of this encounter. There are hints of it in his contributions to *Studies on Authority and the Family* (1936), but it is not until 1941, in an outline for his section of a proposed group effort sponsored by the Institute of Social Research, that Marcuse avows his intention of using psychoanalytical categories for the explication of the politics of fascism and raises the question of the extent to which homosexuality was a major factor in the rise of National Socialist terrorism.[6] In 1950–1951 Marcuse gave a series of lectures at the Washington School of Psychiatry in which he proposed that psychological and political modalities constituted a dialectical unity, the penetration of which might explode the irrationality of capitalist relations of production and bring comfort and liberation to an alienated mankind. These lectures appeared as *Eros and Civilization: A Philosophical Inquiry into Freud,* in 1955, inaugurating the modern school of "Psychohistory," catapulting Marcuse into an unaccustomed role of intellectual leadership on the world stage, and ending his period of silence.

Marcuse had succeeded in accomplishing what others had vainly wished for—the union of Marx and Freud. He did this via an extraordinary *tour de force:* not once in *Eros and Civilization* is the name of Marx mentioned. The spirit of Marx saturates every line in *Eros and Civilization,* but his language has been completely paraphrased. Whether this was due to political timidity (during the McCarthy period) or to a penchant for the method of Aesop is irrelevant: Marcuse cleansed the "accepted" jargon of dialectical materialism of its accumulated and restrictive associations by "translation" into a new terminology.

Marcuse was not the first to attempt a Marx-Freud synthesis. Wilhelm Reich had analyzed the mass psychology of fascism in terms of the inhibition of sexuality and had attempted to establish psychoanalysis as the basis for a Marxist social psychology; Otto Fenichel had already explored the psychological mechanisms of repressive rule and established some of the points of contact between dialectical materialism and psychoanalysis; Harry Slochower had written of "clash and congruence" between Marx and Freud in the 1940's; Erich Fromm had selectively combined Marxist and Freudian concepts within a neo-Rousseauean salvationist framework but had avoided the revolutionary implications of both masters; the last work of Otto Rank attempts to move "beyond psychology" towards a synthesis of psychoanalysis and sociology; it was this synthesis which was at the core of the surrealist vision of revolution; in criticism, Caudwell, Jack Lindsay, Edmund Wilson, Stephen Spender, Kenneth Burke, Walter Abell, Arnold

6. Eugene N. Anderson and Max Horkheimer, eds., *Cultural Aspects of National Socialism* (mimeo., 1941), pp. 19, 22.

Hauser, and a number of minor figures reflected similar desires; most recently, Sartre has claimed that the synthesis is so far advanced that everyone knows that it can be done—the object, therefore, being to actually accomplish it in the sphere of criticism.[7]

Unlike his predecessors, however, Marcuse did not scan the works of Marx and of Freud for evidence of parallelism, but revealed the underlying revolutionary implications of Freudian metapsychology. (He was the first Marxist to accept Freud's speculations on the "primal crime" of prehistory and on the death-directed repetition-compulsion of organic matter.) The parallel task—of drawing together the psychological implications of Marxism—has not yet been undertaken on a major level.

The first selection by Marcuse is "The Images of Orpheus and Narcissus" from *Eros and Civilization*. This is the second of three chapters within that book focusing on the aesthetic dimension. The preceding chapter, "Phantasy and Utopia," is more strictly Freudian, examining the means by which individual fantasy "preserves the archetypes of the genus," mediates between the reality principle (history) and the pleasure principle (biology), and establishes an illusory harmony beyond the reality principle in order to negate historical unfreedom. Dream has the power to reactivate "tabooed realms of gratification"; imagination and fantasy are viewed as protest against "surplus-repression," as means of surmounting an "antagonistic human reality." This is a liberating insistence on the revolutionary claims of fantasy, though Marcuse draws back with a reference to the Aristotelian dual function of art—"to oppose and to reconcile; both to indict and to acquit." Contrary to both his earlier and later writings on art, he maintains these twin aspects of art in a delicate balance. And in the chapter reprinted here he achieves his most optimistic view of the nature of art, seeing it as the vessel which preserves the "strange truths" of humanity's repressed desires regardless of conformity to the "rationality" of the performance principle (the sociohistorical mode of the reality principle). Marcuse seeks out in Orpheus and Narcissus the negative "culture heroes" of mankind—those who oppose domination, reason, productivity, "progress," and repression, those who uphold the images of "joy and fulfillment" and erotic gratification, who "recall the experience of a world that is not to be mastered and controlled but to be liberated." The Orphic-Narcissistic images coincide with the Great Refusal (Whitehead)—the refusal to accept the repressive orders of sexuality and class domination. Eros, play, peace, and salvation are united in Orphic song; Narcissus, though he

7. Others who have more or less rigorously attempted (or urged) such a synthesis include W. H. Auden, Randall Swingler, Robert Gorham Davis, Stanley Edgar Hyman, Edwin Berry Burgum, William Empson, Ernst Fischer, and Attila József.

"symbolizes sleep and death, silence and rest," lives by "an Eros of his own" in which beauty and contemplation merge into a modified Nirvana principle, capable of regeneration.

Extraordinarily, Marcuse specifically rejects the Promethean myth—the Father-God-Establishment-defying myth. He sees Prometheus only as "the culture-hero of toil, productivity, and progress through repression," as "the archetype-hero of the performance principle." The young Marx had written, in his doctoral dissertation, that "Prometheus is the most eminent saint and martyr in the philosophic calendar," and he had seen, as Marcuse does not, that the Promethean rejection of servitude and of mastery ("I hate the pack of gods") is the primal statement of the Great Refusal, the "no" from which the revolutionary "yes" emerges.

In this chapter, Marcuse transcends his innate mistrust of art by identifying with those elements in art which avoid confrontation with the reality principle. His Orphic-Narcissistic images are the images of a pregenital childhood, a revival of the repressed memories of gratifications. Ultimately it is Marcuse's achievement to have created an image of Utopia which conforms to the preadolescent latency period in the life of the individual. And here, perhaps, is one reason for his enormous appeal to the young in our time.

Part of this appeal derives from his vision of a nonrepressive order in which the "body would be resexualized." He recognizes this as a regression, but considers it "a regression in the service of the ego." (Ernst Kris) This would result in a "reactivation of all erotogenic zones and, consequently, in a resurgence of pregenital polymorphous sexuality and in a decline of genital supremacy."[8] This is a veiled defense of the child's undifferentiated and objectless sexuality as opposed to the hierarchical, patriarchal, genital sexuality of the symbols of oppression—the father and mother in the first place, class orders following behind. So, his is an attack upon the sexual supremacy of the elders in the name of an order in which sexuality becomes play, in which the child is dominant, in which liberated sexuality takes precedence over the work principle. Disintegrated would be the "monogamic and patriarchal family." The mothers and the fathers would both disappear.

But Marcuse's is no license for sadism and masochism, which he sees as instruments of the ruling class: perversion "strengthens rather than weakens the roots of instinctual constraint; consequently, it has been used time and again as a prop for suppressive regimes" (page 185). The perversions themselves must be cleansed of their "inhuman, compulsive, coercive

8. *Eros and Civilization*, p. 184.

and destructive forms" which are "linked with the general perversion of the human existence in a repressive culture" (page 185). Utopia arrives through the granting of the prehistoric and childhood wishes of mankind, with one notable exception: the oedipal wish is not to be granted: it will die a natural death in some unspecified form.[9]

Work itself is to become eroticized—transformed into play: "If work were accompanied by a reactivation of pregenital polymorphous eroticism, it would tend to become gratifying in itself without losing its *work* content."[10] Here Marcuse reveals his roots in Fourier, whose central idea is the transformation of labor into pleasure. But he disagrees with Fourier's assumption that such nonalienated labor can take place within the framework of administered and organized communality: "non-repressive sublimation is utterly incompatible with the institutions of the performance principle and implies the negation of this principle."[11] Paul Lafargue's "Right to Be Lazy" has finally found its proper philosophical formulation.

Marcuse's encounter with Freud was a journey through the substructure of humanity—the subworlds of the drives and the unconscious and the ways in which the innate structure of the human psyche is modified, repressed, or liberated by its clash with changing historical situations. Philosophy gave way to metapsychology, which in turn merged with the basic Marxist categories of labor, struggle, and freedom.

But *Eros and Civilization* did not deal with the central questions of Marxist revolutionary theory—the nature of the state and of the historical forces necessary to transcend the present stage of mankind's prehistory. And so, this period of Marcuse's thought also ended in deadlock. He knew too well that the realm of the polymorphous-perverse, of Orpheus and Narcissus, could not serve as the "instrument of liberation" which he had been seeking; rather, it was an abandonment of the possibilities of change, a retreat into intellectual "dream history" once again.

Setting aside the Marx-Freud synthesis (by 1963, he was lecturing on "The Obsolescence of Psychoanalysis"), Marcuse returned to sociology (or metasociology, if you wish) in a sustained and often devastating critique of "advanced industrial society," seeking out and analyzing the technological bases of repression, searching out and methodically discard-

9. Marcuse's "erotization of the entire organism" has as its necessary consequence the passing of the orgasm as well as of genital supremacy. Whether procreation has a place in this Orphic (androgynous) and Narcissistic (autoerotic) Utopia is unclear, but the vision of a world in which the body becomes its own subject-object is so fetching that it makes such questions immaterial to Marcuse's admirers.

10. *Eros and Civilization*, p. 196.

11. *Ibid.*, p. 199.

ing all possible avenues of liberation in the Western world—conventional politics, parliamentarianism, terror, the working class, the lumpenproletariat, the students—but never abandoning the search itself. The critique of industrial society itself is part of a long tradition—of Ruskin, Carlyle, Marx, Engels, Kropotkin, Morris, Veblen, C. Wright Mills. What is new is the concept, as Jerry Cohen has put it, "that contemporary society uses the instruments of liberation to contain, divert and defeat the struggle for liberation."[12] The terminology of digestion dominates Marcuse's imagery in *Soviet Marxism* (1958), *One-Dimensional Man* (1964), and *An Essay on Liberation* (1969); "incorporation," "introjection," "co-option," "integration," "containment," "absorption" confront Marcuse's prior terminology, in which the "explosive" and the "liberating" metaphors had held sway. And it is the conflict between the devouring and the liberating which defines the modalities of Marcuse's treatment of art in his later works. The Utopian view of art as transcendence and as the conveyor of the archetypes of freedom remains, but is increasingly overwhelmed by the pessimistic belief that art, like revolution, is doomed by the incorporative power of the ruling class in the modern era. "The absorbent power of society depletes the artistic dimension by assimilating its antagonistic elements," writes Marcuse in *One-Dimensional Man* (page 61). "In the realm of culture, the new totalitarianism manifests itself precisely in a harmonizing pluralism, where the most contradictory works and truths peacefully coexist in indifference." The development of technological reality undermines "not only the traditional forms but the very basis of the artistic alienation," extending to "the very substance of art" (page 62). Art, although directed toward the transcendence of fear and oppression, is "more powerless and more illusory" (page 239) than ever before. The ability of artistic form to master chaos and assuage terror locks it into an insoluble dilemma: its indictment of reality is simultaneously canceled "in the aesthetic form," thus "redeeming the suffering, the crime."[13] In another essay, Marcuse laments that "the images and ideas by virtue of which art, literature, and philosophy once indicted and transcended the given reality are integrated into the society."[14] And in his 1969 Guggenheim Museum lecture, "Art as a Form of Reality," he holds out virtually no hope for the revolutionary artist, whose indictment of society "anaesthetizes the terror" in direct proportion to the radicalism of its images. Even "anti-art" can not escape the dialectical trap, for it draws "negation" and "rebellion" into "the daily universe, as an enjoyable and understandable element of this universe."

12. *New Left Review,* no. 57, p. 49.
13. *Essay on Liberation,* p. 43.
14. *Five Essays,* p. 58.

Fearful of the void, Marcuse grasps Brecht's theory of the "estrangement effect" as a means of re-establishing a communicable artistic truth. "Not empathy and feeling, but distance and reflection" are required. Art must not attempt to overcome alienation, but to *enlarge* it, *emphasize* it by estranging itself from real life. Art must not recoil from the pacifying consequences of form, but must use form to comprehend and thereby negate reality. By now, we are going in circles from which there is no apparent escape, and art's sole function is reduced to its negativity. The transcendent, goal-projecting functions of art, which Marcuse had touched upon in *Eros and Civilization,* have been largely abandoned.

Dialectical theory (or "critical theory," as he often calls it) itself can offer no remedy to Marcuse in his one-dimensional period. Fourier is no defense against Schopenhauer. Marcuse writes that "on theoretical as well as empirical grounds, the dialectical concept pronounces its own hopelessness," its "inability to demonstrate the liberating tendencies *within* the established society."[15] Marcuse is merely saying that *he* has not yet found the instrumentalities of liberation (the parent figures are too powerful for him; he shows them the means of their destruction which he has discovered and then draws back in fear of retaliation), but he nevertheless firmly believes that such instrumentalities *can* be found. "I am reproached with being so terribly pessimistic," he told the Berlin students in 1967, but he himself feels like "an irresponsible optimist" who "cannot conceive of even the nicest capitalist system lasting for eternity."[16] In the end, therefore, Marcuse holds out no other hope than hope itself, and *One-Dimensional Man* closes with Walter Benjamin's words: "It is only for the sake of those without hope that hope is given to us."

Hope is the subject of the second selection from Marcuse, "The Power of Negative Thinking." By negative thinking, Marcuse means dialectical thought in the Marxist sense—thought directed toward a critique of the given state of affairs and of "the established system of life," thought which refuses to accept repression and oppression, and constantly seeks the means of their negation. Dialectical thought is the language of contradiction, and this is seen as merging into that avant-garde art which tries to "break the power of facts over the word, and to speak a language which is not the language of those who establish, enforce, and benefit from the facts." Dialectic and poetic language meet "on common ground" in the language of the surrealistic Great Refusal. Art denies a mutilated civilization, it "recovers tabooed meanings" and permits the repressed archetypes to re-emerge as liberating forces. Consciousness and knowledge "may have

15. *One-Dimensional Man,* pp. 253–54.
16. *Five Essays.* p. 101.

caused the wound in the existence of man, the crime and the guilt; but the second innocence, the 'second harmony,' can be gained only from knowledge." Here, Marcuse accepts the criminality of consciousness, transcends his own suspicion of mind and of art, recognizes that if the goal is distant and the means obscure the quest remains good.

Marx had written that the point is to change the world; Marcuse has spent his life asking "How?" He has not yet found the answer, not because it cannot be found, but, perhaps, because his search has been for a single key. Everywhere he has revealed the open doors.

Dialectical thought, removed from history, cannot penetrate its own contradictions or resolve its own antinomies. This is the trap from which both Hegel and Marx emerged by plunging into history. Feuerbach understood this when he wrote: "Time, and not the Hegelian dialectic, is the medium of uniting opposites, contradictories, in one and the same subject."[17] Marcuse, locked within the spiraling dialectic, constantly discovers circles from which there is no emergence, contradictions from which he can find no issue. But like that very Prometheus whom he rejects, he will not bow to the fathers: his Great Refusal, then, becomes an existential leap into faith.

MARCUSE: **THE IMAGES OF ORPHEUS AND NARCISSUS**
from *Eros and Civilization*

The attempt to draft a theoretical construct of culture beyond the performance principle is in a strict sense "unreasonable." Reason is the rationality of the performance principle. Even at the beginning of Western civilization, long before this principle was institutionalized, reason was defined as an instrument of constraint, of instinctual suppression; the domain of the instincts, sensuousness, was considered as eternally hostile and detrimental to reason. The categories in which philosophy has comprehended the human existence have retained the connection between reason and suppression: whatever belongs to the sphere of sensuousness, pleasure, impulse has the connotation of being antagonistic to reason—something that has to be subjugated, constrained. Every-day language has preserved this evaluation: the words which apply to this sphere carry the sound of the sermon or of obscenity. From Plato to the *"Schund und Schmutz"* laws of the

17. Feuerbach, *The Essence of Christianity* (New York, 1957), p. 23. See also *Principles of the Philosophy of the Future* (Indianapolis, Kansas City and New York, 1966), p. 47.

modern world,[1] the defamation of the pleasure principle has proved its irresistible power; opposition to such defamation easily succumbs to ridicule.

Still, the dominion of repressive reason (theoretical and practical) was never complete: its monopoly of cognition was never uncontested. When Freud emphasized the fundamental fact that phantasy (imagination) retains a truth that is incompatible with reason, he was following in a long historical tradition. Phantasy is cognitive in so far as it preserves the truth of the Great Refusal, or, positively, in so far as it protects, against all reason, the aspirations for the integral fulfillment of man and nature which are repressed by reason. In the realm of phantasy, the unreasonable images of freedom become rational, and the "lower depth" of instinctual gratification assumes a new dignity. The culture of the performance principle makes its bow before the strange truths which imagination keeps alive in folklore and fairy tale, in literature and art; they have been aptly interpreted and have found their place in the popular and academic world. However, the effort to derive from these truths the content of a valid reality principle surpassing the prevailing one has been entirely inconsequential. Novalis' statement that "all internal faculties and forces, and all external faculties and forces, must be deduced from productive imagination"[2] has remained a curiosity—as has the surrealist program *de pratiquer la poésie.* The insistence that imagination provide standards for existential attitudes, for practice, and for historical possibilities appears as childish fantasy. Only the archetypes, only the symbols have been accepted, and their meaning is usually interpreted in terms of phylogenetic or ontogenetic stages, long since surpassed, rather than in terms of an individual and cultural maturity. We shall now try to identify some of these symbols and examine their historical truth value.

More specifically, we look for the "culture-heroes" who have persisted in imagination as symbolizing the attitude and the deeds that have determined the fate of mankind. And here at the outset we are confronted with the fact that the predominant culture-hero is the trickster and (suffering) rebel against the gods, who creates culture at the price of perpetual pain. He symbolizes productiveness, the unceasing effort to master life; but, in his

1. A bill proposed by the New York Joint Legislative Committee on Comic Books would prohibit the sale and distribution of books portraying "nudity, sex or lust in a manner which reasonably tends to excite lustful or lecherous desires . . ." (*New York Times,* February 17, 1954).

2. *Schriften,* ed. J. Minor (Jena: Eugen Diederichs, 1923), III, p. 375. See Gaston Bachelard, *La Terre et les Rêveries de la Volonté* (Paris: José Corti, 1948), pp. 4–5.

productivity, blessing and curse, progress and toil are inextricably inter-
twined. Prometheus *is* the archetype-hero of the performance principle.
And in the world of Prometheus, Pandora, the female principle, sexuality
and pleasure, appear as curse—disruptive, destructive. "Why are women
such a curse? The denunciation of the sex with which the section [on
Prometheus in Hesiod] concludes emphasizes above all else their economic
unproductivity; they are useless drones; a luxury item in a poor man's
budget."[3] The beauty of the woman, and the happiness she promises are
fatal in the work-world of civilization.

If Prometheus is the culture-hero of toil, productivity and progress
through repression, then the symbols of another reality principle must be
sought at the opposite pole. Orpheus and Narcissus (like Dionysus to
whom they are akin: the antagonist of the god who sanctions the logic of
domination, the realm of reason) stand for a very different reality.[4] They
have not become the culture-heroes of the Western world: theirs is the
image of joy and fulfillment; the voice does not command but sings;
the gesture which offers and receives; the deed which is peace and ends the
labor of conquest; the liberation from time which unites man with god,
man with nature. Literature has preserved their image. In the *Sonnets to
Orpheus:*

> Und fast ein Mädchen wars und ging hervor
> aus diesem einigen Glück von Sang und Leier
> und glänzte klar durch ihre Frühlingsschleier
> und machte sich ein Bett in meinem Ohr.
>
> Und schlief in mir. Und alles war ihr Schlaf.
> Die Bäume, die ich je bewundert, diese
> fühlbare Ferne, die gefühlte Wiese
> und jedes Staunen, das mich selbst betraf.
>
> Sie schlief die Welt. Singender Gott, wie hast
> du sie vollendet, dass sie nicht begehrte,
> erst wach zu sein? Sieh, sie erstand und schlief.
> Wo ist ihr Tod?[5]

3. See Norman O. Brown, *Hesiod's Theogony* (New York: Liberal Arts Press,
1953), pp. 18–19, 33; and *Hermes the Thief* (University of Wisconsin Press, 1947),
pp. 23ff.

4. The symbol of Narcissus and the term "Narcissistic" as used here do not imply
the meaning given to them in Freud's theory.

5. "Almost a maid, she came forth shimmering/From the high happiness of song
and lyre,/And shining clearly through her veils of spring/She made herself a bed
within my ear//And slept in me. All things were in her sleep:/The trees I marvelled

Or Narcissus, who, in the mirror of the water, tries to grasp his own beauty. Bent over the river of time, in which all forms pass and flee, he dreams:

Narcisse rêve au paradis . . .
Quand donc le temps, cessant sa fruite, laissera-t-il que cet écoulement se repose? Formes, formes divines et pérennelles! qui n'attendez que le repos pour reparaître, oh! quand, dans quelle nuit, dans quel silence, vous recristalliserez-vous?
Le paradis est toujours à refaire; il n'est point en quelque lointaine Thulé. Il demeure sous l'apparence. Chaque chose détient, virtuelle, l'intime harmonie de son être, comme chaque sel, en lui, l'archétype de son cristal;—et vienne un temps de nuit tacite, où les eaux plus denses descendent: dans les abîmes imperturbés fleuriront les trémies secrètes . . .
Tout s'efforce vers sa forme perdue . . .[6]

> Un grand calme m'écoute, où j'écoute l'espoir.
> La voix des sources change et me parle du soir;
> J'entends l'herbe d'argent grandir dans l'ombre sainte,
> Et la lune perfide élève son miroir
> Jusque dans les secrets de la fontaine éteinte.[7]

> Admire dans Narcisse un éternel retour
> Vers l'onde où son image offerte à son amour
> Propose à sa beauté toute sa connaissance:

at, the enchanting spell/Of farthest distances, the meadows deep,/And all the magic that myself befell.//Within her slept the world. You singing god, o how/Did you perfect her so she did not long/To be awake? She rose and slept./Where is her death?"
—Rainer Maria Rilke, *Sonnets to Orpheus: Duino Elegies*, transl. Jessie Lemont (New York: Fine Editions Press, 1945), p. 3 (with minor changes in translation). Reprinted by permission of Columbia University Press.

6. "Alas, when will Time cease its flight and allow this flow to rest? Forms, divine and perennial forms which only wait for rest in order to reappear! O when, in what night, will you crystallize again?

"Paradise must always be re-created. It is not in some remote Thule; it lingers under the appearance. Everything holds within itself, as potentiality, the intimate harmony of its being—just as every salt holds within itself the archetype of its crystal. And a time of silent night will come when the waters will descend, more dense; then, in the unperturbed abysses, the secret crystals will bloom . . . Everything strives toward its lost form . . ."—André Gide, *Le Traité du Narcisse*.

7. "A great calm hears me, where I hear Hope. The voice of the wells changes and speaks of the night; in the holy shade I hear the silver herb grow, and the treacherous moon raises its mirror deep into the secrets of the extinguished fountain."—Paul Valéry, *Narcisse Parle*.

> Tout mon sort n'est qu'obéissance
> A la force de mon amour.

> Cher CORPS, je m'abandonne à ta seule puissance;
> L'eau tranquille m'attire où je me tends mes bras:
> A ce vertige pur je ne résiste pas.
> Que puis-je, ô ma Beauté, faire que tu ne veuilles?[8]

The climate of this language is that of the *"diminution des traces du péché originel,"*—the revolt against culture based on toil, domination, and renunciation. The images of Orpheus and Narcissus reconcile Eros and Thanatos. They recall the experience of a world that is not to be mastered and controlled but to be liberated—a freedom that will release the powers of Eros now bound in the repressed and petrified forms of man and nature. These powers are conceived not as destruction but as peace, not as terror but as beauty. It is sufficient to enumerate the assembled images in order to circumscribe the dimension to which they are committed: the redemption of pleasure, the halt of time, the absorption of death; silence, sleep, night, paradise—the Nirvana principle not as death but as life. Baudelaire gives the image of such a world in two lines:

> Lá, tout n'est qu' ordre et beauté,
> Luxe, calme, et volupté.[9]

This is perhaps the only context in which the word *order* loses its repressive connotation: here, it is the order of gratification which the free Eros creates. Static triumphs over dynamic; but it is a static that moves in its own fullness—a productivity that is sensuousness, play, and song. Any attempt to elaborate the images thus conveyed must be self-defeating, because outside the language of art they change their meaning and merge with the connotations they received under the repressive reality principle. But one must try to trace the road back to the realities to which they refer.

In contrast to the images of the Promethean culture-heroes, those of the

8. "Admire in Narcissus the eternal return toward the mirror of the water which offers his image to his love, and to his beauty all his knowledge. All my fate is obedience to the force of my love. *Body,* I surrender to your sole power; the tranquil water awaits me where I extend my arms: I do not resist this pure madness. What, O my Beauty, can I do that thou dost not will?"—Paul Valéry, *Cantate du Narcisse,* Scène II.

9. "There all is order and beauty, luxury, calm, and sensuousness."

Orphic and Narcissistic world are essentially unreal and unrealistic. They designate an "impossible" attitude and existence. The deeds of the culture-heroes also are "impossible," in that they are miraculous, incredible, superhuman. However, their objective and their "meaning" are not alien to the reality; on the contrary, they are useful. They promote and strengthen this reality; they do not explode it. But the Orphic-Narcissistic images do explode it; they do not convey a "mode of living"; they are committed to the underworld and to death. At best, they are poetic, something for the soul and the heart. But they do not teach any "message"—except perhaps the negative one that one cannot defeat death or forget and reject the call of life in the admiration of beauty.

Such moral messages are superimposed upon a very different content. Orpheus and Narcissus symbolize realities just as do Prometheus and Hermes. Trees and animals respond to Orpheus' language; the spring and the forest respond to Narcissus' desire. The Orphic and Narcissistic Eros awakens and liberates potentialities that are real in things animate and inanimate, in organic and inorganic nature—real but in the un-erotic reality suppressed. These potentialities circumscribe the *telos* inherent in them as: "just to be what they are," "being-there," existing.

The Orphic and Narcissistic experience of the world negates that which sustains the world of the performance principle. The opposition between man and nature, subject and object, is overcome. Being is experienced as gratification, which unites man and nature so that the fulfillment of man is at the same time the fulfillment, without violence, of nature. In being spoken to, loved, and cared for, flowers and springs and animals appear as what they are—beautiful, not only for those who address and regard them, but for themselves, "objectively." "Le monde tend à la beauté."[10] In the Orphic and Narcissistic Eros, this tendency is released: the things of nature become free to be what they are. But to be what they are they *depend* on the erotic attitude: they receive their *telos* only in it. The song of Orpheus pacifies the animal world, reconciles the lion with the lamb and the lion with man. The world of nature is a world of oppression, cruelty, and pain, as is the human world; like the latter, it awaits its liberation. This liberation is the work of Eros. The song of Orpheus breaks the petrification, moves the forests and the rocks—but moves them to partake in joy.

The love of Narcissus is answered by the echo of nature. To be sure,

10. Gaston Bachelard, *L'Eau et les Rêves* (Paris: José Corti, 1942), p. 38. See also (p. 36) Joachim Gasquet's formulation: "Le monde est un immense Narcisse en train de se penser."

Narcissus appears as the *antagonist* of Eros: he spurns love, the love that unites with other human beings, and for that he is punished by Eros.[11] As the antagonist of Eros, Narcissus symbolizes sleep and death, silence and rest.[12] In Thracia, he stands in close relation to Dionysus.[13] But it is not coldness, asceticism, and self-love that color the images of Narcissus; it is not these gestures of Narcissus that are preserved in art and literature. His silence is not that of dead rigidity; and when he is contemptuous of the love of hunters and nymphs he rejects one Eros for another. He lives by an Eros of his own,[14] and he does not love only himself. (He does not know that the image he admires is his own.) If his erotic attitude is akin to death and brings death, then rest and sleep and death are not painfully separated and distinguished: the Nirvana principle rules throughout all these stages. And when he dies he continues to live as the flower that bears his name.

In associating Narcissus with Orpheus and interpreting both as symbols of a non-repressive erotic attitude toward reality, we took the image of Narcissus from the mythological-artistic tradition rather than from Freud's libido theory. We may now be able to find some support for our interpretation in Freud's concept of *primary narcissism*. It is significant that the introduction of narcissism into psychoanalysis marked a turning point in the development of the instinct theory: the assumption of independent ego instincts (self-preservation instincts) was shaken and replaced by the notion of an undifferentiated, unified libido prior to the division into ego and external objects. Indeed, the discovery of primary narcissism meant more than the addition of just another phase to the development of the libido; with it there came in sight the archetype of another existential relation to *reality*. Primary narcissism is more than autoeroticism; it engulfs

11. Friedrich Wieseler, *Narkissos: Eine kunstmythologische Abhandlung* (Göttingen, 1856), pp. 90, 94.

12. *Ibid.,* pp. 76, 80–83, 93–94.

13. *Ibid.,* p. 89. Narcissus and Dionysus are closely assimilated (if not identified) in the Orphic mythology. The Titans seize Zagreus-Dionysus while he contemplates his image in the mirror which they gave him. An ancient tradition (Plotinus, Proclus) interprets the mirror-duplication as the beginning of the god's self-manifestation in the multitude of the phenomena of the world—a process which finds its final symbol in the tearing asunder of the god by the Titans and his rebirth by Zeus. The myth would thus express the reunification of that which was separated, of God and world, man and nature—identity of the one and the many. See Erwin Rhode, *Psyche* (Freiburg, 1898), vol. II, p. 117 note; Otto Kern, *Orpheus* (Berlin, 1920), pp. 22–23; Ivan M. Linforth, *The Arts of Orpheus* (University of California Press, 1941), pp. 307ff.

14. In most pictorial representations, Narcissus is in the company of an Amor, who is sad but not hostile. See Wieseler, *Narkissos,* pp. 16–17.

the "environment," integrating the narcissistic ego with the objective world. The normal antagonistic relation between ego and external reality is only a later form and stage of the relation between ego and reality:

> Originally the ego includes everything, later it detaches from itself the external world. The ego-feeling we are aware of now is thus only a shrunken vestige of a far more extensive feeling—a feeling which *embraced the universe* and expressed an *inseparable connection of the ego with the external world*.[15]

The concept of primary narcissism implies what is made explicit in the opening chapter of *Civilization and Its Discontents*—that narcissism survives not only as a neurotic symptom but also as a constitutive element in the construction of the reality, coexisting with the mature reality ego. Freud describes the "ideational content" of the surviving primary ego-feeling as "limitless extension and oneness with the universe" (oceanic feeling).[16] And, later in the same chapter, he suggests that the oceanic feeling seeks to reinstate "limitless narcissisms."[17] The striking paradox that narcissism, usually understood as egotistic withdrawal from reality, here is connected with oneness with the universe, reveals the new depth of the conception: beyond all immature autoeroticism, narcissism denotes a fundamental relatedness to reality which may generate a comprehensive existential order.[18] In other words, narcissism may contain the germ of a different reality principle: the libidinal cathexis of the ego (one's own body) may become the source and reservoir for a new libidinal cathexis of the objective world—transforming this world into a new mode of being. This interpretation is corroborated by the decisive role which narcissistic libido plays, according to Freud, in sublimation. In *The Ego and the Id,* he asks "whether all sublimation does not take place through the agency of the ego,

15. *Civilization and Its Discontents* (London: Hogarth Press, 1949), p. 13. Italics added.

16. *Ibid.,* p. 14.

17. *Ibid.,* p. 21.

18. In his paper "The Delay of the Machine Age," Hanns Sachs made an interesting attempt to demonstrate narcissism as a constitutive element of the reality principle in Greek civilization. He discussed the problem of why the Greeks did not develop a machine technology although they possessed the skill and knowledge which would have enabled them to do so. He was not satisfied with the usual explanations on economic and sociological grounds. Instead, he proposed that the predominant narcissistic element in Greek culture prevented technological progress: the libidinal cathexis of the body was so strong that it militated against mechanization and automatization. Sachs' paper appeared in the *Psychoanalytic Quarterly,* II (1933), 420ff.

which begins by changing sexual object-libido into narcissistic libido and then, perhaps, goes on to give it another aim."[19] If this is the case, then all sublimation would begin with the reactivation of narcissistic libido, which somehow overflows and extends to objects. The hypothesis all but revolutionizes the idea of sublimation: it hints at a non-repressive mode of sublimation which results from an extension rather than from a constraining deflection of the libido. We shall subsequently resume the discussion of this idea.

The Orphic-Narcissistic images are those of the Great Refusal: refusal to accept separation from the libidinous object (or subject). The refusal aims at liberation—at the reunion of what has become separated. Orpheus is the archetype of the poet as *liberator* and *creator:*[20] he establishes a higher order in the world—an order without repression. In his person, art, freedom, and culture are eternally combined. He is the poet of redemption, the god who brings peace and salvation by pacifying man and nature, not through force but through song:

> Orpheus, the priest, the mouthpiece of the gods,
> Deterred wild men from murders and foul foods,
> And hence was said to tame the raging moods
> Of tigers and of lions . . .
> In times of yore it was the poet's part—
> The part of sapience—to distinguish plain
> Between the public and the private things,
> Between the sacred things and things profane,
> To check the ills that sexual straying brings,
> To show how laws of married people stood,
> To build the towns, to carve the laws in wood.[21]

But the "culture-hero" Orpheus is also credited with the establishment of a very different order—and he pays for it with his life:

> . . . Orpheus had shunned all love of womankind, whether because of his ill success in love, or whether he had given his troth once for all. Still, many women felt a passion for the bard; many grieved for their love repulsed. He set

19. *The Ego and the Id* (London: Hogarth Press, 1950), p. 38.

20. See Walther Rehm, *Orpheus* (Düsseldorf: L. Schwann, 1950), pp. 63ff. On Orpheus as culture-hero, see Linforth, *The Arts of Orpheus,* p. 69.

21. Horace, *The Art of Poetry,* transl. Alexander Falconer Murison, in *Horace Rendered in English Verse* (London and New York: Longmans, Green, 1931), p. 426. Reprinted by permission of the publisher.

the example for the people of Thrace of giving his love to tender boys, and enjoying the springtime and first flower of their growth.[22]

He was torn to pieces by the crazed Thracian women.[23]

The classical tradition associates Orpheus with the introduction of homosexuality. Like Narcissus, he rejects the normal Eros, not for an ascetic ideal, but for a fuller Eros. Like Narcissus, he protests against the repressive order of procreative sexuality. The Orphic and Narcissistic Eros is to the end the negation of this order—the Great Refusal. In the world symbolized by the culture-hero Prometheus, it is the negation of *all* order; but in this negation Orpheus and Narcissus reveal a new reality, with an order of its own, governed by different principles. The Orphic Eros transforms being: he masters cruelty and death through liberation. His language is *song,* and his work is *play.* Narcissus' life is that of *beauty,* and his existence is *contemplation.* These images refer to the *aesthetic dimension* as the one in which their reality principle must be sought and validated.

MARCUSE: **A NOTE ON DIALECTIC**
from *Reason and Revolution*

This book was written in the hope that it would make a small contribution to the revival, not of Hegel, but of a mental faculty which is in danger of being obliterated: the power of negative thinking. As Hegel defines it: "Thinking is, indeed, essentially the negation of that which is immediately before us." What does he mean by "negation," the central category of dialectic?

Even Hegel's most abstract and metaphysical concepts are saturated with experience—experience of a world in which the unreasonable becomes reasonable and, as such, determines the facts; in which unfreedom is the condition of freedom, and war the guarantor of peace. This world contradicts itself. Common sense and science purge themselves from this contradiction; but philosophical thought begins with the recognition that the facts do not correspond to the concepts imposed by common sense and scientific reason—in short, with the refusal to accept them. To the extent that these concepts disregard the fatal contradictions which make up reality, they abstract from the very process of reality. The negation which dialectic applies to them is not only a critique of a conformistic logic, which denies

22. Ovid, *Metamorphoses*, X, 79–85, transl. Frank Justus Miller (Loeb Classical Library), vol. II, p. 71. See Linforth, *The Arts of Orpheus*, p. 57.

23. Ovid, *Metamorphoses*, XL, 1ff; vol. II, pp. 121–22.

the reality of contradictions; it is also a critique of the given state of affairs on its own grounds—of the established system of life, which denies its own promises and potentialities.

Today, this dialectical mode of thought is alien to the whole established universe of discourse and action. It seems to belong to the past and to be rebutted by the achievements of technological civilization. The established reality seems promising and productive enough to repel or absorb all alternatives. Thus acceptance—and even affirmation—of this reality appears to be the only reasonable methodological principle. Moreover, it precludes neither criticism nor change; on the contrary, insistence on the dynamic character of the status quo, on its constant "revolutions," is one of the strongest props for this attitude. Yet this dynamic seems to operate endlessly within the same framework of life: streamlining rather than abolishing the domination of man, both by man and by the products of his labor. Progress becomes quantitative and tends to delay indefinitely the turn from quantity to quality—that is, the emergence of new modes of existence with new forms of reason and freedom.

The power of negative thinking is the driving power of dialectical thought, used as a tool for analyzing the world of facts in terms of its internal inadequacy. I choose this vague and unscientific formulation in order to sharpen the contrast between dialectical and undialectical thinking. "Inadequacy" implies a value judgment. Dialectical thought invalidates the a priori opposition of value and fact by understanding all facts as stages of a single process—a process in which subject and object are so joined that truth can be determined only within the subject-object totality. All facts embody the knower as well as the doer; they continuously translate the past into the present. The objects thus "contain" subjectivity in their very structure.

Now what (or who) is this subjectivity that, in a literal sense, constitutes the objective world? Hegel answers with a series of terms denoting the subject in its various manifestations: Thought, Reason, Spirit, Idea. Since we no longer have that fluent access to these concepts which the eighteenth and nineteenth centuries still had, I shall try to sketch Hegel's conception in more familiar terms:

Nothing is "real" which does not sustain itself in existence, in a life-and-death struggle with the situations and conditions of its existence. The struggle may be blind or even unconscious, as in inorganic matter; it may be conscious and concerted, such as the struggle of mankind with its own conditions and with those of nature. *Reality* is the constantly renewed result of the process of existence—the process, conscious or unconscious in which "that which is" becomes "other than self"; and *identity* is only the

continuous negation of inadequate existence, the subject maintaining itself in being other than itself. Each reality, therefore, is a *realization*—a development of "subjectivity." The latter "comes to itself" in history, where the development has a rational content; Hegel defines it as "progress in the consciousness of freedom."

Again a value judgment—and this time a value judgment imposed upon the world as a whole. But freedom is for Hegel an ontological category: it means being not a mere object, but the subject of one's existence; not succumbing to external conditions, but transforming factuality into realization. This transformation is, according to Hegel, the energy of nature and history, the inner structure of all being! One may be tempted to scoff at this idea, but one should be aware of its implications.

Dialectical thought starts with the experience that the world is unfree; that is to say, man and nature exist in conditions of alienation, exist as "other than they are." Any mode of thought which excludes this contradiction from its logic is a faulty logic. Thought "corresponds" to reality only as it transforms reality by comprehending its contradictory structure. Here the principle of dialectic drives thought beyond the limits of philosophy. For to comprehend reality means to comprehend what things really are, and this in turn means rejecting their mere factuality. Rejection is the process of thought as well as of action. While the scientific method leads from the immediate experience of *things* to their mathematical-logical structure, philosophical thought leads from the immediate experience of *existence* to its historical structure: the principle of freedom.

Freedom is the innermost dynamic of existence, and the very process of existence in an unfree world is "the continuous negation of that which threatens to deny (*aufheben*) freedom." Thus freedom is essentially negative: existence is both alienation and the process by which the subject comes to itself in comprehending and mastering alienation. For the history of mankind, this means attainment of a "state of the world" in which the individual persists in inseparable harmony with the whole, and in which the conditions and relations of his world "possess no essential objectivity independent of the individual." As to the prospect of attaining such a state, Hegel was pessimistic: the element of reconciliation with the established state of affairs, so strong in his work, seems to a great extent due to this pessimism—or, if one prefers, this realism. Freedom is relegated to the realm of pure thought, to the Absolute Idea. Idealism by default: Hegel shares this fate with the main philosophical tradition.

Dialectical thought thus becomes negative in itself. Its function is to break down the self-assurance and self-contentment of common sense, to undermine the sinister confidence in the power and language of facts, to

demonstrate that unfreedom is so much at the core of things that the development of their internal contradictions leads necessarily to qualitative change: the explosion and catastrophe of the established state of affairs. Hegel sees the task of knowledge as that of recognizing the world as Reason by understanding all objects of thought as elements and aspects of a totality which becomes a conscious world in the history of mankind. Dialectical analysis ultimately tends to become historical analysis, in which nature itself appears as part and stage in its own history and in the history of man. The progress of cognition from common sense to knowledge arrives at a world which is negative in its very structure because that which is real opposes and denies the potentialities inherent in itself—potentialities which themselves strive for realization. Reason is the negation of the negative.

Interpretation of that-which-is in terms of that-which-is-not, confrontation of the given facts with that which they exclude—this has been the concern of philosophy wherever philosophy was more than a matter of ideological justification or mental exercise. The liberating function of negation in philosophical thought depends upon the recognition that the negation is a positive act: that-which-is *repels* that-which-is-not and, in doing so, repels its own real possibilities. Consequently, to express and define that-which-is on its own terms is to distort and falsify reality. Reality is other and more than that codified in the logic and language of facts. Here is the inner link between dialectical thought and the effort of avant-garde literature: the effort to break the power of facts over the word, and to speak a language which is not the language of those who establish, enforce, and benefit from the facts. As the power of the given facts tends to become totalitarian, to absorb all opposition, and to define the entire universe of discourse, the effort to speak the language of contradiction appears increasingly irrational, obscure, artificial. The question is not that of a direct or indirect influence of Hegel on the genuine avant-garde, though this is evident in Mallarmé and Villiers de l'Isle-Adam, in surrealism, in Brecht. Dialectic and poetic language meet, rather, on common ground.

The common element is the search for an "authentic language"—the language of negation as the Great Refusal to accept the rules of a game in which the dice are loaded. The absent must be made present because the greater part of the truth is in that which is absent. This is Mallarmé's classical statement:

Je dis: une fleur! et, hors de l'oubli où ma voix relègue aucun contour, en tant que quelque chose d'autre que les calices sus, musicalement se lève, idée même et suave, l'absente de tous bouquets.

I say: a flower; and, out of the oblivion where my voice banishes all contours, musically rises, different from every known blossom, the one absent from all bouquets—Idea itself and delicate.

In the authentic language, the word

n'est pas l'expression d'une chose, mais l'absence de cette chose. . . . Le mot fait disparaître les choses et nous impose le sentiment d'un manque universel et même de son propre manque.[1]

is not the expression of a thing, but rather the absence of this thing. . . . The word makes the things disappear and imposes upon us the feeling of a universal want and even of its own want.

Poetry is thus the power "de nier le choses" (*to deny the things*)—the power which Hegel claims, paradoxically, for all authentic thought. Valéry asserts:

La pensée est, en somme, le travail qui fait vivre en nous ce qui n'existe pas.[2]

In short, thought is the labor which brings to life in us that which does not exist.

He asks the rhetorical question: "que sommes-nous donc sans le secours de ce qui n'existe pas?"[3] (*What are we without the help of that which does not exist?*)

This is not "existentialism." It is something more vital and more desperate: the effort to contradict a reality in which all logic and all speech are false to the extent that they are part of a mutilated whole. The vocabulary and grammar of the language of contradiction are still those of the game (there are no others), but the concepts codified in the language of the game are redefined by relating them to their "determinate negation." This term, which denotes the governing principle of dialectical thought, can be explained only in a textual interpretation of Hegel's *Logic*. Here it must suffice to emphasize that, by virtue of this principle, the dialectical contradiction is distinguished from all pseudo- and crackpot opposition, beatnik and hipsterism. The negation is determinate if it refers the established state of affairs to the basic factors and forces which make for its destructiveness, as well as for the possible alternatives beyond the status quo. In the human

1. Maurice Blanchot, "Le Paradoxe d'Aytre," *Les Temps Modernes,* June 1946, p. 158ff.

2. *Oeuvres,* Bibliothèque de la Pleiade, vol. I, p. 1333.

3. *Ibid.,* p. 966.

reality, they are *historical* factors and forces, and the determinate negation is ultimately a *political* negation. As such, it may well find authentic expression in nonpolitical language, and the more so as the entire dimension of politics becomes an integral part of the status quo.

Dialectical logic is critical logic: it reveals modes and contents of thought which transcend the codified pattern of use and validation. Dialectical thought does not invent these contents; they have accrued to the notions in the long tradition of thought and action. Dialectical analysis merely assembles and reactivates them; it recovers tabooed meanings and thus appears almost as a return, or rather a conscious liberation, of the repressed! Since the established universe of discourse is that of an unfree world, dialectical thought is necessarily destructive, and whatever liberation it may bring is a liberation in thought, in theory. However, the divorce of thought from action, of theory from practice, is itself part of the unfree world. No thought and no theory can undo it; but theory may help to prepare the ground for their possible reunion, and the ability of thought to develop a logic and language of contradiction is a prerequisite for this task.

In what, then, lies the power of negative thinking? Dialectical thought has not hindered Hegel from developing his philosophy into a neat and comprehensive system which, in the end, accentuates the positive emphatically. I believe it is the idea of Reason itself which is the undialectical element in Hegel's philosophy. This idea of Reason comprehends everything and ultimately absolves everything, because it has its place and function in the whole, and the whole is beyond good and evil, truth and falsehood. It may even be justifiable, logically as well as historically, to define Reason in terms which include slavery, the Inquisition, child labor, concentration camps, gas chambers, and nuclear preparedness. These may well have been integral parts of that rationality which has governed the recorded history of mankind. If so, the idea of Reason itself is at stake; it reveals itself as a part rather than as the whole. This does not mean that reason abdicates its claim to confront reality with the truth about reality. On the contrary, when Marxian theory takes shape as a critique of Hegel's philosophy, it does so in the name of Reason. It is consonant with the innermost effort of Hegel's thought if his own philosophy is "cancelled," not by substituting for Reason some extrarational standards, but by driving Reason itself to recognize the extent to which it is still unreasonable, blind, the victim of unmastered forces. Reason, as the developing and applied knowledge of man—as "free thought"—was instrumental in creating the world we live in. It was also instrumental in sustaining injustice, toil, and suffering. But Reason, and Reason alone, contains its own corrective.

In the *Logic,* which forms the first part of his *System of Philosophy,* Hegel anticipates almost literally Wagner's Parsifal message: "the hand that inflicts the wound is also the hand that heals it."[4] The context is the biblical story of the Fall of Man. Knowledge may have caused the wound in the existence of man, the crime and the guilt; but the second innocence, the "second harmony," can be gained only from knowledge. Redemption can never be the work of a "guileless fool." Against the various obscurantists who insist on the right of the irrational versus reason, on the truth of the natural versus the intellect, Hegel inseparably links progress in freedom to progress in thought, action to theory. Since he accepted the specific historical form of Reason reached at his time as *the* reality of Reason, the advance beyond this form of Reason must be an advance of Reason itself; and since the adjustment of Reason to oppressive social institutions perpetuated unfreedom, progress in freedom depends on thought becoming political, in the shape of a theory which demonstrates negation as a political alternative implicit in the historical situation. Marx's materialistic "subversion" of Hegel, therefore, was not a shift from one philosophical position to another, nor from philosophy to social theory, but rather a recognition that the established forms of life were reaching the stage of their historical negation.

This historical stage has changed the situation of philosophy and of all cognitive thought. From this stage on, all thinking that does not testify to an awareness of the radical falsity of the established forms of life is faulty thinking. Abstraction from this all-pervasive condition is not merely immoral; it is false. For reality has become technological reality, and the subject is now joined with the object so closely that the notion of object necessarily includes the subject. Abstraction from their interrelation no longer leads to a more genuine reality but to deception, because even in this sphere the subject itself is apparently a constitutive part of the object as scientifically determined. The observing, measuring, calculating subject of scientific method, and the subject of the daily business of life—both are expressions of the same subjectivity: man. One did not have to wait for Hiroshima in order to have one's eyes opened to this identity. And as always before, the subject that has conquered matter suffers under the dead weight of his conquest. Those who enforce and direct this conquest have used it to create a world in which the increasing comforts of life and the ubiquitous power of the productive apparatus keep man enslaved to the prevailing state of affairs. Those social groups which dialectical theory identified as the forces of negation are either defeated or reconciled with

4. *The Logic of Hegel,* trans. W. Wallace (Oxford: Clarendon Press, 1895), p. 55.

the established system. Before the power of the given facts, the power of negative thinking stands condemned.

This power of facts is an oppressive power; it is the power of man over man, appearing as objective and rational condition. Against this appearance, thought continues to protest in the name of truth. And in the name of fact: for it is the supreme and universal fact that the status quo perpetuates itself through the constant threat of atomic destruction, through the unprecedented waste of resources, through mental impoverishment, and—last but not least—through brute force. These are the unresolved contradictions. They define every single fact and every single event; they permeate the entire universe of discourse and action. Thus they define also the logic of things: that is, the mode of thought capable of piercing the ideology and of comprehending reality whole. No method can claim a monopoly of cognition, but no method seems authentic which does not recognize that these two propositions are meaningful descriptions of our situation: "The whole is the truth," and the whole is false.

WALTER BENJAMIN

*Every epoch not only dreams the next,
but while dreaming
impels it towards wakefulness.*
—Walter Benjamin

INTRODUCTION

Walter Benjamin fled from Germany to Paris in 1933. After the fall of France, the exiled Institute of Social Research in New York succeeded in obtaining for him an entry visa to the United States. Arriving on foot at Port Bou in the Pyrenees with a group of refugees, he was turned back by border officials and ordered to return to France the next day. He committed suicide that night, September 26, 1940. His fame has been almost entirely posthumous. He was known during his lifetime only to a small group of colleagues, most of whom were equally obscure. It has been the emergence of Marcuse, Bloch, Adorno, Brecht, and Lukács (and the admiring references to Benjamin by these and by Ernst Fischer, Max Raphael, and Arnold Hauser) which is propelling Walter Benjamin into the forefront of world thought. Adorno and his wife Gretel edited the first publication of Benjamin's *Schriften* in two volumes (Frankfurt, 1955), followed by an important selection, *Illuminationen* (Frankfurt, 1961) and by two volumes of letters (*Briefe,* Frankfurt, 1966) edited by Adorno and Benjamin's close friend, the Palestinian scholar of Jewish mysticism, Gerhard (Gershom)

Scholem. French and English editions followed, and it is hoped that his remaining essays and his major unpublished works (including a study of Goethe, and his unfinished masterwork—*Paris, Capital of the Nineteenth Century*) will soon be printed as well.

Benjamin was born in 1892 into a wealthy German-Jewish family. His father was an antiquarian and a dealer in art objects. Benjamin described his early impressions in *A Berlin Childhood Around 1900* (*Berliner Kindheit um Neunzehnhundert,* written during the late 1930's, published Frankfurt, 1950). He studied philosophy in Freiburg, Munich, and Berne, obtaining his doctorate for a study of *The Concept of Art Criticism in German Romanticism* (*Der Begriff der Kunstwerk in der deutschen Romantik,* Berne, 1920). Benjamin was supported by his parents until their deaths in 1930; he lived the life of a leisured man of letters—translating Baudelaire, Proust, and St.-John Perse into German, contributing book reviews and literary essays to a variety of publications, collecting rare and first editions, and cultivating deep friendships and associations with leading creative thinkers, among them Scholem, Brecht, and Bloch. It was Bloch who introduced him to Marxism during the World War, but it seems to have been a friendship with the Soviet film director Asya Lacis, in 1924, which led to his deeper study of Marx and Engels. It was during this period that he read Lukács' *History and Class Consciousness* and became informally associated with the Frankfurt School; in Frankfurt he wrote *The Origin of German Tragedy* (*Ursprung des deutschen Trauerspiels,* Berlin, 1928). He came close to joining the Communist Party in the mid-1920's and visited the Soviet Union in 1927. Unable to support himself through his literary activities after the death (and financial ruin) of his parents, he finally obtained a small income from Horkheimer's Institute, which maintained him from 1935 until his death, in return for which he published such major works as "The Work of Art in the Age of Mechanical Reproduction," "The Social Standpoint of Contemporary French Authors," "On Some Motifs in Baudelaire," and "Problems of the Sociology of Speech" in the *Zeitschrift für Sozialforschung.*

The influence of Brecht on Benjamin is crucial, not merely for his adoption of the German playwright's theories of "epic theater" and revolutionary estrangement, but for his insistence on the revolutionary role of art, artist, and, by implication, critic. This brought Benjamin into conflict with Adorno and Horkheimer, who were extraordinarily daring in their explorations of the superstructure but were reluctant to come to terms with the more sensuous reality of the substructure of society. Benjamin's major work on nineteenth-century Paris was rejected by the *Zeitschrift*'s editors because it was "lacking in mediation" and "undialectic" in that it at-

tempted to relate superstructural elements "directly, perhaps even causally, to corresponding elements in the substructure."[1] Heretical? Clearly not. Dangerous? Certainly—for the superstructure is often the refuge of the pseudo-revolutionary dialectician, who is Marxist in all but two things: the theory of the state and the desire to change the world. Marx and Engels transcended the rather similar "superstructuralists" of their own time when they wrote in *The German Ideology:* "Not criticism but revolution is the driving force of history."

But Benjamin would not abandon Brecht or Marx's eleventh thesis on Feuerbach. He wrote an early appreciation of the "epic theater," and he insisted in a letter that his agreement with Brecht's ideas "is one of the most important and most strategic points in my entire position."[2] Brecht had insisted on force, revolutionary force, as a principle of Marxist thought: "The main thing is to learn how to think crudely," and Benjamin echoed: "Crude thoughts . . . should be part and parcel of dialectical thinking, because they are nothing but the referral of theory to practice."[3] Leninism entered the Frankfurt School through Brecht's friendship with Benjamin.

In Walter Benjamin a number of exploratory strains of twentieth-century Marxism merge with various ideas drawn from other advanced disciplines into a unique form of philosophical criticism which (perhaps deliberately) arrives at no synthesis. Benjamin acted almost like a medium for the transmission of ideas. He focused the insights of Marx and Engels, Brecht and Lukács, Freud and Valéry, surrealism and Dada, Baudelaire and Fourier, Bergson and Proust upon the nature of art and the discrete art object. In a sense his work arrived at a position analogous to the totality of Marx's and Engels' comments on art and literature—an aesthetics in process of "becoming" but never quite "arrived." This is what makes the analysis of Benjamin's Marxism so difficult and so fruitful.[4] He cannot be "placed"; he was no man's disciple, though he was receptive to the thoughts and formulations of a host of creative thinkers. His work is not definable in

1. Cited by Hannah Arendt, in her introduction to Benjamin, *Illuminations,* p. 10.

2. *Briefe,* vol. II, p. 594.

3. *Illuminations,* p. 15. Elsewhere, Benjamin was to cite Leonardo to the same effect (*Ibid.,* p. 251). Benjamin's most complete acceptance of Brechtian positions may be found in his political-aesthetic lecture "The Author as Producer."

4. Hannah Arendt attempts to "save" Benjamin from Marxism by emphasizing his unorthodoxy and the criticisms of Adorno. What really troubles her is that Benjamin will not conform to the Kautskyist Marxism which she can so easily overcome, any departure from which she sees as an evasion. Even a casual reading of Marx and Engels shows that Benjamin is immersed in their formulations and outlook and that Marxism constitutes the irreducible framework and nourishment of his work.

terms of a particular discipline—he is neither a philosopher nor a literary critic nor an art historian nor a sociologist of art. Perhaps he is best defined as one who "translates" the work of art into a metaphorical Gestalt, who somehow captures the "aura" of the art work by an impressionist recounting of its sources and its "direction." He wrote (following Breton) that "every fundamentally new, pioneering creation of demands will carry beyond its goal" and he saw the task of art to be "the creation of a demand which could be fully satisfied only later."[5] In other words, he saw art as revolutionary and Utopian, leading (rather than lagging behind) society, impelling it toward a better organization of needs. His Utopianism is explicit: "Dreams," he wrote, "in which every epoch sees the images of that which is to succeed it, now show the coming age mingled with elements of ur-history—that is to say of a classless society. The experience of this society, stored in the unconscious of the collective, join with the new to produce the utopia which has left its trace in a thousand configurations of life, from lasting buildings to the most fleeting fashions."[6] Benjamin saw art and Utopia alike in all the artifacts of life, in the insignificant scraps of reality "which had heretofore floated along unnoted in the broad stream of perception"[7]—in the buildings and their interiors, the streets and the subways, the infinite forms in which man impresses his being upon things, imbuing them with a consciousness of present desire which can only be fulfilled by a revolutionary future.

Walter Benjamin considered it the task of criticism to melt the frozen consciousness locked within the "things" of mankind. As Adorno wrote: "He is driven . . . to awaken congealed life in petrified objects."[8] Marx had revealed the petrifaction of human relations in the "things" of class society. Benjamin tried to show us how to break the spell.

――

The following selections indicate only a few of the leading strands of Benjamin's thought. His "The Storyteller: Reflections on the Works of Nikolai Leskov," from which is reprinted one brief section, "Fairy-Tale and Myth," is a richly impressionist survey of the art of the storyteller as

5. *Illuminations,* p. 239.
6. Cited (probably from a draft of his unfinished book on Paris) by Adorno, *Prisms,* pp. 237–38.
7. *Illuminations,* p. 237.
8. Adorno, *Prisms,* p. 233.

manifested in epic, novel, story, and legend. In our selection, he touches (following Ernst Bloch) on fairy tale and myth, reminding us that "the fairy-tale tells us of the earliest arrangements that mankind made to shake off the nightmare which the myth had placed upon its chest." The ramifications of this aphoristic formulation (so transparent, so lightly touched on) are explosive, involving art's ability to temper tragedy and to give instruction in the art of living, of how "to meet the forces of the mythical world with cunning and with high spirits."

Also in the Utopian tradition is the second selection, which is here entitled "Dialectics and Dream." In it, the surrealist strain of Benjamin's thought surfaces; wholly in the tradition of the surrealist synthesis (Hegel-Marx-Freud), he decomposes the spiritual monuments of bourgeois life into their naked materiality and sees the residue as the dreams of a humanity in search of a classless society.

The opening sections of Benjamin's *Work of Art in the Age of Mechanical Reproduction* summarize the historical advance in the techniques of mechanical reproduction of the literary and fine arts and begin to deal with the repercussions of reproducibility in art. The loss of "aura" is the primary element upon which Benjamin concentrates—the presence of the work of art in time and space, "its unique existence at the place where it happens to be." What is jeopardized in reproducibility is "the authority of the object"; the "aura" withers, because the unique art work is replaced by a plurality of copies.[9] This leads to a shattering of tradition, a liquidation of "the traditional value of the cultural heritage." Dialectically, this is both a liberation and a regression, but Benjamin prefers in this context to dwell on the former aspect. (Adorno, in his "The Fetishistic Character of Music and the Regression of Hearing," explicitly set out to refute Benjamin's emphasis.) He sees "aura" as inextricably linked with the "cult value of the work of art in categories of space and time perception." Though he regrets the passing of "aura," he sees the destruction of the ritual basis of art arising from it, and the possibilities of art becoming an instrument ("a weapon") of politics. The politicizing of art is the dealienation of the cultural object and a necessary defense against the fascist aestheticizing of war and the racial myth.

Benjamin's concept of "aura" itself rises from his preoccupation with and superb use of Marx's "fetishism of commodities" concept (see above, pages 38–40). The "central point" of his work on "Paris and its Arcades" (to which he devoted the last decade of his life) "is the concept of the fetish-

9. This concept is partly anticipated in Hegel's *Philosophy of Right*, Section 68, as well as in the writings of the Soviet constructivist, El Lissitzky.

istic character of commodities," he wrote to Scholem.[10] "Aura," then, is commodity fetishism—that mystical veil which substitutes relations between men and things for relations between human beings, the dealienation of which constitutes the motor of revolutionary consciousness. Benjamin himself defines "aura," in his "On Some Motifs in Baudelaire," as "the associations which . . . tend to cluster around the object of a perception"; the "experience of the aura . . . rests on the transposition of a response common in human relationships to the relationship between the inanimate or natural object and man. The person we look at, or who feels he is being looked at, looks at us in turn. To perceive the aura of an object we look at means to invest it with the ability to look at us in return."[11] "Aura" creates distance, mystifies, veils, invests with ritual content. Dealienation results from changing the mode of human sense perception through technological advances in reproducibility of the arts. Whether Benjamin fails to perceive the secondary "aura" which now adheres to the reproductions of the art work (now become a commodity in a clearer sense than previously) is an open question. That he regarded the decay of "aura" ambivalently is a certainty, for he was a passionate collector, and he himself claimed that "the collector . . . always retains some traces of the fetishist" and "by owning the work of art, shares in its ritual power."[12]

The next selection, "Louis-Philippe, or, The Interior," focuses on the collector, the dweller within the interior whose task is seen as "stripping things of their commodity character by means of his possession of them." But negation of commodity character is not the purpose of collecting; Benjamin himself worshipped the things which attached him to his past, to his childhood Berlin home; that is why he devotes himself to the interior, to *objets d'art,* to art nouveau, to the ornaments of existence, and especially to the books which he collected with a gambler's passion. Benjamin's attempt to politicize art is perhaps an attempt to root out his own ties to tradition.

To Benjamin, "aura" may have represented that aestheticist worship of the artistic fetish which prevented him from fully giving himself to the revolution. He therefore took it upon himself to analyze, objectify, and exorcise "aura" in the same way that Marx and Engels had stripped the veil from mystified bourgeois social relations. Marx had grasped the fetishistic qualities of commodities, revealing them as displaced relations between men. One of his greatest achievements was the perception that the dehumanization of social relations in capitalist production leads to an anthropomorphism of

10. May 20, 1935, *Briefe,* vol. II, p. 654.
11. *Illuminations,* p. 190.
12. *Ibid.,* p. 246.

things (commodity fetishism), which become invested with human qualities, become a reservoir of frozen emotions, which unlock upon confrontation with a human presence. Art is such a thing, such a reservoir, in which are stored the human associations of mankind, into which are diverted human emotions which vainly seek a human object. In most forms of art there takes place a libidinization of inorganic materials, a petrifaction of social relations between men.[13] Withdrawn from subject-object (I-Thou), human feeling flows into the objects of art, which thereby become sanctified, holy, invested with "aura."

Contrary to Benjamin's view, however, the removal of "aura" from art is not the ultimate aim; rather it is the redeflection of "aura" from art to the human object which is the goal of art, and which perhaps constitutes the aesthetic emotion. Art shows the way to the restoration of sanctity to the human image. "Aura"—the diversion of human energy from social relationships into the petrified objects of art—awaits reconciliation with its original object. The revolutionary energy of mankind is stored within the artistic fetish. The desanctification of art will proceed from the sanctification of man, but this is a process whose completion lies beyond the second stage of Communism.

The three "Theses on the Philosophy of History" chosen here illustrate the revolutionary thrust of Benjamin's symbolism. The cultural possessions of mankind, the highest achievements of the spirit, were born *intra feces et urinas* of class oppression. "There is no document of civilization which is not at the same time a document of barbarism." The storm of progress is a surrealist ruin of debris. But "the past strives to turn toward that sun which is rising in the sky of history." Here, aphorism turns into a philosophical shock montage which has the emotional impact of art itself.

BENJAMIN: **FAIRY-TALE AND MYTH**
from *The Storyteller*

"Leskov," writes Gorky, "is the writer most deeply rooted in the people and is completely untouched by any foreign influences." A great story-teller will always be rooted in the people, primarily in the working class, but just as this includes the rural, the maritime, and the urban elements in the many

13. This is true of painting, sculpture, musical composition, architecture, printed literature, and the filmed media. The performing arts—dance, theater, music—are more or less exempt from this process; here, it is the performer whose person and movements are invested with deflected energy.

stages of their economic and technical development, there are many grada-
tions in the concepts in which their stores of experience come down to us.
(To say nothing of the by no means insignificant share traders had in the
art of story-telling; their task was less to increase its didactic content than
to refine the tricks with which the attention of the listener was captivated.
They have left deep traces in the narrative cycle of the *Arabian Nights*.) In
short, despite the primary role which story-telling plays in the household of
humanity, the concepts through which the yield of the stories may be
garnered are manifold. What may most readily be contained in the religious
in Leskov seems almost automatically to fall into place in the pedagogical
perspectives of the Enlightenment in Hebel, appears as hermetic tradition
in Poe, finds a last refuge in Kipling in the life of British seamen and colonial
soldiers. All great story-tellers have in common the freedom with which
they move up and down the rungs of their experience as on a ladder. A
ladder extending downward to the interior of the earth and disappearing
into the clouds is the image for a collective experience to which even the
deepest shock of every individual experience, death, constitutes no impedi-
ment or barrier.

"And they lived happily ever after," says the fairy-tale. The fairy-tale,
which to this day is the first tutor of children because it was once the first
tutor of mankind, secretly lives on in the story. The first true story-teller is,
and will continue to be, the teller of fairy-tales. Whenever good counsel
was at a premium, the fairy-tale had it, and where the need was greatest, its
aid was nearest. This need was the need created by the myth. The fairy-tale
tells us of the earliest arrangements that mankind made to shake off the
nightmare which the myth had placed upon its chest. In the figure of the
fool it shows up how mankind "acts dumb" toward the myth; in the figure
of the youngest brother it shows us how one's chances increase as the
mythical primitive times are left behind; in the figure of the man who sets
out to learn what fear is it shows us that the things we are afraid of can be
seen through; in the figure of the wiseacre it shows us that the questions
posed by the myth are simple-minded, like the riddle of the Sphinx; in the
shape of the animals which come to the aid of the child in the fairy-tale it
shows that Nature not only is subservient to the myth, but much prefers to
be aligned with man. The wisest thing—so the fairy-tale taught mankind in
olden times, and teaches children to this day—is to meet the forces of the
mythical world with cunning and with high spirits. (This is how the fairy-
tale polarizes *Mut,* courage, dividing it dialectically into *Untermut,* that is,
cunning, and *Übermut,* high spirits.) The liberating magic which the fairy-
tale has at its disposal does not bring Nature into play in a mythical way,
but points to its complicity with liberated man. A mature man feels this

complicity only occasionally, that is, when he is happy; but the child first meets it in fairy-tales, and it puts him in a happy frame of mind.

BENJAMIN: **DIALECTICS AND DREAM**
from *Paris—Capital of the Nineteenth Century*

My good father had been in Paris.
—Karl Gutzkow: *Letters from Paris* (1842)

Balzac was the first to speak of the ruin of the bourgeoisie. But it was surrealism which first allowed its gaze to roam freely over it. The development of the forces of production had turned the wish-symbols of the previous century into rubble, even before the monuments which represented them had crumbled. This development during the nineteenth century liberated the forms of creation from art, just as in the sixteenth century the sciences freed themselves from philosophy. A start was made by architecture as engineering. There followed the reproduction of Nature as photography. The creation of fantasies was preparing to become practical as commercial art. In the *feuilleton,* creative writing bowed to the exigencies of layout. All these products were on the point of entering the market as commodities. But they still lingered on the threshold. From this epoch spring the arcades and the interiors, the exhibition-halls and the dioramas. They are residues of a dream-world. The utilization of dream-elements in waking is the textbook example of dialectical thought. Hence dialectical thought is the organ of historical awakening. Every epoch not only dreams the next, but while dreaming impels it towards wakefulness. It bears its end with itself, and reveals it—as Hegel already recognized—by a ruse. With the upheaval of the market economy, we begin to recognize the monuments of the bourgeoisie as ruins even before they have crumbled.

BENJAMIN:
THE WORK OF ART IN THE AGE OF
MECHANICAL REPRODUCTION
from *The Work of Art in the Age of Mechanical Reproduction*

*Our fine arts were developed, their types and uses were
established, in times very different from the present, by men whose
power of action upon things was insignificant in comparison with
ours. But the amazing growth of our techniques, the adaptability
and precision they have attained, the ideas and habits they are
creating, make it a certainty that profound changes are impending in
the ancient craft of the Beautiful. In all the arts there is a physical
component which can no longer be considered or treated as it used
to be, which cannot remain unaffected by our modern knowledge
and power. For the last twenty years neither matter nor space
nor time has been what it was from time immemorial. We must
expect great innovations to transform the entire technique of the
arts, thereby affecting artistic invention itself and perhaps even
bringing about an amazing change in our very notion of art.*[1]
—Paul Valéry

PREFACE

When Marx undertook his critique of the capitalistic mode of production,
this mode was in its infancy. Marx directed his efforts in such a way as to
give them prognostic value. He went back to the basic conditions underly-
ing capitalistic production and through his presentation showed what could
be expected of capitalism in the future. The result was that one could
expect it not only to exploit the proletariat with increasing intensity, but
ultimately to create conditions which would make it possible to abolish
capitalism itself.

The transformation of the superstructure, which takes place far more
slowly than that of the substructure, has taken more than half a century to
manifest in all areas of culture the change in the conditions of production.
Only today can it be indicated what form this has taken. Certain prognostic
requirements should be met by these statements. However, theses about the
art of the proletariat after its assumption of power or about the art of a
classless society would have less bearing on these demands than theses
about the developmental tendencies of art under present conditions of

1. Quoted from Paul Valéry, *Aesthetics*, "The Conquest of Ubiquity," trans. Ralph
Manheim (New York: Pantheon Books, Bollingen Series, 1964), p. 225.

production. Their dialectic is no less noticeable in the superstructure than in the economy. It would therefore be wrong to underestimate the value of such theses as a weapon. They brush aside a number of outmoded concepts, such as creativity and genius, eternal value and mystery—concepts whose uncontrolled (and at present almost uncontrollable) application would lead to a processing of data in the Fascist sense. The concepts which are introduced into the theory of art in what follows differ from the more familiar terms in that they are completely useless for the purposes of Fascism. They are, on the other hand, useful for the formulation of revolutionary demands in the politics of art.

I

In principle a work of art has always been reproducible. Manmade artifacts could always be imitated by men. Replicas were made by pupils in practice of their craft, by masters for diffusing their works, and, finally, by third parties in the pursuit of gain. Mechanical reproduction of a work of art, however, represents something new. Historically, it advanced intermittently and in leaps at long intervals, but with accelerated intensity. The Greeks knew only two procedures of technically reproducing works of art: founding and stamping. Bronzes, terra cottas, and coins were the only art works which they could produce in quantity. All others were unique and could not be mechanically reproduced. With the woodcut graphic art became mechanically reproducible for the first time, long before script became reproducible by print. The enormous changes which printing, the mechanical reproduction of writing, has brought about in literature are a familiar story. However, within the phenomenon which we are here examining from the perspective of world history, print is merely a special, though particularly important, case. During the Middle Ages engraving and etching were added to the woodcut; at the beginning of the nineteenth century lithography made its appearance.

With lithography the technique of reproduction reached an essentially new stage. This much more direct process was distinguished by the tracing of the design on a stone rather than its incision on a block of wood or its etching on a copperplate and permitted graphic art for the first time to put its products on the market, not only in large numbers as hitherto, but also in daily changing forms. Lithography enabled graphic art to illustrate everyday life, and it began to keep pace with printing. But only a few decades after its invention, lithography was surpassed by photography. For the first time in the process of pictorial reproduction, photography freed the hand of the most important artistic functions which henceforth de-

volved only upon the eye looking into a lens. Since the eye perceives more swiftly than the hand can draw, the process of pictorial reproduction was accelerated so enormously that it could keep pace with speech. A film operator shooting a scene in the studio captures the images at the speed of an actor's speech. Just as lithography virtually implied the illustrated newspaper, so did photography foreshadow the sound film. The technical reproduction of sound was tackled at the end of the last century. These convergent endeavors made predictable a situation which Paul Valéry pointed up in this sentence: "Just as water, gas, and electricity are brought into our houses from far off to satisfy our needs in response to a minimal effort, so we shall be supplied with visual or auditory images, which will appear and disappear at a simple movement of the hand, hardly more than a sign."[2] Around 1900 technical reproduction had reached a standard that not only permitted it to reproduce all transmitted works of art and thus to cause the most profound change in their impact upon the public; it also had captured a place of its own among the artistic processes. For the study of this standard nothing is more revealing than the nature of the repercussions that these two different manifestations—the reproduction of works of art and the art of the film—have had on art in its traditional form.

II

Even the most perfect reproduction of a work of art is lacking in one element: its presence in time and space, its unique existence at the place where it happens to be. This unique existence of the work of art determined the history to which it was subject throughout the time of its existence. This includes the changes which it may have suffered in physical condition over the years as well as the various changes in its ownership.[3] The traces of the first can be revealed only by chemical or physical analyses which it is impossible to perform on a reproduction; changes of ownership are subject to a tradition which must be traced from the situation of the original.

The presence of the original is the prerequisite to the concept of authenticity. Chemical analyses of the patina of a bronze can help to establish this, as does the proof that a given manuscript of the Middle Ages stems from an archive of the fifteenth century. The whole sphere of authenticity is outside technical—and, of course, not only technical—reproduci-

2. *Ibid.*, p. 226.

3. Of course, the history of a work of art encompasses more than this. The history of the "Mona Lisa," for instance, encompasses the kind and number of its copies made in the 17th, 18th, and 19th centuries.

bility.[4] Confronted with its manual reproduction, which was usually branded as a forgery, the original preserved all its authority; not so *vis à vis* technical reproduction. The reason is twofold. First, process reproduction is more independent of the original than manual reproduction. For example, in photography, process reproduction can bring out those aspects of the original that are unattainable to the naked eye yet accessible to the lens, which is adjustable and chooses its angle at will. And photographic reproduction, with the aid of certain processes, such as enlargement or slow motion, can capture images which escape natural vision. Secondly, technical reproduction can put the copy of the original into situations which would be out of reach for the original itself. Above all, it enables the original to meet the beholder halfway, be it in the form of a photograph or a phonograph record. The cathedral leaves its locale to be received in the studio of a lover of art; the choral production, performed in an auditorium or in the open air, resounds in the drawing room.

The situations into which the product of mechanical reproduction can be brought may not touch the actual work of art, yet the quality of its presence is always depreciated. This holds not only for the art work but also, for instance, for a landscape which passes in review before the spectator in a movie. In the case of the art object, a most sensitive nucleus—namely, its authenticity—is interfered with whereas no natural object is vulnerable on that score. The authenticity of a thing is the essence of all that is transmissible from its beginning, ranging from its substantive duration to its testimony to the history which it has experienced. Since the historical testimony rests on the authenticity, the former, too, is jeopardized by reproduction when substantive duration ceases to matter. And what is really jeopardized when the historical testimony is affected is the authority of the object.[5]

One might subsume the eliminated element in the term "aura" and go on

4. Precisely because authenticity is not reproducible, the intensive penetration of certain (mechanical) processes of reproduction was instrumental in differentiating and grading authenticity. To develop such differentiations was an important function of the trade in works of art. The invention of the woodcut may be said to have struck at the root of the quality of authenticity even before its late flowering. To be sure, at the time of its origin a medieval picture of the Madonna could not yet be said to be "authentic." It became "authentic" only during the succeeding centuries and perhaps most strikingly so during the last one.

5. The poorest provincial staging of *Faust* is superior to a Faust film in that, ideally, it competes with the first performance at Weimar. Before the screen it is unprofitable to remember traditional contents which might come to mind before the stage—for instance, that Goethe's friend Johann Heinrich Merck is hidden in Mephisto, and the like.

to say: that which withers in the age of mechanical reproduction is the aura of the work of art. This is a symptomatic process whose significance points beyond the realm of art. One might generalize by saying: the technique of reproduction detaches the reproduced object from the domain of tradition. By making many reproductions it substitutes a plurality of copies for a unique existence. And in permitting the reproduction to meet the beholder or listener in his own particular situation, it reactivates the object reproduced. These two processes lead to a tremendous shattering of tradition which is the obverse of the contemporary crisis and renewal of mankind. Both processes are intimately connected with the contemporary mass movements. Their most powerful agent is the film. Its social significance, particularly in its most positive form, is inconceivable without its destructive, cathartic aspect, that is, the liquidation of the traditional value of the cultural heritage. This phenomenon is most palpable in the great historical films. It extends to ever new positions. In 1927 Abel Gance exclaimed enthusiastically: "Shakespeare, Rembrandt, Beethoven will make films . . . all legends, all mythologies and all myths, all founders of religion, and the very religions . . . await their exposed resurrection, and the heroes crowd each other at the gate."[6] Presumably without intending it, he issued an invitation to a far-reaching liquidation.

III

During long periods of history, the mode of human sense perception changes with humanity's entire mode of existence. The manner in which human sense perception is organized, the medium in which it is accomplished, is determined not only by nature but by historical circumstances as well. The fifth century, with its great shifts of population, saw the birth of the late Roman art industry and the Vienna Genesis, and there developed not only an art different from that of antiquity but also a new kind of perception. The scholars of the Viennese school, Riegl and Wickhoff, who resisted the weight of classical tradition under which these later art forms had been buried, were the first to draw conclusions from them concerning the organization of perception at the time. However far-reaching their insight, these scholars limited themselves to showing the significant, formal hallmark which characterized perception in late Roman times. They did not attempt—and, perhaps, saw no way—to show the social transformations expressed by these changes of perception. The conditions for an

6. Abel Gance, "Le Temps de l'image est venu," *L'Art cinématographique* (Paris, 1927), vol. 2, pp. 94f.

analogous insight are more favorable in the present. And if changes in the medium of contemporary perception can be comprehended as decay of the aura, it is possible to show its social causes.

The concept of aura which was proposed above with reference to historical objects may usefully be illustrated with reference to the aura of natural ones. We define the aura of the latter as the unique phenomenon of a distance, however close it may be. If, while resting on a summer afternoon, you follow with your eyes a mountain range on the horizon or a branch which casts its shadow over you, you experience the aura of those mountains, of that branch. This image makes it easy to comprehend the social bases of the contemporary decay of the aura. It rests on two circumstances, both of which are related to the increasing significance of the masses in contemporary life. Namely, the desire of contemporary masses to bring things "closer" spatially and humanly, which is just as ardent as their bent toward overcoming the uniqueness of every reality by accepting its reproduction.[7] Every day the urge grows stronger to get hold of an object at very close range by way of its likeness, its reproduction. Unmistakably, reproduction as offered by picture magazines and newsreels differs from the image seen by the unarmed eye. Uniqueness and permanence are as closely linked in the latter as are transitoriness and reproducibility in the former. To pry an object from its shell, to destroy its aura, is the mark of a perception whose "sense of the universal equality of things" has increased to such a degree that it extracts it even from a unique object by means of reproduction. Thus is manifested in the field of perception what in the theoretical sphere is noticeable in the increasing importance of statistics. The adjustment of reality to the masses and of the masses to reality is a process of unlimited scope, as much for thinking as for perception.

IV

The uniqueness of a work of art is inseparable from its being imbedded in the fabric of tradition. This tradition itself is thoroughly alive and extremely changeable. An ancient statue of Venus, for example, stood in a different tradition context with the Greeks, who made it an object of veneration, than with the clerics of the Middle Ages, who viewed it as an

7. To satisfy the human interest of the masses may mean to have one's social function removed from the field of vision. Nothing guarantees that a portraitist of today, when painting a famous surgeon at the breakfast table in the midst of his family, depicts his social function more precisely than a painter of the 17th century who portrayed his medical doctors as representing this profession, like Rembrandt in his "Anatomy Lesson."

ominous idol. Both of them, however, were equally confronted with its uniqueness, that is, its aura. Originally the contextural integration of art in tradition found its expression in the cult. We know that the earliest art works originated in the service of a ritual—first the magical, then the religious kind. It is significant that the existence of the work of art with reference to its aura is never entirely separated from its ritual function.[8] In other words, the unique value of the "authentic" work of art has its basis in ritual, the location of its original use value. This ritualistic basis, however remote, is still recognizable as secularized ritual even in the most profane forms of the cult of beauty.[9] The secular cult of beauty, developed during the Renaissance and prevailing for three centuries, clearly showed that ritualistic basis in its decline and the first deep crisis which befell it. With the advent of the first truly revolutionary means of reproduction, photography, simultaneously with the rise of socialism, art sensed the approaching crisis which has become evident a century later. At the time, art reacted with the doctrine of *l'art pour l'art,* that is, with a theology of art. This gave rise to what might be called a negative theology in the form of the idea of "pure" art, which not only denied any social function of art but also any categorizing by subject matter. (In poetry, Mallarmé was the first to take this position.)

An analysis of art in the age of mechanical reproduction must do justice to these relationships, for they lead us to an all-important insight: for the first time in world history, mechanical reproduction emancipates the work of art from its parasitical dependence on ritual. To an ever greater degree the work of art reproduced becomes the work of art designed for repro-

8. The definition of the aura as a "unique phenomenon of a distance however close it may be" represents nothing but the formulation of the cult value of the work of art in categories of space and time perception. Distance is the opposite of closeness. The essentially distant object is the unapproachable one. Unapproachability is indeed a major quality of the cult image. True to its nature, it remains "distant, however close it may be." The closeness which one may gain from its subject matter does not impair the distance which it retains in its appearance.

9. To the extent to which the cult value of the painting is secularized the ideas of its fundamental uniqueness lose distinctness. In the imagination of the beholder the uniqueness of the phenomena which hold sway in the cult image is more and more displaced by the empirical uniqueness of the creator or of his creative achievement. To be sure, never completely so; the concept of authenticity always transcends mere genuineness. (This is particularly apparent in the collector who always retains some traces of the fetishist and who, by owning the work of art, shares in its ritual power.) Nevertheless, the function of the concept of authenticity remains determinate in the evaluation of art; with the secularization of art, authenticity displaces the cult value of the work.

ducibility.[10] From a photographic negative, for example, one can make any number of prints; to ask for the "authentic" print makes no sense. But the instant the criterion of authenticity ceases to be applicable to artistic production, the total function of art is reversed. Instead of being based on ritual, it begins to be based on another practice—politics.

BENJAMIN: **LOUIS-PHILIPPE, OR, THE INTERIOR**
from *Paris—Capital of the Nineteenth Century*

Une tête, sur la table de nuit, repose
Comme une renoncule.[1]
—Baudelaire, *Une martyre*

Under Louis-Philippe, the private citizen entered upon the historical scene. The extension of the apparatus of democracy by means of a new electoral law coincided with the parliamentary corruption that was organized by Guizot. Under cover of this, the ruling class made history while it pursued its business affairs. It encouraged the construction of railways in order to improve its holdings. It supported the rule of Louis-Philippe as that of the private businessman. With the July Revolution the bourgeoisie had realized the aims of 1789 (Marx).

For the private citizen, for the first time the living-space became distinguished from the place of work. The former constituted itself as the

10. In the case of films, mechanical reproduction is not, as with literature and painting, an external condition for mass distribution. Mechanical reproduction is inherent in the very technique of film production. This technique not only permits in the most direct way but virtually causes mass distribution. It enforces distribution because the production of a film is so expensive that an individual who, for instance, might afford to buy a painting no longer can afford to buy a film. In 1927 it was calculated that a major film, in order to pay its way, had to reach an audience of nine million. With the sound film, to be sure, a setback in its international distribution occurred at first: audiences became limited by language barriers. This coincided with the Fascist emphasis on national interests. It is more important to focus on this connection with Fascism than on this setback, which was soon minimized by synchronization. The simultaneity of both phenomena is attributable to the depression. The same disturbances which, on a larger scale, led to an attempt to maintain the existing property structure by sheer force led the endangered film capital to speed up the development of the sound film. The introduction of the sound film brought about a temporary relief, not only because it again brought the masses into the theaters but also because it merged new capital from the electrical industry with that of the film industry. Thus, viewed from the outside, the sound film promoted national interests, but seen from the inside it helped to internationalize film production even more than previously.

1. "A head rests upon the night-table like a ranunculus."

interior. The counting-house was its complement. The private citizen who in the counting-house took reality into account, required of the interior that it should maintain him in his illusions. This necessity was all the more pressing since he had no intention of adding social preoccupations to his business ones. In the creation of his private environment he suppressed them both. From this sprang the phantasmagorias of the interior. This represented the universe for the private citizen. In it he assembled the distant in space and in time. His drawing-room was a box in the world-theatre.

Digression on *art nouveau*. The shattering of the interior took place around the turn of the century in *art nouveau*. And yet the latter appeared, according to its ideology, to bring with it the perfecting of the interior. The transfiguration of the lone soul was its apparent aim. Individualism was its theory. With Vandervelde, there appeared the house as expression of the personality. Ornament was to such a house what the signature is to a painting. The real significance of *art nouveau* was not expressed in this ideology. It represented the last attempt at a sortie on the part of Art imprisoned by technical advance within her ivory tower. It mobilized all the reserve forces of interiority. They found their expression in the mediumistic language of line, in the flower as symbol of the naked, vegetable Nature that confronted the technologically armed environment. The new elements of construction in iron—girder-forms—obsessed *art nouveau*. Through ornament, it strove to win back these forms for Art. Concrete offered it new possibilities for the creation of plastic forms in architecture. Around this time the real centre of gravity of the sphere of existence was displaced to the office. The de-realized centre of gravity created its abode in the private home. Ibsen's *Masterbuilder* summed up *art nouveau:* the attempt of the individual, on the basis of his interiority, to vie with technical progress leads to his downfall.

Je crois . . . à mon âme: la Chose.
—Léon Deubel, *Oeuvres* (Paris, 1929)

The interior was the place of refuge of Art. The collector was the true inhabitant of the interior. He made the glorification of things his concern. To him fell the task of Sisyphus which consisted of stripping things of their commodity character by means of his possession of them. But he conferred upon them only connoisseur's value, rather than use-value. The collector dreamed that he was in a world which was not only far-off in distance and in time, but which was also a better one, in which to be sure people were

just as poorly provided with what they needed as in the world of everyday, but in which things were free from the bondage of being useful.

The interior was not only the private citizen's universe, it was also his casing. Living means leaving traces. In the interior, these were stressed. Coverings and antimacassars, boxes and casings, were devised in abundance, in which the traces of every day objects were moulded. The resident's own traces were also moulded in the interior. The detective story appeared, which investigated these traces. The *Philosophy of Furniture*, as much as his detective stories, shows Poe to have been the first physiognomist of the interior. The criminals of the first detective novels were neither gentlemen nor apaches, but middle-class private citizens.

BENJAMIN:
THREE THESES ON THE PHILOSOPHY OF HISTORY
from *Theses on the Philosophy of History*

Seek for food and clothing first, then
the Kingdom of God shall be added unto you.
—Hegel, 1807

The class struggle, which is always present to a historian influenced by Marx, is a fight for the crude and material things without which no refined and spiritual things could exist. Nevertheless, it is not in the form of the spoils which fall to the victor that the latter make their presence felt in the class struggle. They manifest themselves in this struggle as courage, humor, cunning, and fortitude. They have retroactive force and will constantly call in question every victory, past and present, of the rulers. As flowers turn toward the sun, by dint of a secret heliotropism the past strives to turn toward that sun which is rising in the sky of history. A historical materialist must be aware of this most inconspicuous of all transformations.

Consider the darkness and the great cold
In this vale which resounds with mystery.
—Brecht, *The Threepenny Opera*

To historians who wish to relive an era, Fustel de Coulanges recommends that they blot out everything they know about the later course of history. There is no better way of characterizing the method with which historical materialism has broken. It is a process of empathy whose origin is the indolence of the heart, *acedia,* which despairs of grasping and holding the

genuine historical image as it flares up briefly. Among medieval theologians it was regarded as the root cause of sadness. Flaubert, who was familiar with it, wrote: *"Peu de gens devineront combien il a fallu être triste pour ressusciter Carthage."*[1] The nature of this sadness stands out more clearly if one asks with whom the adherents of historicism actually empathize. The answer is inevitable: with the victor. And all rulers are the heirs of those who conquered before them. Hence, empathy with the victor invariably benefits the rulers. Historical materialists know what that means. Whoever has emerged victorious participates to this day in the triumphal procession in which the present rulers step over those who are lying prostrate. According to traditional practice, the spoils are carried along in the procession. They are called cultural treasures, and a historical materialist views them with cautious detachment. For without exception the cultural treasures he surveys have an origin which he cannot contemplate without horror. They owe their existence not only to the effects of the great minds and talents who have created them, but also to the anonymous toil of their contemporaries. There is no document of civilization which is not at the same time a document of barbarism. And just as such a document is not free of barbarism, barbarism taints also the manner in which it was transmitted from one owner to another. A historical materialist therefore dissociates himself from it as far as possible. He regards it as his task to brush history against the grain.

Mein Flügel ist zum Schwung bereit,
ich kehrte gern zurück,
denn blieb ich auch lebendige Zeit,
ich hätte wenig Glück.[2]
—Gerhard Scholem, "Gruss vom Angelus"

A Klee painting named "Angelus Novus" shows an angel looking as though he is about to move away from something he is fixedly contemplating. His eyes are staring, his mouth is open, his wings are spread. This is how one pictures the angel of history. His face is turned toward the past. Where we perceive a chain of events, he sees one single catastrophe which keeps piling wreckage upon wreckage and hurls it in front of his feet. The angel

1. "Few will be able to guess how sad one had to be in order to resuscitate Carthage."

2. "My wing is ready for flight,/I would like to turn back./If I stayed timeless time,/I would have little luck."

would like to stay, awaken the dead, and make whole what has been smashed. But a storm is blowing from Paradise; it has got caught in his wings with such violence that the angel can no longer close them. This storm irresistibly propels him into the future to which his back is turned, while the pile of debris before him grows skyward. This storm is what we call progress.

ANDRÉ MALRAUX

Art is not a submission.
It is a conquest.
—Malraux

INTRODUCTION

André Malraux (born 1901) took the above as his motto in his speech to the 1934 Soviet Writers' Congress. And in the following selection, his Address to the International Association of Writers for the Defense of Culture, held in Paris on June 21–25, 1935, this Communist novelist, revolutionary, art historian, friend of Walter Benjamin's during his Paris exile, projected a Utopian image of art into a reality which would not accept it.[1]

Every work of art is created to satisfy a need, a need that is passionate enough to give it birth. Then the need withdraws from the art-work as blood from a body, and the mysterious process of transfiguration sets in. The art-work, thereupon, enters the realm of shades; and it is only our own need, our own passion which can summon it forth again. Until such a time, it is like a great sightless statue, before which there passes a long drawn out procession of the blind.

1. M. Malraux has asked me to specify that the address reprinted here was given extemporaneously from notes and later transcribed stenographically.

But the Utopian radiance is petrified, condensed, congealed within the art object, awaiting contact and confrontation with the revolutionary catalyst—consciousness. The culture of mankind can be reincarnated. It is the purpose of the quest "to recreate the phantom heritage which lies about us, to open the eyes of all the sightless statues, to turn hopes into will and revolts into revolutions, and to shape thereby, out of the age-old sorrows of man, a new and glowing consciousness of mankind."

The task of revolutionary culture, then, is (as Malraux said in June 1936) to "transform destiny into awareness." In Marx, Malraux saw a single watchword: "More awareness." But when Stalinism turned awareness into destiny, Malraux's hymn to culture itself became one of the sightless statues in a petrified revolutionary museum, awaiting its own reincarnation. Unwilling to abandon the quest, Malraux fled from Communism to the protective warmth of his mother country—France—and devoted much of his later life to an attempt to preserve the national cultural heritage. Continuity has marked this central aspect of his life. In the *Temptation of the Occident* (1926) he had written: "The mind supplies the idea of a nation, but what gives this idea its sentimental force is a community of dreams." In 1961, in a debate in the National Assembly, he reiterated his unflagging concern with preservation of the artistic heritage: "Chateaus, cathedrals, museums, are the fraternal and successive landmarks of the immense and lively dream pursued by France for nearly one thousand years. . . . Our monuments are the greatest dream of France. That is why we want to preserve them . . . for the emotional response of the children."

Malraux—one-time assistant Secretary-General of the Kuomintang, nonparty Communist from 1925 to 1939, Colonel in the Spanish Republican Air Force, Commander of the Alsace-Lorraine Brigade of the French resistance, Minister of State for Cultural Affairs in the Gaullist Fifth Republic—understood the latency of art, the gradual unfolding of its implicit meanings by the processes of history, and he attempted to preserve the images of Utopia so that men may some day rearrange their past and transcend man's fate—which is the state that precedes the truly human condition.

MALRAUX: **THE WORK OF ART**
Speech to the International Association of Writers for the Defense of Culture

This Congress of ours has been held under the worst possible conditions. Through the cooperation of a few, and with almost no money. Just have a

look at the press clippings on the bulletin-board at the door. From an occasional outburst of wrath, but above all, from the impressive silence, we are henceforth aware that this Congress exists. Yet, if it held no more than the possibility of giving as large an audience as possible to books which in their own countries are no longer able to find one, if it did no more than cement our union with a host of exiled comrades—a sense of solidarity which will be found expressed in its resolutions—this gathering would not be in vain.

But it has another meaning than that. You read yesterday the speeches of the French Fascists. It is for each of us, then, as man and man, to take his place at the post of combat. But let us not, through an absurd preoccupation with the military aspect of things, underestimate that power of thought, which today makes it possible for our Balkan comrades, banned at home, to return home whether in French or in English, for the simple reason that this Congress has taken it upon itself to have their works translated. It is in the nature of Fascism to be a nation; it is ours to be a world.

Much has been said here concerning the defense of culture; but it may be that the best thing about the Congress is the comprehension borne in upon us that the question is not be be put that way. Let me explain.

When an artist of the Middle Ages carved a crucifix, when an Egyptian sculptor hewed out a funeral-mask, they were creating what we would term fetishes or holy images; they did not think of their carvings as art objects; they would not have been able to conceive of such a thing. A crucifix stood for the Christ, a funeral-mask for the dead; and the idea of their being some day brought together in the same museum, in order that we might study their lines and masses, would have struck their makers as nothing more or less than a profanation. In a locked case in the museum of Cairo, there are a number of statuettes. They are the earliest representations of man. Up to that time, there had been but the concept, a good deal easier to grasp, of the spiritual double, who abandoned man in sleep, before leaving him for good in the sleep of death. As I went through the museum, I caught sight of a visitor who was taking the measurements of these carvings; and I could not but think of how dumbfounded the one who made them would have been, had he been able to foresee that his work would end up as an artistic problem—such the outcome of that moment, some three thousand years before Christ, and somewhere in the neighborhood of the Nile, when a nameless carver of images first took it upon himself to depict the human soul.

Every work of art is created to satisfy a need, a need that is passionate enough to give it birth. Then the need withdraws from the art-work as

blood from a body, and the mysterious process of transfiguration sets in. The art-work, thereupon, enters the realm of shades; and it is only our own need, our own passion which can summon it forth again. Until such a time, it is like a great, sightless statue, before which there passes a long drawn out procession of the blind. And the impulsion which shall bring one of the blind to the statue shall be sufficient to open both their eyes at once.

We have but to go back a hundred years in order to find utterly ignored any number of works which today are among the most indispensable that we possess. Two hundred years, and we shall find the radiant, withered smile of Gothic become synonymous with the grin. A work of art is an object; but it is, in addition, an encounter with time; and I am aware, needless to say, that we have made the discovery of history. Works born of love may find their way to the store-loft or to the museum, which is scarcely a happier fate. Any work is dead, the moment love has ebbed.

Nevertheless, there is a meaning to all this. Art, thought, poems, all the old dreams of mankind—if we have need of them in order to go on living, they have need of us that they may live again. Need of our passion, our longings—*need of our will.* They are not mere sticks of furniture, standing about for an inventory after the owner's death; rather, they are like those shades in the infernos of old, eagerly awaiting the approach of the living. Whether or not we mean to do so, we create them in creating ourselves. His very impulse to create leads Ronsard to resurrect Greece; Racine, Rome; Hugo, Rabelais; Corot, Vermeer. There is not a single great individual creation which is not enmeshed in the centuries, which does not trail after it the slumbering grandeurs of the past. Our inheritance is not handed down; it is one to be achieved.

Writers of the West, we are engaged in a bitter struggle with that which is our own. Comrades of the Soviets, you did well to hold your Moscow Congress beneath the portraits of the great of old; but what we expect of that civilization of yours, which has safeguarded those masterpieces, through blood and famine and typhus, is something more than a mere show of reverence; we expect you once again to wrest from them a fresh and significant aspect.

Down underneath our common volition, a thousand differences are at play. But that volition *is;* and when we shall be no longer anything more than historical phases of our time, when all those differences shall have disappeared in the fraternal embrace of death, we would still that the spirit which, in spite of all our weaknesses and all our bickerings, has brought us together here should be the thing which in the end will work a new metamorphosis on time's wrinkled visage.

For every work of art becomes a symbol and a sign, but not always of

the same thing. A work of art implies the possibility of a reincarnation. And the world of history can only lose its meaning in the contemporary will of man. It is for each of us, in his own field and through his own efforts, and for the sake of all those who are engaged in a quest of themselves, to recreate the phantom heritage which lies about us, to open the eyes of all the sightless statues, to turn hopes into will and revolts into revolutions, and to shape thereby, out of the age-old sorrows of man, a new and glowing consciousness of humankind.

ERNST BLOCH

*The Golden Age, which blind tradition
has placed in the past,
is in the future.*
—Saint-Simon, epigraph of *Discourses
Literary, Philosophical and Industrial*

*The real genesis is not
at the beginning, but at the end.*
—Bloch, *The Principle of Hope*

INTRODUCTION

Ernst Bloch was born in Ludwigshafen, Germany, in 1885. He studied
philosophy in Würzburg, Berlin, and Heidelberg. Like Lukács and Max
Raphael he studied with Georg Simmel, and he joined the Heidelberg
group that included Lukács, Jaspers, and others. He moved to Switzerland
when the war broke out and there wrote his *Geist der Utopie* (published
1918), in which he posits an "inherent utopian tendency" and draws
sustenance from Marx's proposed "alliance between the poor and the
thinkers" in order to create a messianic revolutionary philosophy in which
we "paint images of what lies ahead, and insinuate ourselves into what may
come after us." Bloch's was still a Talmudic-German version of that Chris-
tian Socialism which swept the western world at the *fin-de-siècle* and was
laid to rest by the cataclysm of imperialist war and socialist revolution. But
Bloch is here just emerging; as he says, his book "makes no peace with the
world"; he is at the beginning of a quest for "the *external* interpretation of
the daydream, the *cosmic* manipulation" of the Utopian principle; his eye
is on a paradise beyond paradise, and he does not (nor will he ever) settle

for "the Marxist fixation on an atheistic *status quo* that offers the human soul nothing but a more or less eudaimonistically furnished 'heaven on earth' without the music we ought to hear from this effortlessly functioning economic and social mechanism."[1]

Bloch returned to Germany and lived as a free-lance writer in Munich and Berlin, where he was at the center of the circle of Communist and Marxist intellectuals and artists, a close friend of Walter Benjamin, Brecht, and Kurt Weill, writing numerous articles on political, philosophical, and aesthetic subjects which were later collected in *Durch die Wüste* (1923), *Spuren* (1930), and *Erbschaft dieser Zeit* (1935). His *Thomas Münzer als Theologe der Revolution* (1921) continued the exploration of Utopia, as did his studies of Chiliastic trends within the German Peasant War (1921).

From *Erbschaft dieser Zeit* (*The Heritage of this Time*), Bloch's brief essay on *The Threepenny Opera* is reprinted here, as an example of the aphoristic-expressionist style of his occasional pieces. Benjamin, in a 1934 letter to Brecht, referred to Bloch as the master of the German avant-garde essay. George Steiner places pages of Bloch's mature style alongside Hölderlin and Nietzsche for their "subtle brightness." Slochower regards Bloch's poetic imagery as the source of his persuasive power, producing "incongruous juxtapositions that open up unexpected, startling perspectives."

In 1933 Bloch was forced to leave Germany. He resided in Prague, Vienna, and Paris for several years, continuing to write on art and politics for the antifascist émigré journals. In 1938 he came to the United States, where (with the exception of his participation in the Third American Writers Congress in 1939) he devoted himself entirely to the composition of his three-volume major work—*Das Prinzip Hoffnung* (1954–1959)— and a related volume, *Freiheit und Ordnung: Abriss der Sozialutopien* (1946). In 1949, Bloch returned to East Germany, where he taught in Leipzig. There he wrote studies on Hegel, Avicenna, and the concept of progress. He was involuntarily retired from Leipzig's Karl Marx University in 1957 because of the apparent unorthodoxy (and the theological component) of his Marxism. In 1961 he moved to West Germany, where he has been teaching at Tübingen University and writing expansions and popularizations of his philosophy of hope.

The influence of Bloch on the currents of Marxist thought commenced more than fifty years ago, shaping many of the concerns, directions, and formulations of the early Georg Lukács, T. W. Adorno, Walter Benjamin, and socialist-oriented theologians, but the fascist inferno blocked the

1. Bloch, *Man on His Own* (New York, 1970), p. 38.

concern for Utopia by focusing civilization's energies upon immediate self-preservation. In a sense, the Utopian strain could only be readmitted and reconfirmed by Marxism after the 20th Party Congress of 1956, which put an end to the fiction of Utopia as "already present," and brought the question of "when" and the philosophy of "not-yet" to the fore.

■■■

The central concern in Bloch's philosophy is to fill the "place into which gods were imagined." (Bloch wrote: "Within there is a void that would be filled. So it all begins.") Jürgen Habermas has put this well: "God is dead, but his locus has survived him. The place into which mankind has imagined God and the gods, after the decay of these hypotheses remains a hollow space. The Measurements-in-depth of this vacuum . . . sketch out the blueprint of a future kingdom of freedom."[2] For Bloch, this space into which man had projected his inner longings must remain open "for a possible, still undecided reality of the future." Here, in the "superstructure in the superstructure" is that open terrain of *what lies ahead,* the novum in which the mediated train of human purposes continues."[3] Here is the topos of Utopia, into which are projected the visions of a kingdom of freedom as a defense against chaos, against the "latency of nothingness."[4] Atheism (Feuerbach) opens up the place of the religious vacuum; Utopia (Bloch) fills the vacuum with the ideal of historical freedom—Communism. I think this may already have been implicit in Feuerbach, when he wrote that "the negation of the next world has as its consequence the affirmation of this world" and when he insisted that we must "modify our goals and exchange divinity, in which only man's groundless and gratuitous desires are fulfilled, for the human race or human nature, religion for education, the hereafter in heaven for the hereafter on earth, that is, the *historical future,* the future of mankind."[5]

Bloch has not gone beyond Feuerbach in one important respect: for Feuerbach (before Frazer and Freud) had glimpsed the psychological and anthropological ground out of which religious projection emerges. With Feuerbach, religion rises from the socially conditioned compound of fear and wish which confronts the primitive (and the child, though he did not

2. Jürgen Habermas, "Ernst Bloch—A Marxist Romantic," *Salmagundi,* no. 10–11 (Fall 1969–Winter 1970), p. 313.
3. *Man on His Own,* p. 223.
4. *Ibid.,* p. 224.
5. *Lectures on the Essence of Religion* (New York, 1967), pp. 281, 284.

draw the parallel) at the dawn, creating in him a feeling of dependency which could only be overcome by wish-projection into the void. "The needs and interests of uncivilized man are all below the belt."[6] In religion "man looks for defenses against what he feels dependent on"; "the secrets of religion find their solution and clarification not only in anthropology, but even in pathology as well."[7] It may follow from this that religion is one historically determined aspect of the Utopian principle. God walked the earth as man and lay down upon the green grass before ever he ascended into that space in which Feuerbach and Bloch found him. That space of the deity had previously been filled—by the images of desire, of wish born of fear. The Utopian urge originates in the desire to restore an earlier state of gratification (in Freud and Ferenczi, the mother-infant Eden-eternity; in Engels, primitive matriarchal communism). Utopia arises biographically and biologically before it takes on the raiment of history.[8] If this is correct, then the rise of communal life and class society finds Utopia already at hand awaiting the repressive shapings and redirections of civilization. The first socially molded form of Utopia is the magnified image of the biological Eden, seen as the Golden Age, Paradise before the Fall, before the intrusion of the Fathers. With the stratification of society and the formation of intellectual elites charged with the ordering of communal and class ritual, Utopia is deflected into the hereafters of organized religion. Only then does religion substitute for (suppress) Utopia. Man is compelled to accept as wholly formed and hypostatized the class-derived images of religious Utopia.

But the Utopian principle did not decay. During the millennia of religious channeling of Utopian desires into ritual, Utopia moved underground, into the folk traditions of the common people, into a synthesis of social and pagan-religious strivings. Utopia and the negative-theology of paganism merged; the outlaw and the Utopian hero became synonymous: Sherwood Forest is both the image of a tree-worshipping paganism and an archetypal image of Utopia—the shaded Eden of the British poor. The folk tale and the fairy tale, Matty Groves and the Jew Among the Thorns, the avoidance of tragedy, the insistence on the happy ending, on the miracle of

6. *Ibid.*, p. 76.

7. *Ibid.*, pp. 34, 35.

8. The closing lines of *Das Prinzip Hoffnung* indicate that Bloch himself identified communism as the fulfillment and re-creation of the earliest harmony: "When [man] has comprehended himself and has grounded his life in real democracy without renunciation and estrangement, then there arises in the world something which appears to us all in childhood, and in which none of us yet was—home."

survival and the openness of future expectation keep alive man's attempt to lighten the burden of a supposed mythic (class) destiny.

The Church had harnessed Utopia to religious eschatology. With the bourgeois revolution, however, the entire force of dispossessed eschatology is released and reconverted into Utopia (Buber). Utopia explodes into philosophy and the social sciences, creating the foundations of Communist theory. Utopia surfaces in the ballad and folk-tale revival, and from the creative arts, where it has been kept alive within Don Quixote's Cave of Montesinos, in Kepler's Somnium, on Crusoe's island, and becomes the transcendent swan song of an enlightened but doomed feudal aristocracy. Utopia explodes into view once again in *The Magic Flute* and the *Caprichos,* in the *Grosse Fuge,* in Daumier's *Émigrés,* in the pre-Raphaelitism of Morris's Brotherhood, in Goncharov's *Oblomov* (who says "No" to a progress which excludes beauty and love), in Dostoevsky's Myshkin, in Melville's *Typee* and *Omoo,* in Cooper's primeval forest, on Mann's *Magic Mountain.*

It is at this point that Utopia again undergoes the process of rationalization; Utopia becomes "science" (or science-fiction)—the projection of the tendencies of the present into the future, the extrapolation of contemporary experience into predictive portrayals of life on earth to come. Perhaps it is the dialectic of Utopia that it tends to be converted into science and is then negated to the degree to which it does not conform to history. But the pseudo-scientific Utopias (which Marx and Engels criticized) do not touch the essence of the Utopian spirit: the interweaving of fear and wish into a visionary future modeled on remembrances (imaginary or partially real) of the past. The Utopia of the common people existed before the Fall, before the origins of the monogamous family, private property, and the institutions of the state. It resided in primitive communism, cleansed of the terrors of nature, remembered in the glow of memory as the time of unity with the mother and fraternity with the children. The "scientific" Utopias of Wells, of Bellamy, of Zamyatin, Huxley, and Orwell, are the negation of Utopian transcendence in art—of Dante's *Paradiso,* Shakespeare's *Tempest,* Beethoven's Ninth Symphony, Blake's *Jerusalem,* Ibsen's Gyntiana. For Bloch, the masterworks of art (including the tragic) are Utopian by nature: "The permanence and greatness of major works of art consist precisely in their operation through a fulness of pre-semblance and of realms of utopian significance."[9] The artistic concretizations of Utopian thought contain portions of the blueprints of history, those designs of

9. Bloch, *A Philosophy of the Future* (New York, 1970), p. 94.

mankind's dream cities which Bloch seeks to make visible in his Principle of Hope.

━━━

From Bloch's *A Philosophy of the Future,* the chapters entitled "The Meaning of Utopia" and "Utopia in Archetypes and Works of Art" are reprinted here. Bloch writes that dreams rise from unfulfilled wishes; the night dream is a journey into the past; the daydream is a means of "overtaking" the future, "concerned with an as far as possible unrestricted journey forward," projecting the "images of that which is not yet" into existence.[10] Utopian thought is born and takes externalized shape in a variety of territories—the "geography" of Utopia which fills life and art and philosophy and science with its projections. Utopian thought is exempt from the rule that ideology reflects the ruling class, because its connection with its own time "is always negative." Unlike ideologies, Utopias "do not vindicate and proclaim the ruling class of their society." The great Utopians speak "on behalf of the *coming* bearers of society, and for the particular *tendency to come."* And Utopia is exempt from superstructural decay to the extent that its ideas are "not yet," for "only that which has never yet come to pass never grows old."

Here we encounter a major difficulty in Bloch's ontology. In splitting the daydream from the night dream, and in exempting Utopian projections from any necessary connection with the ruling class, Bloch fails to provide the psychological and the historical mechanisms by which wishes clothe themselves in futuristic patterns. The unfulfilled wish of the present cannot generate a vision of the future, since the present (by definition) lacks those very elements which the wish seeks to possess; and the class which is "not yet" similarly cannot envision its own destiny except by reference to a past in which it itself did not exist. By implication, Bloch posits a self-generating idea. To avoid this crucial difficulty, he therefore proposes that the Utopian mode of thought finds its imagery in "the acquired or 'inherited' *basic images* of the imagination—the famous 'archetypes' " and radiant memories of a past Golden Age. This supplies the missing link, of course, but it breaks another link in the process, for it does not give any explanation of the origin of the mythic Golden Age. Surely these images of past

10. Following Harvey Cox (*Man on His Own,* p. 11), Harry Slochower stresses the essential difference between Freud and Bloch: "Where Freud focuses on what is no longer, or may never become, conscious, Bloch dwells on what has not yet become conscious." ("Introducing: Ernst Bloch," *Judaism,* vol. XXI [Winter 1972], p. 115).

Paradise are the stuff of Utopia; the archetypal heritage is acquired by the present as it is passed down through history. But it did not create itself; Jung and Mircea Eliade to the contrary, it was not there at the beginning, *in illo tempore*. Perception is memory. Dreams are memories transformed into wish fulfillments. Utopia is formed from recollection: it cannot generate the future out of itself. Utopian thought arises from an attempt to *recreate* a biographical or historical locus in which individual or collective gratification had (or was imagined to have) taken place. (Compare Marx: *"All* emancipation is *restoration* of the human world and the relationships of *men themselves."*[11]) Utopian tendencies rise from the gulf between reality and expectation (Paul Tillich) but the images of Utopia are shaped by the memory traces of the past. As Benjamin wrote, "Every feeling is attached to an a priori object, and the presentation of the latter is the phenomenology of the former."[12] Utopian goals arise from disharmony and dislocation (whether these be biological in substance or rooted in the family or social structure) and are achieved in fantasy as prelude to and model for a desired transformation of the individual or of society, a prelude which, when it finds no counterpart in reality, itself becomes part of the fantasy world of past gratification—for illusory gratification in turn is transformed into memory and thereby becomes "historical." Wish, by itself, is not Utopia. Utopia is not chaotic desire: it is *formed* wish, collectivized dream; its contents are the memories of fulfillment organized into imaginative futuristic structures. Marx, in a passage that we have already cited, knew this when he wrote "the world has long dreamed of something of which it only has to become conscious in order to possess it in actuality."[13] Utopia, then, is the social materialization of unconscious desire at the juncture of its historical coming-into-consciousness.

Whether or not Bloch grasps the mechanism by which Utopia generates its projections of daydream upon the screen of the future is a secondary question. For he has recognized in the manifold historical forms of crystallization of Utopian consciousness the embodiment of anticipation, the vision of the horizon, the dream of the space which must be filled, the presemblance of the dawn, the window of the future. For Bloch, then, art is not bound by its temporality. A great work "does not perish with the passing of time: it belongs only ideologically, not creatively, to the age in which it is socially rooted." The concept of progress applies to history, to

11. Easton and Guddat, *Writings of the Young Marx,* p. 241.

12. Cited in Fredric Jameson, "Walter Benjamin, or Nostalgia," *Salmagundi,* no. 10–11, p. 52.

13. Letter to Ruge, September 1843.

the forces of production and to the economic basis, but "it can be relatively invalid in the case of the superstructure."[14] For Bloch, art is a single, slender, swaying bridge to a classless Paradise. Progress in art is only apparently absent: art does progress toward completion (the achievement of Utopia as reality; i.e., the negation of Utopia). And because its goals have not yet come to pass it does not age. The eternity which stretches from our present prehistory to that history which we have not yet entered is informed with the artistic embodiments which keep the hope of history and fulfillment alive. Art is the bridge, the filament which has stored up man's capacity to "dream ahead" (*Traum nach vorwärts*), awaiting release of its energies by renewed contact with a revolutionary audience. If the thread were to be severed, not-yet would become never. Bloch's "principle of hope" aims to reverse the diminishing belief in art, progress, and paradise. The twentieth-century flight of art to "the margins of society" (Edgar Wind), the postindustrial negative forms of art, tend to abandon the archetypes of the past. El Dorado, Eden, The Land of Cockaigne, the Big Rock Candy Mountain, Pastures of Plenty, Oleana, the Island of Apples, the Happy Hunting Grounds, Poor Man's Heaven—all are submerged in the narcissistic anguish of the present moment. Closed off from memory of Eden we cannot enter the gates of Paradise. Art's crystallization of dream is subject to the intrusion of the heavy nightmare of class repression and individual trauma. All of art's intermediate stages are incomplete (Paradise is not yet); together they form the totality of a Utopia from which we may launch the next dream (Marx: "Storming heaven") into that space which must and will be filled.

We are fast approaching a point beyond which Marxism cannot travel without transmuting itself into theology, and we had better be aware of this possibility before we cross the line. (Otherwise we will not know the road back.) For the dialectical coordinate of hope is despair, and the ontology of not-yet by itself may involve a futuristic and messianic quiescence which can only be shattered by the collective outcry of "Now!"

The philosophy of hope masks the agony and malaise from which it rises. One wonders whether Bloch has not suppressed the tragic component of the dialectic from view (Marcuse is more self-revelatory than Bloch in this respect). Despair—Hitler, Auschwitz, the Yezhov purges, Hiroshima,

14. Compare Marx's marginal note to *The German Ideology:* "There is no history of politics, law, science, etc., of art, religion, etc." (Moscow, 1964, p. 657.) See also the Introduction to *A Contribution to the Critique of Political Economy*, p. 309.

Vietnam, Indonesia, Attica—is the root; hope is the branch and the quest. Yourii's outcry in *Sanin* haunts Bloch: "Why should I sacrifice my own life or submit to insult and death in order that the working classes in the thirty-second century may not suffer through want of food or of sexual satisfaction?" Bloch's answer: "While these present ends are enclosed within the possible range of a human life, they must *at the same time* set their sights on the distant goal of a society without alienation. The perspective . . . must not leap over the route to the ideal, but follow its stages without abandoning the ideal."[15] We are not condemned to universal "Sisyphusdom": "hope is moving; with close-range objectives in mind when the long-range end is considered, and . . . with long-range end in mind when the close-range objectives are in view. It is precisely hope (to the extent that it is joined to a world that does not surrender) that neither falls into despair nor sinks into quietist confidence."[16]

Plekhanov too had said not-yet, where Lenin had insisted that ripeness was not all. We are in constant motion toward the unreachable goal—a void that we would fill with passion and with the accumulated desires of an unfulfilled present, modeled on the memories of every man's Golden Age. But—and Bloch, who is a Communist to the bone, knows it well—not-yet is also here-and-now: it intrudes into the present as revolutionary consciousness, as the conditional victory of a single revolutionary moment. Eternal postponement is theological submission, though sensibility must be tempered by renunciation if revolution itself would not be postponed. The cry of *"l'imagination au pouvoir"* requires the echoing call "Power to the People!" if mankind is to break with theological delay. Bloch writes: "The morrow lives in today, and is constantly inquired after. . . . Happiness, freedom, non-alienation, the golden age, the land flowing with milk and honey, the eternal feminine, the trumpet call in *Fidelio,* and the Christ pattern of the resurrection day afterwards—these are so many and diverse witnesses and pictures, yet all have but one focus."[17] Art and the idea of revolution are fragments of that focus.

15. *Man on His Own,* p. 86.
16. *Ibid.,* p. 90.
17. *On Karl Marx,* p. 43.

BLOCH: <u>ON THE THREEPENNY OPERA</u>
from *The Heritage of this Time*

A good many people appreciated its special humor. It was fun, they could hum those tunes all the way home. Sweet or bitter, those were catchy songs, with a curious acerbity to them, yet nothing really disturbing. They made you laugh, therefore they had to be harmless. The hit tunes were of the kind one danced to, though they were better stuff than most. And Peachum's beggars appeared to be quite content with their situation, to judge by the fine time they seemed to be having doing their comic turns and songs. It had a fresh sound that made even the normally inert feel like dancing.

And yet—how fresh was it really? Weill's actual achievement was rather to dredge up, in a lively way, the deep rottenness at the source of the commercial hit song in particular.

> Instead of, instead of, staying at home
> They've got to go out for their kicks

The off-key notes and off-rhythms of these "kicks" are fully exploited and exposed, musically. By this means the audience is tricked in the moment of gratification they usually get out of their hit songs; the hit as a consumer good is switched for something exposed as a synthetic facsimile, as *ersatz*. Behind his facile, even vulgar mask, Weill managed to reach many listeners not ordinarily accessible to good modern music. Even though very few of these were working class people, Weill made of the mixture of "better-class" people not a "folk" audience but a corrupt society whose decomposition goes to the very root of his light music. Weill is not the monolithic and precise radical, like Eisler, and certainly not "musicianly" or faux-naif like that social-democratic primitive, Hindemith. Least of all does he treat the hit as song, as a new kind of folk song. For a long time now the hit song has been a product for sale; especially the more recent sort, derived from poor blacks and from the more refined basic emotions, tends to be quite standardized and rootless, anonymous and meaningless, as a means to filling a need. But there is also, in the hit song, a touch of adultery, of the brothel and the sideshow just off the glittering grand boulevard. While fully conforming to the current fashion in its rhythms, melody, text, there is a twisted look, a penny-sheet cheapness, underneath all that superficial greasepaint which it superficially wipes off. This low-life quality actually gives it a durability beyond that enjoyed by the average popular music of

its period (the tenacity with which some of the early hits hang on in our unconscious is amazing). Because the time was in ferment, *The Threepenny Opera* was able to latch on to this low-life quality: its beggars and crooks are no longer merely the stock types of opera buffa, the "come as a tramp" costume ball, or of social welfare; they stand for the decomposition of society itself. This is what underlies those sounds, the dulcet sneering of Brecht, his razor-edged lightness, the doggerel of Mack-the-Knife and Tiger Brown. This is also behind the sweet, high-pitched voice of Lotte Lenya, light, dangerous, cool with the glimmer of the crescent moon, and behind the daemonic ballad, when she finally gets it out, of Pirate Jenny.

Without Stravinsky's bold representation of decay in his *Histoire du Soldat,* there would have been no *Threepenny Opera;* but it would have been even less thinkable without the actual historic decadence, and least of all without those hit songs of the 1880's. What is pungent in them as well as schmaltzy has never been bettered except in the music in which they are cited. The broken-voiced beauty of the trumpet passage when Polly bids farewell to her highwayman becomes the evocation of a life that has yet to be lived. The experimental *Threepenny Opera* has put the worst kind of music at the service of the most advanced music of our day, and in so doing has revealed itself as dangerous. It took the common whore of our city streets and turned her into an anarchist smuggler, or at least an anarchist.

Various features intermingle, rub elbows: the edgy tone and the fusty air, the self-contained "number" and the mutinous message, the simplified forms and the extraordinary polytonality of Pirate Jenny's dream, the gay melodies and the proliferating despair; and, in the end, a finale that blows up everything. The song does not advance the action but merely reports on it, like any conventional aria; but what it reports is, without exception, a state of the damned (as in the infernal "Do you feel my heart beating" lyrics). Here, an old basement may do duty as a house, a new roof be plunked on the ground, nor will a cross-section of the two help us to predict, let alone foster, a new society. In any case the pleasure of such music, though it does not impede social change, is not exactly conducive to it; it rarely contains a concealed weapon. Besides, there are limits to what art can do, even an art more potent than the experimental *Threepenny Opera,* with its aggressive hit songs. The nail hit on the head by even the most politically calculated music and poetry turns only indirectly into a nail for the coffin of the Establishment. But whereas music cannot change a society, it can, as Wiesengrund rightly says, signalize an impending change by "absorbing" and proclaiming whatever is decomposing and re-forming beneath the surface. Most of all it sheds light on the impulses of those who

would be marching toward the future in any case, but can do so more easily with its help. Weill's music is the only one today with any socio-polemic impact: the wind whistles right through it, the wind that can blow freely only where there are as yet no structures to curb it, where time has not yet turned into reality. Weill has once and for all broken the spell of the "musicianly" performers on their "folk." The Cannon Song of Mac-heath and Tiger Brown shows that there are soldiers on the Left, as well; the real soldiers, in fact. And Pirate Jenny managed, fleetingly, to touch the people's hearts as a true heroine of their cause, dreamer of their dreams, as much as any "pure" heroine of traditional ballad. Nothing else reveals more clearly how much the popular song, and the pleasure of class-barrier-obliterating extemporization can do nowadays.

BLOCH: **THE MEANING OF UTOPIA**
from *A Philosophy of the Future*

Dreams come in the day as well as at night. And both kinds of dreaming are motivated by wishes they seek to fulfill. But day-dreams differ from night-dreams; for the day-dreaming "I" persists throughout, consciously, pri-vately, envisaging the circumstances and images of a desired, better life. The content of the day-dream is not, like that of the night-dream, a journey back into repressed experiences and their associations. It is concerned with an as far as possible unrestricted journey forward, so that instead of recon-stituting that which is no longer conscious, the images of that which is not yet can be phantasied into life and into the world.

Castles built in the air of walks or quiet moments are often empty and shaky because the fixtures and foundations have received little attention during construction, yet often extravagantly daring and beautiful because building-costs were never a consideration. A child's dreaming about pres-ents belongs here; or a youth's desire to be a great man—and above all the image he has of his future beloved. Azure day-dreams range from everyday conceits of self-assertion and revenge, from commonplace reveries of gold linings and gold brocade, all the way to plans for world improvement that are no longer merely focussed on the deserving ego of the dreamer-antici-pator. All the same a sort of rhapsodic enthusiasm can carry the dreamer over any consideration of means and situation; equally it can keep him restless and expectant, full of life and therefore of possible striving ahead.

This is especially true if the day-dream emerges from its mere make-believe. Still, its make-believe pursues it in its actual form, and indeed has a social function in doing so. All those distracting, gilded con-dreams

belong here: all those sham images that misrepresent *u* as *x;* all those daytime dreams of pulp literature in which an impossible stroke of good fortune befalls some poor devil, and in which the happy ending is unhappy deceit. The day-dream of good fortune operates quite differently in the oldest known form of utopian narrative—the fairy tale, where there is no mere distraction and voyeuristic palliation, but a vital stimulus and direct relevance. The brave little tailor conquers the ogres with cunning, that Chaplinesque weapon of the poor, and wins the beautiful princess. And plenty without labor as a frontier-motif is alive in the tale of Cockaigne, where the mountains are changed into cheese, sausages hang from the vines, and the streams are flowing with best Muscatel.

The geographical utopias are not so remote from Cockaigne: the land of milk and honey is the best-known, the earthly paradise that Columbus imagined must lie to the West has been most fraught with consequence. But fairy tales also contain imaginative forecasts of some technical-utopian objects—by no means only in a magical and hence impossible form. "Table, lay yourself!"; the magic horse; the magic carpet; Aladdin's admittedly absurd wish-fulfillment properties; all offer their services and evoke longing: "If only man could do that!"

One might even cull fairy tales to make an inventory of discoveries that have not yet been made—a kind of technical utopia. Bacon's *New Atlantis* already offers an array of this type. Yes, social, geographical and technical utopias are available in the fairy-tale world, and the utopian quality is found in many more areas than its restriction to the so-called utopian romance or novel would allow. This limitation of the utopian theme must eventually cease, yet its somewhat tepid extension to "science fiction" is hardly even half-adequate. Instead, from the consciousness of children and young people (not only desirous or covetous of new things, but believing themselves to be virtually bubbling with new ideas); from times of social and cultural upheaval; from the products of the creative spirit and the countries that it has really appear above the horizon for the first time— lands that were never thus seen before, have never thus been before: from all these there arises a utopian territory of problems, categories and spheres that itself was hardly ever thus envisaged. It is not only that there is (or need be) no tallying with mere humbug in daydreaming, or with "fairy tales" in the pejorative sense, but that even the social utopias themselves (though admittedly they form the main stream of all utopian books) function only in the midst of other, specific utopian areas, with reference to human culture as a whole—indeed to Nature independent of men.

Accordingly, life as a whole is full of utopian projections, mirrored ideals, dream-manufactories, and travel pictures. In literature there are the

characters who stride out ahead into what is not yet manifest; from the wretched Zendelwald in Keller's *Seven Legends,* or Michael Hellriegel in Gerhart Hauptmann's *And Pippa Dances,* right up to the incomparably powerful *Don Giovanni* and *Faust*—not forgetting the admonitory figure of Don Quixote. Above all, for particular spheres of endeavour, there are the utopian lands of medical, technical, architectural and geographical expansion and attainment. Even in the ancestral territory of utopias, the social utopias are not alone: next to the images of possible human happiness in the social utopias, the rational images of possible human dignity are projected as teachings of natural law. And closer still, in effective existence, regarding not perspectives but perplexities, there appear the (always overtaking) moral guiding images and ideals, and the topically still unidentified no-where whither music leads. And again, think of the particular utopia in the many images conjured up as specifics against death, and closely related thereto, in the wish-mysteries of various religions and the Christian mysteries of hope. Item: *humanism has developed in utopia,* and philosophy is justifiably speculative since the actions, testimonies, problems and postulates of not-yet-being mark out its central and in no way merely empirical area of operation.

However, it is necessary that precisely the more common dreams should set their sights appropriately ahead. Their outlines have abandoned mere private wishful thinking, and in most cases have nothing at all in common with it. Neverthless a distinction has to be made between the utopistic and the utopian; the one approaches circumstances only immediately and abstractly, in order to improve them in a purely cerebral fashion, whereas the other has always brought along the constructional equipment of externality. Of course only utopism, as it reaches out abstractly *above* reality, need not fight shy of a mere empiricism that undertakes only another form of abstract apprehension *below* reality. A real utopian critique can only proceed from a viewpoint that is adequate, that does not—so to speak— correct or even replace over-flying by a factistic creeping.

"That's rather utopian!" as a smart depreciative judgment from businessmen's lips, a kind of stock dismissive remark, has at any rate become a phrase denoting anxiety about the future in general. Nevertheless, and precisely because of this, an essential and fundamental distinction must be made between utopias that come to be in the abstract and in the concrete. Social utopias in particular were liable to be abstract, because their designs were not mediated with the existing social tendency and possibility; indeed, they *had to be* abstract, because (precisely on account of existing tendencies and stages of development) they came too early. Hence the Utopians all too frequently had to construct the outlines of a brave new

world out of their own hearts and heads—or, as Engels says: "For the basic plan of their new edifice they could only appeal to reason, just because they could not as yet appeal to contemporary history."[1]

This is true even of the (by no means inimical to the world) schemes of Owen and Fourier (federalistically oriented), of Saint-Simon (with a centralistic orientation); it is properly true of the real and very different "anti-world" humanism in most social utopias. At all events, even if utopian humanism did not accord at all with the existing world, then it may be said: the worse for that still existing world, and the more inevitable and fruitful thought about justice. For this reason, Engels (independently of later deviationists who were far from having a scrupulous concern for humanism) also remarked of Owen, Fourier and Saint-Simon: "We delight in the inspired ideas and germs of ideas which everywhere emerge through their covering of phantasy." Both in Fourier's "critique of existing social conditions" and in Saint-Simon's "breadth of vision of a genius, thanks to which almost all the ideas of the later socialists which are not strictly economic can be found in embryo."[2]

And so, lest the undeniable abstractness of this social-utopian element be exaggerated, the clearly social *schedule* of all these schemes for world-improvement must be remembered. In spite of excessive dreams of the future, they are touched by their own time—precisely because their connexion with it is always negative. Because, unlike ideologies, they do not vindicate and proclaim the ruling class of their society, but rather wish to lay the plans for the future dwelling-place of a new class making its way through for the first time; and do this half as—so to speak—advance billet parties, and half as effective architects of *homo homini homo.* Hence the great Utopians spoke out on behalf of the *coming* bearers of society, and for the particular *tendency to come.* Obviously the interest they assume is no existing, ruling one, but one on the ascent. With Sir Thomas More it is a freer market system, with Campanella the period of absolutist manufacture, and with Saint-Simon the new, more socialized, magical *"de l'industrie."* Consequently, even the utopia that was still an abstract outline (not to mention that which had reached a concrete form) was not the cloud-cuckoo-land implied in the use of "utopia" as a pejorative term by those who found it absurd or even abhorrent.

But the main thing persists and, persisting, holds more importance than the journey's plan, which is not decisive in principle. The main thing is that utopian conscience-and-knowledge, through the pain it suffers in facts,

1. *Anti-Dühring,* p. 290.
2. *Ibid.,* 284.

grows wise, yet does not grow to full wisdom. It is *rectified*—but never *refuted* by the mere power of that which, at any particular time, *is*. On the contrary it confutes and judges the existent if it is failing, and failing inhumanly; indeed, first and foremost it provides the *standard* to measure such facticity precisely as departure from the Right; and above all to measure it immanently: that is, by ideas which have resounded and informed from time immemorial before such a departure, and which are still displayed and proposed in the face of it.

With the prefigured utopia of the *citoyen,* Hölderlin's *Hyperion* rectified the bourgeois (then established); and the *citoyen* was not shelved but remained particularly and naggingly insistent. Of course there is Schiller's dictum with its idealism, its resignation: "Only that which has never come to pass never grows old." But when applied to the *utopicum* and what that postulates, its truth relies solely upon a utopian interpolation—the adverbial "not yet." Then, *cum grano salis* (seasoned with the salt of historically exact understanding, the understanding of latency), the saying is just: "Only that which has never yet come to pass never grows old." It is just in respect of that life beyond labor hinted at in almost all social utopias; or in respect of a coming to be human through fit aims and profound perspectives about us. This not-yet was imaged and imagined in the obviously utopian constructions of great art and religion; it remains unsatisfied in the before-us. Indeed, the more an age sceptically renounces or is dogmatically removed from the not-yet, the more it solicits it. But in any case, without the dimension of the future, conceivable for us as an adequate future, no empirical being will endure long. And so in ages of growing darkness at least a *horror vacui,* and in ages of increasing enlightenment always a *plus ultra,* shows that utopian consciousness is alive.

All the worse then, if a society that will no longer be reconciled in an abstract-utopian manner, but demands the way to the thing itself, errs on the way—and errs dangerously. All the worse if the revolutionary capacity is not there to execute ideals which have been represented abstractly, rather than to discredit or even destroy with catastrophic means ideals which have not appeared in the concrete. Action will release available transitional tendencies into active freedom only if the utopian goal is clearly visible, unadulterated and unrenounced. Even though the utopias have at best promised their still so palpable optima, but have promised them as *objectively* and *really* possible.

BLOCH: **UTOPIA IN ARCHETYPES AND WORKS OF ART**
from *A Philosophy of the Future*

It was proper that dreaming ahead should image that which lay ahead.
Only later was a concept added; for a long time it did not seem an essential
part of the concerns of Thomas More and similar imaginists. Of course this
is only apparently the case, and indeed a fundamental misunderstanding of
such works; nevertheless these utopian constructions were cast in a flaw-
lessly narrative form. They might even be called fairy tales of the com-
monwealth, not mere "novels" of civil society. For this fairy-tale element
had a more than fictive reference, and did more than equate dreams with
shadows. Many fairy tales, such as those about poor children or brave
young men, are powered by a distinct image of happiness, and are already
on the utopian march towards the happy end. Similarly the fairy tale of the
commonwealth was reminiscent above all of the ancient folk dreams,
which had their own already utopian characteristic in the shape of a search
for "good fortune."

But the fairy tale, replete with phantasy, also has a utopian connexion
with so-called "pre-logical" forms—a figurative connexion, yet one in no
way antithetical to the conceptual form of a later period and its enlighten-
ment (which indeed is itself an image). The fairy tale is related to the
acquired or "inherited" *basic images* of the imagination—the famous
"archetypes." Whereas the fairy-tale element, as distinct from the saga, is
not a degenerate form of myth but has a quite specific origin that is even
inimical to the stratified higher social form of the myth, the archetypal
figurative material largely remained in, and expressed itself by virtue of the
context of myth. Consequently the archetypal was stressed not only as
pre-logical but—in essence quite unjustly—as wholly irrational. Jung, for
instance, relegated the archetypal to an unthinking "unconscious of more
than 500 thousand years ago," from which he would allow it only to
"emerge"—quite without future—as no more than *regressio.*

Yet archetypal images have constantly recurred in history (just think of
the dancing on the ruins of the Bastille); and, in the midst of their mythical
context, the really ancient ones often display a wholly luminous, thrustingly
utopian sense and purpose—for example, the radiant memory of the
Golden Age, conceived of as a buried age, or as one approaching in the
future. The latter sort of archetype is already intrinsically utopian and also
appears in the fairy tale as the archetype of Cockaigne or the Never-never
Land.

Many other encapsulated archetypes—such as the invisible castle, or the

saviour king, and their mythicized context—must be cracked on their so to say utopian content. Admittedly a very few archetypes of suppression and lordship—such as the Medusa, or even the Olympian god and his lightning—are without hope. But the encysted or openly humane archetypes are not devoid of the utopian notion; they do not brood, diluvian and mysterious, in the depths of the unconscious. Everyone knows them from his present existence—by the power of images which strike, stimulate, and illumine. Everyone meets them in works of art and in the situations and forms of conflict and resolution they feature; in the inexhaustible power of unequivocal symbols; and even in multi-ambiguous allegories. The enemy, the mother, the saviour; the tyrant's castle and its taking by storm; the labyrinth and Ariadne's thread; the dragon killer; and the saviour in the form of a servant, and his disclosures (Odysseus arriving home, or Jesus): these are archetypes. All scenes of *anagnorisis,* of sudden recognition, are archetypal (Electra and Orestes, Joseph and his brothers), as is the way out of darkness into light—the Exodus from Egypt towards the land of Canaan. The latter fundamental image is already *archetypal utopia* itself; to which land belong the clarion-call of the Gallic cock, the storming of the Bastille, and the dancing on its ruins, when Perseus whose second name is Revolution has liberated more than Andromeda. But it also appears in archetypes with a much more tenuous reference to the Golden Age and the obstacles in its way; for without their crypto-utopian dream enclaves they would all be one gigantic sport or Olympian phantasm—or just the player's Hecuba.

The dream of the conformably human has no faint heart: it looks out for *more.* Not only in the basic acquired images, but in additional newly-fashioned images—in the *works of art* that apply them. Therefore a "significant" work does not perish with the passing of time: it belongs only ideologically, not creatively, to the age in which it is socially rooted. The permanence and greatness of major works of art consist precisely in their operation through a fulness of pre-semblance and of realms of utopian significance. These reside, so to speak, in the windows of such works; and always in windows which open in the direction of ultimate anticipation: driving forward, soaring, or achieving towards a goal—which is never a mere land in the clouds above. One of the most obvious examples of this kind of work of art is *Fidelio,* informed with the striving of the French Revolution.

But even *static* works of art of enduring quality are not wholly circumscribed by their transient existential basis and its corresponding ideology. The slave-holding society of the ancient Greeks, for instance, is a social form we can hardly conceive of at the present time; yet the art of that very

society has provided a "model" by which, much later in time, a form of art has sought to prove its value, or to show its contrasting power. Mediaeval art was tied to a feudal, hierarchical society; today its feudal-clerical patrons can be evoked only as phantoms in comparison with their reality; yet the inwardness, order and mysticism of the art of the Middle Ages still affect us, for they rank above the hierarchies of their own time, and above the mythological out-there. In these cases a "cultural surplus" is clearly effective: something that moves above and beyond the ideology of a particular age. Only this "plus" persists through the ages, once the social basis and ideology of an epoch have decayed; and remains as the substrate that will bear fruit and be a heritage for other times. The substrate is essentially utopian, and the only notion that accords with it is the utopian-concrete concept. Art is not merely the ideology of a particular ruling class, let alone its propagandist servant. And a combined application of sound economic analysis (which removes scales from the eyes) and of sociologistic-schematic blinkers (which serve only as replacements for the scales), even in the form of Georg Lukács's theory of literature, merely obscures the utopian perspective of every great work of art.

Even in the midst of the most triumphant feeling of achievement, there flashed and shone that so often so intractable blue, the fleeting promise of that which is missing: the supreme illumination and above all the most human thing that the perfection of a work of art can afford. Hence Michelangelo called Ghiberti's bronze gates for the baptistry in Florence, "fit to be the gates of Paradise." Of course this ecstatic declaration says nothing of Paradise itself; yet its initial promise of a threshold (Yet that thy *bronze* gates of heaven may ope, and give sweet passage . . .) must be counted with the blue and gold in the window as a further utopian characteristic of a great work of art (indeed, of a great work *tout court*), and as the least deceptive of such signs.

Utopian consciousness remains wholly without deception inasmuch as the moment of its fulfillment is still outstanding—and certainly not for sceptical or agnostic reasons. Yet this utopian consciousness in a work (of art) does not obscure its binding goal with solutions, let alone with mere reified *means* from the route to that goal, and then (even on a Hegelian level) offer an absolutized half-light in conclusion. Its reason for not doing that is superlatively *real*—the most objective correlative ground that utopian consciousness possesses: The world-substance, mundane matter itself, is not yet finished and complete, but persists in a utopian-open state, i.e., a state in which its self-identity is not yet manifest.

If things are commonly seen only as they are, it is not uncommonly paradoxical to put at least as much trust in *their ability to be other than*

they are. Therefore Oscar Wilde's remark about a map of the world without the land of Utopia not being worth a glance evokes no shock but the shock of recognition. True, things themselves offer only a dotted line of extension to something like that land; but all the world's positivists could not erase it from what really is so. Consequently not only the specific existent, but all given existence and being itself, has utopian margins which surround actuality with *real and objective possibility.* Consequently every work which represents and informs this possibility (and every work would accord with the *per definitionem* of "significance") is full of augmented horizon problems; and its own level depends on the level of such problems. Therefore great works of art can dispense least of all with the creative touch of poetic anticipation—not the concealment or repression but the presemblance of what, objectively, is still latent in the world.

This enables us to distinguish the *hermeneutics* of archetypes from that proper to works of art. All non-fairy-tale, non-aurora archetypes have to be opened up in order to discern their utopian content; but in great works of art (even in those that are obviously static and conformist), the self-light of this utopian presence glows on the horizon. In a work of art, sorrow and anguish never remain *unillumined*—just as they are; and joy always dawns as a fore-glow, with the depth and emphasis afforded by shadow. Even the great tragic fall, despite all its blood, death and darkness, and despite the Cross, never has the last word in the work of art, which is ultimately still open. Hence the phenomenon of optimistic tragedy, with a faint though definite richness and fullness even when the end seems so black. Lukács rightly counters "pessimistic tragedy" with this assertion: "The greatest tragedies that we have inherited from the past do not show forth the inescapable vanity and necessary annihilation of human endeavours, but on the contrary the actual or actually recurrent struggle between old and new, in which the collapse of the old, or the fall of the new when opposing the old with weak forces, crowns the realization—or at least the perspective of the realization—of a higher stage of development." Admittedly Lukács's standpoint is again mainly sociological, and he is using the phenomenon of tragedy and its perspective only as a device for non-aesthetic comprehension of social processes; nevertheless, the surplus containing the perspective, and therefore the utopia anticipated here as well by the work of art, is particularly clear in the apparent paradox of optimistic tragedy.

Both depressive and revivifying works of art allow their characters and situations to decline or to develop to that limit or horizon of being where, somehow, after all, there are gates. Schiller's *Ode to Joy* shines beyond what has been experienced hitherto, because (although—and since—it is

only an ode) it already names and summons perfect joy. Schiller supplemented this invocation of joy (it extends from "Daughter of Elysium" in a somewhat Kantian-postulative mode to the by no means factual though wholly utopian statement about the Deity: "He must dwell above the stars") with another in his poem *Columbus,* which is not concerned with Elysium but does say something about its attainable coastline in the utopian connotations of these verses:

> On, keep on! Steer by faith,
> And follow the reticent waters West,
> Where the coast of the land as yet unseen
> Must rise from this ocean.
> Genius and Nature are ever joined,
> And his promise will be her action.

Of course these lines are full of abstract idealism, but they also contain strength of purpose—will; and contain it (*qua* genius) in express conjunction with Nature which creates and naturizes. More than ever duty's call is to do what is within and not to abandon what lies without—not to leave it as it is; more than ever, that is, for every phenomenology of the "spirit" and of its works that makes no peace with the world as already given. Instead, the phenomenology of change and the changeable travels through the world in order to trace and advance what is not yet present in the world.

Utopia in works of art certainly makes fragmentary and negative the offerings of those that are significant, inasmuch as the world really signified in them is itself the least ready and finished of all: it is as often thwarted as it is seldom realized, as often traversed as it is seldom peopled. But an ode to joy is a most valiant effort, for it affords a venturesome even if—unfortunately—only a poetic premium; yet, philosophically too, no mean education is to be obtained from the testing end, and (more permanently) from the experimental beginning.

CONTRIBUTORS' BIBLIOGRAPHIES

THEODOR W. ADORNO

Works By

With Hanns Eisler. *Composing for the Films.* New York, 1947.
Negative Dialectics. New York, 1973.
Philosophy of Modern Music. New York, 1973.
Prisms. Translated by S. and S. Weber. London, 1967. Essays on Kafka,
 Bach, Schoenberg, Benjamin, and others.
"Society." Translated by F. Jameson. *Salmagundi,* no. 10–11 (Fall 1969–
 Winter 1970), 144–53.
"Sociology and Psychology." *New Left Review,* no. 46 (November–Decem-
 ber 1967), pp. 67–80; no. 47 (January–February 1968), pp. 79–96.

Works About

Adorno. "A European Scholar in America." In Donald Fleming and

Bernard Bailyn, eds. *The Intellectual Migration: Europe and America, 1930–1960,* pp. 338–70. Cambridge, Mass., 1969.

Fredric Jameson. "T. W. Adorno, Or, Historical Tropes." *Salmagundi,* vol. II, no. 1 (Spring 1967), 3–42. Reprinted in Jameson, *Marxism and Form.* Princeton, N.J., 1971.

———. "Introduction to T. W. Adorno." *Salmagundi,* no. 10–11 (Fall 1969–Winter 1970), 140–43.

Über Theodor W. Adorno. Essays by Kurt Oppens, Hans Kudszus, Jürgen Habermas, Bernard Willms, Hermann Schweppenhäuser and Ulrich Sonnemann. Frankfurt, 1968.

MIKHAIL BAKHTIN

Works By

Problemy Tvorchestva Dostoevskogo (*Problems of Dostoevsky's Creative Genius*). Leningrad, 1929. Reprinted as *Problemy Poetiki Dostoevskogo* (*Problems of Dostoevsky's Poetics*). Moscow, 1963.

Rabelais and His World, Translated by Helene Iswolsky. Cambridge, Mass., and London, 1968.

BÉLA BALÁZS

Works By

Der Geist des Films. Halle, 1930.

Der sichtbare Mensch, oder die Kultur des Films. Vienna and Leipzig, 1924; 2d edition: *Der sichtbare Mensch: Eine Film-Dramaturgie,* Halle, n.d. [1924?].

The Theory of the Film: Character and Growth of a New Art. Translated by Edith Bone. London, 1952. Reprinted New York, 1970 [1971]. Revised and enlarged edition: *Der Film: Werden und Wesen einer neuen Kunst.* Vienna, 1961.

Works About

Aladár Komlós. Introduction to Béla Balázs, *Az én Utam* (*My Road*). Budapest, 1958.

Georg Lukács. *Balázs Béla és akiknek nem kell (Béla Balázs: and those who don't want him)*. Gyoma, 1918.
Miklos Szabolcsi. Introduction to Béla Balázs, *Lehetetlen emberek (Impossible People)*. Budapest, 1965.

WALTER BENJAMIN

Works By

"The Author as Producer." Translated by John Heckman. *New Left Review*, no. 62 (July–August 1970), 83–96.
Briefe. Edited by T. W. Adorno and G. Scholem. Frankfurt, 1966.
Illuminations. Edited by Hannah Arendt, translated by Harry Zohn. New York, 1968.
"Paris—Capital of the Nineteenth Century." *New Left Review*, no. 48 (March–April 1968), 77–88.
Schriften. Edited by T. W. and G. Adorno. Frankfurt, 1955.
Understanding Brecht. London, 1973.

Works About

T. W. Adorno. "A Portrait of Walter Benjamin." In *Prisms*, pp. 229–41. London, 1967.
Hannah Arendt. "Walter Benjamin: 1892–1940." Introduction to Benjamin's *Illuminations*. New York, 1968.
Ben Brewster. "Walter Benjamin." *New Left Review*, no. 48 (March–April 1968), 72–76.
Fredric Jameson. "Walter Benjamin, or Nostalgia." *Salmagundi*, nos. 10–11 (Fall 1969–Winter 1970), 52–68. Reprinted in Jameson, *Marxism and Form*. Princeton, N.J., 1971.
Frank Kermode. "The Incomparable Benjamin." Review of *Illuminations*, in *New York Review of Books*, Dec. 18, 1969.
Shierry M. Weber. "Walter Benjamin: Commodity Fetishism, the Modern, and the Experience of History." In *The Unknown Dimension*, edited by D. Howard and K. E. Klare. New York and London, 1972.

ERNST BLOCH

Works By

Man on His Own. Translated by E. B. Ashton. New York, 1970. Selections from *The Spirit of Utopia, The Principle of Hope,* and other works.

"Odysseus Did Not Die in Ithaca." From *The Principle of Hope,* translated by Hanna Loewy and George Steiner. In *Homer—A Collection of Critical Essays,* edited by George Steiner and Robert Fables, pp. 81–85. Englewood Cliffs, N.J., 1962.

On Karl Marx. Translated by John Maxwell. New York, 1971.

A Philosophy for the Future. Translated by John Cumming. New York, 1970.

The Spirit of Utopia. Translation in preparation.

Works About

T. W. Adorno. "Blochs Spuren." In *Noten zur Literatur II,* pp. 131–51. Frankfurt, 1961.

Harvey Cox. Foreword to *Man on His Own,* pp. 7–18.

Rugard Otto Gropp, ed. *Ernst Bloch zum 70. Geburtstag.* Berlin, 1955.

David Gross. "Ernst Bloch: The Dialectics of Hope." In *The Unknown Dimension,* edited by D. Howard and K. E. Klare. New York and London, 1972.

Jürgen Habermas. "Ernst Bloch—A Marxist Romantic." In *Salmagundi,* no. 10–11 (Fall 1969–Winter 1970), 311–25.

Fredric Jameson. *Marxism and Form.* Princeton, N.J., 1971.

Jürgen Moltmann. Introduction to *Man on His Own,* pp. 19–30.

———. *Religion, Revolution and the Future,* pp. 148–76. New York, 1969.

Jürgen Rühle. *Literature and Revolution,* pp. 284–93. New York, Washington, and London, 1969.

Harry Slochower. "Introducing: Ernst Bloch." *Judaism,* vol. XXI (Winter 1972), 110–15.

Siegfried Unseld, ed. *Ernst Bloch zu ehren.* Frankfurt, 1965.

BERTOLT BRECHT

Works By

Brecht on Theatre: The Development of an Aesthetic. Edited and translated by John Willett. New York, 1964. A basic selection from multivolume *Schriften zum Theater* (Frankfurt, 1963–1964).
"Notes on Stanislavski." Translated by C. R. Mueller. *Tulane Drama Review,* vol. 9, no. 2 (Winter 1964), 155–66.

Works About

Walter Benjamin. "What is Epic Theater?" In *Illuminations,* pp. 149–56. New York, 1968.
Peter Demetz, ed. *Brecht: A Collection of Critical Essays.* Englewood Cliffs, N.J., 1962. Contains essays by Tretyakov, Ernst Schumacher, Hans Egon Holthusen, John Willett, Hannah Arendt, Martin Esslin, and others.
Martin Esslin. *Brecht: The Man and His Work.* New York, 1960.
———. "Brecht, the Absurd, and the Future." *Tulane Drama Review,* vol. 7, no. 4 (Summer 1963), 43–54.
Frederick Ewen. *Bertolt Brecht: His Life, His Art, and His Times.* New York, 1967.
Herbert Marcuse. *One-Dimensional Man.* Boston, 1964.
Erika Munk, ed. *Brecht.* New York, 1972. Contains essays by Bloch, Baxandall, Eric Bentley, Schumacher, and others.

ANDRÉ BRETON

Works By

"Limits Not Frontiers of Surrealism." In *Surrealism,* edited by Herbert Read, pp. 95–116. London, 1936.
Manifestoes of Surrealism. Translated by Richard Seaver and Helen R. Lane. Ann Arbor, Mich., 1969.
"Manifesto: Towards a Free Revolutionary Art." *Partisan Review,* Fall 1938, pp. 49–53. Co-authored with Leon Trotsky, though Diego Rivera's name appears as collaborator.
What Is Surrealism? Translated by David Gascoyne. London, 1936.

Works About

T. W. Adorno. "Looking Back on Surrealism." In *Literary Modernism,* edited by Irving Howe. Greenwich, Conn., 1967.
Anna Balakian. *Surrealism: The Road to the Absolute.* New York, 1970.
J. H. Matthews. *André Breton.* New York and London, 1967.
Maurice Nadeau. *The History of Surrealism.* New York, 1967.
Herbert Read. "Surrealism and the Romantic Principle." In *Selected Writings, Poetry and Criticism,* pp. 246–82. New York, 1964.
Jean-Paul Sartre. *What Is Literature?* New York, 1949.
Robert S. Short. "The Politics of Surrealism, 1920–1936." In *The Left-Wing Intellectuals Between the Wars, 1919–1939,* edited by Walter Laqueur and George L. Mosse, pp. 3–26. New York, 1966.
Yale French Studies, no. 31, May 1964. Surrealism issue.

NIKOLAI BUKHARIN

Works By

"Crisis of Capitalist Civilization." *International Literature,* 1934, no. 5, pp. 107–20.
Culture in Two Worlds. New York, 1934.
Historical Materialism, pp. 188–241. New York, 1925.
"Marx's Teaching and Its Historical Importance." In *Marxism and Modern Thought,* translated by Ralph Fox. New York, 1935.
"Poetry, Poetics and the Problems of Poetry in the U.S.S.R." Address to the All-Union Soviet Writers' Congress, August, 1934, in *Problems of Soviet Literature,* edited by H. G. Scott, pp. 185–258. Moscow and Leningrad, 1935.

Works About

E. H. Carr. Introduction to Bukharin and Preobazhensky. *ABC of Communism,* pp. 13–25. Baltimore, 1969.
———. *Socialism in One Country,* vol. 1, pp. 162–73. New York, 1958.
Antonio Gramsci. "Critical Notes on an Attempt at a Popular Presentation of Marxism by Bukharin." In *The Modern Prince and Other Writings,* pp. 90–117. New York, 1967.
Sidney Heitman. "Between Lenin and Stalin: Nikolai Bukharin." In *Revi-*

sionism: Essays on the History of Marxist Ideas, edited by Leopold Labedz, pp. 77–90. London, 1962.

————. *Nikolai T. Bukharin: A Bibliography.* Stanford, 1969.

Georg Lukács. "Technology and Social Relations." *New Left Review,* September–October 1966, pp. 27–34.

G. A. Wetter. *Dialectical Materialism,* pp. 92–99 (on Bogdanov), 143–48 (on Bukharin). New York and London, 1958.

CHRISTOPHER CAUDWELL

Works By

The Crisis in Physics. London, 1939. See especially Chapter 4.

Further Studies in a Dying Culture. London, 1949.

Illusion and Reality: A Study of the Sources of Poetry. London, 1937.

Romance and Realism. Princeton, N.J., 1970.

Studies in a Dying Culture. London, 1938.

Works About

Paul Beard. "Biographical Note." In Caudwell's *Poems,* pp. 7–10. London, 1939. Omitted from 1965 reprint.

Maurice Cornforth. "Caudwell and Marxism." *The Modern Quarterly,* vol. 6, no. 1 (Winter 1950–1951), 16–33.

Stanley Edgar Hyman. "Christopher Caudwell and Marxist Criticism." In *The Armed Vision.* New York, 1948. Omitted from Vintage paperback reprint.

David N. Margolies. *The Function of Literature: A Study of Christopher Caudwell's Aesthetics.* New York, 1969.

G. M. Matthews. Contribution to "The Caudwell Discussion." *The Modern Quarterly,* vol. 6, no. 3 (Summer 1951), 268–72.

George Moberg. "Christopher Caudwell: An Introduction to His Life and Work." Unpublished Ph.D. dissertation, Columbia University, 1968.

George Thomson. "In Defence of Poetry." *The Modern Quarterly,* vol. 6, no. 2 (Spring 1951), 107–34.

FRIEDRICH ENGELS
See under Karl Marx

SIDNEY FINKELSTEIN

Works By

Art and Society. New York, 1947.
Composer and Nation. New York, 1960.
"The Creative Thought of Frank Lloyd Wright." *Masses and Mainstream,*
 July 1959, pp. 13–19.
Existentialism and Alienation in American Literature. New York, 1965.
How Music Expresses Ideas. New York, 1952 (revised edition 1970).
Jazz: A People's Music. New York, 1948.
Der junge Picasso. Berlin, 1969.
"The 'Mystery' of Henry James's *The Sacred Fount.*" *Massachusetts Re-
 view,* vol. 3, no. 4 (Summer 1962), 753–76.
"National Art and Universal Art." *Mainstream,* vol. 1, no. 3 (Summer
 1947), 345–61.
Realism in Art. New York, 1954.

Works About

George Steiner. *Language and Silence,* pp. 315–17. New York, 1966.

ERNST FISCHER

Works By

Art Against Ideology. Translated by Anna Bostock. New York, 1969.
The Necessity of Art. Translated by Anna Bostock. Baltimore, 1963.
"Reflections upon the State of the Arts." *Mosaic,* vol. IV, no. 1 (Fall
 1970), 21–34.
Von Grillparzer zu Kafka. Vienna, 1962.
Zeitgeist und Literatur. Vienna, 1964.

ANTONIO GRAMSCI

Works By

Letteratura e Vita Nazionale. Turin, 1950. Spanish translation: *Literatura y vida nacional.* Buenos Aires, 1961.
The Modern Prince and Other Writings. Translated by Louis Marks. London, 1957.
Prison Notebooks. London, 1970.

Works About

John M. Cammett. *Antonio Gramsci and the Origins of Italian Communism.* Stanford, 1967.

KARL KAUTSKY

Works By

Foundations of Christianity. Translated by H. F. Mins. New York, 1953.
Thomas More and His Utopia. Translated by H. J. Stenning. New York, 1927.

Works About

Werner Blumenberg. *Karl Kautskys literarisches Werk. Eine bibliographische Übersicht.* The Hague, 1960.
Kautsky. *Erinnerungen und Erörterungen,* edited by Benedikt Kautsky. The Hague, 1960.
George Lichtheim. "Kautsky." In *Marxism: An Historical and Critical Study.* New York and London, 1961.

ANTONIO LABRIOLA

Works By

Essays on the Materialistic Conception of History. Chicago, 1908.
Socialism and Philosophy [*Letters to Sorel*]. Chicago, 1907.

A collected edition of the works is in progress by Feltrinelli. Milan, 1959 et seq.

Works About

Georgi Plekhanov. *The Materialist Conception of History.* New York, 1940. Also available in appendix to *Fundamental Problems of Marxism,* New York, 1969.
Georges Sorel. Preface to *Essays on the Materialistic Conception of History.* In Labriola, *Socialism and Philosophy,* pp. 182–94.

VLADIMIR ILYICH LENIN

Works By

On Literature and Art. Moscow. 1967.
Philosophical Notebooks. Collected Works, vol. 38. Moscow, 1961.

Works About

Maxim Gorki. *Days with Lenin.* New York, 1932.
N. K. Krupskaya. *Reminiscences of Lenin.* New York, 1970.
A. V. Lunacharsky. "Lenin and Art." *International Literature,* 1935, no. 5, pp. 66–71.
———. "Lenin and Literature." *International Literature,* 1935, no. 1, pp. 55–83.
Stefan Morawski. "Lenin as a Literary Theorist." *Science and Society,* vol. XXIX, no. 1 (Winter 1965), 2–25.
B. Porshnev. "Lenin's Science of Revolution and Social Psychology." In *Social Psychology and History,* pp. 11–64. Moscow, 1970.
Clara Zetkin. "My Recollections of Lenin" and "From My Memorandum Book." In *They Knew Lenin,* pp. 7–52. Moscow, 1968.

GEORG LUKÁCS

Works By

Aesthetik, Teil I: Die Eigenart des Aesthetischen. Neuwied, 1963.
"Art as Self-Consciousness in Man's Development." In Berel Lang and Forrest Williams, eds., *Marxism and Art: Writings in Aesthetics and Criticism,* pp. 228–42. New York, 1972.

"Dialectics of Labor: Beyond Causality and Teleology." *Telos,* no. 6 (Fall 1970), 162–74.

"Dostoevsky." Translated by René Wellek. In *Dostoevsky: A Collection of Critical Essays,* edited by René Wellek, pp. 146–58. Englewood Cliffs, N.J., 1962.

"Essay on the Novel." *International Literature,* 1936, no. 6, 68–74.

Essays on Thomas Mann. Translated by S. Mitchell. New York, 1965.

"Existentialism or Marxism." In George Novack, ed., *Existentialism versus Marxism,* pp. 134–53. New York, 1966.

Goethe and His Age. Translated by Robert Anchor. New York, 1969.

The Historical Novel. Translated by H. and S. Mitchell. Boston, 1963.

History and Class Consciousness. Translated by Rodney Livingstone. London, 1971.

"Idea and Form in Literature." *Masses and Mainstream,* December, 1949, pp. 40–61.

The Meaning of Contemporary Realism. Translated by J. and N. Mander. London, 1962. (U.S. title: *Realism in our Time*)

"The Old Culture and the New Culture." *Telos,* no. 5 (Spring 1970), 21–30.

"Propaganda or Partisanship?" Translated by L. F. Mins. *Partisan Review* (April–May 1934), pp. 36–46.

"The Sociology of Modern Drama." Translated by Lee Baxandall. *Tulane Drama Review* (Summer 1965), pp. 146–70.

Solzhenitsyn. Translated by W. D. Graf. London, 1970.

Studies in European Realism. Translated by Edith Bone. London, 1950.

The Theory of the Novel. Translated by A. Bostock. London, 1971.

Über die Besonderheit als Kategorie der Aesthetik. Neuwied, 1967.

Writer and Critic and Other Essays. Translated by Arthur Kahn. London, 1970.

Works About

Edwin Berry Burgum. "The Historical Novel in the Hands of Georg Lukács." *Science and Society* (Winter 1966), pp. 70–76.

Peter Demetz. *Marx, Engels, and the Poets,* pp. 199–227. Chicago and London, 1967.

Crystal Eastman. "In Communist Hungary." *Liberator* (August 1919), pp. 5–10.

Lucien Goldmann. "The Early Writings of Georg Lukács." *Tri-Quarterly* 9 (Spring 1967), pp. 165–81.

Fredric Jameson. *Marxism and Form.* Princeton, N.J., 1971.

George Lichtheim. *The Concept of Ideology,* pp. 33–43, 245–55. New York, 1967.

————. *Georg Lukács.* New York, 1970.

Maurice Merleau-Ponty. "Western Marxism." In *Les Aventures de la Dialectique.* Paris, 1955. Also *Telos,* no. 6 (Fall 1970), 140–61.

————. "Pravda." In *Les Aventures de la Dialectique.* Paris, 1955. Also *Telos,* no. 7 (Spring 1971), 112–21.

G. H. R. Parkinson, ed. *Georg Lukács: The Man, His Work, and His Ideas.* London, 1970.

Paul Piccone. "Lukács' *History and Class-Consciousness* Half a Century Later." *Telos,* no. 4 (Fall 1969), 95–112.

George Steiner. *Language and Silence,* pp. 325–48. New York, 1967.

Morris Watnick. "Relativism and Class Consciousness: Georg Lukács." In Leopold Labedz, ed., *Revisionism: Essays on the History of Marxist Ideas,* pp. 142–65. London, 1962.

Victor Zitta. *Georg Lukács' Marxism: Alienation, Dialectics, Revolution.* The Hague, 1964.

See also special Lukács issues of: *The Philosophical Forum,* vol. 3 (Spring 1972); *Telos,* nos. 10 and 11 (Winter 1971 and Spring 1972).

ANATOLY LUNACHARSKY

Works By

"Basic Problems of Art: Analyzing Plekhanov's Views on Art." *International Literature,* 1935, no. 12, pp. 43–61.

"Ibsen." In *Henrik Ibsen,* edited by Angel Flores, pp. 7–19. New York, 1937.

"Lenin and Literature." *International Literature,* 1935, no. 1, pp. 55–83.

On Literature and Art. Moscow, 1965. Contains "Theses on the Problems of Marxist Criticism," "Chernyshevsky's Ethics and Aesthetics," "Heroes of Action in Meditation," "Bacon and the Characters of Shakespeare's Plays," and essays on Pushkin, Dostoevsky, Taneyev, Scriabin, Blok, Gorki, Mayakovsky, Swift, Heine, Wagner, Proust, Renoir, and Shaw.

Works About

Pavel Bugayenko. "Outstanding Literary Critic." *Soviet Literature,* 1958, no. 12, pp. 75–81.

Ilya Ehrenburg. *People and Life, 1891–1921.* New York, 1962.

ROSA LUXEMBURG

Works By

Ausgewählte Reden und Schriften. 2 vols. Berlin, 1951.
Briefe an Freunde. Hamburg, 1950.
"Introduction to Korolenko's *History of a Contemporary.*" *International Socialist Review,* January–February 1969, pp. 10–31.
Letters to Karl and Luise Kautsky. New York, 1925.

Works About

Paul Frölich. *Rosa Luxemburg.* London, 1940.
Georg Lukács. "The Marxism of Rosa Luxemburg." In *History and Class Consciousness.* London. 1971.
J. P. Nettl. *Rosa Luxemburg.* London, 1966.

ANDRÉ MALRAUX

Works By

"Reply to Trotsky." In *Malraux: A Collection of Critical Essays,* edited by R. W. B. Lewis, pp. 20–24. Englewood Cliffs, N.J., 1964.
"Three Speeches." *Yale French Studies,* no. 18 (1957), pp. 37–38. Addresses to Congress of Soviet Writers, August 1934; to International Association of Writers for the Defense of Culture, Paris, November 1935; to the same body in London, June 1936.

Works About

R. W. B. Lewis, ed. *Malraux: A Collection of Critical Essays.* Englewood Cliffs, N.J., 1964.
David Wilkinson. "Malraux, Revolutionist and Minister." In *The Left-Wing Intellectuals Between the Wars, 1919–1939 (Journal of Contemporary History,* vol. 2, edited by W. Laqueur and G. L. Mosse), pp. 43–64.
Yale French Studies, no. 18 (1957). André Malraux issue.

HERBERT MARCUSE

Works By

"The Affirmative Character of Culture." In *Negations: Essays in Critical Theory*. Boston, 1968.

"Art as a Form of Reality." In *On the Future of Art*, a symposium sponsored by The Solomon R. Guggenheim Museum, pp. 123–34. New York, 1970.

Counter-Revolution and Revolt, Chapter 3. Boston, 1972.

Eros and Civilization: A Philosophical Inquiry into Freud, Chapters 6–8. Boston, 1955.

An Essay on Liberation, Chapter 3. Boston, 1969.

One-Dimensional Man: Studies in the Ideology of Advanced Industrial Society, Chapter 3. Boston, 1964.

Reason and Revolution: Hegel and the Rise of Social Theory, 3d ed., Preface. Boston, 1960.

Soviet Marxism, Chapter 6. New York, 1958.

Works About

Jerry Cohen. "Critical Theory: The Philosophy of Marcuse." *New Left Review*, no. 57 (September–October 1969), 35–51.

Fredric Jameson. *Marxism and Form*. Princeton, N.J., 1971.

Herbert Read. "Rational Society and Irrational Art." In *The Critical Spirit, Essays in Honor of Herbert Marcuse*, edited by Kurt H. Wolff and Barrington Moore, Jr., pp. 205–15. Boston, 1967.

KARL MARX AND FRIEDRICH ENGELS

Works By

Literature and Art. New York, 1947.

Über Kunst und Literatur. Edited by Manfred Kliem. 2 vols. Berlin, 1967.

Works About

Peter Demetz. *Marx, Engels, and the Poets.* Chicago, 1967.

Sidney Finkelstein. "How Marx and Engels Looked at Art." *New Masses,* Dec. 2, 1947, pp. 7–10; Dec. 9, 1947, pp. 13–14.

Ralph Fox. "Marxism and Literature." In *The Novel and the People,* pp. 21–28. New York, 1945.

Jean Fréville. "What is the Marxist Approach to Literature?" *Dialectics,* no. 1, 1937, 1–10. (Trans. of intro. to Fréville, ed., Marx and Engels, *Sur la Littérature et l'Art,* Paris, 1936.)

Michael Harrington. "Marxist Literary Critics." *The Commonweal,* Dec. 11, 1959, pp. 324–26.

Stanley Edgar Hyman. *The Armed Vision,* pp. 179–203. New York, 1948.

Fredric Jameson. *Marxism and Form.* Princeton, N.J., 1971.

Hans Koch. *Marxismus und Ästhetik.* Berlin, 1955.

Henri Lefèbvre. *Contribution à l'Esthetique.* Paris, 1953.

Mikhail Lifschitz. *The Philosophy of Art of Karl Marx.* New York, 1938. Abridged as "Marx on Esthetics" in *International Literature,* 1933, no. 2, pp. 75–91.

Georg Lukács. *Karl Marx und Friedrich Engels als Literaturhistoriker.* Berlin, 1948.

————. "Marx and Engels on Aesthetics." *Writer and Critic,* pp. 61–88. London, 1970.

Max Raphael. *Proudhon, Marx, Picasso: Trois Études sur la Sociologie de l'Art.* Paris, 1933.

George Steiner. *Language and Silence.* pp. 305–24. New York, 1967.

René Wellek. *A History of Modern Criticism, 1750–1950,* Vol. III, pp. 232–39. New Haven and London, 1965.

———— and Austin Warren. *Theory of Literature,* pp. 82–98. New York, 1956.

Edmund Wilson. "Marxism and Literature." In *The Triple Thinkers,* pp. 197–212. New York, 1963.

Biographies

Auguste Cornu. *Karl Marx et Friedrich Engels: Leur vie et leur oeuvre.* Paris, 1955 et seq.

Gustav Mayer. *Friedrich Engels.* New York, 1936.

Franz Mehring. *Karl Marx: The Story of His Life.* New York, 1935.

Reminiscences of Marx and Engels. Moscow, n.d.

FRANZ MEHRING

Works By

"Charles Dickens." In *Marxism and Art,* edited by Berel Lang and Forrest Williams, pp. 438–42. New York, 1972.

Gesammelte Schriften. Edited by Thomas Höhle, Hans Koch, and Josef Schleifstein. 14 vols. Berlin, 1960–1967.

Gesammelte Schriften und Aufsätze. Edited by Eduard Fuchs. 6 vols. Berlin, 1929–1931.

> Vol. I: *Zur Literaturgeschichte—Von Calderon bis Heine.*
> Vol. II: *Zur Literaturgeschichte—Von Hebbel bis Gorki.*

"Ibsen's Greatness and Limitations." In *Henrik Ibsen,* edited by Angel Flores, pp. 25–34. New York, 1937.

"Karl Marx and Metaphor." In *Karl Marx—A Symposium,* edited by D. Ryazanoff, pp. 95–101. London, 1927.

Karl Marx: The Story of His Life. New York, 1935.

The Lessing Legend. New York, 1938. Abridged.

"Literature and the Class Struggle." *The Communist,* July 1929, pp. 409–12.

"Philosophy and Philosophizing." *The Marxist Quarterly,* April–June 1937, pp. 293–97.

Works About

Thomas Höhle. *Franz Mehring: Sein Weg zum Marxismus 1869–1891.* Berlin, 1956.

Hans Koch. *Franz Mehrings Beitrag zur marxistischen Literaturtheorie.* Berlin, 1959.

Joseph Kresh. Introduction to *The Lessing Legend,* pp. 5–16. New York, 1938.

Georg Lukács. *Beiträge zur Geschichte der Ästhetik,* pp. 318–403. Berlin, 1954.

———. "Propaganda or Partisanship." *Partisan Review,* vol I, no. 2 (1934), 36–46.

Josef Schleifstein. *Franz Mehring: Sein marxistisches Schaffen.* Berlin, 1959.

WILLIAM MORRIS

Works By

The Collected Works of William Morris. London, 1910–1915.
 Vol. 22: *Hopes and Fears for Art; Lectures on Art and Industry.*
 Vol. 23: *Signs of Change; Lectures on Socialism.*

Works About

R. Page Arnot. *William Morris: The Man and the Myth.* London, 1964.
William Gaunt. *The Pre-Raphaelite Dream.* New York, 1966.
Anna von Helmholtz-Phelan. *The Social Philosophy of William Morris.* Durham, 1927.
J. S. Mackail. *The Life of William Morris.* New York and London, 1901.
A. L. Morton. "The Dream of William Morris." In *The English Utopia,* pp. 149–82. London, 1952.
E. P. Thompson. *William Morris: Romantic to Revolutionary.* London, 1955.

GEORGI PLEKHANOV

Works By

Anarchism and Socialism. Translated by E. M. Aveling. Chicago, 1912.
Art and Social Life. Translated by E. Fox and E. Hartley. London, 1953. Contains "Art and Social Life," "Letters Without Address," and "French Dramatic Literature and French Eighteenth Century Painting from the Sociological Standpoint."
Fundamental Problems of Marxism. Translated by J. Katzer. New York, 1969. Contains also "The Materialist Conception of History" and "The Role of the Individual in History."
"Ibsen, Petty Bourgeois Revolutionist." In *Henrik Ibsen,* edited by Angel Flores, pp. 35–92. New York, 1937.
Selected Philosophical Works. Translated by R. Dixon, A. Fineberg, and A. Rothstein, vol. I. Moscow, 1961.
Über Kunst und Literatur. Berlin, 1955.
Utopian Socialism of the Nineteenth Century. Translated by J. Katzer. Moscow, n.d.

Works About

S. H. Baron. *Plekhanov, the Father of Russian Marxism.* Stanford, 1963.
A. V. Lunacharsky. "Basic Problems of Art: Analyzing Plekhanov's Views on Art." *International Literature,* 1935, no. 13, pp. 43–61.
————. "Chernyshevsky's Ethics and Aesthetics." In *On Literature and Art,* pp. 28–89. Moscow, 1965.
M. Rosenthal. "Relative vs. Absolute Criteria in Art." *Dialectics.* no. 8 (n.d.), pp. 15–24.

MAX RAPHAEL

Works By

The Demands of Art. Translated by Norbert Guterman. Princeton, N.J., 1968.
"A Marxist Critique of Thomism." Translated by M. S. [Meyer Schapiro]. *Marxist Quarterly,* vol. 1, no. 2 (April–June 1937), 285–92.
Prehistoric Cave Paintings. Translated by Norbert Guterman. New York, 1945.
Prehistoric Pottery and Civilization in Egypt. Translated by Norbert Guterman. New York, 1947.
Proudhon, Marx, Picasso: Trois Études sur la Sociologie de l'Art. Paris, 1933.

Works About

Herbert Read. Introduction to *The Demands of Art.* Princeton, N.J., 1968.

HARRY SLOCHOWER

Works By

Mythopoesis. Detroit, 1970.
No Voice Is Wholly Lost. New York, 1945. Reissued as *Literature and Philosophy Between Two Wars.* New York, 1964.
Thomas Mann's Joseph Story: An Interpretation. New York, 1938.
Three Ways of Modern Man. New York, 1937.

Works About

Peter Fingesten. Review of *Mythopoesis*. *The Journal of Aesthetics and Art Criticism,* vol. XXXI, no. 1 (Fall 1971), 136–38.
Stanley Edgar Hyman. *The Armed Vision,* pp. 191, 370–72. New York, 1948.

GEORGE THOMSON

Works By

Aeschylus and Athens: A Study in the Social Origins of Drama. London, 1941.
Marxism and Poetry. New York, 1946.
Studies in Ancient Greek Society. Vol. I: *The Prehistoric Aegean.* London, 1949.
Studies in Ancient Greek Society. Vol. II: *The First Philosophers.* London, 1955.

Works About

L. Varcl and R. F. Willetts, eds. GERAS: *Studies Presented to George Thomson.* Prague, 1963.

LEON TROTSKY

Works By

"Céline and Poincaré." In *The Basic Writings of Trotsky,* edited by Irving Howe, pp. 343–55. New York, 1963.
"Class and Art." *Fourth International,* July 1967, pp. 51–60.
Literature and Revolution. New York, 1957.
On Literature and Art. Edited by Paul N. Siegel. New York, 1970.

Works About

Edward Hallett Carr. *Socialism in One Country, 1924–1926.*
	Vol. I, pp. 137–52. New York, 1958.
Isaac Deutscher. *The Prophet Unarmed,* pp. 164–200. London, 1959.

Trotsky. *My Life.* New York, 1960.
Edmund Wilson. *To the Finland Station,* pp. 403–44. New York, 1953.

ALICK WEST

Works By

Crisis and Criticism. London, 1937.
"The Detective Story." *Left Review,* vol. 3, pp. 707–11; 795–98.
A Good Man Fallen Among Fabians. London, 1950.
The Mountain in the Sunlight. London, 1958.
"The Poetry in Poetry." *Left Review,* vol. 3, pp. 164–68.
"Some Uses of Shakespearian." In *Shakespeare in a Changing World,* edited by Arnold Kettle. London, 1964.

Works About

Stanley Edgar Hyman. *The Armed Vision.* New York, 1948.
Herbert Read. "Socialist Realism." In *A Coat of Many Colours,* pp. 216–21. New York, 1956.
West. *One Man in His Time: An Autobiography.* London, 1969.

ZHDANOVISM

Virtually all Soviet criticism between 1934 and 1956, and much Western Communist criticism between 1946 and 1956, is Zhdanovist to a greater or lesser extent. Typical examples are Howard Fast, *Literature and Reality* (New York, 1950), V. J. Jerome, *Culture in a Changing World* (New York, 1947), Josef Revai, *Literature and People's Democracy* (New York, 1950), Roger Garaudy, *Literature of the Graveyard* (New York, 1948), and V. Kemenov, *Aspects of Two Cultures* (New York, n.d.). For the basic documents, see H. G. Scott, ed., *Problems of Soviet Literature* (Moscow and Leningrad, 1935), reprinting the main addresses to the first Soviet Writers' Congress, August, 1934; *International Literature,* 1936, no. 6, pp. 77–109, containing the Pravda criticism of "Lady Macbeth of Mzensk" and a debate on Formalism by outstanding Soviet writers; George S. Counts and Nucia Lodge, *The Country of the Blind* (Boston, 1949), reprinting Soviet resolutions on theater, motion pictures, and journalism; Alexander Werth, *Musical Uproar in Moscow* (London, 1949), texts relat-

ing to the 1948 Soviet music criticism; A. A. Zhdanov, *Essays on Literature, Philosophy and Music* (New York, 1950).

For Soviet criticisms of the continuance of Zhdanovist restraints and concepts in the post-Stalin period, see especially Anon. [Abram Tertz], "Socialist Realism," in Eugen Weber, ed., *Paths to the Present* (New York and Toronto, 1963), pp. 395–411, and Alexander Solzhenitsyn, "Letter to the Fourth National Congress of Soviet Writers (In Lieu of a Speech)," in *The New York Times,* June 5, 1967. Perhaps the earliest, and surely one of the most passionate statements of revolution's need for artistic "heresy" is Evgeni Zamyatin, "On Literature, Revolution, and Entropy" (1924), reprinted in Patricia Blake and Max Hayward, eds., *Dissonant Voices in Soviet Literature* (New York and Evanston, Ill., 1964), pp. 12–19.

SUPPLEMENTARY READINGS

Following is a selective listing of Marxist writings on criticism, aesthetics, and the various arts, arranged according to subject matter. Items listed are in the English language, with a few significant exceptions. Bibliographical data on the main contributors to the anthology appears separately (see above, Contributors' Bibliographies), and has not been duplicated here except insofar as such listings may serve to highlight their work in specific critical fields. Non-Marxist writings on the subject of this book may be found in the footnotes and among the listings of secondary sources in the Contributors' Bibliographies. The listings for each author are of typical or exemplary works; for fuller listings of certain authors, the reader is referred to Lee Baxandall, *Marxism and Aesthetics: A Selective Annotated Bibliography,* New York, 1968 (hereafter referred to as "Baxandall").

Because the primary emphasis of this anthology has been to explore the theoretical implications and evolution of Marxist aesthetics, and to focus on substantive questions, relatively few examples of the actual application of Marxism to the various arts have been included in the anthology proper. A quite different anthology might have been constructed out of exemplary applications of one or another aspect of Marxist theory to the various arts.

Those who wish to explore this more fully should consult the contributors' bibliographies as well as the following bibliography. I particularly wish to draw attention to the listings of works by the following notable critics, whose "critical performances" are not represented in the anthology itself:

Frederick Antal, Jacob Bronowski, Jean Cassou, Dorothy van Ghent, Lucien Goldmann, Wilhelm Hausenstein, Arnold Hauser, Ivan Kashkeen, Arnold Kettle, Henri Lefèbvre, F. O. Matthiessen, G. M. Matthews, Hans Mayer, Ernst Meyer, A. L. Morton, Harry Alan Potamkin, T. K. Whipple, Edmund Wilson, and Arnold Zweig.

THEORY

Agostí, Hector. "A Defense of Realism." In George J. Becker, ed., *Documents of Modern Literary Realism*. Princeton, N.J., 1963.

———. *Nation y Cultura*. Buenos Aires, 1959.

Bisztray, George. "Literary Sociology and Marxist Theory: The Literary Work as a Social Document." *Mosaic,* vol. V, no. 2 (Winter 1971–72), pp. 47–56.

Blaukopf, Kurt. "Ideology and Reality." *Modern Quarterly,* vol. 2, no. 4 (Autumn 1947), pp. 373–79.

Bogdanov, A. A. "The Criticism of Proletarian Art." *The Labour Monthly,* December 1923, pp. 344–56.

———. "Proletarian Poetry." *The Labour Monthly,* May 1923, pp. 275–85; June 1923, pp. 357–62.

———. "Religion, Art and Marxism." *The Labour Monthly,* August 1924, pp. 489–97.

———. "The Workers' Artistic Inheritance." *The Labour Monthly,* September 1924, pp. 549–56.

Burke, Kenneth. "My Approach to Communism." *New Masses,* March 20, 1934, pp. 16–20.

———. "The Nature of Art Under Capitalism." *The Nation,* Dec. 13, 1933, pp. 675–77.

della Volpe, Galvano. *Critica del Gusto*. Milan, 1963.

———. *Crisi dell' Estetica romantica*. Rome, 1963.

———. *Critica dell' Ideologia Contemporanea*. Rome, 1967.

———. "Theoretical Issues of a Marxist Poetics." In Berel Lang and Forrest Williams, eds., *Marxism and Art: Writings in Aesthetics and Criticism*. New York, 1972 (from *Critica del Gusto*).

Enzensberger, Hans Magnus. "Constituents of a Theory of the Media." *New Left Review,* no. 64 (November–December 1970), pp. 13–36.

Farrell, James T. *A Note on Literary Criticism.* New York, 1936.

Fox, Ralph. *Aspects of Dialectical Materialism.* London, 1934.

———. *The Novel and the People.* New York, 1945.

Fréville, Jean. "What Is the Marxist Approach to Literature?" *Dialectics,* no. 1 (1937), pp. 1–10.

Gallas, Helga. *Marxistische Literaturtheorie.* Neuwied, 1971.

Garaudy, Roger. *D'un réalisme sans rivages.* Paris, 1963.

———. "Marxism and Art." In *Marxism in the Twentieth Century,* pp. 164–97. New York, 1970.

Goldmann, Lucien. "Genetic-Structuralist Method in History of Literature." In Berel Lang and Forrest Williams, eds., *Marxism and Art: Writings in Aesthetics and Criticism,* pp. 243–55. New York, 1972.

———. 'Matérialisme Dialectique et Histoire de la Littérature." In *Recherches dialectiques,* pp. 45–63. Paris, 1959.

———. "Socialism and Humanism." In Erich Fromm, ed., *Socialist Humanism,* pp. 38–49. New York, 1965.

———. "The Sociology of Literature: Status and Problems of Method." In Albrecht, Barnett, and Griff, eds., *The Sociology of Art and Literature: A Reader,* pp. 582–610. New York and Washington, 1970.

Harap, Louis. *The Social Roots of the Arts.* New York, 1949.

Hauser, Arnold. *The Philosophy of Art History,* pp. 1–40. Cleveland and New York, 1963.

Jameson, Fredric. *Marxism and Form: Twentieth Century Dialectical Theories of Literature.* Princeton, N.J., 1971.

Klingender, Frances. *Marxism and Modern Art.* New York, 1945.

Koch, Hans. *Marxismus und Ästhetik.* Berlin, 1955.

Lafargue, Paul. *The Origin and Evolution of the Idea of the Soul.* Chicago, 1922.

———. *The Right to Be Lazy and Other Studies.* Chicago, 1909.

———. *Social and Philosophical Studies.* Chicago, 1906.

Lassalle, Ferdinand. "Letter to Karl Marx," March 6, 1859. In "Marx and Engels to Lassalle," *International Literature,* October 1933, pp. 108–22.

Lefèbvre, Henri. *Contribution à l'esthétique.* Paris, 1953.

Lifschitz, Mikhail. *The Philosophy of Art of Karl Marx.* New York, 1938.

———. *Literature and Marxism: A Controversy by Soviet Critics.* Edited by Angel Flores, pp. 7–15, 23–30, 43–51, 74–85. New York, 1938.

———. "Karl Marx and Present-Day Culture." In *Karl Marx and Modern Philosophy,* pp. 143–81. Moscow, 1968.

———. "Responsibility of Art to Society in Belinsky's Esthetics." *Science and Society,* Summer 1949, pp. 243–57.

Lindsay, Jack. *Perspective for Poetry*. London, 1944.

Morawski, Stefan. "On the Objectivity of Aesthetic Judgments." *British Journal of Aesthetics,* October 1966, pp. 315–38.

———. "Realism as an Artistic Category." *Actes du IV Congrès International d'Esthétique,* pp. 571–78. Athens, 1960.

———. "Vicissitudes in the Theory of Socialist Realism." *Diogenes,* Winter 1961, pp. 110–36.

———. "What is a Work of Art?" In *Radical Perspectives in the Arts,* edited by Lee Baxandall, pp. 324–70. Baltimore, Md., 1972.

Morel, Jean Pierre. "A 'Revolutionary' Poetics." *Yale French Studies,* no. 39, pp. 160–79.

Rosenberg, Harold. "The Resurrected Romans." In *The Tradition of the New,* pp. 154–77. London, 1962.

Rosenthal, Mark. "Relative vs. Absolute Criteria in Art." *Dialectics,* no. 8 (n.d.), pp. 15–24.

Samson, Leon. "Proletarian Philosophy of Art." In *The New Humanism,* pp. 191–201. New York, 1930.

Sanchez Vazquez, Adolfo. *Las Ideas Esteticas de Marx*. Mexico City, 1965.

Schaff, Adam. *Introduction to Semantics*. London, 1962.

———. "Language and Reality." *Diogenes,* Fall 1965, pp. 147–67.

———. "On Vagueness." *Studia Filozoficzne,* 1962, no. 1, pp. 157–70.

Schlauch, Margaret. *The Gift of Tongues*. New York, 1942.

———. "The Social Base of Linguistics." *Science and Society,* Fall 1936, pp. 18–44.

Serge, Victor. "Is a Proletarian Literature Possible?" *Yale French Studies,* no. 39, pp. 137–45.

Stalin, Joseph. *Marxism and Linguistics*. New York, 1951.

Strachey, John. *Literature and Dialectical Materialism*. New York, 1934.

Voronsky, Alexander. *Critical Essays* [in Russian]. Moscow, 1963.

Williams, Raymond. "Literature and Sociology: In Memory of Lucien Goldmann." *New Left Review,* no. 67 (May–June 1971), pp. 3–18.

Wilson, Edmund. "Marxism and Literature" and "The Historical Interpretation of Literature." In *The Triple Thinkers,* pp. 197–212, 257–70. New York, 1963.

See also the following collections of Soviet materials:

Art and Society: A Collection of Articles. Moscow, 1968.

Problems of Modern Aesthetics. Edited by S. Mozhnyagun. Moscow, 1969.

REVOLUTIONARY AND POLITICAL LEADERS ON ART

Browder, Earl. *Communism and Culture.* New York, 1941.

Bukharin, Nikolai. SEE CONTRIBUTORS' BIBLIOGRAPHIES.

Castro, Fidel. "Address to 1st National Writers and Artists Congress, Havana, August 18–22, 1961." In *The Revolution and Cultural Problems in Cuba.* Havana, 1962.

Dimitrov, Georgi. "Revolutionary Literature in the Struggle Against Fascism." *International Literature,* 1935, no. 4, pp. 53–56; *Left Review,* June 1935, pp. 343–46.

Gomulka, Wladyslaw. "The Party and Literature." *Polish Perspectives,* November 1964, pp. 3–11.

Guevara, Che. "Socialism and Man in Cuba." *Progressive Labor,* December 1965, pp. 83–95.

Khrushchev, Nikita. *The Great Mission of Literature and Art.* Moscow, 1964.

Lenin, V. I. SEE CONTRIBUTORS' BIBLIOGRAPHIES.

Luxemburg, Rosa. SEE CONTRIBUTORS' BIBLIOGRAPHIES.

Mao Tse-tung. *On Literature and Art.* Peking, 1967.

Radek, Karl. "Contemporary World Literature and the Tasks of Proletarian Art." In H. G. Scott, ed., *Problems of Soviet Literature,* pp. 73–182. Moscow and Leningrad, 1935.

Stalin, Joseph. "On Culture." *International Literature,* 1939, no. 12, pp. 84–117.

Togliatti, Palmiro. "Political 'Testament.'" *New York Times,* Sept. 5, 1964, p. 2.

Trotsky, Leon. SEE CONTRIBUTORS' BIBLIOGRAPHIES.

Zetkin, Clara. "Kunst und Proletariat." *Ausgewählte Reden und Schriften,* vol. 1, pp. 490–505. Berlin, 1957.

LITERATURE—GENERAL

Bakhtin, Mikhail. SEE CONTRIBUTORS' BIBLIOGRAPHIES.

Balázs, Etienne. *Chinese Civilization and Bureaucracy.* New Haven and London, 1964.

Benjamin, Walter. SEE CONTRIBUTORS' BIBLIOGRAPHIES.

Bloch, Ernst. SEE CONTRIBUTORS' BIBLIOGRAPHIES.

Brecht, Bertolt. SEE CONTRIBUTORS' BIBLIOGRAPHIES.

Breton, André. SEE CONTRIBUTORS' BIBLIOGRAPHIES.

Brown, Norman O. *Hermes the Thief: The Evolution of a Myth.* New York, 1969.

Bukharin, Nikolai. SEE CONTRIBUTORS' BIBLIOGRAPHIES.

Burgum, Edwin Berry. *The Novel and the World's Dilemma.* New York, 1947.

Cassou, Jean. "Cervantes." *International Literature,* 1937, no. 9, pp. 33–50.

Davydov, Yuri. *The October Revolution and the Arts.* Moscow, 1967.

Engels, Friedrich. SEE CONTRIBUTORS' BIBLIOGRAPHIES AND LISTING OF MARX–ENGELS ENGLISH EDITIONS.

Ewen, Frederick. *Bertolt Brecht: His Life, His Art and His Times.* New York, 1967.

Fischer, Ernst. *The Necessity of Art.* Baltimore, 1963. SEE ALSO CONTRIBUTORS' BIBLIOGRAPHIES.

Flores, Angel, ed. *Henrik Ibsen.* New York, 1937. Contributions by Lunacharsky, Engels, Mehring, and Plekhanov.

Garaudy, Roger. *Literature of the Graveyard.* New York, 1948.

Goldmann, Lucien. *The Hidden God: A Study of Tragic Vision in the Pensées of Pascal and the Tragedies of Racine.* New York, 1964.

———. "A Propos de 'La Maison de Bernarda.' " *Recherches dialectiques,* pp. 239–44. Paris, 1959.

Gorki, Maxim. *On Literature: Selected Articles.* Moscow, n.d.

Gramsci, Antonio. *La Letteratura e Vita Nazionale.* Turin, 1950.

Grib, V. *Balzac.* New York, 1937.

Hauser, Arnold. *The Social History of Art.* New York, 1957.

Hobsbawm, E. J. *The Age of Revolution, 1789–1848,* pp. 229–326. New York, 1964.

Humboldt, Charles [pseud. Clarence Weinstock]. "The Novel of Action." *Mainstream,* Fall 1947, pp. 389–407.

———. "The Art of Lu Hsun." *Masses and Mainstream,* July 1957, pp. 10–30.

Kresh, Joseph. "Georg Büchner." *Dialectics,* no. 6, pp. 1–11; no. 7, pp. 19–31.

———. "The Mystic Strain in Toller's Work." *Science and Society,* Winter 1940, pp. 78–84.

Lafargue, Paul. *Critiques littéraires.* Paris, 1936.

Lefèbvre, Henri. *Alfred de Musset.* Paris, 1955.

Lenin, V. I. SEE CONTRIBUTORS' BIBLIOGRAPHIES.

Lu Hsun. *Selected Works.* Peking, 1957–1960.

———. *A Brief History of Chinese Fiction.* Peking, 1959.

Lukács, Georg. SEE CONTRIBUTORS' BIBLIOGRAPHIES.

Lunacharsky, Anatoly. SEE CONTRIBUTORS' BIBLIOGRAPHIES.

Luxemburg, Rosa. SEE CONTRIBUTORS' BIBLIOGRAPHIES.

Markov, P. A. *The Soviet Theatre.* New York, 1935.

Marx, Karl. SEE CONTRIBUTORS' BIBLIOGRAPHIES AND LISTING OF MARX–ENGELS ENGLISH EDITIONS.

Mayer, Hans. *Steppenwolf and Everyman: Outsiders and Conformists in Contemporary Literature.* New York, 1971.

———. "The Struggle for Kafka and Joyce." *Encounter,* May 1964, pp. 83–89.

Mehring, Franz. SEE CONTRIBUTORS' BIBLIOGRAPHIES.

Merleau-Ponty, Maurice. *Humanism and Terror.* Boston, 1969.

Meyerhold, Vsevelod. "From 'On the Theatre.'" *Tulane Drama Review,* May 1960, pp. 134–48.

Nizan, Paul. "André Gide Comes to Revolution." *International Literature,* 1934, no. 3, pp. 138–47.

Novitsky, Pavel. *Cervantes.* New York, 1936.

Pascal, Roy. *The German Sturm und Drang.* London, 1953.

———. *The German Novel.* Manchester, 1956.

Piscator, Erwin. *Das Politische Theater.* Berlin, 1929.

Plekhanov, Georgi. SEE CONTRIBUTORS' BIBLIOGRAPHIES.

Prusek, Jaroslav, ed. *Studies in Modern Chinese Literature.* Berlin, 1964.

Sartre, Jean-Paul. "Class Consciousness in Flaubert." *Modern Occasions,* vol. 1, no. 3 (Spring 1971), pp. 379–89.

Schumacher, Ernst. "Piscator's Political Theatre." In Peter Demetz, ed., *Brecht: A Collection of Critical Essays,* pp. 86–96. Englewood Cliffs, N.J., 1962.

Slochower, Harry. SEE CONTRIBUTORS' BIBLIOGRAPHIES.

Talmadge, Irving D. W., ed. *Pushkin: Homage by Marxist Critics.* New York, 1937. Contributions by Gorki, Zeitlin, Lunacharsky, and Vinogradov.

Thomson, George. SEE CONTRIBUTORS' BIBLIOGRAPHIES.

Thorlby, Anthony. "Self-consciousness and Social Consciousness in Literature." In *Aspects of History and Class Consciousness,* edited by István Mészáros, pp. 173–91. London, 1971.

Trotsky, Leon. SEE CONTRIBUTORS' BIBLIOGRAPHIES.

Willetts, R. F. "The Critical Realism of the Last Play of Aristophanes." *Modern Quarterly,* vol. VIII, no. 1, pp. 34–43.

Wilson, Edmund. *Axel's Castle.* New York, 1931.

———. *The Wound and the Bow.* New York, 1941.

Winspear, Alban D. *The Genesis of Plato's Thought.* New York, 1956.

Yermilov, V. *Fyodor Dostoyevsky, 1821–1881*. Moscow, n.d.
Zweig, Arnold. "The Jew Among the Thorns." *Mainstream,* September 1960, pp. 2–10.

See Baxandall for writings by Louis Aragon, Isaac Babel, Henri Barbusse, J. R. Becher, Ilya Ehrenburg, Paul Eluard, Carlos Fuentes, André Gide, Feodor Gladkov, Nicolás Guillén, Heinrich Heine, Leonid Leonov, Vladimir Mayakovsky, Pablo Neruda, Martin Anderson Nexö, Romain Rolland, Anna Seghers, Mikhail Sholokhov, Andrei Sinyavsky, Alexander Solzhenitsyn, Ernst Toller, Sergei Tretyakov, Peter Weiss, and Evgeni Zamyatin.

ENGLISH LITERATURE

Beer, Max. *A History of British Socialism*. London, 1919–1920.
Bronowski, Jacob. *William Blake: A Man Without a Mask*. London, 1944.
Caudwell, Christopher. SEE CONTRIBUTORS' BIBLIOGRAPHIES.
Daiches, David. "Literature and Social Mobility." In *Aspects of History and Class Consciousness,* edited by István Mészáros, pp. 152–72. London, 1971.
Deutscher, Isaac. *Heretics and Renegades,* pp. 9–22. Indianapolis and New York, 1969.
Fox, Ralph. *The Novel and the People*. New York, 1945.
Hicks, Granville. *Figures of Transition*. New York, 1939.
Hill, Christopher. "Society and Andrew Marvell" and "Clarissa Harlowe and Her Times." *Puritanism and Revolution,* pp. 337–94. London, 1958.
Jackson, T. A. *Charles Dickens: The Progress of a Radical*. London, 1937.
Kautsky, Karl. *Thomas More and His Utopia*. New York, 1927.
Kettle, Arnold. *Introduction to the English Novel*. 2 vols. New York, 1960.
———, ed. *Shakespeare in a Changing World*. New York, 1964.
Kozintsev, Grigori. *Shakespeare*. New York, 1966.
Lindsay, Jack. *John Bunyan: Maker of Myths*. London, 1937.
———. *George Meredith*. London, 1956.
Lukács, Georg. *The Historical Novel*. Boston, 1963.
———. *The Meaning of Contemporary Realism*. London, 1963.
Matthews, G. M. "Othello and the Dignity of Man." In Arnold Kettle, ed., *Shakespeare in a Changing World,* pp. 123–45. New York, 1964.

————. "Sex and the Sonnet." *Essays in Criticism,* vol. II, no. 2 (1952), pp. 119–37.

————. "A Volcano's Voice in Shelley." In G. M. Ridenour, ed., *Shelley: A Collection of Critical Essays,* pp. 111–32. Englewood Cliffs, N.J., 1965.

Mirsky, Dmitri S. *The Intelligentsia of Great Britain.* London, 1935.

————. "James Joyce." *International Literature,* April 1934, pp. 92–102.

Morton, A. L. *The English Utopia.* London, 1952.

————. *The Everlasting Gospel: A Study in the Sources of William Blake.* London, 1958.

————. *The Language of Men.* London, 1945.

————. *The Matter of Britain: Essays in a Living Culture.* London, 1966.

O'Casey, Sean. *The Green Crow.* New York, 1956.

Rubinstein, Annette T. *The Great Tradition in English Literature.* New York, 1953.

Samarin, Roman, and Nikolyukin, Alexander, eds. *Shakespeare in the Soviet Union: A Collection of Articles.* Moscow, 1966.

Schlauch, Margaret. *Antecedents of the English Novel: 1400–1600.* Warsaw, 1963.

————. *English Medieval Literature and its Social Foundations.* Warsaw, 1956.

————. "The Language of James Joyce." *Science and Society,* Fall 1939, pp. 482–97.

Siegel, Paul N. *Shakespearean Tragedy and the Elizabethan Compromise.* New York, 1957.

Smirnov, A. A. *Shakespeare: A Marxist Interpretation.* New York, 1936.

Strachey, John. *The Coming Struggle for Power,* pp. 193–234. New York, 1935.

van Ghent, Dorothy. *The English Novel: Form and Function.* New York, Evanston, and London, 1961. See especially "Moll Flanders," pp. 33–43, and "Great Expectations," pp. 125–38.

Weimann, Robert. "The Soul of the Age: Towards a Historical Approach to Shakespeare." In Kettle, ed., *Shakespeare in a Changing World,* pp. 17–42. New York, 1964.

West, Alick. SEE CONTRIBUTORS' BIBLIOGRAPHIES.

Wilson, Edmund. *The Wound and the Bow.* New York, 1941.

See Baxandall for writings by W. H. Auden, C. Day-Lewis, John Lehmann, Hugh MacDiarmid, Rex Warner.

AMERICAN LITERATURE

Ames, Russell. *Citizen Thomas More and His Utopia.* Princeton, N.J., 1949.

Arvin, Newton. "Individualism and the American Writer." In Morton D. Zabel, ed., *Literary Opinion in America,* pp. 523–29. New York, 1937.

———. *Whitman.* New York, 1938.

Brooks, Obed [pseud.]. "The Problem of the Social Novel." *Modern Quarterly* [Baltimore], Autumn 1932, pp. 77–82.

Burgum, Edwin Berry. *The Novel and the World's Dilemma.* New York, 1947.

Calverton, V. F. *The Liberation of American Literature.* New York, 1932.

———. *The Newer Spirit: A Sociological Criticism of Literature.* New York, 1925.

Charvat, William. "American Romanticism and the Depression of 1837." *Science and Society,* Winter 1937, pp. 67–82.

———. "The People's Patronage" and "Literature as Business." In Spiller, Thorp, Johnson, and Canby, eds., *The Literary History of the United States,* pp. 513–25, 953–68. New York, 1957.

Cowley, Malcolm. *Think Back on Us.* Carbondale and Edwardsville, Ill., 1967.

———, ed. *After the Genteel Tradition.* New York, 1937; Gloucester, Mass., 1959.

Finkelstein, Sidney. *Existentialism and Alienation in American Literature.* New York, 1965. SEE ALSO CONTRIBUTORS' BIBLIOGRAPHIES.

Fraina, Louis. See Baxandall for complete listing.

Freeman, Joseph. Introduction to *Proletarian Literature in the United States: An Anthology,* edited by Granville Hicks et al., pp. 9–28. New York, 1935.

Giles, Barbara. "The South of William Faulkner." *Masses and Mainstream,* February 1950, pp. 26–40.

Gold, Michael. *The Hollow Men.* New York, 1941.

———. "Thornton Wilder: Prophet of the Genteel Christ." In *The Mike Gold Reader,* pp. 45–50. New York, 1954.

Hicks, Granville. *The Great Tradition: An Interpretation of American Literature Since the Civil War.* New York, 1935.

———. "The Critical Principles of V. L. Parrington." *Science and Society,* Fall 1939, pp. 443–60.

Humboldt, Charles [pseud. Clarence Weinstock]. "Communists in

Novels." *Masses and Mainstream,* June 1949, pp. 13–31; July 1949, pp. 44–65.

James, C. L. R. *Mariners, Renegades and Castaways: The Story of Herman Melville and the World We Live In.* New York, 1953.

Kashkeen, Ivan. "Alive in the Midst of Death." In Carlos Baker, ed., *Hemingway and His Critics,* pp. 162–80. New York, 1961.

———. "Ernest Hemingway: A Tragedy of Craftsmanship." *International Literature,* 1935, no. 5, pp. 72–90.

London, Joan. *Jack London and His Times.* New York, 1939.

Matthiessen, F. O. *American Renaissance.* London, Toronto, and New York, 1941.

———. *The Achievement of T. S. Eliot.* New York and London, 1947.

Nye, Russell. "Stephen Crane, Social Critic." *Modern Quarterly* [Baltimore], Summer 1940, pp. 48–54.

Schneider, Isidor. "Proletarian Poetry." In Henry Hart, ed., *The American Writers Congress,* pp. 114–20. New York, 1935.

Slochower, Harry. SEE CONTRIBUTORS' BIBLIOGRAPHIES.

Smith, Bernard. *Forces in American Criticism: A Study in the History of American Literary Thought.* New York, 1939.

Solomon, Maynard. "Stephen Crane." *Masses and Mainstream,* January 1956, pp. 25–42; March 1956, pp. 31–47. Excerpt in Lettis, McDonnell, and Morris, eds., *Stephen Crane's "The Red Badge of Courage": Text and Criticism.* New York, 1960.

Spender, Stephen. "Henry James." In *The Destructive Element: A Study of Modern Writers and Beliefs,* pp. 23–112, 189–200. London, 1935.

van Ghent, Dorothy. "The Poetry of Archibald MacLeish." *Science and Society,* Fall 1938, pp. 500–511.

———. "When Poets Stood Alone." *New Masses,* Jan. 11, 1938 (Literary Supplement), pp. 41–46.

Whipple, T. K. *Spokesmen.* Berkeley and Los Angeles, 1963.

———. *Study Out the Land.* Berkeley and Los Angeles, 1943.

See Baxandall for writings by Edward Dahlberg, Theodore Dreiser, Ralph Ellison, Howard Fast, Kenneth Fearing, Horace Gregory, Langston Hughes, Walter Lowenfels, Clifford Odets, and Richard Wright.

For examples of earlier American socialist, populist and Christian socialist criticism, see Randolph Bourne, *History of a Literary Radical* (New York, 1920); Hamlin Garland, *Crumbling Idols* (Boston, 1894); William Dean Howells, *Criticism and Fiction* (New York, 1891); Frank Norris, *The Responsibilities of the Novelist* (New York, 1903); literary

reviews by Jack London in Philip S. Foner, ed., *Jack London, American Rebel* (New York, 1947); and Upton Sinclair, *Mammonart: An Essay in Economic Interpretation* (Pasadena, Calif., 1925). What apparently is the first socialist literary criticism in the United States is Orestes Brownson, "American Literature" (1839), in H. F. Brownson, ed., *The Works of Orestes A. Brownson* (Detroit, 1885), vol. XIX, pp. 22–39.

FILM

Adorno, Theodor W. SEE CONTRIBUTORS' BIBLIOGRAPHIES.

Balázs, Béla. SEE CONTRIBUTORS' BIBLIOGRAPHIES.

Benjamin, Walter. *Illuminations,* pp. 227–44. New York, 1968.

Brecht, Bertolt. *Brecht on Theatre,* edited by John Willetts, especially pp. 47–51, 77–80. New York, 1964.

Eisenstein, Sergei. *Film Form* and *The Film Sense.* New York, 1957.

———. *Notes of a Film Director.* Moscow, 1946.

Eisler, Hanns. "Music in Films." *Films,* Winter 1940, pp. 5–20. SEE ALSO SECTION 6.

Hauser, Arnold. *The Social History of Art,* vol. IV, pp. 239–59. New York, 1958.

Lawson, John Howard. *Film: The Creative Process.* New York, 1964.

Leyda, Jay. *Kino: A History of the Russian and Soviet Film.* New York, 1960.

Montagu, Ivor. *Film World.* Baltimore, 1964.

Potamkin, Harry Alan. *The Eyes of the Movie.* New York, 1934.

———. "Eisenstein and the Theory of Cinema." *Hound and Horn,* July–September 1933, pp. 678–89.

———. "Kino and Lichtspiel. *Close Up,* November 1929, pp. 387–98.

———. "Pabst and the Social Film." *Hound and Horn,* January–March 1933, pp. 293–305.

———. "Pudovkin and the Revolutionary Film." *Hound and Horn,* April–June 1933, pp. 480–93.

———. "René Clair and Film Humor." *Hound and Horn,* October–December 1932, pp. 114–23.

Pudovkin, V. I. *Film Technique.* London, 1933.

———. *Film Acting.* London, 1958. Also includes *Film Technique.*

Schapiro, Meyer. "A Metaphysics for the Movies." *Marxist Quarterly,* July–September, 1937, pp. 406–17.

Tretyakov, Sergei. *Der Film.* Moscow, 1928. [Not seen.]

See Baxandall for relevant periodical entries by Joris Ivens, Erwin Piscator, Dalton Trumbo, and the various Soviet film directors.

MUSIC

Adorno, Theodor W. SEE CONTRIBUTORS' BIBLIOGRAPHIES.

Blaukopf, Kurt. *Musiksoziologie.* Vienna, n.d.

Bloch, Ernst. SEE CONTRIBUTORS' BIBLIOGRAPHIES.

Bush, Alan. "Music." In C. Day-Lewis, ed., *The Mind in Chains.* London, 1937.

Cazden, Norman. "How Pure Is Music?" *Masses and Mainstream,* April, 1949, pp. 20–30.

———. "Musical Consonance and Dissonance: A Cultural Criterion." *Journal of Aesthetics and Art Criticism,* September, 1945, pp. 3–11.

———. "Towards a Theory of Realism in Music." *Journal of Aesthetics and Art Criticism,* vol. X, 1951, pp. 135–51.

Eisler, Hanns. SEE SECTION 6, and Baxandall, pp. 48–49.

Finkelstein, Sidney. SEE CONTRIBUTORS' BIBLIOGRAPHIES.

Hauser, Arnold. *The Social History of Art.* New York, 1957.

Lloyd, A. L. *English Folk Song.* London, 1965.

Lunacharsky, Anatoly. "Tanayev and Scriabin" and "Richard Wagner." In *On Literature and Art,* pp. 136–58, 340–54. Moscow, 1965.

Meyer, Ernst H. *English Chamber Music.* London, 1946.

———. "Consort Music." In *New Oxford History of Music,* vol. IV: *The Age of Humanism.* London, New York, and Toronto, 1968.

Newton, Francis [pseud. Eric Hobsbawm]. *The Jazz Scene.* London, 1959.

Ryzhkin, I. "Music and Reality." In anon., ed., *Art and Society.* Moscow, 1968.

Siegmeister, Elie. *Music and Society.* New York, 1938.

Solomon, Maynard. "Beethoven and Bonaparte." *The Music Review,* May 1968, pp. 96–105.

———. "Beethoven, Sonata, and Utopia." *Telos,* no. 9 (Fall 1971), pp. 30–47.

Tchemodanov, Sergei. "An Economic Approach to Music." *Modern Music,* May–June 1933, pp. 175–81.

See Baxandall for writings on music by Marc Blitzstein, Aaron Copland, Woody Guthrie, Dmitri Kabalevsky, Aram Khachaturian, Zoltan Kodály, Sergei Prokofiev, and Dmitri Shostakovich.

ART HISTORY

Antal, Frederick. *Classicism and Romanticism*. London, 1966.

———. *Florentine Painting and Its Social Background: XIV and Early XV Centuries*. London, 1948.

———. *Fuseli Studies*. London, 1956.

———. *Hogarth and His Place in European Art*. London, 1962.

Balet, Leo. *Die verbürgerlichung der deutschen Kunst, Literatur und Musik in 18. Jahrhundert*. In collaboration with E. Gerhard (pseud. Eberhard Rebling). Strassburg, 1936.

Berger, John. *Toward Reality: Essays in Seeing*. New York, 1962.

———. *Success and Failure of Picasso*. Baltimore, 1965.

Billiet, Joseph, "The French Revolution and the Fine Arts." In *Essays on the French Revolution*, pp. 197–208. London, 1945.

Blunt, Anthony. "Dalou and His Workers' Monument." *Left Review*, October 1936, pp. 693–98.

———. "Art Under Capitalism and Socialism." In C. Day-Lewis, ed., *The Mind in Chains*. London, 1937.

Brown, Milton W. *American Painting from the Armory Show to the Depression*. Princeton, N.J., 1955.

———. *The Painting of the French Revolution*. New York, 1938.

Bukharin, Nikolai. *Historical Materialism,* pp. 197ff. New York, 1925.

Finkelstein, Sidney. SEE CONTRIBUTORS' BIBLIOGRAPHIES.

Hausenstein, Wilhelm. *Vom Geist des Barock*. Munich, 1920.

———. *Giotto*. Berlin, n.d. [1922?].

———. *Die Kunst und die Gesellschaft*. Munich, 1917.

———. *Rokoko*. Munich, 1918.

———. "Versuch einer Soziologie der bildenden Kunst." *Archiv für Sozialwissenschaft und Sozialpolitik,* May 1913.

Hauser, Arnold. *Mannerism: The Crisis of the Renaissance and the Origin of Modern Art*. New York, 1965.

———. *The Philosophy of Art History*. New York, 1958.

———. "Propaganda, Ideology and Art." In *Aspects of History and Class Consciousness,* edited by István Mészáros, pp. 128–51. London, 1971.

———. *The Social History of Art*. 4 vols. New York, 1958.

Kautsky, Karl. SEE CONTRIBUTORS' BIBLIOGRAPHIES. Kautsky's contributions to the *Zeitschrift für Plastik* during the 1880's are available at La Bibliothèque Nationale, Paris.

Klingender. Frances D. *Art and the Industrial Revolution*. London, 1947.

———. *Goya in the Democratic Tradition*. London, 1948.

Larkin, Oliver. *Art and Life in America.* New York, 1949.

———. Four articles on Daumier and Courbet. *Science and Society,* Spring 1937, Winter 1939, Fall 1940, Summer 1941.

Lindsay, Jack. *J. M. W. Turner: a Critical Biography.* New York, 1966.

Lloyd, A. L. "Modern Art and Modern Society." In *Five on Revolutionary Art,* edited by Betty Rae, pp. 53–71. London, 1935.

Lukács, Georg. "On Writing the History of Art." *Communist Review,* October 1952, pp. 309–16.

Lunacharsky, Anatoly. " 'The Man Who Painted Happiness' (On Viewing the Canvases of Renoir)." In *On Literature and Art,* pp. 365–74. Moscow, 1965.

Morris, William. SEE CONTRIBUTORS' BIBLIOGRAPHIES.

Péret, Benjamin. "Notes on Pre-Columbian Art." *Horizon,* June 1947, pp. 364–74.

Plekhanov, Georgi. "French Dramatic Literature and French Eighteenth-Century Painting from the Sociological Standpoint." In *Art and Social Life.* London, 1953.

Raphael, Max. SEE CONTRIBUTORS' BIBLIOGRAPHIES.

Schapiro, Meyer. "Style." In *Aesthetics Today,* edited by Morris Philipson, pp. 81–113. Cleveland and New York, 1961. See Baxandall for Schapiro's contributions to *Marxist Quarterly, Art Front, Partisan Review,* and *New Masses.*

Tafuri, Manfredo, ed. *Socialismo, città, architettura URRS 1917–1937.* Rome, 1971.

See Baxandall for listings by Jean Cassou, Harold Rosenberg, and "Marion Summers," and for writings on art by Philip Evergood, Fernand Léger, Jack Levine, Pablo Picasso, Diego Rivera, David Alfaro Siquieros, and the Surrealists.

BIBLIOGRAPHIES

Baxandall, Lee. *Marxism and Aesthetics: A Selective Annotated Bibliography. Books and Articles in the English Language.* New York, 1968. The most recent and comprehensive listing. Though poorly organized and containing numerous errors, it is an indispensable bibliographical aid.

Birnbaum, Norman. "The Sociological Study of Ideology, 1940–1960." *Current Sociology,* vol. IX, no. 2 (1960), pp. 127–72. An extremely important annotated guide.

Flores, Angel. "History of Literature." *Dialectics,* no. 7 (n.d., [1938]), pp. 16–18. A few listings of full-length histories of literature from Marxist viewpoint. Several non-Marxist works are also included.

Lachs, John. *Marxist Philosophy: A Bibliographical Guide.* Chapel Hill, N.C., 1967. The best available general guide to materials on Marxist philosophy in English. Good selected listings in aesthetics. Excellent listing of bibliographies of Marxist materials.

"Marxism and the Arts: A Bibliography." *New Foundations,* Summer 1948, pp. 250–53; Fall 1948, pp. 80–86. Brief but accurate guide to materials then available in English.

"Marxism and Philosophy: A Bibliography." *New Foundations,* Fall 1947, pp. 90–96.

Rubel, Maximilien. *Bibliographie des oeuvres de Karl Marx.* Paris, 1956. *Supplément.* Paris, 1960. A comprehensive guide to the works of Marx and Engels.

SOURCES FOR SELECTIONS

Following are the printed sources from which the selections in the anthology have been drawn. More detailed descriptions of the English-language editions used for the selections by Marx and Engels in "A Reader in Marxist Aesthetics" are given below, on pp. 643–6. The editor has supplied all titles for the selections by Marx and Engels. Other titles supplied by the editor are indicated by an asterisk in this listing.

A READER IN MARXIST AESTHETICS

Marx, *Theories of Surplus Value* (Kautsky edition), vol. I, pp. 388–89. Cited from *Karl Marx: Selected Writings in Sociology and Social Philosophy,* edited by T. B. Bottomore and M. Rubel (London, 1963), p. 100.

34 THE UNIVERSAL AND THE PARTICULAR
Marx, Introduction to *A Contribution to the Critique of Political Economy,* p. 269.

35 BEING, CONSCIOUSNESS, AND THE IDEOLOGICAL REFLEX
Marx and Engels, *The German Ideology,* pp. 36–37.

36 IDEOLOGY AND FALSE CONSCIOUSNESS
Engels to Mehring, July 14, 1893, in *Selected Works,* vol. III, p. 496.

37 ON THE PRODUCTIVITY OF ALL PROFESSIONS
Marx, *Theories of Surplus Value,* vol. I, pp. 386–87.

38 THE FETISHISM OF COMMODITIES, I
Marx, *A Contribution to the Critique of Political Economy,* pp. 30–31, 50–51.

39 THE FETISHISM OF COMMODITIES, II
Marx, "The Fetishism of Commodities and the Secret Thereof," *Capital,* vol. I, pp. 41–43.

40 ALIENATION
Marx, *Capital,* vol. I, pp. 660–61.

41 PROGRESS AND ALIENATION
Marx, Speech at the Anniversary of the People's Paper, April 14, 1856, in *Selected Works,* vol. I, pp. 500–501.

42 THE ILLUSION OF THE EPOCH, I
Marx and Engels, *The German Ideology,* pp. 49–51.

44 THE ILLUSION OF THE EPOCH, II
Marx and Engels, *The Holy Family,* p. 109 (translation amended).

44 THE SYMBOLIC POWER OF MONEY
Marx, *Economic and Philosophic Manuscripts,* pp. 137–39.

46 THE PSYCHOLOGY OF CAPITAL ACCUMULATION
Marx, *Capital,* vol. I, pp. 604–5.

47 ALL KNOWING IS SENSUOUS MEASUREMENT
Engels, *Dialectics of Nature,* p. 328.

48 INVERTED CONSCIOUSNESS AND SELF-ALIENATION
Marx, Introduction to *A Contribution to the Critique of Hegel's Philosophy of Right,* in *On Religion,* pp. 41–42.

49 CLASS DETERMINATION OF SUPERSTRUCTURE
Marx and Engels, *The Communist Manifesto,* in *Selected Works,* vol. I, p. 123.

WILLIAM MORRIS

NIKOLAI BUKHARIN

ANATOLY LUNACHARSKY

MAXIM GORKI

YURI DAVYDOV

MAO TSE-TUNG

JEAN-PAUL SARTRE

255 THE NOVEL AND REALITY*
Speech at a Conference of European Writers, Leningrad, Summer 1963. *New Left Review,* no. 29 (January–February, 1965), pp. 37–40.

W. E. B. DU BOIS

259 THE NATURE OF INTELLECTUAL FREEDOM
A paper presented at the Cultural and Scientific Conference for World Peace, New York, March 25–27, 1949. *Speaking of Peace,* ed. Daniel S. Gillmor (New York, 1949), p. 78.

ANTONIO GRAMSCI

266 MARXISM AND MODERN CULTURE
The Modern Prince and Other Writings, translated by Louis Marks (London, 1957), pp. 82–85.

ERNST FISCHER

272 PRODUCTIVE MEMORY
Art Against Ideology, translated by Anna Bostock (New York, 1969), pp. 165–66.

SIDNEY FINKELSTEIN

277 ART AS HUMANIZATION
From "The Artistic Expression of Alienation," in *Marxism and Alienation: A Symposium,* ed. Herbert Aptheker (New York, 1965), pp. 26–30.

BÉLA BALÁZS

284 THE VISIBLE MAN
From *Der Sichtbare Mensch,* reprinted in *Theory of the Film,* translated by Edith Bone (New York, 1970), pp. 39–45.

FRIEDRICH ENGELS

HARRY SLOCHOWER

ALICK WEST

ANDRÉ BRETON

Speech to the International Association of Writers for the Defense of Culture, Paris, June 1935. Translated by Samuel Putnam. *Partisan Review,* vol. II, no. 9 (October–November 1935), pp. 41–43.

ERNST BLOCH

MARX AND ENGELS: EDITIONS CITED

Quotations and excerpts from the works of Marx and Engels in this anthology are cited from the following English-language editions. The edition first listed is the one which has been utilized. The list is arranged in chronological order, according to the date of composition rather than of publication. The parenthetical numbers following each date refer to the number assigned to each work in Maximilien Rubel, *Bibliographie des Oeuvres de Karl Marx, avec en appendice un Répertoire des Oeuvres de Friedrich Engels* (Paris, 1956), and to the *Supplément* to the same work (Paris, 1960).

1837 (840) Marx. Letter to his Father. In Loyd D. Easton and Kurt H. Guddat, eds. and trans., *Writings of the Young Marx on Philosophy and Society,* New York, 1967, pp. 40–50.

1839–1841 (8) Marx. Doctoral Dissertation, *The Difference Between the Democritean and Epicurean Philosophy of Nature.* In Norman D. Livergood, *Activity in Marx's Philosophy,* The Hague, 1967, pp. 55–109.

1839–1841 (8) Marx. *Notes to the Doctoral Dissertation.* In *Writings of the Young Marx,* pp. 51–56.

1842 (12) Marx. "The Leading Article of No. 179 of the *Kölnische Zeitung.*" Marx and Engels, *On Religion,* Moscow, 1957, pp. 16–40; also in *Writings of the Young Marx,* pp. 109–30.

1842 (27) Marx. "Comments on the Latest Prussian Censorship Instruction." In *Writings of the Young Marx,* pp. 67–92.

1843 (857) Marx. Letter to Arnold Ruge, Sept., 1843. In *Writings of the Young Marx,* pp. 211–15.

1843–1844 (38) Marx. "Contribution to the Critique of Hegel's *Philosophy of Right:* Introduction." In *On Religion,* pp. 41–58; also in *Writings of the Young Marx,* pp. 249–64, and in T. B. Bottomore, ed. and trans. *Karl Marx: Early Writings,* London, 1963, pp. 43–59.

1844 (41) Marx. *Economic and Philosophic Manuscripts of 1844,* Moscow, n.d.; 2nd ed., Moscow, 1961, with slightly different pagination; also in *Early Writings,* pp. 69–219.

1844–1845 (E 18) Engels. *The Condition of the Working-Class in England.* In Marx and Engels, *On Britain,* Moscow, 1962, pp. 1–338.

1845 (44) Marx and Engels. *The Holy Family,* Moscow, 1956.

1845 (46) Marx. "Theses on Feuerbach," edited by Engels. In Marx and Engels, *Selected Works,* 3 volumes, Moscow, 1969–1970, vol. I, pp. 13–15; Marx's original version is cited from *The German Ideology,* Addenda, pp. 645–47, and also appears in Bottomore and Rubel, *Karl Marx: Selected Writings in Sociology & Social Philosophy,* London, 1963, pp. 67–9.

1845–1846 (48) Marx and Engels. *The German Ideology,* Moscow, 1964.

1846–1847 (55) Marx. *The Poverty of Philosophy.* Edited by C. P. Dutt and V. Chattopadhyaya, Moscow, n.d.

1847–1848 (70) Marx and Engels. *Manifesto of the Communist Party*. In *Selected Works*, vol. I, pp. 96–137.

1850 (193) Marx and Engels. Review of Daumer's *The Religion of the New Age*. In *On Religion*, pp. 89–95.

1850 (E 40) Engels. *The Peasant War in Germany* [revised 1870], Moscow, 1956.

1851–1852 (215) Marx. *The Eighteenth Brumaire of Louis Bonaparte*. In *Selected Works*, vol. I, 398–487.

1856 (451) Marx. Speech at the Anniversary of the *People's Paper*, April 14, 1856, In *Selected Works*, vol. I, pp. 500–1.

1857–1858 (489) Marx. *Pre-Capitalist Economic Formations* [extract from *Grundrisse der Kritik der politischen Oekonomie*], London, 1964.

1857–1858 (489) *The Grundrisse* [selections from *Grundrisse der Kritik der politischen Oekonomie*]. Ed. and trans. by David McLellan, New York, Evanston, San Francisco, London, 1971.

1857–1859 (529) Marx. *A Contribution to the Critique of Political Economy*, Chicago, 1904. The "Preface" to this work (1859) is cited from *Selected Works*, vol. I, pp. 502–6. The "Introduction" to this work (1857) is cited from the 1904 edition.

ca. 1861–1879 (633, 635, 636) Marx. *Capital: A Critical Analysis of Capitalist Production*, London, 1889 (vol. I), Moscow, 1961–1962 (vols. II and III).

1862–1863 (637) Marx. *Theories of Surplus-Value*, Moscow, 1963, 1968, 1971, 3 volumes.

1875 (732) Marx. *Critique of the Gotha Programme*, New York, 1938.

1878 (E 76) Engels. *Herr Eugen Dühring's Revolution in Science (Anti-Dühring)*, Moscow, 1962.

1880 (E 79) Engels. *Socialism: Utopian and Scientific* [3 revised chapters from *Anti-Dühring*, with an appendix on "The Mark"]. In *Selected Works*, vol. III, pp. 95–151.

1884 (E 93)
Engels. *The Origin of the Family, Private Property and the State* [4th revised edition, 1894]. In *Selected Works,* vol. III, pp. 191–334.

ca. 1873–1886
(E 85)
Engels. *Dialectics of Nature,* New York, 1940.

1886–1888 (E 97)
Engels. *Ludwig Feuerbach and the Outcome of Classical German Philosophy.* In *Selected Works,* vol. III, pp. 335–76.

1868–1895
Engels. *Correspondence with Paul and Laura Lafargue, 1868–1895,* Moscow, 1959 *et seq.*

1846–1895
Marx and Engels. *Selected Correspondence,* Moscow, 1965. For other correspondence in translation see *Selected Correspondence, 1846–1895,* New York, 1942; *Letters to Americans, 1845–1895,* New York, 1953; *On Britain,* pp. 533–84; *Selected Works,* vol. I, pp. 517–30; *Selected Works,* vol. II, pp. 413–34; *Selected Works,* vol. III, pp. 31–40, 152–61, 477–506; *Writings of the Young Marx,* pp. 203–15. The letters on literature (to Harkness, M. Kautsky, P. Ernst, Lassalle etc.) are cited from Marx and Engels, *Literature and Art,* New York, 1947, or from *International Literature,* 1933, No. 3, pp. 112–24, and 1933, No. 4, pp. 108–22.

ACKNOWLEDGMENTS

Grateful acknowledgment is extended to the following, for permission to reprint material:

American Dialog, successor to The New Masses: "Literature and Society" by Harry Slochower, in *The New Masses*, April 25, 1939.

Beacon Press and Allan Lane/The Penguin Press: From *Eros and Civilization* by Herbert Marcuse. Copyright 1955, © 1966 by The Beacon Press.

Beacon Press and Merlin Press Ltd.: From *The Historical Novel* by George Lukács, translated by Hannah and Stanley Mitchell. Copyright © 1962 by Merlin Press Ltd.

George Braziller, Inc. and Penguin Books, Ltd.: From *Art Against Ideology* by Ernst Fischer, translated by Anna Bostock. Copyright © 1966 by Rohwolt Verlag GmbH. Originally published in Germany by Rohwolt in 1966 as *Kunst und Koexistenz*. Translation Copyright © 1969 by Anna Bostock, and first published in 1969 by George Braziller, Inc.

Dennis Dobson Books Ltd.: From *Theory of the Film* by Béla Balázs, translated by Edith Bone. Copyright 1952 by Dennis Dobson Books Ltd. U.S. publisher: Dover Publications, Inc.

Doubleday & Company, Inc.: From *Writings of the Young Marx on Philosophy and Society,* translated and edited by Lloyd D. Easton and Kurt H. Guddat. Copyright © 1967 by Lloyd D. Easton and Kurt H. Guddat.

Shirley Graham Du Bois and the Estate of W. E. B. Du Bois: "The Nature of Intellectual Freedom." Copyright 1949 by the National Council of Arts, Sciences and Professions.

Harcourt Brace Jovanovich, Inc. and Suhrkamp Verlag: From *Illuminations* by Walter Benjamin, translated by Harry Zohn. Copyright © 1955 by Suhrkamp Verlag, Frankfurt-am-Main; English translation Copyright © 1968 by Harcourt Brace Jovanovich, Inc.

Herder and Herder: From *A Philosophy for the Future* by Ernst Bloch, translated by John Cumming. Copyright © 1963 Suhrkamp Verlag, Frankfurt-am-Main; English translation Copyright © 1970 by Herder and Herder, 232 Madison Avenue, New York, N.Y.

Hill and Wang, Inc. and Methuen & Co. Ltd.: From *Brecht on Theatre,* translated by John Willett. Copyright © 1957, 1963, 1964 by Suhrkamp Verlag, Frankfurt-am-Main. Translation and notes © 1964 by John Willett.

Humanities Press, Inc.: From *Marxism and Alienation: A Symposium* edited by H. Aptheker. Copyright © 1965 by Humanities Press, Inc. From *Reason and Revolution* by Herbert Marcuse. Copyright 1941 by Oxford University Press, New York; Copyright 1954 by Humanities Press, Inc. Preface, "A Note on Dialectic," Copyright © 1960 by Herbert Marcuse.

International Publishers: From *Historical Materialism: A System of Sociology* by Nikolai Bukharin. Copyright 1925 by International Publishers. From *Dialectics of Nature* by Friedrich Engels, translated by C. P. Dutt. Copyright 1940 by International Publishers. From *Literature and Art* by Karl Marx and Friedrich Engels. Copyright 1947 by International Publishers.

Lawrence & Wishart Ltd.: From *Illusion and Reality* by Christopher Caudwell. From *The Modern Prince and Other Writings* by Antonio Gramsci, translated by Louis Marks. Copyright © 1957 by Louis Marks. From *Pre-Capitalist Economic Formations* by Karl Marx, translated by Jack Cohen, edited by E. J. Hobsbawm. Copyright © 1964 by Cohen and Hobsbawm. From *Art and Social Life* by George Plekhanov, translated by Eleanor Fox and Eric Hartley, edited by Andrew Rothstein. From *Aeschylus and Athens* and *Studies in Ancient Greek Society: The Prehistoric Aegean* by George Thomson. From *Crisis and Criticism* by Alick West. From *Karl Marx: A Symposium,* edited by D. Ryzanoff.

The Macmillan Company and Jonathan Cape, Ltd.: From *The History of Surrealism* by Maurice Nadeau, translated by Richard Howard. Copyright © 1965 by The Macmillan Company.

Merlin Press Ltd.: From *The Meaning of Contemporary Realism* by Georg

Lukács, translated by John and Necke Mander. Copyright © 1962 by Merlin Press Ltd.

The M.I.T. Press: From *Rabelais and His World* by Mikhail Bakhtin, translated by Helene Iswolsky. Copyright © 1968 by M.I.T. Press, Inc.

The New Hungarian Quarterly: "Introduction to a Monograph on Aesthetics" by György Lukács. English version from *The New Hungarian Quarterly,* vol. V, no. 14. Copyright © 1965 by György Lukács. Reprinted by permission of the author.

New Left Review: From "Paris—Capital of the 19th Century" by Walter Benjamin, in *New Left Review* 48. Copyright © 1968 by New Left Review. Speech by Jean-Paul Sartre to Leningrad Conference, 1963, in *New Left Review* 29. Copyright © 1963 by New Left Review. London.

New Park Publications: From "Class and Art" by Leon Trotsky, in *The Fourth International,* vol. 4, no. 2, July 1967.

Partisan Review and André Malraux: "The Work of Art" by André Malraux, translated by Samuel Putnam, in *Partisan Review,* October–November 1935, vol. 2, no. 9. Copyright 1935 by Partisan Review.

Princeton University Press: From *Prehistoric Cave Paintings* by Max Raphael, translated by Norbert Guterman, Bollingen Series IV (Pantheon Books 1945). Copyright 1945 by The Bollingen Series, Old Dominion Foundation. From *The Demands of Art* by Max Raphael, translated by Norbert Guterman, Bollingen Series LXXVIII (Princeton University Press, 1968). Copyright © 1968 by Bollingen Foundation.

Quarterly Review of Literature: From "André Malraux" by Harry Slochower, in *Quarterly Review of Literature,* vol. II, no. 1, Fall 1944. Reprinted by permission of the publisher and the author.

Rogner & Bernhard GmbH: From *Composing for the Films* by Hanns Eisler and T. W. Adorno, translated by George MacManus and Norbert Guterman. Copyright © 1947 by Oxford University Press Inc. Published by Verlag Rogner & Bernhard GmbH., Munich, 1969. ISBN 3 920802 27 6.

Russell & Russell, Publishers: From *Foundations of Christianity* by Karl Kautsky, translated by Henry F. Mins, 1953.

Suhrkamp Verlag KG: From *Erbschaft dieser Zeit* by Ernst Bloch. Copyright © 1969 by Suhrkamp Verlag, Frankfurt-am-Main.

University of Michigan Press: From *Manifestoes of Surrealism* by André Breton, translated by Richard Seaver and Helen R. Lane. Copyright © 1969 by the University of Michigan. Originally published as *Manifestes du Surréalisme.* Copyright © 1962 chez J.-J. Pauvert.

Yale French Studies. From "The Function of Myth in Existentialism" by Harry Slochower, in *Yale French Studies,* vol. 1, no. 1, 1948.

INDEX

ABOUT THE AUTHOR

Born in New York City in 1930, Maynard
Solomon is the author of the widely ac-
claimed *Beethoven* (1977). He is a regular
contributor to *Musical Quarterly, Music
& Letters, Beethoven Studies,* and other
journals. In addition to his extensive writ-
ings on music and aesthetics he has pub-
lished papers on Freud in *American
Imago,* a psychoanalytic journal of which
he is an associate editor. He is editor of
*Myth, Creativity, Psychoanalysis: Essays
in Honor of Harry Slochower* (Wayne
State University Press, 1979). Professor
Solomon teaches at the Graduate School
and University Center of City University
of New York.